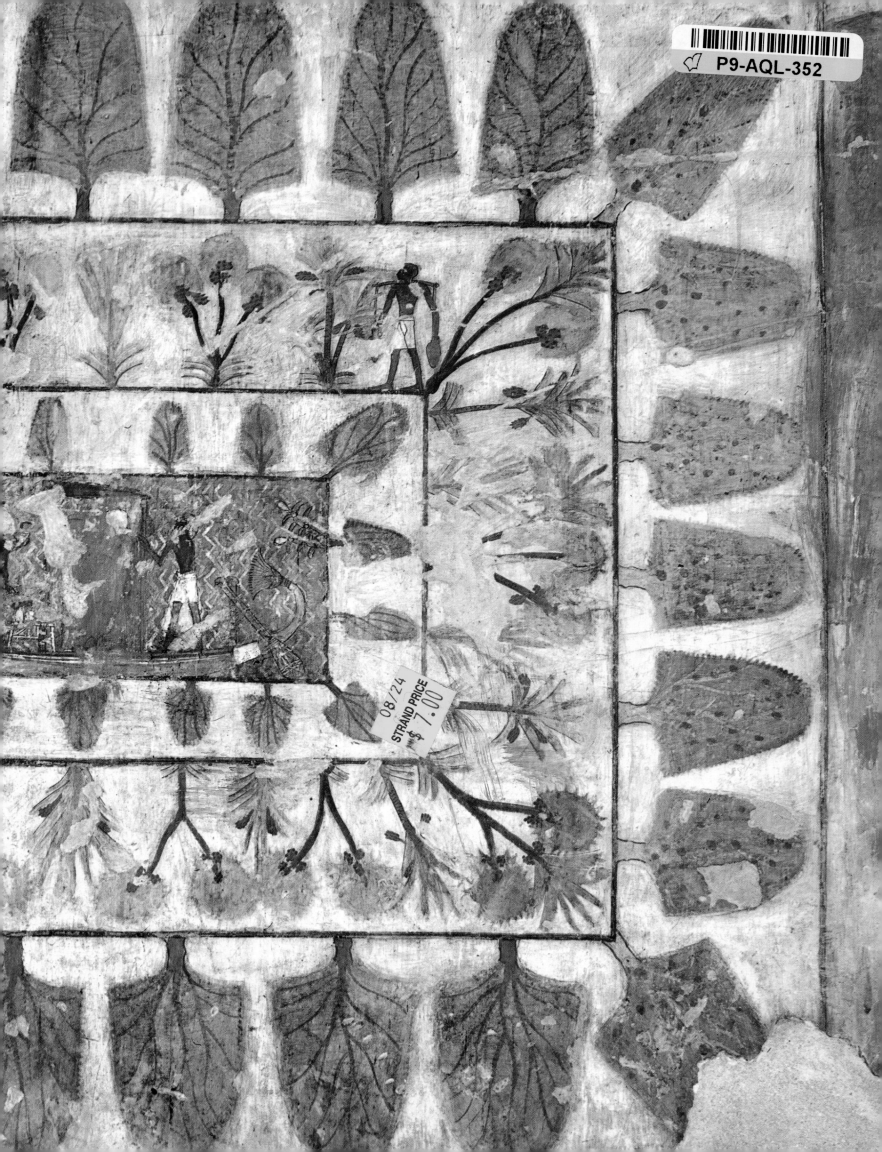

ART OF ANCIENT EGYPT

ART OF

Kazimierz Michalowski

ANCIENT EGYPT

HARRY N. ABRAMS, INC., Publishers, New York

Conceived, designed, and executed under the supervision of

LUCIEN MAZENOD

THE PHOTOGRAPHS

All color photographs are by JEAN VERTUT, except for the following :
Jean Mazenod, figs. 1, 4, 5, 9, 11, 12, 15, 18, 26, 35, 37-39, 46, 47, 70, 71, 86, 109, 113, 116, 117, 121, 123, 130, 134; Hermann Friedrich, figs. 7, 80, 81; K. Michalowski, figs. 13, 90, 91, 143; Scala, figs. 14, 16, 53, 79; State Museums, Berlin, 40, 89, 103, 104; Egyptian Museum, Turin, fig. 41; Service de la documentation photographique des musées nationaux de France, 42-44, 74, 137, 139, 140; Robert Fleming, figs. 50, 56, 65, 68, 129, 132, 142; Metropolitan Museum of Art, New York, figs. 52, 82, 83; Brooklyn Museum, figs. 55, 73; Roger Viollet, fig. 58; Erwin Meyer, fig. 64; Tadeusz Biniewski, figs. 66, 78, 131, 135, 138; Derek Balmer, fig. 75; J. Lipinska, fig. 100; Holford, fig. 102; Bulloz, fig. 105; Almasy, fig. 127; British Museum, London, fig. 136.

Black-and-white photographs in Section 14, Documentary Photographs, are reproduced courtesy of the museums or custodians of the works of art, unless otherwise specified.

Black-and-white photographs in Section 15, Descriptions of Archaeological Sites, are by Jean Vertut, except for the following: H. Cartier-Bresson, Magnum, fig. 817; Roger Viollet, figs. 818, 835, 850 ,852, 883, 888, 944, 949, 950; Emery, Archaic Egypt, figs. 821, 822; H. de Segogne, figs. 824, 827, 839, 842, 846, 856, 898, 930, 942, 946, 947, 963-67; J. Mazenod, figs. 828, 854, 858, 866, 867, 879, 894, 905, 914, 915, 927, 931, 937, 968; Museum of Fine Arts, Boston, fig. 851; J.-M. Bresson, Atlas Photo, fig. 857; K. Michalowski, figs. 870, 871, 958; J. Lipinska, figs. 890, 891, 962; Atlas Photo, figs. 900, 907; C. de Witt, Archives Comité des Fouilles Belges d'El Kab, fig. 922; Bulloz, fig. 941; Centre de Documentation, figs. 952, 953; A. Dziewanowski, figs. 956, 957.

Translated and adapted from the Polish and the French by Norbert Guterman

Library of Congress Catalog Card Number : 68-26865
Standard Book Number: 8109-0013-0

Copyright in France by Éditions d'Art Lucien Mazenod, Paris

Colorplates and black-and-white illustrations printed in France
Text printed in France. Bound in the Netherlands

ART OF ANCIENT EGYPT

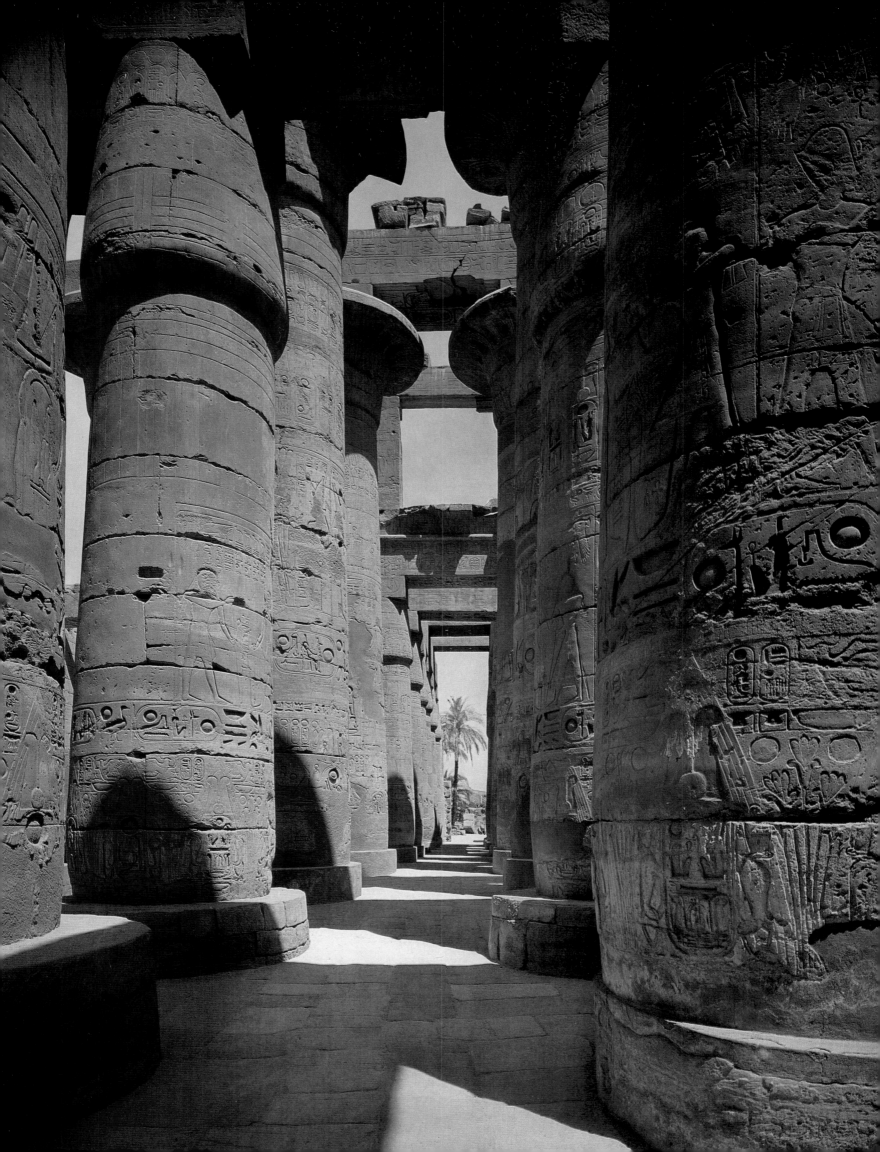

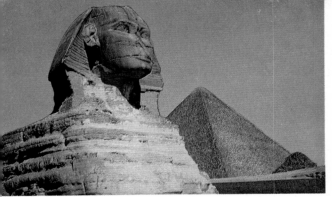

4

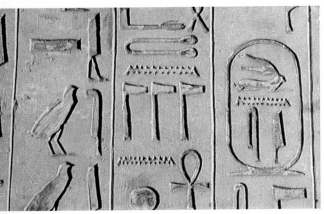

5

6

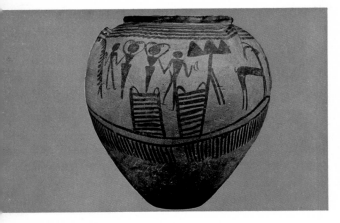

7

8

CONTENTS

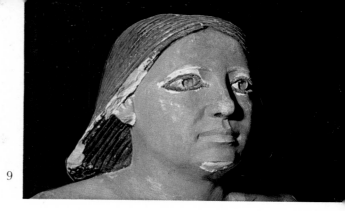

9

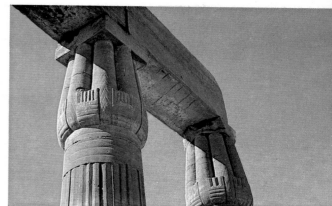

10

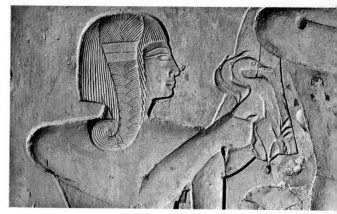

11

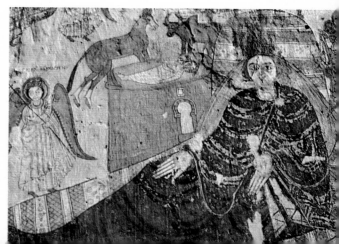

12

13

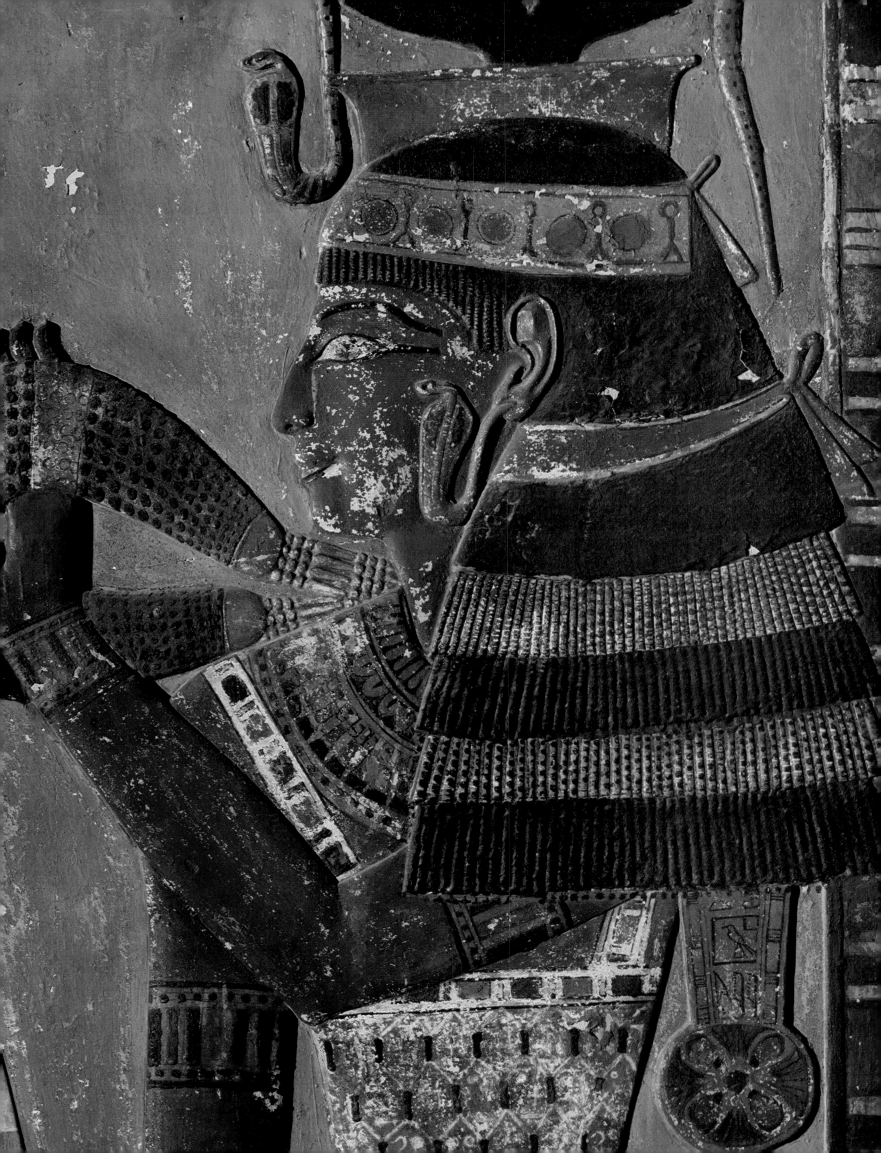

FOREWORD

FOREWORD

THIS *book requires a few words of explanation by way of introduction: it does not resemble the usual survey of Egyptian art, nor has it the character of a textbook. It was conceived as the successor to the first volume in this series,* Treasures of Prehistoric Art *by A. Leroi-Gourhan, on which it has been modeled in some respects.*

I was reluctant to accept this project. I believed, and still believe, that a number of my colleagues in the ranks of Egyptologists would have been better qualified to write this book. If I nonetheless agreed to write it, this was because of other considerations.

My background in Greek archaeology has given me a somewhat different approach to ancient Egyptian art and culture from that of many Egyptologists. The narrow compartmentalization that once prevailed in the study of the great Mediterranean cultures is beginning to break down; in its extreme form, the individual Mediterranean cultures were cut off completely from their common foundation: the Graeco-Roman world was considered apart from the civilization of ancient Egypt, for instance, or from Mesopotamia. A new way of grasping ancient civilization as a whole is now gaining ground, and almost constitutes a new branch of knowledge: namely, Mediterranean culture. This approach brings with it a certain danger of superficiality, if not incompetence, for the quantity of materials to be mastered is enormous and each ancient civilization has specific features that set it off from the others. There is still no dispensing with intense specialization.

These considerations would have been entirely justified a few decades ago, when the archaeologist was looked upon exclusively as a researcher and each new scholarly discovery usually associated with a single individual. Archaeological methods today, however, require a carefully matched team of specialists working under an experienced leader. Each investigation is subject to collective control from its inception. Such methods forestall the risk that a given problem will be approached superficially or incompetently.

Extensive field work, not confined to a single site, results in a grasp of individual problems that is based on a broad range of comparative knowledge. This is the path I have followed, and it has led to my own generalizations concerning the character and content of Egyptian art. To me this art is a unique phenomenon, determined by historical, social, and geographical factors.

A few years ago I wrote for the Polish publishers Wiedza Powszechna *(Popular Science) a book entitled* Not Just the Pyramids *that was intended to suggest a departure from the usual books about ancient Egypt; it served as the basis for the broader presentation that I offer here. These views may seem uncanonical, for all that they deal with the canon of Egyptian art. Inevitably, the archaeologist who spends most of his time in the field has not the same approach to his data as the archaeologist who spends most of his time studying printed sources.*

This book is not a history of Egyptian art. Rather, it aims at giving the reader a key with which to understand and evaluate that art. Each period is considered as a whole, its characteristic features brought into relief by examples drawn from every branch of art. A reader interested only in sculpture or architecture, for instance, will not always find his path made easier where specific questions of these arts are concerned: individual monuments are discussed only to illustrate the most distinctive traits of art in a given period.

Whatever our degree of familiarity with the art of ancient Egypt, it remains more remote from us than Greek art, however much the latter owes to Egyptian masters. Greek art, not Egyptian, is the wellspring of European art and culture. Thus the discussion of key problems of Egyptian art is preceded by introductory chapters on the country and the people, their language, literature, history, and religion. To grasp the true expressiveness of the art of ancient Egypt we must see it faithfully mirrored in its natural environment and in the social conditions that prevailed in the Nile valley at certain stages of Egypt's history.

The foregoing remarks suffice to account for Part One of this book; Part Two requires further comment. The idea was to bring problems expounded in Part One into relationship with concrete examples: that is, in Part Two is included a section describing Egypt's most important archaeological sites, our main sources for knowledge of its ancient art. Such a section could not be limited to a topographical description of surviving ruins. My aim has been to outline—insofar as possible—the historical development of each given town, necropolis, or religious complex. This involves numerous difficulties, because many matters widely believed to be self-evident are actually not so at all. On the contrary, they are complicated and raise serious problems. An illustration of how far we are from scientific exactness in archaeological publication: it is not easy to find two works on the Giza pyramids that give them the same set of over-all measurements!

To pick and choose among existing archaeological sites is no simple matter, and one's choice can always be questioned. I may well be criticized for including one site while omitting another equally deserving of attention. I expect that I shall be obliged to recognize many such criticisms as justified. Some others, perhaps, I can forestall here. I have omitted all prehistoric sites, such as Nagadah, Badari, and others mentioned in Part One. These have given us invaluable historical evidence concerning the earliest stages of artistic activity in the Nile valley and other features of its history. These sites, however, no longer have archaeological importance, for there is nothing left to see; it is difficult to recognize them as sites. What matters today is not the sites but the discoveries made there, now housed in museums. These continue to supply a basis for historical or typological judgments.

Once the principle is accepted that archaeological sites are localities in which traces of human culture remain, if only as architectural ruins, then the exclusion of prehistoric sites will surely be understandable. (The rock drawings in Nubia present an altogether different problem, which I have tried to clarify in the section devoted to this area.)

Another aspect of Part Two that might well be questioned is its internal organization. Alphabetical order had to be rejected, for the description of sites is not intended to be encyclopedic. Nor was geographical arrangement suitable—nome by nome, for instance; actually, the character of the sites discussed was never determined by the geography of ancient Egypt. Similarly, a guidebook breakdown (in terms of convenient order of visit) had to be rejected. It would have obliged me to begin the survey at Alexandria, ancient Egypt's last great city, which was founded by comparative latecomers—hardly a suitable introduction to a three-thousand-year-old history of human settlement. For these reasons I have chosen to begin with the two oldest urban settlements, Heliopolis and Memphis—especially noteworthy for having given birth to the two oldest religious systems of ancient Egypt—and the royal necropolises adjoining them: Saqqarah, Medum, Dahshur, Giza, Abu Roash, and Abusir.

The Nile delta played a crucial part in Egypt's earliest history. It also served as the stage for the last

act of ancient Egypt's history: the Ptolemaic, Roman, and Christian periods. This is why Lower Egypt occupies the second category in our survey.

The Fayum region has always constituted a compact economic whole, and politically it played a very important role in ancient Egypt, especially during the Middle Kingdom. It forms the third category in our survey. Middle Egypt—falling between the Fayum and Upper Egypt and including the necropolises of Middle Kingdom dignitaries at Beni Hasan and Deir el Bersheh—is treated as a transitional area, although it must be admitted that this represents a considerable compromise with geography. Upper Egypt, from Abydos to Kom Ombo, forms a single category, if only because of the representative character of the monuments situated there. The area of the First Cataract serves as a stepping-off point to Nubia, which here has deliberately been treated more sketchily then other areas. This decision is explained in the opening paragraphs of the section dealing with Nubia.

The Egyptian Christian monasteries, whether in Upper Egypt, on the shores of the Red Sea, or at Abu Mina, constitute a separate group. The oases have been omitted, primarily because they have still to be systematically explored, though once this is done they may well assume greater archaeological importance.

In the matter of place names, I have been guided by a practical rather than a strictly scientific principle. The first name given for a site is most often that currently used. This name may be that of a nearby Arab village; sometimes it is the Greek name by which the archaeological site became universally known.

In conclusion, a few bibliographical remarks: in Part One references are made, wherever possible, to the most important texts and sources of illustration bearing upon the matters discussed, excluding all papers in scientific periodicals. The references and bibliography will only be of service to readers searching for the most basic orientation. In Part Two, however, I thought it advisable to cite the most important publications concerning the excavations themselves, together with a few specialized treatises that supply the source for views which I support. Two basic works could have been cited over and over again: P. Montet, Géographie de l'Égypte ancienne, I-II, Paris, 1957-61; and J. Vandier, Manuel d'archéologie égyptienne, II; part 1, L'architecture funéraire (Paris, 1954), and part 2, L'architecture religieuse et civile (Paris, 1955).

In the choice of color illustrations the French publisher, Lucien Mazenod, has collaborated with the author. In choosing the rest of the illustrative material, which provides the basic documentary part of the book, I was greatly assisted by my pupil, Dr. Jadwiga Lipinska, to whom I am also indebted for many valuable observations concerning the composition of the text. To these two I am grateful for help and encouragement in, bringing the work to completion. However, I could never have undertaken the book at all were it not for my extensive work in the field, assisted by students and colleagues to whom I wish here to extend my most cordial thanks.

Both the publishers and I are greatly indebted to Dr. Sarwat Okasha, Minister of Culture and Art of the United Arab Republic, and to Professor Gamal Mokhtar, the general director of the Egyptian Antiquities Service in Cairo, for all they did to facilitate photography under especially trying conditions.

K. M.

ACKNOWLEDGMENTS

It would be impossible to give proper thanks to all who have helped and counseled us in the various stages of work on this book. But we shall take the opportunity here to express our particular gratitude to the conservators and directors of the following: the Egyptian Museum (Cairo); the Monuments of Saqqarah; the Necropolis of Thebes; the Egyptian department of the Metropolitan Museum of Art (New York); British Museum (London); Louvre (Paris); State Museums of Berlin; Brooklyn Museum; Kofler-Truniger Collection (Lucerne); Ny Carlsberg Glyptotek (Copenhagen); Kestner Museum (Hanover); Kunsthistorisches Museum (Vienna); Museum of Fine Arts (Boston); National Museum (Cracow); National Museum (Warsaw); Egyptian Museum (Turin); Rijksmuseum van Oudheden (Leiden); Roemer-Pelizaeus Museum (Hildesheim); University Museum of the University of Pennsylvania (Philadelphia); and the Walters Art Gallery (Baltimore).

Our most cordial thanks go to Jean Vertut and to the team of photographers who, despite difficult technical conditions, successfully made the remarkable photographs that illustrate this study. We are also grateful to the members of the Polish Archaeological Institute who facilitated their task by accompanying them on their photographic missions.

And finally, we wish to acknowledge the work of Dr. Jadwiga Lipinska, who was at Deir el Bahari during the time the first photographs were taken and later came to Paris to arrange many of the last details of this book. Associated with her in this pursuit were Zsolt Kiss and Jean-Dominique Rey.

Part One : Egypt, its Art and its History

1. THE RIDDLE OF ANCIENT EGYPT

Early legends about the pyramids

Bonaparte's expedition to Egypt

Denon surveys the ancient sites

Champollion deciphers the hieroglyphs

Egyptology and Egyptologists

Archaeological discoveries

15 a. GIZA. HEAD OF THE SPHINX
*This colossal statue having a lion's
body and a man's head reproduced
the features of King Chephren. It was
carved from an outcropping of rock
in the quarries at the foot
of the pyramids. Dynasty IV.*

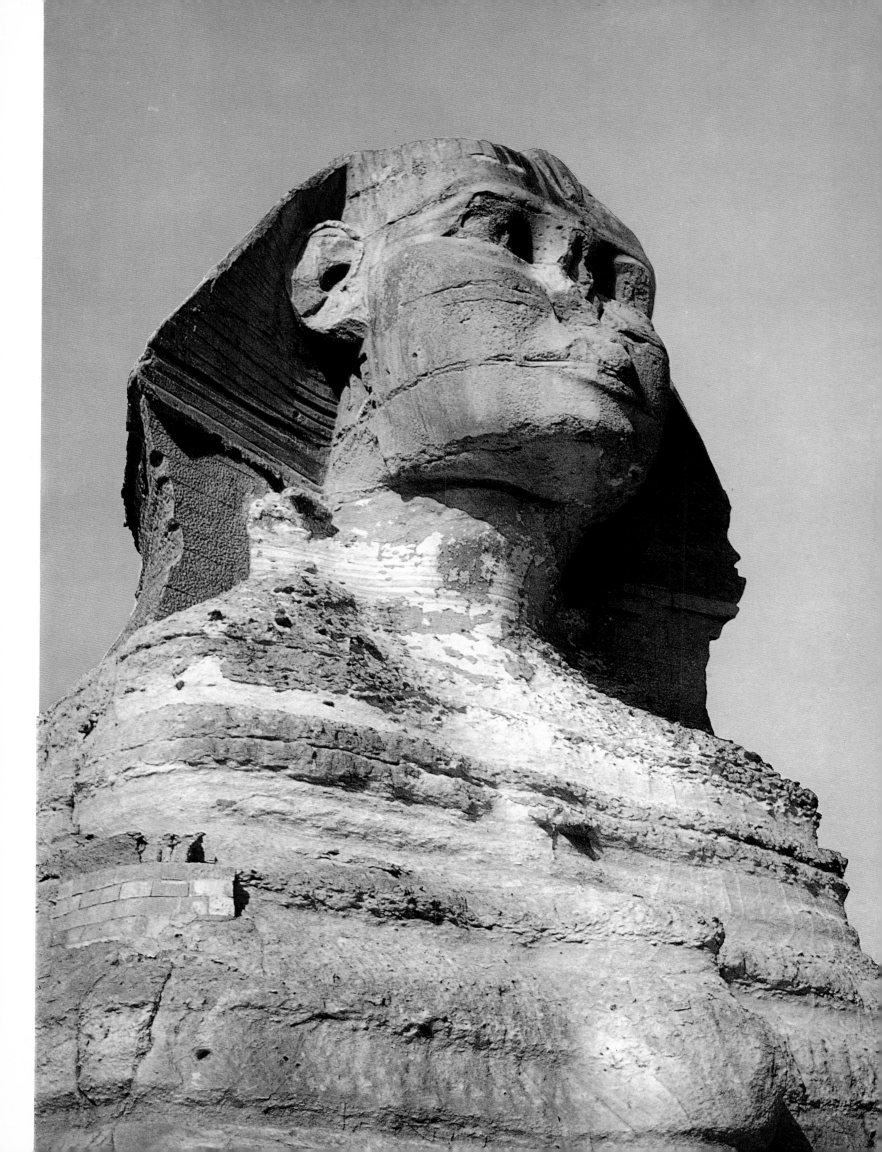

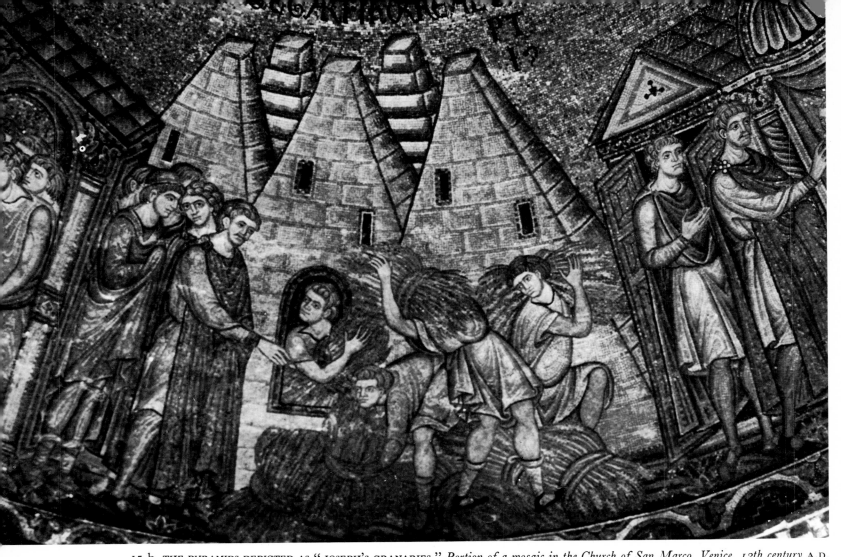

15 b. THE PYRAMIDS DEPICTED AS "JOSEPH'S GRANARIES." *Portion of a mosaic in the Church of San Marco, Venice. 13th century* A.D.

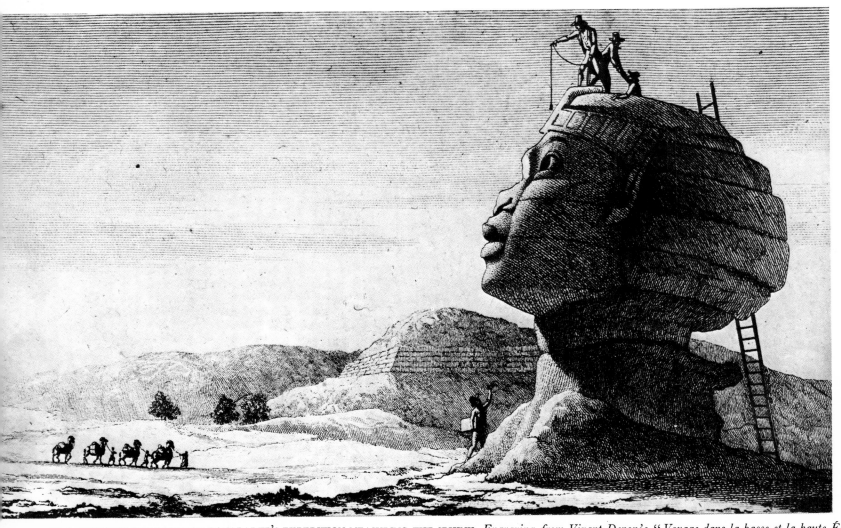

15 C. MEMBERS OF NAPOLEON BONAPARTE'S EXPEDITION MEASURING THE SPHINX. *Engraving from Vivant Denon's " Voyage dans la basse et la haute Égypte."*

1. THE RIDDLE OF ANCIENT EGYPT

Even before the end of Roman rule in Egypt, the monuments of that country's great past had become a mystery to its population. The Sphinx was not the only riddle. The art of reading the hieroglyphs had been forgotten: even the temple priests interpreted them as philosophical symbols. Such writers of the Early Christian era as Clement of Alexandria (second–third century) and Ammianus Marcellinus (fourth century) tried to make sense of them, but in vain.

There was no lack of legends, however, and the tales of Greek and Roman writers were picked up and embroidered upon by the Arabs, who conquered Egypt in the seventh century A.D. According to an Arabic manuscript dating from the first half of the tenth century, the pyramids were built by the legendary King Surid. When his astrologers warned of an imminent universal deluge, he had the pyramids constructed in order to preserve the sum total of knowledge and art from destruction. They were to shelter treatises on arithmetic, geometry, astrology, and medicine, as well as a number of scientific instruments. King Surid was acting in much the same spirit as those who today bury time capsules to be found by the survivors of some future holocaust.

There were numerous other explanations, equally fanciful, for the origin of the pyramids. Medieval pilgrims to the Holy Land believed they were the storehouses for grain which, according to the Old Testament, the Pharaoh built at Joseph's suggestion. In the church of San Marco in Venice there is a thirteenth-century mosaic depicting this legend (fig. 15 b).

In their desert setting, the pyramids possess a purity of form that is spell-

binding, whatever the meaning given them. Latter-day artists have been struck by them, no less than visitors of other times, and have offered their own interpretations of this unique complex of geometrical forms in drawings and sketches, and more rarely in finished paintings. Paul Klee, who visited Egypt in the winter of 1928–29, made most original treatments of the Great Pyramid and other Egyptian scenes.

When did the art and culture of ancient Egypt cease to be a complete enigma? Who was the first to apply something resembling modern scientific and historical criteria to the study of Egyptian art? Johann Joachim Winckelmann (1717–1768) may be considered the father of Greek art history. He was the first to succeed in making sense of the scattered materials generations of travelers had collected, the first to formulate an over-all view of Greek art, inexact though it may have been. Winckelmann was by character and training well prepared for the task he set himself. The corresponding figure in Egyptian art history, Dominique Vivant Denon, was not even a scholar, let alone a historian of antiquity.

However, Denon was a bit of everything else: artist, diplomat, playwright, dabbler in archaeology, interior decorator. In this last capacity he had been commissioned by Louis XV to design a suitable presentation of Madame de Pompadour's collection of medals and precious stones. At the same time he knew Voltaire and was a friend of the painter Jacques-Louis David. It was David who saved this favorite of Louis XV from the guillotine during the French Revolution. Denon lived on to win Bonaparte's friendship and become a member of Josephine's intimate circle. He designed some of the uniforms of the Revolutionary army and in 1798 joined the group of scholars who went along on Bonaparte's expedition to Egypt. He was then fifty-one.

To Bonaparte, the expedition was for scientific purposes no less than for military conquest. He persuaded some of the most eminent scholars of the day, many of them members of the French Institute, to put up with the discomforts of life in the field, and its dangers as well. Representing the recently founded Egyptian Institute, Vivant Denon accompanied General Desaix de Veygoux on his march up the Nile to Aswan and the First Cataract. Prior to his departure for Upper Egypt, Denon had made the first survey of the necropolis at Giza, protected by two hundred soldiers (this was only a few weeks after the Battle of the Pyramids). He was not content merely to sketch from a distance the Giza pyramids, long since stripped of their outer layer of stones to provide masonry for Cairo's oldest mosques and fortifications; Denon also made a close examination of the King's Chamber inside the Cheops pyramid. He described the head of the Sphinx (the rest was then buried in the sand), finding its expression one of "sweet serenity" (fig. 15 c).

Later, he directed excavations in the cemetery at Saqqarah, which yielded hundreds of jars containing the mummified remains of five hundred ibises.

His greatest opportunity, however, came during General Desaix's march. Undeterred by the harassing raids of the Mamelukes, and frequently working under the fire of battle, Denon sketched in the closest possible detail every temple and every ruin he came across. He was the first to observe that Egyptian drawing falls into three basic types, though the chronological order he attributed to these was incorrect. The first type is the so-called outline work, either incised in stone or laid on with color. The second is drawing in color, analogous to the work of European painters. The third is drawing in relief, which he correctly subdivided into high, low, and sunken. Denon also observed that the ancient Egyptians had applied colors to their low reliefs in order to emphasize their sculptural qualities. He found the recurrent compositional motifs in these low reliefs—gods, and kings offering sacrifices to them, for example—reminiscent of French playing cards.

The rapidity of Desaix's march and repeated attacks by bands of Mameluke horsemen prevented Denon from remaining at many sites for as long as he would have wished or as long as the sites deserved. He managed, however, to make a sketch of the famous zodiac in the temple of Denderah (the original tablet is now in the Louvre; a plaster cast is at the site). Denon collected a number of Roman lamps and the little figurines known as *shawabtis*, which according to Egyptian belief act as servants in the afterlife. He tells us how the French troops, at the sight of the great temple at Luxor, spontaneously came to attention and presented arms. He was disappointed by the Colossi of Memnon, finding them devoid of charm, incapable of arousing any enthusiasm. At Karnak, the crowding together of so many temples struck him as pompous, theatrical, and inappropriate to a sacred place. He regretted not having had more time to linger over the tombs in the Valley of the Kings and complained that all he saw of Kom Ombo was a brief glimpse from the other bank of the Nile. The only temples he was able to sketch in this region were those at Esneh and Edfu.

Denon's richly illustrated *Voyage dans la Basse et la Haute Égypte*, published in 1802, was the first modern, scientific presentation of ancient Egyptian art and architecture. *Description de l'Égypte* (Paris, 1809–28), based on many years' research by the French scholars who accompanied Bonaparte, contains important supplements to the material published by Denon, although the art of ancient Egypt is only briefly treated. This official publication of the French Institute covers in great detail Egyptian geography, flora, and fauna, as well as the everyday life of Egyptians at the time of the French expedition.

Denon's presentation of Egyptian art might not have had such immediate repercussions throughout Europe had not Jean-François Champollion,

working at about the same time, succeeded in deciphering the hieroglyphs. Champollion's discovery came after one of Bonaparte's officers, charged with an engineering project at the mouth of the Rosetta, a branch of the Nile, came across a block of black basalt on which were incised three kinds of written characters: Egyptian hieroglyphs, Greek, and what was soon established to be demotic script (the simplified writing that was used in Egypt after c. 700 B.C.).

Inscribed on this block of basalt, now known as the Rosetta stone, was a decree by Ptolemy V Epiphanes (205–180 B.C.) promulgated simultaneously in three languages. The Greek inscription provided Champollion with a key with which to decipher the Egyptian characters. This small stone was considered important enough to be mentioned in the Treaty of Capitulation which the French were compelled to sign in 1801 by the commander of the victorious English troops; one article of the treaty specified that the Rosetta stone would be handed over to the British, but that French scholars would retain the right to publish its text. Today the original is in the British Museum in London and the Louvre has a copy.

Hieroglyphs are an integral part of most Egyptian works of art. They cover temple walls and the surfaces of reliefs; they are incorporated in the composition of paintings and incised on colossal granite statues. Without knowledge of what the hieroglyphs say, no proper evaluation of Egyptian art is possible, not to mention any real grasp of its nature and original significance. If today we need no longer speak of ancient Egyptian culture as a "riddle," we owe this to the pioneering work of Denon and Champollion.

Of course, the contributions of the two Frenchmen cannot really be compared. Champollion's name has remained a touchstone of modern scholarly research; Denon, though he was no scholar, managed by means of his drawings and observations to arouse tremendous interest in ancient Egypt throughout the educated European world. Thanks to him, the venerable monuments on the banks of the Nile—as well as the linguistic discoveries—have played a role of primary importance in the attempt to penetrate the darkness of Egypt's past.

As modern interest in ancient Greece and Rome developed, scholars carried "specialization" to great lengths: classical philology was pursued separately from archaeology, numismatics apart from epigraphy, and so on. In studying ancient Egypt, such specialization is much less appropriate. All aspects of Egyptian culture are closely intertwined: hieroglyphic writing with art, art with religion, religion with poetry, and poetry with political history. This is why there came into being a single science of Egyptology,

dealing with ancient Egypt as a whole. Champollion was unquestionably the father of this science.

Even today the historian of Egyptian art cannot dispense with a command of the written language, since hieroglyphic texts accompany many works of art. At the same time, however, excavations have steadily increased the quantity of source material to be interpreted, and a certain degree of specialization within Egyptology has become necessary. Scholars who spend their lives deciphering hieratic or demotic texts cannot be expected to be fully conversant with new discoveries in Egyptian sculpture or painting. Thus, archaeological teams working in the field include specialists in various branches of Egyptology.

Specialization extends to the scholarly literature. As a rule, those who write grammars of the Egyptian language are different individuals from those who publish works on Egyptian art. Linguists tend to follow in the footsteps of Champollion, the author of the earliest grammars and dictionaries of the Egyptian language, whereas art historians are indebted to Vivant Denon's work.

HERE we cannot possibly list all the important works on the history of Egyptian art published in the nineteenth and twentieth centuries. We must confine our mention to the monumental *Denkmäler aus Ägypten und Äthiopien* (1849–59) by the German Egyptologist Richard Lepsius; his studies confirmed Champollion's method of deciphering the hieroglyphs, and his drawings of the monuments, even today, more than a century after their publication, still provide us with valuable documentation.

Nor can we survey in detail the various and sometimes conflicting views that the study of Egyptian art has inspired. Friedrich von Bissing, in his *Ägyptische Kunstgeschichte* (1934–35), devoted two separate volumes to each period of Egyptian art—one dealing with the history of the period, the other with an evaluation of controversial views on specific problems. Also deserving of mention are three scholars whose comprehensive treatments of the history of Egyptian art are still valid: Gaston Maspero, a Frenchman, author of *L'Histoire générale de l'art de l'Égypte* (Paris, 1912); Jean Capart, a Belgian, author of *L'Art égyptien* (Brussels, 1909–47); and the German Heinrich Schäfer, whose *Von ägyptischer Kunst* (Leipzig, 1930) has been revised and enlarged four times.

I did not know Gaston Maspero personally. I became acquainted with Jean Capart when he was heading a Belgian archaeological group at El Kab, not far from the Franco-Polish excavations at Edfu in Upper Egypt which I was then directing. As a distinguished elder Egyptologist, he played a leading part at international meetings and conventions where I came further

to appreciate his talents. A man of tremendous erudition, he was also a brilliant organizer, instrumental in creating the Queen Elisabeth Foundation which finances Belgian research and publication in the field of Egyptology. Among the Egyptologists of his time, he was the only one who, in his books, called attention to the gaps in our knowledge of ancient Egyptian culture and warned against drawing overrash conclusions. Even today, few laymen realize that many of the generalizations about ancient Egyptian life, based on tomb paintings and reliefs, lack a sound scientific basis. So far, only about six hundred tombs of Egyptian dignitaries have been discovered. The oldest ones date from Dynasty VI, the majority from the New Kingdom (especially Dynasties XVIII and XIX). Thus, the six hundred tombs are distributed over a span of twelve hundred years. Allowing for the two Intermediate Periods, and counting only tombs of individuals buried according to the Osiris ritual, we obtain an average of sixty tombs per century, or twelve to thirteen individuals per generation. To base our ideas of Egyptian life on such scanty evidence is equivalent to deriving our ideas of France solely from the tombs in the Panthéon in Paris.

Considerations of this sort may depreciate the value of the data we actually possess, but Capart's common-sense criticism remains of value in a field where many have been unduly impressed by their own erudition. Until his death, shortly after World War II, Capart was still publishing both monographs and popular books on the life and culture of the ancient Egyptians.

I met the third scholar, Heinrich Schäfer, at the Sixth International Congress of Archaeology, which was held in the tense atmosphere of Berlin in August, 1939. At the invitation of Schäfer and Hermann Junker, another prominent Egyptologist, I attended a meeting at which a decision was to be taken concerning a new edition of Lepsius' great work. Schäfer was the first to discern the different ways in which Egyptian sculptors portrayed rulers, dignitaries, and gods, on the one hand, and servants and ordinary people, on the other. The former (which he called Group A) are characterized by the frontality of the figures and their hieratic attitudes, while the latter (his Group B) show a more realistic treatment. Twenty-five years later, with Schäfer's studies as a base, I formulated my own theory of the three groups of the Egyptian canon (see Chapter 8).

The record of archaeological work in Egypt amounts to a real romance—this word, significantly, has found its way into the titles of many more or less popular works, such as W. H. Boulton's *The Romance of Archaeology*, which was widely read in the 1930s. During the past two decades a great many books of this type have appeared in nearly every language: C. W. Ceram's *Gods, Graves, and Scholars* is perhaps the best-known English work.

During the nineteenth century, Egyptian regulations concerning the excavation and removal of antiquities were comparatively liberal. Anyone willing

and able to conduct archaeological excavations in the Nile valley was permitted to do so. The last to hold such a concession was the Earl of Carnarvon, whose name is linked to the discovery of Tut-ankh-amon's tomb. For the past thirty years, however, permission for digging has been restricted to institutions accredited with the Egyptian government, for example, the French Institute of Oriental Archaeology, and to expeditions organized by universities, museums, and other scientific bodies, such as the Egypt Exploration Society in England. This society sponsored one of the leading figures in Near East archaeology, Sir Flinders Petrie, whose expeditions investigated almost every important area of Egypt.

In recent years, the eyes of the learned world have been fixed on the large-scale archaeological undertakings in Nubia devoted to saving the cultural remains of this southern region of ancient Egypt. The question of the ethnic make-up of the population in this area in antiquity—a problem which concerns archaeologists working there today—was raised as early as 1907 by the American archaeologist G. A. Reisner. It was the great English archaeologist F. L. Griffith who, inspired by Reisner, designated this mysterious population by the symbol X. He inferred the existence of such a people —whom we today identify as the Nobadas—from the surviving remains of modest tombs that he had picked out from the other burial places scattered along the Nile between the First and Third Cataracts.

If the art of ancient Egypt is today sufficiently accessible so that we can follow its evolution and discern its guiding principles, this results, in large part, from the unceasing labors of archaeologists in the field, who are steadily increasing the stock of our source materials.

2. THE COUNTRY AND THE PEOPLE

2. THE COUNTRY AND THE PEOPLE

HERODOTUS, the Greek historian who visited Egypt toward the end of the fifth century B.C., described the country as a "gift of the Nile." Amru, commander in chief of the troops of Caliph Omar, who conquered Egypt around 641 A.D., reported to his sovereign that, apart from a stretch of very fertile land, the country was a barren desert. Both were right.

The most fertile part of Egypt, the Nile delta, is entirely a gift of the great river. The ground itself has been built up by the sediment deposited during the Nile's annual summer floods. Without the Nile the thin strip of cultivated land in Upper Egypt, which is surrounded on both sides by desert mountains called the Gebel, could not have supported its population. Rain almost never falls in Upper Egypt; the entire agricultural economy is based on a system of canals and primitive irrigation methods. The latter include water lifts *(shadoofs)* and water wheels *(sakiehs)* drawn by oxen. This method has hardly changed since antiquity. In a few of the more progressive villages the buckets attached to the *sakieh* are of metal, but in most places they are still made of clay.

The alluvial deposit of the Nile does not require a metal plow: wooden ones are perfectly adequate. There are two and sometimes three harvests a year. The ancient division of the year was into three seasons: the period of the flood, or *akhet* (summer-autumn), the period of budding and fruit bearing, or *peret* (winter-spring), and the period of harvest gathering, or *shemu* (spring-summer). The annual cycle is still well described in these terms. But when the new dam at Aswan, called Sadd el Aali, is completed—the scheduled date is 1970—there will be a radical change in Egypt's climatic and agri-

cultural conditions. The area of arable soil will be enlarged by a new source: a man-made lake three hundred miles long, which has already submerged large areas of Nubia between the First and Second Cataracts. At the same time, however, the new dam will cut off the fertile sediment carried from distant Ethiopia by the waters of the Blue Nile, which swells each year during the Ethiopian rainy season. The new agricultural economy will have to depend on chemical fertilizers, and evaporation from the large lake formed in Nubia will probably increase rainfall in Upper Egypt. These consequences, however, await the time when the waters of the Nile fill the new Aswan reservoir. The adjective "new" is crucial, for Nubia was partially flooded after the first Aswan dam was completed. The older dam, however, was not intended to provide a permanent reservoir. Yearly, just before the July floods, the reservoir was drained, and the submerged Nubian temples became visible for a period of two months. The new artificial lake will be kept at a fixed level.

Evacuation of the population from Egyptian Nubia to the north, and from Sudanese Nubia to the southeast (to Khasm el Girba near the Ethiopian border), has now been completed. Despite the efforts of the two governments to make the move a smooth one, it has meant severe dislocation for the Nubians. Equally dramatic in a different way have been the strenuous attempts to preserve the monuments of ancient Nubian art and architecture. Entire temples have been dismantled and reconstructed at other sites. This work is being carried out by the Egyptian government under the auspices of UNESCO, with the assistance of archaeological teams from many countries.

German archaeologists dismantled the temple at Kalabsha and moved it to another site near the new dam, where there will be no risk of inundation. The French did the same with the temple at Amada. The Americans have provided most of the funds for cutting the temple at Abu Simbel away from the rock. The two Nubian temples at Tafeh and Dabod were dismantled in a joint effort by Egyptian and Polish archaeologists.

While the main purpose of the archaeological groups has been the rescue of the ancient architectural monuments, they have also recognized that this is the last opportunity to excavate a great many sites soon to be permanently under water—in Sudanese as well as in Egyptian Nubia. Since 1960 several archaeological expeditions have carried on intensive work throughout the area, making many important finds. One of the most interesting of these finds was the Polish group's discovery of a magnificent set of murals in a Coptic-Byzantine cathedral long buried in the sand at Faras, in northern Sudan. They uncovered invaluable historical inscriptions, including a list of the bishops who presided over the ancient town of Pachoras. The Faras murals, which range in date from the eighth to the twelfth century A.D., add considerably to our knowledge of the development of Byzantine painting.

Together with other antiquities discovered at Faras, they have transformed our understanding of the history of the Christian kingdom in Nubia, which in the early Middle Ages was the last remnant of ancient Egypt's great civilization. The country was then called Kush, first governed by viceroys of the Pharaohs and later by the independent kings of Meroë (figs. 13, 143).

In a few years the landscape of Egypt and the northern Sudan will be transformed. There have been, to be sure, other more gradual changes throughout recent history. Ancient Egyptian reliefs show kings hunting waterfowl in papyrus thickets, but this plant, so characteristic of the ancient period, has long since disappeared from the banks of the Egyptian Nile; today it can only be found in the southern Sudan. Similarly, hippopotamuses and crocodiles, formerly common along the Nile, have moved southward. Construction of the first Aswan dam in 1898–1902 seems to have created an impassable barrier for crocodiles and eliminated them from the northern reaches of the river. Today, only in the area around Abu Simbel may the crocodile be seen—and very rarely at that—yet in the period of Roman rule this animal was regarded as the symbol of Egypt.

Since the beginning of written history, and even before, Egypt has been, for the most part, a desert. Except for the Delta and the narrow ribbon of land bordering the Nile, its climate is uniformly hot and dry. But in the Pleistocene era (660,000–10,000 B.C.) the country presented a very different aspect, with a subtropical climate and abundant lakes. As the climate slowly became drier, these lakes shrank to oases in the desert, the most important in Egypt being the great Siwa oasis in the north, the Fayum in the center, and the Khargeh in the southwest. In the forests that originally covered these regions, the first inhabitants gathered fruits and plants, which provided their basic diet, supplemented by fish and game. In desert areas of present-day Egypt, far from the Nile, excavations have uncovered prehistoric fishermen's settlements—eloquent testimony to the climatic changes that have occurred over the millenniums.

Egypt's transformation from a land of primitive settlements to a highly stratified society is difficult to reconstruct in detail. The process probably began when the slow encroachment of the desert sands forced the original Negroid population to retreat southward. They were in turn replaced by Hamitic peoples from the Arabian Peninsula—the vanguard of the later Semitic migration.

The fertile delta and banks of the Nile favored the rapid development of an agricultural economy. The basic crops were barley ($\vert \overset{\bullet}{\underset{...}{}}$ = 'it) and wheat ($\Psi \overline{} \cdot\!\bullet$ = bôte). Leguminous plants were also important. Flax provided raw

material for weaving, an invention that the ancient Egyptians attributed to the goddess Tait. Because Egyptian mythology reflects all the characteristics of an agricultural, cattle-breeding society, we are justified in inferring that the principal religious beliefs of ancient Egypt go back to this early period of settlement along the Nile.

Tombs of Egyptian nobles, which are known as mastabas and date from the second half of the third millennium B.C., contain many scenes that show the harvest and transport of sacks of grain to round-roofed granaries. Various kinds of domestic fowl and cattle are also portrayed; among the latter, the *gamus*—a buffalo with low-curved horns still a familiar sight in Egypt—predominates. The donkey was used for transport, for the horse was not introduced into Egypt until the first half of the second millennium B.C. By the beginning of the Dynastic Period, Egypt no longer had any forests and, in this respect, the landscape is not greatly changed today: there are still palm groves along the Nile, and scatterings of tamarisks, sycamores, and wild acacias mixed with mimosa.

Egypt was compensated for its scarcity of timber by an abundance of minerals and metals, which were used to make tools and everyday objects. Furthermore, the alluvial deposits of the Nile provided excellent clay for earthenware vessels and for building materials in the form of sun-dried bricks. At the border between Upper and Lower Egypt, which is a short distance south of Cairo, the exploitation of the Turah limestone quarries began at a very early date, supplying material for the monumental architectural constructions of the Pharaohs. Near the First Cataract there were great beds of granite, both red and black. From the desert flanking the Nile valley came stone that served for the making of precious vases—alabaster (mainly from the environs of Tell el Amarna), basalt, and sandstone. But the greatest variety was to be found in the eastern desert—diorites and dolerites, porphyry and serpentine. From the same region came semiprecious gems such as amethyst, chalcedony (in the form of agate, onyx, jasper, and carnelian), rock crystal, turquoise, and stones of the beryl family (emeralds, for instance); the mining of the latter, however, did not begin until the Graeco-Roman period. In prehistoric times, beads were already being made out of steatite (a dense form of talc); black obsidian (of volcanic origin) and flint were used for arrowheads and amulets.

During the earliest dynasties, gold was smelted in the eastern desert, and even earlier, copper had been mined in the Sinai Peninsula. The quantities of metal found in Egypt, however, were insufficient for its needs. The Egyptian kings imported copper from Cyprus and gold from Nubia, which became a subject territory of Egypt. Silver was very rare, which may account for the fact that in some periods it was valued more highly than gold. Tin, which is necessary for the manufacture of bronze, had to be imported from Asia

Minor. Although there were rich deposits of iron ore in the eastern desert, these were not exploited until much later.

CLIMATIC differences divided Egypt into two major areas: the broad Nile delta, and the narrow ribbon of arable land surrounded by desert. Gradually the scattered settlements within the two regions were united into kingdoms: Lower Egypt (the Delta) and Upper Egypt. This early division had lasting influence upon the history of ancient Egypt. It survived in administrative nomenclature, royal titles, religious symbols, and court etiquette. Even after the two kingdoms were united into one state, the ruler officially maintained two granaries and two treasuries—one for Upper Egypt and one for Lower Egypt. The vulture, representing the goddess Nekhbet, was the tutelary deity of the southern kingdom, while the cobra, worshiped at Buto as the goddess Edjo, was the symbol of the Delta. The Pharaoh had two royal crowns—a red coif as the crown of Lower Egypt, and a white tiara as the crown of Upper Egypt—and he always bore the title "King of Upper and Lower Egypt" (Chart II, p. 565).

Today we can establish fairly exactly the time at which the two kingdoms were unified. This was around 3000 B.C., after centuries of conflict between the two kingdoms. Unity was inevitable, for Egypt was predestined, as it were, by its geographical conditions to be governed by a central authority. The regularity of the Nile floods on which Egyptian agriculture is based necessitated a unified system of irrigation. Without it, the population could not survive, for any disturbance in the territory between the First Cataract and the mouth of the Nile had serious effects elsewhere. Nature itself compelled the formation of Egypt as a single entity that not only endured for the three thousand years of dynastic history, but still continues down to our own day, despite temporary interruptions by domestic upheaval and foreign occupation.

Once Egypt had been unified, its society developed a system of strictly defined classes. At the top of the social ladder stood the king, sometimes considered a god, sometimes the gods' representative on earth. To the ancient Egyptians the king was the equal of the gods and so was worshiped as one of them. The Egyptian kings frequently entered into marital unions with their own sisters, although they also maintained sizable harems for their private pleasure. The common people rarely saw their king, and then it was usually from a considerable distance, as during great religious processions.

The country was actually governed by the chancellor, today usually referred to as the vizier. He was both the chief executive and the chief judicial authority; in exercising the latter function, however, he relied upon detailed

legal codes which he always kept at hand among his papyri. The vizier was assisted by a number of court dignitaries—treasurers, chief architects, supervisors of granaries, and high military commanders. Some of them bore titles, such as prince ($\overbrace{}^{}$ = *iri-pat*) or count (= *hati-a*), but these titles were not hereditary. Administratively, Lower and Upper Egypt were divided into nomes. Their number varies according to the source cited. Thus, the oldest records mention sixteen nomes in Lower Egypt; in Ptolemaic times their number was twenty, as can be inferred from the text incised on the walls of the temple at Edfu. As for Upper Egypt, the number of nomes is generally given as twenty-two, although here too the records show slight variations. Each nome was named: in Upper Egypt, Nome IV was called The Was Scepter; Nome VI, The Crocodile; Nome X, The Cobra; Nome XVII, The Dog; and Nome XXII, The Knife. Each nome was governed by a nomarch with the assistance of a complex bureaucracy (Map II, pp. 583–84).

The centralization of power—a result of the country's unification—was undoubtedly a step forward in Egypt's early development. As time passed, however, the management of so large a territory, the regulation of a complex irrigation system, and the construction of canals and dams, led to an over-developed bureaucracy.

Officially, the fellaheen, or peasants, who tilled the soil were free; slavery was not instituted until the middle of the second millennium B.C., and its introduction is generally associated with the numerous prisoners of war brought into Egypt by the Pharaohs of the New Kingdom. In reality, the lot of the common people scarcely differed from that of slaves. Out of the meager yield from their small parcels of land they were compelled to pay heavy tribute to the royal granaries and treasuries, and at work they were urged on by the whips of government supervisors.

Thus we divide the social system of Egypt into three groups, or classes. There were those who wielded political power: the king, the princes linked with him dynastically, and the high dignitaries who traced their origins to the royal family. The second group included those who held executive posts in the administrative machinery, from the village mayor to the provincial governor, who were not usually of royal blood. The third group consisted of the peasants and craftsmen upon whose labor the existence of the entire population depended.

Although it sometimes had considerable political power and influence, the Egyptian priesthood may be considered part of the second social class, that of administrators and bureaucrats. Within its ranks there was a strict hierarchy. The colleges of priests in the various temples were divided into two groups: the *hemunetcher*, or "prophets," and the *wabu*, or ordinary (lit-

erally "pure") priests. Apart from this over-all division, the priesthood included a number of "specialist" categories, such as readers, horologists, astronomers, and astrologers.

Theoretically the king was the archpriest of every temple, but this office was actually filled by the "First Prophet." Down to the New Kingdom, the most important religious posts were held by high civil servants. Priests were not usually exempt from taxes and other obligations to the state; only certain colleges of priests were freed of such burdens.

Perpetuation of the strictly hierarchical social structure was insured, not merely by the royal power, but by the official religion. Aside from the complicated Egyptian pantheon, which will be discussed later, the basic element of ancient Egyptian religious belief was the conviction that life on earth is but a brief episode in comparison with the infinite time spent in the beyond. In order to attain eternal happiness after death man had to live in harmony with the powers that be and respect their teachings.

Every Egyptian, according to his means, made careful preparations for the afterlife. Even the most modest graves were furnished with the essential objects of everyday use. Although only the wealthy could afford mummification, this widespread practice bears eloquent witness to the pervasive Egyptian belief in a life beyond death. Both religion and art perpetuated the conviction that earthly conditions are unchangeable and that one must bear them humbly. No other art in history has been more closely connected to the existing social and religious aspects of a culture.

16. FEMALE BREWER
 Painted limestone model; height 16 1/2".
 Dynasty IV. Archaeological Museum,
 Florence.

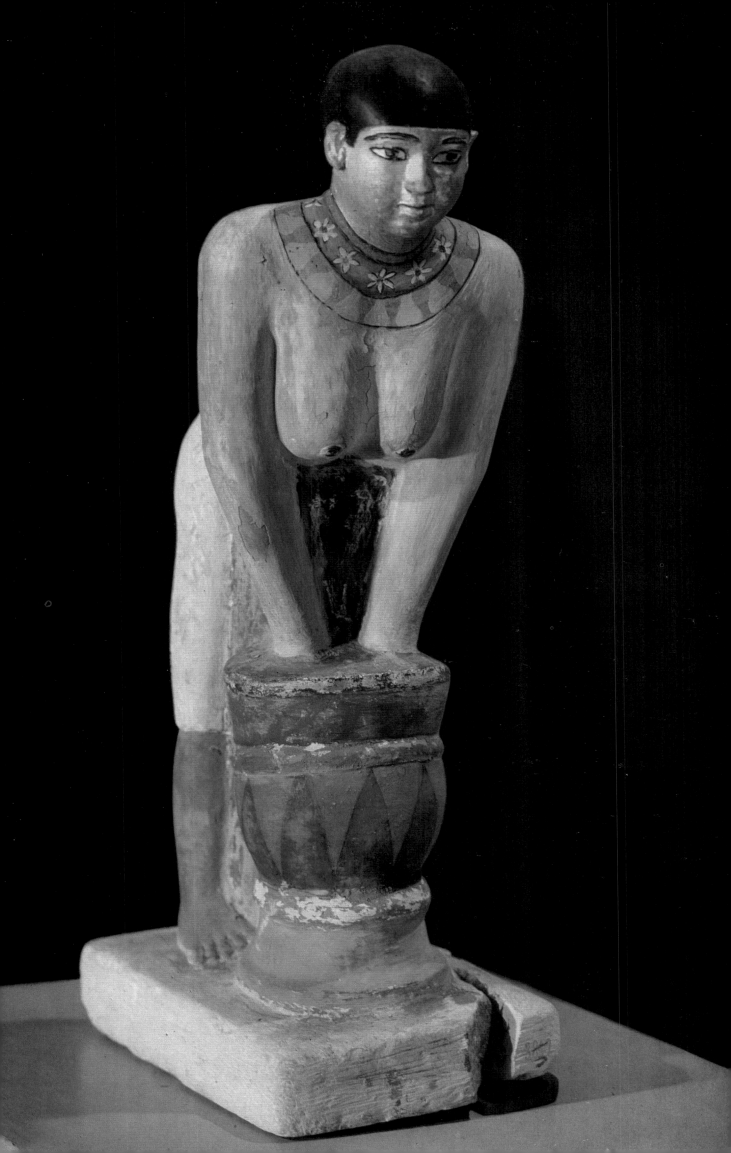

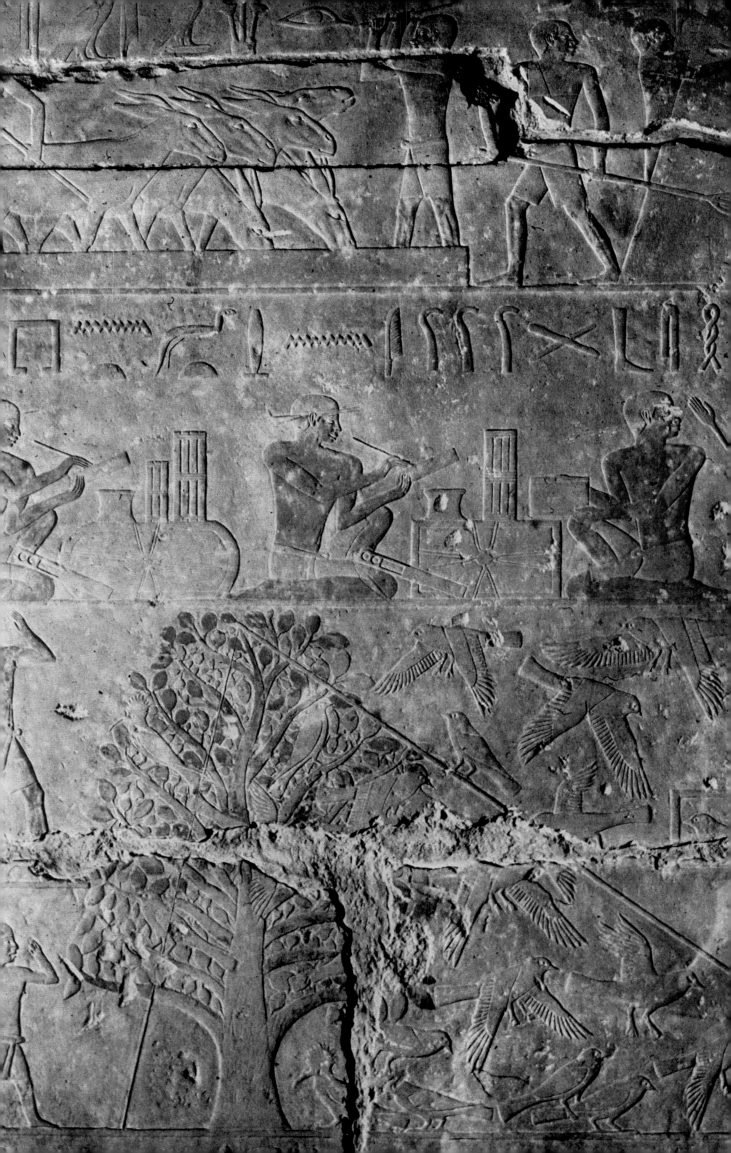

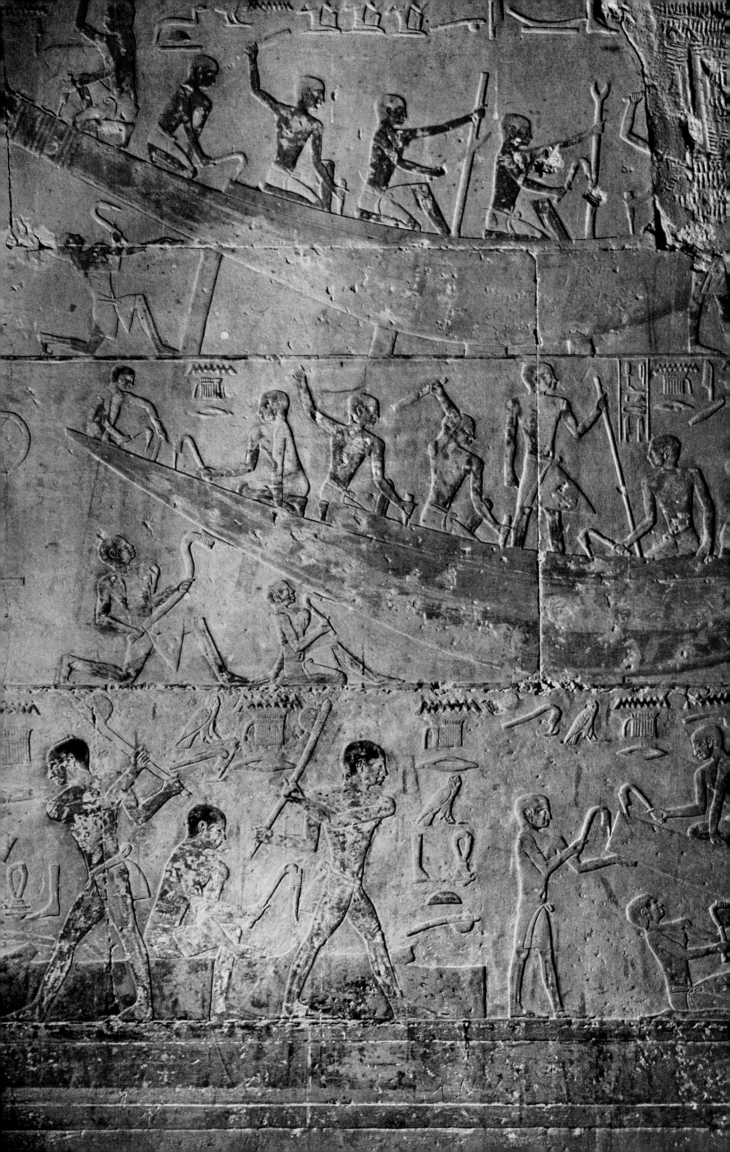

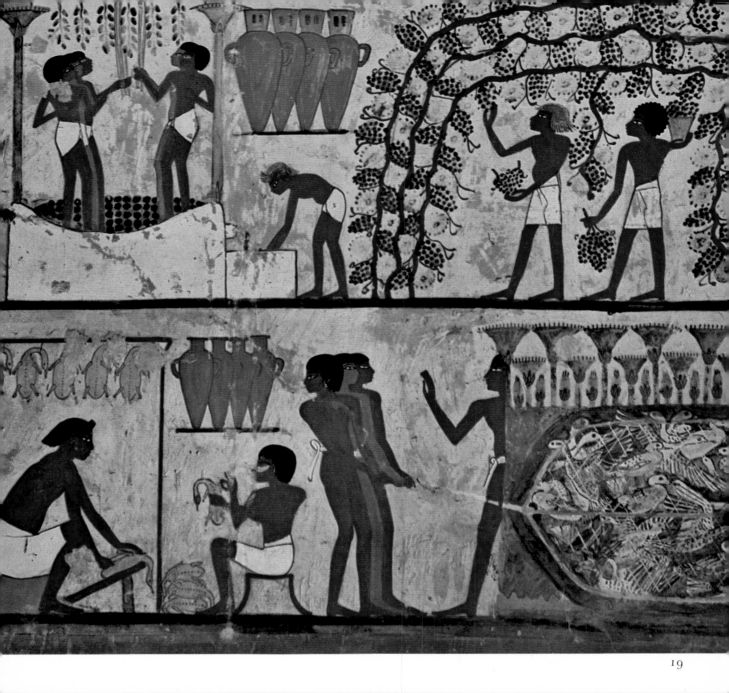

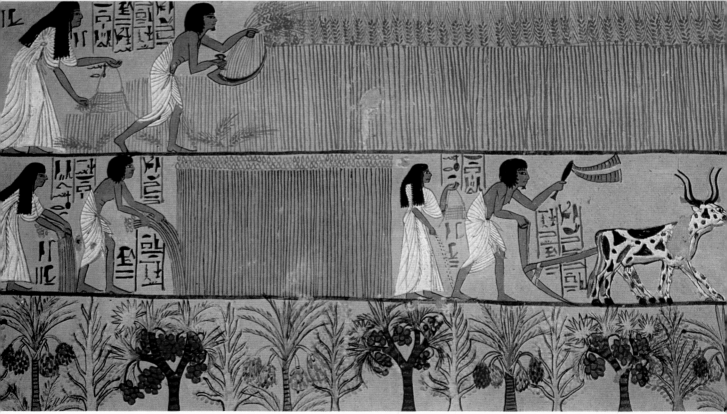

53

3. LANGUAGE AND WRITING

Hieroglyphs

Hieratic and demotic scripts

Mathematics, geometry, astronomy, literature

The oldest papyri

3. LANGUAGE AND WRITING

THE population of ancient Egypt was of Hamitic origin and spoke a language related to the Semitic languages. In the course of ancient Egypt's three-thousand-year history this language underwent a number of transformations. When we encounter it for the first time—for example, in the Pyramid Texts—it is already very old, as is proved by the elaborate syntax which employs a number of grammatical forms outdated even at that time (fig. 38). This earliest known phase in the development of the language is called Old Egyptian.

Old Egyptian passed into Middle, or "classical," Egyptian with only a little change as the Middle Kingdom was ushered in at the close of the third millennium B.C. The language had become standardized; its vocabulary and many of its idioms were to survive for a very long time. At the same time, however, a vernacular was developing which, by the last half of the second millennium B.C., during the New Kingdom, had assumed national importance. This new language differed grammatically from the "classical" language and was rendered, not by hieroglyphs, but by a simplified writing called hieratic. (The latter should not be confused with the "cursive hieroglyphic" style of writing.) Later still, about 700 B.C., an even more simplified and schematic writing appeared, known as demotic. The last stage of the Egyptian language was Coptic, which became current toward the end of the second century A.D. Written Coptic used the Greek alphabet but retained seven characters from the demotic to express sounds that could not be rendered with Greek letters.

The oldest form of Egyptian writing is hieroglyphs, so called by Greeks

who traveled or settled in Egypt. Looking at the hieroglyphs inscribed on temple walls and on statues of the gods, they realized that this was a kind of writing but assumed that it must be sacred and called it *hieroglyphika grammata*, from which is derived the term "hieroglyph" (in Greek, *hiero* means "sacred" or "arcane").

We must devote considerable attention to the hieroglyphs because, as noted earlier, they form an integral part of many Egyptian works of art. They turn up in sculpture, in reliefs, and in paintings. As a rule, hieroglyphs were carved in low relief or sunken relief; frequently they were also painted (figs. 22–37).

Hieroglyphs developed from pictographs (fig. 21). For every idea denoting an objective phenomenon, there was a corresponding sign: for instance, the idea of "head" was represented by a drawing of the human face; "eye" and also the act of seeing were represented by a schematized eye the foreparts of a seated lion denoted the beginnings of something; and the image of a goose referred to this fowl. But because the word for "goose" sounded like the word for "son" (![goose sign] = *sa'*), the same sign represented both. Similarly, a schematized human face could stand for a man's head (![face sign] = *hr*), but it could also convey the sense of "on top of." By a similar extension of meaning, the sign for the eye, "seeing" (![eye sign] = *'irt*), came to denote the performance of an action, "doing" (*'iri*). Over the centuries some signs lost their original meanings entirely: the pictograph of a hare, for example, eventually had no meaning other than "to open." In its last stage of evolution, Egyptian writing had twenty-four signs for rendering consonant sounds. The hieroglyph for "leg" (![leg sign]), for example, came to indicate the pronunciation of the consonant *b*; that for "snake" (![snake sign]) the pronunciation of the consonant *f*; that for "owl" (![owl sign]) the consonant *m*; and so on (Chart IV, p. 568).

The Egyptian "alphabet," like the Arabic and other Semitic alphabets, has no signs for vowels. In Arabic writing, vocalization (supplementing a consonant with a vowel) is indicated by points or strokes above or below the letters expressing consonants. In hieroglyphs, although there are some semi-vowels (the pictograph for "reed" ![reed sign] denotes the sound *y*, and for "quail" ![quail sign] the sound we usually transcribe as *w*), often even these are not indicated. This lack of vowels is a considerable obstacle in the decipherment of the Egyptian language. We are able to restore its vocalization to a certain extent with the help of Coptic, which was written in the Greek alphabet and thus had vowels. Semitic peoples, however, have had centuries of training in reading unvocalized texts, and can supply the missing vowels as readily as we make sense of unvocalized abbreviations such as Ph.D., B.S., ms., and so forth.

In order to avoid ambiguity in reading hieroglyphic texts, the Egyptians employed two devices: so-called phonetic complements and determinatives. When a given sign could be read with a number of different pronunciations (and senses), a purely phonetic complement would be added to single out the particular pronunciation and meaning intended in a given context. This device was employed very freely, even where it was not really needed. The determinatives had various functions. For example, the hieroglyph of a seated man (🪑) or a seated woman (🪑) might be put in to indicate that the preceding hieroglyphs should be read as a proper name, either masculine or feminine. In a similar way the hieroglyph of a mountain range or a desert (⛰) could be put in to indicate a place name. The hieroglyph of a papyrus scroll (➖) was added to show that the preceding signs were to be taken in an abstract rather than a literal sense.

It is important to note that the Egyptians did not hesitate to alter the "correct" order of the signs, especially when these signs accompanied reliefs and paintings. For decorative reasons, they left out hieroglyphs that did not "fit" and repeated others in patterns—two by two, for example. Obviously, calligraphy and the general appearance of the inscription were more important than grammar and spelling. In Egyptian paintings and reliefs, hieroglyphs never obscure the composition—on the contrary, they often clarify it. For example, a row of hieroglyphs over a representation of muleteers or reapers might echo the disjointed cries and commands of the men; occasionally whole sentences of speech appear.

Finally, two further peculiarities of ancient Egyptian writing are worth mentioning. Whereas a determinative was normally placed after a word to indicate its correct meaning, "sacred" or "venerable" signs preceded certain words. Thus, the disk-shaped sign that symbolizes the sun and the god Ra (☉) was placed ahead of royal names to indicate that the expression referred to a god (⅂ = netcher). The second point concerns the way the royal names themselves were written. An oval-shaped outline called a cartouche ((⬭)) was drawn around the Pharaoh's name; this was the symbol for the word "name" = ren. As a rule, the Pharaoh had several names, one of which might be "Horus," and in such cases the name of the king would be inscribed in a representation of the façade of a royal palace and surmounted by the figure of a falcon, the symbol for the god Horus (🦅).

Not all Egyptian writing, however, was executed in hieroglyphs. To draw long texts on papyrus scrolls, using a reed pen dipped in black or red ink, was too laborious. The Egyptians quickly developed a simplified version of hieroglyphs—the so-called hieratic writing, which was itself preceded by a cursive form of hieroglyphic writing. (The exact definition of "cursive hieroglyphic" style is not universally agreed upon.)

Hieroglyphs were normally written from right to left, although for purposes

of decorative symmetry or clarity, they might also be written from left to right. The direction in which a text should be read can be determined from the position of the head in human and animal figures, for these generally face toward the beginning of the line. Hieratic texts were also usually written from right to left. Hieratic script gave birth to an even more schematic system of writing which was widely used in the Late Period, and especially in Ptolemaic and Roman times. This is demotic, in which not only individual signs but also phrases and whole sentences were abbreviated—a kind of shorthand.

Hieroglyphs, hieratic, and demotic are the three forms of ancient Egyptian writing. Later, as we have mentioned, the Egyptians employed the Greek alphabet augmented by seven demotic signs. This Coptic phase of the language has survived to this day in the Egyptian Coptic Church.

READING and writing were taught in secular schools attached to government offices, and in schools attached to temples. The curriculum also included mathematics, geometry, astronomy, and medicine. Although the Egyptians used a decimal system, with 1,000,000 the highest unit, their method of carrying out arithmetic operations was rather laborious. Multiplication was reduced to successive doubling. For instance, to multiply 77 by 7, they broke up the multiplier into its components ($1 + 2 + 4$), performed the following multiplications,

$$1 \times 77 = 77$$
$$2 \times 77 = 154$$
$$4 \times 77 = 308$$

and added the results. A similar method was employed in division.

The measures of volume were the *heqat*, corresponding approximately to one bushel, and the *hin*, about one pint; sixteen *heqat* made one *khar* (bag).

For surveying purposes the Egyptians based computations on the rectangle, the area of which they obtained correctly by multiplying the longer side by the shorter. However, they applied the same principle in calculating the area of triangles—that is, they multiplied one of the sides by one-half of another, instead of multiplying the base by one-half the height. Thus their results must often have been wide of the mark. On the other hand, they computed the area of circles with considerable accuracy: they subtracted 1/9 from the diameter and multiplied the remaining 8/9 by itself—that is, raised it to the second power. For example, if the diameter was 9, they figured 8^2, or 64, for the area. This differs by only a small fraction from the result obtained with the formula πr^2. In effect they gave π the value 3.1604 rather than 3.1416.

In architecture and sculpture, apart from such planimetric units as the length of a foot, used in the older periods, the basic units of length were the small ell and the royal ell. The latter (about 21 inches) was normally used in architecture and was subdivided into 7 palms or 28 digits. For sculpture, the small ell (about 18 inches) was used; it broke down into 6 palms, each equal to 4 digits. From Dynasty XXVI on, the small ell was completely replaced by the royal ell. It is interesting to note that according to the Egyptian canon of sculpture, the correct height of the human figure was six feet from head to foot.

Today it is difficult for us to understand how the Egyptian priests could achieve so high a degree of accuracy in astronomy when their mathematics was comparatively primitive. Apparently the shortcomings of the latter were corrected by constantly repeated observations. We know that on the first and on the sixteenth night of each month two priests sat opposite each other on the temple roof and noted on squared sheets of papyrus the positions of individual constellations. The observations were set down above the right or left ear of a human face drawn in the center of the sheet.

The Egyptians measured time by water clocks, with a measured quantity of water dripping from an upper into a lower container which was marked off into twelve equal parts. The twenty-four-hour period was divided into twelve hours of day and twelve hours of night. Although this division of time is faithful only to conditions at the equator, and certainly does not correspond to those in Upper Egypt, nonetheless the Egyptians adhered to it strictly. One of their religious beliefs, for example, maintained that the human soul takes twelve hours of night to make the journey to the afterlife. Sundials were also used to measure time; there is some reason to believe that in certain cases an obelisk acted as a pointer, and that the shadow it cast on the temple told the hour of the day.

The main source for our knowledge of Egyptian mathematics is the Rhind Papyrus in the British Museum. This is a copy, made about 1580 B.C., of older documents. Original sources for ancient Egyptian medicine are much more plentiful. The most important are two papyri in the Chester Beatty collection in England and the Ebers Papyrus in the University Library at Leipzig, which deals with surgical methods.

Space does not permit an extensive discussion of ancient Egyptian literature; there are a number of reliable and generally available recent works which supply the basic information. Some knowledge of Egyptian literature and its ethical and artistic values is essential to a full understanding of Egyptian art. The literature touches upon and clarifies many questions closely connected with Egyptian life and history. Because works of art so often involve myths

or religious beliefs, many of these are incomprehensible without the aid of literature.

Proper understanding of the lengthy development of Egyptian art requires familiarity with such documents as The Instruction of Ptahhotep (a vizier in Dynasty V) or a similar text by Amenemhat I, preserved in the Sallier Papyri I and II. Other important texts are The Instructions of Amenemope and The Maxims of Ani, which date from the New Kingdom. Some especially magnificent works, reflecting the great upheaval that took place in life and art during the First Intermediate Period, are The Harpist's Songs recorded in the Harris Papyrus, The Admonitions of Ipuwer, and a papyrus in the Berlin Museum which contains The Dialogue Between a Pessimist and His Soul. The Hymn to the Sun, which is connected to the Pyramid Texts dating from Dynasties V and VI, and the hymn to Aten by Amenhotep IV (Akhenaten) reflect the specific character of their respective periods and help to explain the mood expressed in certain contemporary works of art. The same is true of the papyri that deal with magic. A number of Egyptian secular narratives are also important, such as The Story of Two Brothers, The Bewitched Prince, as well as The Adventures of Wenamon, The Story of the Famous Sinuhe, and The Story of the Shipwrecked Sailor, which is recorded in the famous hieratic scroll known as the Golenishchev Papyrus, now in the Hermitage Museum in Leningrad. (Golenishchev, a Russian Egyptologist of the late nineteenth and early twentieth century who made important contributions to Egyptian philology, also made the fine collection of Egyptian art that is now in the Pushkin Museum in Moscow.)

In a broad sense, Egyptian literature also includes commercial, juridical, and administrative records. These written sources, mostly dating from the New Kingdom, illuminate the social and economic conditions of ancient Egypt. The most important come from ostraka (singular, ostrakon), a term originally denoting pottery fragments but extended to include texts inscribed on rock fragments. Recorded on these ostraka are merchants' inventories, lists of workmen that note the number of days worked by each, receipted bills, and tax accounts. Occasionally fine colored drawings and even architectural plans are found on them. Other notable documents of this kind complain about the robbing of tombs in the Valley of the Kings, the famous royal necropolis just west of Thebes. The Abbot Papyrus, for instance, contains a detailed account of police investigations into burglaries of certain tombs.

It was mentioned earlier that the Egyptians taught writing and arithmetic in their schools. One of the most important courses in the curriculum was the art of letter writing. Only a very few people knew how to read and write; the overwhelming majority of the population had recourse to the services of letter-writers, professional scribes who could also formulate petitions to government authorities and prepare contracts and receipts. (The village

scribe is still a feature of the Egyptian scene.) In ancient Egyptian schools, scribes were specially trained in the technique of letter writing. There were established models for every sort of correspondence. These "form letters" were copied time and again over the generations; some dating from later times have been preserved, among them reports from minor army commanders in the provinces.

Finally, written documents play a crucial role in the chronology of ancient history. Periods from which we have no written documents are classified as prehistoric; we enter the historic period as soon as written sources are encountered. Any documents which refer, however casually, to past events are extremely important in our attempts to reconstruct the actual facts of Egypt's past.

21. IVORY TABLET OF KING ZET (WADJI)
From Abydos. Dynasty I.
Egyptian Museum, Cairo.

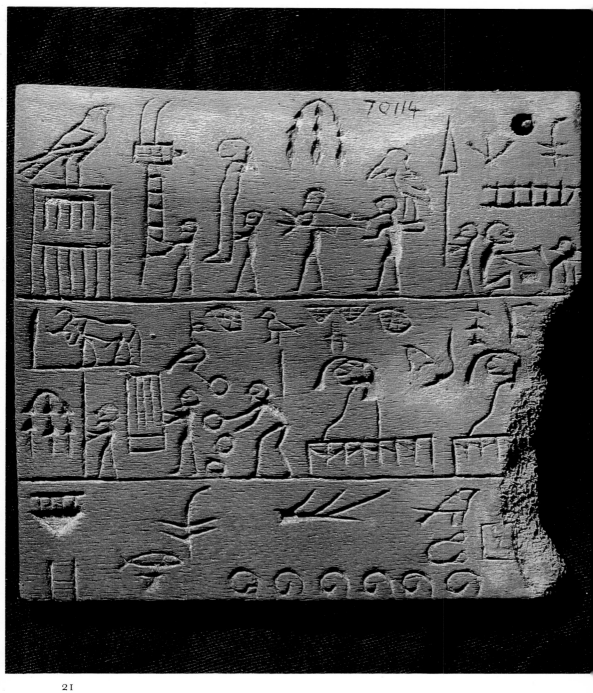

21

22

37

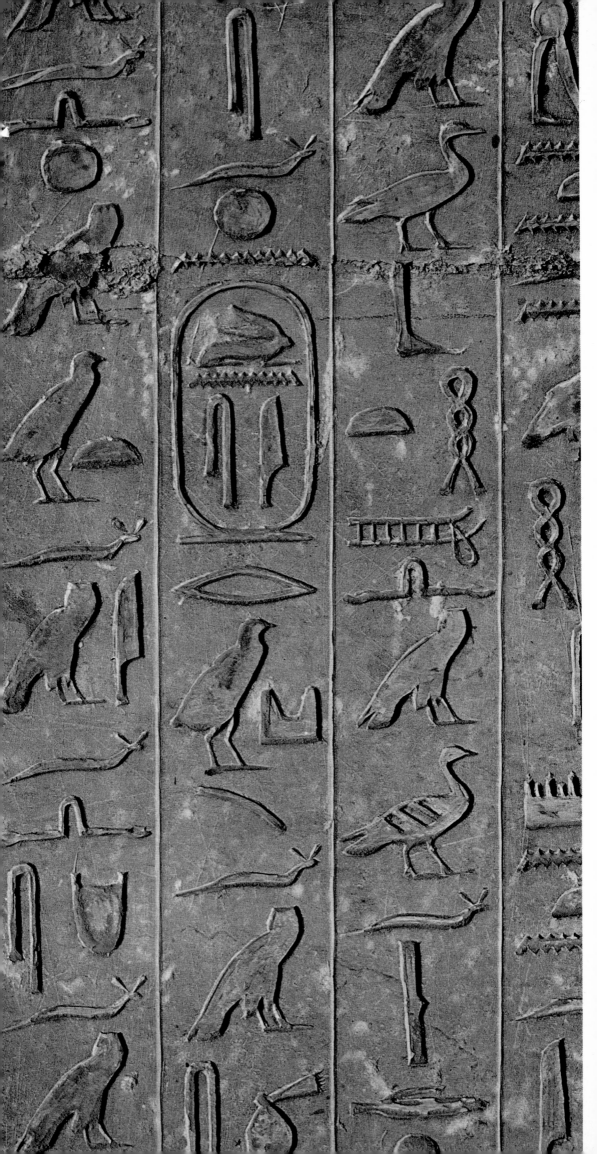

4. THE CHRONOLOGY OF ANCIENT EGYPT

The difficulties of establishing a reliable chronology

Manetho's chronicles and the Egyptian calendars

The prehistory of Egypt as brought to light by archaeologists

Narmer unifies the country

The Thinite dynasties

The power of the Old Kingdom Pharaohs

Revolutionary upheaval in the First Intermediate Period

Egypt's revival during the Middle Kingdom

The Hyksos

The conquests and flowering of culture in the New Kingdom

The heretic king

Foreign invaders

The Ptolemies found a new dynasty

Egypt becomes a Roman colony

Christianity reaches the Nile

The Meroïtic kingdom in Nubia

4. THE CHRONOLOGY OF ANCIENT EGYPT

During World War I, while thousands of soldiers were dying in the trenches, one of Germany's most eminent Egyptologists, Kurt Sethe, was working night and day on the chronology of ancient Egypt. He had some misgivings about spending so much time on such remote and abstruse matters, especially since the best he could often do was to ascertain that a given Pharaoh's reign had lasted a year or two more, or less, than previously supposed. But he kept on at his self-appointed task, knowing that trifling details may turn out to be important in a scientific discipline. It is the sum total of established facts that gives solidity to knowledge, and details are the mortar, if not the blocks of the edifice. Had Sethe not painstakingly clarified many niggling details of chronology, we could not go on today to the larger question of "periods" of ancient Egyptian history. (Chart I, pp. 562–64, lists the dynasties and principal rulers of ancient Egypt. The dates used throughout this book are based on this chronology).

The earliest historian of Egypt was Manetho, a priest of Sebennytos, who lived under the first two Ptolemies, that is, between the fourth and third century B.C. It was he who divided his country's history into thirty-one dynasties or ruling houses. Only an epitome (abridgement) of his work has come down to us—a list of rulers with the duration of their reigns. Manetho's original text also contained some general observations, a few of which are known to us through two Christian writers: Sextus Julius Africanus (fl. 221 A.D.) and Eusebius (c. 263–339 A.D.). Manetho had access to the chronicles kept by temple scribes, who set down the important events of each reign. Even in antiquity abbreviated versions of these chronicles circulated, consist-

ing of little more than lists of the succession of kings. Some of these lists have survived, among them the inscription on the so-called Palermo stone, from Dynasty II; the list of kings of Tuthmosis III, incised on the walls of his temple at Karnak (now in the Louvre); the list of kings in Sety I's temple at Abydos; and those found in the tomb of the scribe Thunery at Saqqarah. Certain papyri also contain fragmentary lists of kings such as the famous Turin Papyrus, which dates from the reign of Ramesses II.

Though Egyptologists have found little to quarrel with in Manetho's sequence of dynasties, his work has been of little aid in establishing absolute dates for individual dynasties. Scholars have long wrestled with this difficult problem, which is complicated by the fact that the Egyptians used three different calendars simultaneously—and all are different from ours.

THE first calendar was based on the movements of the star Sothis, or Sirius, which is sometimes called the Dog Star; its annual appearance, shortly before sunrise between July 19 and 21, marks the beginning of the dog days in the Mediterranean region. Sothis ($\P \blacktriangle \underline{\ }\ \ \overset{\frown}{\star} = spd$) was dedicated to Isis and occasionally identified with Hathor. But the solar year (on which our own calendar is based) is longer than the Sothic year by about six hours. As a result, every four years a whole day must be added to the Sothic year, or a whole year every 1,460 years. The ancient Egyptians were not unaware of the flaw in this system of keeping time. As early as Dynasty III (2686–2613 B.C.), Imhotep, chief architect to the Pharaoh Zoser, effected the first reform of this calendar, and further corrections were made later on, the last being the famous Canopus decree under Ptolemy III Euergetes (246–221 B.C.). The Sothic calendar was introduced by the priests of one of Egypt's oldest capitals, the city of On, which the Greeks called Heliopolis—today a section of Cairo. The calendar had special significance for that locality, because it was between July 19 and 21 that the Nile reached the flood stage at Heliopolis—and also at Memphis, which later became the capital. The life of ancient Egypt revolved around the annual flooding of the Nile, and to ordinary folk the day the river overflowed its banks represented the beginning of a new year. Thus the Sothic calendar reflected the rhythm of everyday life.

However, as we know today, after 2937 B.C. another calendar was also used. We may think of this as the civil—as opposed to the priestly—calendar. It was based on the years of a given reign as well as on the regularity of the Nile floods; the basic unit of time was more often two years than one.

Finally, the third calendar, closely connected with the second but mainly employed to determine the dates of religious holidays and other solemn observances, was based on the phases of the moon. It consisted of twelve

months of thirty days each. Each month was divided into three decades; each decade was under the protection of a different god. Altogether, then, one year had thirty-six decades. To make up for the difference between this lunar calendar and the Sothic (or solar) calendar, a thirty-seventh decade was added every two years. This, incidentally, helps us understand the rationale behind the two-year time unit in the civil calendar.

In practice, the discrepancies between the various calendars could not pass unnoticed. Religious feasts were celebrated annually, making it necessary to find a solution every year—not every two years—to lessen the rapidly increasing difference between the lunar and the Sothic calendar. An improved lunar calendar was eventually developed; instead of adding ten days after every two years, five days (called epagonal days) were added at the end of each year. Each of these five days was consecrated to a different god: the first to Osiris, the second to Horus, the third to Seth, the fourth to Isis, and the fifth to Nephthys.

Finally, as a further complication, attempts were made at Alexandria in Roman times to combine the three Egyptian calendars with the Julian calendar. The year was then supposed to begin on the first day of the ten-day period consecrated to Thoth (August 29 on our calendar). Leap years were to have six epagonal days instead of five.

W_E have already noted that the Egyptians themselves considered the turning point in their history to have been the unification of Upper and Lower Egypt under a single ruler. According to tradition, this was achieved by Menes, king of Upper Egypt, whose second name was probably Narmer. Statues of Menes were carried in religious processions alongside statues of the gods. Symbolic representations of the unification are numerous, for in the eyes of the Egyptians the event marked the break between "ancient" and "modern" times. The stabilization of political, economic, and social conditions so strongly reflected in Egyptian art was one consequence of the unification of the two kingdoms (fig. 40).

But just when did the unification occur? In view of the difficulties created by the Egyptian calendars, no one should be surprised that it has taken modern scholars a long time to establish the chronology of ancient Egypt. In the late 1920s, Sir Flinders Petrie in his London lectures expressed the view that Menes unified the two kingdoms around 5000 B.C. The German Egyptologist Ludwig Borchardt, taking into account the efforts made by Egyptian priests to reduce the difference between the solar year and the Sothic calendar, concluded that the first reliable observation of the recurrent appearances of the star Sirius goes back to the year 4241 B.C. He reasoned that careful astronomical observations might well have been made possible

by a stable administrative organization (a result of unification) and suggested 4241 B.C. as a date for the reign of Menes. The great German historian Edward Meyer, however, obtained still another date. According to him unification was effected sometime around 3500 B.C. Shortly before World War II, Hermann Junker advanced the reign of Menes to about 3000 B.C., and in the 1950s Alexander Scharff gave 2850 B.C. for this "watershed" date in the history of ancient Egypt.

Today we prudently compromise, and assign the dates 3100–2890 B.C. to the first dynasty that ruled over a unified country. Admittedly, the hardest problem to decide is just when the sequence of the dynasties began. From the New Kingdom onward—that is, since about 1500 B.C.—the situation is much clearer. The names of the Pharaohs of this period who fought wars of annexation on the eastern frontiers of Egypt, above all in Syria, are recorded in annals and chronicles of other ancient kingdoms. Professor Sethe deserves our gratitude for coordinating Egyptian records with those of other ancient peoples. Beginning with Dynasty XVIII, the major problem in dating is merely to decide whether the reign of a particular Pharaoh should be a year longer or shorter than previously calculated.

According to the present state of our knowledge, the history of ancient Egypt may be summed up as follows. The earliest traces of human activity go back to Paleolithic times, when an extreme climatic change took place across the whole of northern Africa. As the grasslands and woodlands slowly turned to desert, groups of nomadic hunters moved ever closer to the great river. Flint sickles, found in the desert along with arrowheads, suggest that agriculture had already begun at that early date, but the first positive proof of sedentary life in Egypt dates from the Neolithic Period. Detailed analysis of relevant archaeological material suggests that the Neolithic population of the Nile valley may have been fundamentally different from its Paleolithic predecessors. Excavations on the western fringes of the Delta at Merimdeh Beni Salameh (in the northern limits of the Fayum oasis) and in the northern part of Upper Egypt (sometimes referred to as Middle Egypt) have yielded striking evidence that the inhabitants of these primitive settlements cultivated barley and flax, wove baskets from reeds, and made clay vessels by hand. (Certain late Neolithic cemeteries—for example, the one discovered at Deir Tasa, a village in Middle Egypt—are linked to the Predynastic Period.) The tools found at these Neolithic sites are still made of flint, for copper was not used in tool making until the Early Predynastic (Chalcolithic) Period.

Another early culture, which takes its name from finds made near the village of Badari, is characterized by clay vessels made in a variety of shapes, with red polished surfaces and black tops. The earliest terracotta human figurines date from the Badari culture.

At Nagadah, in Upper Egypt, Sir Flinders Petrie discovered extensive Predynastic settlements. His study of the tomb furnishings and other archaeological material from the local cemeteries led him to distinguish three stages in the cultural development of this period—an Amratian, a Gerzean, and a Semainean culture, named after sites at El Amrah, El Gerza, and El Semaineh; these are also distinguished as Nagadah I, II, and III, respectively. As early as 1944, however, Helene Kantor revised Petrie's classification. She pointed out that only two stages of civilization were discernible at these sites—Early and Late Predynastic—because there is no essential difference between the Nagadah III–Semainean and the Nagadah II– Gerzean cultures. The material culture of Dynasty I is a direct continuation of Nagadah II. In 1956–57 the German archaeologist Werner Kaiser, after a careful study of the Predynastic cemetery at Erment, returned to the tripartite division and tried to divide each of the three periods into subperiods. Carbon-14 dating methods have not given entirely satisfactory results, but they do enable us to assign the earliest phases of the Nagadah culture to the first two centuries of the fourth millennium B.C.

According to E. J. Baumgartel, Nubet (the so-called South Town) may have been the chief settlement of the Nagadah tribes toward the end of the Nagadah I period. At this time a new wave of migration arrived in Egypt from an as yet unknown place in Asia, probably entering by the Red Sea and the Wadi Hammamat. It is Baumgartel's belief that the newcomers developed the culture called Nagadah II and that "with them begins the development which led to the foundation of the historic Egyptian state and culture."

Differences between the cultures of Upper and Lower Egypt can be clearly discerned as early as the Predynastic Period. In the south (Upper Egypt) flint arrowheads and club heads of granite or other hard rock continued to be made. Clay vessels found there are black or red with incised ornamentation painted white. Cosmetic palettes are made of hard slate, simple in shape. Sometimes the decoration resembles wickerwork; sometimes there are stylized animal figures or hunting scenes. Stone vases are rare. Anthropological analysis of bones from sites in Upper Egypt suggests that its inhabitants were of slender build and had long thin faces. The few terracotta figurines seem to indicate that the men wore their beards like those of their Libyan contemporaries.

Lower Egypt was, in some respects, at a higher stage of development in the Early Predynastic Period. Burial customs were more elaborate than in the south: the tombs were built more carefully, wooden beams supported the roofs, and the floors of individual chambers were covered with woven mats. The pottery of Middle and Lower Egypt, however, was not comparably advanced. It is often decorated with scenes painted in red, depicting

human figures and boats. These boats have many oars and their deckhouses are inscribed with various signs which may be totemic emblems of Predynastic communities—probably the forerunners of individual nome emblems found in the art of later periods. In the tombs of Lower Egypt many stone vessels and implements have been discovered, as well as bronze objects and glazed stone beads. Some of the cosmetic palettes are carved in animal shapes. The occasional presence of lapis lazuli suggests contact between Lower Egypt and Asia. Anthropological measurements of human remains indicate that the people of the Delta were similar in height and bone structure to the inhabitants of Upper Egypt but had broader faces.

On the basis of the archaeological material and other data yielded by excavations, the social organization of Early Predynastic Egypt can be roughly reconstructed. The individual tribal communities, from which the nomes later developed, were probably organized into two loose confederations, one in Upper Egypt, one in Lower Egypt. The political center of Upper Egypt was probably Nagadah, where the god Seth was worshiped. In Lower Egypt the principal deity was Horus, represented in the form of a falcon; the center of his cult may have been Behdet in the west Delta. Objects characteristic of Lower Egypt have been found in Upper Egyptian tombs, indicating that the northern confederation, which undoubtedly played a dominant role in Egyptian culture, exercised some kind of hegemony over the communities of Upper Egypt—perhaps only intermittently.

By the time of the Late Predynastic Period—today fixed as the two hundred years between 3300 and 3100 B.C.—two kingdoms were already in existence. The capital of Lower Egypt was Buto; that of Upper Egypt Hierakonpolis. This period was marked by continual struggles between the two kingdoms as each sought mastery of the whole country. Scenes engraved on cosmetic palettes of the time represent warfare between the two kingdoms, now the one side victorious, now the other. In the end, as we have seen, the country was finally unified by Menes-Narmer, the southern ruler who conquered Lower Egypt and was Egypt's first historical figure.

MENES' accession to the throne inaugurates ancient Egyptian history. The first two dynasties (3100–2890 and 2890–2686 B.C.) seem to have governed from Thinis, probably situated in Upper Egypt near Abydos, although even today the site is uncertain. Nor can we say with certainty that the tombs of the Dynasty I kings, discovered at Abydos, were not so-called cenotaphs— that is, commemorative tombs which Egyptian tradition bade the rulers erect at Abydos, the place where Osiris died and the center of his worship. However, we are now sure that Memphis, situated at the border between Lower and Upper Egypt, was founded during Dynasty I, and that its location,

a short distance south of the Delta, made it particularly well suited to be the eventual capital of both kingdoms.

The first two, or so-called Thinite, dynasties were followed by ancient Egypt's "classical" era, the Old Kingdom (2686–2181 B.C.), which includes Dynasties III through VI. This period was marked by a supreme flowering of art and culture, which culminated in the building of the great pyramids and the sphinx at Giza, as well as monumental temples and mastabas. There is no doubt that Egypt enjoyed considerable prosperity at this time. The crafts were developing and trade expanded; recent excavations at Buhen near the Second Cataract have yielded evidence of Egyptian trading posts deep inside Nubia. The kingdom was efficiently governed and the priesthood completely subordinated to royal authority. The kings took advantage of the seasonal unemployment caused by the Nile floods and set the fellaheen to work on the pyramids; building materials were carried down the swollen waters of the Nile from the nearby quarries at Turah. Toward the end of Dynasty VI, during the reign of Pepy II, serious conflicts broke out at the court of Memphis. These rapidly took on the proportions of a revolution that shook the entire society.

We know little about the so-called First Intermediate Period (2181–2133 B.C.), which followed Dynasty VI, but it is certain that Dynasties VII through X, listed by Manetho, did not exercise actual power throughout the whole of Egypt. Royal authority was virtually nonexistent. The provinces were governed by nomarchs, often elevated to this position by the people. Later papyri show that a real social revolution took place at this time. We learn that "the poor have taken possession of property; he who formerly could not afford a pair of sandals is now the possessor of treasures; the wealthy lament while the poor rejoice. People say: let us attend to the rich who are among us.... Fire consumes the palace, the colonnades, and in the provinces buildings are destroyed. Gold, silver, and precious stones now adorn the necks of slave girls, while noble ladies sigh, 'Ah if only we had something to eat.' They walk about sadly because they are clothed in rags." (The Admonitions of Ipuwer.)

Evidently this social revolution was not confined to the ruination of the rich. The entire economic system of the Old Kingdom was shaken to its foundations. The crafts declined and there were shortages, especially of household goods. People complained that all was lost, that some had neither clothes nor shelter. One of the texts concluded, "Verily, all good things have perished."

Toward the end of the third millennium the nomarchs of Thebes succeeded in bringing the country under a single rule once again. The principal architect

of this reunification, effected about 2050 B.C., seems to have been Mentuhotep I (Neb-hepet-ra) of Dynasty XI (2133–1991 B.C.). Under his rule there began a revival of Egypt's art and culture that continued into Dynasty XII (1991–1786 B.C.). Dynasties XI and XII are usually grouped together as the Middle Kingdom.

Exhausted by civil strife and long neglect of its complex irrigation system, Egypt found itself much poorer than during the Old Kingdom. In order to govern the country more effectively, the new Theban rulers transferred the administrative center to Middle Egypt, to a spot they called Ith-Tawe, not far south of Memphis. They based the country's economy on the rich Fayum oasis, where they carried out a number of irrigation projects, including the creation of a reservoir to regulate the Nile's flood waters.

Meanwhile, it was necessary to defend a weakened Egypt against foreign invaders and to consolidate the new dynasty. Bedouins from the eastern desert had achieved a temporary conquest of the Delta during the First Intermediate Period, and this disaster was fresh in everyone's memory. The Theban rulers built powerful fortifications east of the Delta as a protection against future incursions from that quarter. A similar situation prevailed in the south. Lower Nubia between the First and Second Cataracts had been partially controlled by Egypt during the Old Kingdom and had been a source of gold and other precious minerals. The Middle Kingdom rulers built a series of forts along the banks of the Nile, reaching as far south as the Second Cataract, where they established powerful strongholds at Buhen and Semneh. And at Kerma, beyond the Third Cataract, they set up fortified trading posts.

While taking measures to protect the country against foreign invaders, the Theban rulers made a systematic effort to check the power that the nomarchs had assumed during the First Intermediate Period, when Egypt was broken up into many separate petty states. The Pharaoh who finally succeeded in subduing his provincial governors seems to have been Sesostris III (1878–1843 B.C.).

The Pharaohs of the Middle Kingdom regarded the economic and cultural policies of their predecessors—the Pharaohs of the Old Kingdom— as unsurpassable models to be emulated on all occasions. The same attitude is evident in the art of the period. But the old ideological backbone was lacking. After the upheavals of the First Intermediate Period, no one could continue to believe in the immutability of the world, or, more specifically, in the permanence of class divisions and the power of the Pharaoh. How eloquent are the words that Amenemhat I (1991–1962 B.C.) addressed to his son: "Do not love any of your brothers; have no friends. Those who ate my bread rebelled against me."

Toward the end of Dynasty XII the royal authority once again showed

signs of weakness. There followed the so-called Second Intermediate Period (1786–1650 B.C.), during which the Hyksos, probably of Asiatic origin, began to settle in the Delta region. They took advantage of Egypt's imminent political disintegration by seizing power in the eastern Delta and occasionally extended their influence into southern Egypt. They set up their capital at Avaris (the later Tanis) and recognized Seth as their tutelary deity. Of the five dynasties (XIII through XVII) listed by Manetho for this period, three were certainly native Egyptian, but two (XV and XVI) were Hyksos.

During the Second Intermediate Period, Egypt was not ruined economically to the same extent as during the First Intermediate Period following Dynasty VI. The Hyksos sought to imitate the Egyptian rulers and respected the country's cultural traditions. The famous Rhind mathematical papyrus was copied during the reign of the Hyksos king Apophis I by a scribe named Ahmosis, who mentions that he transcribed it from older records. Toward the end of this period the country was reunited. The Hyksos were defeated in a battle near the gates of Avaris, either by Kamose, the last king of Dynasty XVII, or by his successor Ahmose, founder of Dynasty XVIII; the latter finally succeeded in driving the Hyksos out of Egypt.

Now the capital was moved back to Thebes. The period that followed represents a brilliant upsurge of Egyptian art and culture, as well as the attainment of the country's greatest military and political power. This is known as the New Kingdom (1650–1085 B.C.), comprising Dynasties XVII, XVIII, XIX, and XX. The rulers during this period did not confine themselves to internal reorganization of the country but also carried out a policy of conquest, primarily in the east. Under Dynasty XVIII (1567–1320 B.C.) four Pharaohs bearing the name of Amenhotep and four bearing the name of Tuthmosis were most instrumental in increasing Egypt's power and wealth. In connection with them we must also mention Queen Hatshepsut (1503–1482 B.C.), Tuthmosis II's sister and wife. It was for her that Senmut, her chief architect, vizier, and favorite, built the splendid funerary temple at Deir el Bahari, undoubtedly one of the most interesting and original of all Egyptian temples. Hatshepsut also organized a magnificent trading expedition to Punt (probably the modern Somali).

Trade contacts between Egypt and Crete, evidenced at least as early as the beginning of the second millennium B.C., seem to have continued sporadically through the Second Intermediate Period and on into the New Kingdom. Paintings and reliefs executed in Dynasty XVIII, for example, depict Cretans (called *keftiu* by the Egyptians) carrying gifts, among them such characteristic Cretan vessels as the *rhyton*.

Also dating from the New Kingdom are the most splendid temples in

Egypt and Nubia, hundreds of colossal granite monuments, and priceless works of jewelry. Only an imperfect idea of these splendors is given by the tomb of Tut-ankh-amon, who was one of the least important rulers of Dynasty XVIII and reigned for barely ten years (1361–1352 B.C.).

The rapidly growing wealth of New Kingdom Egypt profited the priesthood, which achieved great influence at Karnak, seat of the worship of Amon, the chief god at that time. The important Harris Papyrus (now in the British Museum) contains a list of donations to temples during the reign of Ramesses III. Gradually a conflict developed between the state and the priestly power at Thebes—a conflict already foreshadowed in the Middle Kingdom.

The most recent research suggests that the famous heresy of Amenhotep IV originated in part with his predecessor Amenhotep III, one of the greatest of all Egyptian Pharaohs. The young Amenhotep IV broke with the religion of the Theban Amon and the other Egyptian gods, and between the fourth and sixth years of his reign moved his capital to the desert in the north, where he built a new city (near today's village of Tell el Amarna), naming it Akhetaten, "The Horizon of Aten."

Aten, the solar disk, was henceforth to be the only god worshiped. The king, having changed his own name from Amenhotep (which stands for "Amon is at peace") to Akhenaten ("the soul of Aten"), ordered all other gods eliminated and the cult of Amon destroyed. He also did away with hieratic court ritual. He had himself portrayed as he actually was— with an egg-shaped head, thin and loosely hanging arms, and a prominent paunch.

The art of Amarna constitutes one of the most remarkable phases in the entire history of ancient Egypt. Its intimate character and grace have been preserved in various reliefs representing the king with his beautiful wife Nofretete and their little princesses. Along with the famous portrait head of the queen, these reliefs are among the finest surviving Egyptian works of art. From his court at Amarna the king corresponded with the rulers of Mesopotamia and Asia Minor. This extensive correspondence, discovered at Tell el Amarna, is written on clay tablets in Babylonian cuneiform characters; in the ancient Near East, Babylonian was the language of diplomacy, like French in modern Europe.

The Amarna episode, however, lasted only the seventeen years of Akhenaten's reign (1379–1362 B.C.). Shortly after his death his successors Semenkhkara and Tut-ankh-amon moved the capital back to Thebes and restored the old religion. The dramatic two-hundred-year conflict between the royal power and the priesthood ended with the victory of Herihor, high priest of Amon at Thebes.

The kings of Dynasties XIX (1320–1200 B.C.) and XX (1200–1085 B.C.)

continued their predecessors' policy of conquest, bringing back spoils of war and thousands of captives who were employed as slaves, primarily in mines and quarries in the desert. The biblical Exodus is believed to have occurred during the New Kingdom reign of Merenptah (1236–1223 B.C.). The only basis for this conjecture is the fact that the name "Israel" appears for the first time in Egyptian records of this period. The event is not even mentioned by Egyptian chroniclers—perhaps they considered it as of no importance.

It was during the New Kingdom that the Egyptians struggled against the "Sea-Peoples" who came from the north by ship and conducted raids along the coasts of Libya and Egypt. Ramesses III (1198–1166 B.C.) finally succeeded in defeating their fleet off the coast of the Delta.

Wᴛᴛʜ the fall of Dynasty XX we reach the Late Dynastic Period, or Late Period. During Dynasty XXI there were two governments, one centered at Tanis, on the eastern frontier of the Delta and headed by Smendes; the other at Thebes, headed by Herihor. Thus begins what some historians regard as a Third Intermediate Period (945–664 B.C.). The Pharaohs of Dynasty XXII (Bubastite) were of Libyan origin; those of Dynasty XXV (Kushite) were of Nubian or Ethiopian origin, descendants of the ruling house of Napata, a small kingdom between the Third and Fourth Cataracts.

An attempt to revive the great traditions of Egyptian civilization was made by the princes of Sais in the Delta who founded Dynasty XXVI (664–525 B.C.). With the help of Greek mercenaries, Psamtik I succeeded in driving out the Assyrians who had captured both Memphis and Thebes. Psamtik II organized a military expedition into Nubia to subdue its local rulers. A later king, Amasis, conquered Cyprus and, being a great Hellenophile, encouraged Greek colonization in Egypt. The Greeks founded Naukratis in 565 B.C. as a free port on the Delta. The Saite rulers, however, were no match for the Persians. The Persian Cambyses conquered Egypt in 525 B.C.; he may be regarded as the founder of a new dynasty (which Manetho called Dynasty XXVII) and ruled Egypt from his capital Persepolis.

The kings of Dynasty XXVIII are not named in hieroglyphic inscriptions, but they do appear in demotic and Aramaean papyri. The names of three rulers of Dynasty XXIX are inscribed on monuments, but Achoris (393–380 B.C.) is the only ruler about whom much is known. A brief period of independence had begun during Dynasty XXVIII, and it was maintained by the kings of Dynasty XXX, Nectanebo I, Teos, and Nectanebo II. Persian domination was reasserted in 341 B.C. and continued until the fall of the Persian Empire a few years later.

Alexander the Great defeated the Persian king Darius III at Issus in

333 B.C. and marched into Egypt the following year. After Alexander's death one of his generals, Ptolemy, set up a new capital at Alexandria. The Ptolemaic dynasty, which he founded in 304 B.C., ended with the fall of Cleopatra VII and the conquest of Egypt by Roman legions in 30 B.C.

Under the Ptolemies, Egypt slowly became Hellenized. However, the Greek language and culture of the ruling classes barely affected the masses of the population, who remained faithful to the cultural tradition of their country. Actually the Ptolemies themselves did not pursue a policy of complete Hellenization, even though they did everything possible to make Alexandria the leading center of Greek culture in their day. In particular they lavished funds upon the Library, attracting eminent scholars and scientists. Greek science and art developed at a dynamic pace in Alexandria. The *sakieh*, a Greek invention, was universally adopted as a device of irrigation; to this day it remains essential to Egyptian agriculture. The Greeks also introduced other technological devices, such as the so-called Archimedean screw, which was used to lift water above its natural level.

Although Alexandrian culture spread throughout Greek-inhabited areas in the eastern Mediterranean and eventually influenced Roman culture in Italy, it never struck deep roots in Egypt itself. The very effort to legitimize their rule obliged the Ptolemies to imitate the Pharaohs in all their official acts and ceremonies. They restored the old Egyptian temples and built new ones in the traditional style. The art of Egypt in this period presents a unique picture of the coexistence of two artistic styles, entirely different in both form and content: one is Ptolemaic art, an extension and outgrowth of the great Egyptian tradition; the other, known as Alexandrian, belongs to the tradition of Hellenistic art.

Once the Romans had made Egypt a province of the empire, they regarded it primarily as a granary. During the three centuries of their rule the Romanization of Egypt was superficial. The people continued to speak Coptic and Greek, the latter having become somewhat naturalized during the Ptolemaic Period. Latin inscriptions are rarely found in Egypt. Although statues of Augustus were placed in the temples next to those of the Egyptian gods, Hadrian was the only Roman emperor who displayed any real interest in Egypt; in his Tivoli villa in Italy he installed the famous replica of Canopus as a reminder of the pleasant banks of the Nile.

Christianity reached Egypt at an early date: the first Patriarchs of Alexandria were named in the second century A.D. The religious ideals of solitude and contemplation were born in the Egyptian desert, and the first monasteries were established there toward the end of the third century. Under Diocletian, Egypt went through a brief period of religious persecution, but in the fourth century—during the so-called Coptic period—the new religion victoriously asserted itself with an art of its own. With Christianization,

Egypt experienced the destruction of some of its priceless treasures of earlier art and architecture; people who owned so much as a fragment of an ancient papyrus were hunted down like criminals. Egypt finally became a province of the Byzantine Empire. When Amru conquered it for the Arabs in 640–641 A.D., the civilization of ancient Egypt may be said to have come to an end.

BUT let us go back a few centuries. The authority of the Ptolemies never extended as far south as the Second Cataract. In Roman times the fortress at Qasr Ibrim between the First and Second Cataracts represented the southernmost outpost. At this time a new state had been formed in the ancient Egyptian province of Nubia. Two periods may be distinguished in the history of this kingdom, known as Kush. The first is the Napatian state (655–295 B.C.), which had its capital at Napata, between the Third and Fourth Cataracts; the second is the kingdom of Meroë (295 B.C.–350 A.D.), with its capital at the city of Meroë, south of the Fifth Cataract. The art and culture of the so-called Meroïtic kingdom continued ancient Egyptian traditions along with some Ptolemaic influences. After the fall of this kingdom there ensued a period of migration and struggle among nomadic desert peoples. Finally three kingdoms arose in Nubian territory: Nobatia in the north, with its capital at Pachoras (the present-day Faras); Makuria in the middle, with its capital at Old Dongola, near Merowe; and Alodia in the south, with its capital at Soba, near today's Khartoum. In the middle of the sixth century these kingdoms adopted Christianity, and Alodia held out successfully against Arab incursions until the beginning of the sixteenth century.

This southernmost portion of Egypt is particularly interesting on two counts: the ancient traditions survived almost down to our own Middle Ages, and Byzantine-Christian influences persisted long after the rest of Egypt had been converted to Islam. In fact, a so-called Coptic art survived nearly to the end of our Middle Ages.

Prior to the Arab conquest the meeting point of the two cultures was the island of Philae near the First Cataract; at one time Philae became the symbol of peaceful coexistence between two countries of different religions and cultures. After the fall of the Meroïtic kingdom, when the nomadic Blemmyes and Nobadas were struggling for possession of Lower Nubia, Byzantium concluded a treaty in 453 A.D. granting the Nubians the right to transport periodically the ancient statue of Isis from Philae to their own country. Yet at that very time a Coptic bishop resided at Philae, and the temples on the island had long since been converted into churches.

39. KING ZOSER
 Portrait statue found in the serdab *at the*
 foot of the step pyramid, Saqqarah.
 The king is enthroned,
 wearing the ritual garb of the Sed festival.
 Limestone; total height 78 3/4" *(see fig.* 184*).*
 Dynasty IV.

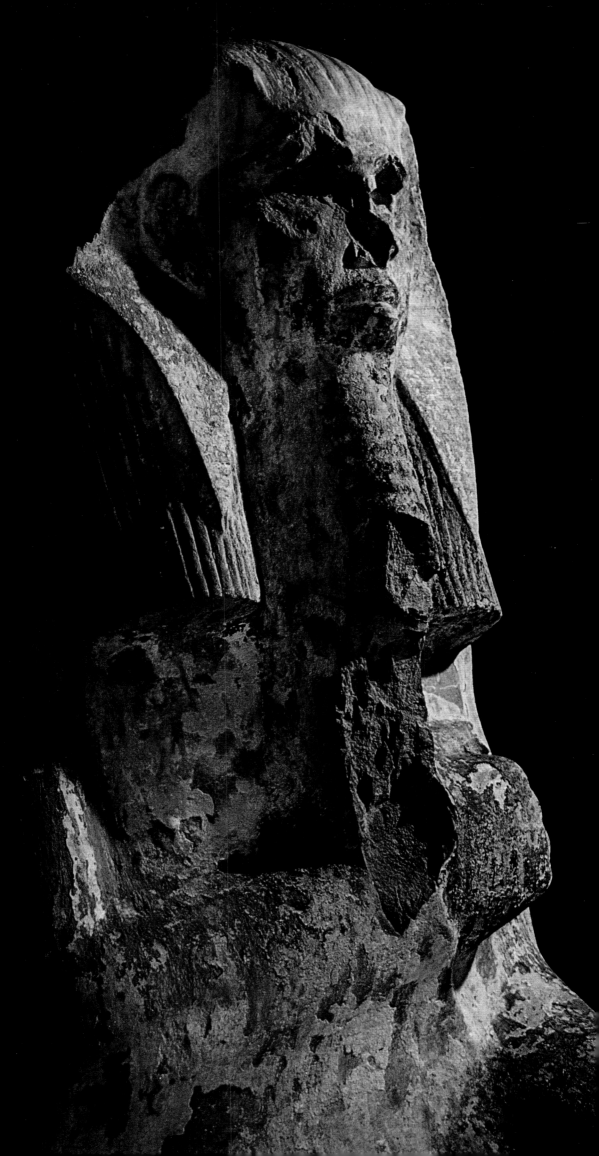

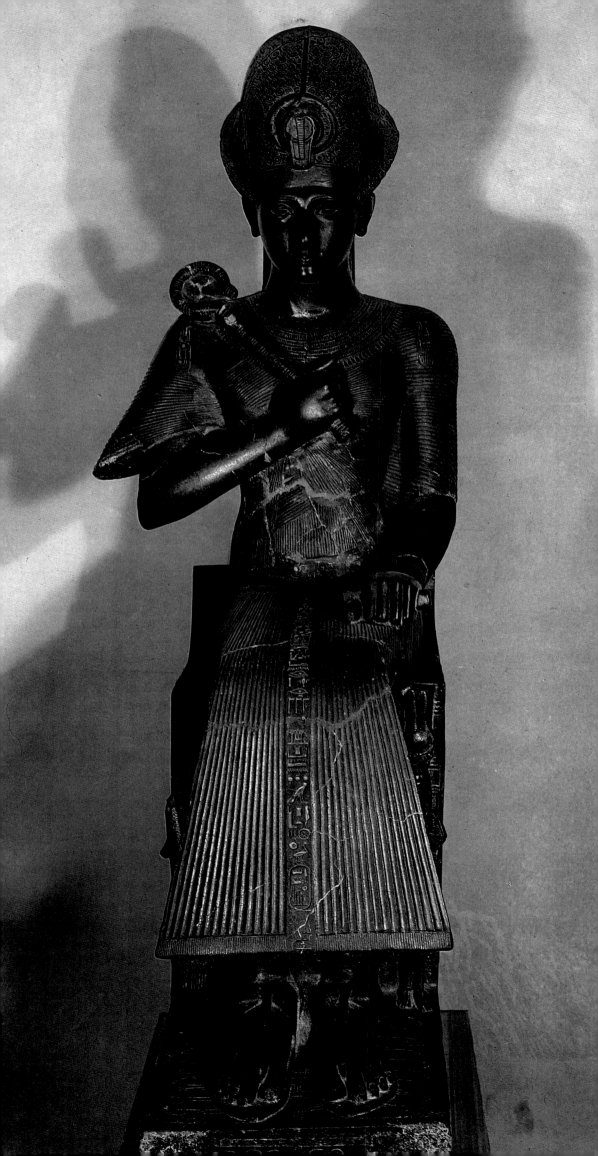

Preceding pages

40. RELIEF PANEL FROM THE THRONE OF
SESOSTRIS I
*From Tanis. The motif symbolizes
the unification of Upper and Lower Egypt.
Granite; height of panel c. 21″.
Dynasty XII. State Museums, Berlin.*

Opposite page

41. RAMESSES II
*This statue was at one time thought
to represent Sety I.
Basalt; height 76 3/8″.
Dynasty XIX. Egyptian Museum, Turin.*

5. RELIGIOUS BELIEFS

5. RELIGIOUS BELIEFS

O f all ancient religions, that of the Egyptians is perhaps the most complex. Although much scholarship has been devoted to it, we still lack a clear understanding of the ancient Egyptians' religious beliefs. There are many reasons for this. Even for the ancient Greeks the Egyptian religion seemed a baffling mystery jealously guarded by priests, who alone could fathom its secrets. The Greeks were shocked to find gods worshiped in the guise of animals; they failed to grasp the symbolism attached to such representations. For the Greeks, man was "the measure of all things" and the gods, naturally, took human form. Such practices as the mummification of ibises and cats seemed wildly eccentric. Nor could the Greeks understand crocodile worship, which included the belief that anyone devoured by a crocodile was a special favorite of the gods.

Yet there can be little doubt that ethical principles were inherent in the Egyptian religion. These principles reached deep into everyday life and over the course of centuries became the basis for individual conduct. Numerous aspects of the ancient Egyptian ethic were incorporated in Judaism and Christianity; in fact, some of the ritual symbolism of Christianity may be traced to the Egyptian religious system.

The main obstacle to understanding Egyptian religion is the fact that it was not a homogeneous body of beliefs. It was not derived from a single tradition or a single "revelation"; rather, it represented an accretion of many, often dissimilar, traditions. The early Neolithic settlers along the banks of the Nile may already have had primitive religious beliefs, which underwent far-reaching changes as the individual communities adapted to

changing climatic and economic conditions. Such age-old traditions probably gave rise to the associations of a particular god with a particular town or region of ancient Egypt. Even before the unification of Lower and Upper Egypt, the various priestly colleges had begun trying to impose some sort of order on these local cults and to integrate them into a more structured religious system.

The Greeks, though they were not in direct contact with Egyptian religious culture until the Late Period, still possessed a more complete knowledge of Egyptian religion than even modern scholarship has been able to reveal. The Greeks identified certain Egyptian deities with the Greek pantheon. They saw Thoth as interchangeable with Hermes, even though he lacked some of the latter's attributes, such as an association with thieves and traders. This inconsistency did not trouble the Greeks, however, for they found other traits of Hermes in other Egyptian deities and thus concluded that all these constituted one and the same god. If we approach ancient Egyptian beliefs from this point of view, it appears that a single religious principle could be worshiped in the guise of several deities whose exterior aspects were quite dissimilar.

On the other hand, certain representations of different gods were sometimes very much alike. The goddess Hathor, for example, is often confused with Isis. Thoth, who was sometimes portrayed as a beetle pushing a ball of animal dung mixed with sand, was associated with the god Khepri, who pushed the solar disk above the horizon (as on the mummy case of a priest of Horus-Thoth; fig. 135).

However, it is possible to postulate an entirely different theory of the origin of Egyptian religion by assuming that it began as a coherent system which, over the centuries, was altered and distorted by popular beliefs. In such a view, the growth of polytheism (recorded in many myths and legends) produced such chaos that even the priests were unable to present it as a logically consistent whole. This theory was advanced by those who believed that the Egyptian religion originated in the mythical island of Atlantis; this explanation, mentioned in Plato's *Critias*, was suggested earlier by Pythagoras and other Greek philosophers who had come into contact with Egyptian culture. Later the Alexandrian Gnostics expressed the same view in a more obscure form.

W E do not have enough information today to form a theory of the origin of Egyptian religion. From the available source material, we are able to view it only as the culmination of a long historical process which took place in the Predynastic Period, for the earliest known cosmogony, or creation

myth, was elaborated by the priests of Heliopolis prior to the unification of Upper and Lower Egypt.

The Heliopolitan theologians accounted for the creation of the world in the following way. Emerging from the primeval ocean (called Nun), the oldest god (whose name was Atum) appeared on a hill in Heliopolis. Atum begot himself. During the Old Kingdom, when the cult of the sun god Ra began to spread, the priests of Heliopolis decided that Atum and Ra were one and the same, and that the father of the gods was Atum-Ra, symbolized by the sacred stone *benben*. This local fetish in the form of a post—perhaps the prototype of the obelisk—marked the place in Heliopolis where the god was born. Atum-Ra begot from his own spittle Shu, god of the air, and Tefnut, goddess of moisture and the darkness under the earth. These two produced the earth god Geb and the sky goddess Nut who in turn bore two sons, Osiris and Seth, and two daughters, Isis and Nephthys. These nine deities together formed the Great Ennead of Heliopolis, to which Horus, the son of Osiris and Isis, was added later.

In addition to the Great Ennead, however, the priests of Heliopolis recognized a Lesser Ennead dominated by Horus, Thoth, Ma'at—a female figure, represented with an ostrich feather in her hair, who was goddess of truth—and the jackal-headed Anubis (fig. 48), who later had an important place as patron of mummification at Osiris' court. The mystical number nine recurs frequently in the Egyptian religion, although sometimes—at Thebes, for instance—the divine Ennead was extended to include as many as fifteen gods. At Abydos, the Ennead was represented by two Khnums, Thoth, two Horuses, and two minor gods called Upwats. The Pyramid Texts, from Dynasty V, suggest the existence of a group of ten gods capable of giving birth to a new god.

At the beginning of the Old Kingdom, when the capital of Memphis was founded on the west bank of the Nile south of Heliopolis, the Memphite priests became jealous of the Heliopolitan priesthood. The chief god worshiped at Memphis was Ptah, patron of artists and craftsmen, whom the Greeks subsequently identified with Hephaistos. In art he was always represented as a mummy holding the *was* scepter, symbol of happiness. He produced eight other Ptahs, thus forming an Ennead all to himself. To stress Ptah's superiority over Atum, the Memphite priests maintained that Nun, the god of the primeval ocean, was an aspect of Ptah (Ptah-Nun). Ptah's third incarnation was the sky goddess Nut, represented as a woman bent forward with outstretched arms (fig. 50). These incarnations of Ptah produced a fourth, Atum; through the latter's mouth and teeth Shu and Tefnut were spat out, themselves forms of Ptah.

According to the Memphite theology, Ptah and his wife, the lion-headed Sekhmet (fig. 53) who destroyed the enemies of Ra, were the parents of still

another aspect of Ptah, Nefertum; this young god, whose task was to amuse the sun god Ra every morning, had the lotus as his symbol. Thoth was the heart or mind of Ptah, while Horus was his tongue, his organ of speech, and his instrument of growth and creativity. As late as the fourth century A.D., Horapollo, an Egyptian priest, affirmed that the heart directs the body and the tongue creates existence.

Heliopolitan theology considered Atum the father of the gods; at Memphis, Ptah was the creator both of gods and men. According to the Memphite tradition, the earth emerged from the primeval ocean as the goddess Tatenen, but since she was an incarnation of Ptah, her real name must have been Ptah-ta-tenen. Ptah was also thought to have been the first to erect statues of gods in the temples; he made them himself, using various kinds of wood, stone, and metal.

It is noteworthy that the Memphite theology did not explicitly claim that Osiris—one of the most popular Egyptian gods—was just another form of Ptah, although one of the most important events in the life of Osiris was supposed to have occurred in Memphis.

The most interesting element in the Memphite cosmogony is the legend of the birth of the sun: Ra was said to have crept from an egg created by Ptah. This story also appears in a third Egyptian theological system, which grew up at Hermopolis, capital of Nome XV in Upper Egypt. This cosmogony was based on a Great Octad, eight gods who constitute the elements of chaos and the primeval ocean. The earth was said to have emerged from the ocean in the shape of a hill at Hermopolis; on this hill the sun god was hatched from an egg and proceeded to set the world in order. The Hermopolitan cosmogony never became widely influential and was later modified, no doubt for political reasons, so as to subordinate it to the then dominant Heliopolitan religion. The priests of Hermopolis agreed that Nun, the primeval ocean, had been the father and creator of Atum. It is interesting to note that the main Hermopolitan god, Thoth, patron of scribes and the inventor of writing, and symbolized by the ibis and the baboon, played no part in the Heliopolitan cosmogony (figs. 44, 47).

These three cosmogonies by no means present all of the gods in the Egyptian pantheon. Important religious centers had their own divine Triads, made up of a national god and two local gods. Thus, at Memphis there was a Triad composed of Ptah, his wife Sekhmet, and their son Nefertum. On the island of Elephantine, the Triad consisted of the ram-headed national god Khnum (who had created man on a potter's wheel) and two local divinities, namely, his wife Anukis and their daughter Satis. Represented with antelope horns, the latter was worshiped on Seheil, one of the little islands in the region of the First Cataract.

During the New Kingdom, the Theban Triad was the most important.

It was headed by Amon (fig. 52) identified with Ra, or Amon-Ra, whose sacred animals were rams and geese. His wife, the vulture-headed goddess Mut, now became the goddess of the sky; their son was the moon god Khonsu, represented as a boy.

It is impossible to list here all the gods of ancient Egypt, each of whom has a strictly defined form in art. Before turning to the most important Egyptian myth, that of Osiris, however, we shall discuss briefly the gods most frequently encountered in Egyptian paintings and reliefs. As we shall see, each of these divinities had its own local cult and at the same time was assigned a place in the official religious system. (Chart III, pages 566–67, illustrates some of the principal gods and goddesses of ancient Egypt.)

For instance, Neith, the goddess worshiped at Sais, was represented as a woman wearing the red crown of Lower Egypt and holding a shield in one hand, two crossed arrows in the other. This is why the Greeks identified her with Athena. Neith was one of the four goddesses who guarded the mummified bodies of the dead and the so-called Canopic jars in which the viscera were preserved. According to some myths Neith gave birth to Tefnut who, in the Heliopolitan cosmogony, was the goddess of moisture, a daughter of Atum-Ra, and the wife of Shu, god of the air. Thus Neith, the local goddess of a small town in the Delta, was probably one of the primeval deities as well.

The same may be said of Hathor. The main centers of her cult were Memphis in Lower Egypt and Denderah in Upper Egypt. She was also the tutelary deity of the copper mines in the Sinai Peninsula. Although she was often represented as a cow with a woman's head or as a woman with horns, the Greeks identified her with their own goddess of love, Aphrodite. The cult of Hathor was one of the most widespread in Egypt and in countries conquered by Egypt, such as Syria, where she was the patron of sailors and called the Lady of Byblos. It seems that before Nut, Hathor must have been worshiped as the sky goddess: her name literally signifies "House of Horus," and stars were often represented on her belly, the solar disk between her horns. Since the Egyptians called the disk "the eye of the sun," Hathor sometimes was considered an older deity than Ra, and sometimes treated as his daughter. She was worshiped also as the protectress of royal births, but at Thebes she was primarily revered as the guardian of the Western Mountain, symbol of the western necropolis (figs. 14, 115). Deir el Bahari was one of the principal centers of her cult.

Among other gods worshiped throughout ancient Egypt we may mention Hapi, god of the Nile floods, represented as a fat man with pendulous female breasts, wearing a bunch of papyrus reeds on his head and holding a well-laden offering table. There was also the snake goddess Rennut, who was

patroness of harvests and the fruits of the earth. Min, originally a local deity of Coptos, was later recognized as a fertility god and closely connected with Amon (fig. 302). The patron of travelers, Min appeared as an ithyphallic figure swathed in mummy bandages and holding a whip, the so-called *nekhekhw*. The falcon-headed Montu, formerly patron of the city of Hermonthis, south of Thebes, achieved the status of god of war during the New Kingdom and was represented as accompanying the Pharaoh into battle.

Another deity closely associated with royal authority was Seshat, the goddess of learning; it was believed that she composed and guarded the royal chronicles. She was represented as a woman and identified by the emblem on her head: a seven-pointed star on a stem, crowned by a pair of upside-down horns. The crocodile god Sobek was worshiped throughout Egypt, but especially in the Fayum oasis and at Kom Ombo in Upper Egypt. The frog goddess Heket, a local divinity of Antinoupolis, was a midwife, and it is not surprising that she was closely associated with Khnum, regarded as the creator of man. The goddess Taweret, represented as a hippopotamus, was also worshiped as a goddess of childbirth. The constellation of Ursa Major was also represented as a hippopotamus—in the famous zodiac at Denderah, for example. Finally, there were a few divinities who were especially revered in the Late Period. One was the cat-goddess Bastet, whose principal center of worship was Bubastis in the Delta. The cult of Bes also grew up during this period. Like Heket and Taweret, he assisted women in childbirth; in his capacity as god of the family hearth, he protected the faithful from snakebites and other dangers. Bes was represented as a dwarf with a leonine face and plumes on his head. Thousands of terracotta figurines of Bes have been found in cemeteries from the Ptolemaic and Roman periods.

WE have already mentioned that Egyptian religion sometimes gave rise to a new divinity by combining two existing ones. The new god usually preserved the characteristic attributes of the other two. Atum-Ra was one of these composite gods; Heliopolis later gave rise to Amon-Ra, the supreme judge. Sobek-Ra and the falcon-headed Ra-Harakhte similarly combined the features of Ra and Horus (Harakhte stands for "Horus of the horizon"). Serapis, whose worship was introduced in Egypt under the Ptolemies, combined the attributes of Osiris with some of those of the Greek Zeus. In Alexandrian art he is represented as a bearded man wearing a cylindrical headpiece called a *modius*. During the Late Period, Harpocrates, "the child Horus," inspired special devotion. He was portrayed as a naked child with a prominent lock of hair and a finger in front of his mouth, and was often shown sitting in Isis' lap, much like the child Jesus in the lap of the Virgin Mary (figs. 617, 618).

Especially popular in the Late Period was the cult of Apis—a bull carefully selected by the priests from among those with a particular spot on the forehead. When each Apis died, it was interred in a large sarcophagus in the so-called Serapeum near Memphis, and mourned by the entire population of the region. The enthronement of a new Apis was greeted with universal rejoicing and solemn processions.

Occasionally one epithet of a god was singled out and became worshiped as a separate deity. This was the case with Onuris (from which the name Onuphrius derives) which means "He-who-brought-back-the-faraway-land." This epithet was given to Osiris after his resurrection.

THERE were many versions of the Osiris myth in ancient Egypt. Since any attempt to list all the legends connected with this god would complicate an already complex strand in the tangled skein of Egyptian religious thought, we shall confine ourselves to the account given by the Graeco-Roman writer Plutarch, a priest in the temple of Apollo at Delphi. According to Plutarch, Osiris was a just and beneficent king who, from the Delta, governed all Egypt. His jealous brother Seth, who was viceroy in the south, invited Osiris to a banquet and then asked his guest to climb into a cunningly wrought chest prepared by Seth and his fellow conspirators (it was made exactly to Osiris' measure). Everyone at the party tried to fit into the chest, but only Osiris succeeded; the moment he did so, the lid was clamped shut and the chest cast into the Nile. (In all versions of the myth Osiris is drowned.)

Osiris' wife Isis, broken-hearted, succeeded in recovering his body. But Seth stole it from her, cut it into fourteen (in some versions, sixteen) parts, and ordered that these be scattered all over Egypt. Helped by her sister Nephthys, Isis succeeded in reassembling the scattered parts except, according to Plutarch, for his phallus. (Older sources do not mention this detail.) By magic Isis managed to bring her husband back to life for a time and even conceived a child by him. When the child, Horus, was born, Isis concealed him among reeds in the region of the Delta.

After Horus grew up he swore to avenge his father's murder. Eventually Horus engaged in hand-to-hand combat with his uncle, Seth, an experienced warrior who gouged out his nephew's eye and cut it up. (According to the Heliopolitan theologians, just as Ra was the eye of the sun, so Horus was the eye of the moon). Thoth found the fragments, joined them together, and gave the "whole" eye back to Horus (hence its name *wadjet*, "the sound eye"). After a great many battles (represented on the walls of the temple at Edfu) Horus defeated Seth and became the ruler of Egypt as his father's legitimate successor.

The struggle between Horus and Seth undoubtedly reflects the wars that

42. STELE OF KING ZET (WADJI)
From Abydos. The Pharoah's royal name
is inscribed within a frame called
a serekh, *which represents the royal palace*
surmounted by the falcon of the god Horus.
Limestone; height 57".
Dynasty I. The Louvre, Paris.

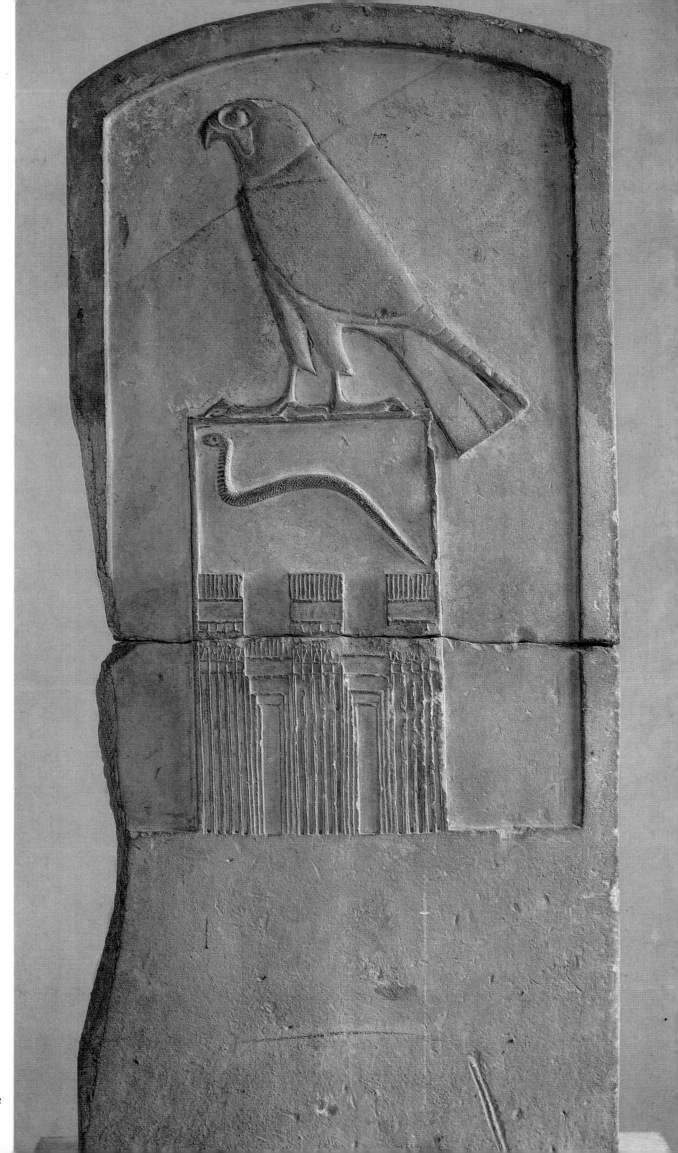

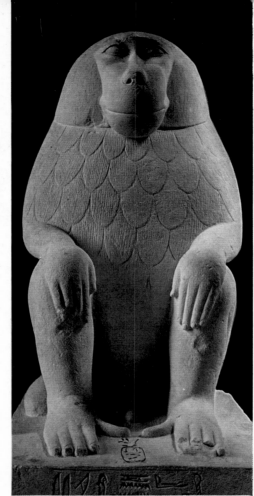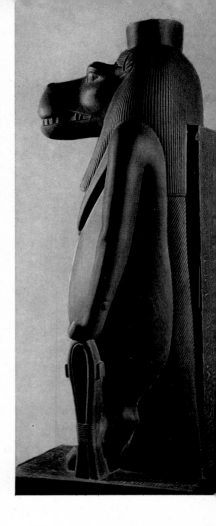

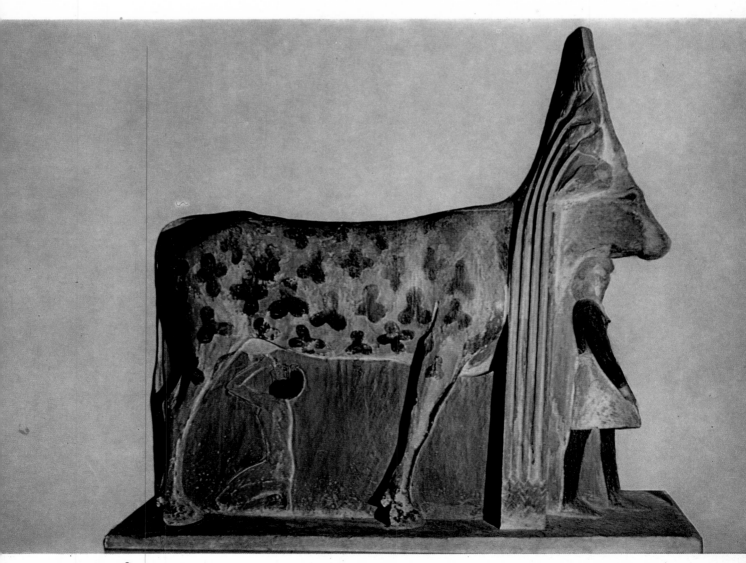

43, 44, 45, 46

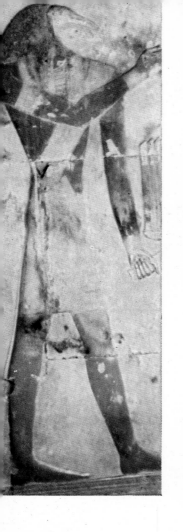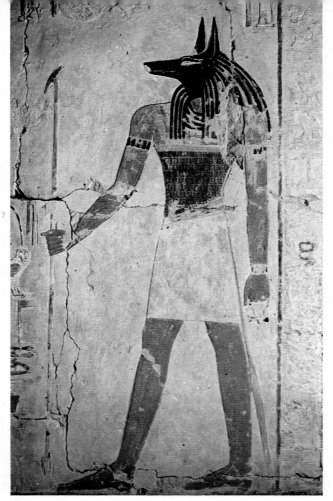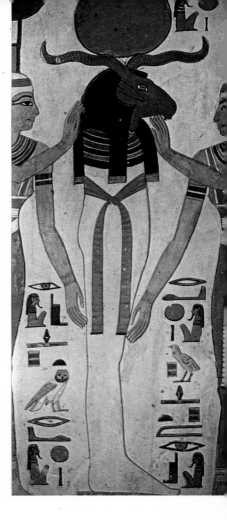

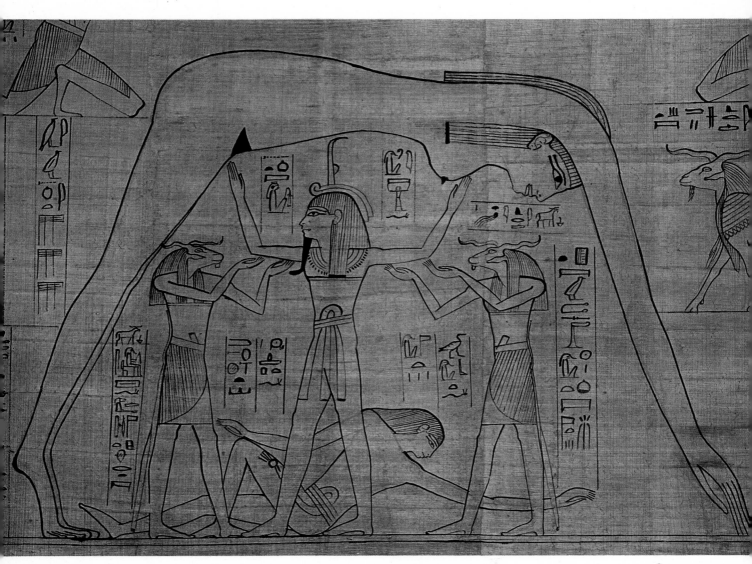

47,48,49,50

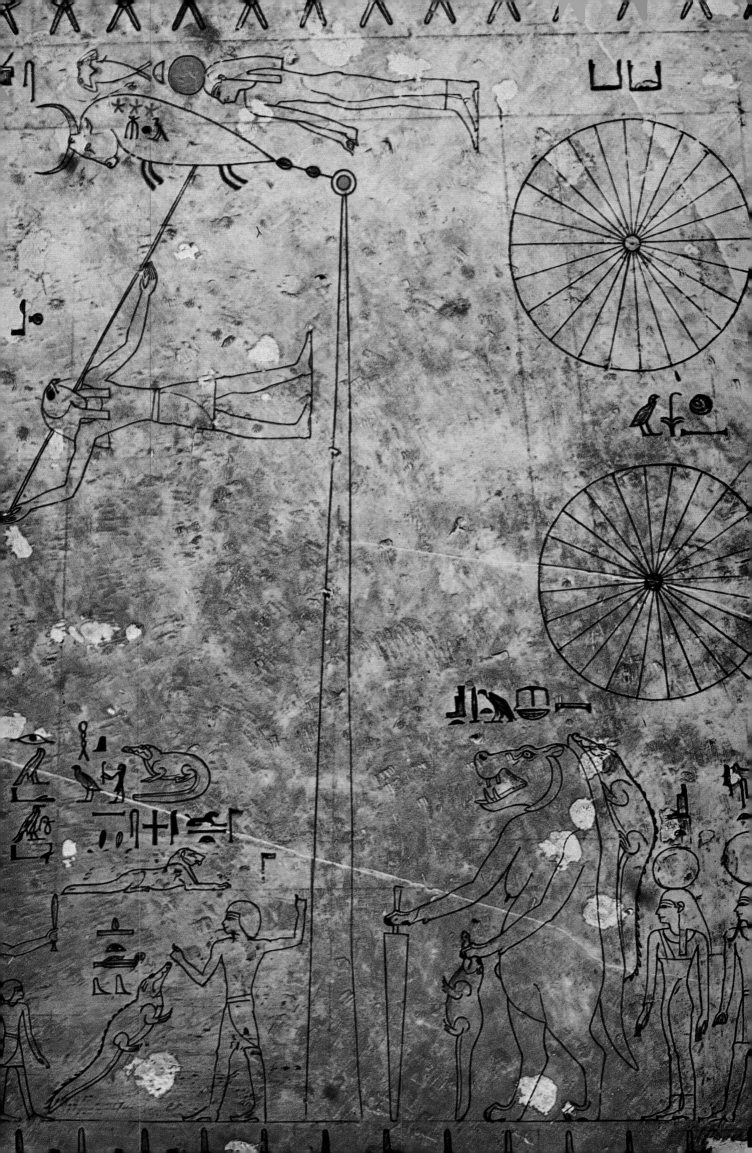

preceded the unification of Lower and Upper Egypt. But the myth must date from an earlier time, because the historical unification was achieved by a ruler of Upper Egypt, and Horus was associated with Lower Egypt. His victory over Seth has a deeper religious meaning, for in the Osiris myth, Seth is a god of evil; natural disasters, such as storms, and every sort of violence are attributed to him. Most often he was represented in an animal form that suggests a wolf or a jackal. Sometimes he appears as a pig, a donkey, an okapi, or—as at Edfu—as a hippopotamus. The Greeks later identified Seth with the monster Typhon.

L ET us look more closely at certain gods. Horus, the celestial deity represented as a falcon (figs. 42, 43), was identified with each Pharaoh throughout his lifetime. Although the most ancient site of Horus' cult was Behdet in the Delta, he became the object of special worship at Hierakonpolis and Edfu in Upper Egypt. He took on various aspects: as a child he was known as Harpocrates; as "old Horus," the Pharaoh's tutelary deity, he was called Harukris; as son of Isis he was known as Harsiesis; and in conjunction with Ra he was Ra-Harakhte.

Isis, the divine wife and mother forever mourning her husband's death, belonged to a group of four goddesses who collectively presided over Egyptian burial customs and practices. The others were Neith, Isis' sister Nephthys, and the little-known scorpion goddess Selket. Isis was represented as a woman; her emblem—the so-called throne of Isis—was worn on her head. Nephthys, whose Egyptian name means "mistress of the house," was represented wearing a stylized symbol of a palace on her head; this, with the hieroglyph *neb*, in the form of a basket, spelled out her name.

The main motif of the Osiris myth—his murder by his brother and his eventual resurrection—had equivalents in other ancient religions. Thus, Osiris became, among other things, the symbol of vegetation, especially of the cereal grains that are sown in the earth and reborn every spring. Since the mysterious process of the rebirth of vegetation takes place underground, Osiris, having entrusted power to his son Horus, became the god of the underworld. This part of the myth explains why Osiris was often shown as a royal mummy. In these representations he wears the double crown of Upper and Lower Egypt, or the *atef*, a crown with feathers; in his hands, folded on his chest, he holds the scepter *heka* and the whip *nekhekhw;* and his face is painted dark green or black.

T HE Egyptians viewed life on earth as merely a brief interlude preceding the eternal happiness of life after death; thus it is not surprising that the god

who ruled the kingdom of the dead was deeply revered. After death every man, if he had purged himself of his sins, would himself become Osiris and live on forever in the Egyptian equivalent of the Elysian Fields. At first this enviable lot in the afterlife was a privilege reserved to the Pharaohs and their families, but by the end of the Old Kingdom the hope of eternal life had been extended to every man.

What might be called the act of "Osirification" required elaborate preparation for the afterlife. The body had to be specially preserved, then mummified and buried according to established rites. The family of the dead person was responsible for these rituals. The actual entombment involved a number of ceremonies, including a symbolic operation known as "the opening of the mouth." It was even more important to provide the deceased with the documents he would need to support his "negative confession" when he went on trial before the tribunal of Osiris. This feature of the Egyptian burial ceremony became widespread in the New Kingdom. A roll of papyrus containing The Book of the Dead was placed in the coffin. It was a collection of religious and magical texts derived from the Pyramid Texts and from magical inscriptions on the sarcophagi of the Middle Kingdom; it also included representations of the tribunal of Osiris and precise instructions for answering the questions of the forty-two divinities attending the trial by denying all possible sins (figs. 748, 752). In the process of the trial the dead man's heart was placed on one scale of a balance, which was watched over by Anubis; the other scale held an ostrich feather, symbol of Ma'at, the goddess of truth.

The numerous extant papyri that contain The Book of the Dead reveal many variations of the trial. In addition to his forty-two jurors, Osiris on his throne is attended by other gods, most frequently by Thoth and occasionally by Isis and Nephthys. In later periods Osiris was represented as a triune god, possessing not only his own features but also those of Ptah and of Sokaris, the god of the necropolises. The dead man, too, is represented in drawings of the trial, occasionally with his wife. If a man had succeeded in defending himself before the divine tribunal, Thoth announced to the gods that he had been found *ma's kheru*—that is, "righteous in his voice" or "telling the truth." Then he was led by Horus up to Osiris himself and was incorporated in the latter. But if the scales of divine justice indicated that a man's heart weighed more than a single ostrich feather, he was thrown to the monster Ammit, "the devourer of the dead." This malevolent creature had the jaws of a crocodile and a body that was half lion, half hippopotamus. Along with The Book of the Dead, numerous amulets and scarabs were also placed in the coffin.

The Egyptians were basically realists who imagined that the afterlife must be very like life on earth; hence scenes from everyday life are found in the

52. THE GOD AMON
From Thebes. Gold; height 6 7/8".
Dynasty XXII. Metropolitan
Museum of Art, New York.

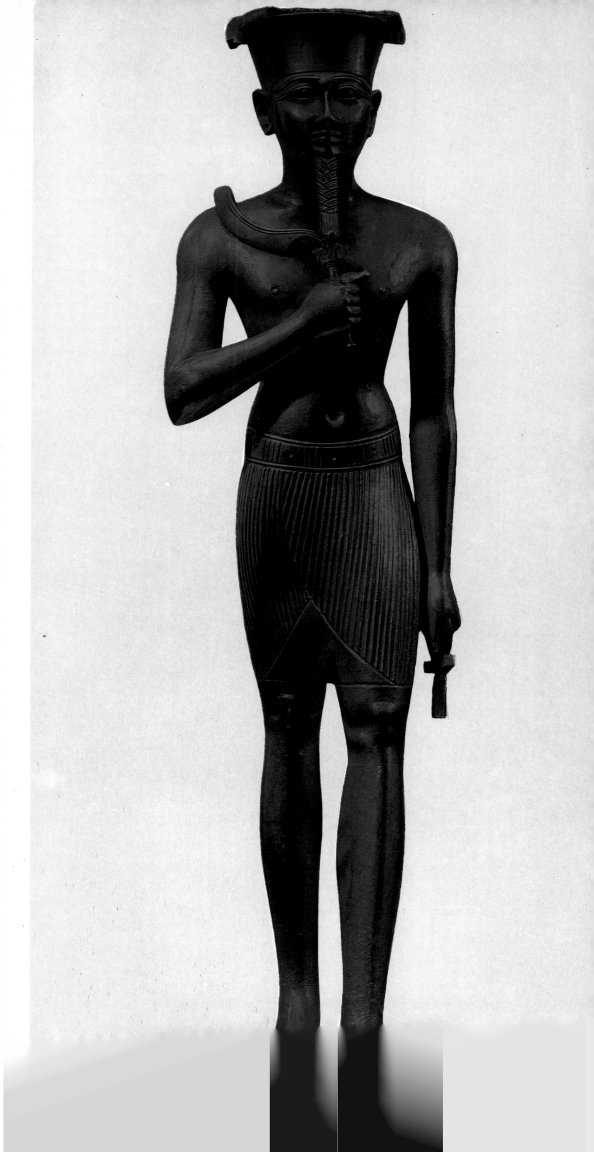

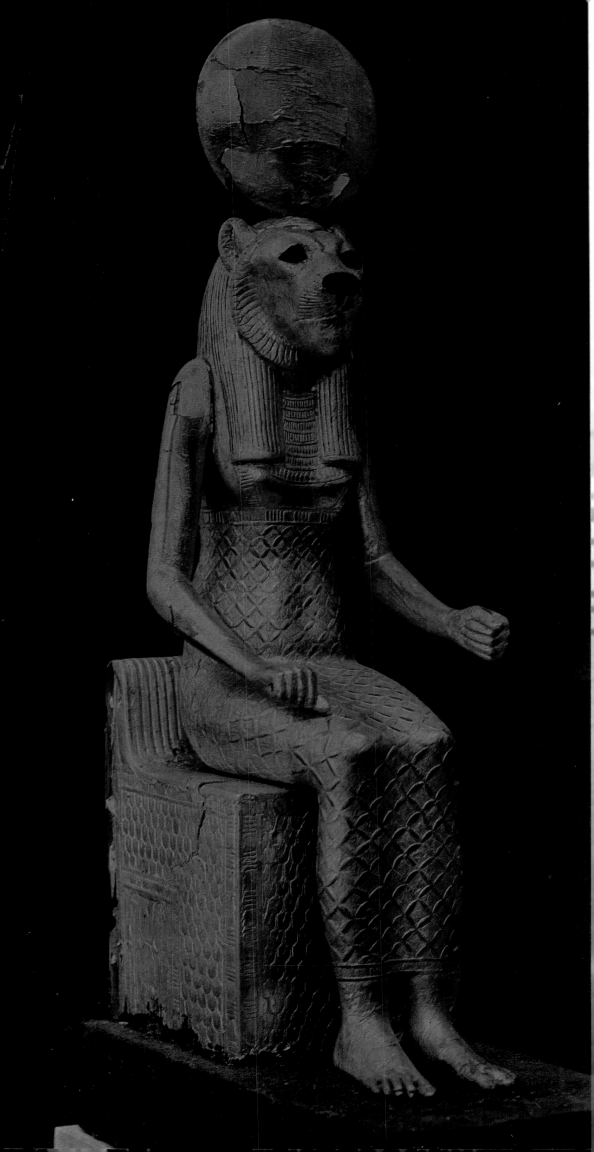

53. THE GODDESS SEKHMET
*From Luxor. Gilded wood; height
98 3/8". Dynasty XVIII. Egyptian
Museum, Cairo.*

Egyptian tombs, particularly in the mastabas of the Old Kingdom. Tombs were elaborately furnished, down to cooking utensils and other necessities to serve the dead man in the nether world. The Egyptians believed that even in the afterlife there was work to be done, and to spare the dead man the indignity of physical labor, *shawabtis* were placed in his coffin. These small figurines, in the shape of mummies and covered with ritual inscriptions, would be his servants in the afterlife. Like the rest of the tomb furnishings, the *shawabtis* varied in size and value according to the wealth of the deceased. The same burial customs obtained for the wealthiest Pharaoh and the humblest of his subjects, but the *shawabtis* of a wealthy man would be sculptured in alabaster or carved in wood and covered with gold leaf, while those of a poor man would be "mass-produced" figurines of faïence or terracotta (figs. 479–85).

One essential condition of eternal life was the preservation of the dead man's body. According to Egyptian belief man is composed of nine parts (again we encounter the mystical number nine). These are: (1) the body—*khet;* (2) the spiritual personality—*ka;* (3) the soul—*ba;* (4) the shadow—*khai bit;* (5) the spirit—*akh;* (6) the heart—*ib;* (7) spiritual energy—*sekhem;* (8) the name—*ren;* (9) the spiritual body—*sakh.* To preserve the dead man's mummy (body) and to perpetuate his name, care was taken to secure the inviolability of the tomb. Wealthy Egyptians hired special priests—sometimes several generations of them—whose duty was to insure lasting protection of the tomb and its contents.

Funeral rites were the immediate concern of every individual and every family, but the rites of religion proper took place in the temples and served to glorify the gods. During the daily ceremonies incense was burned before the statues of the gods, and purification ceremonies were performed by the king in person or by the high priest acting as his deputy. Apart from the priests, no one but the king and his deputy had access to the inner chambers of the temple.

In addition to the daily ceremonies inside the temples, solemn processions were held on days dedicated to a given god, in the course of which his statue was shown to the people. At Thebes one of the most splendid religious festivities was Opet, celebrated in the second month of the flood season. At this time the god Amon sailed up the Nile from Karnak to the temple at Luxor. During the New Kingdom a popular occasion was the Feast of the Valley, when Amon left Karnak, crossed the Nile in a boat, and visited the temples on the western bank.

From the point of view of the royal authority, the most important feast day was Sed, celebrated on the thirtieth anniversary of the Pharaoh's reign

(in later periods, thirty years after he was officially proclaimed the successor to the throne).

As we shall see, the architecture of Egyptian temples was closely bound up with the religious ceremonies performed in them. Because the faithful occupied places determined by their social status, the arrangement of the temple from the New Kingdom onward accurately reflected the class differentiations of the society.

In conclusion, it must be emphasized that practically all our knowledge of Egyptian religion, rituals, gods, and the ideas they symbolize is based on "official" sources—carefully preserved papyrus manuscripts and scenes on the walls of temples and in the tombs of kings and high dignitaries. A very few surviving documents cast some light on the beliefs of ordinary Egyptians, which were often elaborations of the already complex tenets of the official religion. Occasionally such documents refer to practices incompatible with the official religion. For instance, in the temple of Tuthmosis III a Polish archaeological mission in 1962 brought to light hundreds of inscriptions and invocations that had been scrawled over the walls and pillars by pilgrims who visited the temple in the Ramesside period. These have proved to be prayers and offerings to the goddess Hathor—yet the temple was officially dedicated to the Theban Amon! We may suspect that the popular tradition perhaps simply ignored the official cult of Amon that had been transplanted from the eastern bank of the Nile, and on the western bank continued to worship Hathor, ancient goddess of the Western Mountain.

6. THE BEGINNINGS OF EGYPTIAN ART

6. THE BEGINNINGS OF EGYPTIAN ART

WHEN we think of ancient Egypt, there comes at once to the mind's eye the majestic vista of the Sphinx emerging from the desert sands in brilliant sunshine, with the three pyramids of Giza looming in the near distance. And yet these monuments are only a tiny fraction of the art and architecture of ancient Egypt and represent the achievements of but three Pharaohs of Dynasty IV—Cheops (Khufu), Chephren (Khafre), and Mycerinus (Menkaure). Although this is no negligible fraction, it can hardly be considered representative of the rich artistic heritage of three millenniums of Egyptian history—to say nothing of the preceding, equally long, period of prehistoric development.

Egypt arrived at its characteristic artistic style, readily distinguishable from the styles of ancient Mesopotamia, Asia Minor, Greece, and Rome, only after a long period of about three thousand years. So we too must trace the origins of this art to prehistoric times, that is to say, to the Chalcolithic Period, which in Egypt was about 4000 B.C.

Sir Flinders Petrie undertook a careful classification of the abundant archaeological material available from the Predynastic Period and worked out a relative chronology consisting of eighty successive sequences, classifying objects within each sequence, or period. Most of these are everyday utensils, but their shapes and decorations justify our looking upon them as works of art. The earliest are flint objects—arrowheads, knives, club heads, axes, and saws. Ceramics comprise a large group. The vessels of the Badari culture, which were made without the potter's wheel, belong to sequences 21 through 29 in Petrie's classification. The earliest ivory

objects—combs and spoons with stylized ornamentation—also appear at about this time. (A variety of Predynastic objects are illustrated in figs. 144–82.)

The ceramic objects found at El Amrah in Upper Egypt and dating from the first period of the Nagadah culture are slender in shape, reminding us of bottles. They are decorated with incised drawings of animals such as hippopotamuses, lions, and snakes, whose characteristic features are brilliantly rendered with a few lines. In addition to such motifs we find some geometric decoration, painted in white or off-white on the polished red clay. In the second, or so-called Gerzean (named after El Gerza), period of the Nagadah culture, pottery vessels of all the previous shapes turn up again, and boats, flamingoes, and ostriches are added to the repertory of motifs. From this period also comes the first glazed work, as well as a number of cylindrical and spherical vessels hollowed out of hard stone, such as basalt, syenite, porphyry, serpentine, and diorite. Fashioned from blocks that sometimes weighed over four hundred pounds, these vases are light and shapely; the thinness of their walls and their meticulously wrought surfaces are the more remarkable when we realize that they were executed without the aid of corundum grinding wheels or metal implements. The only tools used were flint implements for cutting and shaping, and emery powder for finishing and polishing. Some of the vases are decorated with carved human or animal heads; occasionally the entire vessel is given the shape of a bird, a frog, or a hippopotamus.

Toward the end of the Predynastic Period such soft stones as alabaster and pink limestone began to be worked in the making of utensils; techniques for working stone were also improved. The production of stone vessels, which occupy sixty-two of Petrie's eighty sequences, increased to such a point that this work almost entirely supplanted ceramics. However, we know from finds in Nubia and the tombs of Nubians in Egypt (called "pan graves") that pottery vessels continued to be used by the poor as late as the First Intermediate Period.

Among the most characteristic finds of the Predynastic Period are the so-called cosmetic palettes. These were often votive offerings placed in tombs and temples. Most are made of hard slate. The earliest are geometric in shape and without decoration; later they were carved in the form of animals, the turtle for instance. The latest, at the end of the Predynastic Period, are decorated in low relief.

Objects made of bone are mostly pins, sometimes worked into the silhouette of a bird or a bull's head, and toilet articles, such as combs, decorated with antelopes, gazelles, or human figures. At this time, too, metal makes its appearance: copper objects, such as razors, and decorative gold work on knife handles, with hunting or battle scenes in *repoussé*. Predynastic

tombs are rich in jewelry: glass beads, belts, necklaces, pendants for bracelets, and ring ornaments made of turquoise, carnelian, bone, ivory, and sometimes ordinary stone. These tombs have also yielded fragments of wooden tables, stools, and beds with feet carved in the shape of bulls' hoofs.

AMONG the most interesting and least-known relics of the Predynastic Period are drawings incised or hammered into rock. A great many such drawings have been discovered by recent archaeological expeditions to Nubia (fig. 54). They represent boats and also animals, including some species that disappeared from Nubia thousands of years ago (giraffes, for example). Large-scale painting seems hardly to have been used in prehistoric Egypt. The only known example is on the walls of a tomb in Hierakonpolis (fig. 919); it recalls, on a large scale, the primitive drawings on Nagadah II ware—silhouettes of animals, people, and boats (fig. 7). The polychromy, however, is particularly noteworthy: female figures are painted in yellow ocher, male figures in red ocher; black or white is used for other motifs. Although the composition is chaotic and the individual scenes do not form coherent wholes, still this early painting foreshadows the great art of Dynastic Egypt in many details. The animals and the faces and legs of the human figures are shown in profile, while the human torso is presented frontally. This mode of figure representation will become a basic convention of Egyptian art. One scene prefigures an important motif in later royal iconography: a warrior is about to lower his club on a group of kneeling, bound captives.

In Predynastic sculpture, special mention must be made of terracotta figurines of women, perhaps representing slaves from African tribes. Well-defined breasts and pronounced steatopygia stress their feminine attributes; traces of color lead us to believe that they were represented as clothed. One most interesting terracotta was found in a fourth-millennium tomb at Mamarya and is now in the Brooklyn Museum. Although it undoubtedly represents a goddess, we can safely say that this graceful statuette also expresses the characteristic conception of feminine beauty that prevailed in the fourth millennium (fig. 55).

Sculpture developed very slowly. We have already mentioned sculptured decoration on stone vases and bone objects. Only at the very end of the Predynastic Period do small figures of animals and men make their appearance carved in stone, like those in the low reliefs on cosmetic palettes or knife handles.

THE architecture of this epoch, whether private, sacred, or funerary,

falls within the realm of the social historian rather than that of the art historian. Artistic considerations scarcely apply to ordinary huts of mud and reeds, with corners sometimes reinforced by wooden posts and roofs made of thatched reeds. These buildings were constructed according to a round or oval ground plan which gradually evolved toward a rectangular one. Even so, it is interesting to note that the mud walls, when viewed in cross section, form an elongated trapezoid that becomes increasingly high according to the number of mud layers used in construction. Although the mud material justifies this type of wall, slanted outward toward the base, the same solution survives in later monumental edifices—for example, the inclined walls of the temple pylons—and becomes a characteristic Egyptian form. Yet many centuries before the Dynastic Period, as early as Nagadah II, the introduction of sun-dried brick had made possible the building of perpendicular walls.

Scholars distinguish four stages of development for the sanctuaries, but here we are interested only in the fourth—the so-called chapels (national shrines) in Upper and Lower Egypt. Their outward form has been preserved for us by the shapes of the two hieroglyphs *per-wr* and *per-nw*. The sign for *per-wr* gives a schematic view of the side of a chapel: the roof is rounded, there are two poles in front, and oblique lines probably denote gutters. The hieroglyph *per-nw* shows a chapel façade from the front: the monumental entrance is surmounted by a large roll of matting which later, in stone architecture, developed into a cylindrical cornice; the roll of matting is crowned by a vault of dried brick.

AFTER Upper and Lower Egypt were consolidated, a basic change took place in Egyptian art. The unification proved beneficial, and the resulting stabilization of social and political conditions is fully reflected in the art of the first two dynasties. The difference between the artistic vision of the Predynastic Period and the new art that followed is vividly illustrated by a comparison of two works separated by only a short time span. These are two palettes, the first made in the period immediately preceding unification (fig. 56), and the second executed during the reign of Narmer, the Pharaoh we today identify with Menes, the unifier of Egypt and founder of the first dynasty (figs. 57, 178).

The composition on the Predynastic palette is chaotic, and not just because the object is in fragmentary condition. It is hard to make out what is actually represented. At the upper left there are two naked men, their hands tied behind their backs to standards emblematic of different nomes. On the right we see the lower portion of a walking female figure preceded by that of a male; his foot rests on the body of a fallen man who is being

devoured by a lion. Behind the lion a naked man is fleeing. Bodies of other people occupy the lower part of the composition; vultures pluck out their eyes and tear at their entrails.

The large Narmer palette, found in Hierakonpolis and now in the Cairo Museum, is decorated on both faces and crowned by two protomas with curving horns. Between the protomas on each side of the palette is the king's so-called Horus name. On one side is a large figure of the king, wearing the crown of Upper Egypt and dressed in a short girdle with a long lion's tail attached at the back. In his upraised hand he holds a mace and menaces the Libyan captive kneeling at his feet. Above the Libyan, the falcon-Horus holds another bearded captive on a leash; the god is perched on six stylized lotus blossoms—representing six thousand captured prisoners—growing out of the captive's back. At left behind the king stands the small figure of a court official holding a vessel in his right hand and a pair of sandals in his left. At the bottom of the palette, separated from the main scene by a broad band, two naked, bearded Lybians are fleeing.

On the other side of the palette, underneath the protomas and the Horus name, the field is divided into three registers. In the upper register the tallest figure is the king, here wearing the crown of Lower Egypt; he advances, holding his mace in his left hand and in his right (the arm is bent at the elbow) the whip *nekhekhw*. Walking behind him and half the height of the king, is the same court official represented on the reverse of the palette. In front of the king and also considerably smaller walks his vizier (identified by the inscription above his head). In front of the vizier march four standard-bearers, each holding a tall pole surmounted by a nome emblem. On the right we see the corpses of beheaded enemies, lying prone in two separate rows; their arms are bound and their heads lie between their feet.

The artist has represented the entire scene with extraordinary clarity. We recognize the king not only by his crown, but also because he is twice as tall as the dignitaries accompanying him. Moreover his name, Narmer, is spelled out in front of his head in the oval field between the vizier and the standards. The standard-bearers are correspondingly smaller than the vizier, symbolizing their lower position on the social scale. As for the defeated enemies, we see that they were many and that their arms were bound before they were killed.

The middle register of the palette presents an interesting scene. Two men hold leashes around the lionlike heads of two fantastic animals. The necks have been elongated and intertwined to form the rounded hollow of the palette. This register is defined by two bands; the upper one serves as the ground for the figures in the register above it, while the lower band supports the paws of the fantastic lions. In the lowest register a bull (symbol of the

ruler) is battering a fortress with his horns while trampling a Libyan beneath his forelegs.

The more closely we compare the two palettes, the more clearly we appreciate the changes that occurred in Egyptian art after Narmer unified Upper and Lower Egypt. The country is governed from now on by a single ruler, and all that takes place is dependent upon his will. The entire ideological structure has been reshaped to glorify the Pharaoh's power and to strengthen popular conviction that a permanent order has been established; this order can be preserved only by defining every individual's position in a hierarchical society and his duty in relation to the state, that is, to the royal power.

For art to play an active part in the ideology of the unified kingdom, for it not merely to express this ideology but to perpetuate it in the people's minds, in short, for it to be used as a propaganda instrument, it was necessary first of all to make it clear and comprehensible to all. It is obvious that unambiguous works of art speak far more effectively than words. Images are vividly remembered and influence the way we look upon men and events.

Although the Narmer palette was a luxury object—probably a votive offering and therefore not intended to be seen by the masses—it already exhibits the principles that later, on the walls of the temples, would be directed to the entire society.

In what respect is this art new, and how did it suddenly become accessible to all? On the Predynastic palette, it is difficult to make out the meaning of the picture because the composition is so chaotic that we simply do not know where to begin. On the Narmer palette, however, the individual scenes are arranged in orderly registers. There is obviously a connection between this type of composition—whether in drawing, painting, or low relief—and the arrangement of hieroglyphic inscriptions. Thus the different scenes are to be "read" in the same sequence as the different rows of an inscription. The device of indicating the main figures of a scene by sheer size is no doubt primitive, but nonetheless effective. Similarly, it may strike us as naïve to have presented the bodies of the slain frontally and on top of one another rather than in depth, but we must admit that the artist made his point clearly and vividly, with no ambiguity whatsoever.

We now confront one of the major problems posed by Egyptian art: How do we perceive it, and how should we look at it? Today, a drawing, a relief, or a painting is most readily grasped when the fragment of reality it represents—a human figure, a still life, a landscape—is shown with the help of perspective foreshortening, that is, with objects in the background

54. GRAFFITO OF DEER.
From Tongala.
Culture "A," Late Predynastic
or Early Dynastic Period.

55. FEMALE FIGURINE.
 Painted clay, height 11".
 Amratian Period (Nagadah I).
 Brooklyn Museum.
 This figurine is probably an early
 representation of a goddess.

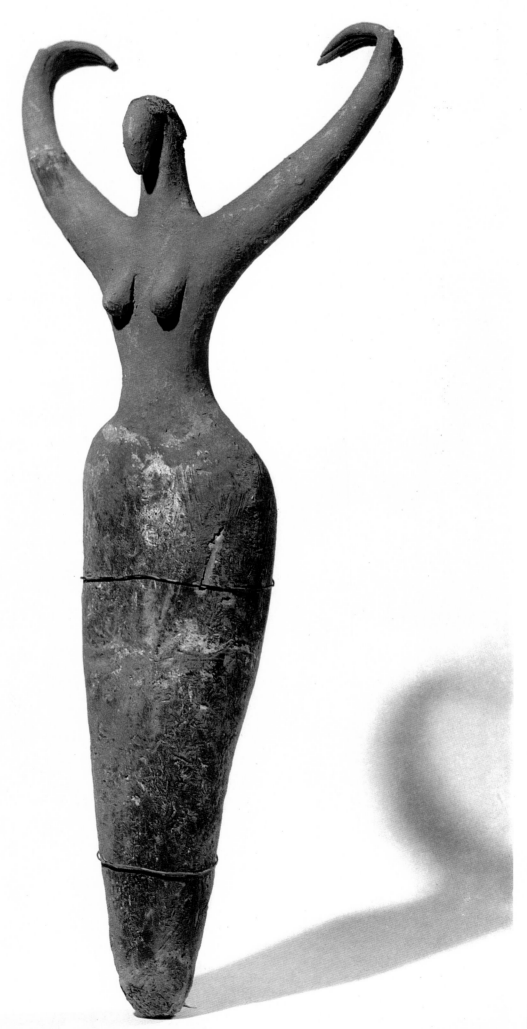

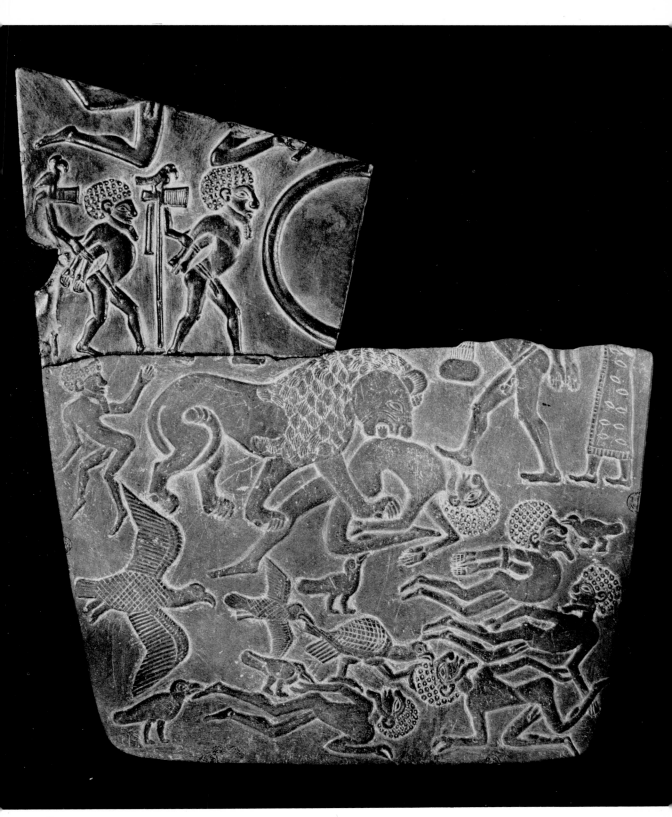

56. COSMETIC PALETTE, KNOWN AS THE
BATTLEFIELD PALETTE.
Probably from Abydos
Slate, maximum width 11 ¾".
Late Predynastic Period.
British Museum, London.
The lion devouring an enemy
apparently symbolizes the king.

57. PALETTE OF KING NARMER.
From Hierakonpolis.
Slate, height 25 ¼".
Dynasty I. Egyptian Museum,
Cairo (for other side, see fig. 178).

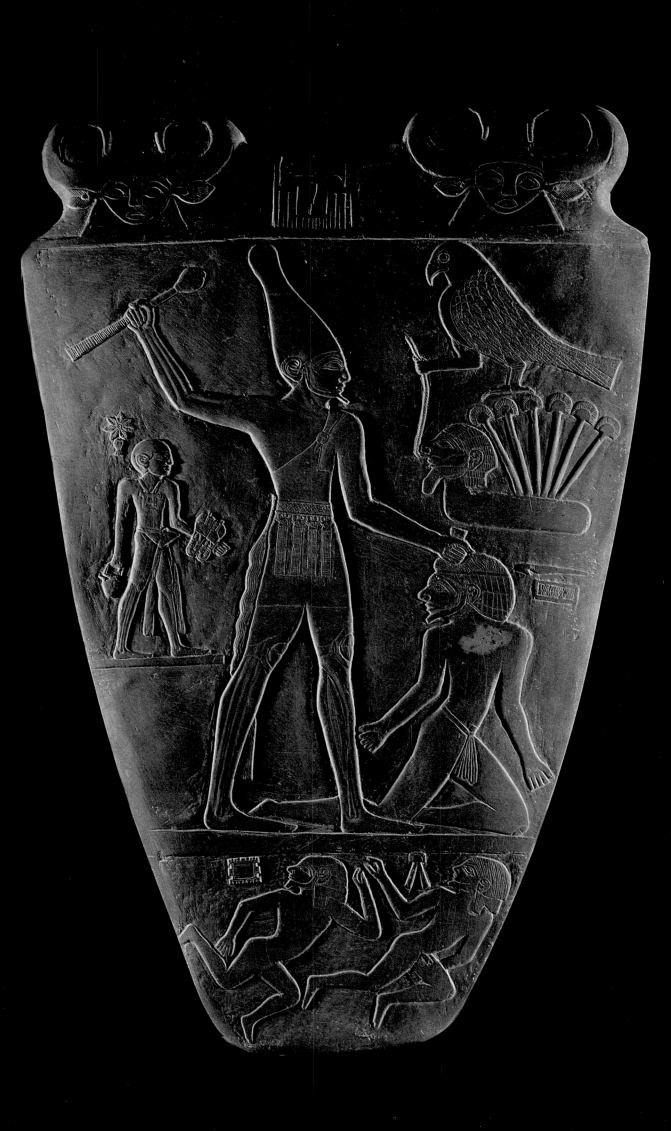

drawn proportionately smaller than those in the foreground. And if the portion of reality is represented from a single vantage point, namely, the artist's, the picture acquires maximum clarity. Despite recent artistic experiments which have revolutionized our views of how an artist re-creates or translates reality, we have been trained to accept as "realistic" only works presented from a single vantage point, those that convey an image of three-dimensional space transposed onto a two-dimensional surface. But we are perfectly aware that any picture necessarily presents an incomplete version of reality; any one viewpoint is limited, for from another angle the same scene would look very different. We have thus come to accept the profile representation of a person as showing only one arm, or that of a table drawn in perspective as having only two or three legs (though we know perfectly well that it "really" has four). In the Western tradition, we expect a picture to represent our subjective view of things, not things as they really are. Children draw very differently: having not yet learned the conventions for rendering our subjective view, they try to render things as they know them to be "really." Our artistic conventions for rendering nature have developed relatively recently; it was only in the middle of the fifth century B.C. that the Greeks introduced a method of representing three-dimensional space on a two-dimensional surface. The convention of perspective was not fully developed until the Renaissance and, like so many of our fundamental cultural habits, this too goes back to the Greeks: to this extent we are right in speaking of the eternal values of Greek art and culture.

In ancient Egypt a very different set of conventions grew up. The representation of reality, it was felt, should not be deceptive or illusory, but should "show things as they really are"—not as the artist alone saw them but as he knew them "truly" to be. It would be incorrect, however, to say that the Egyptians never employed perspective. They had a "projective" perspective for representing three-dimensional space on a flat surface—it could be compared to the drawings used by a cabinetmaker, for whom a photograph or a perspective drawing that merely presents his model from a single side would be insufficient. Egyptian artists, of course, employed these conventions for rendering space; it would be wrong to ascribe to them the sort of drawing now needed for projective geometry (see Chart VII, p. 571).

In the other example in Chart VII, from the Neb-Qed Papyrus, there is represented the funeral rite of "opening the mouth." At the upper left we see the squatting figure of a professional mourner; next to her, a priest wearing a panther skin and holding a key-shaped metal instrument performs the ceremony on a mummified body shown upright before the tomb. (Actually, the mummy is laid out in its anthropoid sarcophagus.) To the right we see the open gates of the tomb, with steps leading down, and the soul of the deceased, his *ba*, flying away.

The lower part of the drawing represents the inside of the tomb. In the first chamber the doors are drawn projecting toward the bottom of the picture; above are votive objects, such as a table of offerings. From this chamber a smaller one could be reached through a door, this time drawn projecting toward the top. In this smaller chamber there is a narrow window through which we glimpse the mortuary chamber and the sarcophagus—here shown in profile; sketched above are objects customarily placed near the body, including a censer and jars on stands.

The mortuary chamber was entered only once, at the time of burial; then it was walled up, with only a narrow window left as an opening. The sarcophagus was accompanied by tomb furnishings, most of which were placed in a room situated in the rear and separated from the central part of the tomb by a wall. The door shown in the drawing is located in this wall, and behind it we are given a profile view of some of the tomb furnishings—for instance, a chest and a number of amulets.

There can be little doubt that the Egyptian artist set down every element of importance—including the last scene of the funeral, just before the sarcophagus is placed in the tomb. We see the interior of each chamber with its contents, and the sarcophagus is even shown in its final resting place after all the funeral rites have been observed.

ALTHOUGH this representation of a tomb dates from the New Kingdom, the artistic conventions it displays had been worked out as early as the so-called Thinite dynasties (Dynasties I and II). Although the art of the Thinite dynasties does not have monumental dimensions, certain examples offer evidence of the high technical level already achieved. These include the famous stele of King Zet of Dynasty I, excavated at Abydos (fig. 42), on which the name of the Pharaoh is represented by a serpent, and the slate statuette of King Khasekhem of Dynasty II from Hierakonpolis (now in the Cairo Museum). We also have many stone statuettes of animals dating from the same period.

The early kings were buried at Nagadah in Upper Egypt, and at Saqqarah south of Giza, near Memphis. Their tombs were similar to the mastabas which during the Old Kingdom became the typical tomb for prominent persons. One of the most interesting Dynasty I tombs, discovered by De Morgan at Nagadah, is built of dried brick with a façade punctuated by projections and niches (see Chart IX, p. 574). Inside were a chapel and chambers with tomb furnishings, separate from the underground funerary chambers. In the tomb of King Wedymu at Saqqarah, also of Dynasty I, the external construction, built over funerary chambers cut from the natural rock, resembles a three-story mastaba.

One of the most typical tombs of this period is the "Nebetek mastaba" at Saqqarah, dating from Dynasty I, which was probably never completed. Three of the outer faces are built up in steps, while the fourth is perpendicular to the ground. The top level formed a terrace enclosed by a niched wall of dried brick reminiscent of the façade of the Nagadah tomb. Today it seems reasonable to assume that structures such as the tomb of Wedymu and the other royal mastabas found by Walter B. Emery at Saqqarah served as prototypes for Imhotep, the builder of the step pyramid of Zoser, a Pharaoh of Dynasty III.

No palace of a Thinite ruler has thus far been discovered. This is not surprising, for their residences, like those of ordinary mortals, were built of mud and dried brick, neither a very durable material. However, thanks to representations on the stele of Zet and on certain sarcophagi of the Old Kingdom, we have some idea of how the façades of these palaces were decorated. They had two entrances (perhaps symbolizing the tradition of the two kingdoms), and the outer brick walls were accented with niches that recall the Nagadah tomb.

The artistic tendencies already evident in both the architecture and sculpture of the two first dynasties were to be realized more fully in the art of the Old Kingdom.

7. ARCHITECTURE AND DECORATIVE ART IN THE OLD KINGDOM

7. ARCHITECTURE AND DECORATIVE ART IN THE OLD KINGDOM

Dᴜʀɪɴɢ the Old Kingdom, between Dynasty III and Dynasty VI, Egyptian art reached its highest flowering in every field—painting, sculpture, architecture, and the crafts. This period saw the elaboration of certain rules of construction and composition which were to endure for nearly three thousand years.

As pointed out in the preceding chapter, certain tombs from Dynasties I and II foreshadow the pyramid. The man who contributed most to the development of monumental architecture in Egypt was Imhotep, chancellor and court architect under Zoser, the second ruler in Dynasty III. Subsequent generations recognized the greatness of Imhotep's achievements and regarded him as a demigod. Eventually he was worshiped as the patron of science and medicine. The Greeks later identified him with Asklepios, their god of medicine.

On the high desert plateau of Saqqarah, overlooking the capital city of Memphis and near the tombs of earlier rulers, Imhotep built the earliest group of monumental stone funerary constructions. The size of a city, this new architectural complex—destined to be Zoser's final resting place —may well have been as large as the capital city where the Pharaoh had his earthly residence.

Formerly it was believed that in building Zoser's step pyramid, Imhotep first constructed a large stone mastaba over the subterranean tomb chamber. The walls of one of the underground galleries were faced with faience tiles; this revetment, like the thousands of alabaster vessels found in the subterranean passages, is evidence of a highly developed technical proficiency.

Colonnades, chapels, and a funerary temple, all built of stone blocks, surrounded the mastaba. A high wall enclosed the entire complex. But the new edifices completely masked the mastaba that was intended to be the main focus of the architectural complex; therefore, it was once believed, Imhotep was obliged to raise the mastaba, building a second one on top of the first; when this proved insufficient, a third was added, and so on until the great six-step pyramid was completed (fig. 59). This hypothesis, however, has today been abandoned.

It is possible that originally only one large mastaba had been intended but that Imhotep, when commissioned to enclose it with chapels and colonnades, thereupon conceived the idea of a gigantic pyramid. Recently, when the debris around the Zoser pyramid was being cleared away, a carefully joined limestone facing was discovered around the base. There can now be no doubt that the step pyramid, built of crudely hewn stone blocks, was merely the core of the structure proper. Perhaps Imhotep's plan was never carried out in its entirety and his pyramid remained unfinished, without the facing intended for it. What is certain is that Imhotep did complete the stone facing of the walls of the funerary temple, the chapels, and the walls enclosing the entire area. One of the chapels symbolized the Sed festival; the other two were developed versions of the primitive shrines found in Lower and Upper Egypt. In front of the pyramid stood a small separate building, a kind of monumental *serdab*, in which a stone statue of the seated king was found (fig. 39).

Unlike the pyramid itself, which may have been inspired by older tombs in the extensive necropolis of Saqqarah, Imhotep's stone architecture around the pyramid had no precedents. (Incidentally, he may also have built the pyramid of Sekhem-khet, Zoser's presumed successor, which was discovered in the 1950s by the Egyptian archaeologist Zakaria Goneim.) For more than thirty years now, the monumental funerary complex that Imhotep created has been carefully preserved and partially restored by J. P. Lauer, a French architect employed by the Egyptian Antiquities Service. Zoser's architect had for models only palaces and walls made of dried brick. In such constructions, bundles of reeds were used as elements of support for the light, matted roofs and door frames because wood was scarce. Imhotep brilliantly re-created in stone the distinctive features of this brick-and-reed construction. The corridor that led from the sanctuary entrance into the main court south of the step pyramid is lined with projecting pillars ending in half-columns. These columns have grooves which at first sight bring to mind the fluting of Ionic columns. But they are actually a monumental translation into stone of the reed bundles which served as supports in dried-brick construction. Other half-columns are topped with capitals shaped like open lotus calyxes (fig. 60). The appearance of the walls, composed

of small limestone blocks placed end to end in a regular pattern, suggests the bricklayer's technique. Like all truly original achievements, Imhotep's architecture has some negative features: forms characteristic of brick-and-reed construction do not make sense when translated into stone, and there is insufficient attention given here to the peculiar properties of the new building material so ambitiously, so courageously employed.

T HE following generations of architects working under Dynasty IV rulers exploited further the structural and decorative potentialities of stone. They created the three pyramids at Giza which constitute the classic models of this type of construction (fig. 58a). A straight line of development runs from Imhotep's conception to the unfinished pyramid at Medum, probably belonging to Sneferu, the first king of Dynasty IV, and from it to the pyramid of Cheops, known as the Great Pyramid and regarded by the Greeks as one of the Seven Wonders of the World. In ancient Egypt it was called the "Horizon of Cheops." (Map III, p. 584, shows the principal pyramids of Lower Egypt.)

The Egyptians had no term to designate pyramids. What we call the pyramid of Chephren was called "Great-is-Chephren," and the pyramid of Mycerinus was "Divine-is-Mycerinus." The Greek word *pyramis* may possibly have been derived from the Egyptian *per-em-us*, a term denoting the height of a pyramid.

The following figures will give some idea of the dimensions of the pyramid of Cheops. It was 481 feet high; each side was 755 feet long. The stone—more than 87 million cubic feet—covers an area of about 13 acres. The angle of inclination of the sides is 51°50'.

Cheops' successors Chephren and Mycerinus built two pyramids nearby, both very impressive though smaller. Napoleon I, who was always fascinated by the great monuments of antiquity, calculated that with the stone used to build the three pyramids at Giza he could make a wall almost ten feet high and a foot wide to encircle France. He was not alone in his fascination. The pyramid of Cheops has given rise to an extensive literature, of which a considerable portion can hardly be called scientific. Many authors have tried to find a mystical significance in the arithmetical proportions of the edifice. According to some of these so-called studies, the Great Pyramid was the work of a civilization that came from Atlantis, and only later was it converted into Cheops' tomb.

There is no doubt that the proportions of this pyramid are based on careful mathematical computation. The same is true of the inner corridors and the funerary chamber of the king, where the empty sarcophagus lay. From this chamber a ventilating shaft leads to the outside, and above it

are a few empty rooms built for the purpose of lightening the weight of the immense mass of stone. The pyramid lies on the thirtieth parallel. Originally its base was oriented to the four cardinal points, but because of the precession of the equinoxes (the gradual shifting of the angle of the earth's axis) this placement is no longer exact.

IT is difficult to add anything new to the many interpretations of this well-known monument, particularly of those elements or details that have given rise to arbitrary, often esoteric views. Recently, however, one of my collaborators, Wieslaw Kozinski, who spent a long time at the Polish excavations in the Nile valley, advanced an explanation for those features of the Great Pyramid that have struck many as "mysterious."

Kozinski started from a thoroughly modern premise: reflecting on the actual construction of the pyramids, he concluded that the technical problems involved—preparation of the raw materials, orderly transportation, planning of the structure, coordination among the various teams of specialists—required a tight work schedule, well planned in advance. The carrying out of so monumental a project could only have been entrusted to an organization of highly trained technical experts capable of supervising large numbers of unskilled laborers. Kozinski conjectures that such an organization must have come into being as early as Dynasty III, perhaps in connection with the Zoser pyramid, and that before undertaking the pyramid of Cheops, it had acquired experience in building the pyramids of Sneferu at Medum and Dahshur. The construction of the Great Pyramid presupposed setting up an extensive building area in the vicinity, where materials could be stored and workshops organized for cutting, dressing, and polishing the blocks used for facing. As is well known, these blocks fit together with extraordinary precision. Kozinski surmises that the construction area for the pyramid of Cheops was set up in a leveled area and that this in turn was used as a platform for the pyramid of Chephren. Thus the ramp leading to the Chephren pyramid was originally a road constructed for transporting building materials from the foot of the Giza plateau. The core of the pyramids was made of large blocks from the adjacent quarry below; limestone blocks quarried at Turah were conveyed on barges down the Nile and its secondary canals. According to Herodotus (II, 124), the building of the Great Pyramid required thirty years, of which ten were spent constructing the road for hauling the stones, and twenty on the pyramid itself. The number of men employed in this project was probably around one hundred thousand, and they worked three months out of the year.

Detailed computations, based on the quantity of building materials used, the labor that would have been involved in dressing the stone blocks, and

the coordination of different teams of laborers, fully confirm Herodotus' information. Today, using computers to estimate the time and labor involved to achieve the result, we get about the same figures. A project requiring so much manpower and thirty years for completion could hardly be accomplished without a number of modifications in the original plan, made necessary as the work progressed. For it must be kept in mind that the pyramid of Cheops is the first entirely successful pyramid and that its angle of inclination represents the best possible solution to actual construction problems.

Kozinski suggests that such a project could not have been carried out exclusively on the basis of drawings and plans, and required a scale model or "maquette" like those used today for large-scale construction projects. At this point he does not hesitate to make a suggestion that will certainly shock Egyptologists, although it has a certain logic. In his opinion, the three so-called "little" pyramids situated just south of the Great Pyramid are such models, built to the scale of 1:5 and representing three successive stages in the evolution of the original plan for the Great Pyramid.

If one studies a cross section of the Great Pyramid (fig. 58 b), one notices, that the main funerary chamber, known as the King's Chamber, does not fall along the central vertical axis but is somewhat to the left. To account for such oddities in the interior organization, some authors have indulged in extravagant speculation turning upon "mysteries" of numbers involved in the actual dimensions of the structure. Kozinski has another explanation.

We know that the King's Chamber is faced with red granite blocks and the Grand Gallery with fine-grained limestone (called Egyptian alabaster) from the Moqattam. To provide a regular supply of stone from quarries near the First Cataract must have posed very difficult problems—real "bottlenecks," we would say today—even for experienced contractors. Similarly, squaring off huge blocks of granite involves considerably more labor than polishing Turah limestone. Kozinski surmises that at one stage of the work, when the builders of the Great Pyramid were engaged in facing the Grand Gallery with limestone blocks, shipments of granite fell behind schedule and the King's Chamber was delayed. In order not to leave men idle and interrupt the coordinated work schedule, the architects decided to extend the corridor farther than had been originally planned. Purely technical construction and labor problems, then, might account for the axial deviation of the King's Chamber. Two elements indicate that the original plan was different. One is the air passage, which is visible at the right in the north-south cross section. This passage presently opens into the upper end of the Grand Gallery, but it was undoubtedly once intended to open into the main funerary chamber located on the pyramid's vertical axis. Furthermore, there is a lower chamber, the so-called Queen's Chamber, which is actually situated on the vertical axis.

When deliveries of granite were resumed, the King's Chamber was built and another air passage added. The five small rooms built above the chamber were probably intended to relieve the strain on the ceiling. However, once the edifice was finished, the ceiling of the "displaced" mortuary chamber failed to support the tremendous weight of stone above it. This can be confirmed by any visitor who enters the chamber. Millions have passed through it, and surely tens of thousands must have noticed the cracked ceiling, but no one has yet drawn the obvious inferences from this fact. As is well known, granite does not crack quietly. The noise made by the cracking ceiling must have been heard outside, through the ventilation ducts and the entrance to the pyramid which had not as yet been blocked up. It is hard to believe that under such circumstances the builders of the pyramid would have persisted in their original intention to make this chamber the Pharaoh's tomb. It is not necessary to be an Egyptian living in the third millennium B.C. to interpret the cracked ceiling as an unfavorable sign. Thus, the reason no lid was found on the royal sarcophagus is that it had never been put in place. Earlier investigators have noted that the original plan of the Great Pyramid was modified during the course of construction. The Queen's Chamber, for example, has been explained as a later arrangement. But Kozinski's interpretation provides us with the first original, thoroughly practical explanation of what is "mysterious" about the Cheops pyramid, and it also gives a plausible account of how this type of monument was built.

THE tomb of the Pharaoh, however, was not limited to a single pyramid: the pyramid is only the most prominent of a number of edifices which together form an architectural complex around the actual burial place. The placement and interrelations of the individual architectural elements are closely bound up with the funeral rites observed at the burial of a Pharaoh. The funeral procession with the royal coffin sailed down the Nile from the royal palace toward the west bank of the river, entering a narrow channel which served the port near the necropolis; here the first part of the ceremony was held in the lower, so-called valley temple. From this temple either a hidden portico or an open ramp led to the upper temple, which had a main corridor, a central courtyard, and—after Mycerinus' times—five niches containing statues of the deceased Pharaoh, each corresponding to one of his royal names. (It was Mycerinus who first adopted a fifth name, "Son of Ra.") Farther back there was a chapel with false doors and an offering table. Near the upper funerary temple stood the pyramid; during the Old Kingdom the pyramid entrance was located on the north side. Once the body had been placed in the underground mortuary chamber,

this northern entrance was carefully masked. Among the rocks around the pyramid were concealed large wooden boats which Horus would use in his voyage to the nether world after the Pharaoh's death. A boat more than 131 feet long was recently discovered near the pyramid of Cheops.

The classic grouping of funerary structures was complemented by smaller structures outside the precincts—namely, a few smaller pyramids, which in the case of Cheops and Mycerinus may have served as tombs for the Pharaohs' wives. Somewhat later, and until the end of the Old Kingdom, other small structures of this type were erected, often near the southeast corner of the royal pyramid (the so-called satellite pyramids). In the vicinity of each pyramid there was usually a large cemetery filled with mastabas where dignitaries were buried (see Chart IX, p. 574).

The architectural complex that grew around the pyramid did not reflect merely the long-established ceremonial of the royal funeral, but, in its wider setting, the existing social system as well. In this city of the dead the king occupied the highest place, just as he had in the city of the living, and the pyramid may rightly be looked upon as a monument glorifying the ruler and raising him to the rank of a divinity.

Nobles and high court officials remained in the king's shadow. They often bore the title "royal companion"; their allotted duty was to surround the king during his life and to keep him company in the afterworld. To leading members of the government bureaucracy—the king's executive arm—the prospect of a tomb close to the royal pyramid must have represented the highest good, the greatest possible honor. They were thus assured that after death they would still be near their god—for the king was like a god even in his lifetime, and sure to become one after death.

In the funerary architecture of the great necropolises we find no reflection of the third social class—the working people. The value of the people was measured solely in terms of the physical labor they performed on earth. On the plane of eternity in the afterworld, they served no purpose. The ruler had no personal contact with physical laborers; the hosts of peasants, herdsmen, and artisans who figure anonymously on the reliefs that cover the interior walls of the mastabas served only the nobles and dignitaries. In the monumental royal necropolises, the common people's existence is simply not acknowledged.

THE building of any pyramid took a very long time. Presumably each Pharaoh began construction of his own immediately after acceding to the throne. The heart of the pyramid was either built up layer by layer, stepwise, or all the way to the top with the aid of a ramp. The outer facing of limestone blocks was added last, from the top down.

As we have noted, most of the work, including transportation of the building materials, was done in the season of the flooding of the Nile. The work demanded strenuous exertion, for this was—and still is—the hottest time of year. The workmen were whipped on by foremen whose only concern was the timetable laid down by the architect-engineers. Yet this was not true "slave labor" (the buildings formerly believed to be workmen's barracks near the pyramid of Chephren are now considered storerooms). The rest of the year the workers lived in their own homes with their families and pursued their normal occupations. During the three months they were fed and probably permitted to keep part of their rations for their families. The overseer's whip, the *raisa*, continued to be a traditional feature in important projects of construction and irrigation in Egypt until shortly before World War II.

The quarry at the foot of the Giza plateau supplied most of the stone for the core structure of the Great Pyramid. When the steep road built to transport building materials was converted into a ramp leading from the lower Chephren temple to the upper one, all that remained of this old quarry was an unusable mass of rock, which vaguely resembled a reclining lion. Egyptologists believe this was the origin of the Sphinx (fig. 15 a). Rather than cut away the rock, the builders transformed it into a colossal sculpture, 187 feet long and 65 1/2 feet high. The "lion's" head was given the features of the reigning king, Chephren, and covered by the traditional *klaft* (kerchief). In this monumental portrait, the nose alone is 67 inches high.

Even in ancient times the desert sands covered the Sphinx so that only the head was visible. It looked this way to Napoleon and his troops, and was immortalized by Denon (fig. 15 c). Tuthmosis IV, one of several Pharaohs who had the sand cleared away, built between the Sphinx's paws a kind of chapel with a stele dedicated to the memory of past dynasties. A wall of dried brick was built around the Sphinx to keep it from being buried in the sand, but this was not effective for very long; it is still necessary to dig out the Sphinx after a heavy sandstorm.

THE monumental architecture of the Old Kingdom included two types of temple. First, there were funerary temples, built near the pyramids and dedicated to worship of the dead Pharaohs. The most interesting of them is the lower Chephren temple, which is built of immense blocks of red granite and paved with slabs of Egyptian alabaster (fig. 61). It had no ornamentation or reliefs, but in front of the pillars and the walls there were twenty-three colossal statues of the Pharaoh. The Chephren temple presents us for the first time with a building whose architect was fully aware of the artistic

value of smooth monolithic pillars and granite architraves. This architectural style is rightly categorized as the austere "stone style."

Besides funerary temples, there were temples dedicated to various gods. Among the most representative are the so-called solar temples, associated with the Heliopolitan cult of Ra. The best preserved of these is the temple of Ne-user-ra at Abusir (figs. 860, 861). Its most striking feature is a great obelisk made of carefully fitted stone blocks; this obelisk served as symbol of the ancient *benben* stone of Heliopolis. Subsequent obelisks took on a slimmer shape. As is well known, monolithic granite obelisks were later erected in front of temple pylons. The Egyptian word for these was *tekhen*, but the Greek word was *obeliskos*, a diminutive of *obelos* (a "spit").

The plans of Old Kingdom temples reveal that they were not built according to any single principle, that they vary to suit the ritual connected with the cult of a given god. The classic temple plan developed later, in the New Kingdom, when social and cultural conditions favored such standardization.

A classic type of mastaba was, however, realized in the Old Kingdom. The origin of this structure is very simple. It is a monumentalized mound, like that formed by earth or sand whenever a grave is dug. A mastaba that served as the burial place for a notable was normally constructed in three parts: the underground funerary chamber; the perpendicular shaft that connected it vertically to the surface; and a rectangular building of dried brick or stone. The rectangular building, erected above ground, had a trapezoidal cross section and reminded the Arabs of a bench—hence its Arabic name, *mastaba*. Carved into the wall of the building was a false door through which the soul of the dead person could freely enter and leave the tomb. Above the false door was a stone slab, the stele, covered with inscriptions containing ritual formulas and a relief representation of the dead man, sometimes with his wife and children making offerings to him. A stone offering table was placed in front of the false door. Once the funeral was over, the shaft leading down to the actual burial chamber was filled up or blocked with stones.

Wealthy owners of mastabas might make additions to the basic arrangement. For example, there might be a *serdab* in which steles and occasionally the portrait of the dead man would be placed. The building above ground might be enlarged to accommodate a funeral chapel or—as the Franco-Polish mission discovered during excavations at Edfu before World War II — a second story might be added to provide burial places for the family of the deceased. The façade occasionally had small niches along with its false door; these probably symbolized doors for the souls of the dead man's family.

The monumental architecture of the Old Kingdom created several types

of column and decoration which became traditional in Egyptian art. Imhotep's work near the Zoser pyramid includes half-columns of the papyrus type with lotus capitals. Another type of column with a lotus-shaped capital appears as early as Dynasty V in the Ptah-shepses mastaba at Abusir, and granite columns with palm capitals were used in the nearby funerary temple of Pharaoh Sahura and also inside the Unas pyramid at Saqqarah (see Chart XI, pp. 578–79). Architectural decoration at this time included such highly characteristic features as a cornice reminiscent of a roll of matting, a frieze of bundles of flowering reeds (the so-called *hekeron*), and spouts in the shape of lions' heads to drain water from parapets, roofs, and terraces. Even at this early date we find corbeled vaults, most often resting on wall projections. So-called overhang arches were also used. Occasionally a stone slab placed horizontally over two standing slabs made a kind of arch. On the basis of some fragments discovered at Giza, Professor Junker reached the conclusion that in the period of pyramid construction the Egyptians knew how to build domes supported by pendentives.

Thus far, only funerary architecture and temple architecture have been discussed. With the possible exception of the workmen's village near the Chephren pyramid at Giza, in which certain dwellings seem to have been occupied by officials or perhaps by priests overseeing the construction, no remains of a city or town dating from this period have been preserved. (The earliest clues to the nature of Egyptian city planning are found in the ruins of Middle Kingdom structures.) Private dwellings, whether modest homes or royal palaces, were always constructed of perishable materials. Rarely did a Pharaoh reside in the palace of his father—he preferred to build a new residence for himself.

It is, however, possible to state that royal palaces and the country residences of the nobles included a number of small structures as well as gardens containing a pond or artificial pool. There was no lack of arbors and porticoes, and the whole estate was surrounded by a wall. Occasionally farm buildings (circular silos, for instance) were placed within the enclosure. This evidence is primarily of interest to archaeologists for what it reveals of living conditions at a given period; the buildings themselves are not necessarily works of art.

Furniture of the early dynasties is something else again. Thanks to the custom of furnishing tombs, many examples of the decorative arts under the Old Kingdom have come down to us. The objects found in tombs, however, are obviously luxury articles, and we often wonder whether they were actually used or reserved exclusively for the afterlife. In the tomb of Queen Hetep-heres, mother of Cheops, a beautiful armchair was found

(fig. 808). Carved in ebony, its exquisitely shaped armrests supported upon blue lotus flowers and its legs terminating in animals' paws, it may have been used for years. Such things as wooden litters, beds, armchairs, and taborets were often beautifully overlaid with gold. There are also headrests of alabaster, marble, or wood, occasionally ornamented in gold, silver, or electrum (a natural alloy of gold and silver); these are among the most characteristic pieces of Egyptian furniture.

The finest vases of alabaster and other stone date from the Old Kingdom. On the whole the dominant shapes are those already prevalent in the Predynastic Period—namely, spherical vases or elongated perfume bottles, called *bas* vessels, with lids. Proportions are less varied than before, yet graceful. In addition to vases as tall as five feet, small containers for cosmetics and perfumes were manufactured. Among the finest of the latter are some discovered in the mortuary chambers of the wife of Isi, a vizier and later high priest at Edfu during Dynasty VI. (The false door to this tomb, covered with beautiful reliefs, is now in the National Museum in Warsaw, fig. 66.) Some vases were royal gifts: they bear dedications and the cartouche of the Pharaoh. Most of the alabaster vases that have survived were found in the tombs of kings and nobles, for only they could afford such costly artifacts. The less fortunate contented themselves with clay pottery, red or brick-colored, which frequently had the same shapes as the stone and copper vessels characteristic of the period—especially popular were deep wash-basins accompanied by water jugs with spouts carved in the shape of birds' beaks. We also find lamps with bases; mirrors, either round or, more rarely, slightly oval; and copper razors.

The quantities of jewelry found in Egyptian tombs lead us to imagine a people given over to personal adornment of all kinds, from modest terra-cotta beads and copper rings and bracelets to highly refined gold and silver jewelry set with precious stones. One typical necklace of this period is the *usekh;* its multiple strands of pearls and pendants extended from shoulder to shoulder, around the neck.

The tombs of the period also contained small disks of stone or ebony decorated with inlay work and reliefs. A hole drilled in the center indicates that these could be swung on a rope or revolved on a stick. These precious objects had a purpose beyond ornamentation—they were also offerings to the gods or used as liturgical objects. A head of Horus as a hawk, dating from Dynasty VI and found in the temple at Hierakonpolis, is decorated with two tall feathers. Except for these, the head is made of one piece of hammered gold and the eyes are inlaid with obsidian. (The body was probably wood, covered with copper.) This is perhaps the most beautiful surviving piece of gold work from the Old Kingdom (fig. 256).

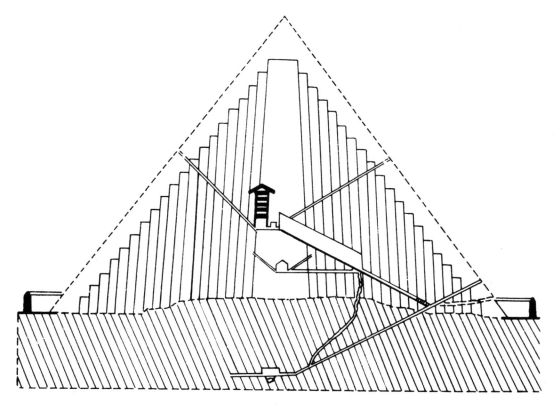

GIZA. PYRAMID OF CHEOPS
North-south section

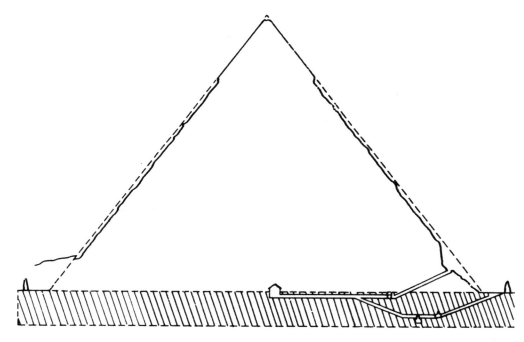

GIZA. PYRAMID OF CHEPHREN
North-south section.

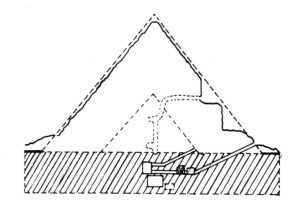

GIZA. PYRAMID OF MYCERINUS
North-south section.

| 0 | 100 | 200 | 300 ft. |

58 GIZA. ROYAL PYRAMIDS
View from the southwest. From left to right: the pyramids of Mycerinus, Chephren, and Cheops; in the foreground, the satellite pyramid in the Mycerinus complex. Dynasty IV.

59. SAQQARAH. PYRAMID OF ZOSER
View from the east. Known as the step pyramid, this is the first royal tomb in the form of a pyramid; it was built by the architect Imhotep. Dynasty III.

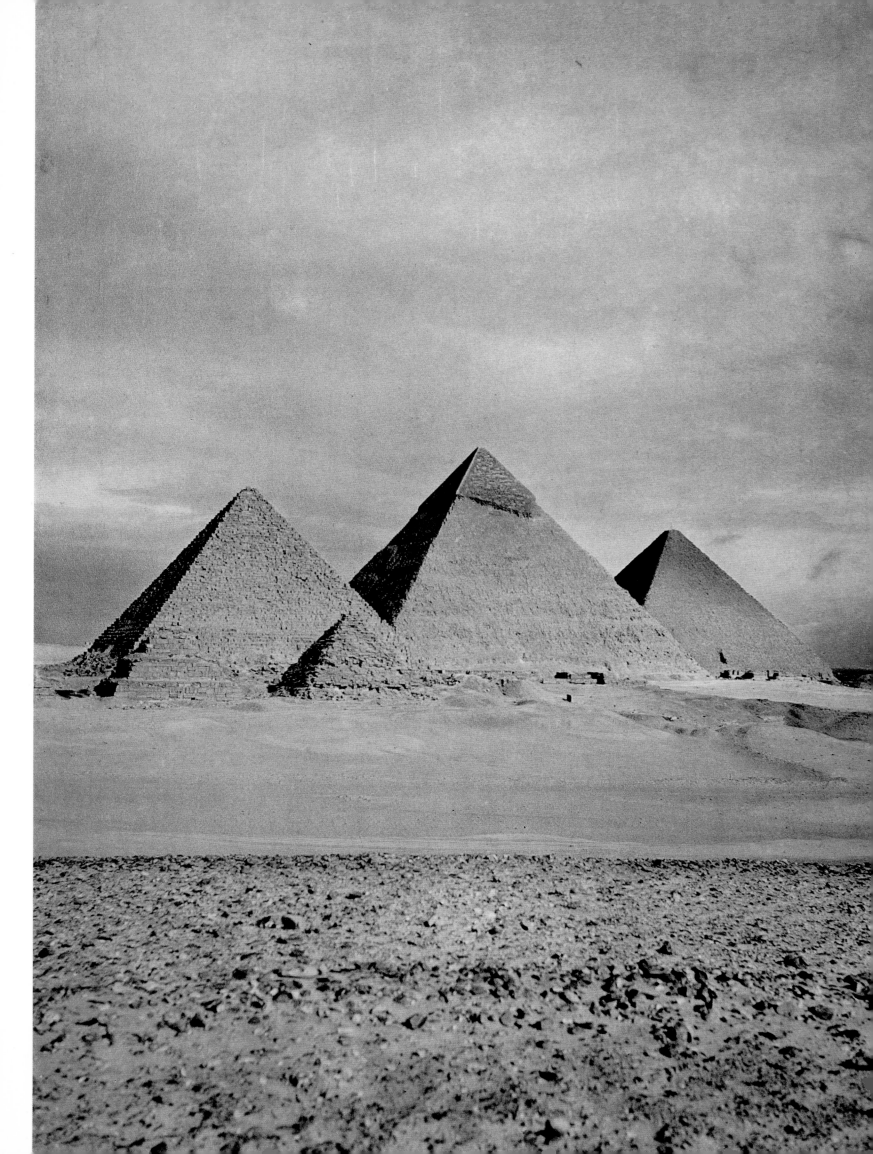

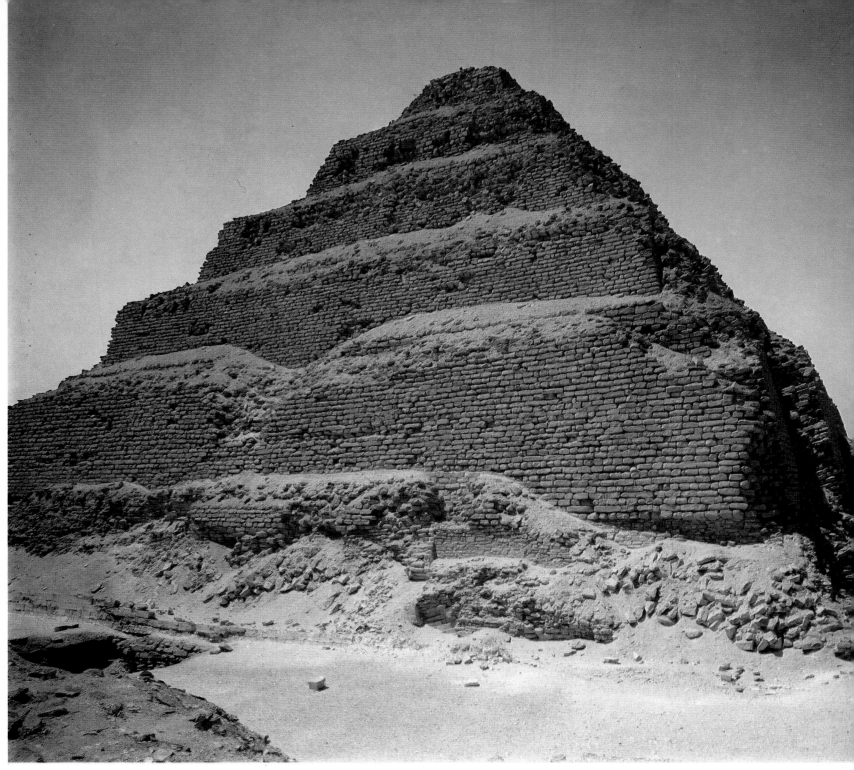

59

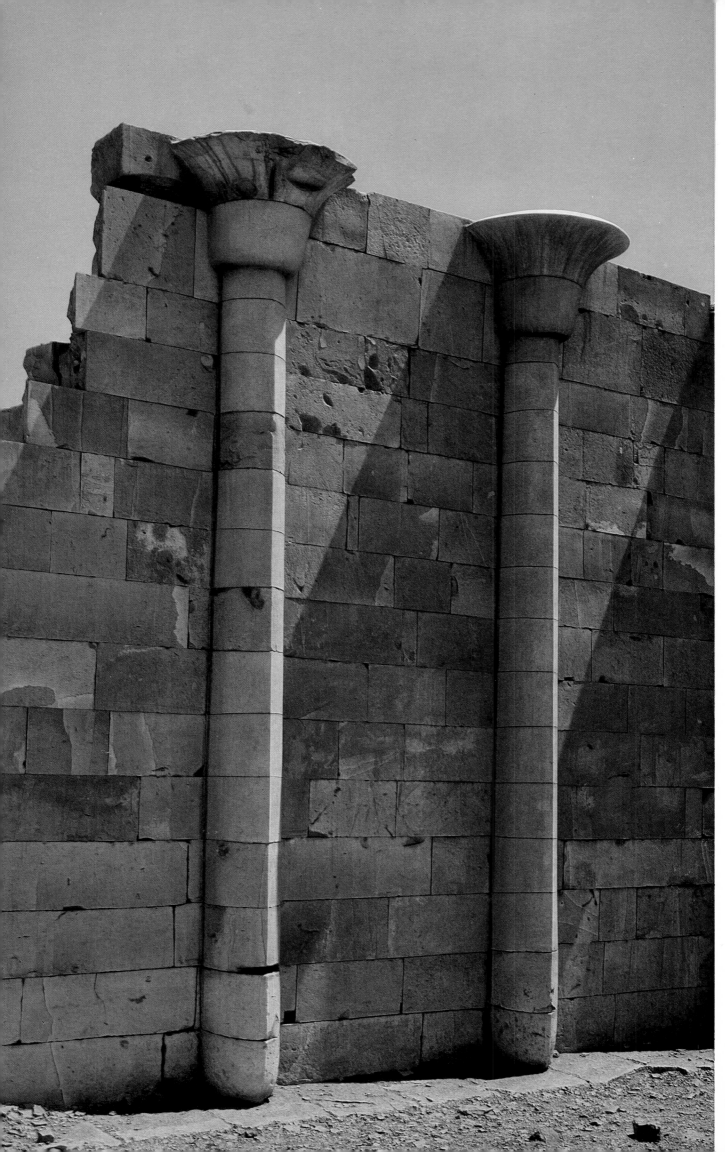

60. SAQQARAH. NORTH HOUSE OF THE ZOSER
FUNERARY COMPLEX
*On the façade are slender papyrus
half-columns, their form symbolizing the
Delta. Dynasty III.*

61. GIZA. HYPOSTYLE HALL, VALLEY TEMPLE
OF CHEPHREN
Granite pillars, alabaster pavement.
The hypostyle hall originally contained
23 statues of Chephren. Dynasty IV.

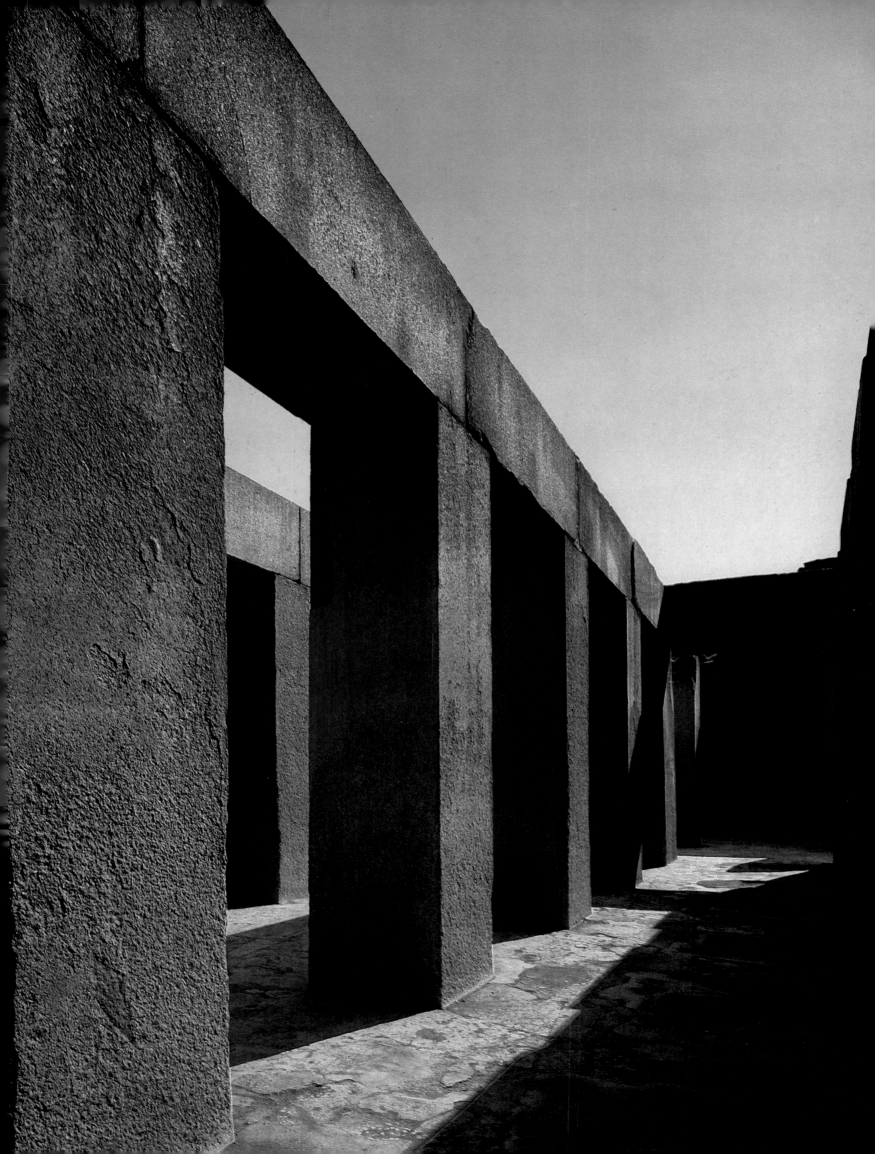

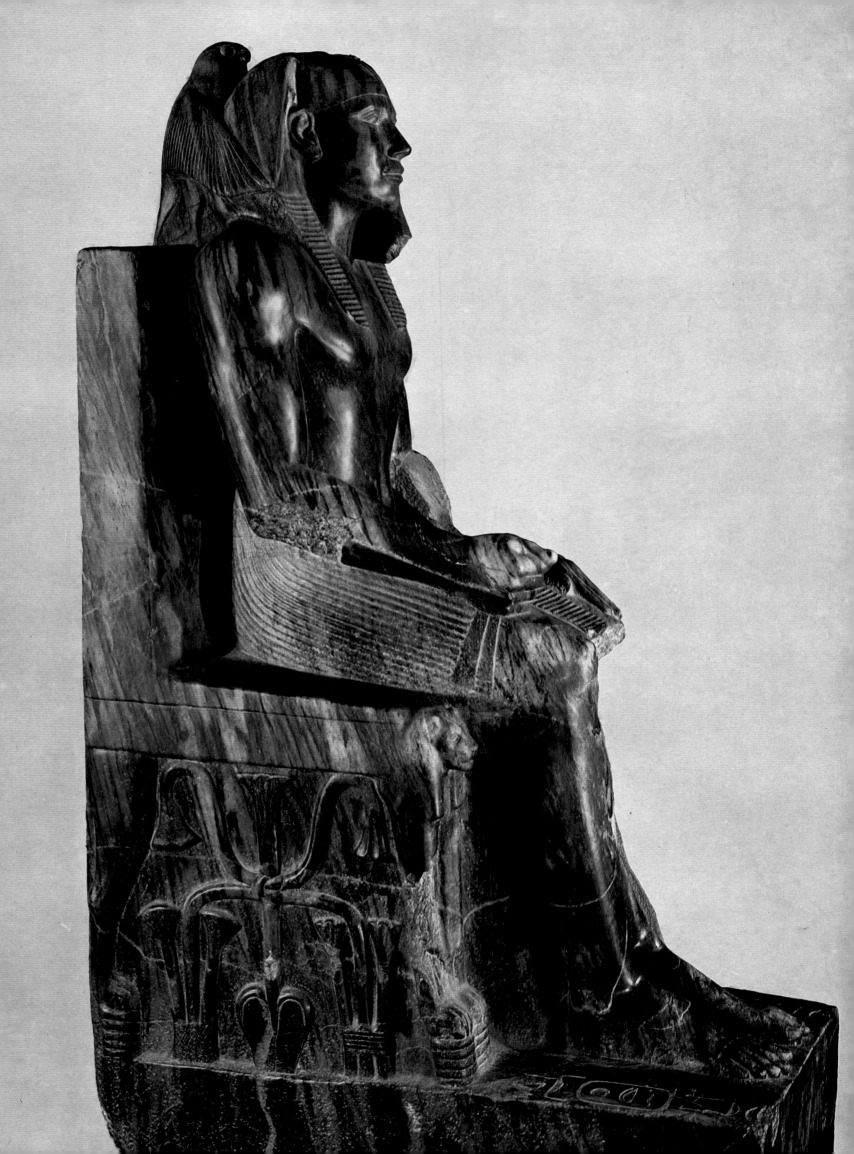

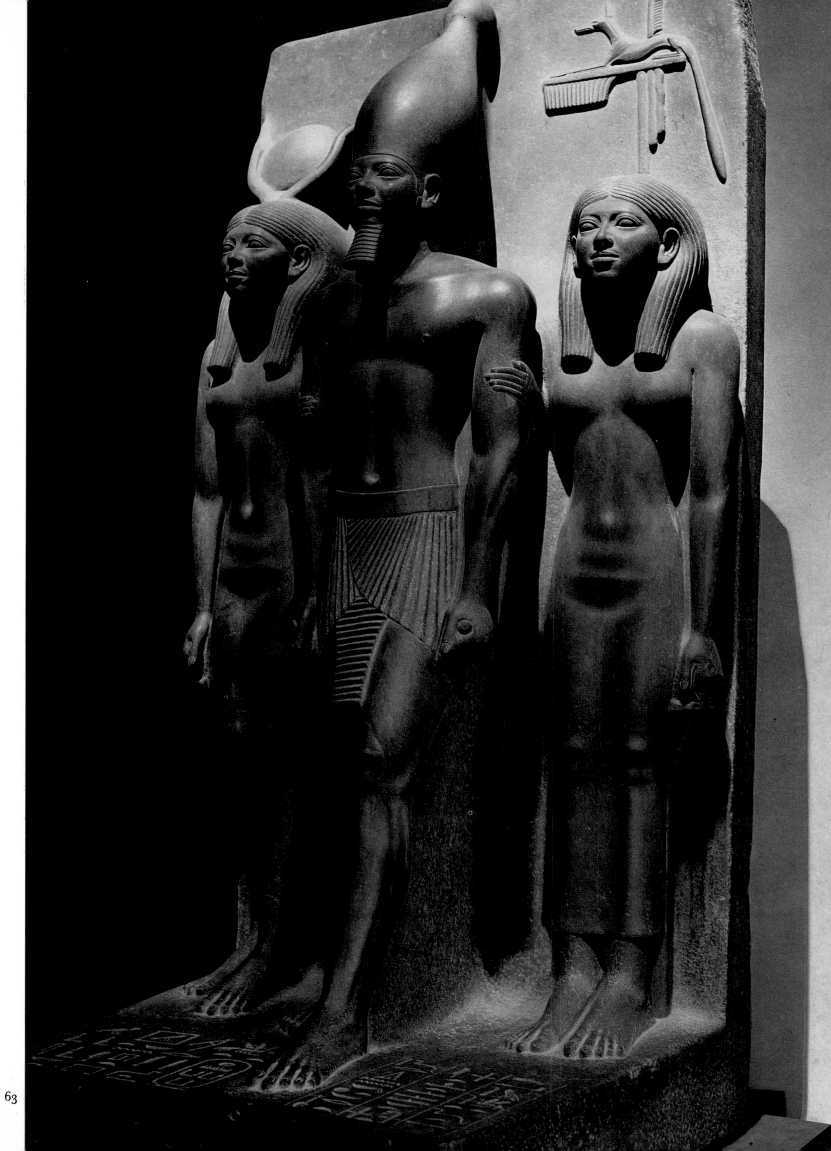

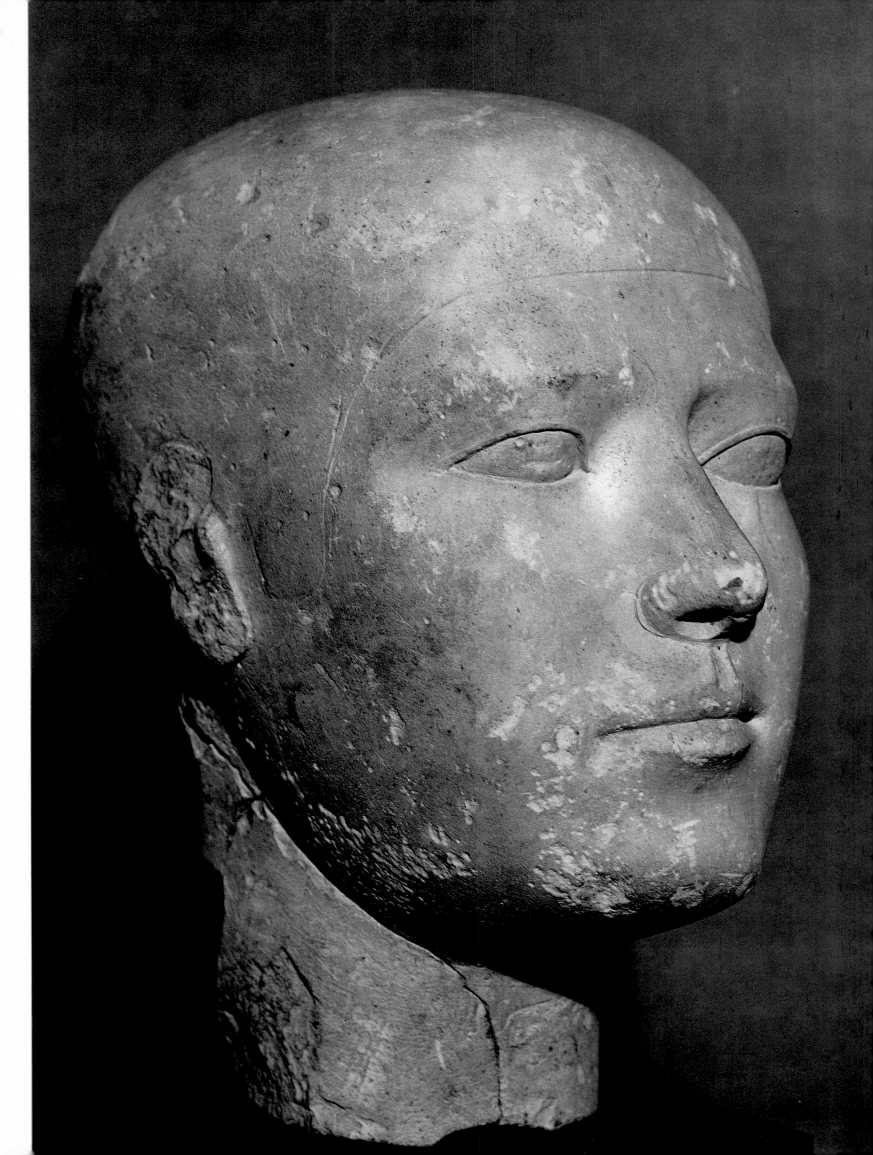

65. STANDING WOMAN

The body, emphatically modelled, is represented in the classic pose: standing with feet joined together and arms against the sides. Alabaster; height 18 7/8". Beginning of Dynasty V. British Museum, London.

66. ISI WITH HIS SONS

Sunken relief on the false doors of the mastaba of the dignitary Isi, Edfu. Painted limestone. Dynasty VI. National Museum, Warsaw.

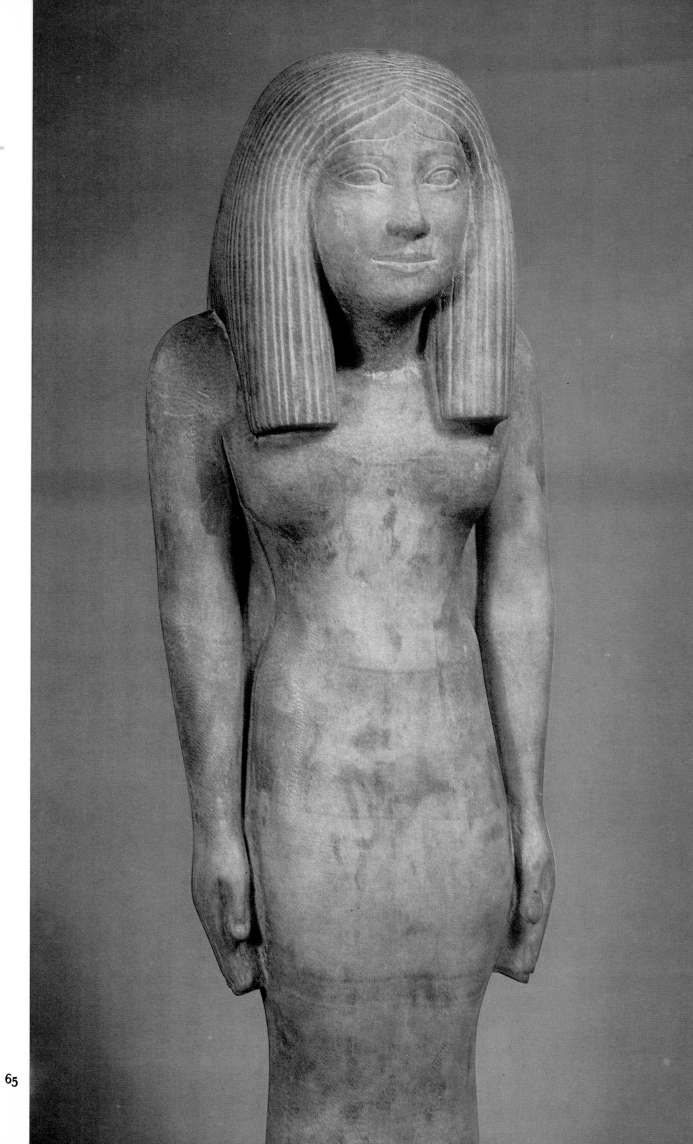

65

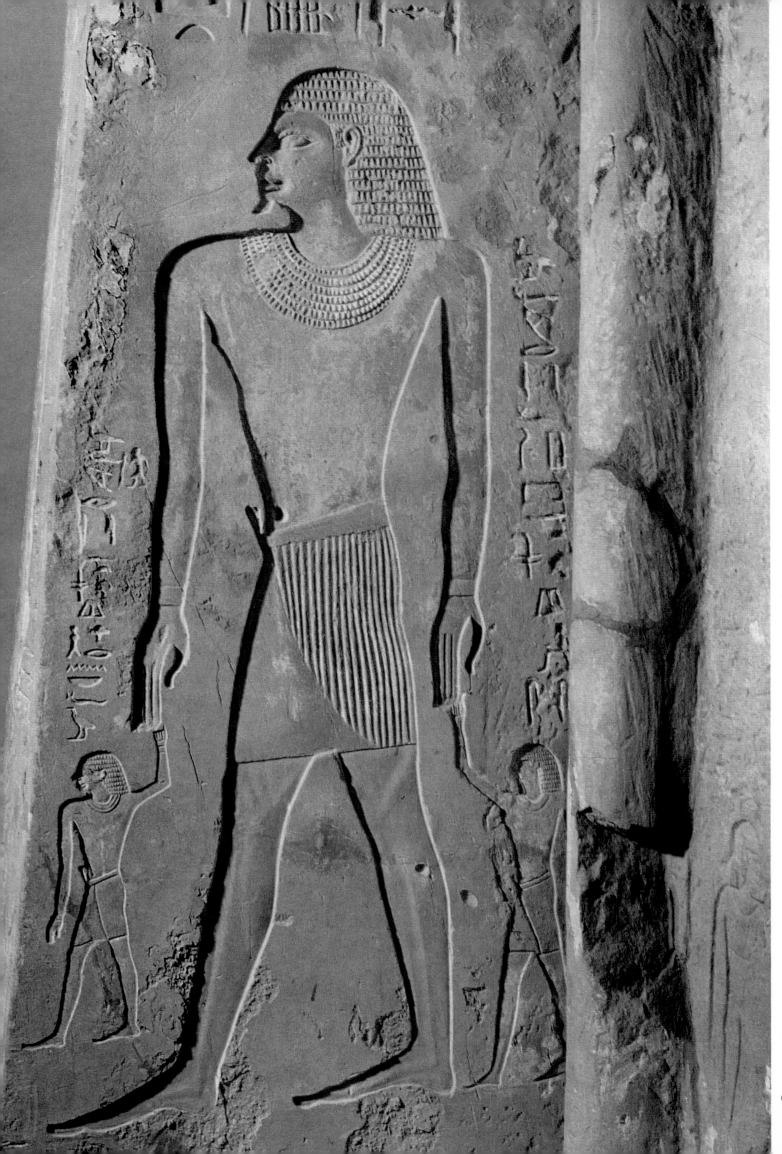

8. THE CANON OF THE HUMAN FORM

Art as propaganda

Representation of the human body

The canons of proportion

The life of the artist

Art as a reflection of social reality

The official portrait

The three social classes and the canon

The special case of the scribes

Realism in Egyptian art

8. THE CANON OF THE HUMAN FORM

Afterthe unification of Upper and Lower Egypt, toward the end of the fourth millennium B.C., art became a powerful instrument of propaganda, used not only to glorify the ruler and the gods, but to establish the image of a stable and unchanging society. Works of art became more legible and communicative as a result of the more orderly pictorial organization in horizontal registers, and the use of "projective" perspective. These formal devices, along with the canon of human proportions, persisted for thousands of years and constitute the distinctive characteristics of Egyptian art.

The canon, or set of rules, for representing the human figure was not the sudden inspiration of a single artist; rather, it was worked out gradually and the steps of its evolution may be followed from the earliest experiments to the later, more classical formulation. At this point, we must establish a clear distinction between two Egyptian methods of representing a human figure. The method used in free-standing sculpture is to render the figure in three dimensions, as it is found in nature; the second, as in painting or relief, involves the transposition of three-dimensional space onto a flat surface.

We shall begin with the second approach, for here we can more easily observe the essential characteristics of the Egyptian canon. Throughout the Predynastic Period, Egyptian artists followed the principle (characteristic of all so-called primitive art) of representing the human figure as fully as possible. Thus a more or less triangular torso is shown frontally, with both arms visible, while the head and legs are in profile. Although Old Kingdom artists preserved this traditional method of representation, they nevertheless

sought to introduce greater realism by establishing a set of proportions that would correspond to those of the average human body. This long, experimental process resulted in a definitive solution to the problem of creating a generally accepted, clearly recognizable image of man.

According to the Egyptian canon, the proportions of a figure were determined in the following manner. A standing figure was traced on a papyrus sheet or stone slab divided into eighteen rows of squares (a nineteenth row was reserved for the hair). The distance from hairline to neck was two rows; from neck to knees, ten rows; from knees to soles of the feet, six rows. A seated figure occupied only fifteen rows. This system of proportions was used until the Late Period, but from Dynasty XXVI on, the rows were increased to twenty-one and one-quarter (figs. 67, 68; Chart V, p. 569).

Just as squared papyrus sheets helped establish proportions of the human figure in paintings and reliefs, so plaster or stone models were used as a guide in free-standing sculpture. Generally small, the models were made according to the canon, with squares actually traced on the back of the figure; most surviving models of this type date from the Ptolemaic Period. By a method similar to that later known as "pointing," a statue could be made as large as desired, while preserving the proportions of the model.

Diodorus Siculus (first century B.C.) tells of two Greek sculptors of the sixth century B.C., Telekles and Theodorus of Samos, who collaborated on a statue of the Pythian Apollo, each executing one half. They followed the rule, then current in Egypt, of dividing the human figure into twenty-one and one-quarter parts. When each had completed his share of the work, the two halves fitted perfectly. Whether or not this actually happened, Diodorus' account is a faithful reflection of the artistic practices of ancient Egypt.

The canon was strict and accurate and left no doubt as to the proper placement of even the smallest detail. But what were these details? To answer this question is to grasp the sense of the canon as it was actually applied.

ON two-dimensional surfaces the human body is represented in dual perspective—for example, the head is in profile although the eye is shown in frontal view, as are the shoulders, so that both arms and both hands with all their fingers are visible. Needless to say, it is impossible to turn one's neck in a manner that will produce this effect. Even more implausible is the way the rest of the human anatomy is represented. The shoulders and chest face the viewer but the lower torso seems twisted, with the navel at the edge of the silhouette. In female figures, the breasts are in profile, but they are directly under the shoulders which are in frontal view. The legs and

feet, too, are shown in profile, the inside rather than the outside view of the foot being preferred (see Chart V, p. 569).

When the artist could choose the direction in which the figure faced, he always chose the right profile; the figure, therefore, appears to be walking toward the right. (The canon provided only for striding and seated figures.) When the figure was supposed to extend one arm, the left arm was preferred, the right arm held by the side.

As for dress and ornament, these varied from period to period. Only children were represented naked. In the Old Kingdom the Egyptians wore short aprons; these were much longer in subsequent periods. Also the style of necklace changed. Some details of the clothing were specified by the canon: for instance, the apron pleated over the hips—one of the most characteristic male garments in the Old Kingdom.

The proportions laid down by the canon were so exact that, in theory, there could be no error in reproducing a figure if the model on a papyrus sheet or stone slab were followed. These models, the earliest of which may have been developed in the artistic workshops of Memphis when it was the capital, were circulated to all provincial centers of government and religion and were faithfully followed wherever temples or tombs were to be decorated with paintings or reliefs (fig. 69).

Nevertheless errors were made (see Chart V, p. 569). A provincial draftsman, working from models of figures turned to the right, might try to repeat the same scene in the opposite direction (for instance, when decorating the walls on either side of a door). This involved making the figures on one wall turn to the left, and in such cases the artist sometimes went astray. He confused the arrangement of arms, or even placed the folds of the apron on the wrong side. But in general, the strictly defined rules of the canon, and the ready availability of scale models illustrating them, assured high standards of artistic quality and execution throughout Egypt. Only a specialist can discern the minute differences that distinguish the products of one artistic workshop from another.

Thanks to the canon, already elaborated at the beginning of the Dynastic Period, Egyptian art preserved its unity, its distinctive style, and its excellence for three thousand years. To be sure, both standing and seated figures exhibit a number of variations from period to period; but deviations from the canon are minor, and at no period do they seriously threaten the fundamental style of Egyptian art. Thus, the Egyptian canon must be regarded as a progressive development in its time, for it was powerfully effective, especially as a stimulus to workshop production.

Today we tend to think that any sort of constraint necessarily puts a damper on artistic originality. This point of view was unheard of in ancient Egypt, a land habituated to the constraints of nature and society. To the Egyptians, compelled to a round of seasonal activity imposed by the flooding of the Nile, the only meaningful art was one that reflected this unchanging reality. They needed an art to match their environment, as fixed as the positions of the stars in the heavens, as unvarying as the sunshine, as regular as the creaking of the *shadoof*. Within the over-all framework of the canon, there remained scope for artistic invention. Some artists introduced variations in the composition of reliefs, or in the disposition of scenes; a few went so far as to represent human figures from the back, although this development did not occur until the New Kingdom (fig. 93).

Finally there is the matter of quality of execution. Many magnificent works, as well as some considerably weaker ones, have survived. Yet what we have said still does not account for the conditions under which the Egyptian canon was created: we have also to consider the process of production itself, the conditions prevailing in the workshops, the organization of the work, and the position of artists in Egyptian society.

In contrast to ancient Greece—not to mention more recent periods of art history—all ancient Egyptian works of art were anonymous. From three thousand years' production we have only a few signed works, and the signatures bear little resemblance to what we think of as an author's signature. Greek sculptors and painters signed their works; so did vase makers and vase painters. By confirming that a given vase originated in a given workshop, they undoubtedly raised the value of their works. Not so in Egypt. The few "signatures" that have come down to us fall into two groups—the portrait signature and the so-called marginal signature. To give one instance: the decorator of a tomb might in some inconspicuous fashion introduce the hieroglyph of his name, or a self-portrait, thereby sneaking at least a fragment of his personality into the work. One inscription found in a tomb states that its author "is indeed not a painter to whom some superior can give orders, but a scribe with adroit fingers from the Khnum temple [at Esneh] whom the high priest in person brought here [to El Kab] and who directed the work with his own heart"; this clearly implies that the scribe somewhat disdained the artist's calling. One of them, for instance, observes that he had never heard of a sculptor or goldsmith entrusted with directing a government project. "To the contrary," he adds, "I saw a bronze worker standing close by his furnace: his fingers reminded me of a crocodile, and he smelled worse than rotten fish" (Sallier Papyrus, II, 4, 6).

Egyptian artists had trade organizations not unlike the medieval guilds, and their tutelary deity was Ptah, the chief god of Memphis. Among the

hosts of artists and craftsmen, the most talented could rise to the position of "head" craftsman or "head" sculptor, painter, goldsmith. The artist always felt that he was a member of a team of fellow artists. We have a detailed list of titles used in a sculptor's workshop; they cast interesting light on the way Egyptian artists worked together. There were strict divisions of labor: one specialist made the designs, another worked in plaster, and others specialized in stonecutting, in relief sculpture, in carving statues, in finishing and polishing them, in decorating temple walls, and so on. The jeweler's art also had specialist categories: workers who washed the gold, workers who melted it down, workers who shaped it; still others polished gems, did enamel work, and there was even a category of bead stringer. In theory at least, no work was executed entirely by a single artist.

Artistic workshops were attached to the royal treasury and the temples. Often skills were passed on from father to son; for instance, the title "chief painter of Amon" stayed in the same family for seven generations. Thus the Egyptian system favored specialization over creative individuality and developed something of a caste mentality in its artists. Sculptors, painters, and goldsmiths were looked upon as mere craftsmen, belonging to the same social class as carpenters, bakers, weavers, dyers, and tailors. They ranked far below the scribes, for example, but they were no doubt held superior to peasants, fishermen, or herdsmen. Interestingly enough, architects were assimilated not to the class of craftsmen but to that of government officials. The artist's social position was essentially the same in both Egypt and Greece. The Greek sculptors and painters who achieved distinction as individual talents—Phidias, Zeuxis, Apelles—were altogether exceptional; by and large, most Greek artists were considered craftsmen, or *banausoi*—persons who worked with their hands.

WHAT has been said thus far about the Egyptian canon by no means exhausts the subject. It was much more than a mere set of rules for drawing in two dimensions or in relief.

Artists were bound to observe all the rules of the canon when portraying the ruling class—the gods, the Pharaohs, and high dignitaries (usually only those of royal blood). Whether in painting, relief, or statuary, they are always shown striding or seated in the formal poses they assumed during their rare public appearances. It would have been unthinkable to present a Pharaoh with intimacy or familiarity. Few Egyptians ever laid eyes on him, save from a distance, and then he was a hieratic figure in solemn religious ceremonies. Whatever physical defects the Pharaoh might have were concealed by his elaborate costume. He was a god, the living Horus, and as a divinity his body had always to be represented as timelessly youthful.

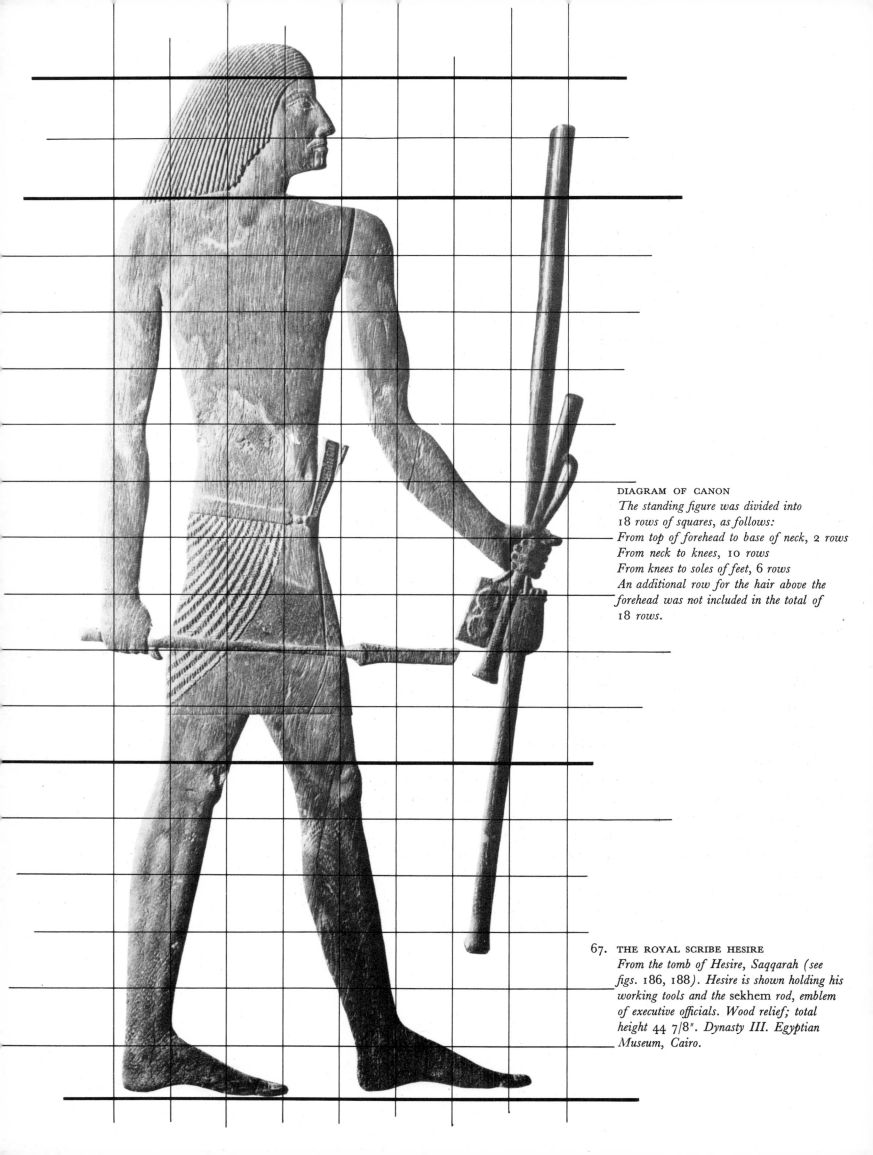

DIAGRAM OF CANON
*The standing figure was divided into
18 rows of squares, as follows:*
From top of forehead to base of neck, 2 rows
From neck to knees, 10 rows
From knees to soles of feet, 6 rows
*An additional row for the hair above the
forehead was not included in the total of
18 rows.*

67. THE ROYAL SCRIBE HESIRE
*From the tomb of Hesire, Saqqarah (see
figs.* 186, 188). *Hesire is shown holding his
working tools and the sekhem rod, emblem
of executive officials. Wood relief; total
height* 44 7/8". *Dynasty III. Egyptian
Museum, Cairo.*

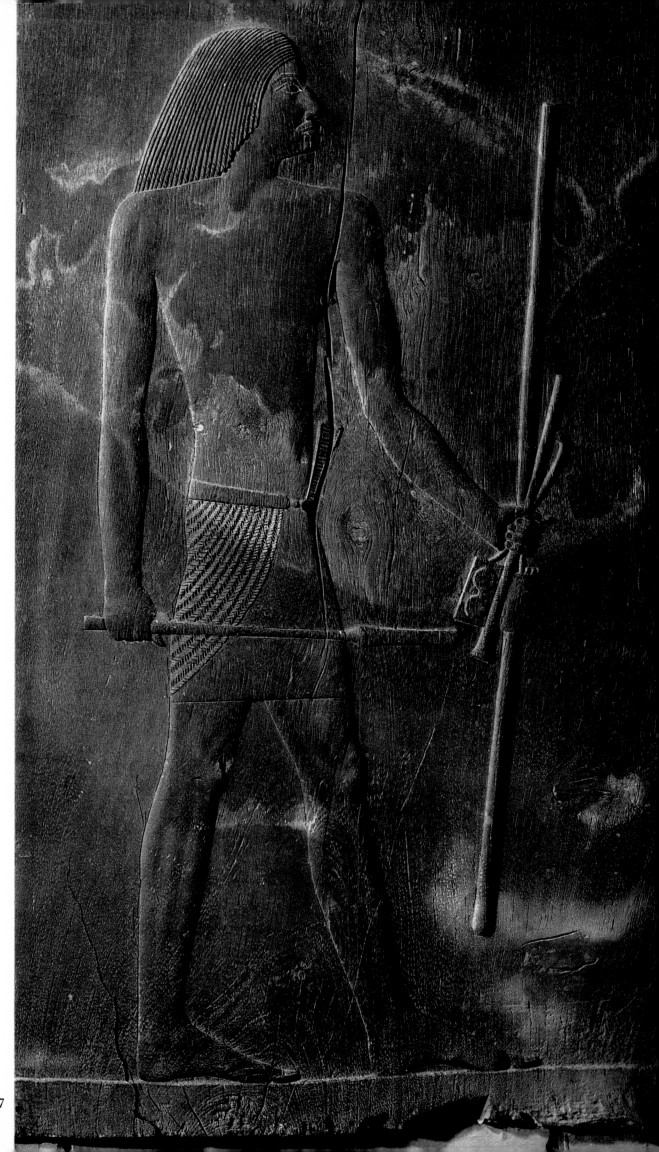

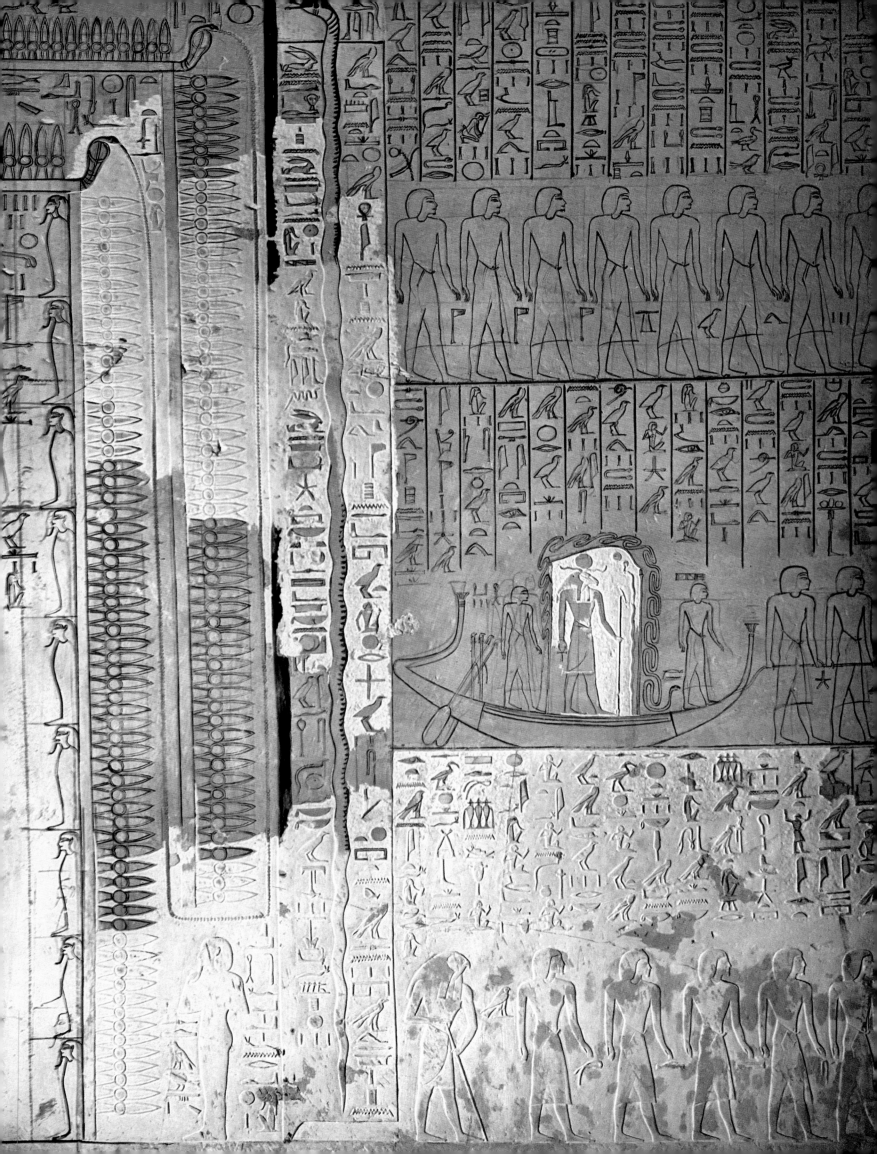

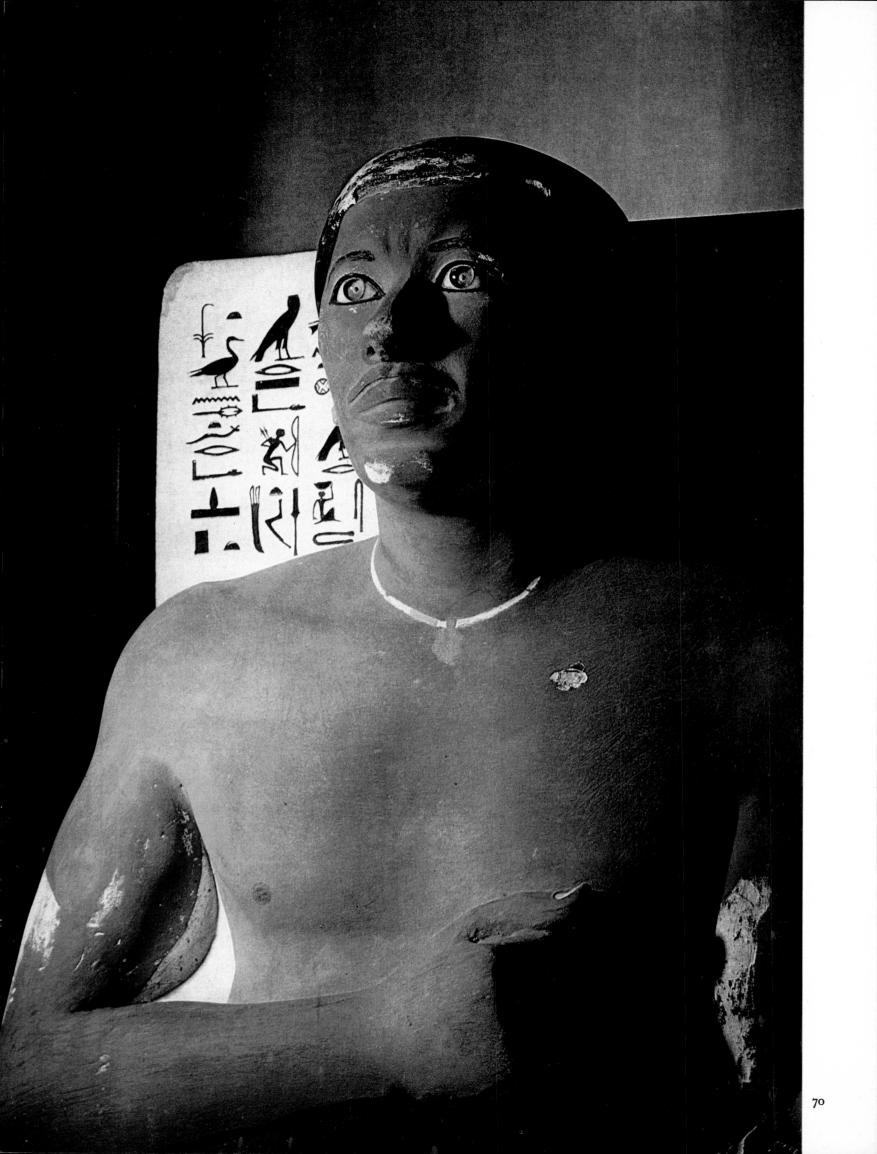

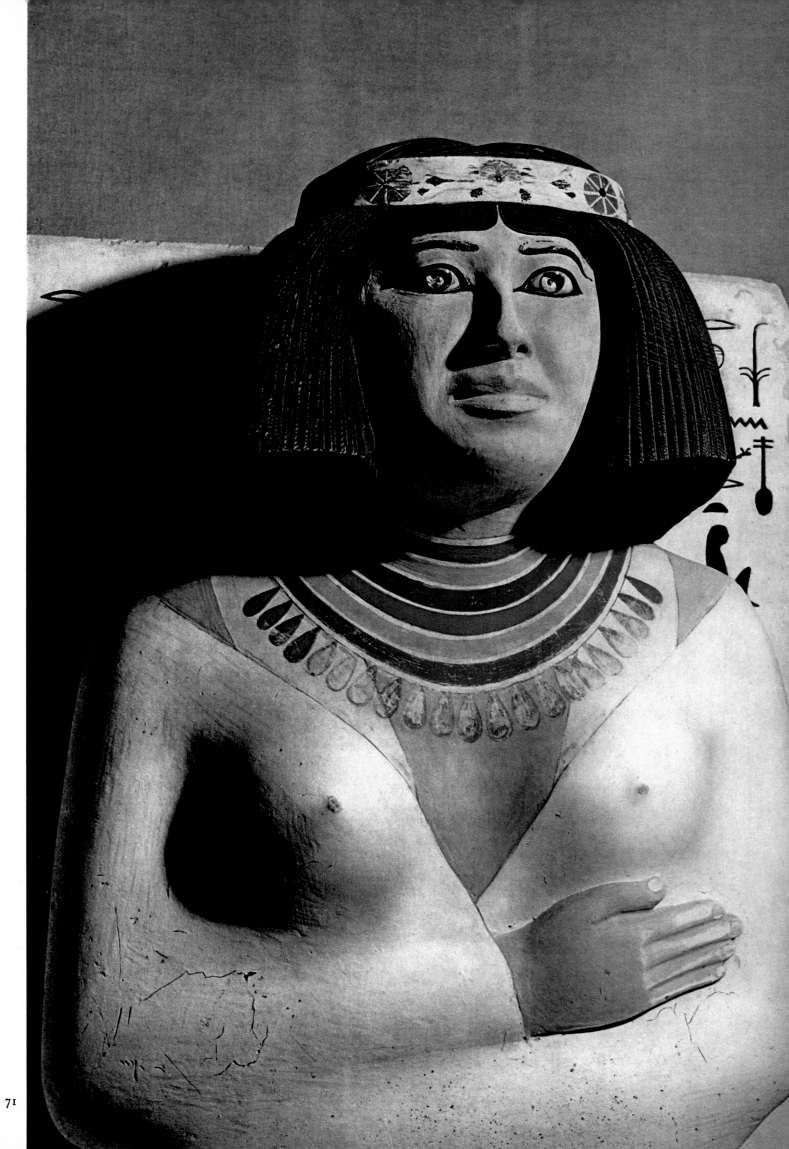

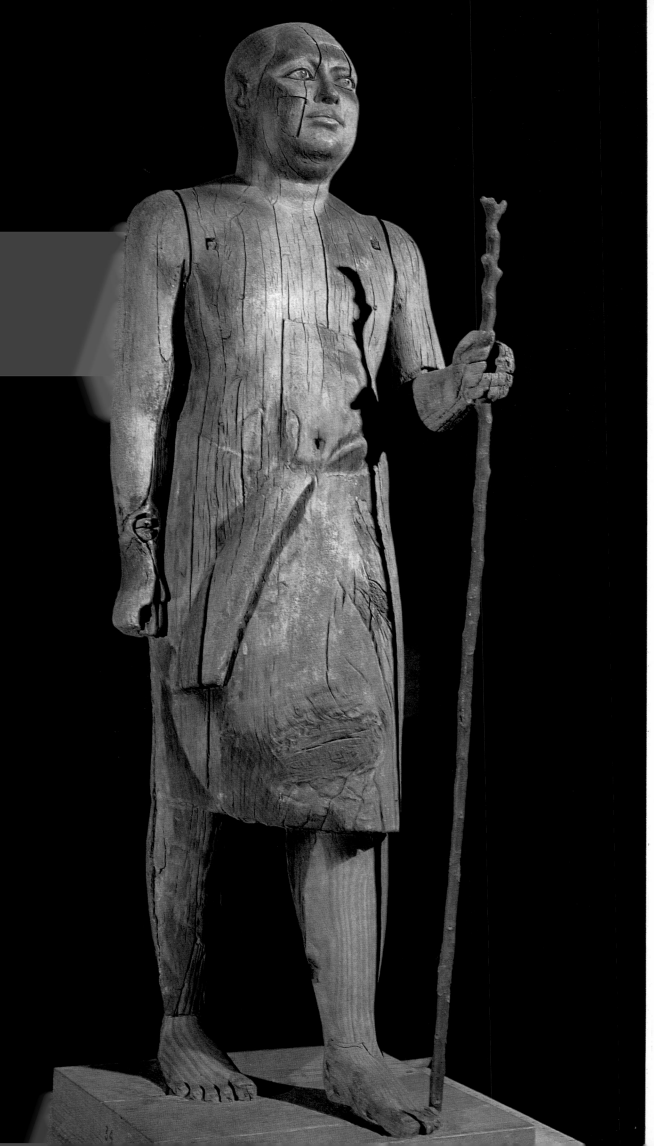

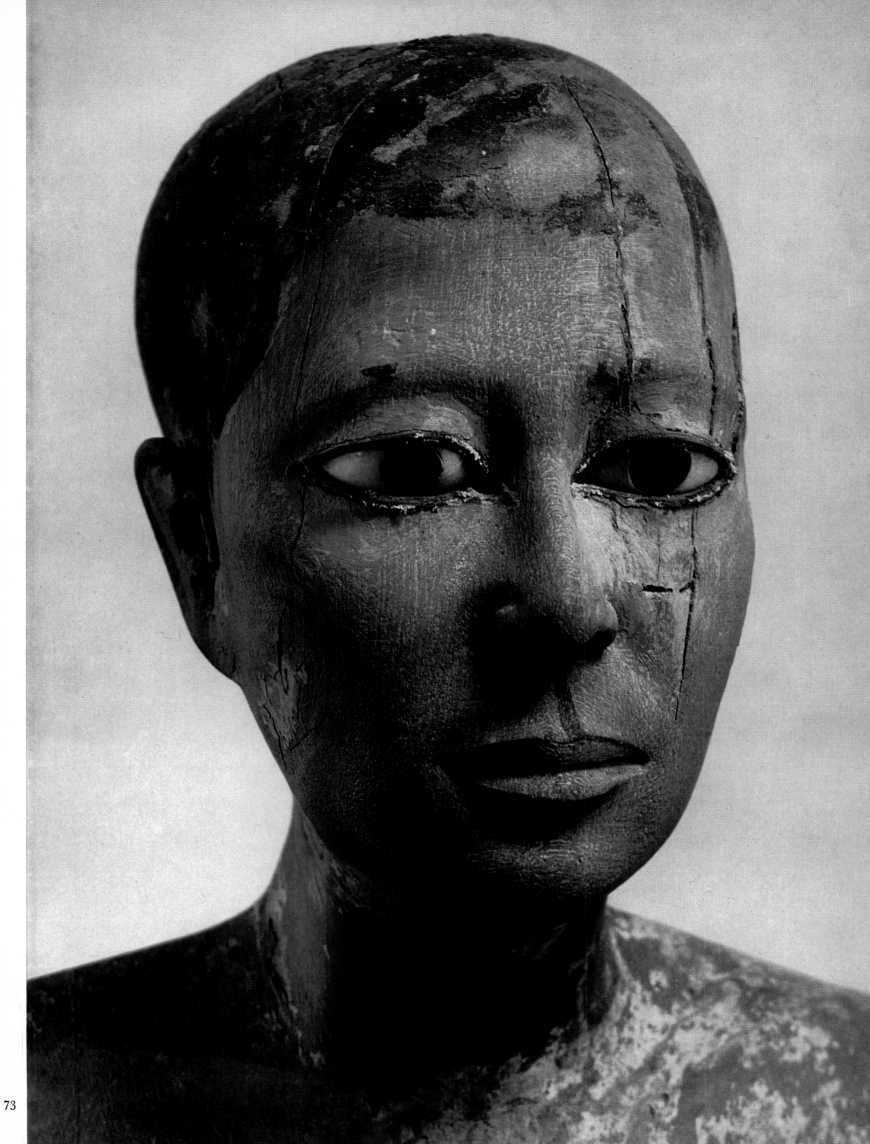

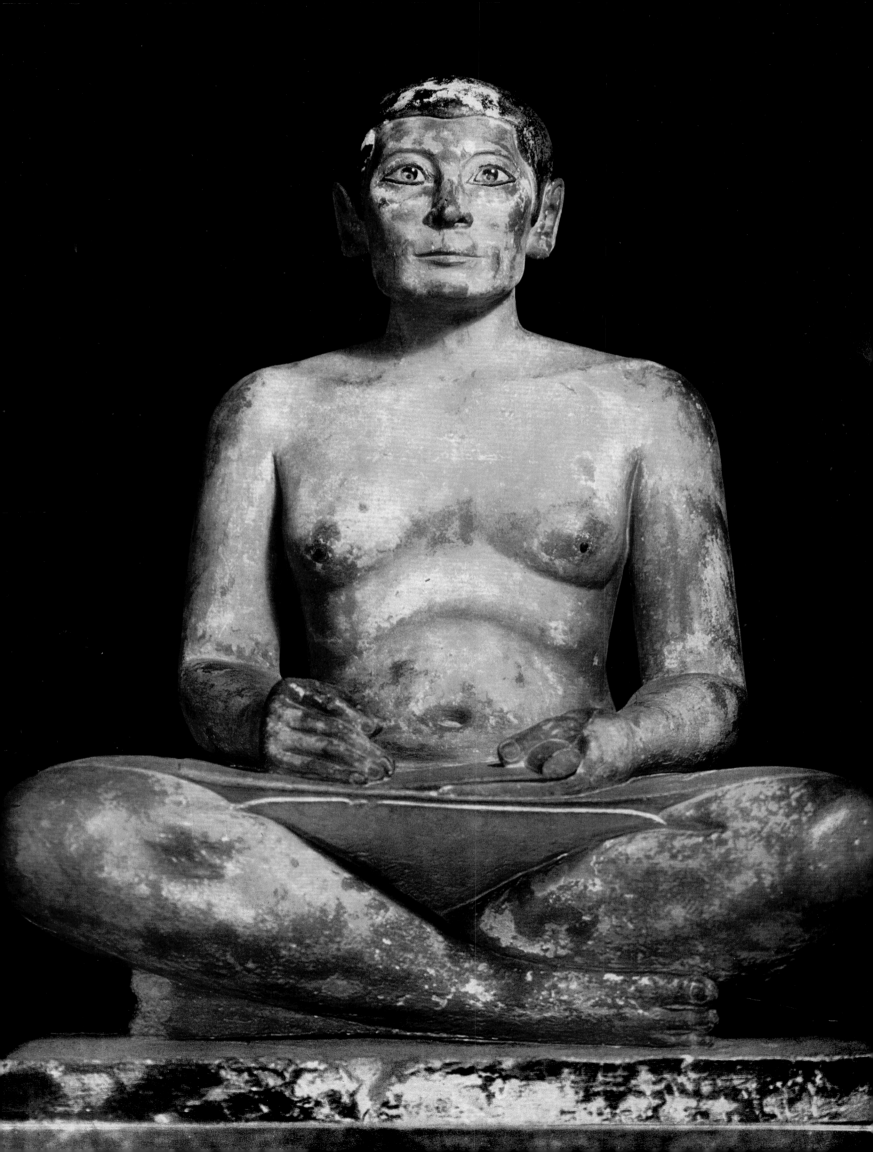

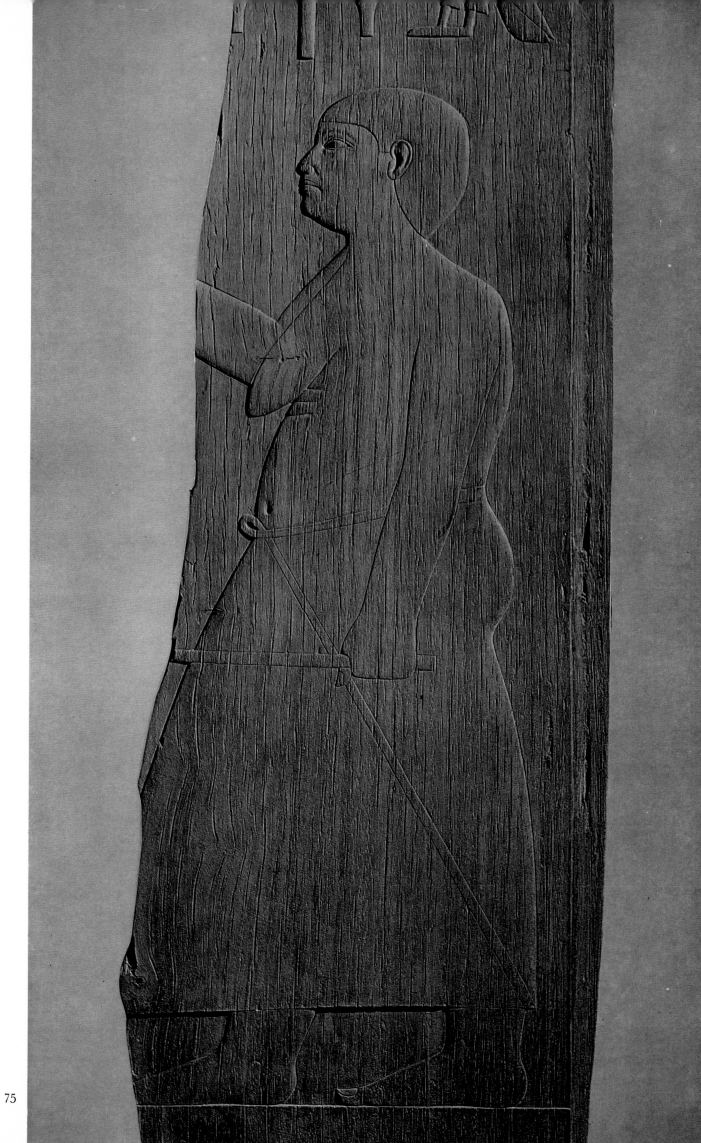

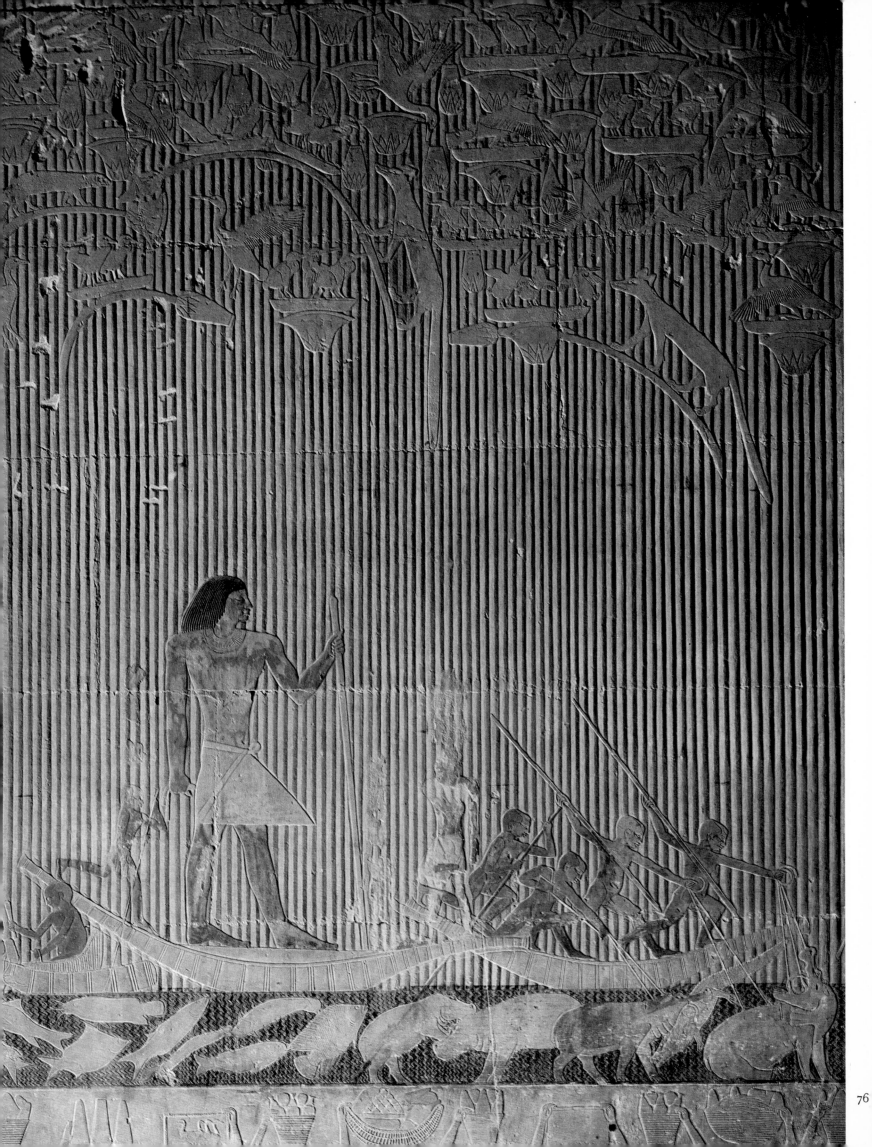

68. DRAWING EXERCISE
*Sketch on wood coated with stucco, showing
grid for establishing proportions in
representing the human body. Length c. 21".
Dynasty XVIII. British Museum, London.*

69. THEBES. TOMB OF HOREMHEB
*Portion of wall decoration in one chamber
of the royal tomb (see figs. 502–8).
Corrections in the drawing are visible, and
inscriptions and reliefs appear at various
stages of completion. Dynasty XIX.*

70, 71. PRINCE RAHOTEP AND HIS WIFE
NOFRET
*Upper portions of statues found at
Medum by A. E. Mariette (see
figs. 197, 198). The high quality of
these statues indicates that they were
probably made in a royal workshop.
Painted limestone; entire height 47 1/4".
Dynasty IV. Egyptian Museum, Cairo.*

72. SHEIKH EL BELED (THE VILLAGE MAYOR)
*Found in a niche in the tomb of Ka-aper,
Saqqarah, by A. E. Mariette (see also
fig. 227). This statue represents Ka-aper
in a hieratic pose. Wood; height 43 1/4".
Dynasty IV. Egyptian Museum, Cairo.*

73. METHETHY, CHIEF OF THE ROYAL
FARMERS UNDER KING UNAS
*From Saqqarah. Painted wood, inlaid
eyes; total height 24 1/4" (see fig. 230).
Dynasty V. Brooklyn Museum.*

74. SEATED SCRIBE
*This is the finest known statue of a scribe.
Wearing a loin cloth, he is seated with
legs crossed, an open roll of papyrus on
his knees, and a reed pen in his right hand.
Painted limestone; height 20 7/8" (see
fig. 211). Dynasty V. The Louvre, Paris.*

75. DIGNITARY
*The date of this work is controversial.
Though formerly assigned to Dynasty VI,
certain specialists now see it as later than
the Old Kingdom, some even dating it in
the Late Period. Wood relief. Private
Collection.*

76. SAQQARAH. TOMB OF TI
*Hippopotamus Hunt. The dignitary Ti
stands in a boat in a papyrus thicket;
the servant figures are smaller in scale to
emphasize their lower social status.
Painted relief (portion; see also
figs. 237–42, 245, 246). Dynasty V.*

The ruler's features, however, were known to all men, for his statue stood in every temple of the land. Needless to say, these were official portraits and presented only the most obvious facial characteristics. The type of official portraiture is that found wherever government art prevails: the faces on our coins and postage stamps, for instance. The purpose of such portraits is not to analyze the subject's personality, but to provide a readily recognizable likeness. In this sense, Old Kingdom portraits may be called "synthetic" portraits.

Consider, for example, the diorite statue of Chephren, which represents the Pharaoh seated on his throne, hands resting on thighs; Horus' wings embrace the royal headgear (fig. 62). A second posture permitted by the Old Kingdom canon is illustrated by the statue of Mycerinus which shows the king between the goddess Hathor, standing at his right, and a woman personifying "The Dog" nome (figs. 63, 208). The Pharaoh is shown striding; his hands with clenched fists hang straight along his idealized, youthful body; and his head (wearing the crown of Upper Egypt), like that of Chephren, presents typically synthetic features. Also to be mentioned in this connection are the large statue of Pharaoh Pepy I and the smaller one of his son Mernera (both in the Cairo Museum), made of sheets of hammered copper riveted with copper nails to a wooden frame. The technique of casting was known in the Old Kingdom, but used only for small sculptures. Among the most interesting sculptures of the period are the statues of Prince Rahotep and his wife Nofret (figs. 70, 71, 197, 198). They are executed in limestone; the man's body is painted a dark brick color, the woman's is yellow.

As for the second social class—the administrative officials—commoners could see them at close quarters. Even a poor man might occasionally present a petition to a provincial governor, or nomarch, and everyone came face to face with his village mayor. For this reason portraits of such dignitaries often revealed physical imperfections; but the artist was bound to observe the rules of the canon for indicating social status—that is, officials were shown striding or seated, in poses not unlike those of gods or rulers. Their bodies, however, are not idealized but are portrayed more realistically in accordance with their greater closeness to the populace.

The seated figure of Prince Hemiunu, who was a dignitary of Dynasty IV (fig. 199), is a typical portrait of a man who has risen to a place of importance in the hierarchy. Since he was not a prince of the blood, the artist represented Hemiunu realistically, emphasizing the layers of fat on his body. In reliefs, lesser dignitaries were frequently shown with sagging flesh, prominent bellies, and thick legs, but in a dignified hieratic posture, carrying

a staff. The well-known wood sculpture of a village mayor, the Sheikh el Beled, shows a plump, smiling figure with chubby cheeks and prominent paunch, striding in the hieratic manner befitting an official (fig. 72).

The main difference, then, between portraits of the two highest classes, the royalty (those who held the reins of power) and the bureaucracy (those who carried out the ruler's orders), lies in the modeling of the body. The convention of timeless youth was obligatory for the first group, whereas dignitaries were shown more realistically. Several references have been made to the unusually important social position held by scribes in ancient Egypt. This occupation qualified a man as a member of the bureaucracy, although he had no executive powers (apart from the post of "chief" scribe). Yet the scribe's functions involved working with the hands, and Egyptian art reflected the dual character of this occupational group. In paintings and reliefs, scribes are often represented in the hieratic striding posture, carrying their writing paraphernalia to indicate their function. The scribe Hesire is thus represented, in a wood relief found in his tomb at Saqqarah (figs. 67, 186). But in this case the scribe is performing executive functions: in his right hand he holds a kind of scepter, and in his left, in addition to the inkwell and writing instruments, a staff. In a famous statue from Dynasty V (figs. 74, 211), the scribe is represented in still another aspect—that is, carrying out his purely scribal functions. He is seated, legs tucked under his body, with a scroll of papyrus spread over his knees. In this working posture, the scribe actually belongs to the third social class—that of people who work with their hands.

Because of the scribes' prominent social role, a sort of subdivision of the canon was developed to regulate their portraits. Ultimately, the figure of the seated scribe was treated as a cube covered with inscriptions, with only the head protruding. This format was already used in the Old Kingdom, as can be seen in the statuette of a scribe named Ib (Dynasty VI), discovered at Edfu and now in the National Museum of Warsaw. During the New Kingdom, this treatment of the seated scribe became widespread.

THE canon also regulated the portrayal of the third social class, the working people. In paintings and reliefs the figures had to be shown in profile, but a certain freedom was allowed in the postures they assumed. The only reason to portray a man at work was to make his precise function clear and unmistakable. He did not count as an individual, but as a producer.

The mastabas dating from Dynasties IV and V at Saqqarah contain magnificent reliefs of laborers, harvesters, herdsmen, and artisans at work in warehouses, fields, pastures, and workshops. There are also fishermen and boat builders, musicians and dancers. These reliefs comprehensively

and accurately mirror the life of the mass of the population in ancient Egypt. When we examine them closely, we realize that in representing men at work, the artist was bound less strictly by the canon—the shoulders, for example, are not always shown frontally. Thanks to this freedom, the realistic scenes of common people possess great expressive power (figs. 17, 18, 237–54).

Among the most interesting and most highly prized surviving works are limestone sculptures and statuettes painted in many colors, representing people engaged in some everyday occupation—a housewife grinding grain by hand or a brewer at work—their movements superbly and realistically portrayed (figs. 16, 224–26). For a long time such representations were treated as "minor" works, while only those of gods, kings, and nobles were classified as "major." This distinction does not make sense: to begin with, "major" works (by this definition) are often actually quite small; nor does the distinction correspond to that between "official" and "unofficial" sculpture. Scenes of working people are to be found in unequivocally "official" works, such as the reliefs on temple walls, where we see large numbers of servants bent under the weight of sacrificial offerings or, as in the temple of Hatshepsut at Deir el Bahari, the weight of merchandise brought back from the land of Punt (figs. 342–44).

Classification of works of art by subject can be useful, but it can never serve as the principal criterion; what really matters is the composition. This is especially true of ancient Egyptian art, where the composition reflects social realities. The treatment of figures according to their social status may best be illustrated by a relief that shows a dignitary named Ti on a boat amidst his servants. He is much taller than the others, his posture is hieratic, and he is represented according to all the rules of the canon. His attendants, each in a posture descriptive of a particular function, make a scene that not only is unusually expressive as a formal composition, but also tells us of themselves and their time (fig. 76).

Especially noteworthy are the extraordinarily accurate representations of animals in ancient Egyptian art, and the skill with which their movements are rendered. Among numerous works that could be cited are the relief just mentioned, and the painting of geese from a tomb at Medum (fig. 194).

Egyptian realism is frankly native in character and as such is unique. It reflects the nature of the country, and thus the unvarying rhythms of life during a long historical period of minimal technological progress. Both clothing and tools remained virtually unchanged for thousands of years. The Egyptians achieved a high level of civilization with remarkable speed, but after that they made few advances.

Greek civilization followed a different course. Between the archaic and Hellenistic periods—a span of but a few hundred years—culture, science, and technology developed so rapidly that the way of life was completely

transformed. No wonder we feel closer to Greek culture, the basis of European civilization, than to Egyptian.

Thus, the art that was clear and intelligible to the Egyptians does not always seem so to us. We are surprised by its rigidity and strict adherence to certain patterns, as Plato was surprised when he observed that Egyptian artists were forbidden to make changes in old models or to maintain any but traditional standards. Yet this tradition, based on carefully elaborated artistic rules, was completely in keeping with the life of ancient Egypt and met the needs of the time; thanks to its simplicity and clarity, Egyptian art was comprehensible to the majority of the people.

Today we are able to draw a relatively clear distinction between naturalism and realism. We speak of naturalism when an artist records in his individual way some chance or passing moment in the world around him. Realism is a broader concept: it denotes the effort to represent a given phenomenon in its most typical form, and the fact recorded by the artist has thus a general significance that every viewer can grasp. In this sense, Egyptian art was certainly realistic. Because it played an active part in the ideological superstructure of the state, it occasionally became somewhat stereotyped, but then, the Egyptian way of life allowed only limited individuality. Just as the king and the high priest were portrayed in strictly prescribed postures, so human labor was reduced to strictly prescribed gestures, each activity having its characteristic gesture. If one observes modern assembly-line workers, one sees that they perform a limited number of operations over and over again. The Egyptian artist looked at a woodcutter or butcher and reduced the laborer's motion to a specific gesture. The specialization of artistic activities in Egypt has already been described; there was similar specialization in all fields, and this is reflected in portrayals of men at work. Add to this a certain theatricality characteristic of all Eastern art, and one can begin to understand the representational devices used by Egyptian artists.

The foregoing observations on the canon governing sculpture and painting in the Old Kingdom may be summed up as follows:

1) The canon was a unique historical phenomenon and has a peculiar indigenous character.

2) It was the result of a lengthy process of observation and experimentation which culminated in an art based on the most typical forms of nature; as such, the canon was formulated in terms of certain constant proportions.

3) The aim of the canon was to record phenomena in the most legible and understandable manner, to reflect reality in both its visual and its social aspects.

4) The canon performed an important function in the ideological super-structure, serving the ruling class by perpetuating the conviction that the existing social system was a just and permanent one. One way that art served this function was by glorifying the gods and the Pharaohs.

5) The canon was essential to the maintenance of artistic quality and standards of workmanship.

9. DECLINE OF ART
IN THE INTERMEDIATE PERIOD
AND ITS REVIVAL
IN THE MIDDLE KINGDOM

9. DECLINE OF ART
IN THE INTERMEDIATE PERIOD
AND ITS REVIVAL
IN THE MIDDLE KINGDOM

In the period that followed the Old Kingdom, social upheavals, struggles among the nomarchs, and breakdown of central authority were accompanied by a general economic decline. Governors of small districts could no longer afford tombs decorated with reliefs, or stone sarcophagi, not to mention monumental constructions; usually they were buried in simple wooden coffins. In their own districts they exercised less power than previous Pharaohs had held over the whole of Egypt.

In addition to unceasing internal conflicts, the southern borders were subject to raids by Nubians and nomadic tribes. Egypt's precarious situation at this time may be illustrated by an important discovery made at Edfu in Upper Egypt during the Franco-Polish excavations of 1936–39. There it appeared that during the First Intermediate Period a necropolis—a city of the dead whose peace was not to be disturbed—dating from Dynasty VI had been converted into a bastion. The spaces between the mastabas were filled in with brick walls to form a solid fortification system.

During this same excavation at Edfu significant information was assembled on burial practices during the First Intermediate Period. The cemetery beside the "wall of mastabas" contained three types of tomb (fig. 929). The first is reminiscent of a small catacomb: a low, twisting corridor cut out of friable rock, both sides lined with hollows which served as graves for the poorest classes of the population. Their bodies, placed on reed mats, were put in these graves. In the fill of the entry passage were found a number of figurines, primitive in style—the so-called concubines (fig. 78). There was a certain "democratization" at this time; the possibility of becoming

one with Osiris after death was no longer restricted to the Pharaohs and leading dignitaries, but open to any man whose family could give him proper burial. Even the poorest artisan could afford to have a small terracotta figurine of a naked woman in his grave, to serve as his concubine in the afterlife and also as his *shawabti*.

The second type of Edfu tomb consisted usually of a vaulted tomb chamber of sun-dried brick and an access shaft of almost equal size, built within a large man-made pit. Some of these tombs had more than one level; in such cases the pit was dug deeper, for the tombs rose only slightly above the surface of the earth. The exterior of one such tomb was originally pierced by four arched openings leading onto the shaft; these openings were blocked up with bricks after the bodies, enclosed in wooden sarcophagi, had been put in place. Finally, the entire construction was buried so that it would not be noticed. It seems likely that these tombs belonged to families of middle-class status, artisans or priests of lesser rank.

The third type also consisted of brick-vaulted tombs, but these were built entirely above the ground. The individual chambers frequently housed several sarcophagi placed in layers, one atop the other. These tombs may have belonged to the wealthiest class, who could afford the construction involved and also the more elaborate oblong coffins. In shape, these anticipate a type of coffin widely used in the Middle Kingdom. Certain of these tombs must in fact date from that later period, for in one of them was found a scarab with the name of Amenemhat II.

On the other hand, the funerary stele of the nomarch Nefer (found at Edfu and now in the National Museum, Warsaw) shows the characteristic features of the art of the First Intermediate Period, although it may date from the end of Dynasty VI, when Egyptian unity was already being weakened by a succession of palace revolutions (fig. 268). The proportions of the main figure mark a considerable departure from the carefully established rules of the canon. The head of the dignitary is too large; his eye and his left hand raising a vessel both seem excessively long. The work suggests a certain loosening of compositional rules, and there is a clear decline in the quality of execution.

The so-called models, executed for high dignitaries, may be considered the most characteristic works of art from this period. The term "models" is inaccurate, for they are actually figure groups of small dimensions, fashioned of wood, painted, and then placed in princely tombs. One of the most interesting groups represents ranks of marching soldiers (figs. 79, 276–90).

THE artistic situation changed radically after the country was reunified by the Theban princes, the founders of Dynasties XI and XII. The architecture

of this period is notable for the fortifications built by Middle Kingdom Pharaohs to defend the country against foreign invaders. Egypt needed a period of lasting peace to recover from economic and cultural ruin. It was during this time that strongholds were built near the Second Cataract to protect the country from armed raids by Nubian tribes and to facilitate Egypt's colonial penetration in the south. Many examples of this military architecture—at Semneh, Mirgissa, and Buhen, for instance—form compositionally homogeneous ensembles. The fort of Buhen, recently excavated by Professor Emery of London, may be taken as a representative example. However, no trace has yet been found of the famous defensive fortification called the "wall of the prince" built by Middle Kingdom rulers in the northeastern region of the Delta to keep out Asiatic invaders.

In their various undertakings the Pharaohs of the Middle Kingdom followed the great tradition of the Memphite dynasties. Fascinated by the past, they sought to imitate their powerful predecessors of Dynasties IV and V. Their economic base, however, was considerably weaker than that of the Old Kingdom. They could no longer afford so grandiose an undertaking as the great pyramids and the surrounding necropolis at Giza, though this would have affirmed their power and authority.

Opposite the new capital of Thebes, on the west bank of the Nile in the valley today called Deir el Bahari, Mentuhotep I (Neb-hepet-ra), founder of Dynasty XI, built his funerary temple; original in conception, it was, on a small scale, a synthesis of the Old Kingdom pyramid complexes (fig. 893). A long road led up from the Nile into the barren valley and culminated at a stone ramp bordered by sycamores and tamarisks, planted by design to shade statues of the king. This ramp led up to a large terrace supported in front by a pillared portico. A second, smaller terrace, similarly supported by a peristyle open on three sides, rested on top of the first terrace. The massive stone pyramid that appeared to crown the second terrace was actually set on a high base in the middle of the columned hall on the main terrace. Behind the covered hall on the upper terrace was a court surrounded by porticoes, followed by another large columned hall with an altar, and finally the sanctuary proper—a sort of niche in the rear (west) wall of the hall—containing a statue of the king or god. The temple walls were covered with carefully executed reliefs and hieroglyphic inscriptions; some of the latter are themselves true works of art (figs. 270, 274, 275). This unusual architectural complex was to inspire Senmut several centuries later when he built Queen Hatshepsut's funerary temple nearby.

THE Pharaohs of Dynasty XII moved to a new residence at Ith-Tawe, not far south of Memphis. They erected their pyramids and funerary temples

at the edge of the desert south of their new capital, thus extending, so to speak, the belt of Old Kingdom royal necropolises running from Abu Roash through Giza, Abusir, Saqqarah, Dahshur, Lisht, and Medum, as far south as Hawara and Lahun. But they were not always able to build in stone. The pyramids at Hawara and Lahun are considerably smaller than those of the Old Kingdom and are constructed of dried brick with a stone facing. The funerary temples attached to them are also of brick and contain a great many small rooms which form a veritable labyrinth. Part of the famous "Fayum Labyrinth," described by Herodotus and Strabo, may have been the funerary temple of Amenemhat III (Dynasty XII).

Whereas funerary temples in dried brick are of considerable size, the stone temples of this period are much smaller. The best preserved is the one at Medinet Madi, which was dedicated by Amenemhat III and Amenemhat IV to the harvest goddess Rennut and the god Sobek. It is a small structure with a rectangular plan. The recessed portico of the main façade has two columns in the form of papyrus bundles. Inside there is a small hall as a kind of antechamber, and three chapels with statues of the gods.

One of the most beautiful sanctuaries of this period is the kiosk of Sesostris I at Karnak, which was demolished under Amenhotep III. It was restored not far from the original site by the French architect H. Chevrier from blocks he discovered in the foundations of the third pylon of the Karnak temple (fig. 894).

Not only the Pharaohs were fascinated by the monumental architecture of the Old Kingdom. Lesser princes, and even provincial nomarchs, strove to imitate the grandeur of the pyramids. For instance, two princes named Wahka and a third named Ibu, who were governors of Nome X in Upper Egypt, built at Qaw el Kebir, on the eastern bank of the Nile, modest tombs which in their over-all design recall the pyramid complexes at Giza. These structures were not mere imitations of earlier models; they were original and imaginative. Directly on the Nile a sort of landing slip was built in the form of a gateway-portico, set high enough above the normal height of the water to be protected from the river in flood. From the gateway a covered passage led to an upper sanctuary disposed at successively higher levels connected by stairways. The exterior wall of the court behind the temple rises nearly to the full height of the rocky hillside. It lacks only the final element—a pyramid. But instead the abruptly sloping rock forms a harmonious crown for this interesting architectural complex (see Chart IX, p. 575).

The tombs for nobles hewn from the solid rock of Middle Egypt—at Beni Hasan, Deir el Bersheh, Assiut, Meir—and farther south at Aswan, have come some distance architecturally from their antecedents of the First Intermediate Period. Halfway up the hillside, tombs were cut out of the rock, the only access being via a steep, narrow ramp. The antechamber consisted of

a portico with columns carved out of the rock. In some tombs, these columns had narrow vertical grooves that suggest the fluting on Doric columns, hence their name "proto-Doric." In other tombs the columns were carved on the model of the so-called lotus columns introduced by the architect Imhotep in Dynasty III (see Chart XI, pp. 578–79). Behind the portico was a room cut into the rock, containing a niche for the statue of the deceased. False doors were carved on the rocky walls, and nearby, a carefully concealed shaft led to the actual funerary chamber. These rock-cut tombs, their details influenced by the mastaba, were used by the nobility in the Middle Kingdom period; not until the New Kingdom did the large rock tombs, concealed and inaccessible, become the resting place for Pharaohs.

During the Middle Kingdom a new type of capital made its appearance. It replaced stylized palms, papyrus reeds, or lotus leaves with the head of the goddess Hathor (see Chart XI, pp. 578–79). In subsequent periods the so-called Hathoric capital became a classic element in Egyptian architecture. The same is true of the Osiride column, which has the figure of Osiris carved on the front of a square pillar. (Pillars of the Osiride type may, in fact, already have existed in the valley temple adjacent to the Chephren pyramid.) Granite sphinxes (figs. 85, 325, 327) also appeared in the decorations of large temple complexes, as did paired obelisks; these became increasingly slender in shape, cut from single blocks of red granite and covered with inscriptions. The tips of such obelisks were usually covered with sheets of polished metal.

WHEN Sesostris II, following the example of his immediate predecessors, began to erect a pyramid at Lahun, on the edge of the Fayum, he ordered that a town be built in the desert to house the workmen, artisans, and officials connected with the construction of the pyramid. Thanks to Petrie's excavation of this site, which he called Kahun, we possess the plan of a large part of this Middle Kingdom town. Although it was built of dried brick, the ruins were buried in the sand and have been relatively well preserved. The town rapidly grew to considerable dimensions and formed a true urban complex. In this respect, Kahun is an exception among the known communities of ancient Egypt, where towns often seem to have been simple agglomerations of decaying dwellings along the Nile. Kahun was built according to a careful plan: a clear separation was observed between the rectangular workmen's area—walled off from the rest of the town—and a more elegant area with comfortable villas for supervisors, officials, and priests. Sesostris himself occasionally resided here, overseeing the progress of construction. The poorer section was 787 1/2 feet long and 345 feet wide, whereas the section reserved for dignitaries was more than twice as large and the houses considerably fewer; some of the latter took up an area of more than half an acre.

The appearance of one type of small dwelling from this period has been preserved in the terracotta "houses of the souls" which were occasionally placed beside the dead in their graves (fig. 281). From a walled courtyard onto which several rooms faced, a stairway led to upper rooms. Windows were provided with bars. Residences of the well-to-do contained several rooms, some of them supported by columns. In such residences there was an antechamber, a long corridor, a kind of waiting room, a porticoed courtyard, a reception room, the apartment of the master of the house, separate rooms for his wives—his harem—and finally outbuildings that served as kitchens, storehouses, cisterns, and servants' quarters.

Aᴛ the beginning of the Middle Kingdom, under Dynasty XI, two main schools of sculpture can be distinguished. In the north, in the area around Memphis, splendid Old Kingdom monuments and reliefs in the great necropolises of Giza, Abusir, and Saqqarah provided artists with excellent models for their commissions under the new dynasty. Northern sculpture thus achieved more successful composition and more balanced proportions. In the south, however, the Old Kingdom had left no great works of sculpture and there were no local traditions upon which to elaborate. Southern monuments such as the statue of Mentuhotep exhibit a certain crudeness of execution and naïveté in the treatment of facial characteristics (fig. 77).

From the beginning of Dynasty XII, however, a unified style prevailed over the entire range of Egyptian art; availing themselves of uniform models and patterns, the workshops attained and kept a high artistic level. But the artists did more than strive to equal Old Kingdom art. In many instances they surpassed it, especially in the treatment of detail. Hieroglyphs at this time are drawn with much greater care and exactness than during the Old Kingdom, and the same is true of relief work, the principal type now being sunken relief. Among representations in the official style, the dominant symbol is the reunion of Upper and Lower Egypt expressed by the joining in a vertebrate column of the lotus and the papyrus, plants symbolizing the two countries (fig. 40). A new theme also appeared, one that would have been inconceivable in the Old Kingdom: the figures of king and god are now put on the same footing. This equality is daringly represented in a scene depicting a ritual race or dance, where Sesostris is shown before the statue of the god Min (fig. 302).

Tomb paintings are now on a larger scale than was usual in the Old Kingdom. Certain traditional scenes, like those of woodcutters have changed (see Chart VI, p. 570). The composition has become tighter, the figures occupy less space. Among the tomb paintings there are some genuine masterpieces,

especially those at Beni Hasan: the scene showing a caravan (fig. 86) or the fattening of oryx antelopes (fig. 87).

The jewelers of this period also produced works surpassing in precision and artistic invention those of their great predecessors. The pectoral decorations discovered in the royal tombs at Dahshur (figs. 791, 793, 795) are distinguished by unusually careful execution of enamel on gold, and by the imaginative composition of the religious symbols on the pendants. One of the most beautiful pieces of jewelry from this period is the diadem of a princess named Khnumet, also found at Dahshur and now in the Cairo Museum. In ceramics and stone vases the dominant forms are squat, related to the spherical vases of the Old Kingdom.

THE art of this period lacks something of the majestic serenity characterizing Old Kingdom monuments, all of which seem to have been made for eternity. In a wood sculpture, King Hor, probably the co-regent of Amenemhat III, had himself immortalized naked except for the official wig, with an attached beard and the *ka* symbol in the shape of upraised arms set atop his head (fig. 330). The same type of representation includes a medium-sized painted wood statue of Sesostris I wearing the crown of Lower Egypt (fig. 83). Occasionally one has the impression that Middle Kingdom artists were less convinced than their ancestors had been of the indestructibility of their works. This would not be surprising, since they were conscious of being separated from the glorious era of Cheops and Chephren by a long period of dissidence and disorder, revolutions, famines, the decline of the state, and the undermining of all formerly immutable values.

The current of pessimism expressed in some literary works of the period also appears in the plastic arts. This is particularly evident in the portrait of Sesostris III, one of the most outstanding of the Dynasty XII monarchs, whose reign lasted thirty-five years. In the modeling of the head, the artist violated the first principle of "synthetic" portraiture, for he presents a face seamed with furrows, pouches beneath the eyes, and heavy eyelids. This is a portrait of a worried, apparently disillusioned man, with an almost melancholy expression—how different from portraits of Chephren or Mycerinus! Never before had an artist ventured, in an official portrait, to represent the ruler's mood: here we have the worried features of a king who seems to fear that the unity of his kingdom, achieved after painful struggle, may yet prove short-lived (fig. 84).

The portrait of Sesostris, one of the greatest achievements of Middle Kingdom art, has no parallel. In spite of visible attempts by certain artists to break with conventions, the statues of this period, generally speaking, are characterized by a cold, sometimes banal academic classicism. This is

especially true of statuettes of high government officials, with their large, prominent ears (figs. 82, 319–24). Even in motifs that by their nature would seem to require freer treatment—scenes from daily life, such as a woman feeding her child—the artists slavishly followed set patterns; one might say that they avoided anything that would reveal their own personalities.

Perhaps there was not enough time for Middle Kingdom art to reach its fulfillment. The country was plunged into fresh turmoil with the invasion of the Hyksos and once more its unity was destroyed. In their Delta kingdom the Hyksos did not seek to destroy the monuments of the past. They frequently usurped Middle Kingdom monuments, by adding cartouches of their own. Yet they proved incapable of giving new impetus to the development of art and culture. Once again Egypt underwent the travail of an intermediate period. Although the Second Intermediate Period had less destructive effects than the First, it nonetheless arrested the course of artistic development for nearly two centuries.

77. MENTUHOTEP I (NEB-HEPET-RA)
Found under the funerary temple of Mentuhotep, Deir el Bahari. The statue is typical of the work of the Theban school. Painted sandstone; height 68 7/8". Dynasty XI. Egyptian Museum, Cairo.

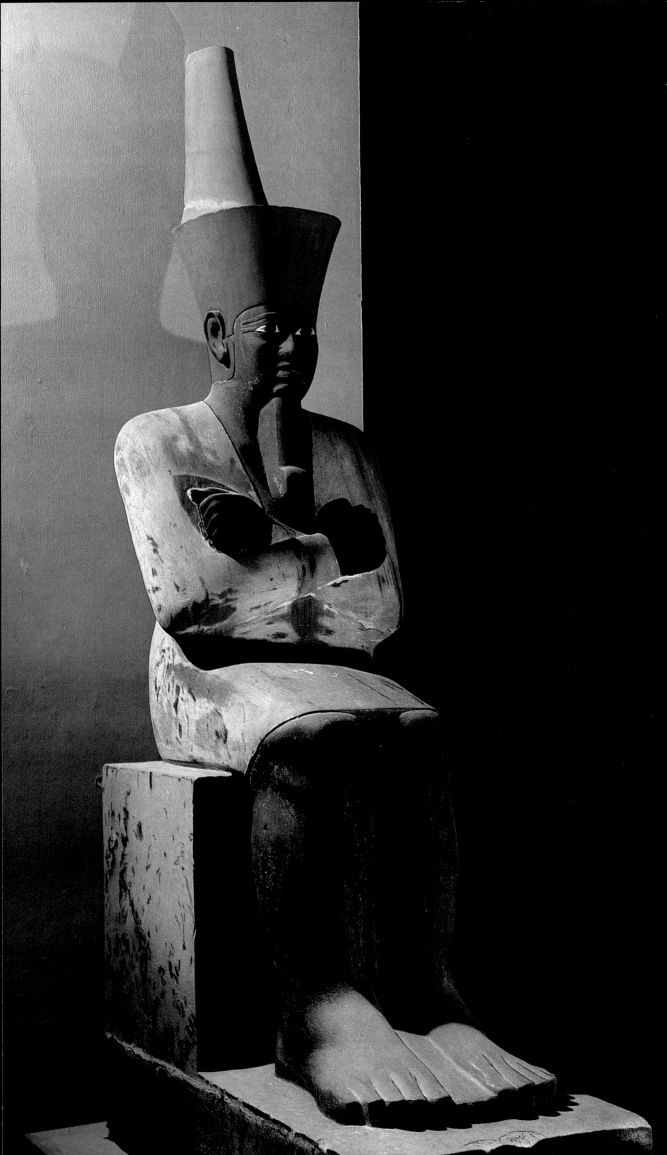

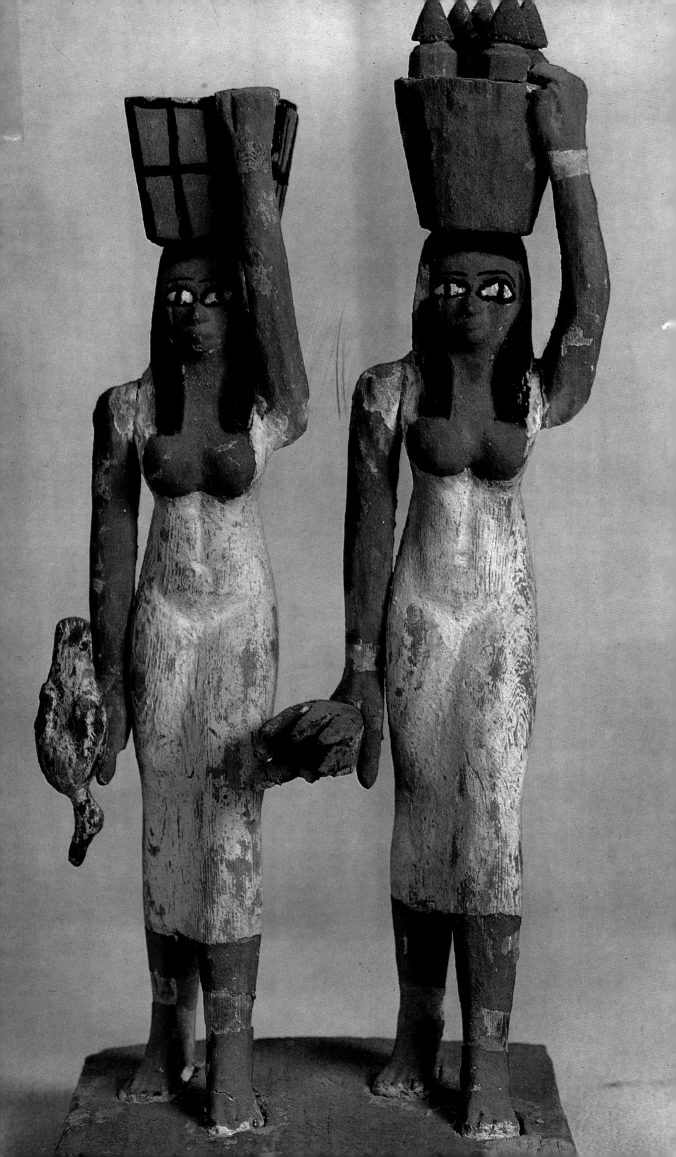

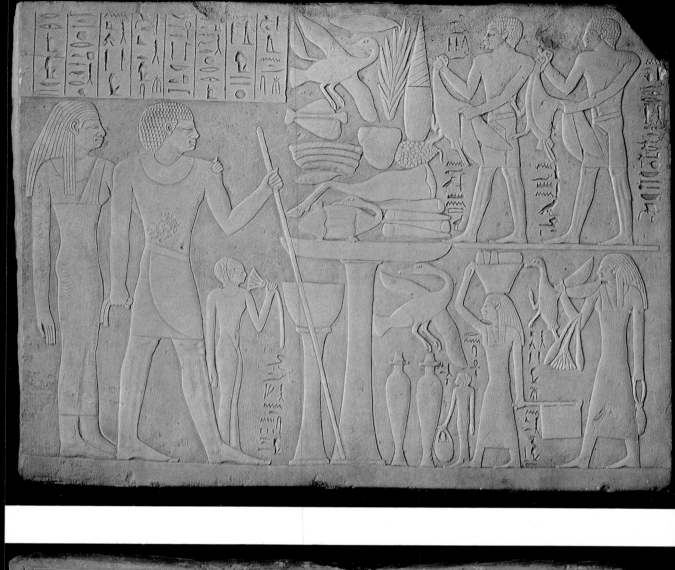
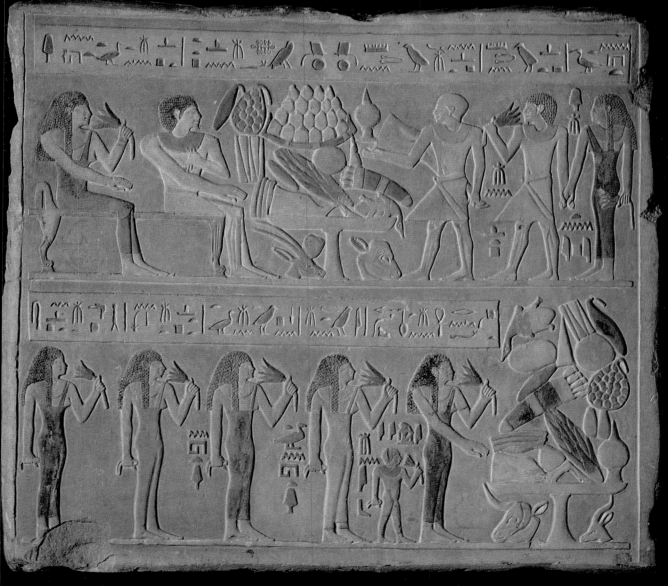

83

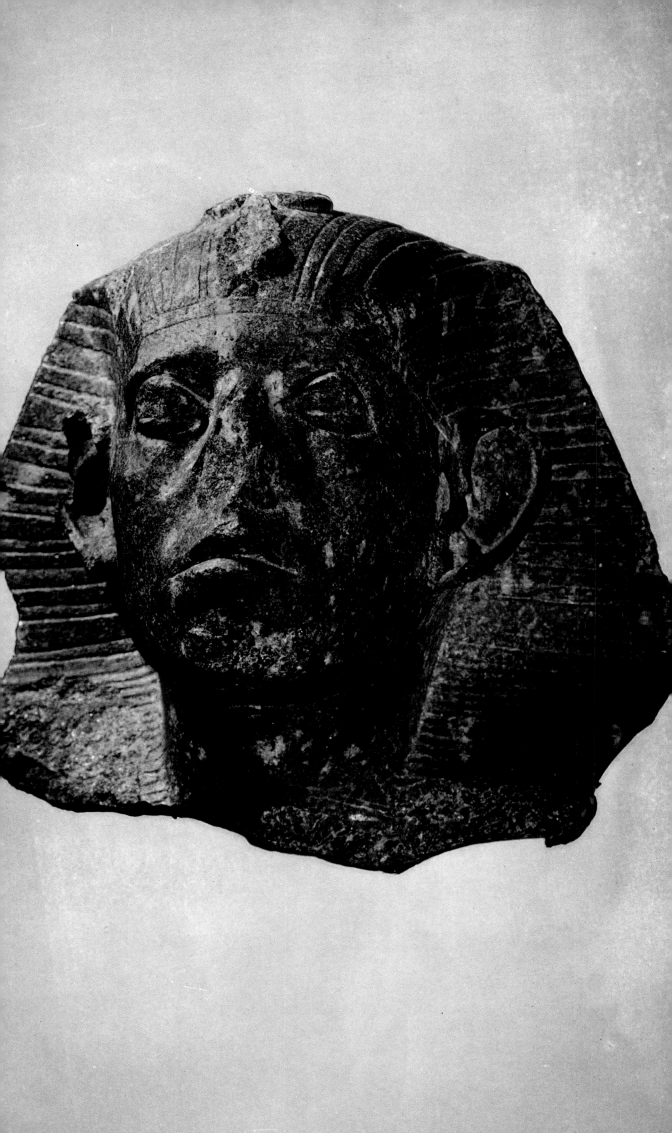

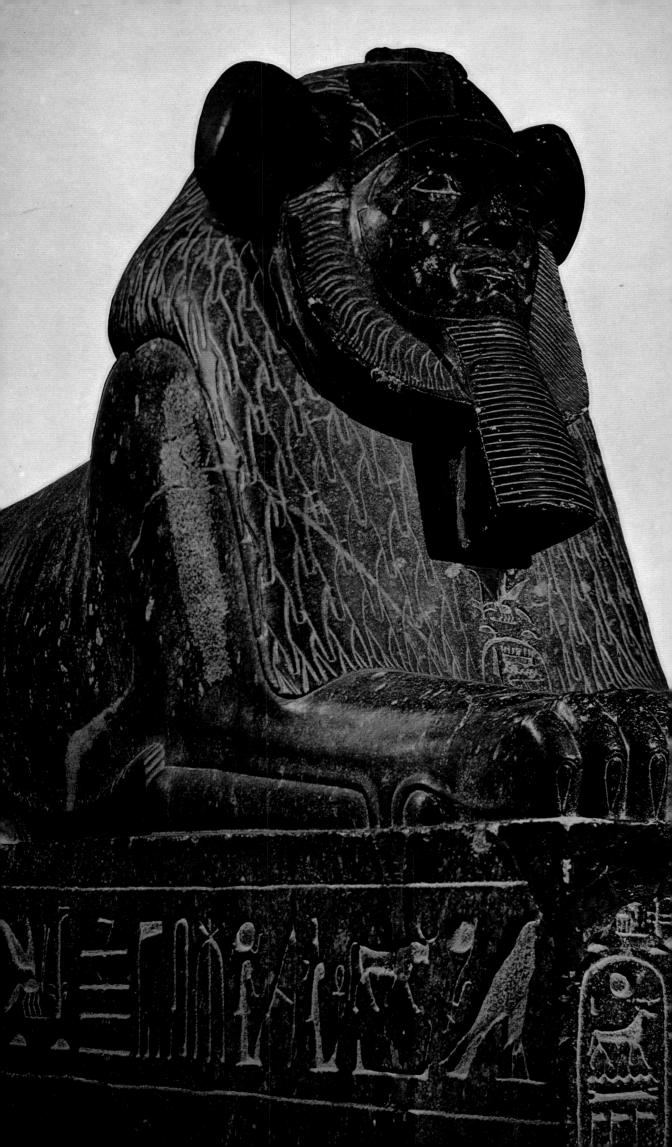

10. THE CLASSICAL ART OF THE NEW KINGDOM AND THE AMARNA EPISODE

Egypt's growing wealth

The "golden age" of painting

Discoveries at Deir el Bahari

Tendencies to classicism

Conservative and progressive artists

Brilliant innovations at Tell el Amarna

Return to tradition

The grandiose projects of the Ramessides

Egyptian love of nature

10. THE CLASSICAL ART OF THE NEW KINGDOM AND THE AMARNA EPISODE

UNDER the New Kingdom, Egypt not only achieved the peak of its political, military, economic, and cultural power, but a splendid flowering of art. In the course of five hundred years, three dynasties—XVIII through XX—erected more architectural and sculptural monuments than all other periods combined. Today there is hardly a site in Egypt or Nubia where New Kingdom remains do not predominate. The length of the Nile valley, up to the Second Cataract and even farther south, was decorated with temples, chapels, and rock-hewn steles.

Even if these other sources did not testify to the great power of the state, the many surviving works of art would be sufficient to prove the strength of the country's economy, its prowess on the battlefield, and the richness of its war spoils. The great granite statues and the immense reliefs carved into the walls of the temples served above all to glorify the ruler and the gods. But the large number of portraits of architects and scribes, the decorated tombs of craftsmen and stone masons, the funerary steles of "commoners" erected at Abydos—the center of the Osiris cult—far from their local burial places, all demonstrate that almost every social class benefited from the general prosperity. No doubt the slave labor of war prisoners had something to do with bettering the lot of ordinary Egyptians. These prisoners were employed in large numbers in the mines and on other public works, even in certain temples. The group least affected by improved living conditions was probably the peasantry.

Opportunities for social advancement were greater than before. This is not to say that the over-all hierarchy of social classes became in any sense

less fixed—such a change was out of the question—but the careers of the architects Senmut and Amenhotep, son of Hapu, are indeed remarkable. Senmut became a favorite of Queen Hatshepsut and educator of her children, while Amenhotep, son of Hapu, was granted permission to build a funerary temple for his own *ka*, or spirit—an unprecedented honor, tantamount to placing an ordinary mortal on the same footing as a king.

There was no branch of art that did not achieve both technical and aesthetic excellence in this period. Painting entered its "golden age." It became a fully independent branch of art, whereas earlier (except at Beni Hasan and in the tombs of Middle Kingdom nobles at Thebes) it had been confined almost exclusively to supplying colorful accents for reliefs and statuary.

Decorative art, which had a great tradition from both the Old and Middle Kingdoms, now reached new heights, as seen in the furnishings of Tut-ankh-amon's tomb (figs. 105–7, 464–85, 809, 811, 815). These include splendid chests and couches; exquisite alabaster vases with handles carved in the form of lotus buds; carved staffs decorated with figures of Africans and Asiatics; an ebony throne incrusted with gold, enamel, and semiprecious stones; the Pharaoh's anthropoid sarcophagus with his portrait modeled in gold; and jewelry, such as pectoral decorations (figs. 794, 796, 798), necklaces, and isolated pendants, gold scarabs, and amulets studded with precious stones. The fondness for luxury objects, born perhaps from warlike and commercial contact with Asiatic peoples, was not confined to the kings and nobles. Toilet articles of metal, stone, or wood have been found in the tombs of simple artisans; these objects are beautifully carved and constitute true works of art.

The elegance that characterizes these furnishings, toilet accessories, personal adornments, and dress is also found in sculpture and painting. The human figure is portrayed as more slender, light and graceful. Drawing and modeling reveal a clear preoccupation with beauty, along with a tendency to apply the canon of representation with greater freedom than before. The painter who decorated the tomb of Tuthmosis III's vizier Rekhmira boldly showed the figure of a maidservant from the back (fig. 93). This calls to mind a maxim of the vizier Ptahhotep: "Art has no limits; thus no artist achieves perfection." Although this was written during Dynasty V, the first phrase could well be applied to the New Kingdom period.

Most paintings dating from the New Kingdom come from tombs of Theban dignitaries at Gurneh, and from Deir el Medineh near Gurneh, the site of a necropolis of craftsmen and master builders responsible for the

mighty resting places of New Kingdom Pharaohs in the Valley of the Kings. Painting in this period develops in stages more or less parallel to developments in relief and statuary.

Down to the end of Tuthmosis III's reign, artists continued to model themselves on the masters of the Old and the Middle Kingdom. This is why we can, following A. Mekhitarian, describe their style as archaic, to the extent that it marks a return to the forms of a remote past. This is true, for instance, of a painting in the tomb of Menkheperra-seneb, high priest of Amon, that shows a procession of foreigners carrying tribute (figs. 403–6). The proportions are entirely in keeping with the old canon, but the theme— the representation of foreigners—is most frequent in the art of the New Kingdom. We come across foreigners at every step: presenting tribute, in rows of shackled prisoners humbled before the Pharaoh, and as defeated soldiers on the battlefield.

The greatest masterpieces of relief dating from the first Pharaohs of Dynasty XVIII are those in Queen Hatshepsut's temple at Deir el Bahari (figs. 92, 342–45, 347, 348) and in the temple of Tuthmosis III located in the same valley (figs. 90, 100, 349–54). In these reliefs both the composition and the rendering of the figures reveal a tendency to adhere to the classical canon. The reliefs in the temple of Tuthmosis III are especially valuable because the polychromy that emphasizes the detail has been perfectly preserved. Among the finest are the fragment of a boat with oarsmen, their bodies painted in a dark bronze color indicating their Nubian origin; the figure of the god Amon-Min; a fragment of a heap of offerings; and a portrait of the Pharaoh himself.

As for sculpture in the round, notable examples from this period include "cubiform" statues of Senmut (fig. 89), and one of the most splendid royal portraits, the statue of Tuthmosis III (fig. 91). The Pharaoh is seated on his throne in a hieratic attitude: hands on thighs, *klaft* on his head, the short official apron over his hips. On this statue clear traces of paint have also been preserved—yellow on the head cloth, blue on the beard.

This detail compels us to take another look at the coloring of great Egyptian sculpture. Hitherto polychromy has been discussed in connection with statues carved in soft stone, such as limestone. The effect of hard, highly polished stone such as black granite would suit most tastes today; but the ancient Egyptians' sense of beauty evidently led them to apply color even to the polished surfaces of hard stone. This discovery is not easy to accept, for it fundamentally alters our criteria for evaluating monumental Egyptian art. But we must do so, just as for several generations we have been resigned to the fact that Greek monuments also were painted in many colors. The romantic vision of pure white Greek marble has now gradually gone by the board.

U<small>NDER</small> Amenhotep II and Tuthmosis IV a new style came to the fore, at once attractive and graceful, which endows the entire art of the New Kingdom with a character of its own. One of the most representative works in this style is the famous scene in the tomb of a scribe named Nakht, showing girl musicians (fig. 94). Their bodies are visible through the folds of light garments. The harpist's slender fingers gracefully pluck at the strings. There is coquetry in the girls' almond-shaped eyes. The almost nude figure of the central musician is shown in *contraposto*, later used so effectively in Greek sculpture of the fifth century B.C. Here the weight of the body is supported by the left leg, while the right leg barely touches the ground with the toes. The weight of the arms is distributed inversely: the left arm is free, while the right arm bears the instrument (see Chart V, p. 569).

In the tomb of another scribe, named Menena, who was employed on a royal farm, some of the women's faces are so full of individual expression that they suggest portrait drawings (figs. 95, 96). Atop one woman's head is an unusual conical object (the musicians in the painting discussed above wear something similar). This was a lump of fat saturated with perfumes; as it melted, the entire body was gradually drenched in scent.

In the low reliefs of this period artists used a technical device that endows the figures with a graceful melancholy, a very different expression from the earlier engraved reliefs in the temples of Hatshepsut and Tuthmosis III. There the eyebrows and eyelids were sharply delineated; now the eye is modeled so softly that it hardly stands out from the rest of the relief (fig. 99). This device anticipates the *sfumato* of later Alexandrian sculptures in marble. The refined modeling of the eye survives in certain works of the following period, that of the last Pharaohs of Dynasty XVIII.

Under Amenhotep III, the greatest ruler of Dynasty XVIII, the art of the New Kingdom reached its peak. An already well-established tendency toward classicism found its full expression in both architecture and the plastic arts, "official" and "unofficial" alike. The conventions of official representation are harmoniously combined with refinement of draftsmanship and precise rendering of detail, as is seen in the very flat reliefs from the tomb of Ramose, vizier and governor of Thebes under Amenhotep III and Akhenaten (figs. 433, 434). For example, the dignitary is seated on his throne in the official hieratic attitude; at the same time, the modeling of the face is unusually sensitive and every detail is rendered very accurately, down to the individual tufts of hair (fig. 98).

In this period we can follow clearly a struggle between two tendencies in Egyptian art. The more conservative of these pays tribute to the old principles of symmetry and the clear definition of objects, and preserves the absolute legibility of the image. However, the other tendency, which was

certainly the more progressive in the period, strives for uniform composition while giving maximum expression to the subject. This is illustrated by a group of wailing women, on another wall of the tomb of Ramose, clad in transparent garments and gesticulating expressively. Noteworthy is the figure of a child without clothes (fig. 112). In the tomb of Huy, viceroy of Nubia, a contemporary of Tut-ankh-amon, the painting of Africans carrying gifts and leading a giraffe (fig. 114) is in keeping with the older convention, whereas the balding carpenter from the tomb of the sculptor Ipy owes a great deal to direct observation (figs. 118, 566–68).

W HENEVER, at a given moment of history, art attains new heights of expression, it is soon threatened by academism. It will become ossified and fall into conventionalism unless a new style, building on earlier artistic and technical achievements, creates new forms to express the new content. Despite the rigorous discipline imposed on the artists by its centuries-old canon, Egyptian art proved itself capable of truly revolutionary change, for it went on to create the highly original Amarna style. To break with the canon could not have been easy, for it was bound up with religious and Pharaonic tradition. The break was made possible by Akhenaten's heresy. This Pharaoh left Thebes, which was increasingly dominated by the priesthood of Amon, and chose for his new capital a site on the edge of the desert near today's village of Tell el Amarna. The art that grew up there stands out as a glorious episode, however brief, in the long history of ancient Egyptian art. When the king, in a newly erected temple, limited his worship to a single god—Aten (not to be confused with Atum)—he broke entirely with tradition. A poet himself, he strove to free art from the rules that had shackled it for so many centuries. He ordered his artists to represent faithfully what they saw: not to embellish his own features or to glorify his majesty. He wanted to be portrayed as he actually was. He did not limit his artists to official themes but permitted, even encouraged, them to portray him in scenes of everyday life, caressing his wife or playing with his children.

Despite the encouragement of the ruler himself, it was not easy for artists, accustomed to working in traditional patterns, to rise to the challenge. The exhortation to freedom, far from making their task easier, made it much harder. Such an experiment could only be a success to the degree that a body of trained and experienced artists already existed. There can be no doubt that Akhenaten took the most talented artists of the day to his new capital.

Within only a short time the Amarna artists turned out a large number of sculptural monuments in the new spirit. The Pharaoh was portrayed with all his mortal imperfections (figs. 101, 449). An egg-shaped skull, a

long, almost horsy jaw, a thin neck, limp arms, a prominent belly—such was the image they produced of this indisputably brilliant man who singlehandedly broke through the thousand-year-old crust of custom, courageously opposing the priesthood and other bastions of tradition. The greatest masterpieces at Amarna are the low reliefs and paintings that represent intimate scenes of court life: the king and the queen on their throne surrounded by the little princesses (fig. 440); one of their little daughters eating roast duck (fig. 439); two princesses sitting stark naked on pillows in their room (fig. 102).

Among Akhenaten's entourage at Amarna were his two younger brothers. The older of the two, Semenkhkara, seems to have been chosen as successor to the throne. The other, the child Tut-ankh-amon, then called Tut-ankh-aten, was the especial favorite of the king's wife, the beautiful Nofretete. It seems that in the last years of Akhenaten's reign all did not go smoothly at the Amarna court. Possibly the philosopher-king, more and more absorbed in mystical meditation, became slightly mad; perhaps there were other causes. At all events, Nofretete moved to another palace situated in the northern part of the city—this much is reasonably certain from archaeological evidence—taking along little Tut-ankh-amon and her four youngest daughters. Could it be that the queen had begun to doubt her husband's religious and political innovations?

Rather than pursue conjectures, let us grasp what the art works of Amarna have to tell. One relief, for instance, shows Semenkhkara, the king's brother, with his wife, who holds up a bunch of flowers for him (fig. 104). Both he and his beloved have all the anatomical defects of Akhenaten: egg-shaped heads, elongated jaws, and pendulous bellies. Undoubtedly there was a family likeness, but the real reason for this becomes apparent when one looks at other sculptures of the period, such as a relief of servants carrying gifts or offerings; they too have egg-shaped heads. The artists were so strongly attached to the idea of having a canon that, once they had created a naturalistic image of the ruler, they proceeded to endow all figures with his physical traits. In other words, they created another canon reflecting the kind of mannerism into which Amarna art had fallen. Even in modern times persons living or working around a royal court tend to imitate the ruler's way of dressing, his manners, pastimes, and often his way of moving and speaking. But to portray everyone in the image of the ruler is altogether different, and can be explained only by the Egyptian artist's ingrained habit of representing the human figure in accordance with a canon.

What had begun as a healthy tendency to turn away from tradition in favor of realistic treatment thus degenerated quickly into mannerism. The Amarna style came to an end with the death of Akhenaten, and all his successors resumed the traditions of the past. Semenkhkara reigned for

less than three years, possibly as Akhenaten's co-regent, and we know little about him; but the furniture and paintings in Tut-ankh-amon's tomb bear unmistakable witness to the revival of the power of Amon's priests at Thebes. Egyptian art returned to the old forms and the traditional canon.

Certain stylistic innovations of the Amarna artists survived, however. The way artists later treated drapery—softly, fluidly—was derived from Amarna naturalism. We find this not only in the works executed for Tut-ankh-amon but also in the art of his successors. One of the last works executed in the Amarna workshops is the famous head of Queen Nofretete, discovered in 1912 (fig. 103). It must have been a study for the queen's portrait in hard stone. It represents a woman past her youth, with a long slender neck, wearing a crown possibly intended to conceal the egg-shaped head obligatory in the Amarna style. The unusually subtle modeling of the face, however, and the conspicuous absence of a prominent jaw, seem to suggest that artists were willing to compromise here at least, so as to emphasize the regularity of the queen's beautiful features.

D URING the reign of the general Horemheb, last king of Dynasty XVIII, artists adhered strictly to the rules of the old canon. Once again the king is represented offering sacrifices to the gods and leading processions (fig. 115). It is only in details of treatment that these traditional subjects reveal the influence of Amarna art. The impression of movement is more delicately conveyed than before; there is greater elegance of posture; the rendering of all details is more refined. As the figures perform the rituals, their hands seem barely to touch the objects they are holding. Gestures are somewhat affected, theatrical. The "normal" way, introduced by Amarna artists, of representing the toes (showing the outer side of the foot) becomes more and more frequent.

Thus we can say that Egyptian art now embarked upon a species of academism, within an over-all classical style. This academism is expressed in some fine works dating from the reign of Sety I (Dynasty XIX). Among these are reliefs in the temple at Abydos (figs. 117, 510–15), some of which show the king offering a sacrifice to Isis or Osiris. But the obligatory scenes of ritual involving ruler and gods now diverge greatly from Old Kingdom patterns. At first the Pharaohs had conversed with the godhead as with an equal; in the Middle Kingdom period the king had been in front of the god, in representations of the ritual race or dance; now Sety can be seen kneeling before Isis and somewhat later Ramesses II takes an even more submissive posture in the presence of the god (fig. 537).

The granite statue of Sety I on his throne, upon which Ramesses II later superimposed his own cartouche, represents the king wearing a light, almost

transparent garment, and his face with a slightly aquiline nose has refined, somewhat Semitic features (fig. 41). He is not the only Pharaoh of the New Kingdom whose portrait has a softness and gentleness that set it apart fundamentally from the large, rough-hewn heads of Old Kingdom Pharaohs. The earlier and the later ruling classes could almost belong to different races: the portraits of Chephren and Mycerinus are faces of Egyptian fellaheen, while the kings and princes of the New Kingdom are more sophisticated, more refined. Undoubtedly intermarriage between the royal families of Egypt and other Near Eastern countries (the Hittite and Mitannian empires) had created a physical type which, by New Kingdom times, was distinct from that of the native population.

Under the Ramessides, art developed on two levels. Some works maintain the same high quality of technical execution and the same subtlety of draftsmanship as earlier ones; but at the same time they reveal a pronounced tendency to decorativeness for its own sake. Among such works are the wall paintings from the tomb of Ramesses II's wife, Nofretari, in the Valley of the Queens (figs. 119, 559–65). Most works of this period also exhibit the defects of mass production. The Ramessides, especially Ramesses II and Ramesses III, built so many temples that there were not enough first-rate artists to go around. Too many buildings, sculptures, and paintings were turned out, and too hastily.

The mind reels to envisage the number of sculptors and painters required to provide the artistic decorations for the tombs in the Valley of the Kings and for the monumental temples erected all along the Nile. These works, however, are much inferior to such relatively smaller undertakings as the tomb of Queen Nofretari, and even to the comparably large-scale bas reliefs in Dynasty XVIII temples, those built by Hatshepsut and Tuthmosis III, for example. No doubt, in making such comparisons we must take into account the different materials available in different times and places. Tombs cut out of rock necessarily had rough walls, and although these were often plastered over to make a smooth surface, uniform results could not be achieved on every wall inside the colossal tombs. As for the buildings of the Ramesside period, sandstone was the most available material, and it does not lend itself to an accurate rendering of detail.

Often the motif itself dictated a simplification of forms. In this period temple walls were given over to every sort of military theme. The enormous temple of Karnak, the Ramesseum, and the temples at Abydos and Abu Simbel record battle scene after battle scene. Among these, one motif dominates: the battle of Kadesh, fought by Ramesses II, and celebrated in a poem by Pentawur (figs. 551, 552). It shows the oversized figure of

the Pharaoh in a battle chariot drawn by plumed horses, trampling the enemy. A similar format was applied in the reliefs of the great temple of Ramesses III at Medinet Habu (fig. 122). In a hunting scene there is powerful realism in the agony of the bulls pierced by arrows, despite its somewhat formal decadence (fig. 553).

Although there was a marked decline in the quality of Ramesside art, it is unfair to indict the artists' taste. By adapting their artistic conceptions to fit large-scale decorations, artists found they had to neglect certain details and forego a certain precision of draftsmanship. In the case of temple walls, their task was to obtain the most decorative effects possible, achieved by a skillful use of light and shadow. And so the relief is cut even deeper; the composition of each scene is meant to be perceived as a whole. The meticulously rendered detail in Old Kingdom reliefs and in the tombs of Dynasty XVIII dignitaries has no place on these vast surfaces: it would divert the viewer's attention and weaken the over-all effect. It must be remembered that the primary function of this art was to glorify the exploits of the ruler.

That the artists had not lost their skills or taste is apparent from the so-called ostraca, drawings and paintings on fragments of limestone; the most important of these were found in the craftsmen's settlement at Deir el Medineh. These sketches, or studies, are distinguished by the impeccable observation of movement, particularly animal movement. Some of the ostracon scenes suggest illustrations to books of Egyptian fables and tales—true pictorial anecdotes (figs. 753–63).

This picture of New Kingdom art would not be complete without a mention of the role played by nature. That the Egyptians loved trees, plants, and flowers, that they knew how to animate a landscape with figures of animals, birds, and fish, was already clear in Old Kingdom bas reliefs, especially the scenes of hunting and fishing amid papyrus thickets. But in the New Kingdom, when artists had greater freedom to choose themes for tomb decoration (the tombs of private individuals especially), one finds masterly observations of nature in work after work: people dining out of doors, amid flowers and greenery, or cats prowling through the underbrush. In no other Near Eastern art does landscape play so great a role as it does in that of Egypt. No other ancient art created quite the "botanical garden" found at Karnak in reliefs dating from the reign of Tuthmosis III (figs. 355–62). In portraying the beauties of the natural world, the Egyptians had no equals.

89. BLOCK-STATUE OF SENMUT
 One of the most famous works from the
 reign of Hatshepsut, the architect Senmut
 is represented with the queen's daughter,
 Nefrure. Granite; height 36 3/8".
 Dynasty XVIII. State Museums, Berlin.

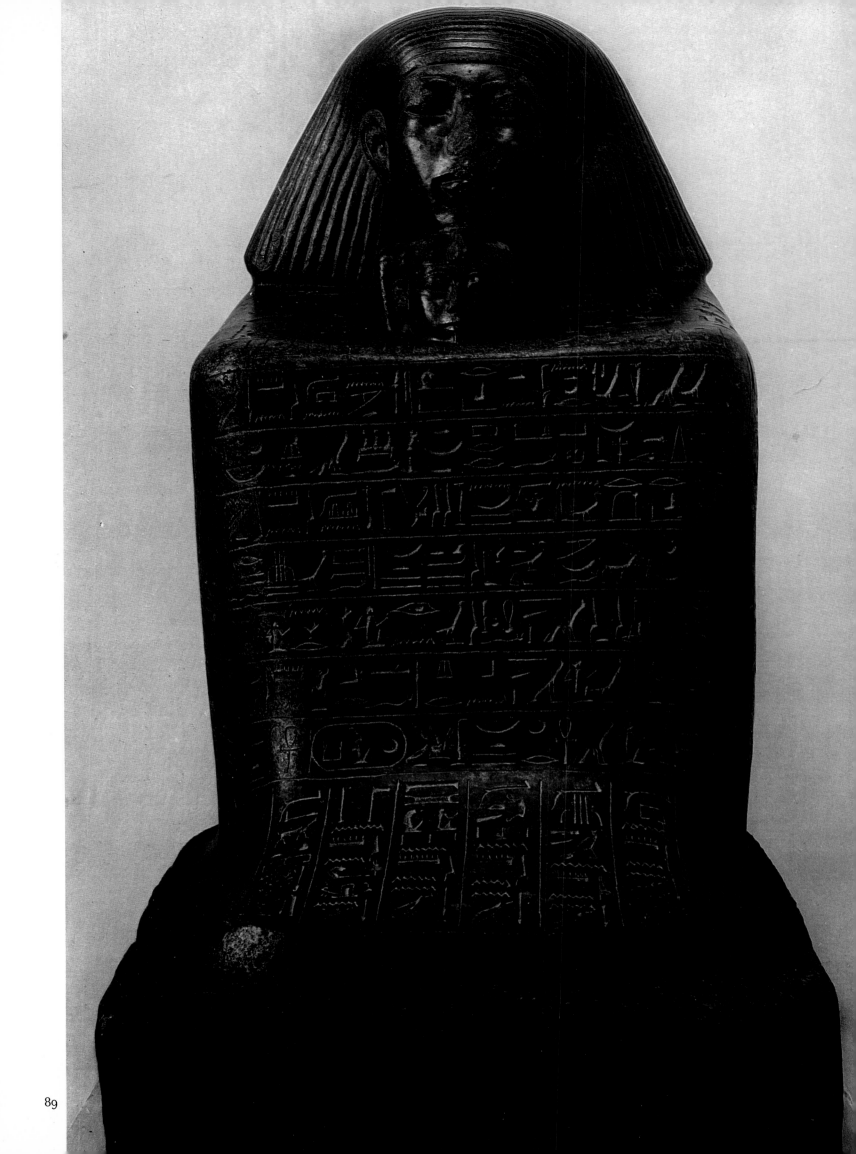

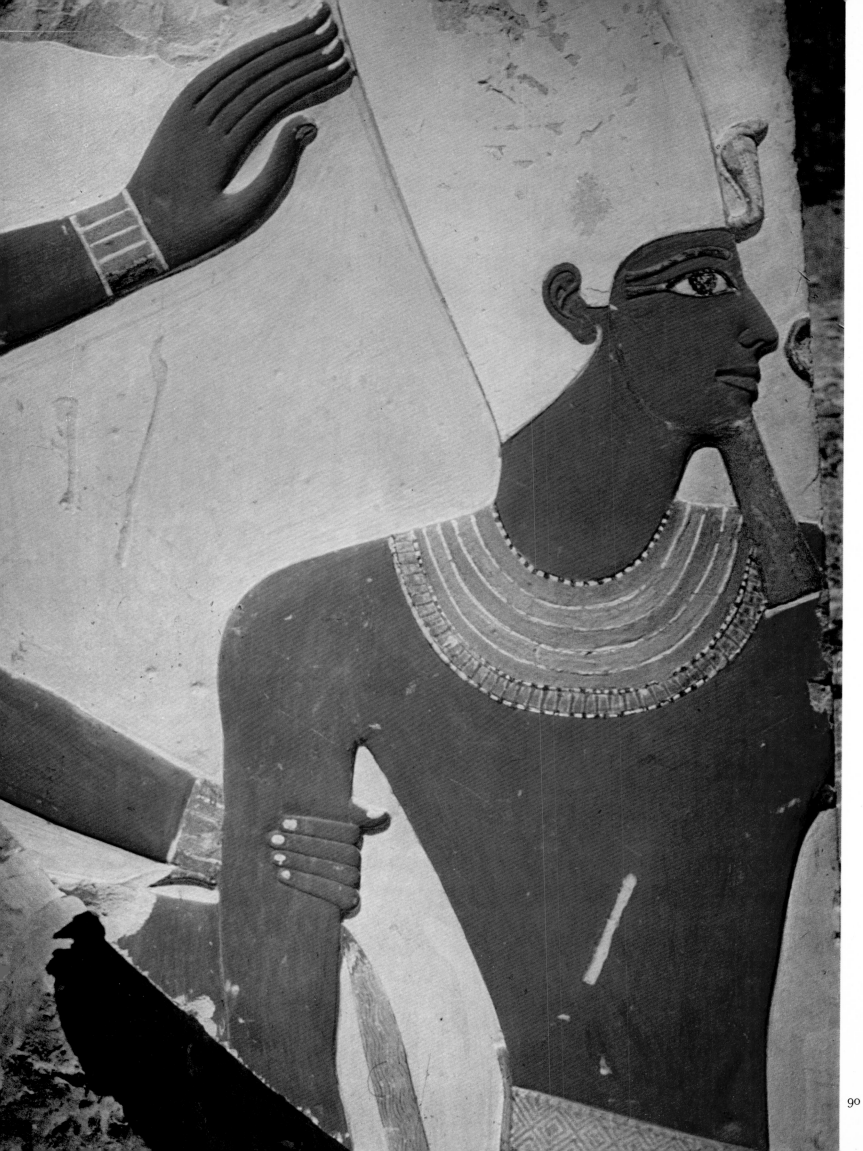

90. TUTHMOSIS III

Fragment of a coronation scene. The relief was discovered in 1964–65 by the Polish mission in the ruins of the temple of Tuthmosis III, Deir el Bahari. Painted limestone relief; height 29 1/2" (see figs. 349–54). Dynasty XVIII.

91. TUTHMOSIS III
Portion of a statue discovered in 1964–65 by the Polish mission in the ruins of the temple of Tuthmosis III, Deir el Bahari. Dark gray granite, traces of polychrome; total height c. 6'. Dynasty XVIII.

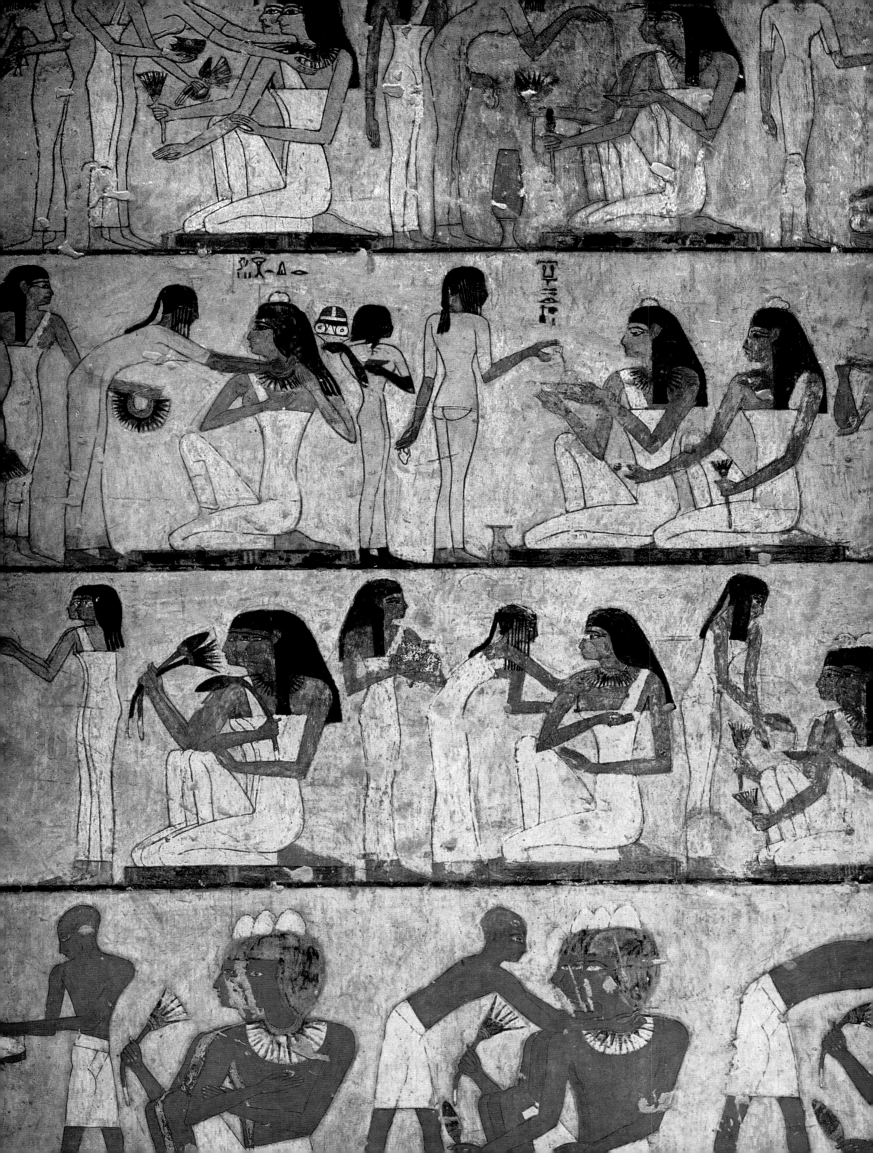

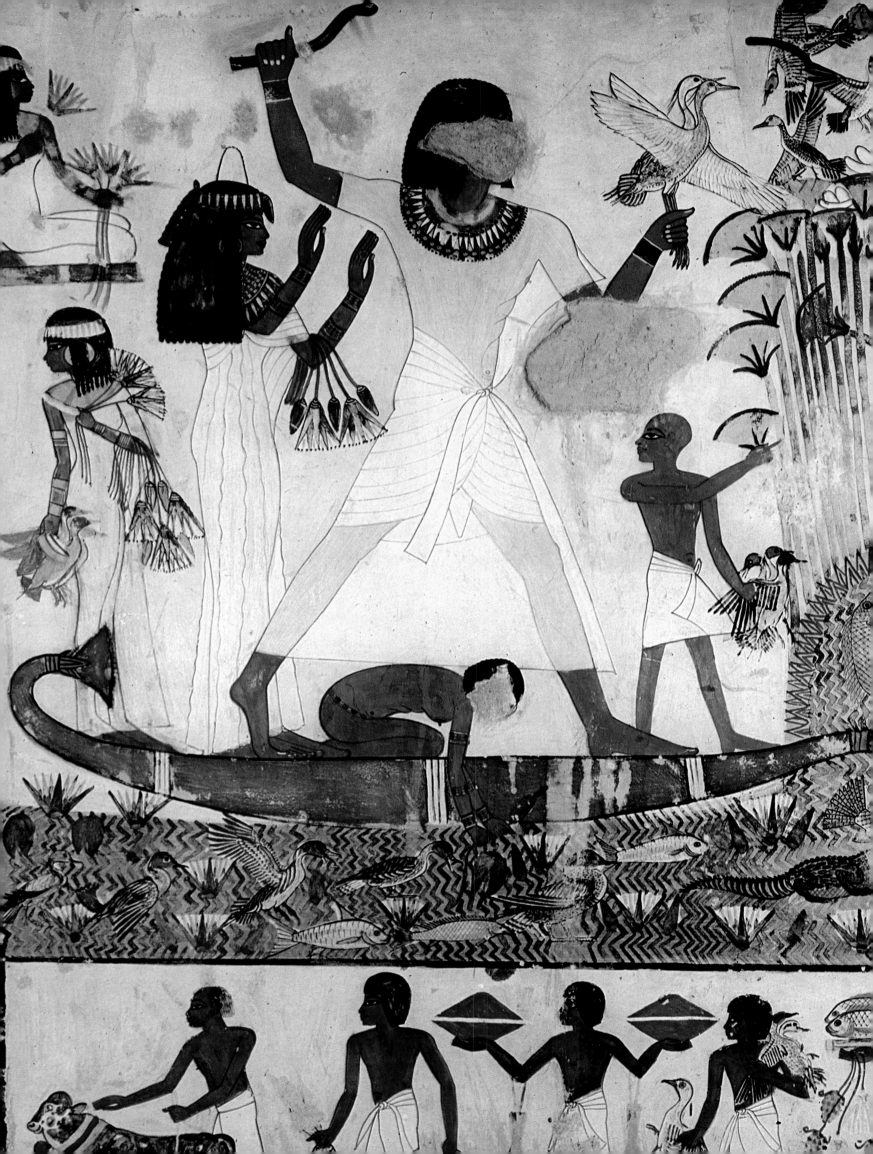

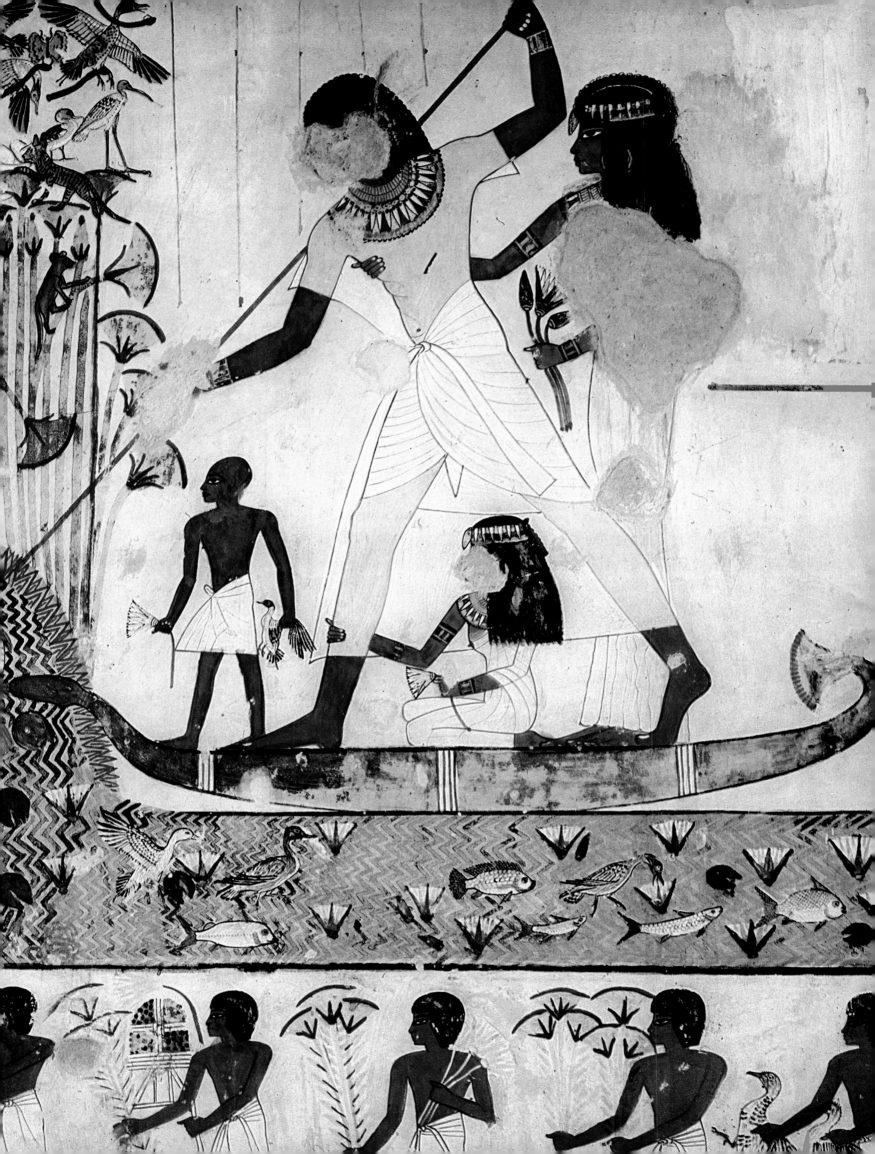

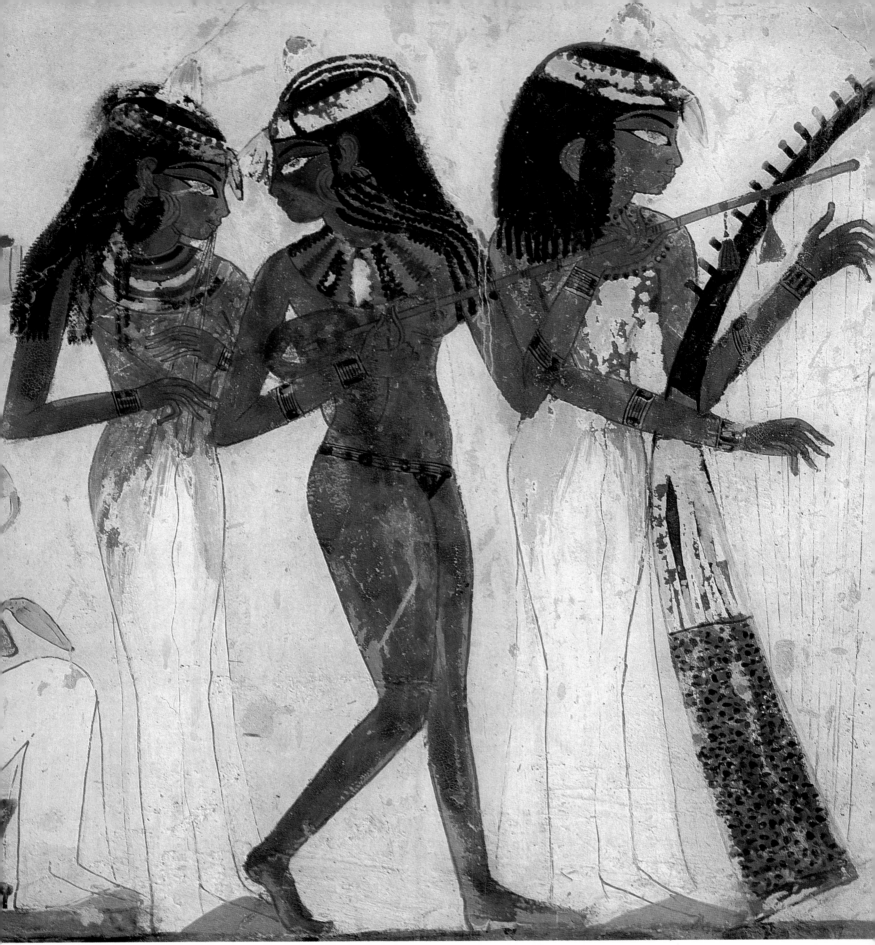

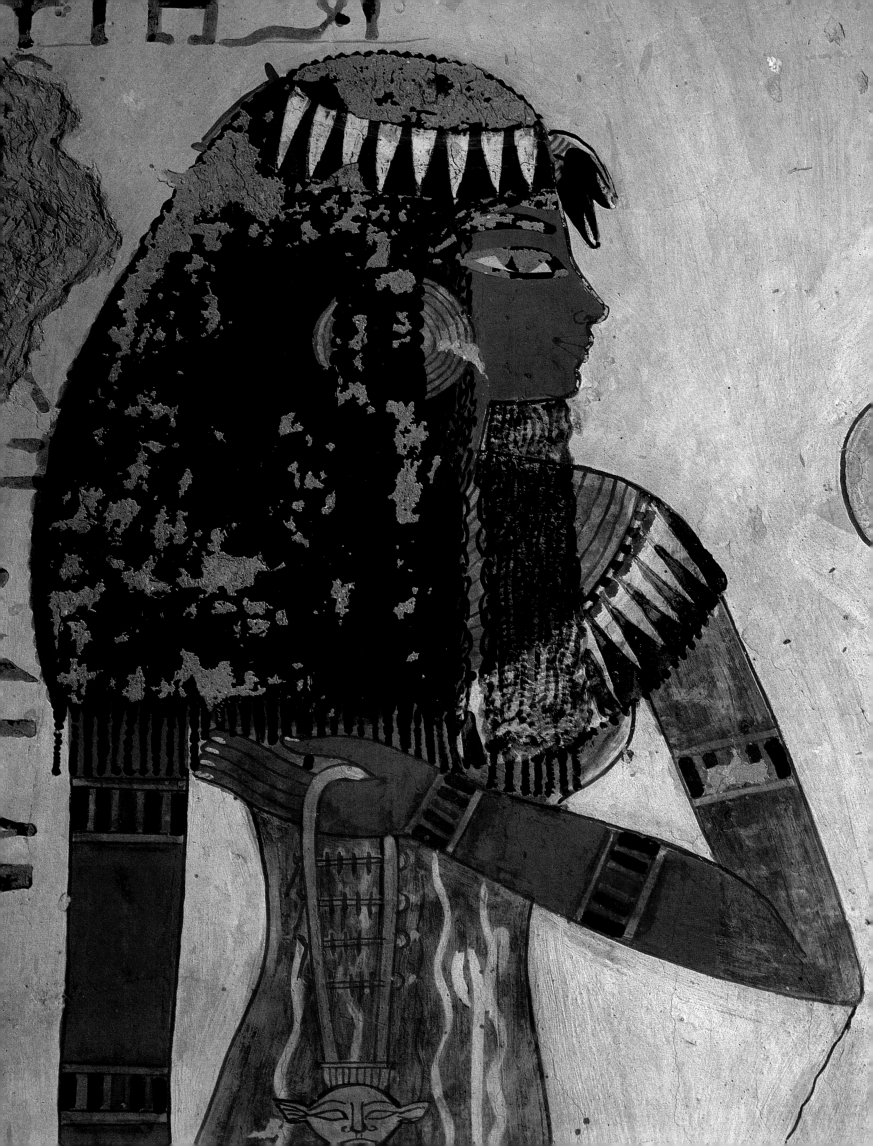

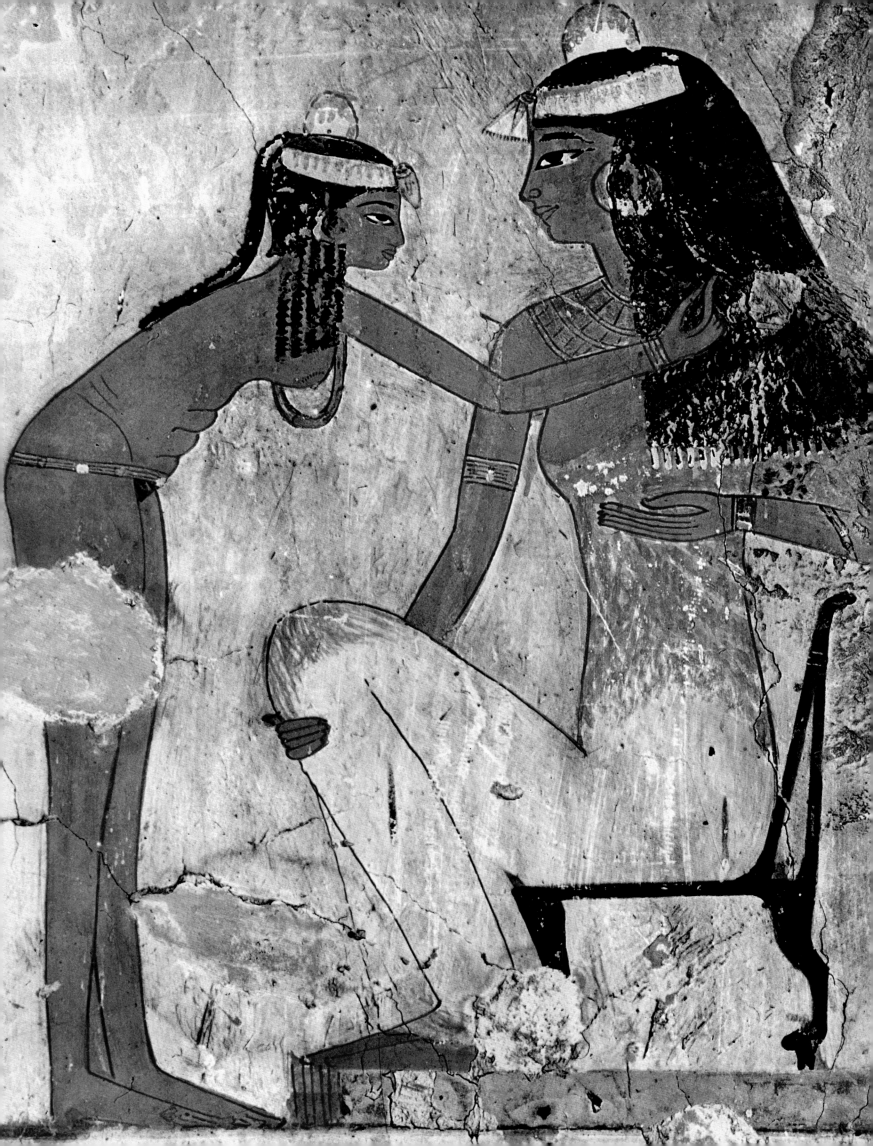

92. THE QUEEN OF PUNT
*Painted relief from the temple of
Hatshepsut, Deir el Bahari. This detail
is from the famous Punt Portico, decorated
with reliefs describing the expedition sent
by Hatshepsut to Punt (see fig. 348).
Dynasty XVIII. Egyptian Museum, Cairo.*

93. THEBES. TOMB OF REKHMIRA
*Funerary Banquet. The representation of
the back of the servant girl marks a break
with the traditional canon and demonstrates
the artistic freedom of this period. Wall
painting (portion; see figs. 394–401).
Dynasty XVIII.*

94. THEBES. TOMB OF MENENA
*Hunting and Fishing in the Marshes.
Menena's face was probably obliterated by
a personal enemy. Wall painting (detail;
see figs. 427–32). Dynasty XVIII (reign
of Tuthmosis IV).*

95. THEBES. TOMB OF NAKHT
*Musicians. In this group from a funerary
banquet scene, one girl plays a harp,
another a lute, the third a double flute.
Wall painting (detail; see fig. 415).
Dynasty XVIII (reign of Tuthmosis IV).*

96. THEBES. TOMB OF MENENA
*Portrait of an Elegant Lady. The
fashionable lady wears an elaborate wig
wreathed with lotus blossoms, enormous
earrings, and a necklace. In her left hand
she holds a sistrum. Wall painting
(detail; see figs. 424–29). Dynasty XVIII
(reign of Tuthmosis IV).*

97. THEBES. TOMB OF DJESERKARESENEB
*Guest and Servant Girl. Wall painting
(detail; see figs. 416–20). Dynasty XVIII
(reign of Tuthmosis IV).*

98. THEBES. TOMB OF RAMOSE
Mai and His Wife Urel, Members of the
Family of the Vizier Ramose. One of the
best examples of the refined style that was
immediately succeeded by the Amarna
period. Limestone relief (detail; see
figs. 433, 434). Dynasty XVIII (end of
reign of Amenhotep III).

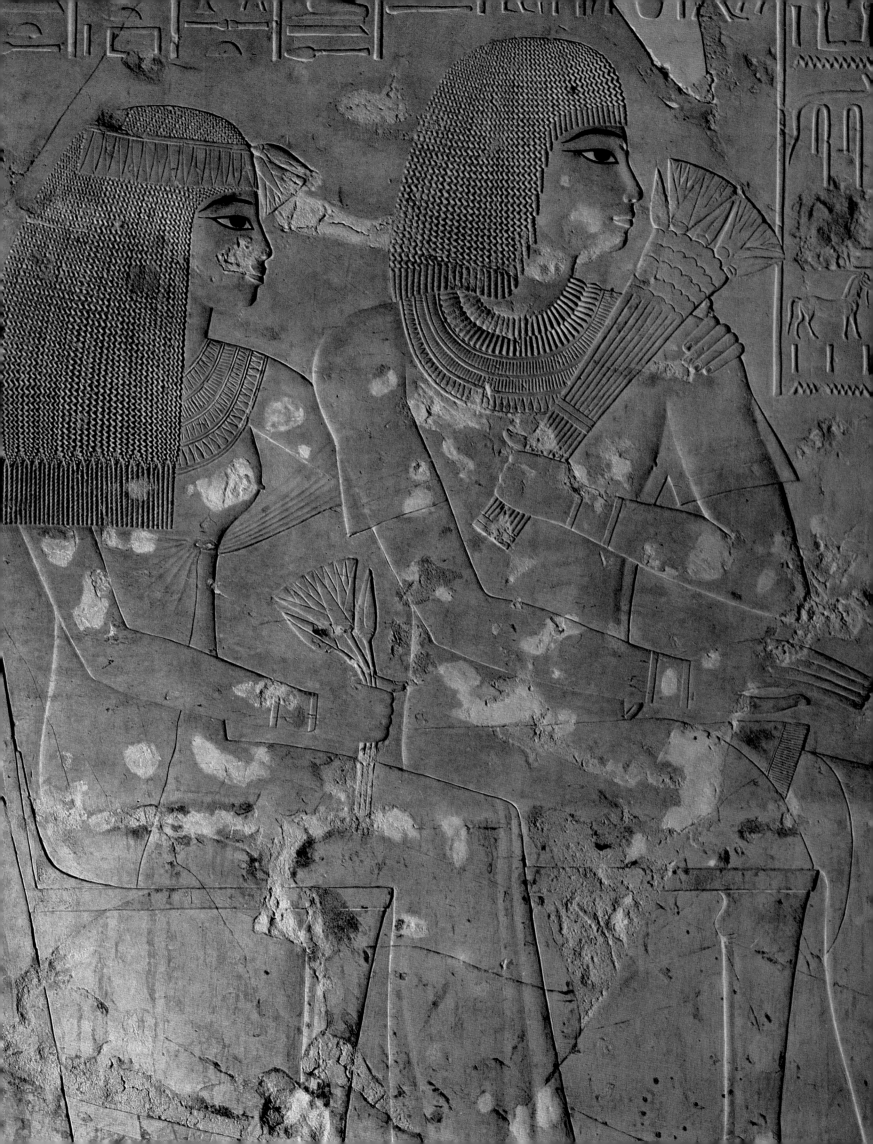

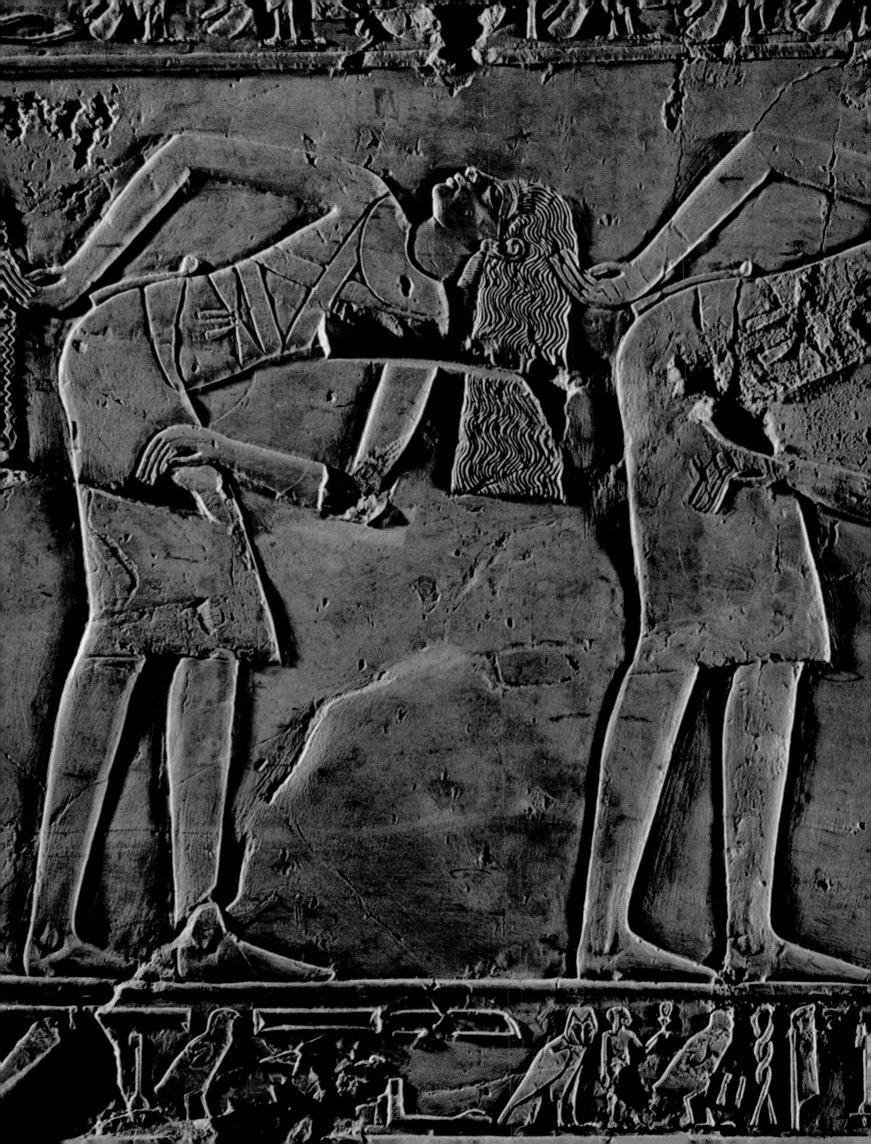

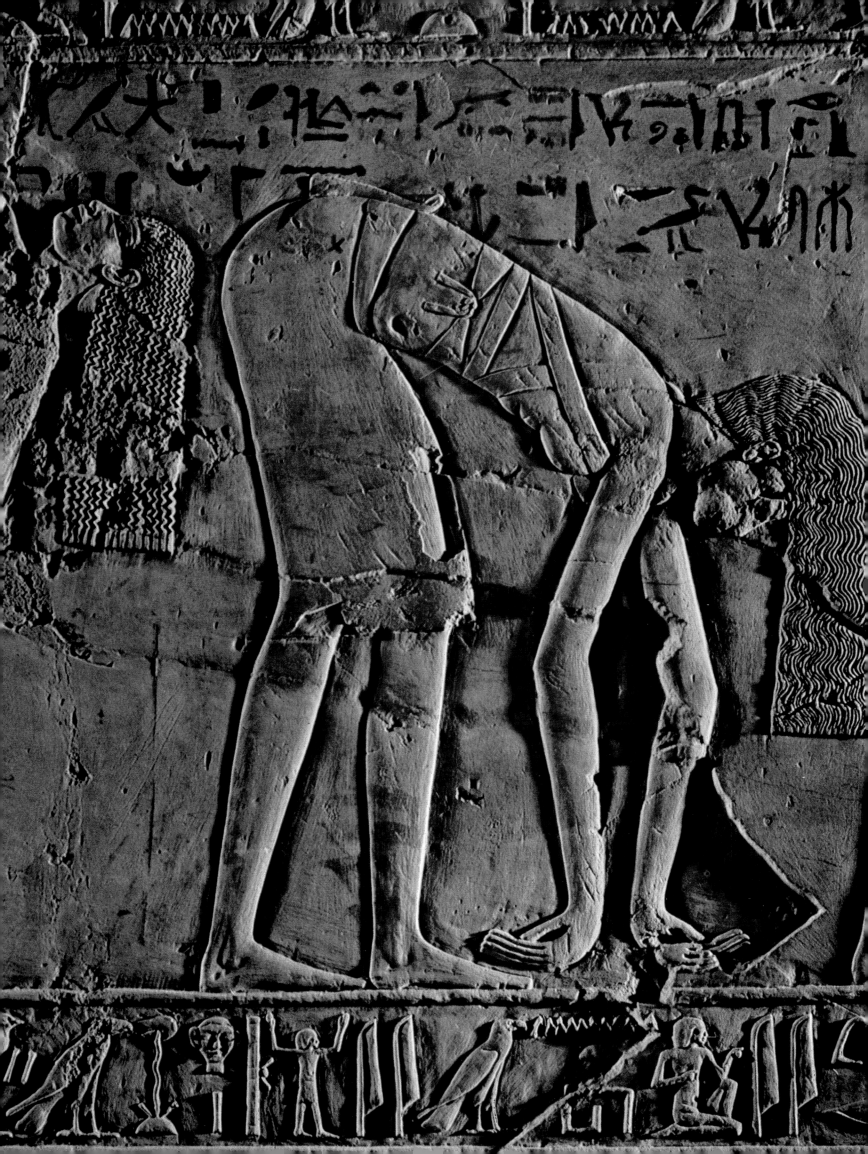

Preceding pages

99. THEBES. TOMB OF KHERUEF
 Acrobatic Dancers Performing a Ritual
 Dance. Limestone relief (detail; see
 figs. 435, 436). Dynasty XVIII (end of
 reign of Amenhotep III).

Opposite page

100. TUTHMOSIS III AND THE GOD AMON
 The face of Amon was mutilated during
 the Amarna heresy. Found in the ruins of
 the temple of Tuthmosis III, Deir el
 Bahari, by the Polish mission in 1964-65.
 Painted limestone relief, fragment;
 height 14 5/8". Dynasty XVIII.

245

101. AKHENATEN
*Head of a colossal statue from the
destroyed Aten temple built by
Amenhotep IV (Akhenaten) at Karnak,
east of the great Amon temple; found
with about 20 others near the columns of
the peristyle. In this statue we find all
the characteristics of Amarna mannerism.
Yellow sandstone; height of fragment
60 1/4" (see figs. 447, 449, 450).
Dynasty XVIII. Egyptian Museum,
Cairo.*

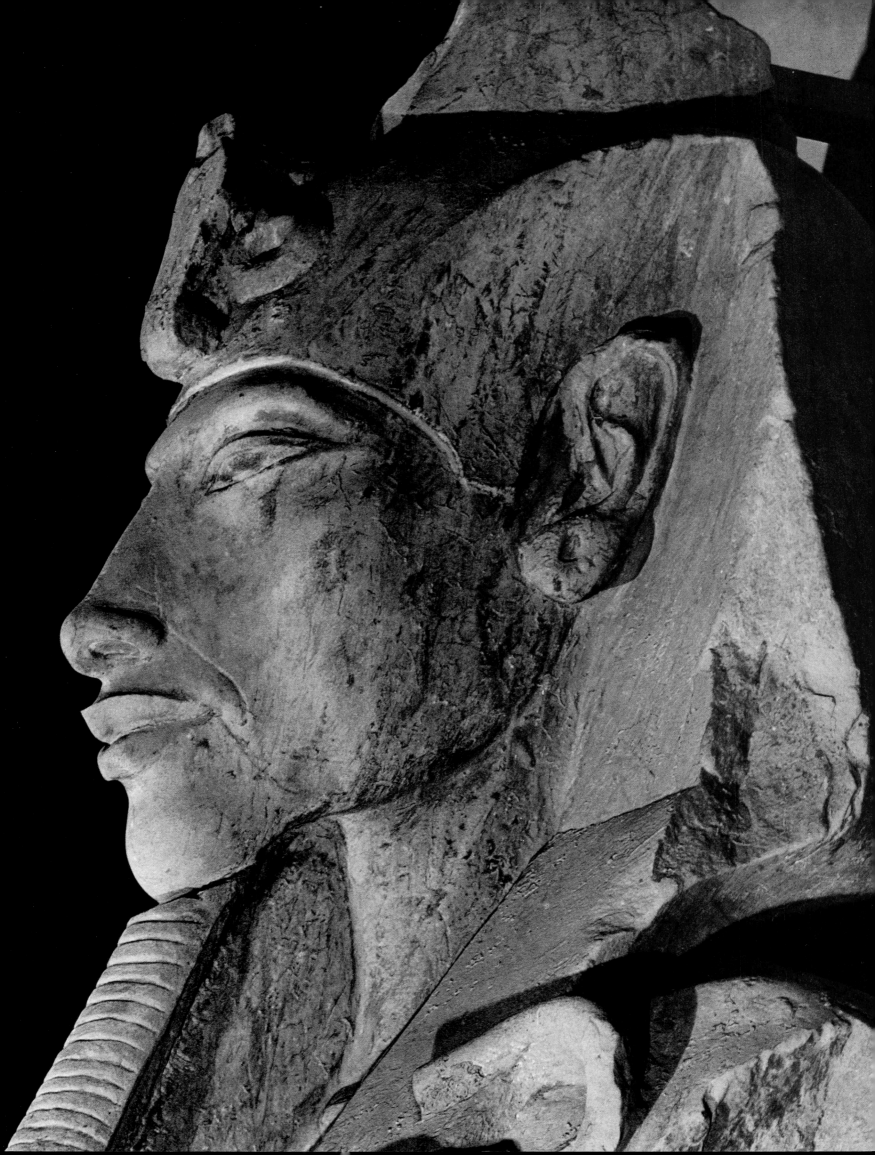

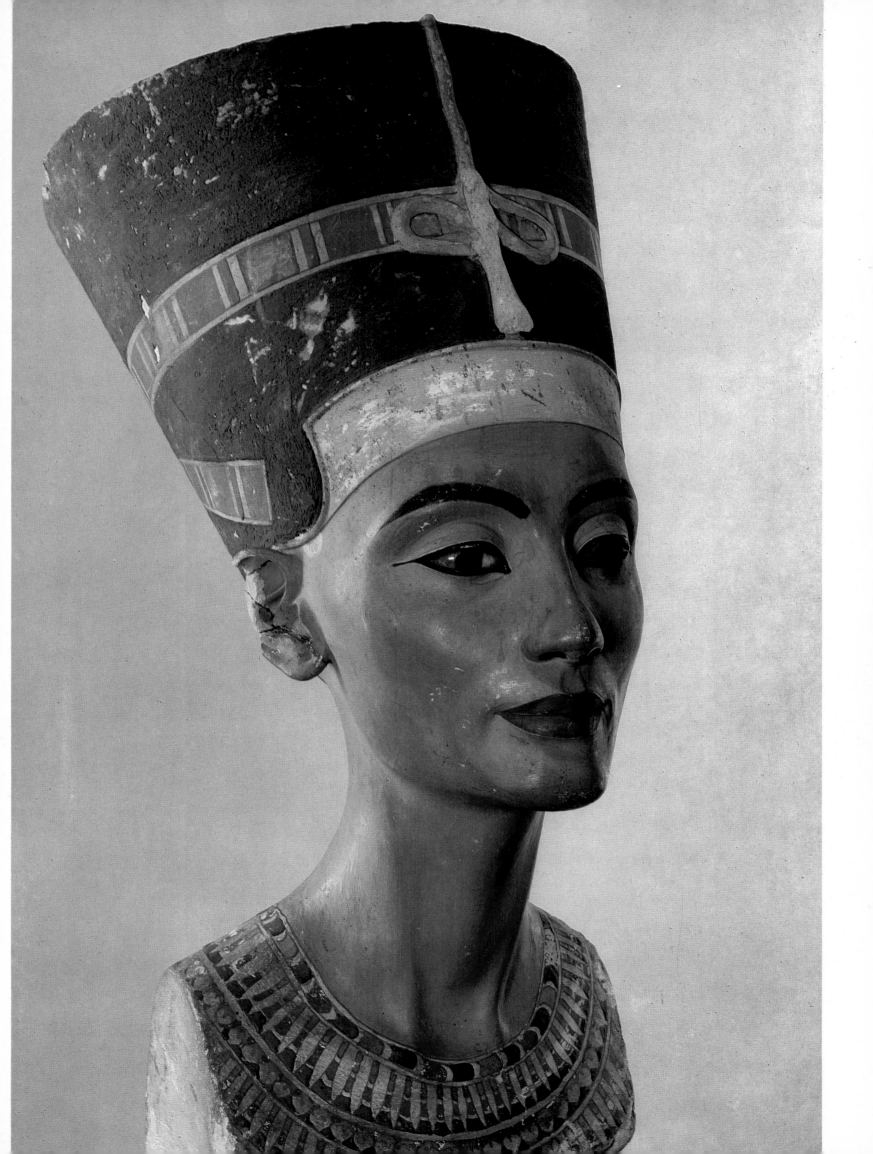

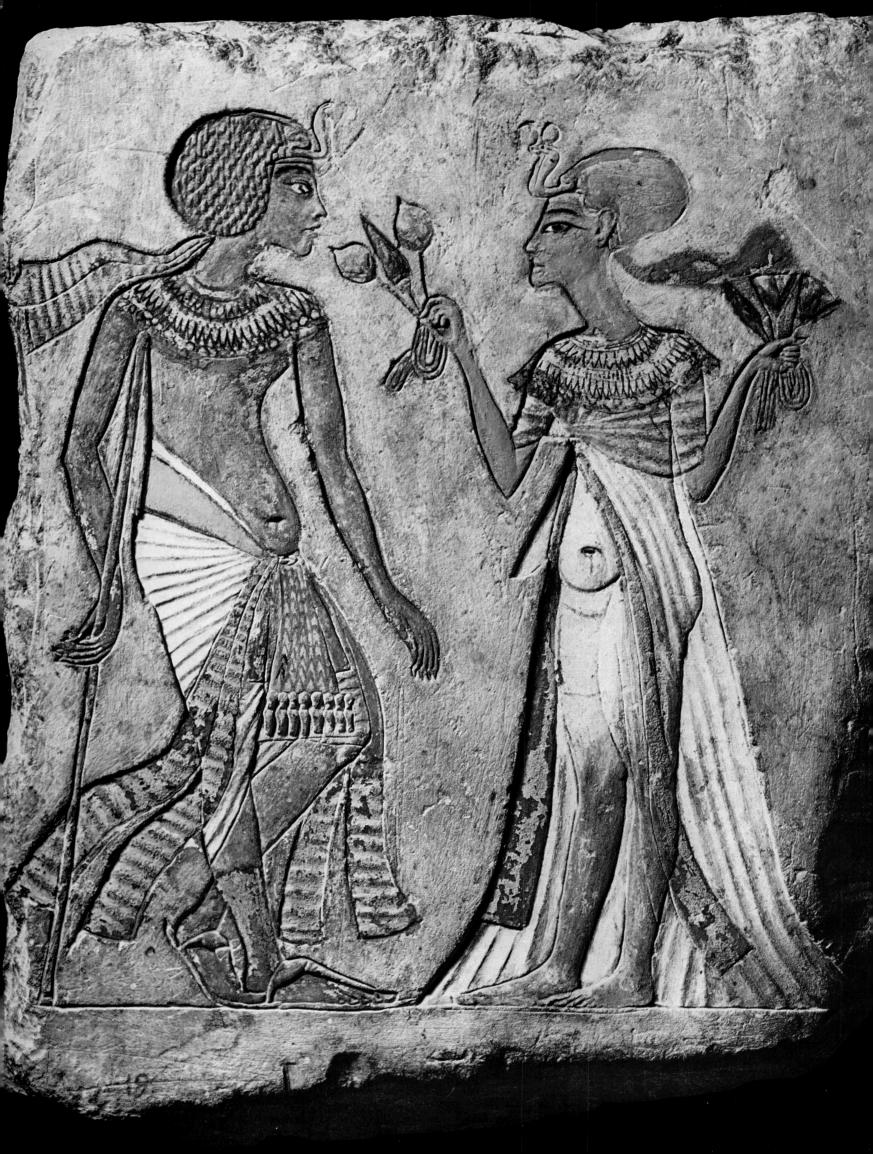

105. BED OF TUT-ANKH-AMON
 Detail from one of the three beds found
 in his tomb at Thebes. Wood, covered
 with gilded plaster; total length 6' 2"
 (see fig. 811). Dynasty XVIII. Egyptian
 Museum, Cairo.

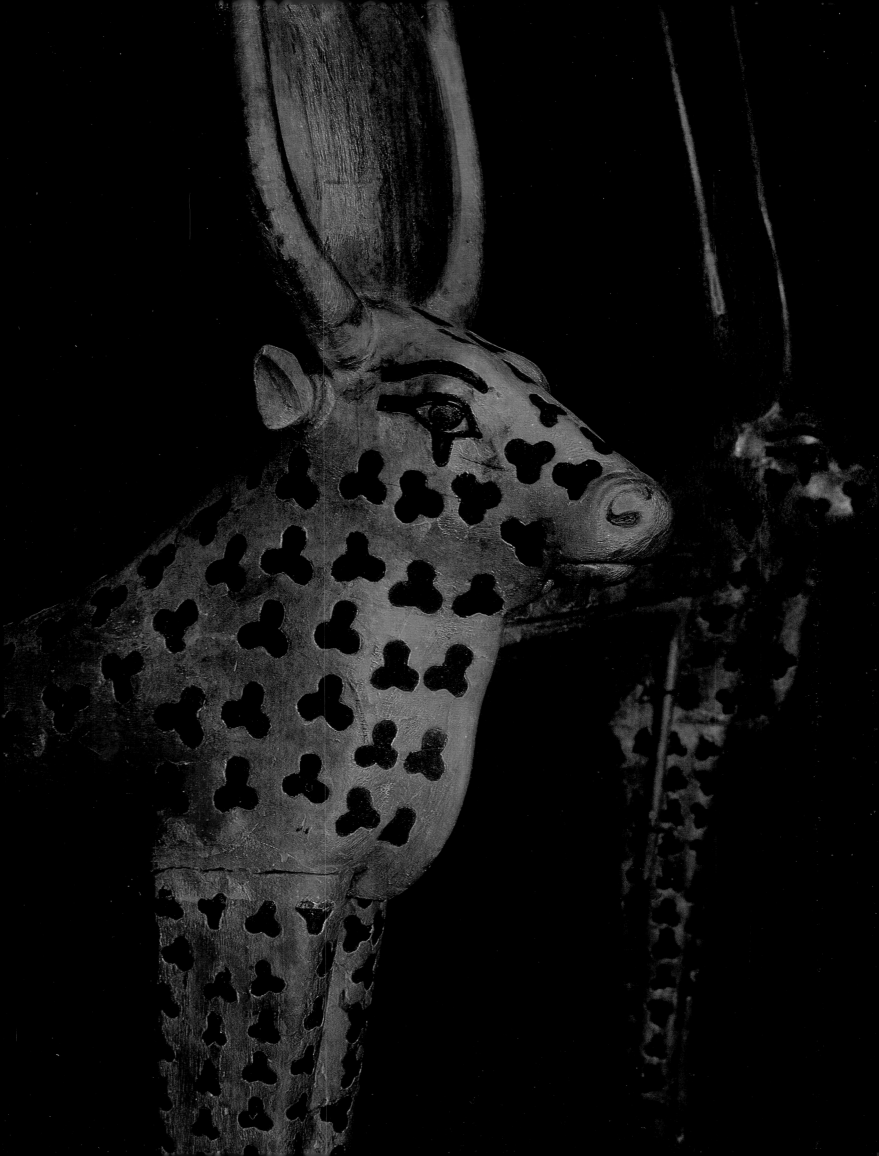

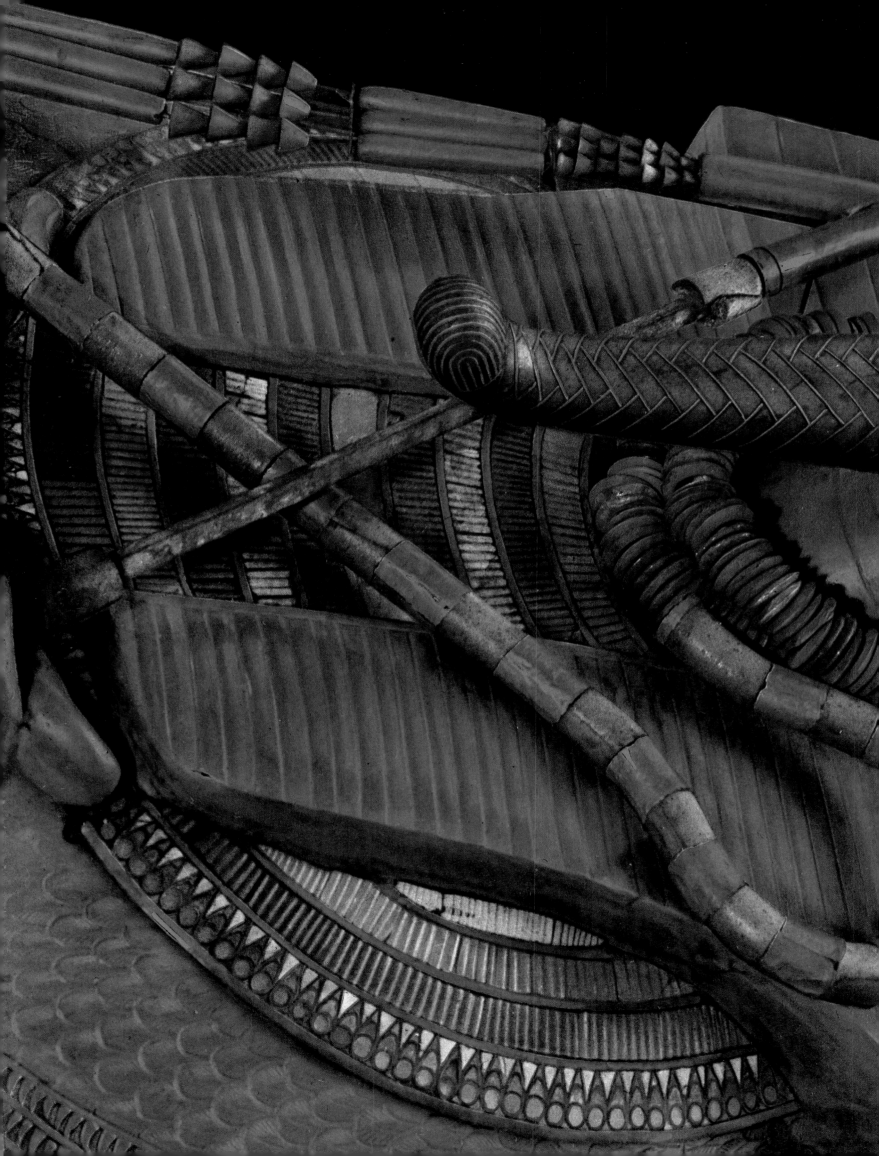

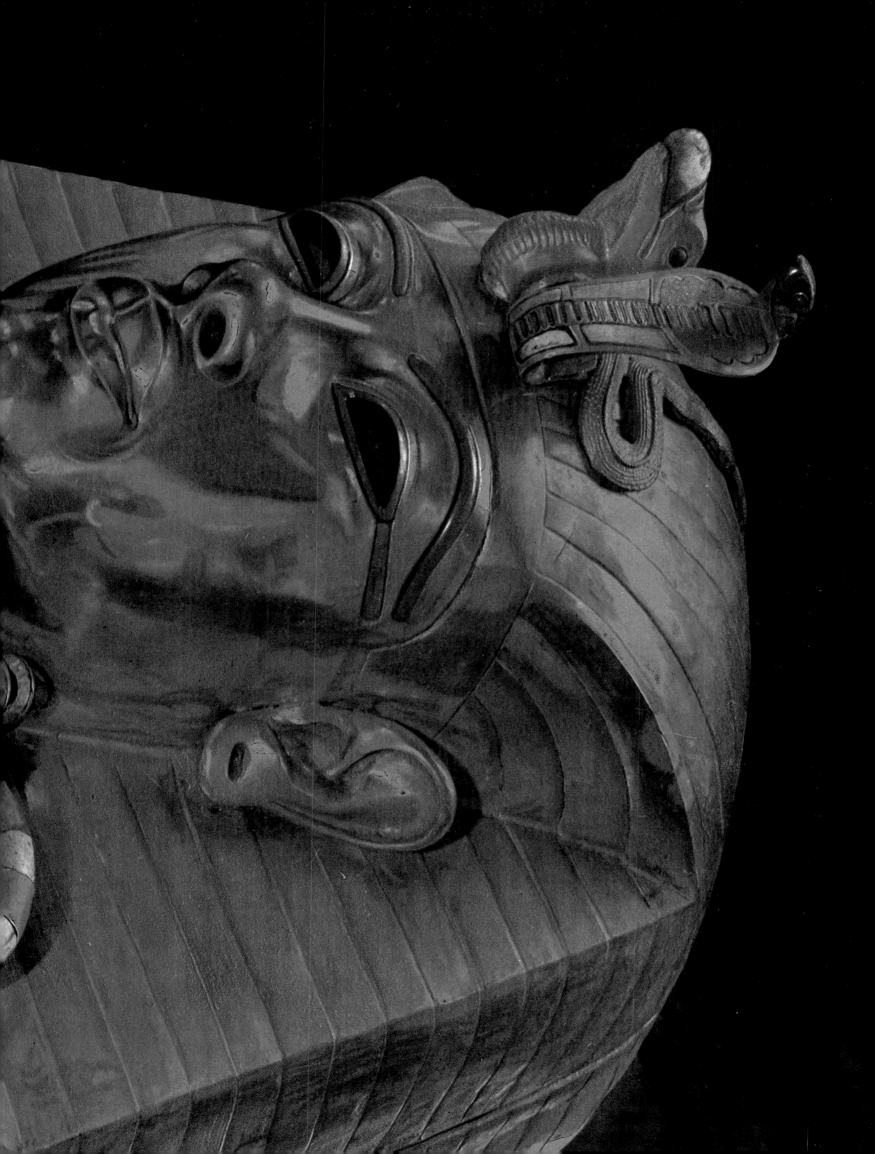

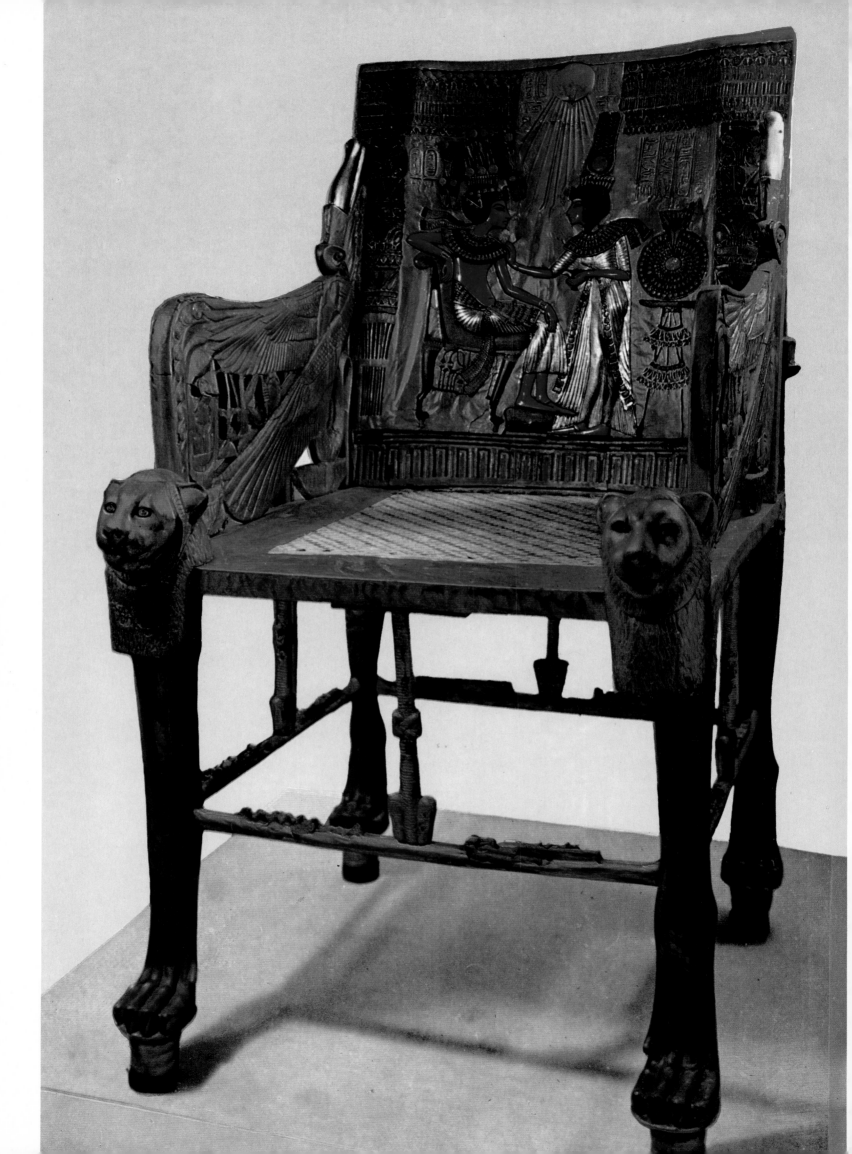

Preceding pages

106. INNER COFFIN OF TUT-ANKH-AMON
*The king, represented as Osiris, holds a
scepter and the* nekhekhw *whip; the
insignia on his forehead are a serpent
and a vulture. Solid gold with
incrustations of faience, glass paste, and
semiprecious stones; total length 6' 1"
(see fig. 476). Dynasty XVIII. Egyptian
Museum, Cairo.*

Opposite page

107. ROYAL THRONE OF TUT-ANKH-AMON
*At the top of the panel of the chair is the
solar disk, symbol of the god Aten.
Wood, covered with gold leaf,
incrustations of faience, glass paste,
semiprecious stones, and silver; height 41".
Dynasty XVIII. Egyptian Museum,
Cairo.*

108. THEBES. TOMB OF HUY
Lance Bearers. Wall painting (detail).
Dynasty XVIII.

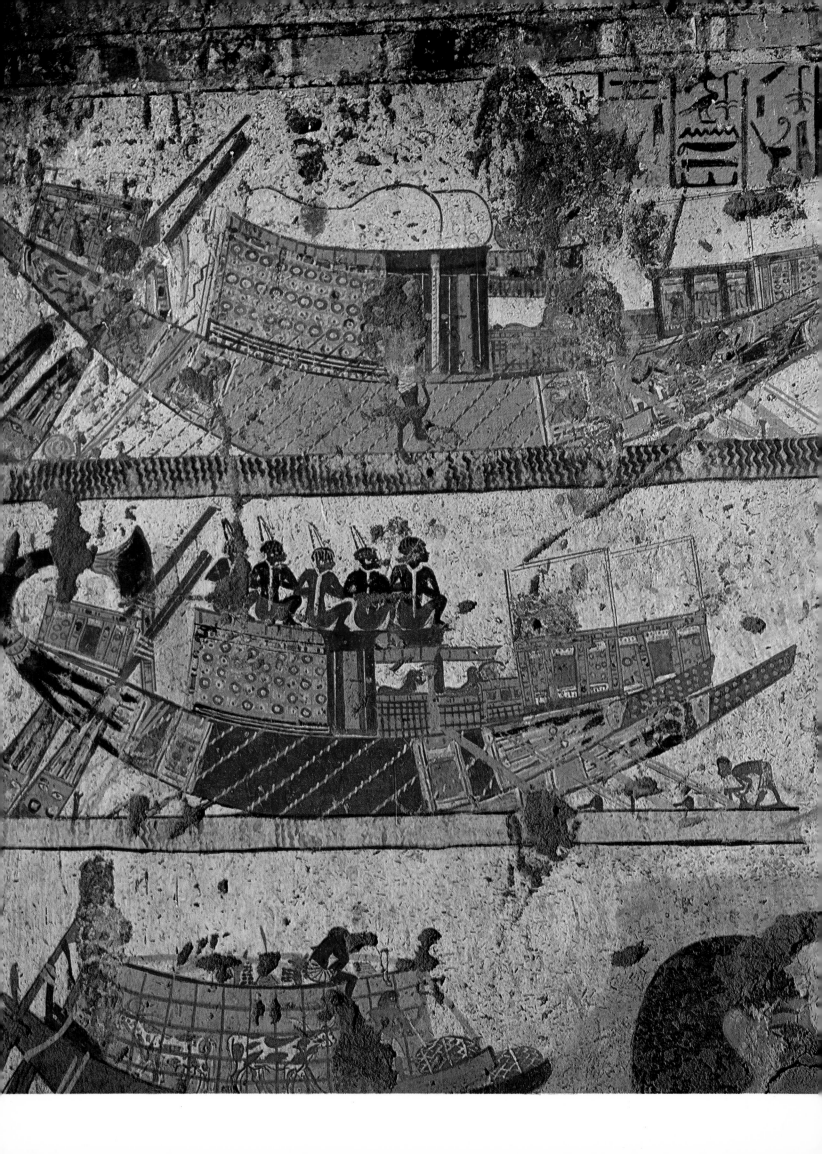

109

110

111

112

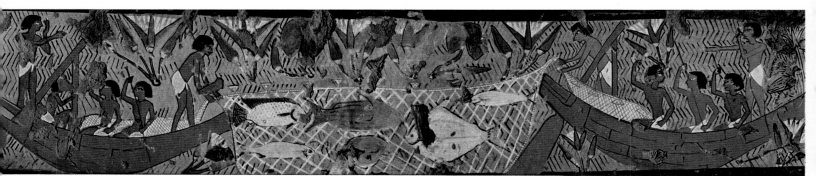

113

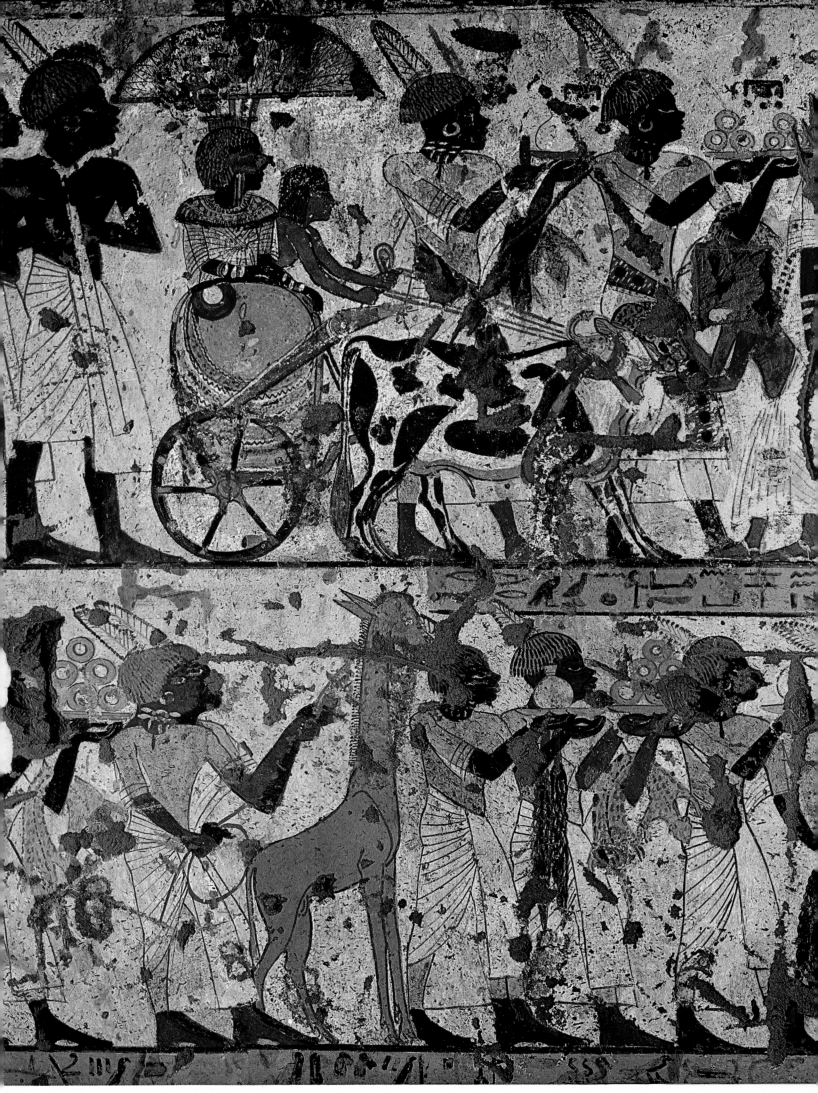

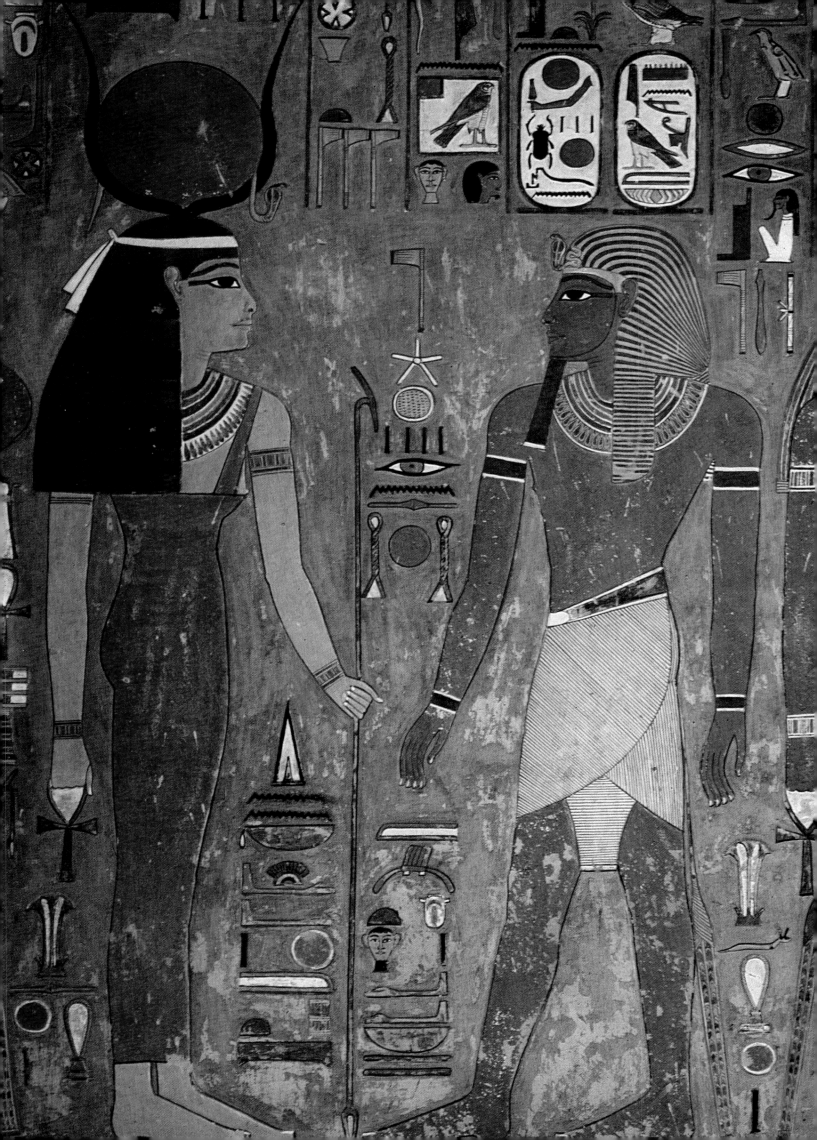

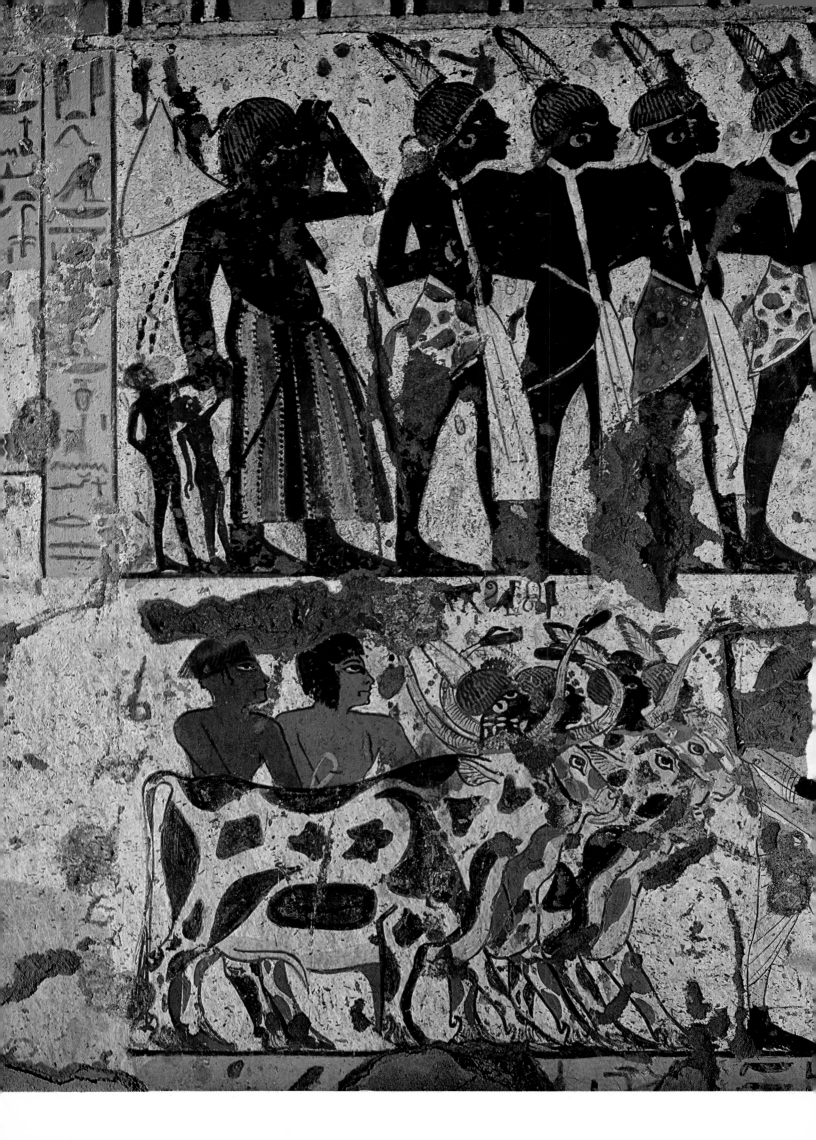

116. THEBES. TOMB OF SETY I
The Heavenly Cow. An astronomical representation. Painted relief (detail; see figs. 502–8). Dynasty XIX.

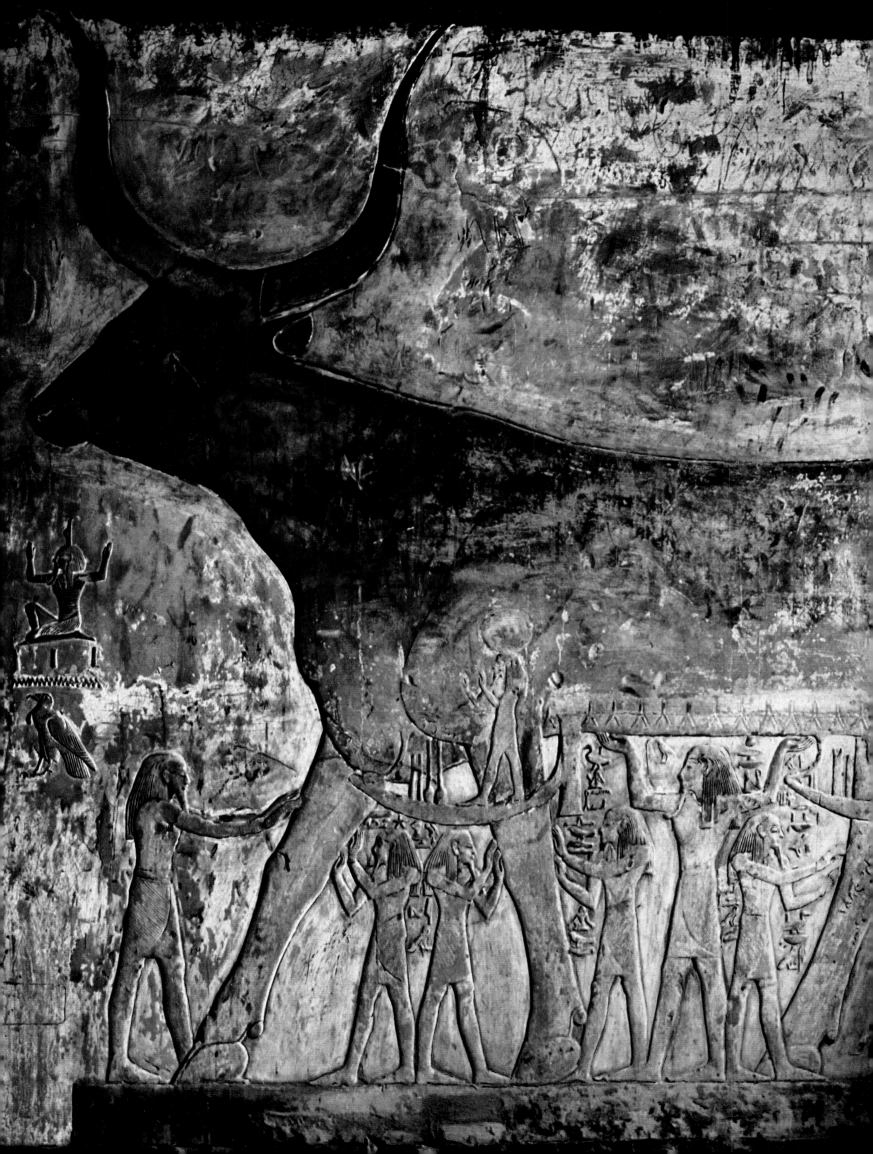

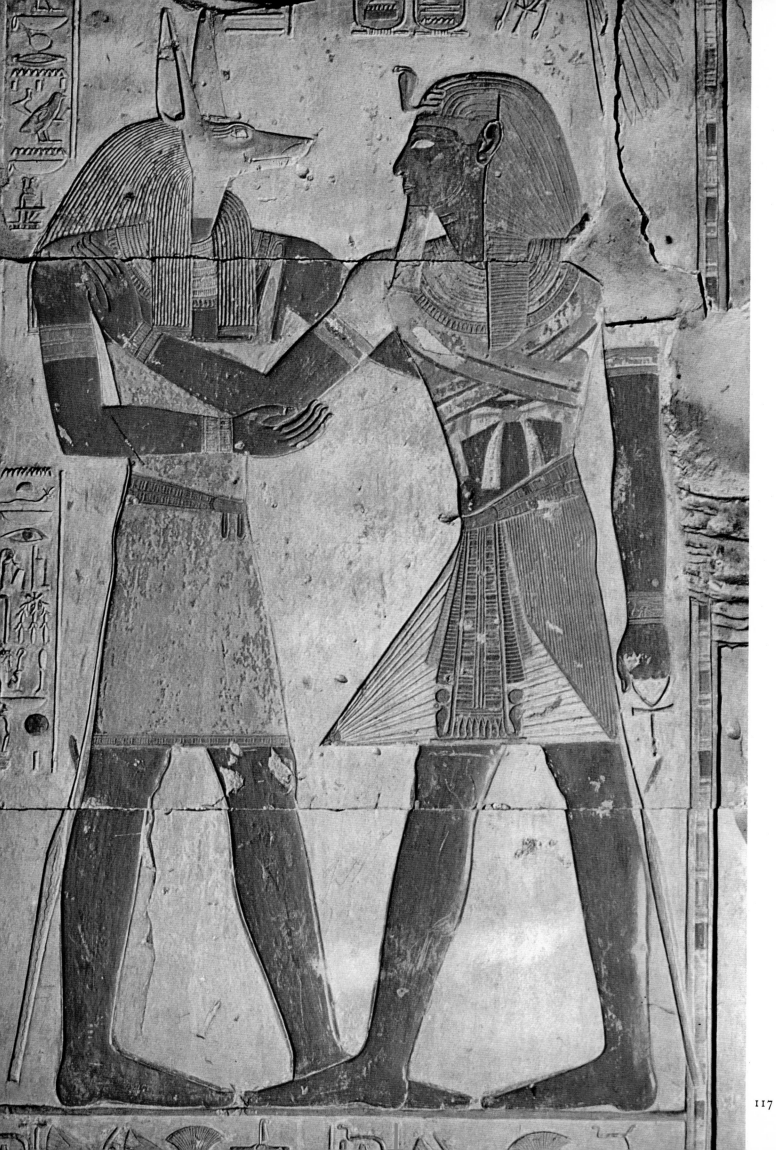

117. ABYDOS. TEMPLE OF SETY I
*Sety I and the God Anubis. Painted relief
(detail; see figs. 509–15). Dynasty XIX.*

118. DEIR EL MEDINEH. TOMB OF IPY
 Preparation of Tomb Furnishings,
 Sarcophagi, and Votive Objects. This
 painting in the tomb of the sculptor to
 Ramesses II is interesting for its many
 picturesque elements, although the style is
 rather slack. Wall painting (detail; see
 figs. 566–68). Dynasty XIX.

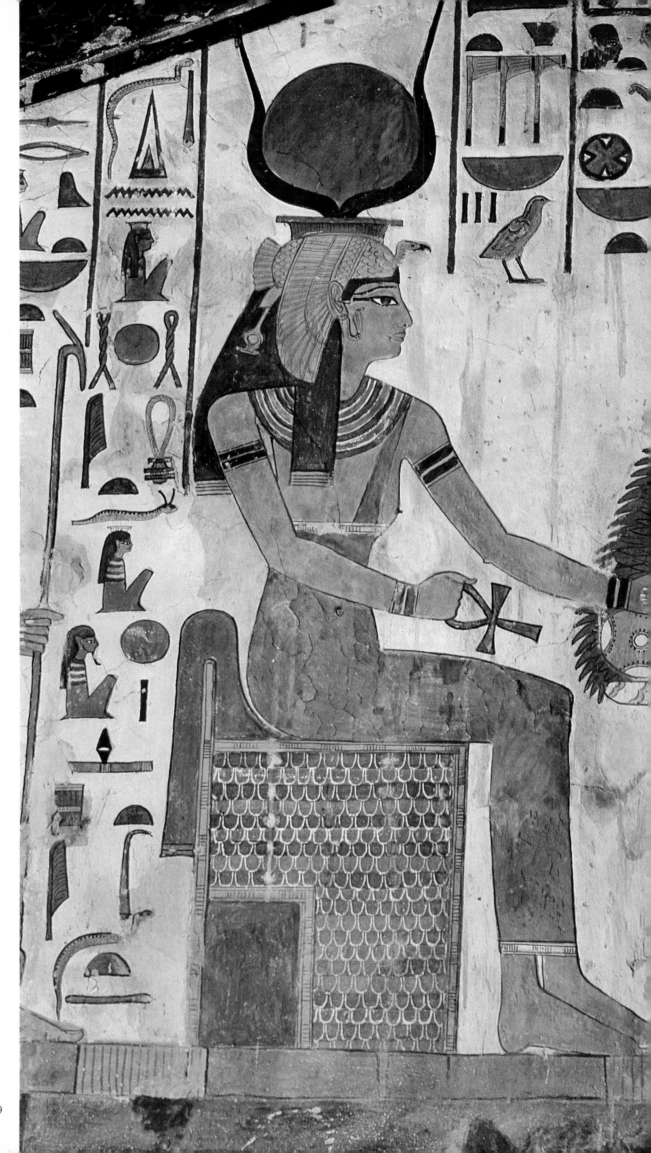

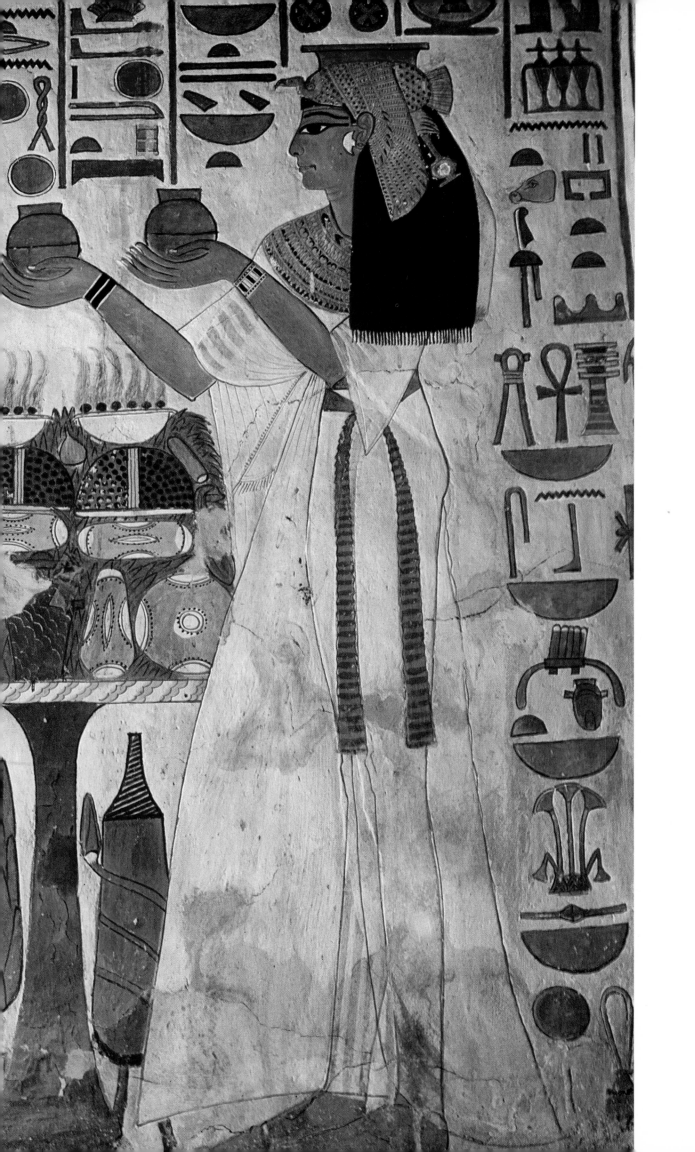

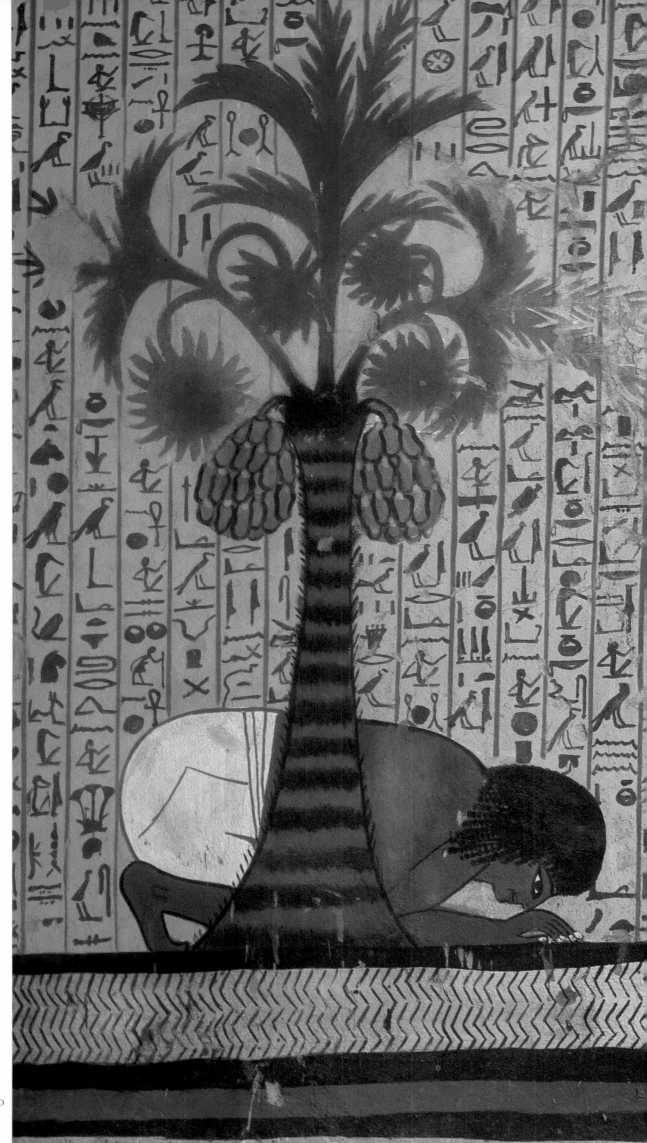

121. HEAD OF THE STATUE OF A WIFE OF
RAMESSES II
*Found in the Ramesseum, Thebes. The
wig is composed of fine tresses held by a
diadem with two uraei; the crown uses
the motif of uraeus and disk. Painted
limestone; height 28 3/4". Dynasty XIX.*

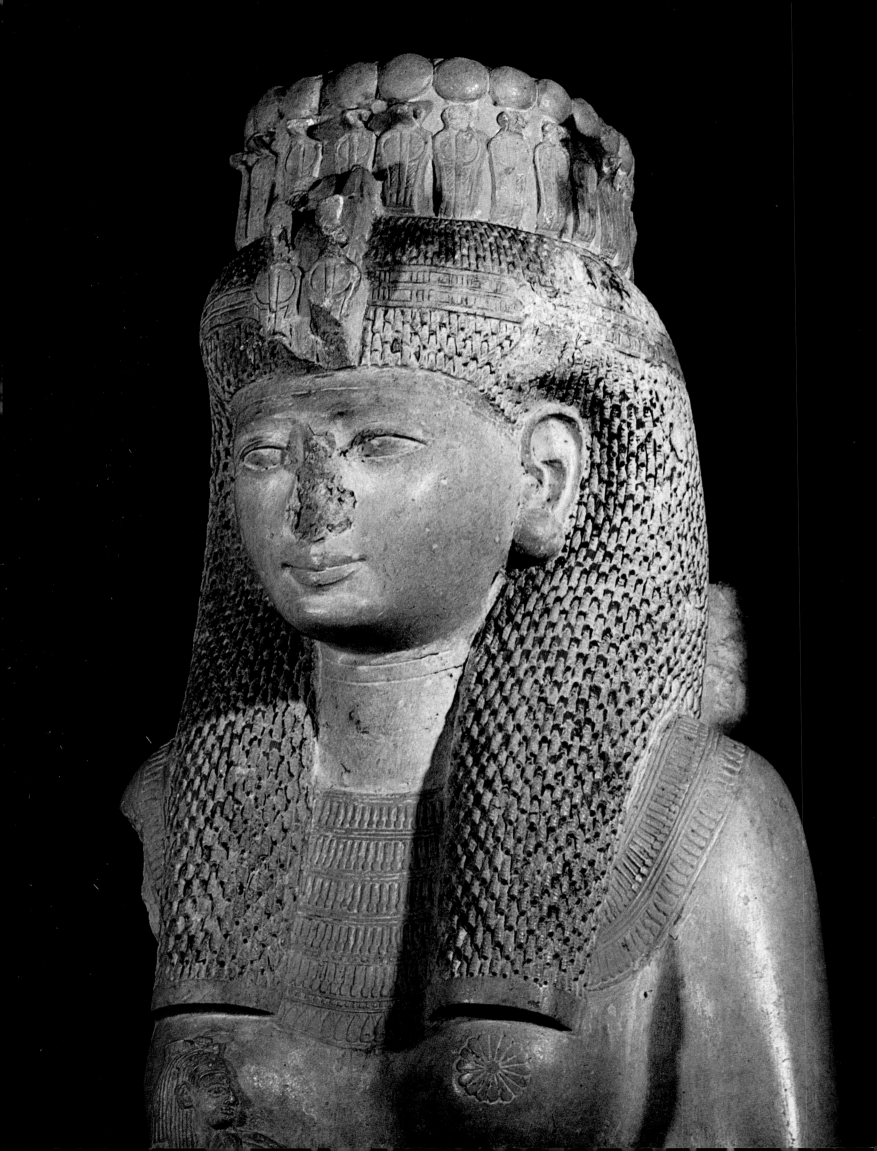

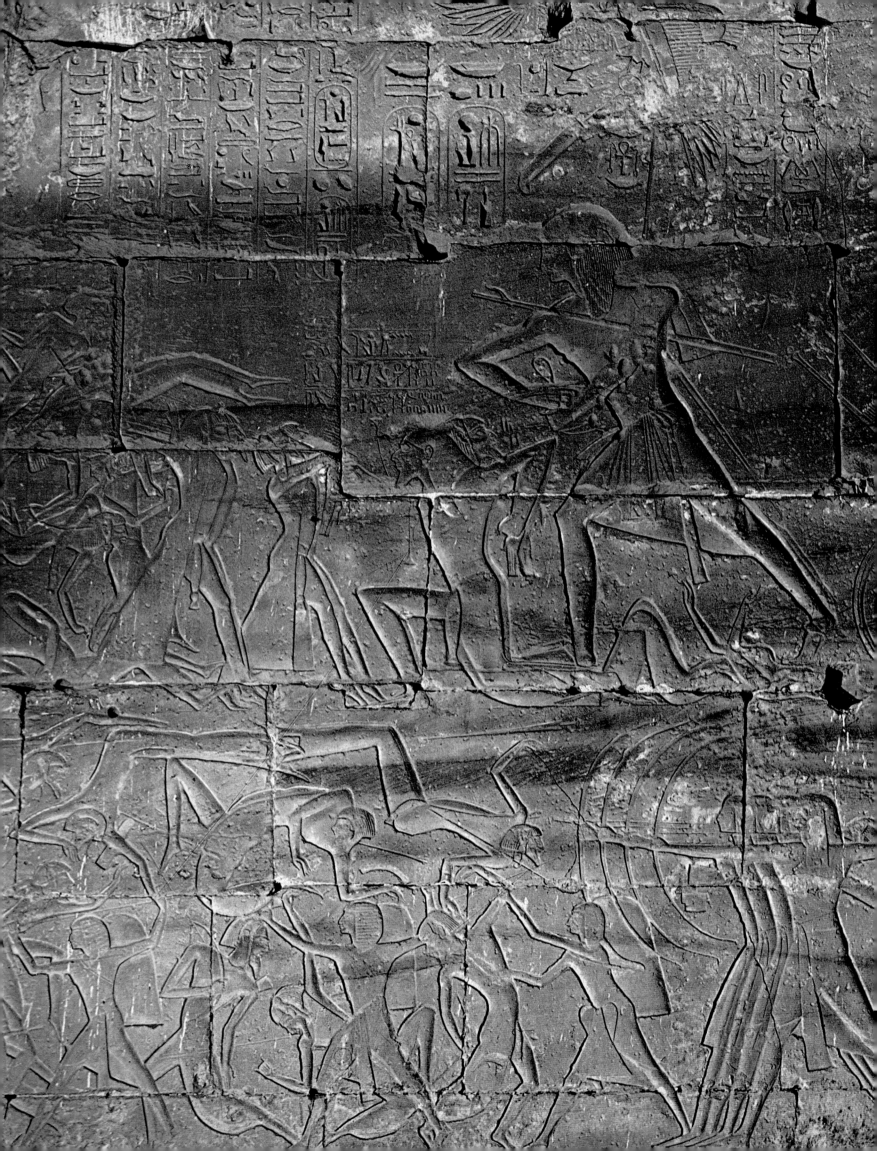

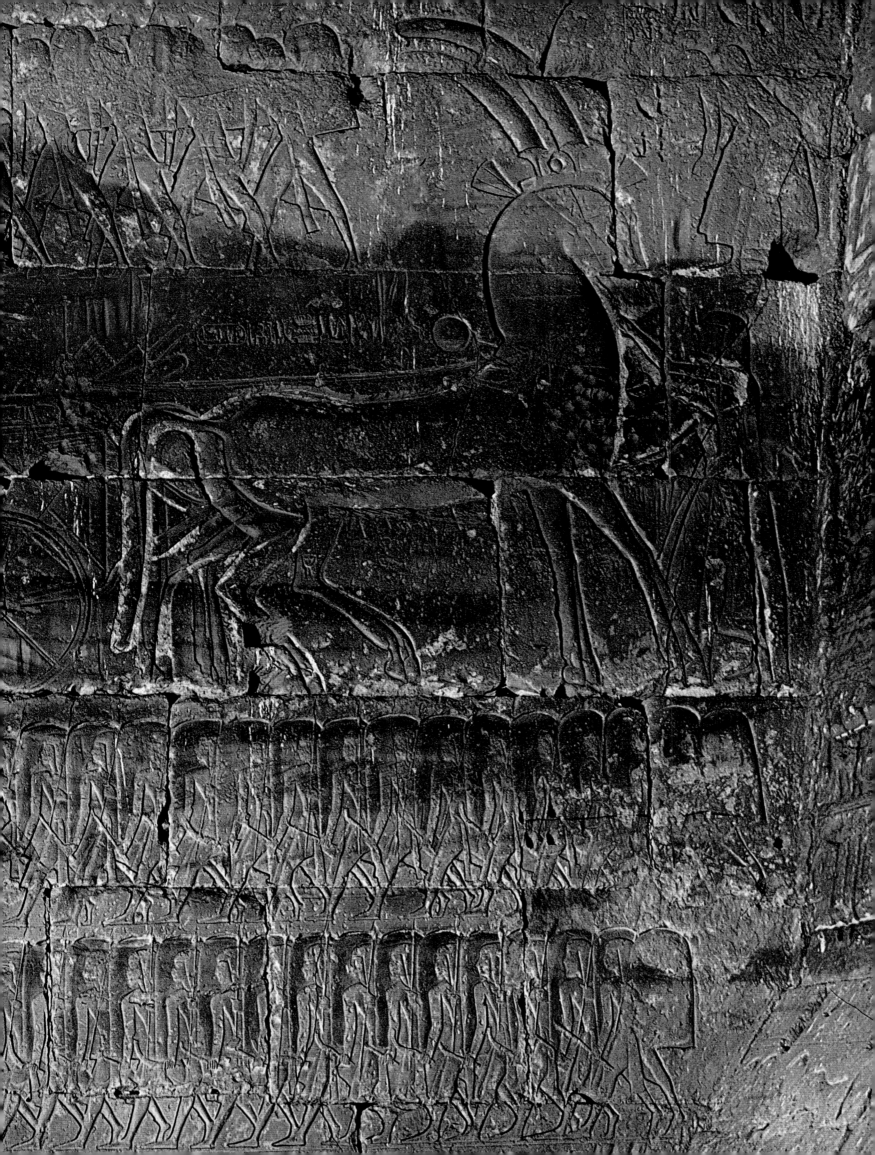

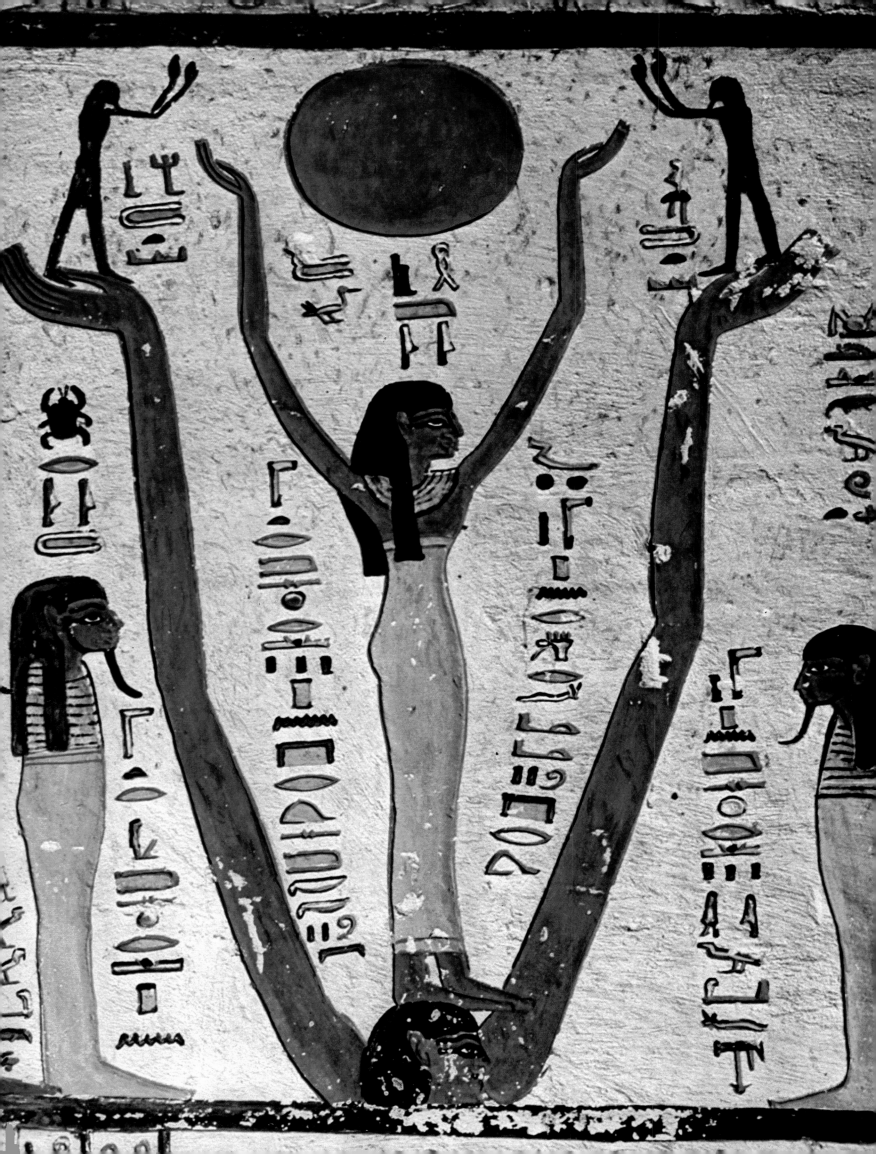

11. THE CANON OF THE TEMPLE AND THE ARCHITECTURE OF THE NEW KINGDOM

Temple design and contemporary social structure

The canon of temple building

The builder of the first "classical temple"

Position of the architect in society

The Valley of the Kings and other royal burial places

Country villas and urban dwellings

Deir el Bahari, Luxor, and Karnak

The rock-cut temple at Abu Simbel

11. THE CANON OF THE TEMPLE AND
THE ARCHITECTURE OF THE NEW KINGDOM

NEITHER the Old Kingdom nor the revival during the Middle Kingdom created a standard temple plan. The reasons for this are diverse. The important role of the secular power in the Old Kingdom and the glorification of the Pharaoh favored the creation of a "classical" type of funerary structure—hence the birth of the pyramid. In this period priestly functions were often performed by secular members of the king's entourage, and the funerary temple of the dead Pharaoh was probably the main center of religious worship; in any event, our present knowledge about the monuments suggests this hypothesis. Because of the weakened royal authority in the Middle Kingdom, the Pharaohs constructed buildings according to the wishes of the priests in the temples dedicated to the gods. The excavations at Karnak, still incomplete, suggest that the Middle Kingdom Pharaohs were building small but beautiful temples (such as the little temple of Amenemhat III and Amenemhat IV at Medinet Madi) that later inspired the builders of the temple of Ptah at Karnak, constructed under Tuthmosis III. Each plan had three basic elements: a columned vestibule, an antechamber, and three chapels for statues of the divine triad.

Monumental temples dedicated to the gods are entirely a creation of the New Kingdom. At that time the power of the priesthood grew rapidly as a result of the increasing wealth of the temple treasuries. The resulting conflicts and power struggles—which led to the heresy of Akhenaten and ended with the accession of Herihor, the high priest of Amon, to the throne of Egypt—created favorable conditions for the development of a canon of sacred architecture, a "classical" type of Egyptian temple. It was at this

very time that glorifications of the Pharaoh's military exploits began to appear on temple walls in the form of large battle scenes in relief (the temple of Sety I at Karnak and of Ramesses III at Medinet Habu); also, a new statuary type portraying the Pharaoh kneeling before the god was introduced.

The temple became the most representative Egyptian building. Both its internal arrangement and monumental scale performed an active function in political propaganda: they implanted in the society a conviction of the immutable power of the priests as servants of the god, those to whom even the Pharaoh himself must bow.

The "classical" temple had seven main elements (see Chart X, p. 577):

1) On the banks of the Nile there was a small landing stage for the procession of barges carrying the statue of the god and the accompanying priests.

2) An avenue of sphinxes led from the landing stage to the pylons in front of the temple (fig. 128).

3) Colossal statues of the king and tall flagstaffs stood in front of these pylons (in Egyptian, *bekhnet*).

4) Beyond the pylons lay a large court usually surrounded on three sides by columns.

5) Next came a large hypostyle hall; sometimes the two central rows of columns were taller than the others and they formed a kind of nave, as at Karnak (fig. 3).

6) At the back of the large hypostyle hall an opening led, sometimes across a smaller hall, to the sacred barge chamber; the latter could be surrounded by corridors leading to other rooms.

7) The final element, beyond the barge chamber, contained the chapel or sanctuary proper, sometimes preceded by a vestibule in which stood the statue of the king or god. The sanctuary consisted of three chapels—a main chapel and two side chapels, in keeping with the Egyptian system of worship of divine triads.

On the sides of this major architectural complex, and built along the same axis, there were many rooms—treasuries, archives, storehouses, and the like—according to the size of the temple and its importance within the official cult. The temple complex always included a sacred lake, and often a park.

Within this over-all scheme, the arrangement of the component buildings was flexible. Many New Kingdom temples had two or three hypostyle halls in which the faithful could contemplate the statue of the god. The hall of offerings, and often the hypostyle halls as well, might be preceded by a colonnaded antechamber. In addition to the surviving monuments, we

have a faithful description of an Egyptian temple in the writings of Strabo, a Greek traveler of the early first century A.D.; by and large it fits the above scheme.

IF we consider its three main elements—court, hypostyle hall, and adytum (the chamber for the sacred barge, together with the chapel)—the temple may be likened to the palatial residence of a Pharaoh or high dignitary. In terms of residential functions, the court corresponds to the living room or sitting room, the hypostyle hall to the dining room, and the adytum to the bedroom. In effect, an undeniable link existed between the domestic habits of the upper classes and the sacred ritual of the temples. Because the god had to a certain extent assumed the functions of the earthly sovereign, his temple had to symbolize this power to its fullest extent. We have here in part a reversal of roles: in the Old Kingdom the Pharaoh—the living Horus—was a god on earth; in the New Kingdom the god or, *de facto*, his high priest exercised the earthly power previously granted to the Pharaoh.

Far more important, in my opinion, was the connection that existed between this form of temple and the prevailing social structure. The plan of the New Kingdom temple, and hence the liturgy it reflects, accentuated class differences in Egyptian society. The working people had access to the temple court, where, under the blazing sun (shelter was afforded only by the shallow colonnades), they "participated" in the ceremonies taking place in the interior of the building. The ardent believers might occasionally glimpse through the high, wide doors leading to the hypostyle hall the statue of the god carried by the priests during the ceremony. Only officials (including scribes), nobles, and military personnel were admitted into the hypostyle hall, as into the palace's reception rooms. In temples with several hypostyle halls, admittance to each must have been further differentiated in keeping with the rigorous hierarchical organization of society itself. Other than the priests, only the very highest dignitaries ever crossed the threshold of the barge chamber. Aside from the Pharaoh—who had to fall to his knees—only the highest priests, perhaps the vizier and the clergy who performed the routine daily worship, could be near the divine statue.

Such, in general, is the social meaning of the canon of the Egyptian temple. Of course, the subject is far from exhausted. The rooms, for example, were disposed in such a way as to achieve certain natural lighting effects:

1) The court was drenched in sunlight.
2) The hypostyle hall was in semidarkness, for light entered only from the doors, through barred windows located in the central clerestory above the tallest columns, and sometimes through narrow openings in the roof.

3) The chamber in which the sacred barge was kept had still less light.

4) The chapel with the statue of the god was in total darkness, although occasionally (as in the Ptah temple at Karnak) a single ray of light entered through an opening in the roof directly above the statue.

It was not only openings to the sky that produced this dramatic lighting. The halls and chambers leading up to the sanctuary had progressively lower ceilings and progressively higher floor levels; each level was preceded by low steps. This gradual elevation of the floor level sometimes began right behind the pylons, the forecourt sloping upward toward the hypostyle. The main hypostyle hall had the same width as the forecourt, the width of the temple itself, followed by several halls. Within the temple enclosure each of these rooms was surrounded by passages or by cellae of lesser dimensions. If we follow the axis of the temple from one end to the other, its design evokes the image of the opened bellows of an old-fashioned folding camera, the plate corresponding to the pylons, and the lens to the statue of the god.

The arrangement of the temple gave expression to convictions implicit in Egyptian religious belief and observance. A number of Egyptologists have claimed that all temples faced east, as in ancient Greece, but temples so oriented are actually rare in Egypt. The famous Nubian temple of Ramesses II at Abu Simbel and the temples at Deir el Bahari do face east, but the overwhelming majority of New Kingdom temples, including all the important ones, face northwest (Karnak), south (the Khonsu temple), or north (the temple of Mut and the temple at Luxor). There is thus no justification for the frequently repeated statement that Egyptian temples were always designed so that the first rays of the rising sun fell on the statue of the god in the innermost sanctuary. Apart from the fact that the sun rises at different points on the eastern horizon in different seasons, such an assumption is also contradicted by texts dealing with the ceremony in which the Pharaoh delineates the plan of the temple. For instance, one of the texts from the Edfu temple says: "I grasp a wooden ring and the handle of my staff [scepter]. I hold the string with [the goddess] Seshat; my eyes follow the course of the stars; they rest on Mesektyw [Ursa Major]. The god who tells time stood beside my *merkhet* [water clock]; I established the four corners of the temple." This text clearly shows that the axis of the temple was not determined by the position of the sun.

During the entire Dynastic Period, solar gods were worshiped throughout Egypt—for instance, Ra in the Old Kingdom and Amon in the New Kingdom—but it does not follow that temples dedicated to the worship of other gods were built along a so-called solar axis. Taking as a

general premise the fact that the Egyptian religion was based on astral cults, we may assume that New Kingdom temples dedicated to particular gods were oriented toward the position of an individual planet at some strictly defined time of night. The intention was that the light of a given planet at some particular moment in its orbit should fall on the statue of the god in the sanctuary. In advancing this theory, however, we must recognize that this problem has not yet been sufficiently studied or adequately explained.

In any event, there is no proof that the axial orientation of New Kingdom temples was left to chance or chosen to suit a whim of either the Pharaoh or his architect. On the contrary, it is, like the entire canon of the Egyptian temple, closely connected with social reality, with sacraments of the cult, and with dogma, which the Egyptians perceived in a realistic, not a mystical way. This is why the "foundation ceremony," described in inscriptions at the Edfu and Denderah temples, agrees with the actual orientation of these temples.

The canon of the Egyptian temple reflects, I believe, not only the social system and the dogmas of the prevailing cult (or rather official cults); the temple decorations and the interior arrangement also exhibit a marked tendency toward the realistic re-creation of nature. The Egyptian temple is an image of Egypt's earthly nature, not of imaginary celestial realms as Egyptologists of preceding generations believed. The Egyptian temple rises out of the fertile earth, and the base of its walls is usually decorated with plant motifs. In some temples the exterior wall has a molding at the base decorated with stylized plant motifs; this also performs the utilitarian function of protection against snakes. The palm, lotus, and papyrus columns in the hypostyle halls have capitals in the form of calyxes, appropriately closed in the semidarkness. Only in the central naves or colonnades linking different areas of the temple, as at Luxor, do we find capitals with open calyxes (fig. 126).

The temple ceiling is decorated with golden stars in a dark blue field— the so-called decan constellations presiding over the thirty-six divisions of the sky—and zodiacal and astral divinities are shown sailing across the sky in boats. Along the sides are figures of large vultures with outspread wings; winged disks are a frequent image. In other words, the interior of the temple represents the Nile valley landscape at night, as it might appear from a grove of palm trees or a papyrus thicket. The temple sets a frame around the Egyptian night—a moonless Egyptian night— preserving only its timeless characteristics (figs. 51, 502–8).

In its use of elements characteristic of the Egyptian landscape, the architecture reveals its peculiarly indigenous character. In spite of its high artistic level, Egyptian architecture—unlike Greek art—cannot be adapted to other

settings, other times. It is an architecture so bound to the economic and social conditions from which it arose that any present-day attempts to return to its forms, even in Egypt, leads to bizarre results.

In conclusion, we may say that:

1) The canon of the Egyptian temple arose under specific historical conditions, as an expression of the priesthood's influence and power—chiefly that of the priests of the Theban Amon—during the New Kingdom.

2) The temple plan, designed to follow the sacred ritual, reflects the class differentiations within Egyptian society.

3) The choice of axial orientation of the temple underlines the basic dogma of the particular cult.

4) The internal arrangement and decoration of the temple exhibit strikingly realistic elements, which are characteristic of ancient Egyptian art as a whole.

WE must still consider the specific historical moment at which the Egyptian temple canon assumed its definitive form. Until recently it was believed that the "classical" type of temple did not appear until Dynasty XX. In studies made since 1945, however, I have been able to establish that the "standard" temple plan appeared two centuries earlier, toward the end of Dynasty XVIII, and that the creator of the canon was the chief architect of Amenhotep III. He bore the name Amenhotep, son of Hapu, and the plan of his own funerary temple at Thebes, not far from Medinet Habu, exhibits all the essential features of the classical Egyptian temple.

Needless to say, this architect's innovations in the field of temple construction were the result of a long process. The elements of the canon had developed gradually, as the relations between the Amon priesthood and the royal court led to a new balance of social forces in the New Kingdom. But Amenhotep, son of Hapu, was the creator of the temple canon in the sense that he was the first to realize fully the classic principles of internal arrangement, axial orientation, and realistic decoration. This achievement probably accounts for the extraordinary honor conferred upon him by the Pharaoh (no doubt with the agreement of the high priests of Amon)—the right to build a funerary temple to his own *ka*, or spirit. Not even the greatest of his architectural monuments, the funerary temple of Amenhotep III—only its famous Colossi of Memnon remain—would of itself account for this privilege, unique in Egyptian history (fig. 124).

This man was revered in later periods as a hero on a par with Imhotep, the great architect who built the pyramid complex for Zoser (Dynasty III).

Amenhotep, son of Hapu, died between the thirty-first and the thirty-fourth years of Amenhotep III's reign. The famous funerary temple was consecrated by the vizier Amenhotep, who became the successor to the post of chief royal architect. This second architect Amenhotep built the Khonsu temple at Karnak during the reign of Amenhotep III (it was restored under Ramesses III, as has recently been shown by the Russian Egyptologist M. Mathieu). This is the temple that early Egyptologists rightly regarded as the best example of the Egyptian temple canon. A fragment of its sphinx-lined avenue has survived.

Architects enjoyed greater prestige and occupied a much higher social rank than painters or sculptors. In a sense they were entitled to such treatment because of their professional knowledge; they were even more important than scribes. But they certainly did not owe their special position in the social hierarchy to the temples and palaces they built. Their eminence was rather due, in my opinion, to one special phase of their work: it was they who designed and built the royal tombs. The security of the dead Pharaoh was in their hands: they were the principal bulwark against desecration and rifling of the tomb, for it was they who designed the secret entrance. In one of his inscriptions, Ineni, architect to Tuthmosis I, says that he alone "directed the building of the royal tomb so that nobody would see or hear anything." Other "overseers of works" expressed themselves in similar terms. The architect was the man who created the surroundings for the eternal dwelling place of the *ka*. Thus, whether eternal life in the afterworld would be spent in favorable conditions depended largely on the architect. Surely such a man deserved to be generously rewarded.

So we should not be surprised that the tomb of the architect Kha, active under Amenhotep II, contained a measuring rod made of gold. The Pharaohs bestowed such gifts on the chief architect so that he would execute his task as well as possible. Unlike painters or sculptors, architects were scarcely replaceable: to switch architects in mid-construction would not merely imperil the solidity of the edifice, it would risk divulging the secret location of the entrance to the eternal resting place. With this in mind, it is easier to understand the phenomenal careers of Imhotep, Senmut, and Amenhotep, son of Hapu, and many other Egyptian architects.

In no other culture in antiquity did architects manage to rise so high in the social hierarchy. Even Iktinos, creator of the Parthenon, was subject to Phidias' orders, and in Rome architects generally played a secondary role. Only at the very close of ancient times did architects again attain a position comparable to that of such Egyptians as Ineni, Hapu-seneb, Puyem-ra, Hori, Suti, and others, including the three already mentioned. Cassiodorus, the Roman secretary to Theodoric the Great in the sixth century A.D., quotes the text of a royal letter addressed to a newly appointed architect

charged with directing public works. King Theodoric stresses the importance of the architect's task and the high honor that has been given him; he concludes with this remarkable statement: "Consider, also, with what favor you are treated: of my numerous retinue, you alone, with your golden rod, walk the first when before the king."

Among the most interesting New Kingdom works are the great rock-cut tombs of the Pharaohs. Some of them, like the tombs of Tuthmosis III and Amenhotep III, are veritable labyrinths of winding corridors that lead to oddly arranged chambers and chapels. Others, such as the tomb of King Sety I, are underground palaces with passages at different levels, connected by staircases and full of dead ends that help prevent the uninitiated from entering the hidden burial chamber. The walls of these tombs are covered with paintings and polychrome reliefs representing the dangers to which the soul is exposed after death, until it has been purified before the tribunal of Osiris. The spaces between these representations are inscribed with prayers. The ceilings are decorated with stars, and in the burial chambers these sometimes show the position of the constellations on the day of the Pharaoh's birth, or the course of the soul's nightly twelve-hour journey across the celestial ocean.

Tuthmosis I was the first Pharaoh who, to preserve the secret of his tomb, built his funerary temple at some distance from his hidden rock-cut sepulcher. His successors followed his example, but, as is well known, this precaution did not prevent the pillaging of royal tombs.

To celebrate the cult of the dead Pharaohs, many temples were built on the western bank of the Nile, at the edge of the Theban desert. Their actual burial places, however, where the royal mummy and the rich tomb furnishings were installed, were hidden in the subterranean chambers of the Valley of the Kings. A similar necropolis for their wives was situated not far away in the Valley of the Queens.

Occasionally the funerary temple was connected with the royal palace, as at Medinet Habu. However, this palace, built under Ramesses III, was not the Pharaoh's permanent residence. He stayed there only at the time of religious festivals, when he would show himself at a palace window to the hosts of faithful worshipers, to whom he was a living god. Egyptian rulers usually built themselves palatial residences, as well as tombs for the afterlife. Amenhotep III, for example, built a vast residence in western Thebes, at Malkata, for himself and Queen Tiy. But the palace best known through excavation is the palace of Akhenaten and his wife Nofretete at Tell el Amarna.

Only in size did the palaces of the rulers differ from the villas of the great

landowners and high dignitaries. Like such villas, the royal palace was set amid beautiful gardens. The antechambers and reception halls had light wooden columns, covered with painted plaster. The walls of the various rooms were decorated with paintings. Country houses built during the New Kingdom are essentially the same as those of the preceding period, but in the cities multilevel houses came into use. Usually the ground floor was occupied by workshops, the reception rooms were on the second floor, and the bedrooms on the third.

However, neither the royal palace nor the nobleman's villa can be regarded as typical of Egyptian architecture. What is really representative is the temple, as it is in Greece. Among the better-preserved funerary temples are the modest temple of Sety I at Gurneh and the imposing ruins of the funerary temple and the palace of Ramesses II, the famous Ramesseum. The beautiful temple of Queen Hatshepsut at Deir el Bahari may be considered a special application of the canon evolved from the Old Kingdom Valley Festival held annually at Thebes (fig. 125). The over-all design was complemented by a series of kiosks along a road down to the Nile.

The latest Polish excavations suggest that Deir el Bahari was the site of what must have been a beautiful and harmonious collection of monumental architecture. The buildings extended in a semicircle to the steep walls of the Theban Gebel; at the center, towering above all others, stood the funerary temple of Tuthmosis III, which these excavations first brought to light. Abutting it on the right—that is, the north side—was the great ensemble of terraces built by Senmut for Hatshepsut. To the left of these, south of the temple, the composition was completed by the older terraced temple of Mentuhotep, Pharaoh of the Middle Kingdom.

In the New Kingdom the pyramid was no longer a symbol reserved for royalty. At Deir el Medineh small pyramids were placed on top of funerary chapels belonging to ordinary craftsmen (see Chart IX, p. 576). Deir el Medineh is also an important site because French archaeologists, under B. Bruyère, here uncovered the remains of a village of craftsmen and laborers employed in the construction of the royal tombs. Though situated in a relatively broad ravine, there was not enough space for a conventional layout like that of the village at Lahun on the edge of the Fayum desert. At Deir el Medineh the streets are narrow and winding, and the plan of the village is irregular. It looks as though houses were added as the needs of the project grew.

The funerary temples of the New Kingdom rulers were not the principal centers of religious worship; this took place in temples dedicated to the gods. The most important and best-known New Kingdom temple of this

kind is the Luxor temple, notable for its broken-axis construction. This departure results from the fact that it was built in two stages, and that its architects tried to orient it toward the avenue of sphinxes connecting this temple of Amon with the Khonsu temple at Karnak.

The main temple at Karnak is not a unified structure. It is composed of large edifices that were built by such rulers as (among others) Tuthmosis III, Hatshepsut, and Amenhotep III. The immense hypostyle hall with a court and pylons was added later, by Sety I and Ramesses II. Their successors, too, made additions and embellishments: Ramesses III was responsible for a temple. Even as late a ruler as Taharqa (Dynasty XXV, Kushite) added a colonnade to the Great Court, and there are buildings dating from the Ptolemaic Period. The main axis of the colossal Karnak temple runs west-east; but there is also a second axis running north-south with a line of pylons leading to the temple of the goddess Mut, which is decorated with a splendid series of granite statues of the lion-goddess Sekhmet. Besides the great Amon, Mut, and Khonsu temples, there were many smaller sanctuaries at Karnak, such as the well-preserved Ptah temple. Karnak runs the architectural gamut, including every type of column and decoration, from the "proto-Doric" to the most complicated capitals and Osiride pillars. The granite pillars dating from the reign of Tuthmosis III, with their heraldic capitals showing lilies and papyri—the symbols of Upper and Lower Egypt—represent an innovation (see Chart XI, pp. 578-79).

The temple revealing most completely the hierarchy of the gods during Dynasty XIX is the temple of Sety I at Abydos. It has two hypostyle halls and seven chapels, six dedicated to gods and one to the king.

The heresy of Akhenaten, which left such enduring traces in the sculpture and painting of the New Kingdom, was also reflected in temple architecture. The temple dedicated to the Aten disk had pylons and a large hypostyle hall but no roof, so that the life-giving rays of the sun would not be shut out.

PERHAPS the most interesting New Kingdom architectural monument, much discussed in recent years, is the great rock-cut temple built by Ramesses II at Abu Simbel in Nubia, not far from the present border of the Sudan (fig. 127). The entire temple was carved out of the pink limestone cliff by order of this Pharaoh to celebrate the thirtieth year of his reign. The enormous trapezoidal façade recalls temple pylons. The entrance is flanked by two pairs of statues of the enthroned Pharaoh, each sixty-five feet high. At the feet are smaller statues of the members of his family, the most notable being that of his beautiful wife Nofretari. Nearby a smaller temple dedicated to her was also carved out of the rock.

Above the rock-hewn façade are decorative friezes, the uppermost repre-

senting a row of monkeys. The tall entrance portals led to a large hall, its roof supported by eight Osiride pillars. This large rock chamber corresponds to the court of the classical Egyptian temple. Beyond is a second hypostyle hall, and still farther back the chamber for the sacred barge and the chapel. On the rear wall of the sanctuary four statues of gods are carved out of the rock—Ptah, Amon, the deified Ramesses II, and Ra-Harakhte. This temple faced due east, so that on the anniversary of the beginning of the Pharaoh's reign the first rays of the rising sun fell directly upon the features of the deified Ramesses.

Today the entire temple has been moved from its original site. Of the many plans suggested for rescuing this monument from submersion by the new Nubian reservoir, UNESCO and the government of the United Arab Republic selected the Swedish plan. This provided for cutting up the temples of Ramesses and Nofretari into thirty-ton blocks, at a cost of about $40 million, and transporting them to the top of the cliff (197 feet above the original site), where the temples have been reconstructed from their original elements.

How best to save the Nubian monuments, especially these magnificent ones, gave rise to much lively discussion, not only among archaeologists. The salvaging of the Abu Simbel temples, made possible by funds contributed by many countries and by the devotion of many specialists, is a landmark in international cooperation for the safeguarding of one of mankind's most splendid artistic achievements, a cultural treasure that belongs to the world.

124. THEBES. THE COLOSSI OF MEMNON
*View from the southeast. These statues
of Amenhotep III stood in front of the
pylons of his funerary temple, since
destroyed, on the west bank of the Nile.
Sandstone; original height c. 64'.
Dynasty XVIII.*

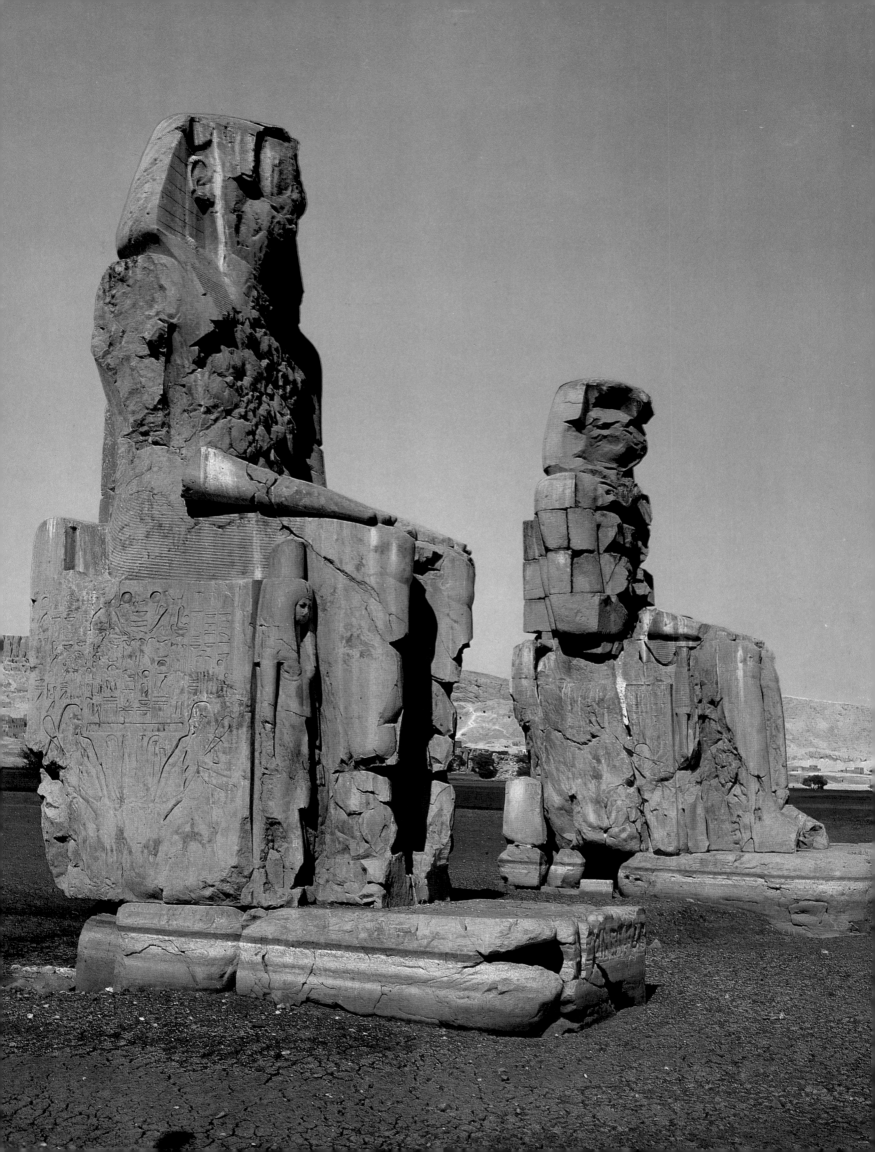

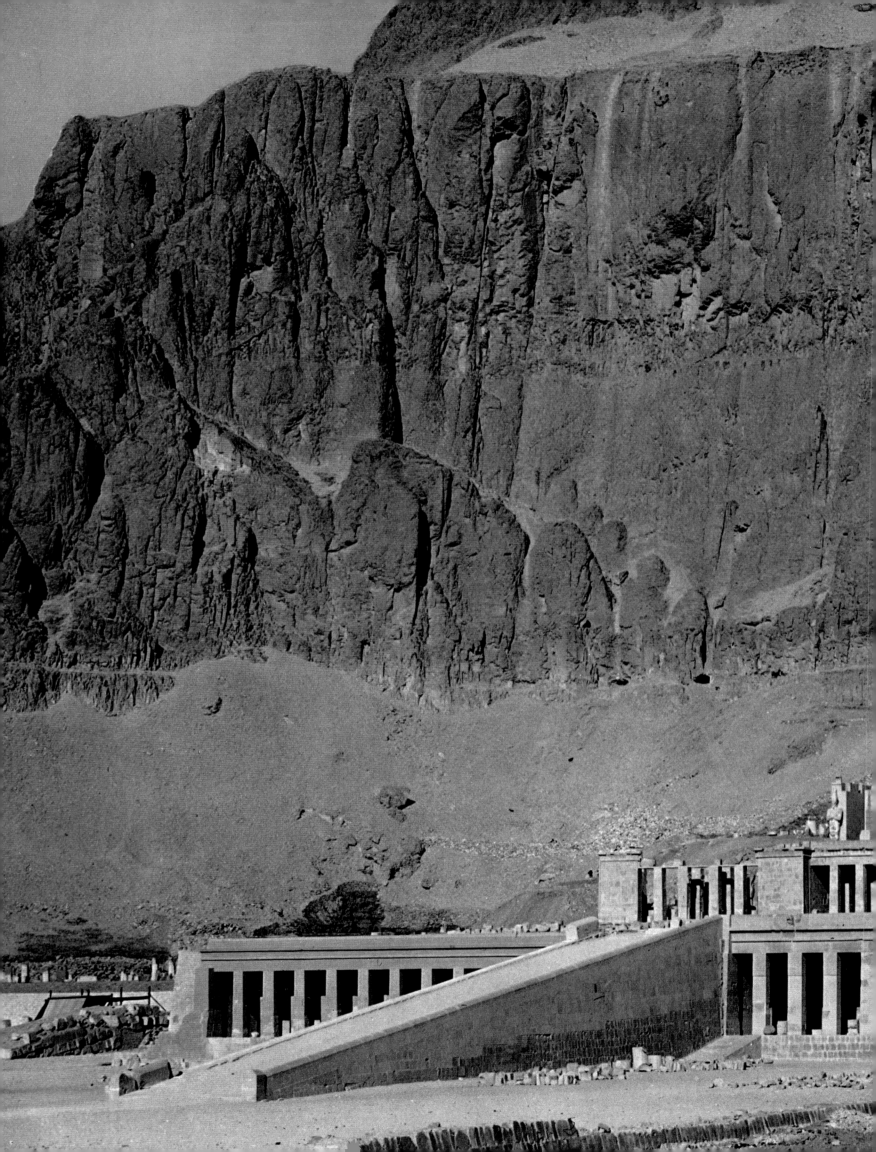

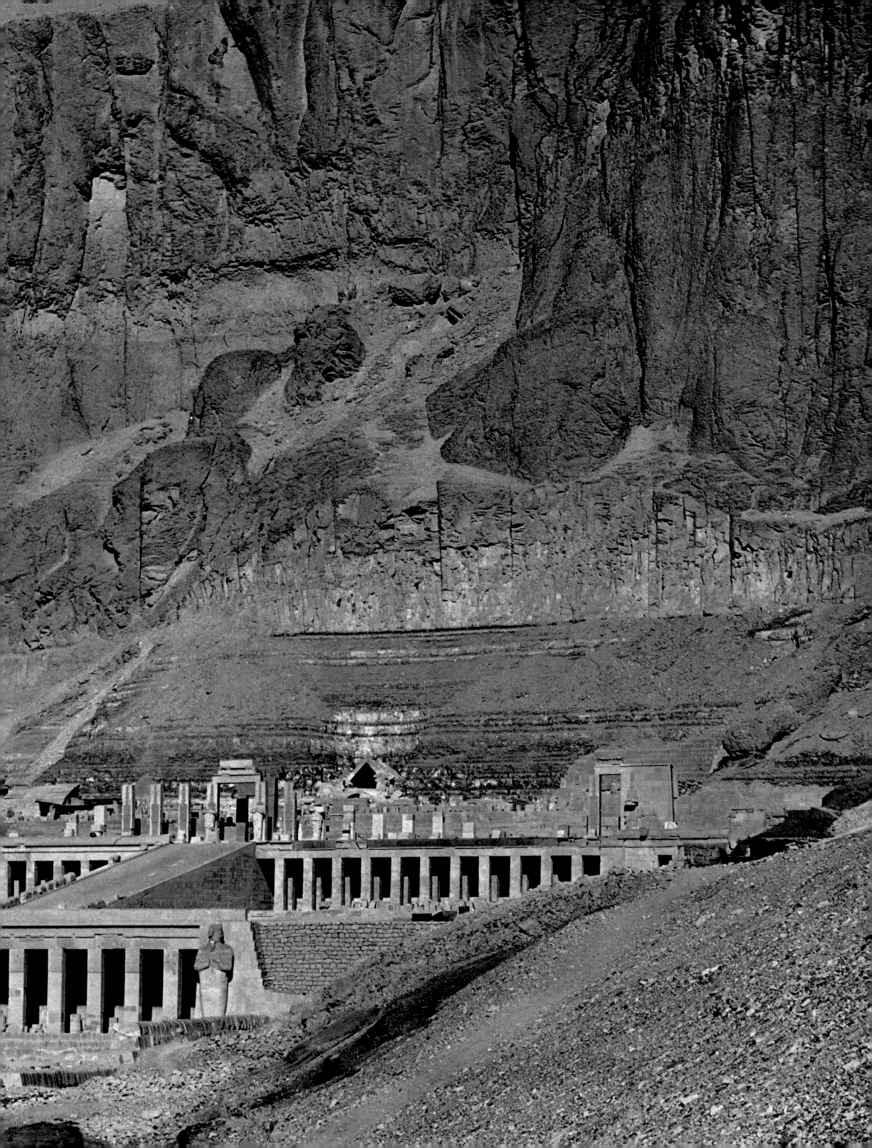

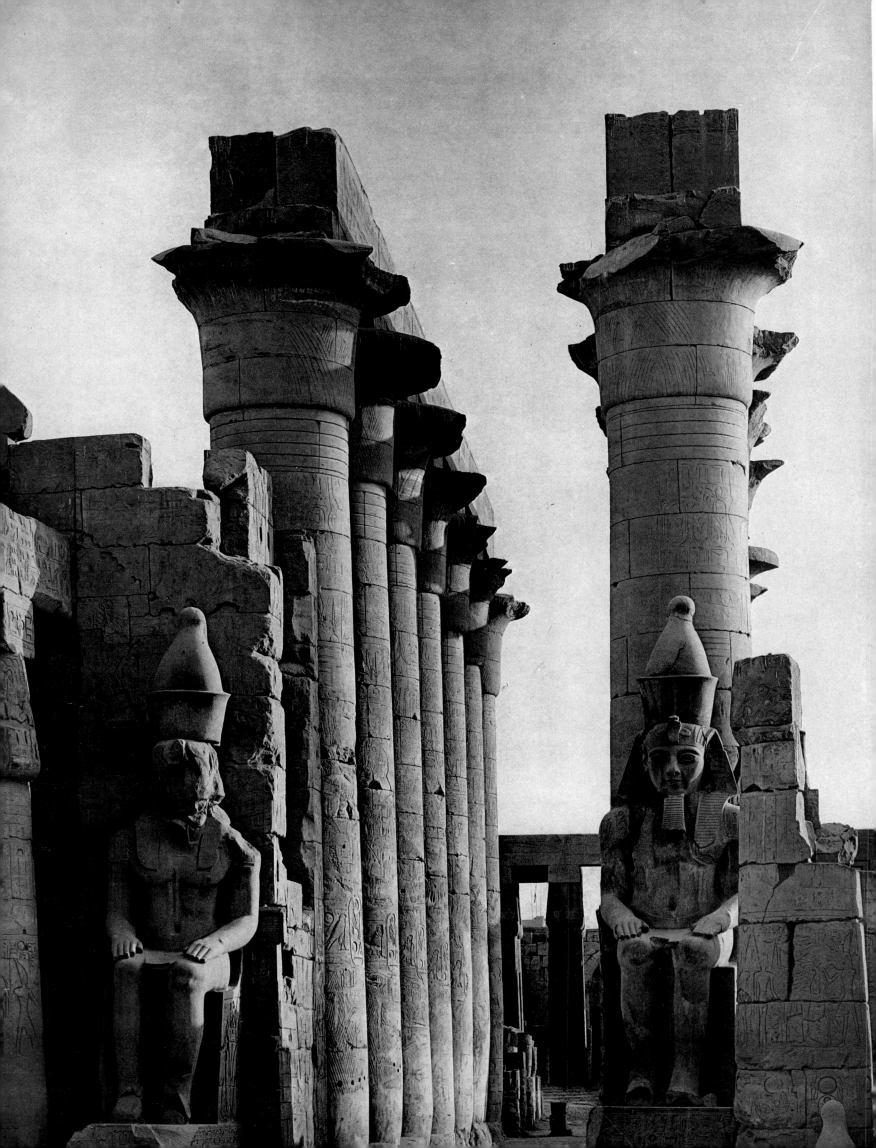

Preceding pages

125. DEIR EL BAHARI. TEMPLE OF
HATSHEPSUT
*This complex was designed by the
architect Senmut, and built at the foot of
the Libyan Gebel on the west bank of the
Nile, opposite the great temple of Amon
at Karnak. Dynasty XVIII.*

Opposite page

126. LUXOR. THE COLONNADE OF THE
GREAT TEMPLE OF AMON
*View from the north. The colonnade was
begun by Amenhotep III and completed
by Ramesses II. Height of columns 52'.
Dynasties XVIII–XIX.*

127. ABU SIMBEL. THE COLOSSI OF
RAMESSES II ON THE FAÇADE OF THE
ROCK-CUT TEMPLE
*View from the northeast. This temple has
since been cut into large blocks and
reassembled at a location above the new
artificial lake in Nubia. Height of statues
over 65'. Dynasty XIX.*

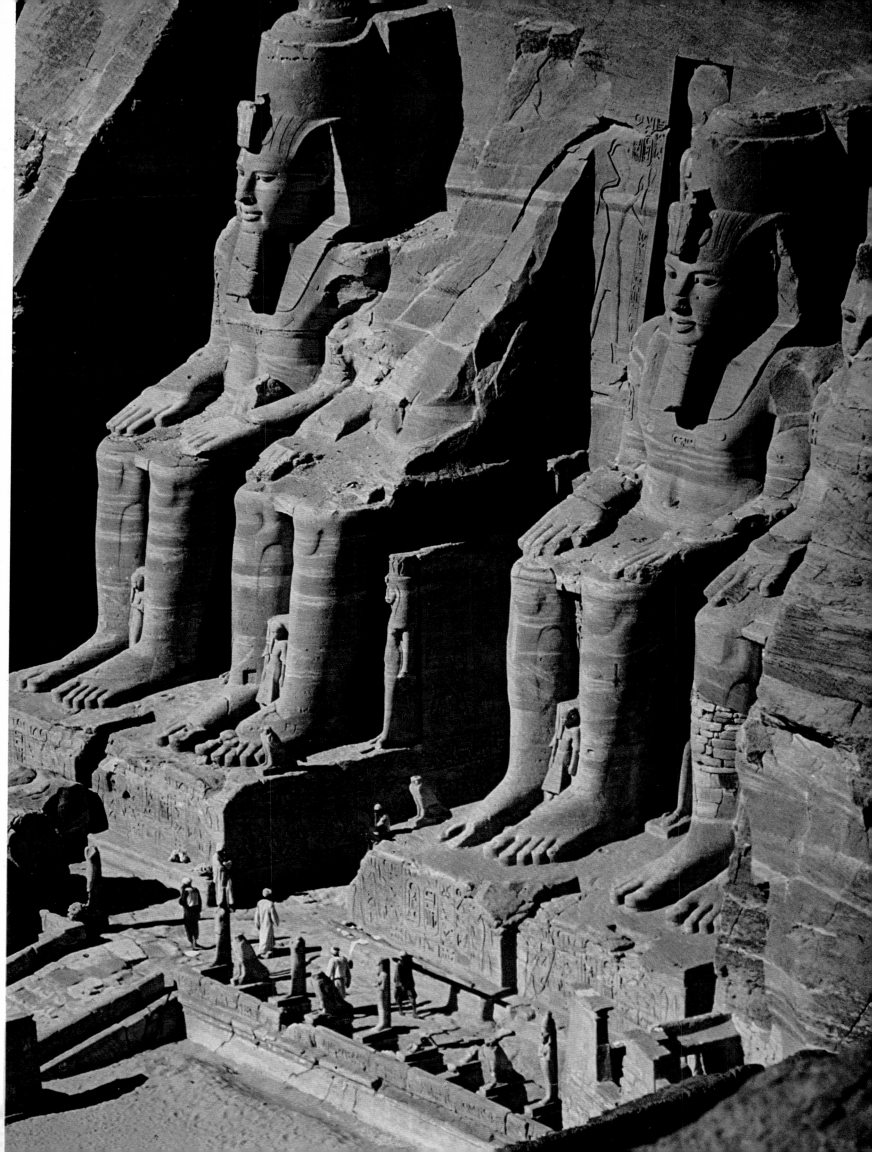

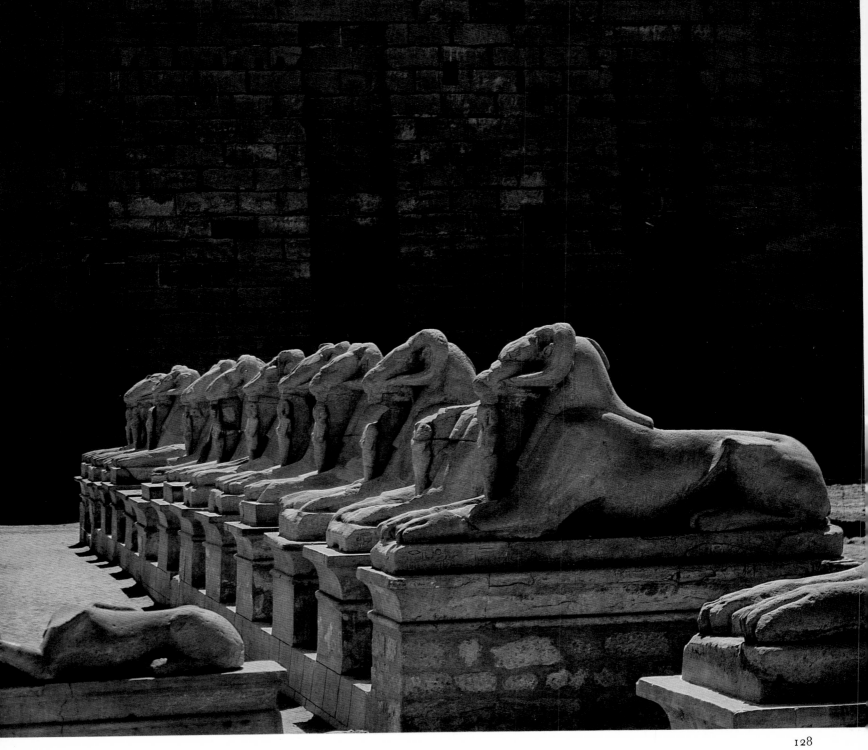

128. KARNAK. AVENUE OF RAM-HEADED
SPHINXES
View from the northwest. This avenue was built by Ramesses II, and once extended from the great temple of Amon to the Nile. Dynasty XIX.

12. THE LATE PERIOD AND THE PTOLEMAIC AND ROMAN ERAS

The decline of Egyptian art

Pyramids in the Sudan

Saite neoclassicism

Greek influence under the Ptolemies

New rulers and old gods

The Roman occupation

Egyptian tradition in the Nubian kingdoms

of Meroë and Nobada

12. THE LATE PERIOD AND THE PTOLEMAIC AND ROMAN ERAS

THE sunset of Egyptian art lasted more than a thousand years—a short time compared to the millenniums of development that preceded the brilliance of the Old Kingdom. Opinions may differ as to whether it reached its zenith under Cheops, the Amenemhats and the Sesostrises, or later, in the New Kingdom, but there can be no doubt that it was declining toward the close of the Ramesside dynasty. The period that then began is usually referred to as the Late Period—a time when the power of the Pharaohs grew weak and successive invaders from the south and the west seized the throne. The turbulence of the times was unfavorable to the development both of the country and of its art. Under Dynasty XXI, Egypt became a country divided between Thebes, the seat of the priest kings (the first of whom was Herihor, high priest of Amon), and Tanis, on the edge of the Delta, where other kings enlarged the northern capital founded by Ramesses II. The very modest tombs of Dynasty XXI and XXII rulers at Tanis, discovered by P. Montet, were built inside the temple courtyards. These simple structures, made of roughly finished stone blocks, have rather mediocre decorations. Silver rather than gold is predominant in the sarcophagi and tomb furnishings.

Meanwhile an independent state developed in Nubia. As the power of the Egyptian rulers declined, the authority of the Egyptian viceroys there grew weaker and weaker. In the region of Napata, west of the Fourth Cataract, a new center of government came into being and soon controlled a large territory, including the regions south of the First Cataract formerly subject to the viceroy of Nubia. Piankhy (751–716 B.C.), whose capital was

at Napata, conquered the rest of Egypt and founded a Nubian (sometimes called an Ethiopian) dynasty, Egypt's Dynasty XXV. Although the Nubian kings officially resided at Thebes or Tanis, they built their stone tombs, shaped like small slender pyramids, near the Gebel Barkal in the Napata region. A magnificent Dynasty XXV portrait of a governor of Thebes, Mentuemhat, represents a man with typical Nubian features and an unusual hair style (fig. 594).

Defeated by the Assyrians, who captured and destroyed Thebes, the kings of Dynasty XXV withdrew to their native Nubia, where they preserved and sustained the great tradition of Egyptian culture. The history of the Nubian kingdom can be divided into two main periods. The first lasted until 295 B.C., when Napata, the capital, was destroyed. In the second period Meroë (between the Fifth and Sixth Cataracts) was the capital; this Meroïtic period lasted down to the middle of the fourth century A.D. Meroïtic art is Egyptian in form and to a very considerable extent in content as well.

MEANWHILE, in the north, in Egypt proper, a young Egyptian prince from the city of Sais in the Delta fought beside Ashurbanipal, conqueror of "the thousand-templed Thebes," and later proclaimed himself king of all Egypt. After the withdrawal of the Assyrians, he also conquered Upper Egypt with the help of Ionian and Carian mercenaries. This prince, Psamtik, was the founder of Dynasty XXVI. This period saw the emergence of a new "classicism" in art, modeled not upon Old Kingdom art but upon that of Dynasty XVIII—thus Saite art can be termed "neoclassical."

Dynasty XXVI (or the Saite Dynasty) lasted less than one hundred years, from 664 to 525 B.C. Nevertheless, the Saite style left an unmistakable imprint on later Egyptian art. Herodotus waxed enthusiastic about the magnificent edifices built by the Saite kings in the Nile delta, almost none of which have survived intact. Since 1957, Polish excavations at Tell Atrib (the former Athribis, one of the three largest cities in Late Period Egypt) uncovered traces of some peculiar funerary structures. A box deposited in the foundation trench contained gold sheets bearing the name of the Pharaoh Amasis (570–526 B.C.), whom the Greeks honored for having subsidized the building of the temple of Apollo at Delphi. As a protection against the damp soil of the Delta, these tombs were built on high rectangular mounds of sand reinforced with dried bricks. In the course of recent American excavations at Mendes the foundation of an immense temple dating from this period has been uncovered. Seven layers of limestone blocks lie beneath the granite naos of the temple, which is still standing. This discovery gives

some idea of the mighty scale of the temples that aroused Herodotus' admiration. The Saite kings also built in Upper Egypt; this is shown by chapels of this period in the temple at Karnak, the chapels of the Saite princesses at Medinet Habu, and the precincts of the sanctuary at Medinet Habu (which Nectanebo later usurped and claimed as his own).

In the early 1950s, an inspector of the Egyptian Antiquities Service discovered at Tell Atrib several fragments of the tomb furniture of Queen Tahut, wife of Psamtik II. Among them was a tiny pair of exquisitely worked gold sandals, only a few inches long. These diminutive replicas of the royal sandals are typical of surviving Saite works of art, which are predominantly small in scale. The Saite artist attempted to equal the great art of his ancestors and to underline in every detail his links with the past. One of the best-known works of this period is the famous "green" head—a portrait of an aged priest (fig. 608).

Like the classical art of the New Kingdom, Saite art is characterized by careful treatment of details, but the frequently fragile figures of this period lack the balanced proportions characteristic of Dynasty XVIII. Some works, however, convey a touch of the Greek spirit in their softer treatment of the cheeks and the chin. Another noteworthy feature of Saite art is its predilection for animal figures.

Persian rule in Egypt was marked by a succession of disasters, especially repeated famines. However, even in this period temple-building continued; the Persian king Darius dedicated a temple in the Khargeh oasis to the Theban god Amon. The reliefs carved on its walls lack the careful execution so characteristic of the Saite period. However, the neoclassical tendencies initiated by the Saite kings revived during Dynasty XXX, the last of the native Egyptian dynasties. The avenues of sphinxes at Luxor, a gateway at Karnak, and the "chapel of divine birth," or Mammisi, at Denderah, all of which were built by Nectanebo I, return to traditional, classical Egyptian forms. The same is true of a small stone slab dating from this period, found in the course of Franco-Polish excavations at Edfu—possibly an approved design for a figure of Hathor. The subtle modeling of the face and mouth bring to mind the archaic Greek smile. There is authentic mastery in the exact rendering of the textures of garments, collars, locks of hair, and embroidery. Here is proof that the canon developed more than two thousand years earlier gave Egyptian artists something to fall back

on after times of trouble, when surely neither artists nor their workshops prospered.

Before Ptolemy I Soter ascended the throne of Egypt, in 304 B.C., the country had been ruled first by Alexander the Great and then by his weak successors Philip III Arrhidaeus and Alexander IV. These three reigns, however, contributed little to Egyptian art and culture, apart from (possibly) some minor alterations in the Luxor temple, a small granite sanctuary at Karnak built by Philip III Arrhidaeus, and the foundation laid for a new capital at Alexandria.

THE almost three hundred years of the Ptolemaic dynasty marked a new epoch in Egypt. The development of a money economy was of tremendous importance, although the purchasing power of the Ptolemaic drachma constantly fluctuated and sometimes there were periods of inflation. When Alexander the Great conquered Egypt, most of the land under cultivation was owned by the temples; but within a short time the Ptolemies proclaimed these lands to be royal property and leased them to the priests. State revenues were further increased by taxes on lands granted to retired soldiers and by heavy tributes from occupied lands such as Cyprus. In the aftermath of war and unrest, such measures enabled the Ptolemies to embark upon an ambitious program of restoring ancient Egyptian monuments and building magnificent new temples. They were well aware that only in this way could they establish themselves as successors to the great Pharaohs—a matter of fundamental importance to a foreign dynasty.

To move the capital back to Thebes was out of the question, as it had been too thoroughly destroyed by the Assyrians. Morever, as early as Dynasty XXVI, Thebes had ceased to be the permanent residence of the Pharaohs, and the center of government had increasingly shifted toward the Delta. In view of the new international political order centered on the Mediterranean basin, it was preferable to have a capital that was also a seaport. During the Hellenistic era, fast-growing Alexandria became the largest city of the western world. Its fine harbor attracted merchants and craftsmen from many countries (especially the Levant), for here they found opportunities for rapid self-enrichment. There was also a large Jewish colony.

The Greeks, however, held the leading positions in the city, and they left their mark everywhere in this metropolis. Here Alexandrian poetry was born; valuable fragments of Greek literature have come down to us, written on Egyptian papyri. The Ptolemies encouraged the development of science and the arts in Alexandria, as well as in the provinces. Greeks lived throughout Egypt. They served as government officials and often

owned land, particularly in the Fayum where they introduced the large-scale cultivation of grapes and olives. Most Greeks, however, were tradesmen and small merchants; they established themselves in nearly every town up to the southernmost boundary of Ptolemaic Egypt. Hundreds of Greek ostraca, for instance, have been discovered at Edfu.

BECAUSE the Ptolemies pursued an ambivalent policy—on the one hand they strove to Hellenize Egypt, and on the other they sought to preserve native ways of life—no real fusion of Greek and Egyptian culture could come about. Before Ptolemy I Soter ascended the throne, there was still the possibility of forming a new Graeco-Egyptian culture. The well-known tomb of Petosiris at Tuneh el Gebel, dating from the end of the fourth century B.C., seems to announce such a synthesis. It was built about thirty years after the conquest of Egypt by Alexander the Great, and its reliefs reflect both Greek and purely Egyptian styles. The figures wear Greek garments, and the variety of postures and gestures marks a complete departure from Egyptian tradition. The artists had completely broken down the monotony that occasionally appears in the motifs of Egyptian tomb decorations. The scenes of grape picking, wine pressing, and craftsmen at work are among the finest (figs. 130, 631–38).

Had artists continued along these lines, a great and entirely new style might have arisen in Egypt. The synthesis was never realized, however, because the Ptolemies wanted at all costs to be regarded as heirs to the Pharaohs, rather than as creators of a new Egypt. Greek culture was to develop side by side with Egyptian culture, and did not merge with it in a new "melting pot" civilization. So we find two quite different arts flourishing in Ptolemaic Egypt: Alexandrian (Hellenistic) and Ptolemaic (traditionally Egyptian). In addition to numerous masterpieces of Hellenistic sculpture, Alexandrian artists produced works more typical of the country in which they were created. There are statues of the new gods, such as marble busts of Serapis and many representations of a Hellenized Horus—Harpocrates—as well as genre scenes drawn from the life of Alexandria. Greek artists were often inspired by the tradesmen, drunkards, beggars, and other picturesque characters of the great seaport. Erotic subjects (often inspired by local cults) were especially favored by Alexandrian artists, and most frequently treated in small sculptures. The device of *sfumato* has already been mentioned as a special feature of Alexandrian modeling. Although the Alexandrian is an important chapter in the history of Greek art, any further discussion of it would overstep the boundaries of this book; Ptolemaic art, however, is an integral part of Egyptian tradition.

Under the combined influence of these two artistic traditions—the Hellenistic and the Egyptian—there slowly developed a new style which asserted itself only at the end of the Ptolemaic Period, actually in Roman times. It produced architectural and sculptural works that reflect a compromise between the two traditions. Unfortunately, few examples of this syncretism have survived.

Ptolemaic reliefs do not, at first glance, differ greatly from stereotypes of official Pharaonic art. Only close observation reveals that there have been real innovations, especially in the treatment of the human figure. Modeling has become much less stiff: there is a sense of the underlying bone structure and musculature. This was a typically Greek way of working and one that Egyptian artists had never before used. In most cases Ptolemaic reliefs are deeply incised; this accounts for the strong chiaroscuro which does so much to soften the modeling. Thus an attentive viewer, although unfamiliar with hieroglyphs and unable to read the inscriptions, will quickly notice the difference between Ptolemaic and earlier Egyptian reliefs (figs. 639–47).

In statues of the gods and rulers, only the modeling of the face seems new and different. The entire body retains a rigid hieratic posture, and hardly departs in its modeling from traditional forms. On the contrary, there is sometimes exaggerated stiffness and dryness in the treatment of the body surface (figs. 692–97). In some statues of goddesses Greek influences are apparent in the way the diaphanous garments cling to the body and reveal its contours.

The Ptolemies not only built new temples, they enlarged older ones. Of the many magnificent architectural works that have survived from this period, the complex of temples dedicated to Isis on the island of Philae is the most outstanding. At Denderah the Ptolemies began construction of a temple to the goddess Hathor; the façade columns are connected to one another by a carved screen that rises to about one-third of their height. At Esneh a new temple was built, dedicated to the worship of Khnum. At Kom Ombo a sanctuary consecrated to Sobek and Haroeris had separate entrances leading off the central axis to the chapel of each god. The best-preserved temple is the one the Ptolemies built at Edfu. There had been a less important temple dedicated to Horus as early as the Middle Kingdom, but it was only in 237 B.C. that Ptolemy III Euergetes (246–221 B.C.) began construction of a great temple dedicated to this god. The work was completed two hundred years later, under Ptolemy XII Neos Dionysos (80–51 B.C.). Two immense pylons lead into a court surrounded by columns remarkable for the variety of their capitals. The composite type—formed of lotus calyxes and stems—predominates. It appears for the first time in the Ptolemaic

Period (see Chart XI, pp. 578–79). There are reasons to believe that it was inspired by the Corinthian capital, which became increasingly popular in the fourth century B.C. and eventually, in Hellenistic and Roman times, became dominant in classical architecture. In front of the entrance pylons and outside the façade of the hypostyle hall, there stood tall granite statues of the falcon-headed Horus. The interior of the temple follows the classical plan. To the right of the hypostyle hall there is a stairway leading to the roof, where processions were held. Its walls were decorated with scenes of battles between Horus and Seth (figs. 654–59).

From 1936 to 1939, the tents of the Franco-Polish archaeological expedition were pitched close to the walls of the Edfu temple. Near the temple stands a great *kom*, or artificial hill, formed by the layers of remains from necropolises and settlements ranging from the Old Kingdom to the Arab period. Edfu, the ancient Djeba, was a nome capital and had been from time immemorial an important center of agricultural production as well as a great religious center of the Horus cult.

In the course of three years, working at the foot of the *kom*, the expedition explored the Old Kingdom mastabas and a necropolis dating from the First Intermediate Period. Working from the top down, archaeologists dug through successive layers of a Coptic town and a Roman town beneath it, and brought to light the foundations of a city dating from the Ptolemaic Period which extended over the entire width of the hill. Narrow streets led into small squares lined with shops. This was the market place of the western portion of the original town. Built of dried brick, the houses consisted of two or three vaulted rooms. Small openings in the vaults served as windows, admitting light. The steps leading to the houses sloped downward from the street, because the houses were partly below street level. This Edfu type of house is characteristic of southern Egypt and Nubia, whose inhabitants were primarily concerned with protection from the sun. During the day the interiors were cool, and in the evening open terraces supplied a place for social life. The terraces were formed by filling with sand the spaces between the exterior walls of the house and the vaulted rooms.

Large, slender amphorae for wine and small perfume flasks—so different from traditional local forms—clearly exhibit the influence of Hellenistic Greece on Egyptian ceramics. In the Ptolemaic houses at Edfu there were terracotta figurines of the Egyptian god Bes, and limestone statuettes in the Hellenistic style, among them a version of Leda and the swan, a popular motif in Greek art. Leda's hair, however, is arranged in the typical Egyptian style, like that of female figures dating from the Old Kingdom.

The Roman layer at Edfu (then called Apollinopolis Magna) presented a picture of advanced Hellenization and even Romanization. The houses had bathrooms, tubs coated with watertight cement, and a complex heating system which had fired brick hypocausts heated from below by a furnace —all typically Roman. Such houses probably belonged to centurions of the Roman garrison stationed there. Like the English in their African or Asian colonies, the Romans in Egypt imposed their own way of life and insisted on the conveniences they were accustomed to in Italy, regardless of their suitability to a different climate.

UNTIL quite recently, there stood in the center of modern Alexandria a hill with a fort dating from Napoleonic days. When the local authorities decided to raze the hill, known as Kom el Dikka, to make room for new buildings, the Egyptian Antiquities Service asked the Polish mission to investigate the site before foundations were laid for new structures. Experimental probes shortly gave way to systematic excavations, and among the discoveries were large Roman baths and a theater of the classical type with tiers of marble seats. Although the excavations are not yet complete, it is clear that the theater had been remodeled several times during the Roman occupation. Under the marble seats (made from walls and cornices of an older building near the harbor) coins were found dating from the reign of Constantine II; these indicate that the last remodeling could not have been earlier than the second half of the fourth century A.D. As in other Roman theaters in the eastern provinces of the Empire (for example, the theater at Bosra in Syria), the auditorium was surmounted by a colonnade. Only the foundations of the stage building have been preserved, because in the Christian period the theater was covered by a cupola and converted into a sacred edifice. Enough has survived to permit a partial reconstruction, and today it is once again a theater. Roman baths and other classical theaters have also been found near Alexandria.

Polish excavations at Tell Atrib have brought to light gigantic Roman baths decorated with monolithic columns. The town—a well-known urban center since Dynasty XII and the birthplace of the famous architect Amenhotep, son of Hapu—seems to have become a health resort in Roman times.

Unlike some of the former British colonies, the Egypt conquered by the Romans was no wilderness but rather a country with a civilization thousands of years old. Even in the provinces the mummy cases of officials are distinguished by careful execution, and the scenes painted on them are expressive of a rich religious and philosophic heritage. Like the Ptolemies before them, the Romans were obliged to make concessions in order to adapt themselves

to local cultural traditions. Thus the statue of Augustus from the Karnak temple exhibits the hieratic posture and garb of the Pharaohs (fig. 133). Later emperors, such as Hadrian, followed his example. They built temples dedicated to local gods—for example the recently dismantled Nubian temples at Dabod, Dendur, and Kalabsha—and also embellished ancient shrines with new monuments, like Trajan's kiosk on the island of Philae.

Among other sites rich in artistic and architectural monuments from Roman times are the towns of Karanis, which was excavated by American archaeologists; Ehnasiya (Heracleopolis Magna), excavated by Sir Flinders Petrie; Hermopolis-Ashmunein; Tuneh el Gebel; and Antinoupolis, near which the emperor Hadrian's favorite, Antinoüs, was drowned in the Nile.

F ROM the Fayum oasis come two art forms highly characteristic of Egyptian art in the Roman period. First, there are black granite portraits of priests and local dignitaries, found at Dimeh and dating from the end of the first and the beginning of the second century A.D.; a few similar sculptures have been found at Alexandria. The men are sometimes portrayed wearing Roman dress, although Egyptian sculptors never learned to render it faithfully. The treatment of the heads reflects a compromise between Graeco-Roman forms (the short haircut, for instance) and Egyptian execution (the polished surface and hard stone). Such compromises produced rather stiff portraits, which fail to come up to the best standards of either tradition. It is possible that this was a period of artistic decline so far as the sculpture workshops were concerned. Artists and craftsmen seem to have suffered from the lack of suitable patterns and models for this kind of work. The Egyptian canon of the human figure was no longer widely used, and sculptors failed to develop new forms.

The other Fayum art form—the famous portraits—exhibits very high standards. Here the Egyptian tradition made a creative contribution to the art of late antiquity that was then emerging in the Near East. The wide-open expressive eyes in these portraits mark the beginning of a new development that will culminate in the Byzantine icon (figs. 138, 701–8).

This art was a distinct departure from the arid late Alexandrian syncretism exemplified by the reliefs in the underground necropolis of Kom el Shukafa in Alexandria. There Anubis wears a Roman toga, and Thoth and Horus have legionaries' armor (figs. 684–91). Though they are interesting illustrations of late Hellenistic Gnostic beliefs, they hardly constitute a new art form. Similarly, in Hellenistic vase paintings from the Alexandrian necropolis at Hadra, dating from the early Ptolemaic Period, there are figures of the Egyptian god Bes side by side with traditional Greek ornamentation. The

classical garland and *bucrania* are accompanied by an Egyptian composite capital; a frieze combines cobras and winged disks of the god Ra.

Whereas late Alexandrian syncretism was short-lived and failed to produce satisfactory artistic results, the art of the Meroïtic kingdom presents an entirely different picture. Even after Egypt had become entirely Christianized and the new Coptic art was flourishing in desert monasteries and urban basilicas, the rituals of Egyptian religion and the decorative forms of Egyptian art persisted in the region between the First and Fifth Cataracts.

Meroïtic art was not a rigid imitation of New Kingdom and Saite models. The reliefs in the great temples at Naga and Musawarat, recently subjected to exhaustive study by East German archaeologists under Professor F. Hintze, reveal a number of local motifs, especially in royal garments and the treatment of indigenous gods unknown to the Egyptians (figs. 648–52). Some "classical" Graeco-Roman elements were also adapted. Despite the relative isolation of the Meroïtic kingdom throughout its six-hundred-year history, it had many contacts with Egypt through trade as well as warfare.

As early as 591 B.C., Psamtik II (Dynasty XXVI) organized an expedition against Napata. On the way home, his mercenaries incised the famous graffiti on the legs of the colossal statues at Abu Simbel. Just prior to Alexander the Great's conquest of Egypt, a Nubian king had been the *de facto* ruler of Egypt for three years. In 24 B.C. Meroïtic troops captured the islands of Philae and Elephantine, and carried off, along with other spoils of war, the bronze statue of Augustus—in Roman style—which had been placed there only a short time before. The head of this statue, one of the finest surviving portraits of Augustus, was discovered in the course of archaeological excavations in the palace at Meroë. Petronius, a Roman general under Augustus, conquered the city of Napata, and later Nero sent a military expedition to Meroë which penetrated as far as the great marshlands of the White Nile in the region of Fashoda. In the end, however, the Meroïtic kingdom and the Roman governors of Egypt reached an understanding. The boundary between the two powers—more accurately, between their spheres of influence—ran south of the First Cataract through the area where the partly ruined Roman fort of Qasr Ibrim stands today. The Meroïtic kings regularly sent envoys to the island of Philae, bearing gifts for the temple of Isis.

In 350 A.D. Meroë was conquered by Aizanas, ruler of the Ethiopian kingdom of Axum, together with his allies, the Noba tribes. (These were people who had probably inhabited the Nile valley for a long time; they

were divided into the so-called "Red" Noba, between the Third and Fifth Cataracts, and the "Black" Noba, in the area of the Sixth Cataract.) But before its fall, Meroë had managed to develop a style of its own. Among the finest examples of this art are the ceramics. The thin-walled vessels were carefully fired and decorated with stylized plants or animals. The goldsmith's art, too, flourished here (figs. 801–805). Meroë was famous for its metalwork, especially its iron (it is sometimes called the "African Birmingham"). The syncretism of Egyptian Graeco-Roman art is fully apparent in Meroïtic architectural decorations, where classical plant ornaments are harmoniously combined with cobras crowned with disks.

AFTER the fall of the Meroïtic kingdom a new state emerged in northern Nubia as a result of the struggles between two tribes—the Blemmyes and the Nobadas. The latter, whose cemeteries can today be identified with those of the so-called Group X, conquered the territory between the First and Third Cataracts. The last Nobatian capital was Faras (the ancient Pachoras), where the Polish expedition discovered, among other things, ruins of the royal palace. Its decoration was based entirely on Meroïtic models. The well-known tumuli at Ballana and Qustul near Abu Simbel were certainly tombs of Nobatian rulers, at least in the view of the majority of modern archaeologists; Professor W. B. Emery, however, who discovered these tombs, still believes them to be the resting places of Blemmye chieftains.

The rich furnishings of the Ballana tombs and the decorations on the famous horse trappings found there strikingly reflect the fusion of Egyptian and Graeco-Roman elements so characteristic of Meroïtic culture. This fusion was maintained in the art of the pagan Nobadas.

During the fifth century A.D., Christianity gradually spread to Nobatia from Egypt, which by then had been a province of the Byzantine Empire for almost a century. This may partly account for the Christian tombs found in the pagan cemeteries of Group X.

In this period the authority of the government must not have been particularly strong, since the pagan rulers of Nobatia took a fairly tolerant attitude toward Christianity. The new religion had found many adherents among the impoverished and war-weary population of northern Nubia. When these rulers finally decided to set up their capital at Faras, a little church of dried brick was already standing there on a hill near the Nile. Since this spot was the best site in the region for a fortified royal residence, they razed the church to make room for the new building; but they permitted a new church of exactly the same rhomboidal design as the old one to be constructed to the south of their new palace.

Toward the middle of the sixth century, thanks largely to the efforts of Julian, a Monophysite priest sent by Empress Theodora from Byzantium, Nobatia was officially converted to Christianity. The local kings proceeded to transform the stone structure at the entrance to their fortified residence (on the Nile side) into a royal chapel. In 616 A.D., when their palace was partly destroyed by Sassanian raiders, they built a cathedral on the ruins and moved to a new and more modest residence of dried brick. By this time, however, in Egypt proper, Coptic art was well launched on its fascinating career—the last stage in the art of ancient Egypt.

129. KING TAHARQA IN FRONT OF A RAM
Found in the temple of Amon built by
this Pharaoh at Kawa in Sudanese
Nubia. Gray granite. Dynasty XXV.
British Museum, London.

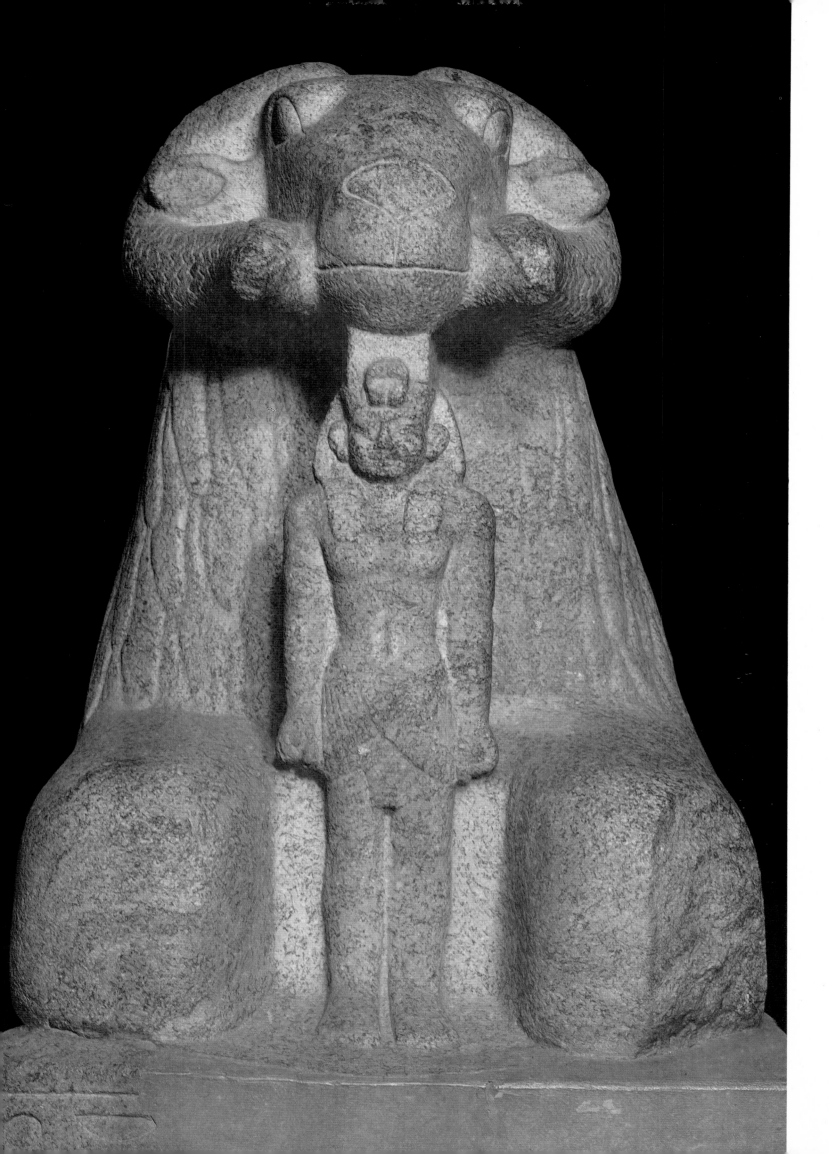

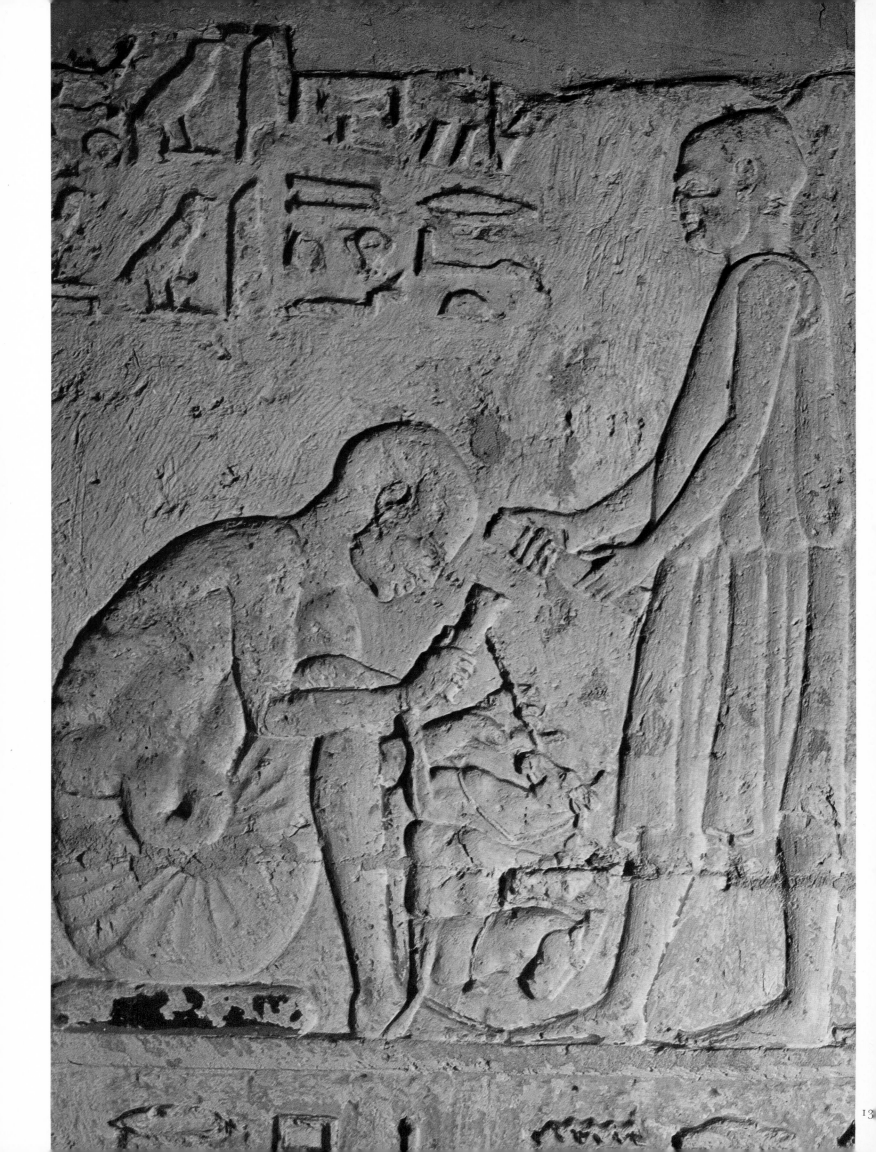

130. TUNEH EL GEBEL. TOMB OF PETOSIRIS
A Sculptor in His Workshop. Executed
in a Hellenistic style, this series of reliefs
decorates the vestibule of the tomb of the
high priest Petosiris. Painted relief
(detail; see figs. 631–38). End of 4th
century B.C.

131. NEFERTUM DANCING ON A LOTUS
FLOWER BETWEEN TWO GODDESSES
Relief on a sandstone column from Edfu.
One goddess holds a sistrum and a menat,
the other holds a tambourine. Late
Ptolemaic Period. National Museum,
Warsaw.

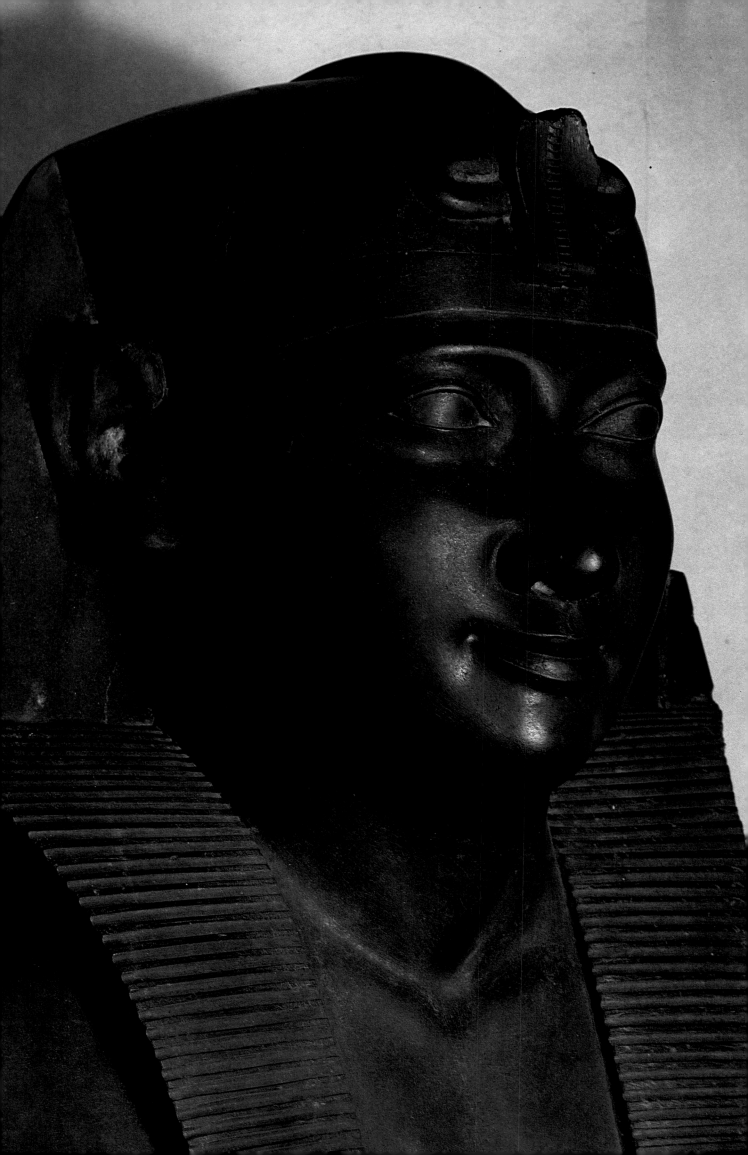

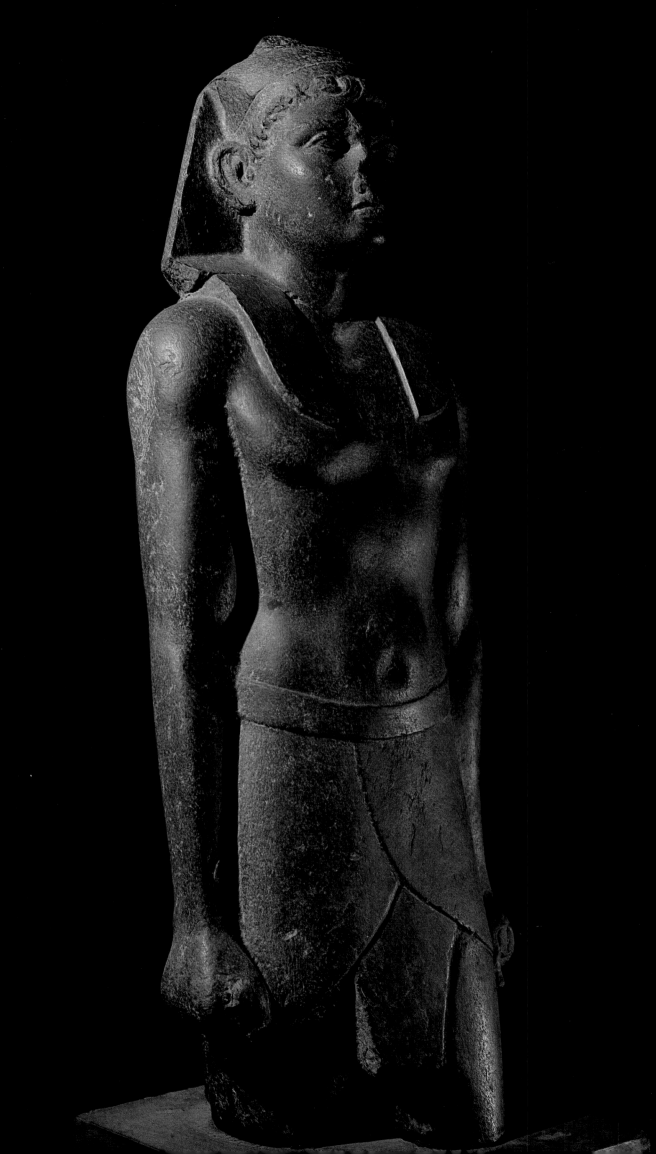

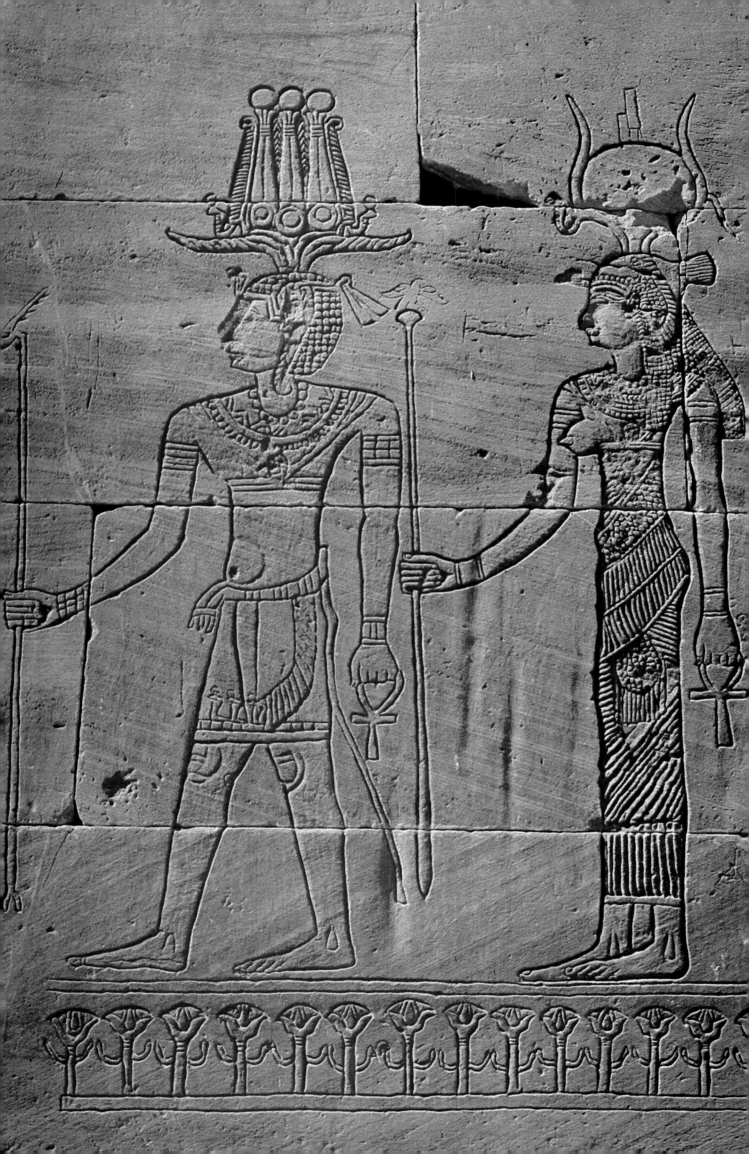

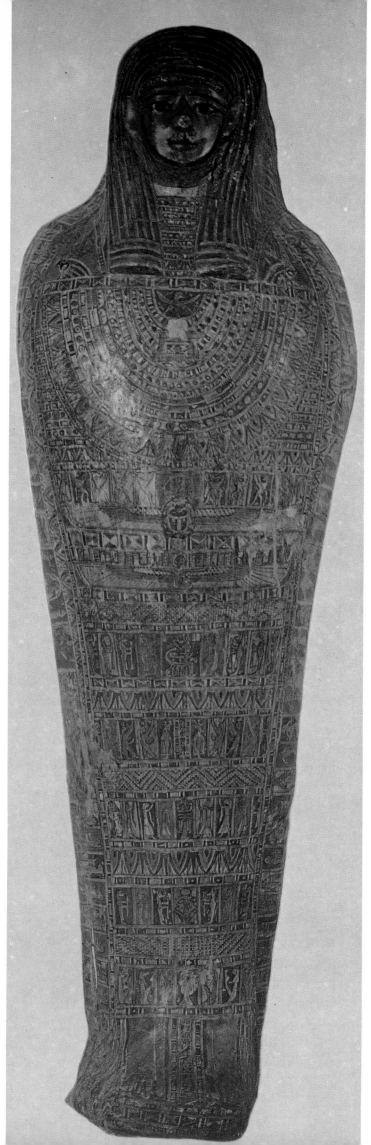

135

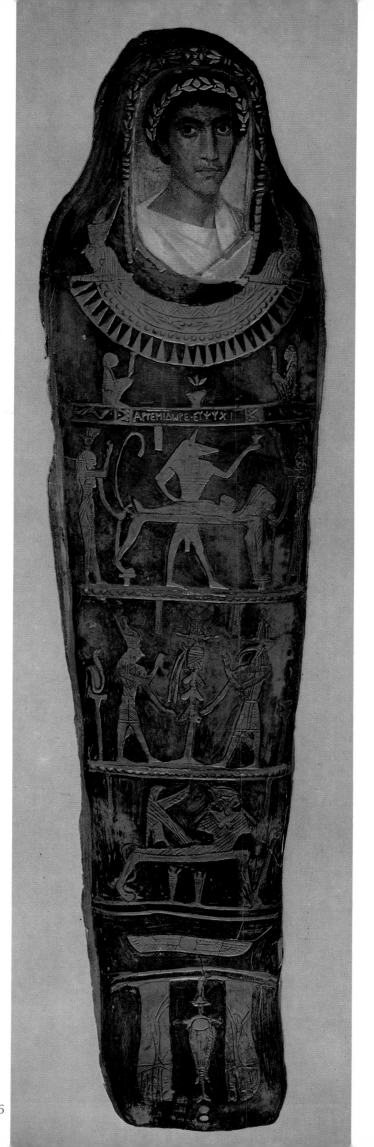

136

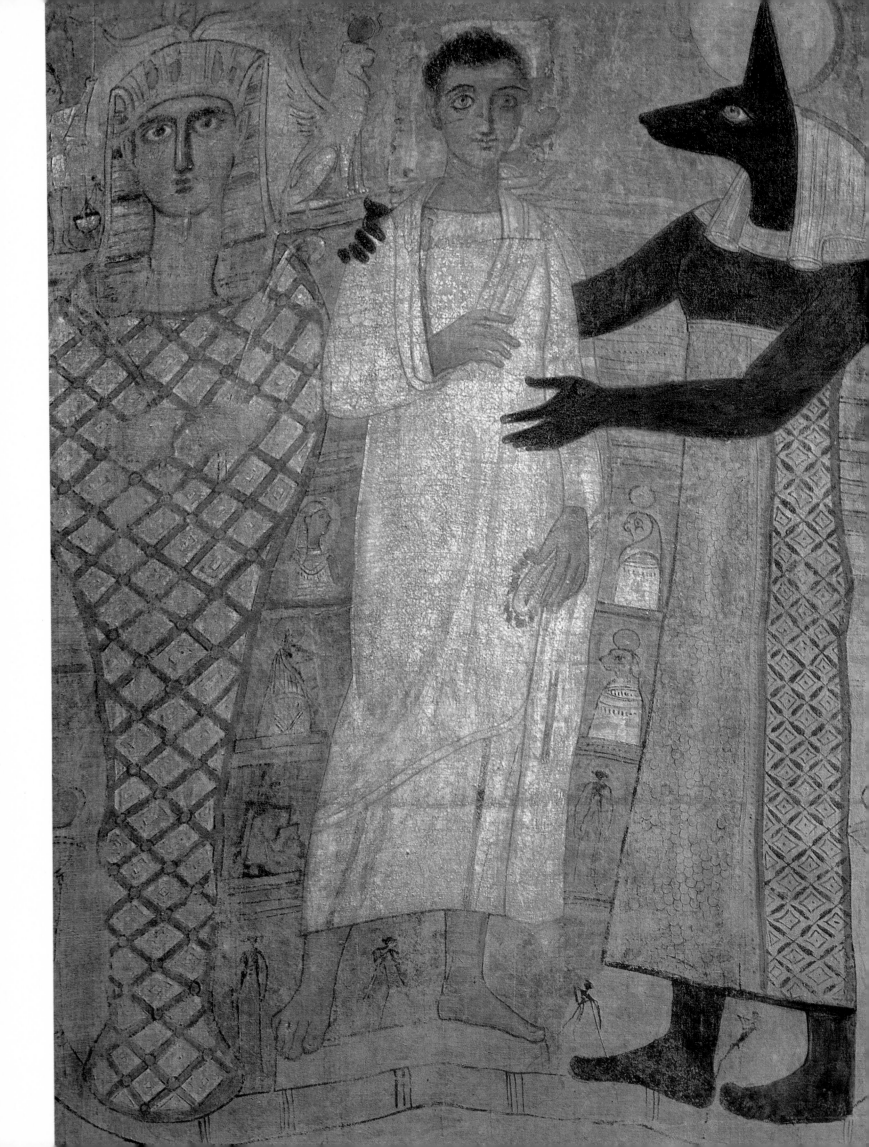

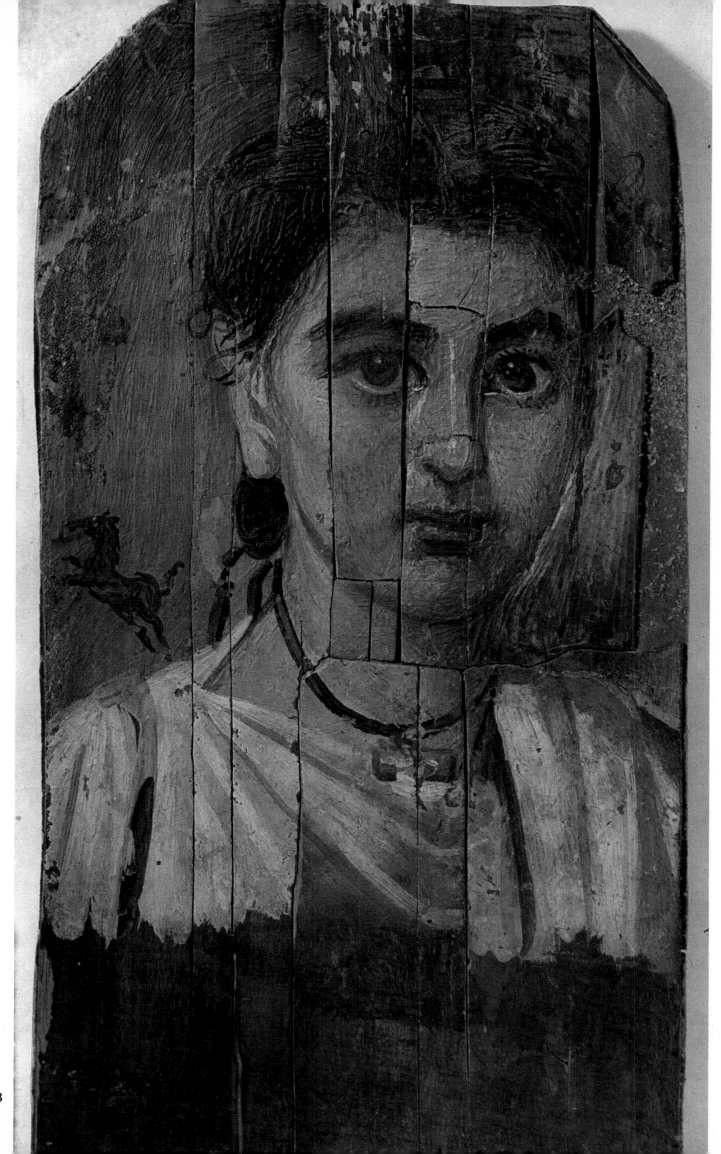

139

13. CHRISTIAN EGYPT

The destruction of the old gods

"Coptic" art, or the art of Byzantine Egypt

The Fayum tradition

Paintings and decorative textiles

The art of Faras

13. CHRISTIAN EGYPT

CHRISTIANITY was introduced into Egypt at a rather early date. St. Mark the Evangelist lived in Alexandria, and this city was the residence of a patriarch as early as the second century A.D. Hermitages had become widespread in Egypt long before the persecution of Christians by Diocletian. The neighboring desert and the many rocky caves of the Gebel provided convenient retreats for hermits, the most famous of whom was St. Anthony. Hidden symbolism in some Fayum portraits suggests that the sitters were Christians. The Edict of Constantine found the country ripe for the new religion, although here and there the centers of worship of the old Egyptian gods, which were being zealously exterminated by the Christians, had managed to survive. This persecution was literally a manhunt: owners of papyrus rolls with drawings of "devils" (as the images of the old gods were called) were tracked down, and many temple reliefs representing religious scenes were obliterated.

Whereas in Byzantium the Melkite version of the new religion became dominant, in Egypt the Monophysites prevailed. Although formally a province of the Eastern Empire, Egypt was rather inefficiently administered. Material remains of the culture show that the country was declining economically. It is therefore not surprising that the art of this period is qualitatively inferior to that of earlier periods. The canon of the human figure and the clarity and legibility of composition, let alone the high quality of execution, were completely lost. And yet, for all its imperfections, the artists of Christian Egypt succeeded in creating a native style, different from that of the Christian East. Egypt, with its unique climate and landscape, was

relatively isolated from the regions to its east and north; but the best explanation for its new artistic flowering can probably be found in the tradition of great Egyptian art and the magnificent development of Hellenistic art in Alexandria. The name "Coptic" by which this art is known is something of a misnomer (the Copts are the Christian minority of present-day Moslem Egypt); "Coptic" art is, more precisely, the Egyptian art of the Byzantine period.

The Christian churches and monasteries could not equal in size the monumental ancient temples. The latter were quickly taken over by the new cult, and their walls were decorated with paintings of Madonnas and archangels. New churches were usually constructed of dried brick, with a main cupola over the crossing of the transept and central nave; smaller cupolas topped the side bays. Only in exceptional cases were fired bricks or stone blocks from older buildings used for religious edifices. The Roman theater recently discovered in Alexandria by the Polish expedition had been converted into a church, as evidenced by capitals and consoles with the sign of the Cross which were found there.

The decoration of churches and monasteries was primarily in the form of large wall paintings. The decorative role of reliefs was very limited, and we know of almost no free-standing sculpture. Coptic representations of St. George slaying the dragon are sometimes in the form of Horus on horseback slaying a crocodile, which becomes a symbol of evil (fig. 718). Elsewhere Greek nymphs and sirens decorate baptistery niches (fig. 716), and even Orpheus appears, playing his lyre (fig. 141).

Coptic art tends to be highly expressive. The faces are dominated by large, wide-open eyes, borrowed from the Fayum portrait style. In contrast, the modeling of the body is not considered important. If the artists on occasion naïvely imitate Greek or Egyptian models, this is simply because they have not yet elaborated suitable patterns for the symbolism of the new religion.

A relief (in the Coptic Museum in Cairo) showing the bathing of the infant Jesus has a seemingly primitive character (fig. 719). Within a classical frame of meanders and rosettes the Child is being bathed in a goblet-shaped basin drawn in "projective" perspective, as though the artist were looking at it from the front and from above at the same time. The woman who bathes the Child is seated at the left; she wears a long embroidered garment and a Phrygian cap; her hair is arranged in Egyptian style. On the right is another woman, dressed in similar fashion, holding a crown in her left hand and a stool in her right. Also illustrated are objects such as a chest, an amphora

on a support, and a disproportionately large comb. The empty spaces are filled with rosettes; this *horror vacui* is characteristie of all primitive art, but here primitivism is harmoniously combined with traditional Greek ornamentation, a remote echo of Egyptian "projective" perspective, and even elements of Eastern iconography, such as the Phrygian caps. Although the work exhibits complete disregard of proportions and even of any sense of reality—the size of the comb corresponds to half the height of a human figure—nevertheless, it possesses a naïve grace. The artist has expressed his intention clearly and legibly.

One of the most striking achievements of Coptic art is its use of decorative motifs. A funerary stele shows a dove carrying a Roman bulla around its neck; in its claws it holds a palm branch and in its beak a cross. Above it, a larger T-shaped cross is placed between two small columns. The whole is framed by two bands of wickerwork ornamentation (fig. 142).

Among the best-known products of Coptic art are the decorations woven in linen, found chiefly on shrouds, which in the dry sand of the desert have been preserved without loss of color. Plants and geometric motifs predominate in borders and bands; there are also human and animal figures, partly taken from the repertory of older art. Such fabrics and occasional ivory reliefs (fig. 722), inlaid in liturgical boxes and caskets, represent Coptic art in most museums (figs. 140, 709–15).

Coptic art came to an end with the Arab invasion in the middle of the seventh century. Remnants, however, survived in some monasteries and churches. Paintings have suffered most; many of them have not only faded but often crumbled away, for they were not executed in the fresco technique but painted on dry plaster. Thus it caused a sensation in the artistic world when the Polish expedition discovered in the Faras cathedral perfectly preserved wall paintings whose importance in the history of art is at least equal to that of the famous collection of icons in the St. Catherine monastery on the Sinai Peninsula.

THE first cathedral at Faras had no paintings. It was built with blocks taken from temples erected by the New Kingdom Pharoahs at Pachoras; the material used came mainly from a temple of Tuthmosis III. In addition, large amounts of pink limestone from the nearby quarries at Argin, near the Second Cataract, were used. Particularly noteworthy are the beautiful pink limestone capitals, with Ionic volutes and grapevine motifs next to Egyptian palmettes.

At the beginning of the eighth century the cathedral was considerably enlarged and supplemented with monolithic granite columns and wall

paintings. The earliest Faras painters cultivated a style that is in part based on Coptic artistic traditions: the figures of angels and the Madonna have the characteristic large, wide-open eyes. Purples, ranging from light to dark shades, and yellow predominate. The figure of St. Anne with a finger pressed to her lips has already become famous. In the middle of the ninth century a new style appears in painting. White becomes the dominant color, and in the portraits of the Faras bishops the features exhibit a strong realism based on direct observation.

In the tenth century, the dominant color in the palette is red. The scene of the Three Hebrews in the Fiery Furnace dates from this period (fig. 728). One of the most magnificent Faras frescoes—a large scene of the Nativity with adoring shepherds and kings—dates from the eleventh century and exhibits a full range of colors. This is a composition without equal, both for its artistic qualities and its iconographic details. The row of horses in the representation of the Three Kings is the earliest painted analogy to the actual horse trappings found in the tumuli at Ballana (figs. 13, 729).

Among the portraits of bishops dating from this period special mention should be made of the portrait of Bishop Marianos protected by the Holy Virgin. Wearing rich liturgical garments, his sallow face framed by a black beard, he brings to mind portraits of Renaissance nobles (fig. 143).

There is no lack of important religious subjects at Faras, including the Crucifixion and the Entombment, otherwise so rare in Nubia. In accordance with the immemorial canon of Egyptian art, the divine faces, and also those of the saints, were painted white, and those of mortals, whether kings, bishops, or shepherds, are usually yellow. Among the diverse ethnic types appearing in the paintings there is Bishop Petros (died in 999), whose dark-brown, almost hairless face clearly indicates Negroid origin. Anthropological analysis of the bones found in his tomb has fully confirmed this. The portraits of these historical figures—a list of bishops with the dates of their tenures was found inscribed on the wall of one niche of the cathedral—provide invaluable data for establishing the various stages of painting, not only in Faras but also in other churches of Nubia and Egypt.

All the Faras paintings have been removed from the walls; half are now in the Archaeological Museum at Khartoum, and half in the National Museum in Warsaw. As revealed by the Polish excavations, Faras was undoubtedly the artistic center of Nubia from the eighth to the thirteenth century. Its style of painting spread both north and south along the Nile valley. This is confirmed by discoveries made by the Dutch expedition at Abdallah Nirgi, north of Abu Simbel, and by Italian excavations now being conducted at Sonki West, south of the Second Cataract.

Can the Faras paintings be classified as Coptic art? Surely not, although there is no doubt that, particularly in the earliest period, Faras artists were

inspired by both Coptic art and the earlier Fayum tradition. Yet the art of Faras has many other elements. The figures of the Three Kings in the great Nativity scene bring to mind Persian miniatures, and the figure of the reclining Madonna is reminiscent of Palmyrene sculpture. Taken as a whole, Faras art is above all a manifestation of Byzantine art as it flourished in the land of the Pharaohs. There, even the T-shaped cross betrays its origin as a stylization of the hieroglyph *ankh*, the symbol of life in ancient Egypt.

140. HEAD OF A DANCER
The style of this fragment shows a Hellenistic tendency. Linen and wool textile; 16 1/2 × 12 5/8". *5th century* A.D. *The Louvre, Paris.*

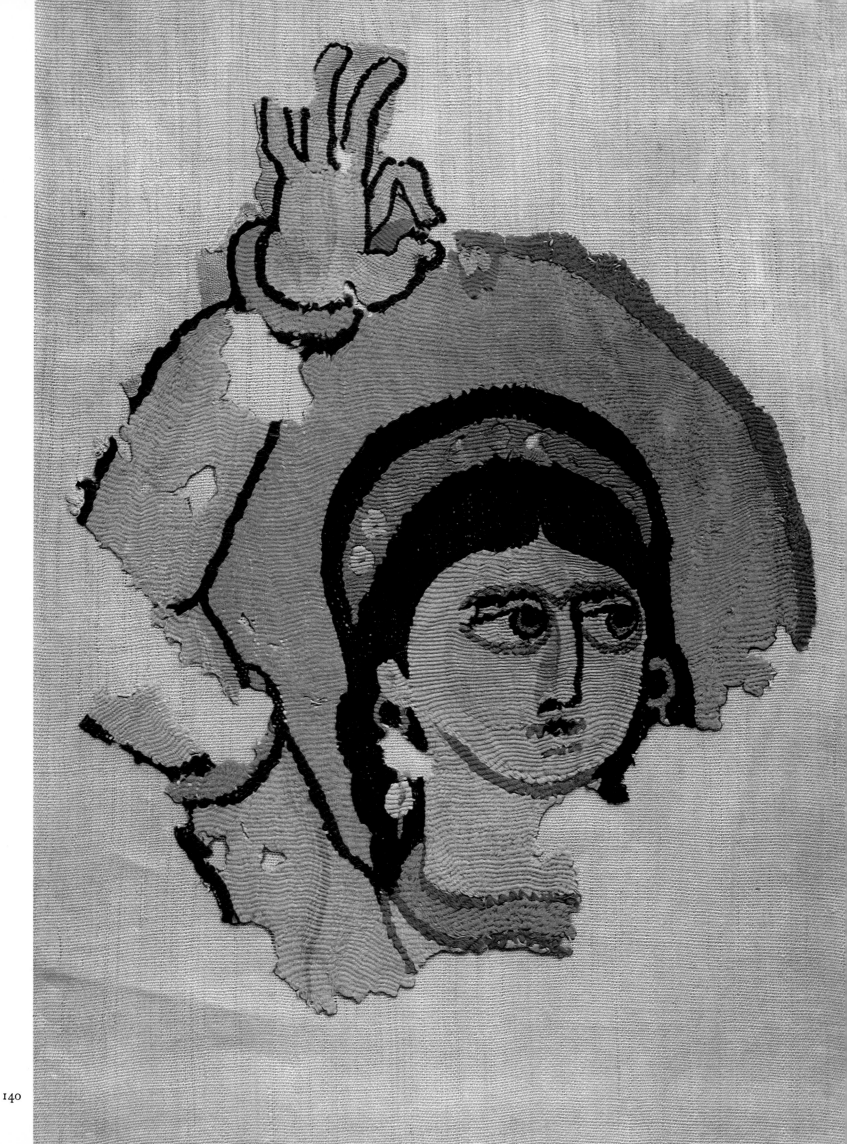

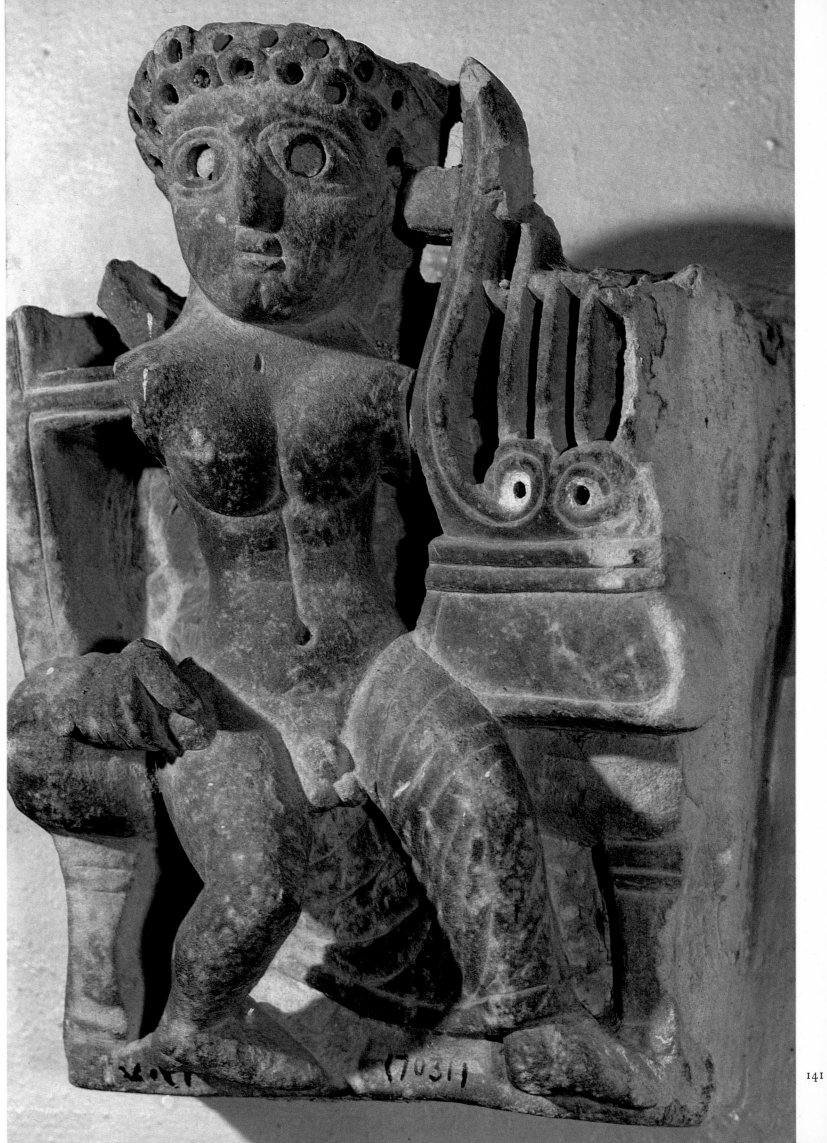

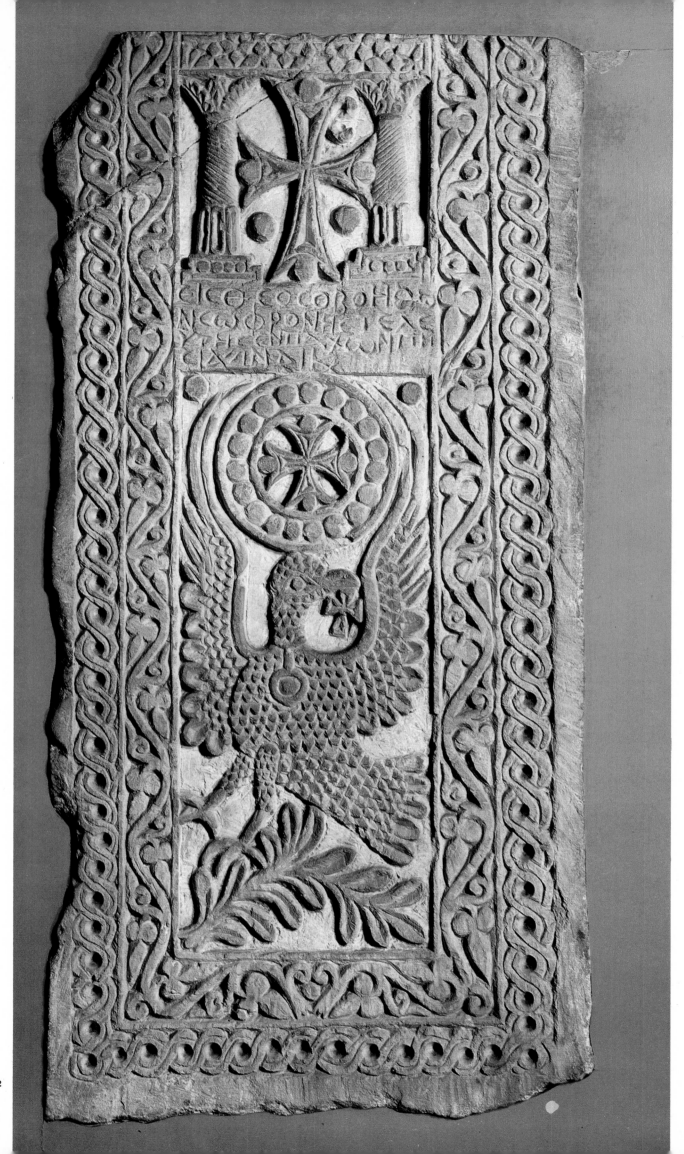

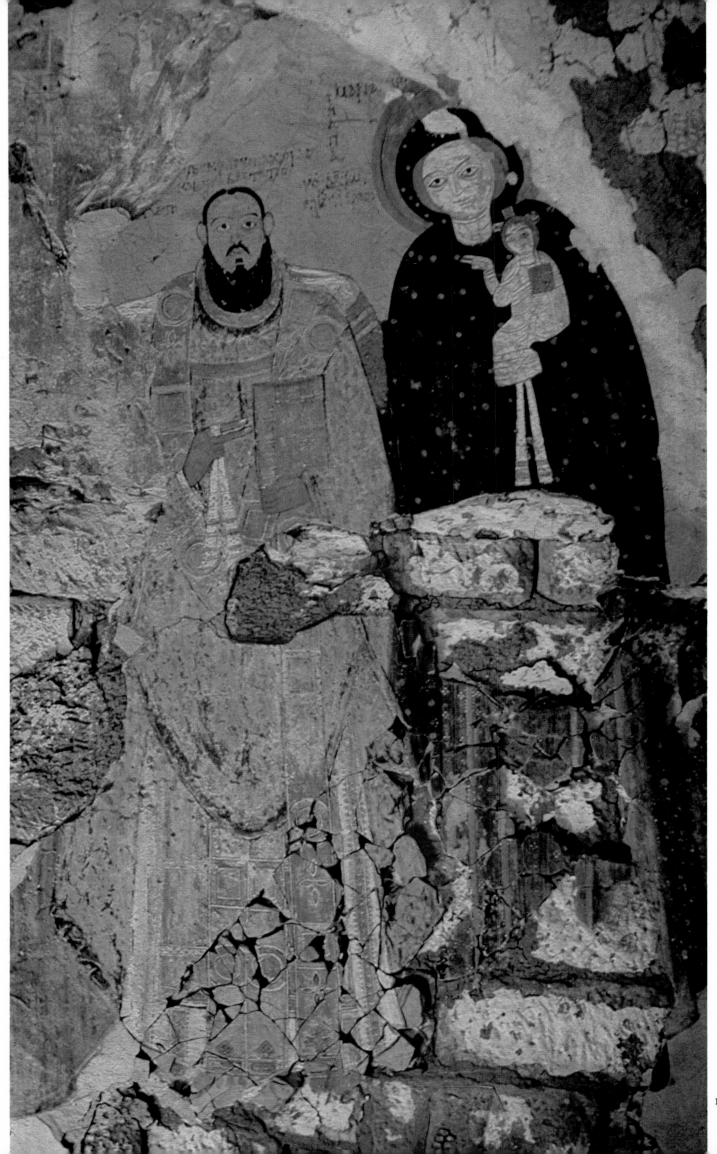

Part Two: Documentation

14. DOCUMENTARY PHOTOGRAPHS

PREDYNASTIC PERIOD

(before 4000 – 3100 B.C.)

THINITE PERIOD

Dynasties I – II

(3100 – 2686 B.C.)

OLD KINGDOM

Dynasties III – VI

(2686 – 2181 B.C.)

FIRST INTERMEDIATE PERIOD

Dynasties VII – X

(2181 – 2133 B.C.)

MIDDLE KINGDOM

Dynasties XI – XII

(2133 – 1786 B.C.)

SECOND INTERMEDIATE PERIOD

Dynasties XIII – XVI

(1736 – 1650 B.C.)

144. CLAY FIGURINE (NAGADAH I)　　145. CLAY FIGURINE (NAGADAH I)　　146. CLAY FIGURINE (NAGADAH I)　　147. CLAY STATUETTE (NAGADAH I)

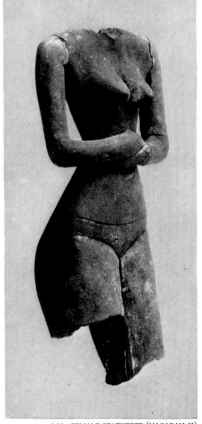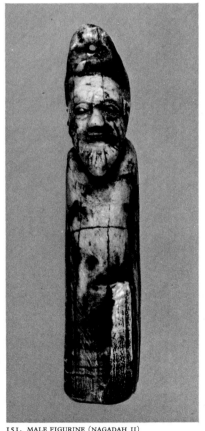

148. SLATE PALETTE (NAGADAH I)　　　　　　　　　　　　　　　　　　　　　　　　　　　　　152. SLATE PALETTE (NAGADAH I)

149. SLATE PALETTE (NAGADAH I)　　150. FEMALE STATUETTE (NAGADAH II)　　151. MALE FIGURINE (NAGADAH II)　　153. SLATE PALETTE (NAGADAH I)

154. HEAD OF A MONKEY (THINITE PERIOD)　　　155. IVORY PERFUME CONTAINER (NAGADAH II)　　　156. FAIENCE BABOON (THINITE PERIOD)

157. STONE JAR (PREDYNASTIC)

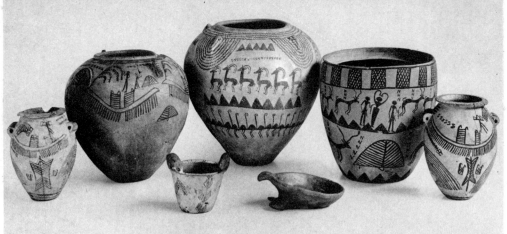

158–164. POTTERY VESSELS WITH FIGURATIVE DECORATION (AMRATIAN)

165. STONE JAR (DYN. I–II)

166. TWO-NECKED VESSEL (AMRATIAN PERIOD)

167. PAINTED CASKET (AMRATIAN PERIOD)

168. TWO-NECKED VESSEL (AMRATIAN PERIOD)

169. FIGURINE OF A BOY (DYN. I)

172. FAIENCE HIPPOPOTAMUS (DYN. I–II)

170. IVORY BOARD GAME PIECE (DYN. I)

171. IVORY COMB (PREDYNASTIC)

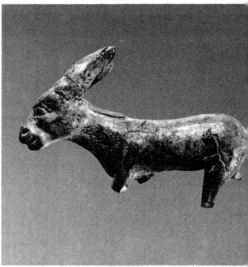

173. IVORY DONKEY (DYN. I–II)

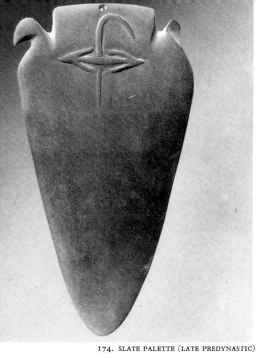

174. SLATE PALETTE (LATE PREDYNASTIC)

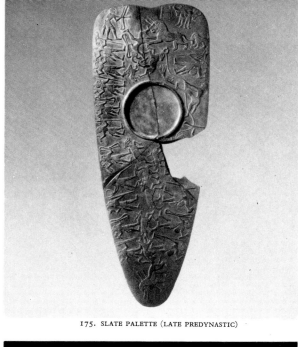

175. SLATE PALETTE (LATE PREDYNASTIC)

176. SLATE PALETTE (LATE PREDYNASTIC)

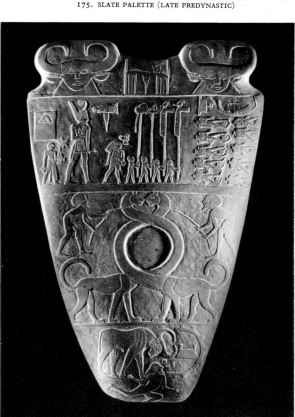

177. SLATE PALETTE (LATE PREDYNASTIC)

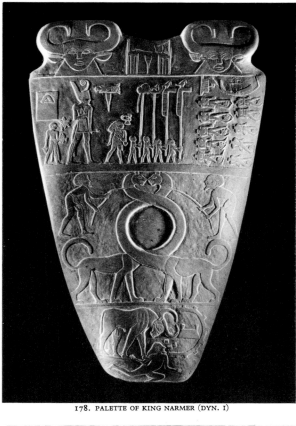

178. PALETTE OF KING NARMER (DYN. I)

179. SLATE PALETTE (LATE PREDYNASTIC)

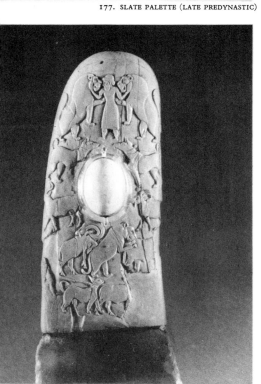

180. IVORY KNIFE HANDLE (LATE PREDYNASTIC)

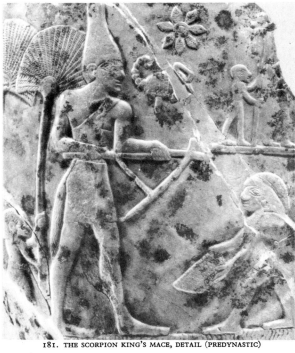

181. THE SCORPION KING'S MACE, DETAIL (PREDYNASTIC)

182. STELE OF LADY KEHEN (DYN. I)

359

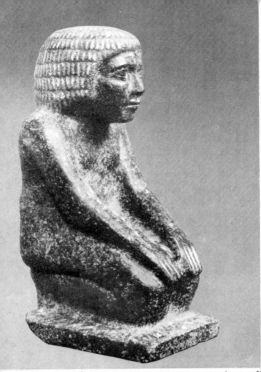

183. HETEPEDIEF, PRIEST OF MEMPHIS (DYN. II?)

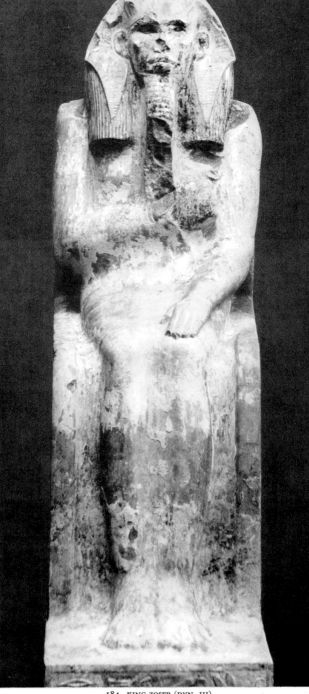

184. KING ZOSER (DYN. III)

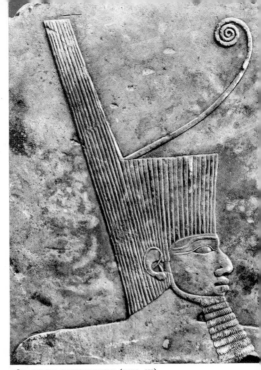

185. RELIEF OF KING ZOSER (DYN. III)

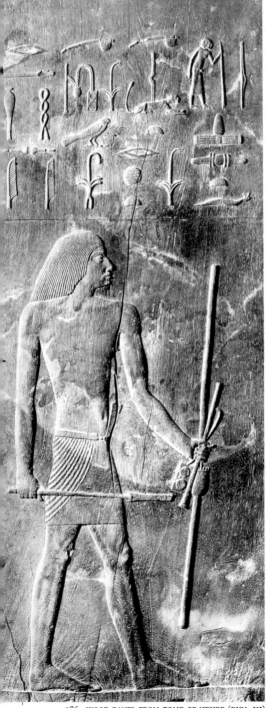

186. WOOD PANEL FROM TOMB OF HESIRE (DYN. III)

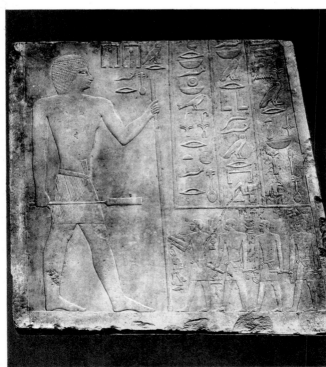

187. FRAGMENT OF DOOR FRAME FROM MASTABA OF NOFER (DYN. IV)

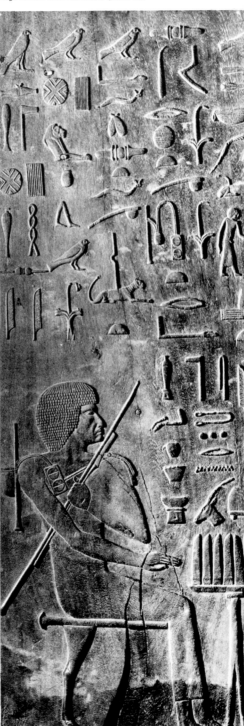

188. WOOD PANEL FROM TOMB OF HESIRE (DYN. III)

360

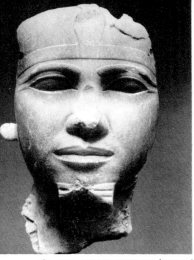

189. HEAD OF KING CHEPHREN (DYN. IV)

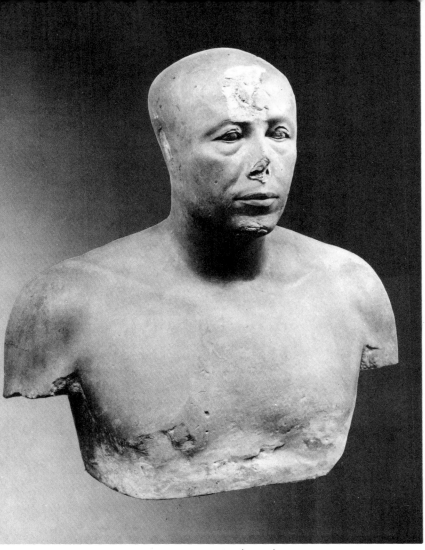

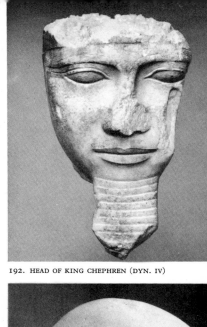

192. HEAD OF KING CHEPHREN (DYN. IV)

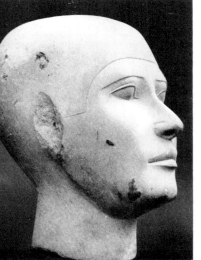

190. RESERVE HEAD (DYN. IV)

191. BUST OF ANKH-HAF (DYN. IV)

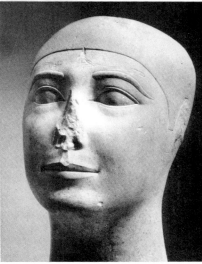

193. RESERVE HEAD (DYN. IV)

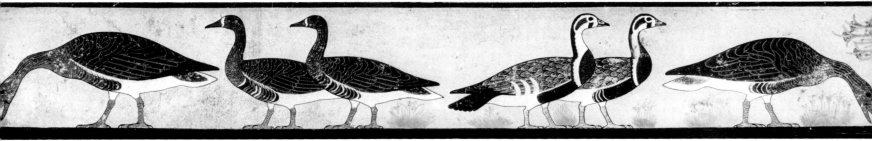

194. PAINTING FROM MEDUM (DYN. IV). GEESE AND DUCKS

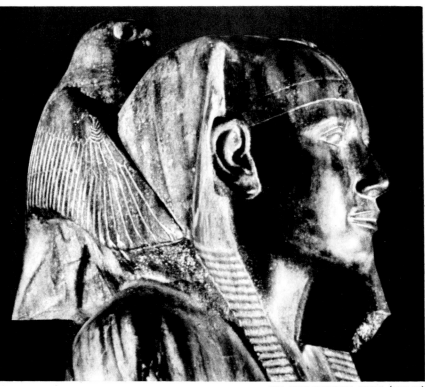

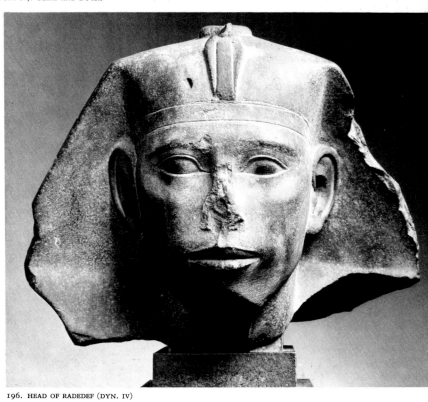

195. KING CHEPHREN, DETAIL (DYN. IV) 196. HEAD OF RADEDEF (DYN. IV)

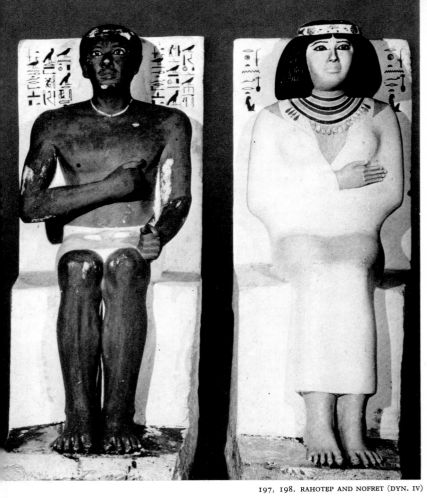
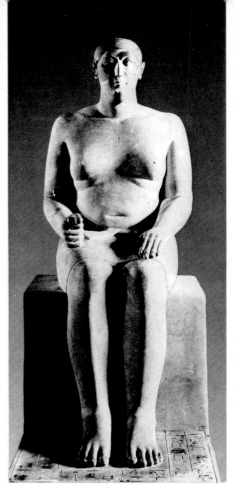
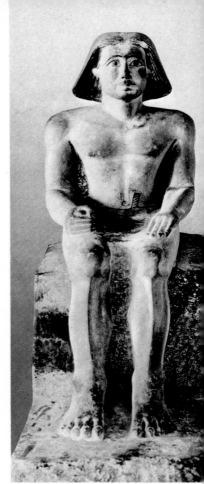

197, 198. RAHOTEP AND NOFRET (DYN. IV) 199. HEMIUNU (DYN. IV) 200. KEKY (DYN. IV)

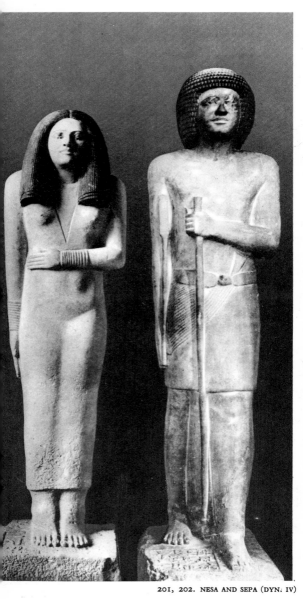
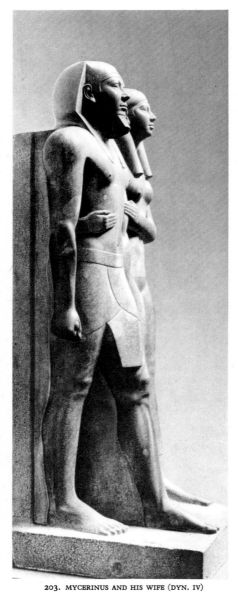
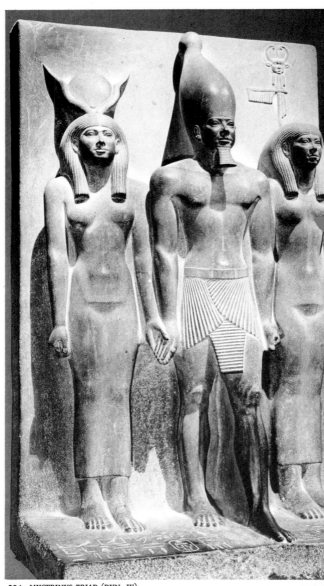

201, 202. NESA AND SEPA (DYN. IV) 203. MYCERINUS AND HIS WIFE (DYN. IV) 204. MYCERINUS TRIAD (DYN. IV)

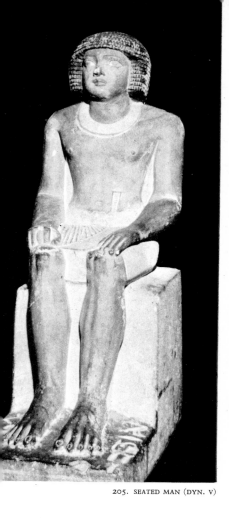

205. SEATED MAN (DYN. V)

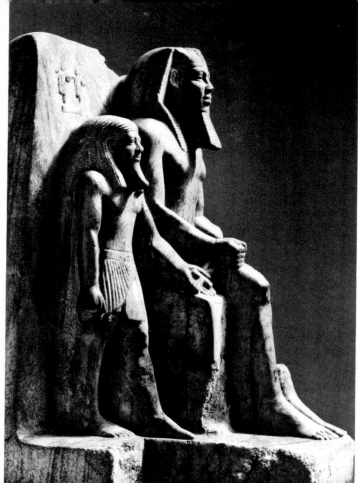

206. SAHURA AND THE COPTOS NOME (DYN. V)

207. SEKHEM-KA (DYN. V)

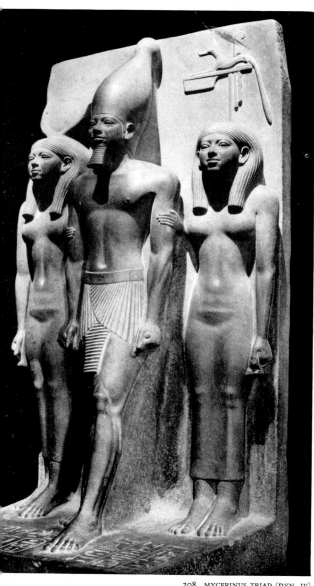

208. MYCERINUS TRIAD (DYN. IV)

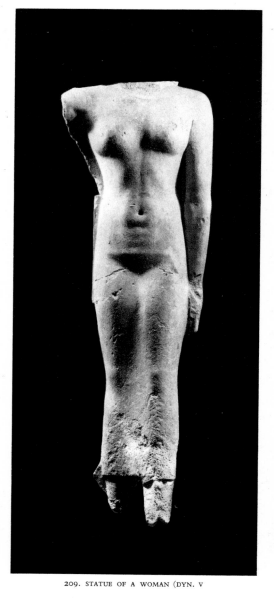

209. STATUE OF A WOMAN (DYN. V

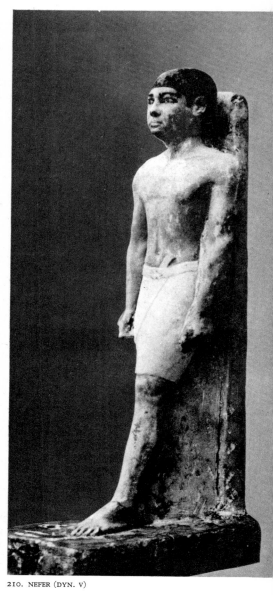

210. NEFER (DYN. V)

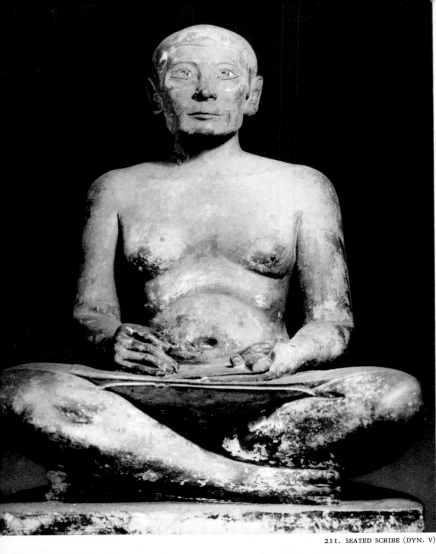

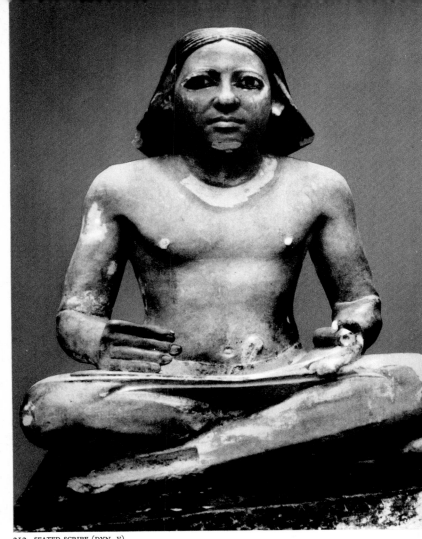

211. SEATED SCRIBE (DYN. V) 212. SEATED SCRIBE (DYN. V)

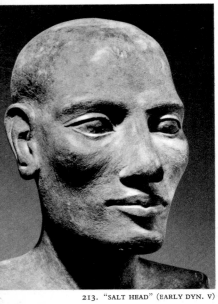

213. "SALT HEAD" (EARLY DYN. V)

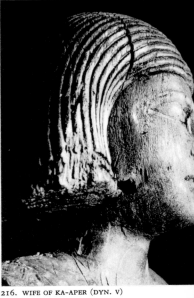

216. WIFE OF KA-APER (DYN. V)

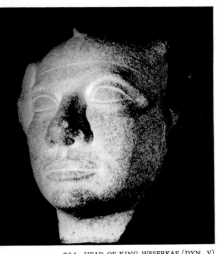

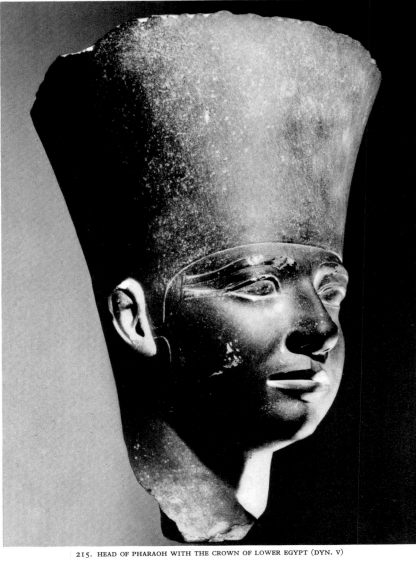

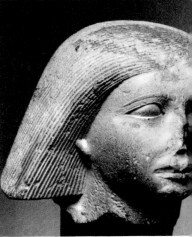

214. HEAD OF KING WESERKAF (DYN. V) 215. HEAD OF PHARAOH WITH THE CROWN OF LOWER EGYPT (DYN. V) 217. HEAD OF A STATUE (DYN. V)

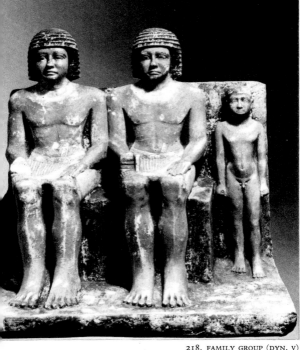

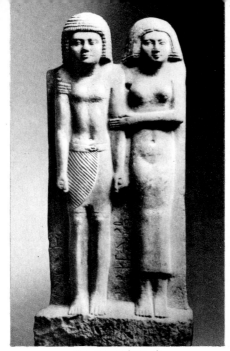

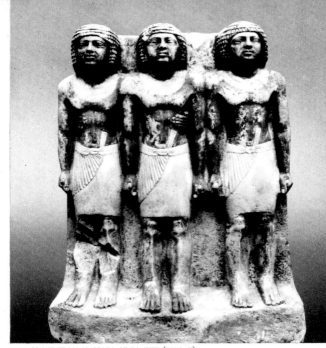

218. FAMILY GROUP (DYN. V)

219. COUPLE (DYN. V)

220. GROUP FROM MASTABA OF RA-WER (DYN. V)

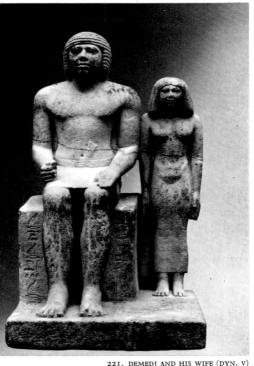

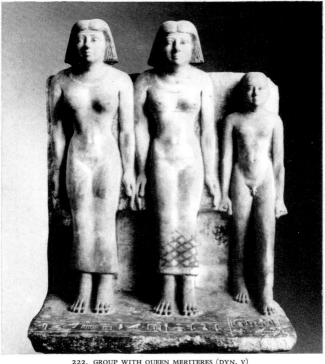

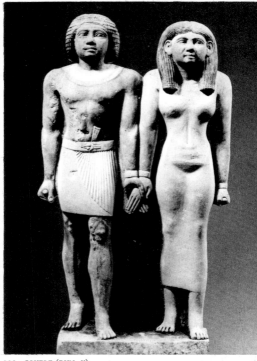

221. DEMEDJ AND HIS WIFE (DYN. V)

222. GROUP WITH QUEEN MERITERES (DYN. V)

223. COUPLE (DYN. V)

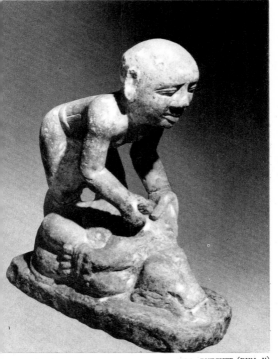

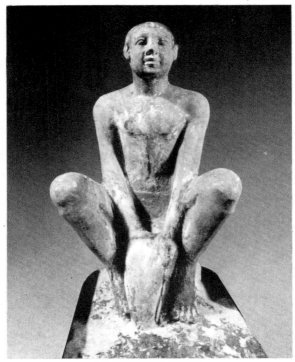

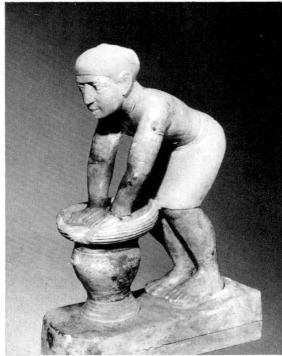

224. BUTCHER (DYN. V)

225. JAR POLISHER (DYN. V)

226. BREWER (DYN. V)

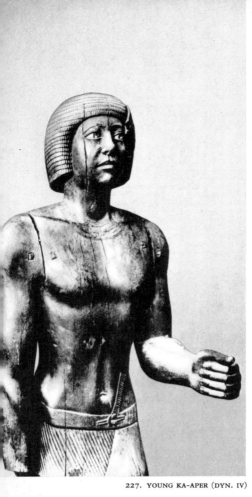

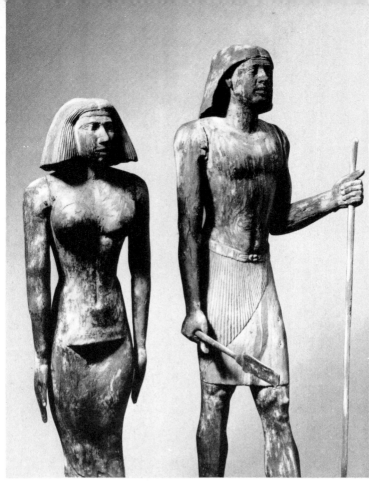

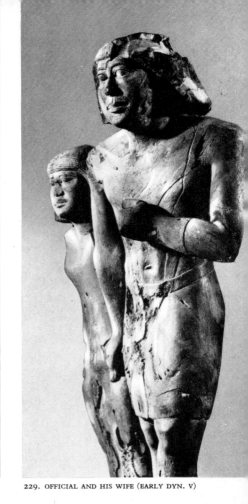

227. YOUNG KA-APER (DYN. IV)

228. MITRY AND HIS WIFE (DYN. V)

229. OFFICIAL AND HIS WIFE (EARLY DYN. V)

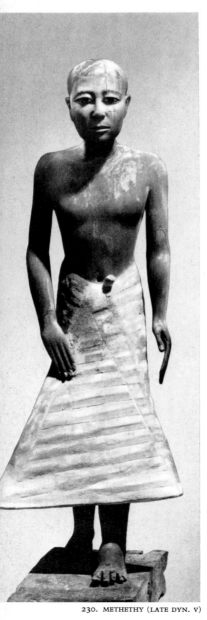

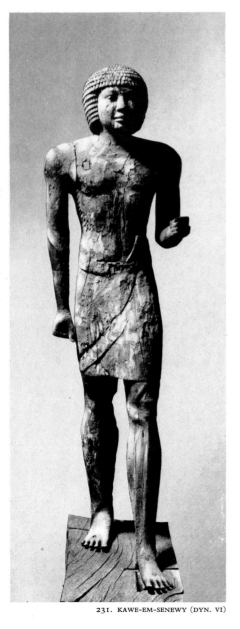

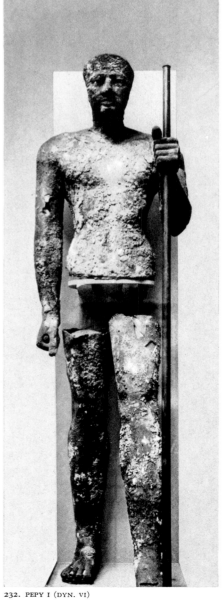

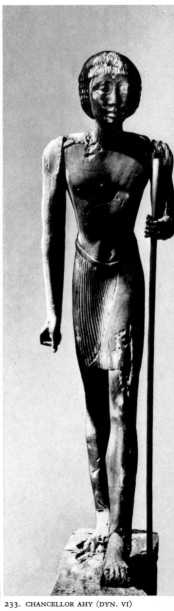

230. METHETHY (LATE DYN. V)

231. KAWE-EM-SENEWY (DYN. VI)

232. PEPY I (DYN. VI)

233. CHANCELLOR AHY (DYN. VI)

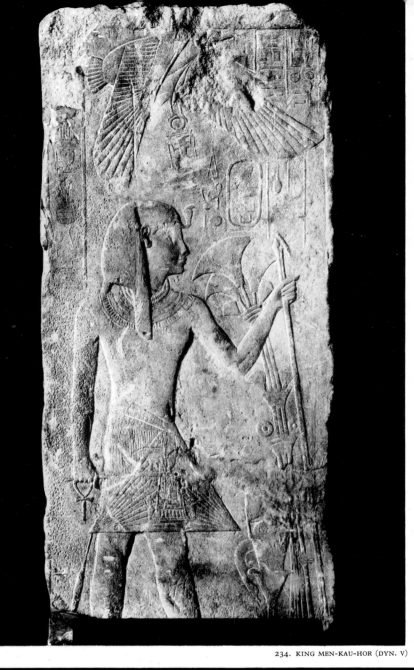

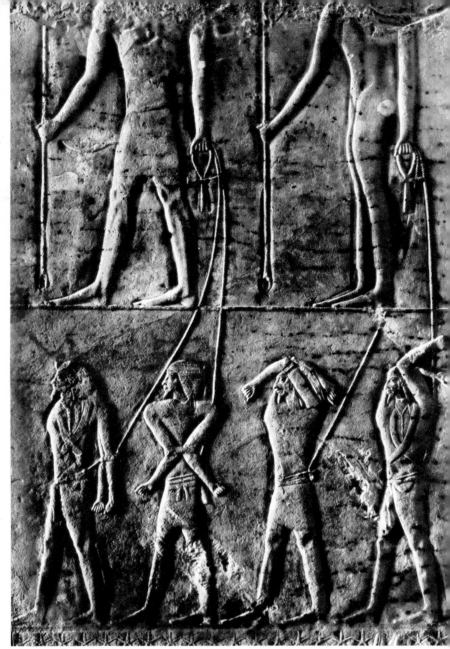

234. KING MEN-KAU-HOR (DYN. V) 235. SAHURA'S CAPTIVES (DYN. V)

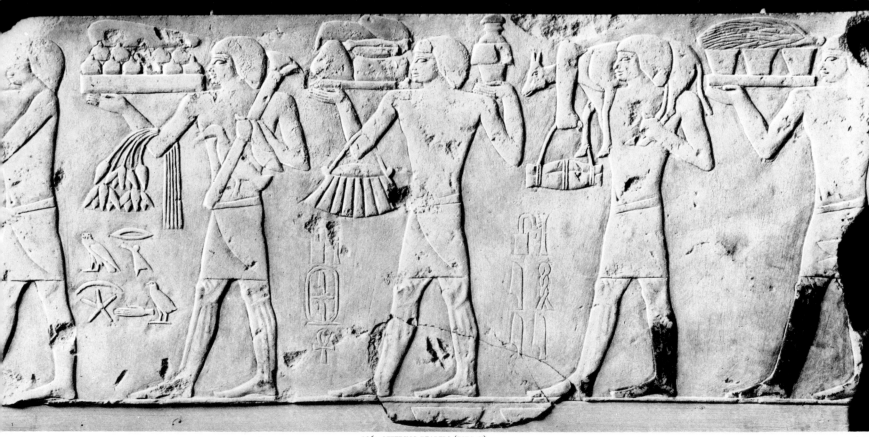

236. OFFERING BEARERS (DYN. V)

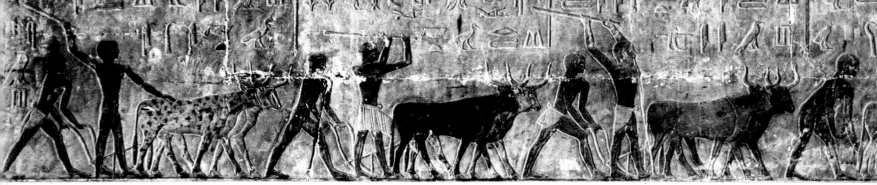

237. SAQQARAH. MASTABA OF TI (DYN. V). PLOWING THE FIELDS

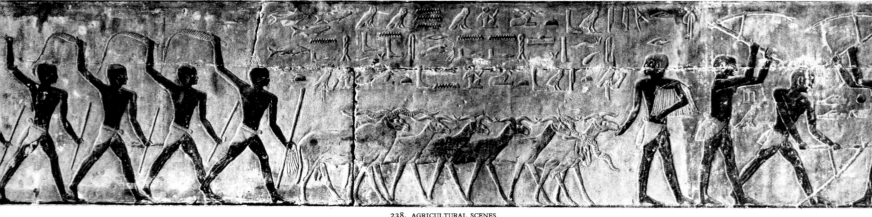

238. AGRICULTURAL SCENES

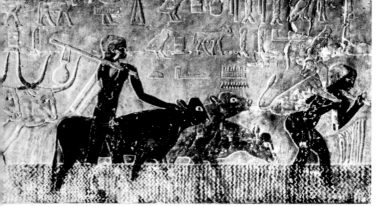

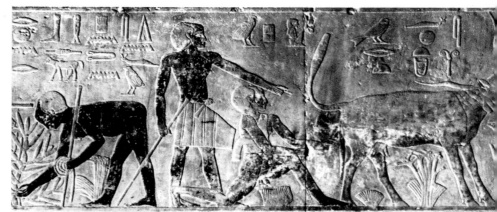

239. FORDING A STREAM 240. PICKING GRAIN AND MILKING COW

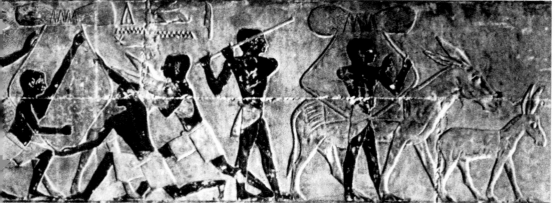

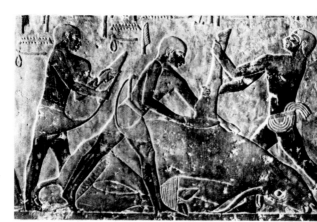

241. DONKEY CARRYING WHEAT 242. SLAUGHTERING ANIMALS

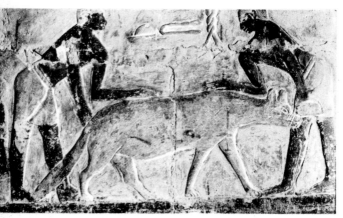

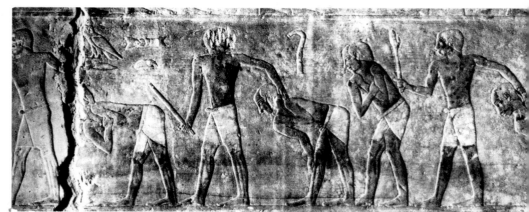

243. MASTABA OF MERERUKA (DYN. V). SCENE WITH LYNX 244. MASTABA OF AKHETHOTEP (DYN. V). WORKMEN BEING PUNISHED

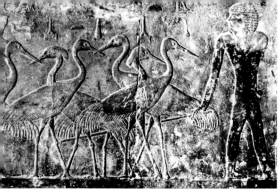

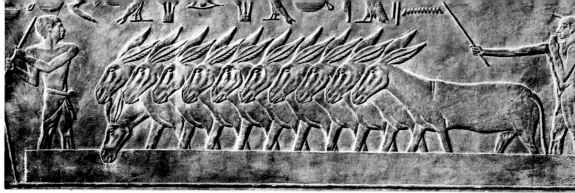

245. SAQQARAH. MASTABA OF TI. HERONS

246. MASTABA OF TI. DONKEYS AT THE TROUGH

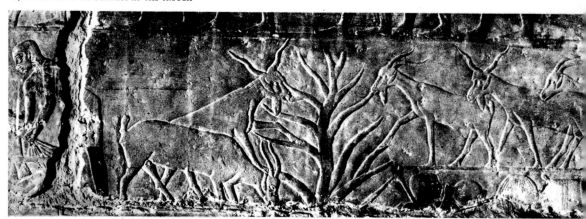

247. MASTABA OF MERERUKA. HUNTING SCENE

248. MASTABA OF AKHETHOTEP. GOATS

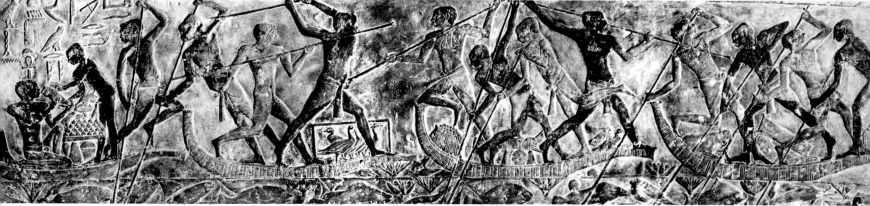

249. MASTABA OF PTAHHOTEP (DYN. V). NAUTICAL TOURNAMENT (?)

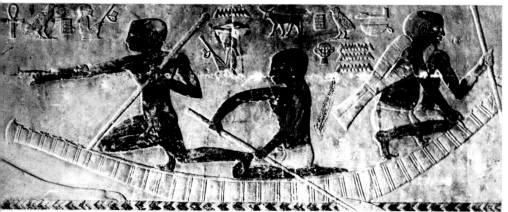

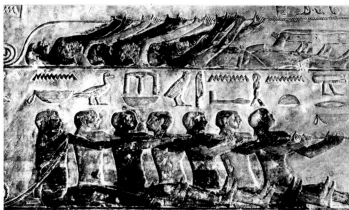

250. MASTABA OF TI. NAUTICAL SCENE

251. MASTABA OF PTAHHOTEP. PULLING IN FISHING NET

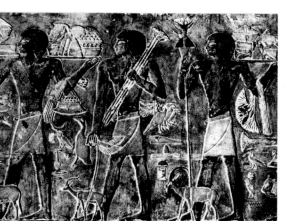

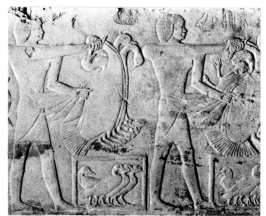

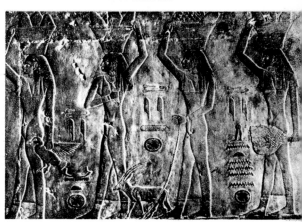

252. MASTABA OF PTAHHOTEP. OFFERING BEARERS

253. MASTABA OF MERERUKA. OFFERING BEARERS

254. MASTABA OF TI. FEMALE OFFERING BEARERS

369

255. KNEELING CAPTIVE (DYN. VI)

256. HEAD OF THE HORUS FALCON (DYN. VI)

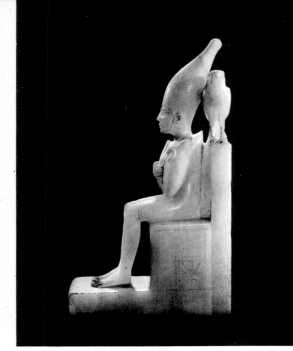

257. ALABASTER STATUETTE OF PEPY I (DYN. VI)

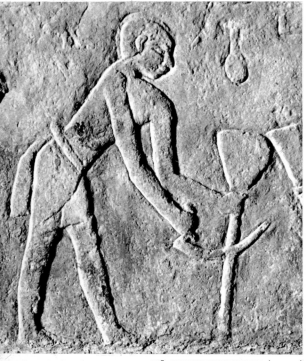

258. MAN WORKING IN FIELD (DYN. VI)

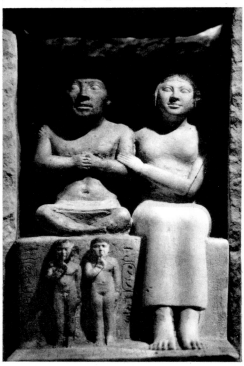

259. DWARF SENEB AND HIS WIFE (DYN. VI)

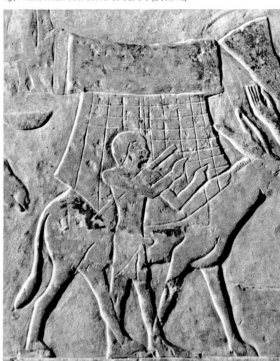

260. DONKEYS CARRYING WHEAT (DYN. VI)

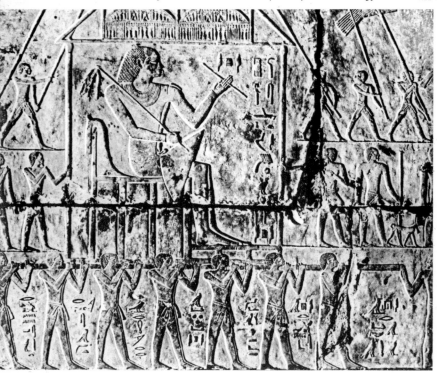

261. IPI CARRIED IN A LITTER (DYN. VI)

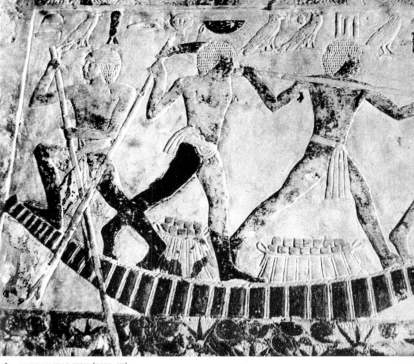

262. HARPOONING FISH (DYN. VI)

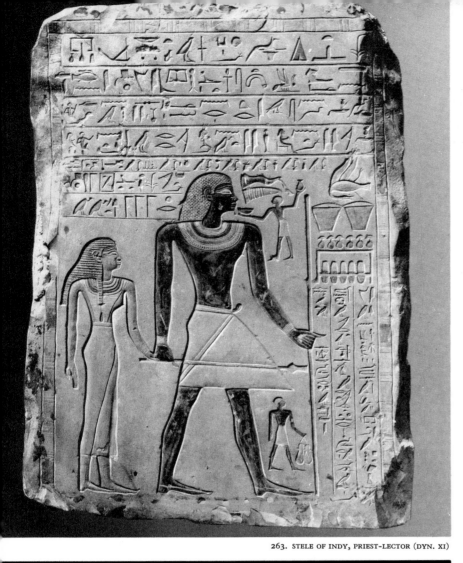

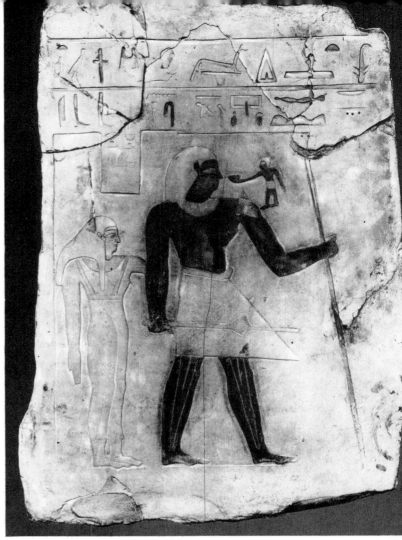

263. STELE OF INDY, PRIEST-LECTOR (DYN. XI) 264. STELE OF BEBI (DYN. VIII)

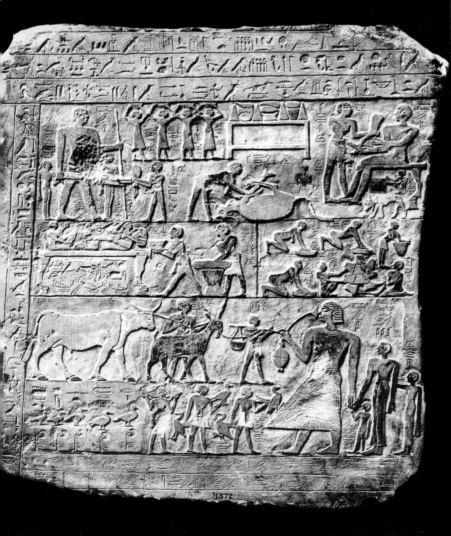

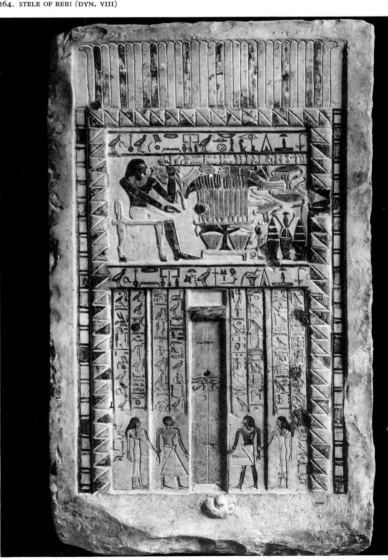

265. STELE OF SEBEK-AA (DYN. VIII) 266. STELE OF CHANCELLOR NEFER-YU (DYN. VIII)

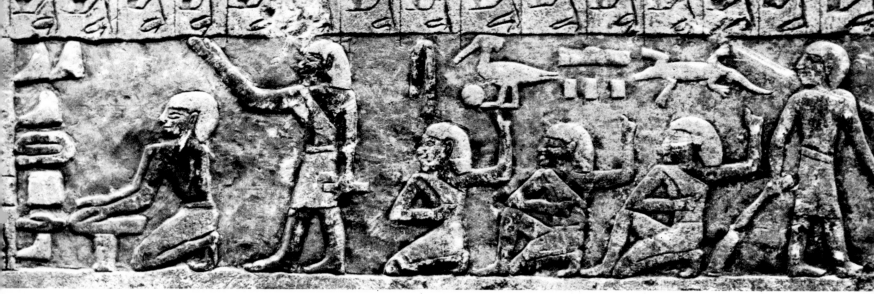

267. DETAIL OF A RELIEF FROM SAQQARAH (DYN. IX–X). OFFERING SCENE

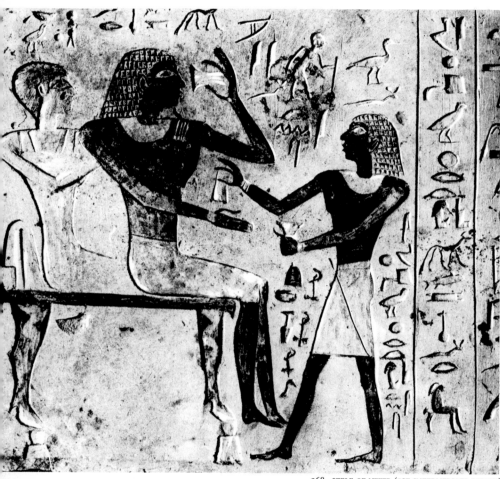

268. STELE OF NEFER (1ST INTERMEDIATE PERIOD)

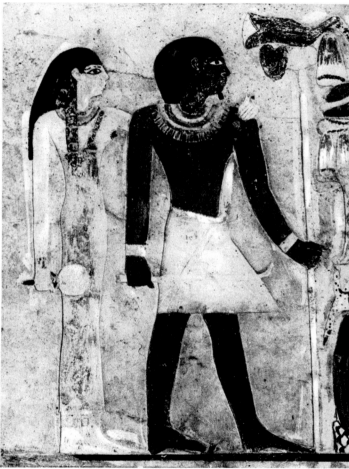

269. DJEDU AND HIS WIFE SIT-SOBEK (DYN. XI)

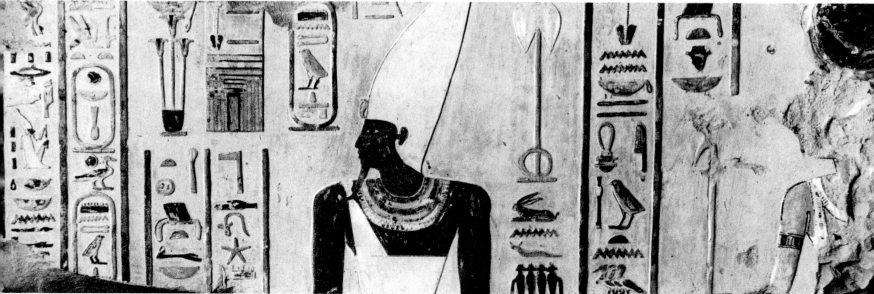

270. RELIEF OF MENTUHOTEP I (DYN. XI)

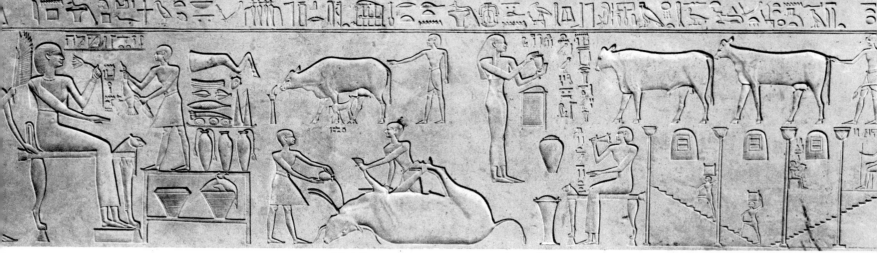

271. RELIEF FROM THE SARCOPHAGUS OF AASHAYT (DYN. XI)

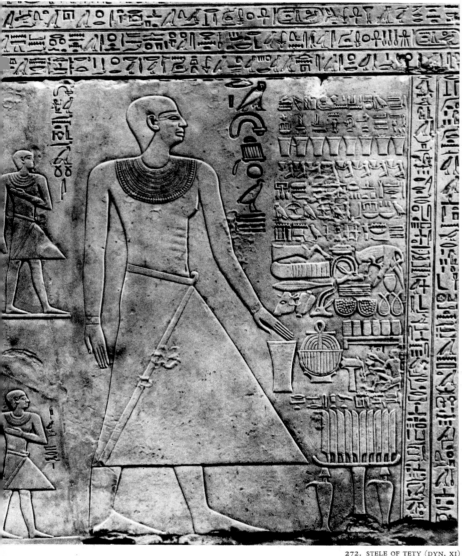

272. STELE OF TETY (DYN. XI)

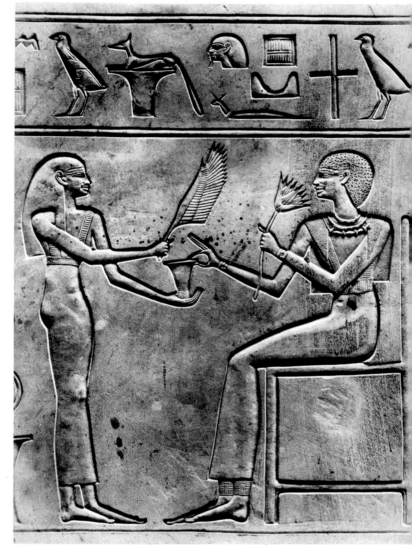

273. RELIEF FROM THE SARCOPHAGUS OF KAWIT (DYN. XI)

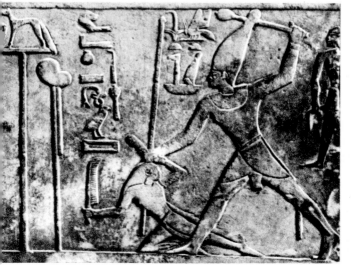

274. RELIEF FROM THE TEMPLE OF MENTUHOTEP I (DYN. XI)

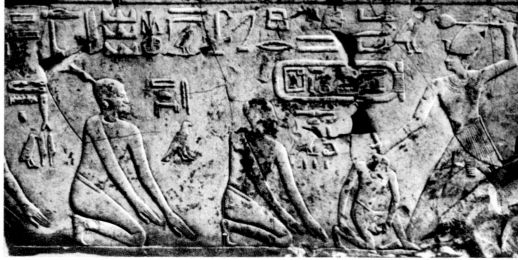

275. RELIEF FROM THE TEMPLE OF MENTUHOTEP I (DYN. XI)

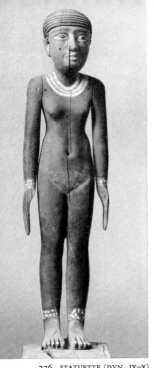

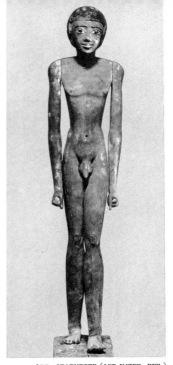

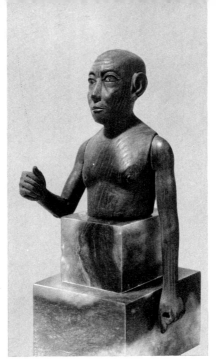

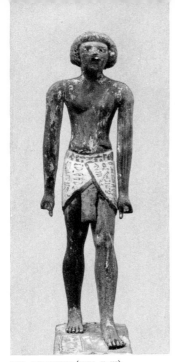

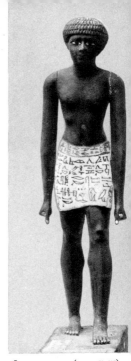

276. STATUETTE (DYN. IX–X) 277. STATUETTE (1ST INTER. PER.) 278. STATUETTE, UPPER PART (DYN. XI) 279. STATUETTE (DYN. X–XI) 280. STATUETTE (DYN. X–XI)

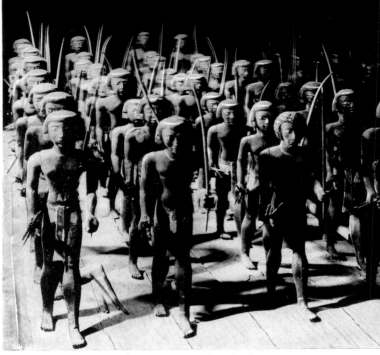

281. WOOD MODEL OF A HOUSE (DYN. XI) 282. ASSIUT SOLDIERS (DYN. IX–X) 283. WOOD MODEL FROM THE TOMB OF MEKET-RA (DYN. XI)

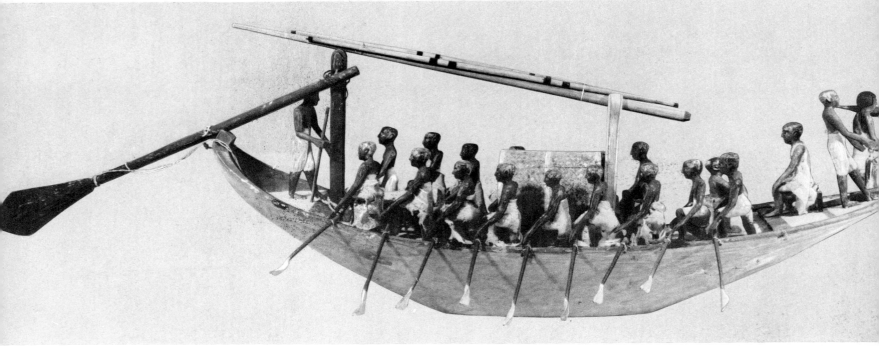

284. WOOD MODEL OF A BOAT FROM THE TOMB OF MEKET-RA (DYN. XI)

285. IVORY STATUETTE (DYN. XII)

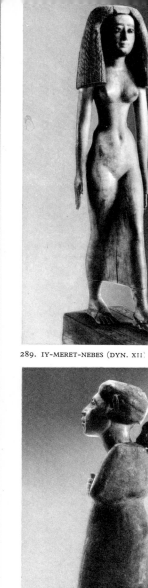

289. IY-MERET-NEBES (DYN. XII)

286. WOMAN AND CHILD (DYN. XI)

287. WOMAN CARRYING OFFERINGS (DYN. XI)

288. WOMAN CARRYING OFFERINGS (DYN. XII)

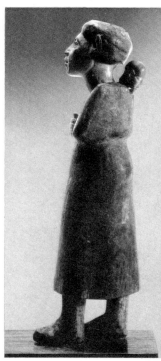

290. WOMAN AND CHILD (DYN. XII)

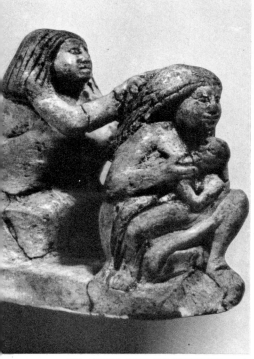

291. WOMAN, CHILD, AND SERVANT (DYN. XII)

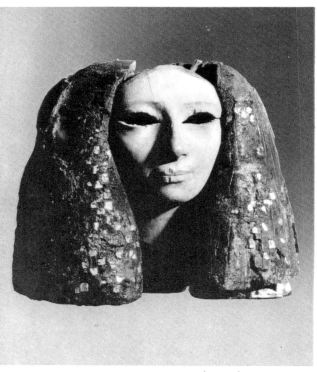

292. HEAD OF A WOMAN WITH WIG (DYN. XII)

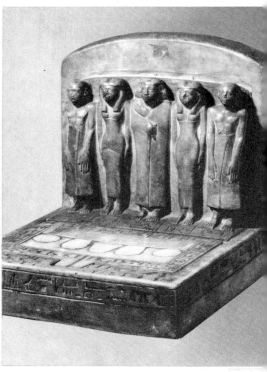

293. SENPU AND HIS FAMILY (DYN. XII)

375

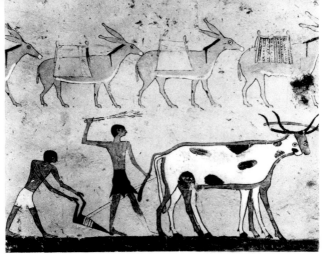

294. DONKEY, FROM TOMB OF ITI, GEBELEIN (DYN. XI) 295. AGRICULTURAL SCENE, FROM TOMB OF ZAR, THEBES (DYN. XI) 296. COW AND CALF, FROM TOMB OF ITI, GEBELEIN (DYN. XI)

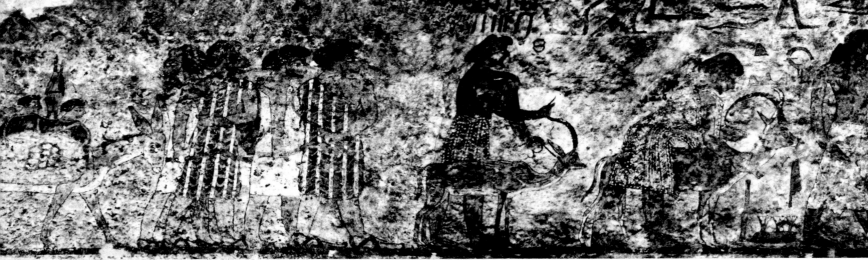

297. BENI HASAN. TOMB OF KHNUMHOTEP (DYN. XII). CARAVAN OF ASIANS

298. BENI HASAN. TOMB OF BAKHT (DYN. XII). WRESTLERS 299. GYMNASTICS, FROM TOMB OF ITI, GEBELEIN (DYN. XI)

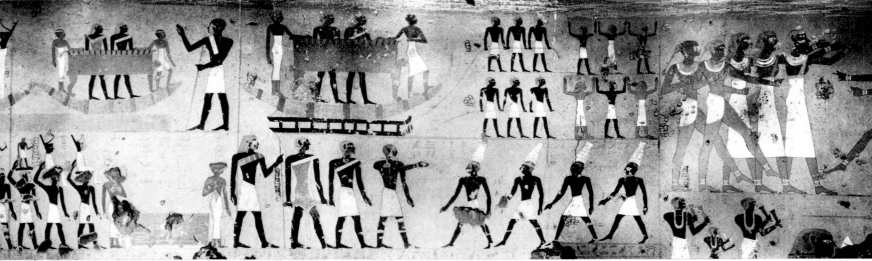

300. THEBES. TOMB OF ANTEFOKER (DYN. XII). FUNERARY SCENES

301. THE GODDESS SESHAT (DYN. XII)

302. SESOSTRIS I DANCING BEFORE THE GOD MIN (DYN. XII)

303. ASWAN. OFFERING BEARER (DYN. XII)

304. SESOSTRIS I AND THE GOD PTAH (DYN. XII)

305. ASWAN. OFFERING BEARER (DYN. XII)

306, 307, 308. ASWAN. RELIEFS (DYN. XII). DUCK, DOGS, COW

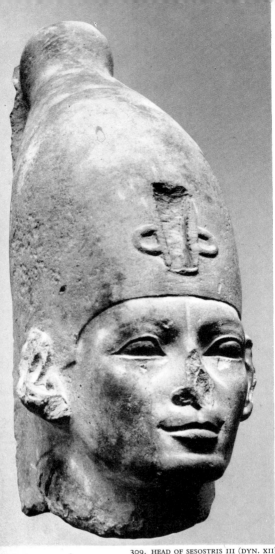

309. HEAD OF SESOSTRIS III (DYN. XII)

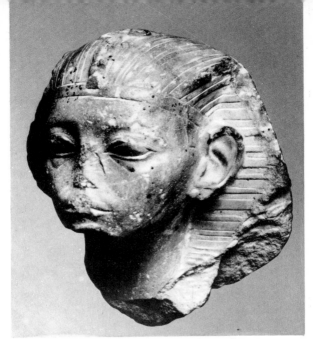

310. HEAD OF AMENEMHAT I (DYN. XII)

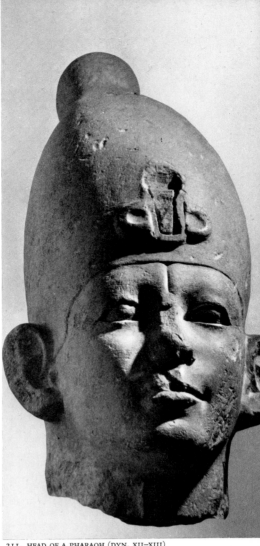

311. HEAD OF A PHARAOH (DYN. XII–XIII)

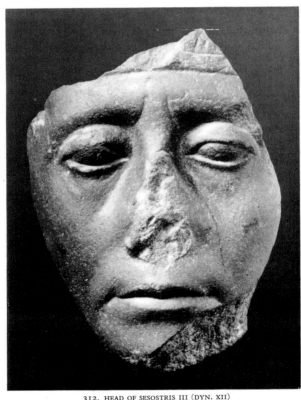

312. HEAD OF SESOSTRIS III (DYN. XII)

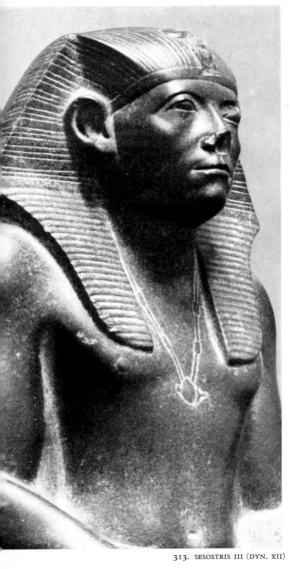

313. SESOSTRIS III (DYN. XII)

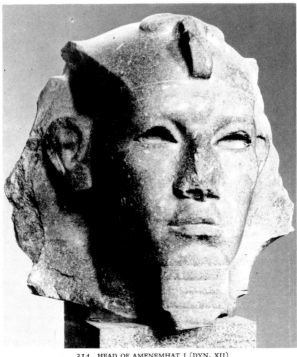

314. HEAD OF AMENEMHAT I (DYN. XII)

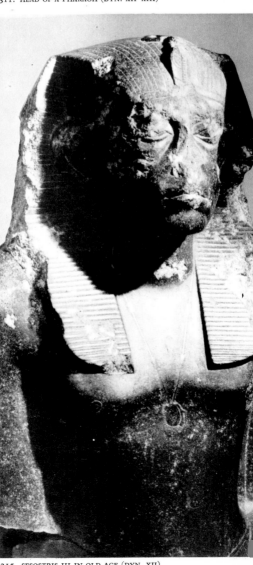

315. SESOSTRIS III IN OLD AGE (DYN. XII)

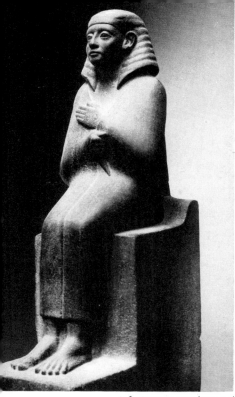

316. CLOAKED MAN (DYN. XII)

317. SEHETEP-IB-RE-ANKH (DYN. XII)

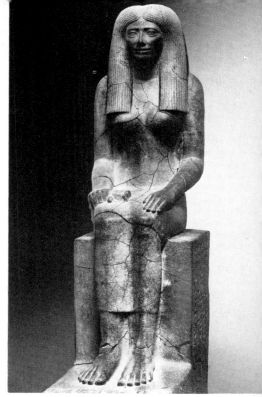

318. LADY SENNUWY (DYN. XII)

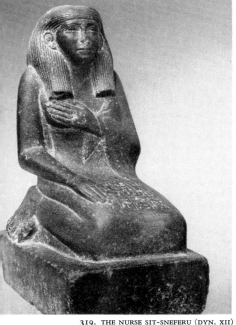

319. THE NURSE SIT-SNEFERU (DYN. XII)

320. TWO PRIESTS (DYN. XII)

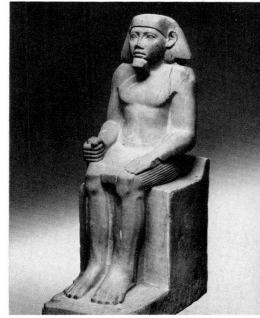

321. AU (DYN. XII)

322. BLOCK-STATUE OF A MAN (DYN. XII)

323. KHNUMHOTEP (DYN. XII)

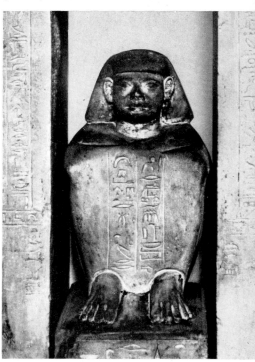

324. BLOCK-STATUE OF SI-HATHOR (DYN. XII)

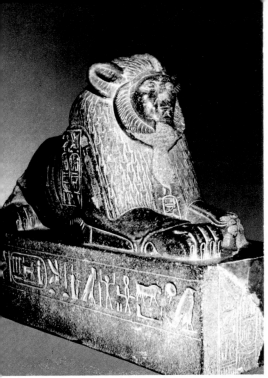

325. SPHINX FROM TANIS (DYN. XII)

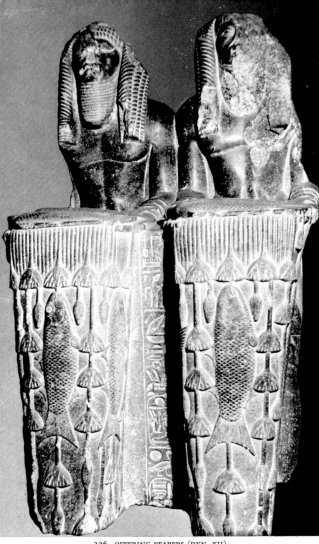

326. OFFERING BEARERS (DYN. XII)

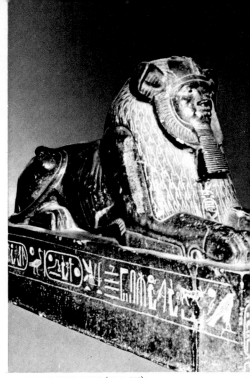

327. SPHINX FROM TANIS (DYN. XII)

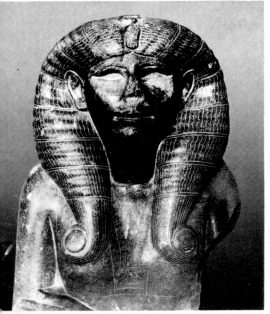

328. QUEEN NOFRET (DYN. XII)

331. PHARAOH IN PRIESTLY DRESS (DYN. XII)

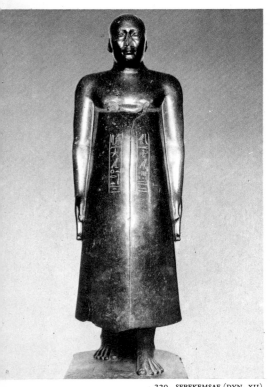

329. SEBEKEMSAF (DYN. XII)

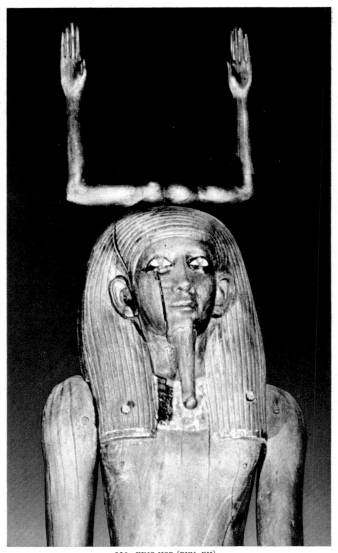

330. KING HOR (DYN. XII)

332. VIZIER IY-MERU (DYN. XIII)

NEW KINGDOM

Dynasty XVII
(1650 – 1567 B.C.)

Dynasty XVIII
(1567 – 1320 B.C.)

Dynasty XIX
(1320 – 1200 B.C.)

Dynasty XX
(1200 – 1085 B.C.)

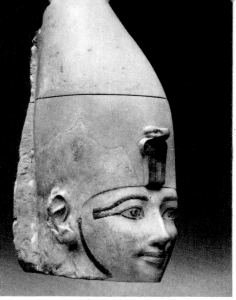

333. HEAD OF HATSHEPSUT (DYN. XVIII)

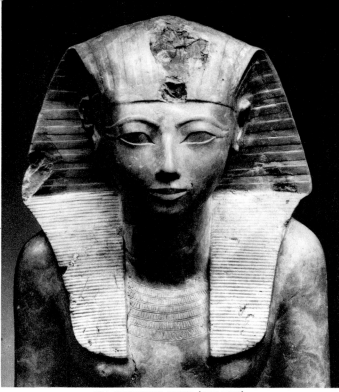

334. HATSHEPSUT, DETAIL (DYN. XVIII)

335. HEAD OF TUTHMOSIS III (DYN. XVIII)

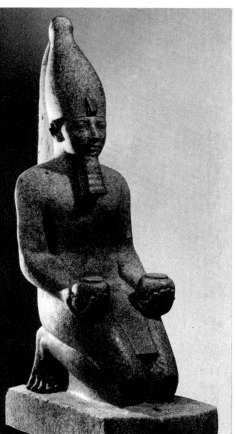

336. HATSHEPSUT KNEELING (DYN. XVIII)

337. SENMUT, HATSHEPSUT'S ARCHITECT (DYN. XVIII)

338. TUTHMOSIS III KNEELING (DYN. XVIII)

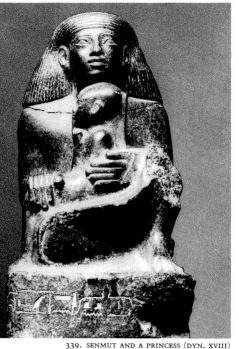

339. SENMUT AND A PRINCESS (DYN. XVIII)

340. HEAD OF TUTHMOSIS III (DYN. XVIII)

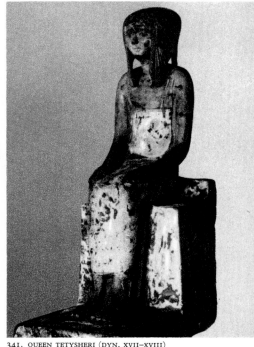

341. QUEEN TETYSHERI (DYN. XVII–XVIII)

383

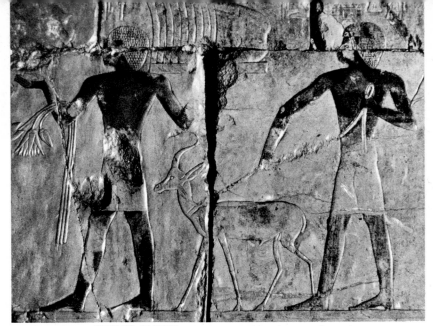
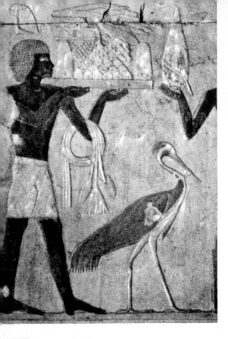
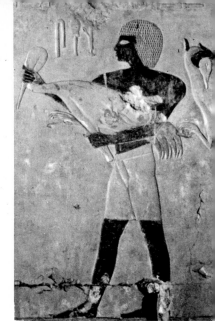

342, 343, 344. DEIR EL BAHARI. TEMPLE OF HATSHEPSUT (DYN. XVIII). OFFERING BEARERS

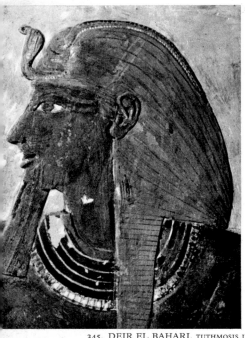
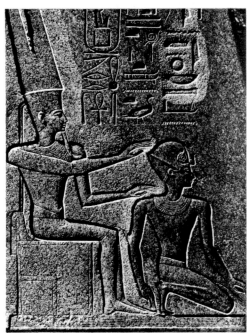
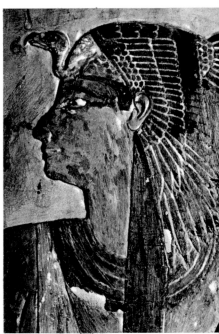

345. DEIR EL BAHARI. TUTHMOSIS I

346. KARNAK. OBELISK: HATSHEPSUT AND AMON-RA

347. DEIR EL BAHARI. QUEEN SENSENEB

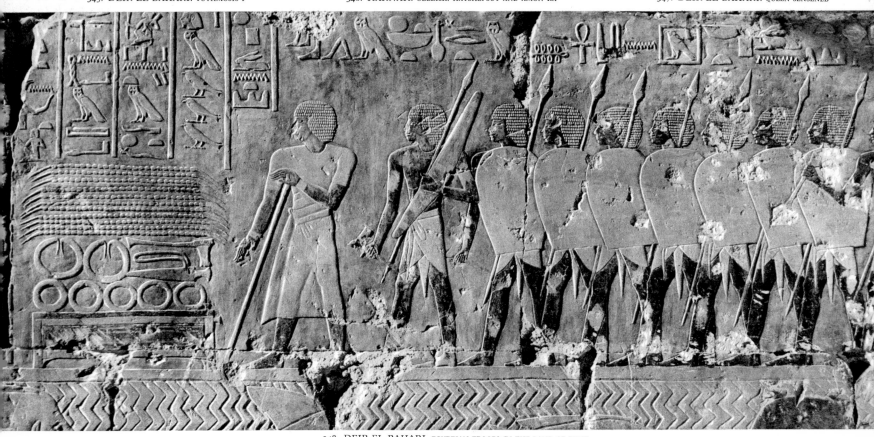

348. DEIR EL BAHARI. EGYPTIAN TROOPS IN THE LAND OF PUNT

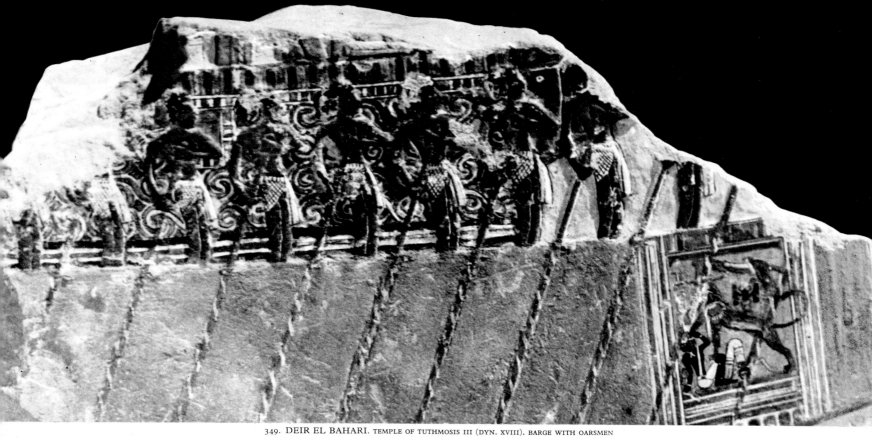

349. DEIR EL BAHARI. TEMPLE OF TUTHMOSIS III (DYN. XVIII). BARGE WITH OARSMEN

350. DEIR EL BAHARI. THE GOD AMON-MIN. 351, 352. DEIR EL BAHARI. FRAGMENT OF A RELIEF; PRIESTS CARRYING A SACRED BARGE

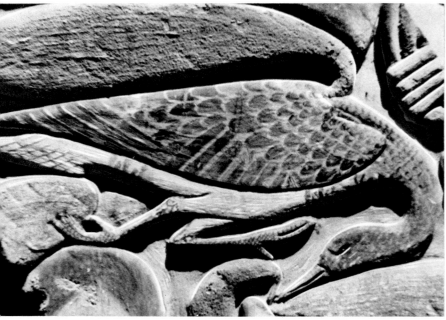 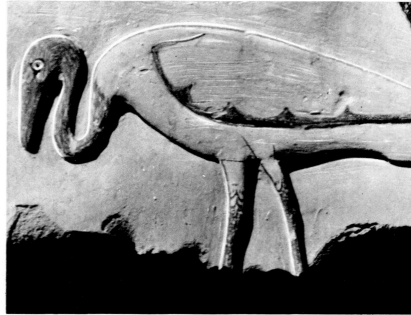

353. DEIR EL BAHARI. FRAGMENT OF OFFERINGS 354. DEIR EL BAHARI. FRAGMENT OF AN INSCRIPTION

355–362. KARNAK. GREAT TEMPLE OF AMON (DYN. XVIII). RELIEFS FROM THE "BOTANICAL GARDEN": EXOTIC PLANTS AND ANIMALS

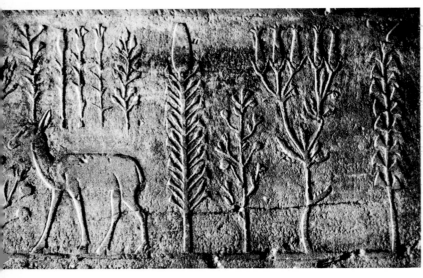
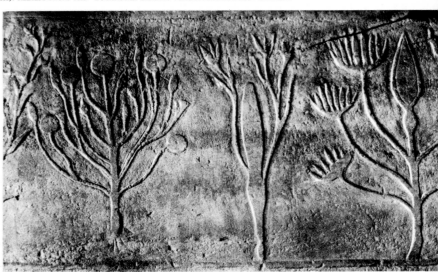

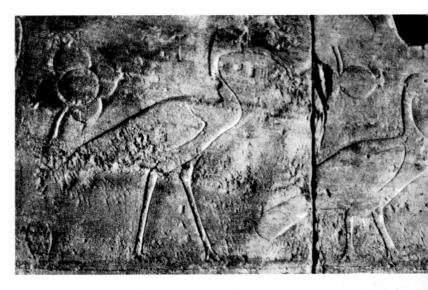

363. KARNAK. TUTHMOSIS III STRIKING CAPTIVES (DYN. XVIII)

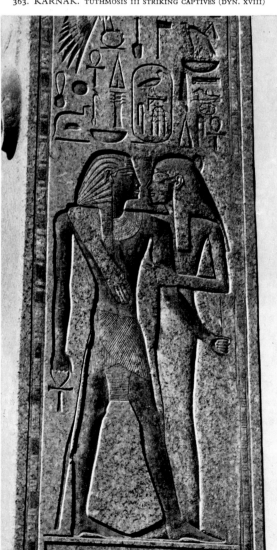
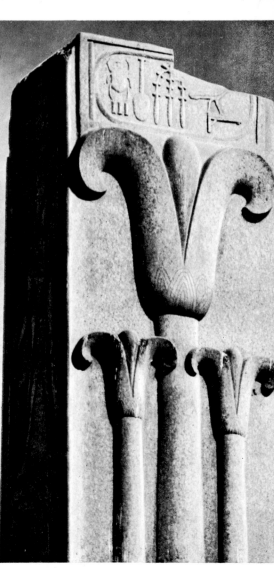

364, 365, 366. THEBES. GREAT TEMPLE OF AMON (DYN. XVIII). CAPITALS AND RELIEF FROM HERALDIC COLUMNS OF TUTHMOSIS III

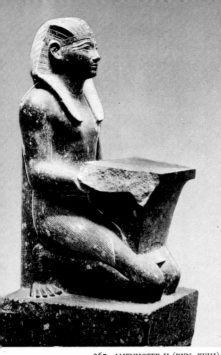

367. AMENHOTEP II (DYN. XVIII)

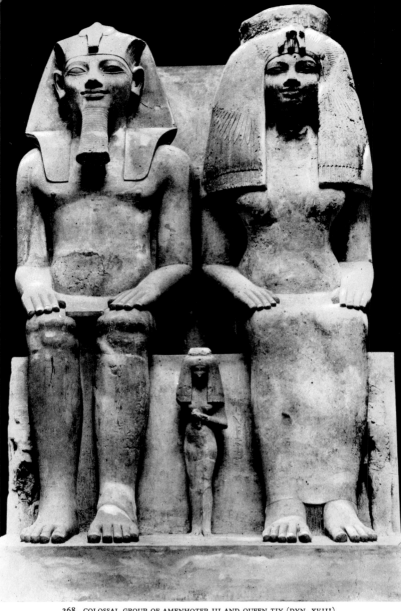

368. COLOSSAL GROUP OF AMENHOTEP III AND QUEEN TIY (DYN. XVIII)

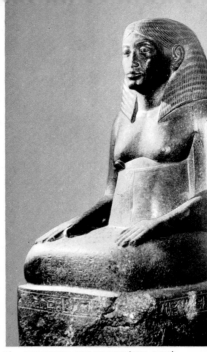

369. AMENHOTEP, SON OF HAPU (DYN. XVIII)

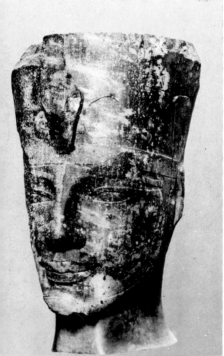

370. HEAD OF AMENHOTEP III (DYN. XVIII)

371. HEAD OF MUT-NEDJENET (LATE DYN. XVIII)

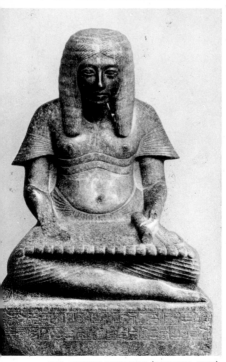

372. GENERAL HOREMHEB (LATE DYN. XVIII)

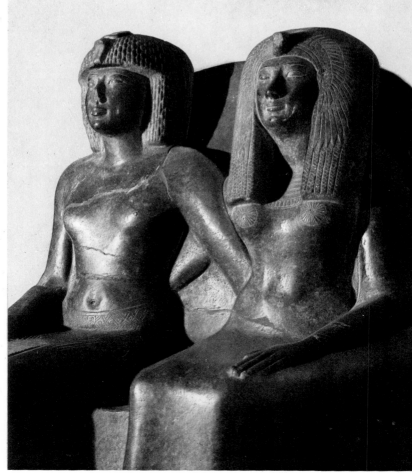

373. TUTHMOSIS IV AND HIS MOTHER TIY (DYN. XVIII)

374. AMENHOTEP-WESERU AND TANT-WASU (DYN. XVI

375. STATUETTE (LATE DYN. XVII) 376. STATUETTE (DYN. XVIII) 377. STATUETTE OF AN OFFICER (DYN. XVIII) 378. SHAWABTI OF HUY (DYN. XVIII-XIX)

379. MAN CARRYING A VESSEL (DYN. XVIII) 380. STATUETTE OF KHA (EARLY DYN. XVIII) 381. SERVANT CARRYING A VESSEL (DYN. XVIII)

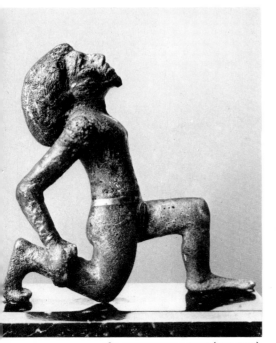

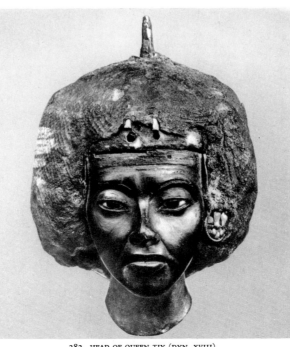

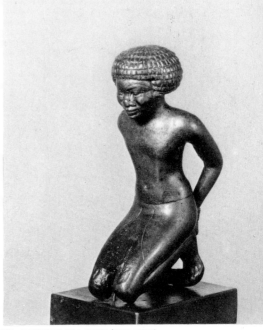

382. STATUETTE OF A SLAVE (DYN. XVIII) 383. HEAD OF QUEEN TIY (DYN. XVIII) 384. STATUETTE OF A SLAVE (DYN. XVIII)

385. VALLEY OF THE KINGS. TOMB OF TUTHMOSIS III (DYN. XVIII). GODS AND SPIRITS OF THE AFTERWORLD. 386. MYTHICAL SCENE

387. NIGHTLY JOURNEY OF THE SUN 388. SPIRITS OF THE AFTERWORLD

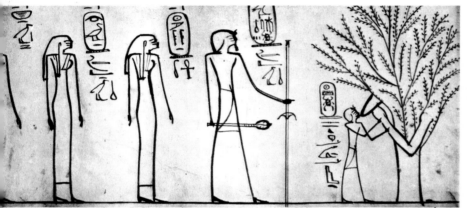

389. THE KING SUCKLED BY THE SACRED TREE (ISIS) 390. VALLEY OF THE KINGS. TOMB OF AMENHOTEP II (DYN. XVIII). SACRED SHEEP

391. SPIRIT AND SNAKE. 392. FOURTH HOUR OF THE SUN'S JOURNEY

393. SPIRITS OF THE AFTERWORLD SUBMERGED BY THE WATERS OF THE SUBTERRANEAN NILE

394. THEBES. TOMB OF REKHMIRA (DYN. XVIII). TANNERS 395. PREPARATION OF OFFERINGS

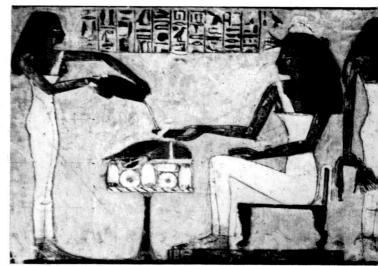

396. GIRLS PLAYING HARP, LUTE, AND SMALL DRUM 397. FUNERARY BANQUET, DETAIL

398. FOREIGN TRIBUTE: ASIANS AND HORSES 399. NEGROES FROM KUSH LEADING A GIRAFFE

400, 401. TRANSPORTING TOMB FURNISHINGS

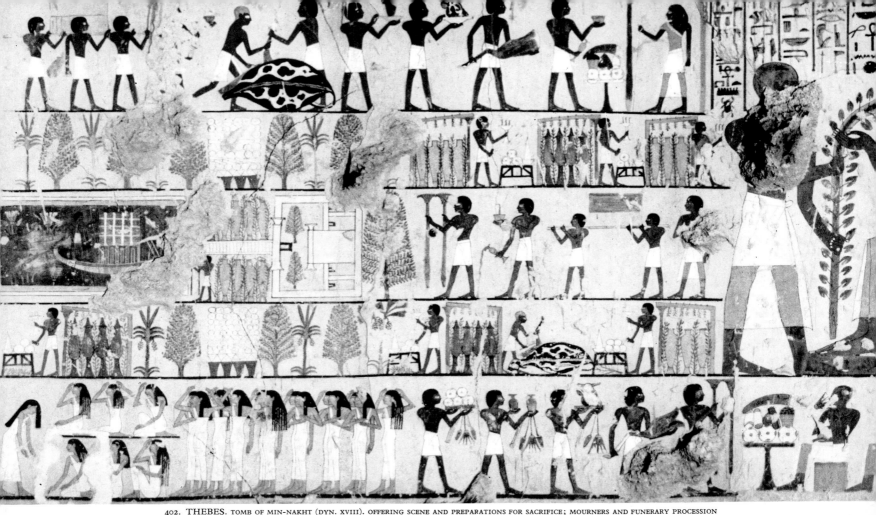

402. THEBES. TOMB OF MIN-NAKHT (DYN. XVIII). OFFERING SCENE AND PREPARATIONS FOR SACRIFICE; MOURNERS AND FUNERARY PROCESSION

403. THEBES. TOMB OF MENKHEPERRA-SENEB (DYN. XVIII). DEPARTURE OF THE TRIBUTE CARAVAN.

404. TRIBUTE BEARERS FROM THE SOUTH AND EAST

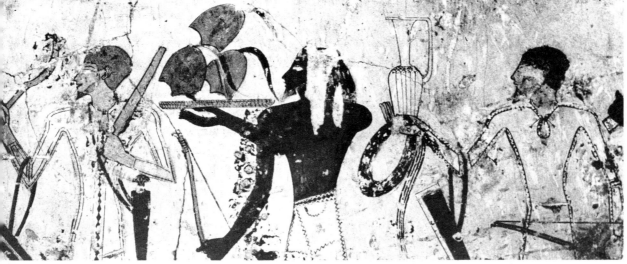

405, 406. FOREIGN TRIBUTE BEARERS

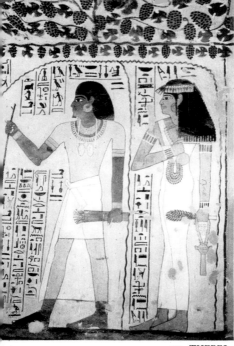
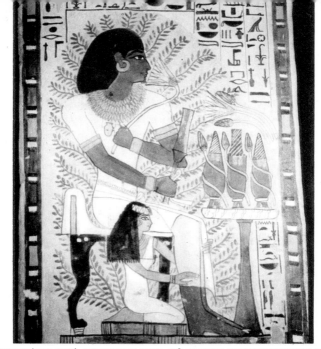
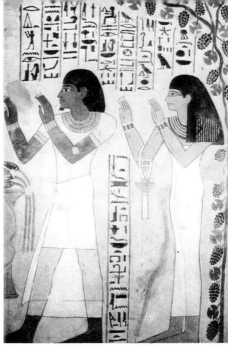

407. THEBES. TOMB OF SENNEFER (DYN. XVIII). PURIFICATION SCENE. 408. SENNEFER BEFORE THE OFFERING TABLE. 409. OFFERING SCENE

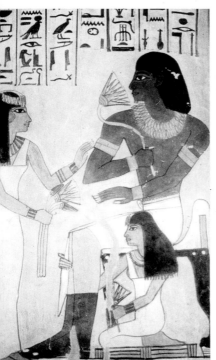
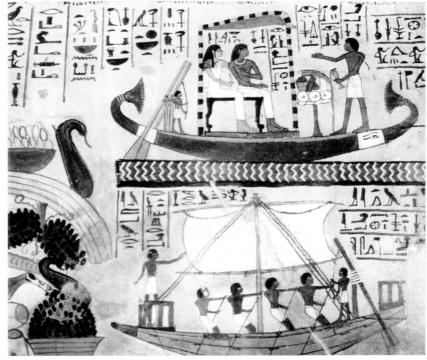
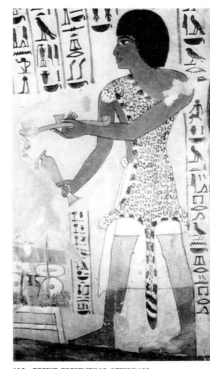

410. SENNEFER, MERIT, AND SENT-NEFER 411. FUNERARY BOATS 412. PRIEST PRESENTING OFFERINGS

413. THEBES. TOMB OF WESERHAT (DYN. XVIII). HUNTING SCENE 414. BARBER AT WORK

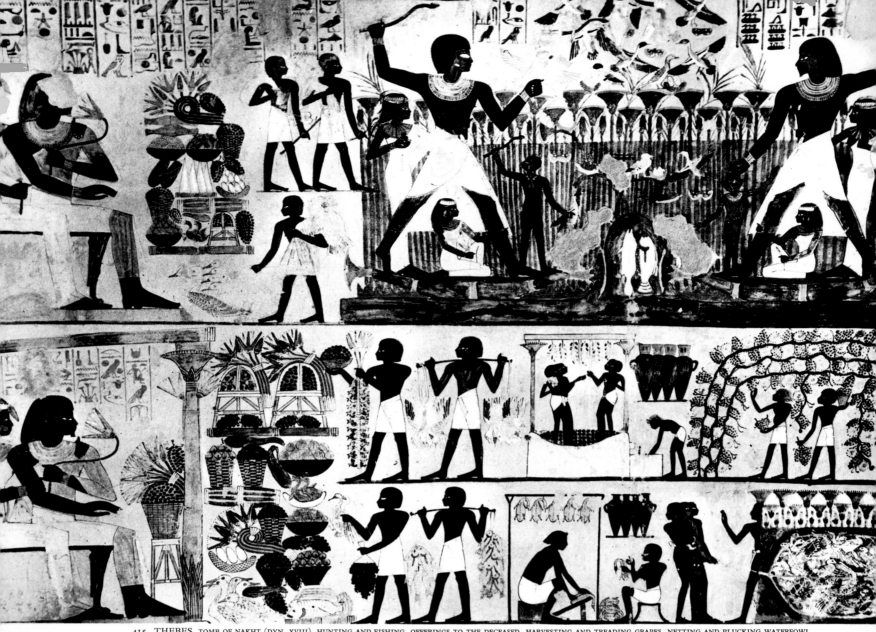

415. THEBES. TOMB OF NAKHT (DYN. XVIII). HUNTING AND FISHING, OFFERINGS TO THE DECEASED, HARVESTING AND TREADING GRAPES, NETTING AND PLUCKING WATERFOWL

416. THEBES. TOMB OF DJESERKARESENEB (DYN. XVIII). YOUNG DANCER AND MUSICIANS 417. GUEST AND SERVANT GIRLS

418. GIRLS CARRYING LOTUS, GRAPES, AND DATES 419. BUTCHERS 420. OFFERING TABLE

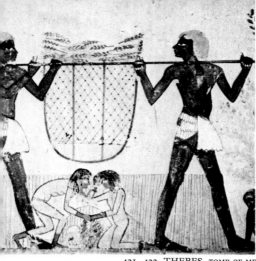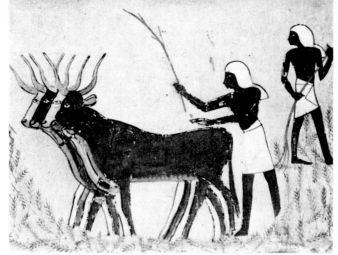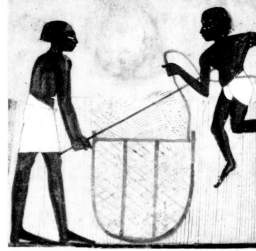

421, 422. THEBES. TOMB OF MENENA (DYN. XVIII). TRANSPORTING WHEAT; TREADING WHEAT. 423. THEBES. TOMB OF NAKHT (DYN. XVIII). GATHERING WHEAT

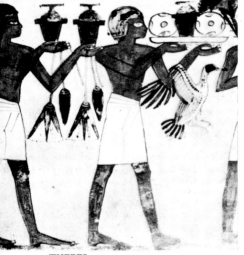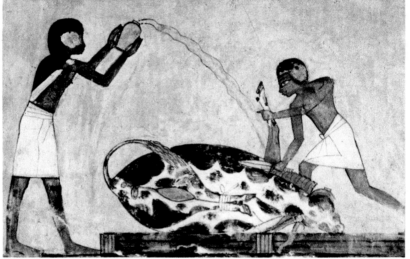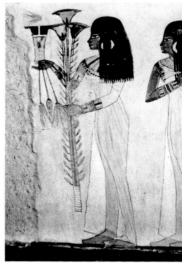

424. THEBES. TOMB OF MENENA. OFFERING BEARERS. 425. SACRIFICE AND PURIFICATION OF AN OX. 426. GIRLS OFFERING FLOWERS

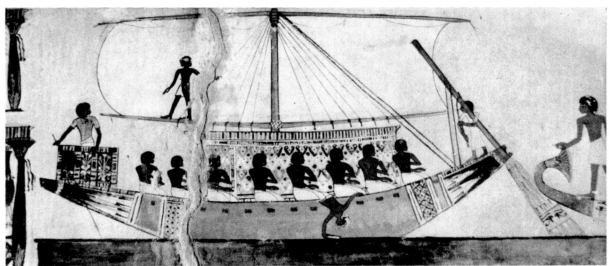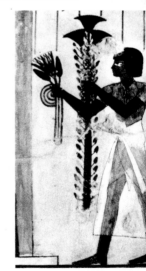

427. OFFERING BEARER 428. FUNERARY BOAT 429. OFFERING BEARER

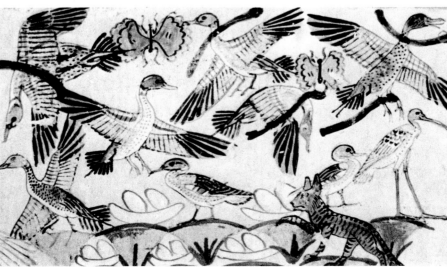

430. WILD DUCKS 431. CAT CHASING BIRDS 432. BIRD AND FISH

433. THEBES. TOMB OF RAMOSE (DYN. XVIII). FIGURES BOWING 434. OFFERING BEARERS

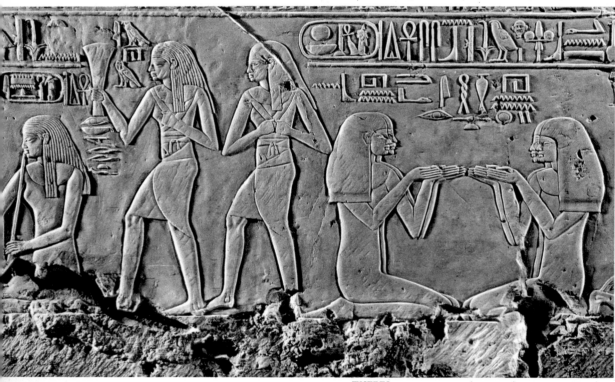

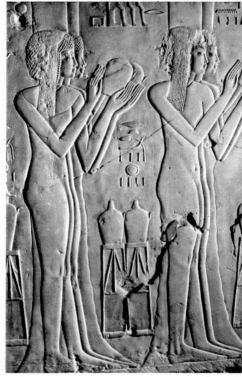

435. THEBES. TOMB OF KHERUEF (DYN. XVIII). MUSICIANS AND DANCERS 436. PRINCESSES

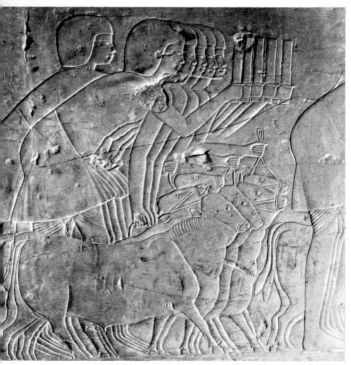

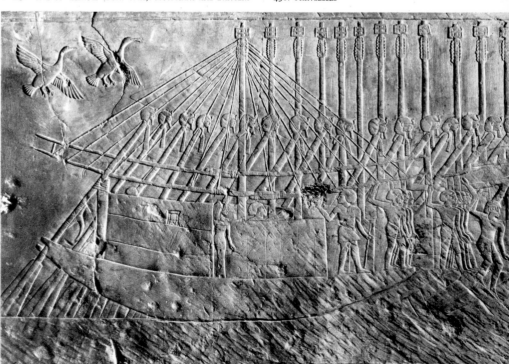

437. THEBES. TOMB OF KHAEMHAT (DYN. XVIII). MOVING THE HERDS 438. THE ROYAL BOAT AT THEBES

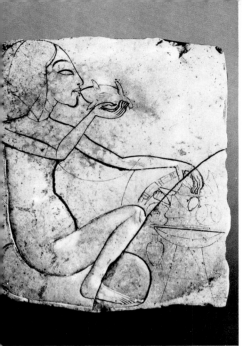

439. PRINCESS EATING A DUCK (DYN. XVIII)

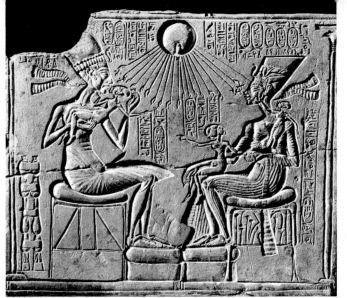

440. AKHENATEN, NOFRETETE, AND THEIR DAUGHTERS (DYN. XVIII)

441. OFFERINGS (DYN. XVIII)

442. HAND OF AKHENATEN (DYN. XVIII)

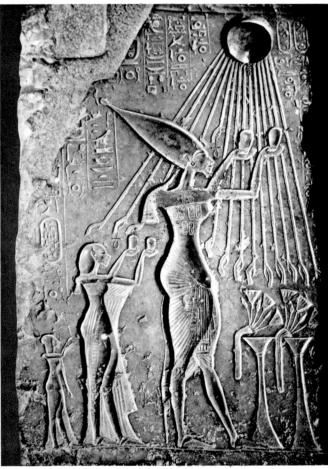

443. AKHENATEN'S OFFERINGS TO THE SOLAR DISK (DYN. XVIII)

444. HAND, DETAIL OF A RELIEF (DYN. XVIII)

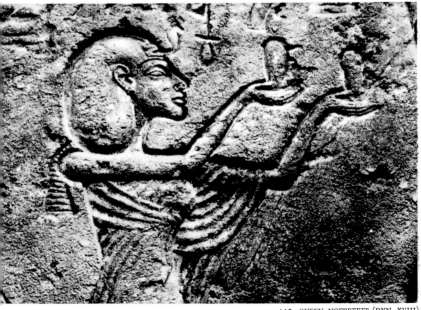

445. QUEEN NOFRETETE (DYN. XVIII)

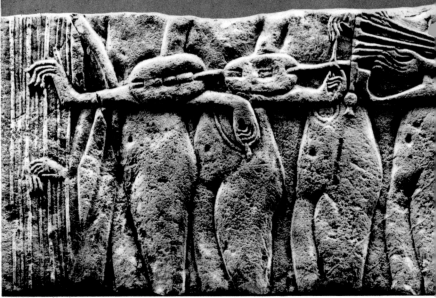

446. MUSICIANS (DYN. XVIII)

397

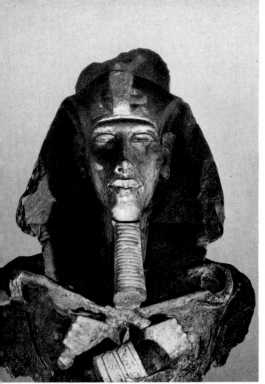

447. STATUE OF AKHENATEN, FRAGMENT (DYN. XVIII)

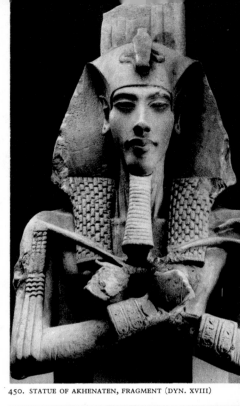

450. STATUE OF AKHENATEN, FRAGMENT (DYN. XVIII)

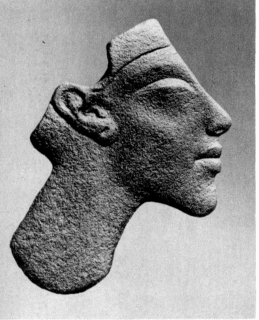

448. PROFILE OF AKHENATEN (DYN. XVIII)

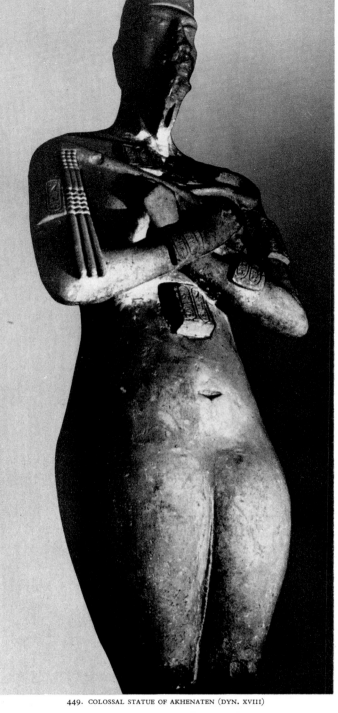

449. COLOSSAL STATUE OF AKHENATEN (DYN. XVIII)

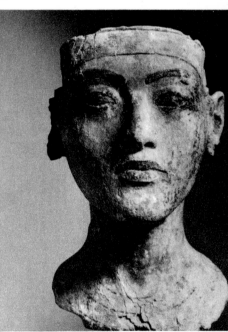

451. AMARNA ROYAL BUST (DYN. XVIII)

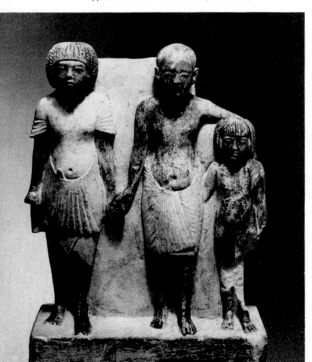

452. TWO MEN AND A BOY (LATE DYN. XVIII)

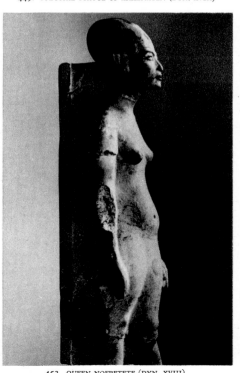

453. QUEEN NOFRETETE (DYN. XVIII)

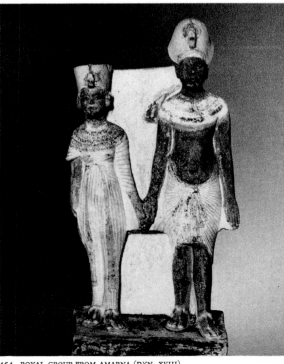

454. ROYAL GROUP FROM AMARNA (DYN. XVIII)

398

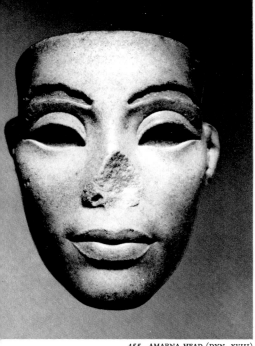

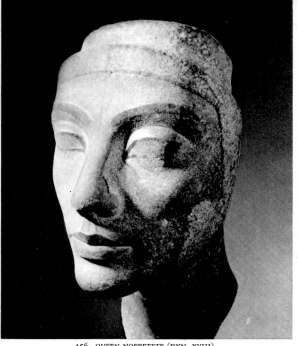

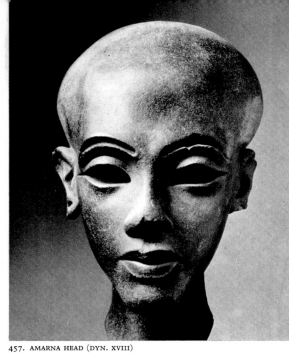

455. AMARNA HEAD (DYN. XVIII)

456. QUEEN NOFRETETE (DYN. XVIII)

457. AMARNA HEAD (DYN. XVIII)

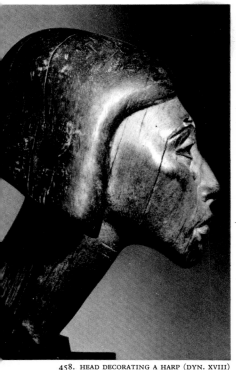

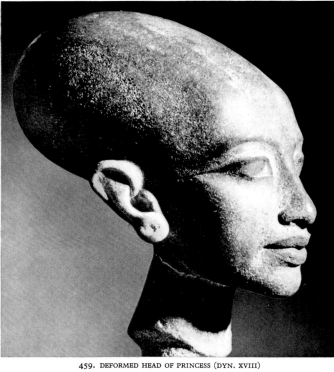

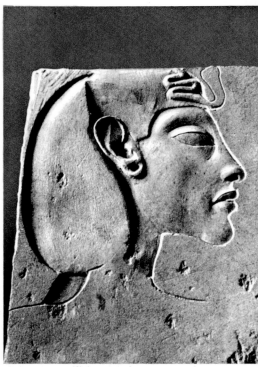

458. HEAD DECORATING A HARP (DYN. XVIII)

459. DEFORMED HEAD OF PRINCESS (DYN. XVIII)

460. AKHENATEN (?) (DYN. XVIII)

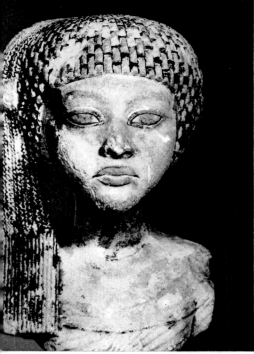

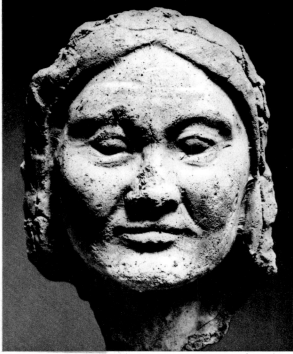

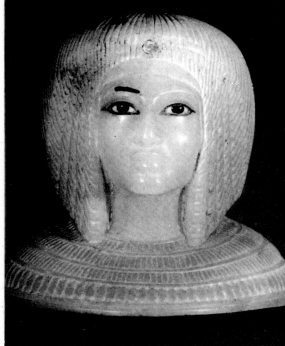

461. AMARNA GIRL (DYN. XVIII)

462. MASK OF AN OLD WOMAN (DYN. XVIII)

463. MERITATEN, DAUGHTER OF AKHENATEN (DYN. XVIII)

464. TOMB OF TUT-ANKH-AMON (DYN. XVIII). FELINE HEAD FROM FUNERARY BED. 465. PAINTED CHEST: DESTRUCTION OF AFRICANS. 466. HEAD OF THUERIS FROM FUNERARY BED

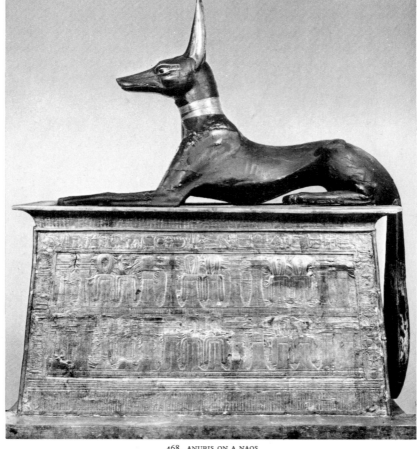

467. ALABASTER VASE 468. ANUBIS ON A NAOS 469. ALABASTER VASE

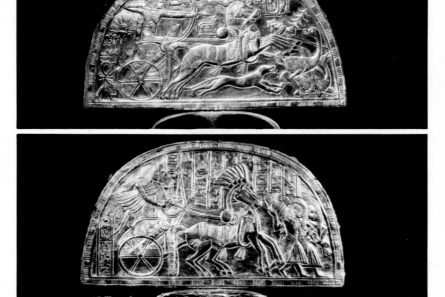

470. GODDESS PROTECTING CANOPIC SHRINE 471. FLABELLUM: OSTRICH HUNT 472. FLABELLUM: RETURN FROM THE HUNT 473. GODDESS PROTECTING CANOPIC SHRINE

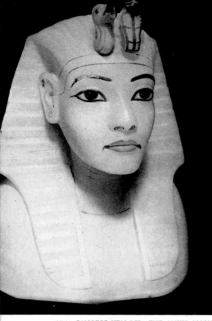

474. CANOPIC URN LID: TUT-ANKH-AMON

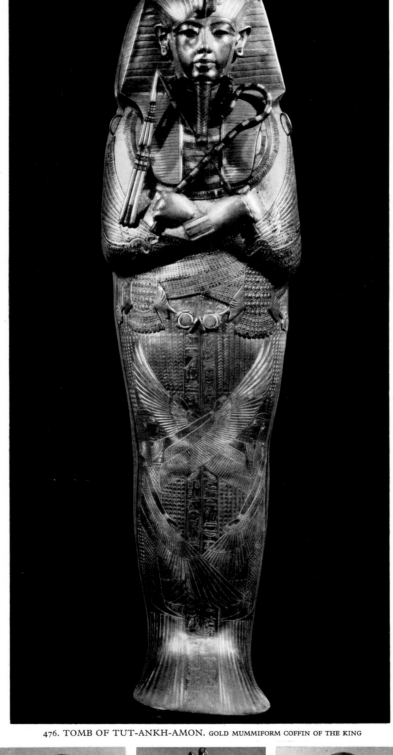

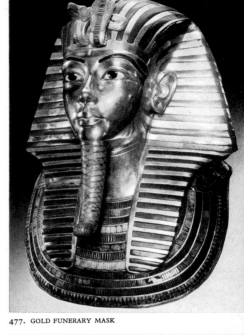

477. GOLD FUNERARY MASK

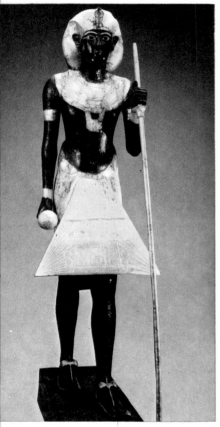

475. THE ROYAL KA-HARAKHTE

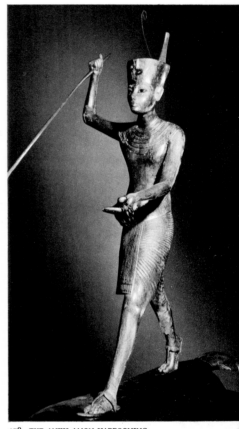

478. TUT-ANKH-AMON HARPOONING

476. TOMB OF TUT-ANKH-AMON. GOLD MUMMIFORM COFFIN OF THE KING

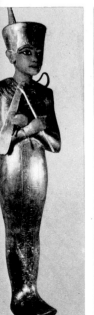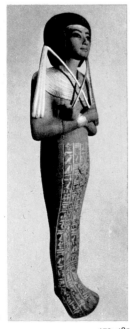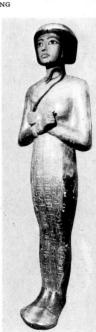

479-481. SHAWABTIS OF TUT-ANKH-AMON. 482. MUMMIFORM COFFIN FOR VISCERA. 483-485. SHAWABTIS OF TUT-ANKH-AMON

486. TELL EL AMARNA. BENDING FIGURES (LATE DYN. XVIII). 487. TOMB OF MERIRE (LATE DYN. XVIII). HORSES. 488. WARRIORS (LATE DYN. XVIII)

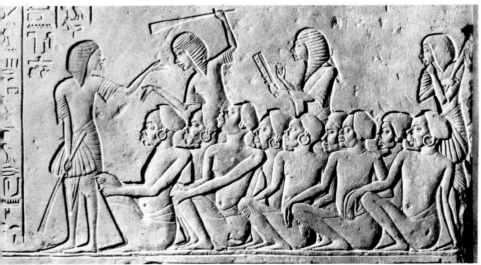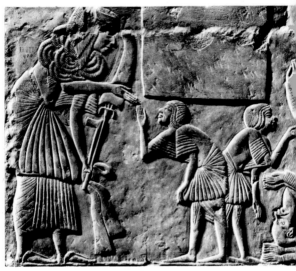

489, 490. RELIEFS FROM THE MEMPHITE TOMB OF HOREMHEB (LATE DYN. XVIII). HORSEMAN; SCENE WITH PRISONERS

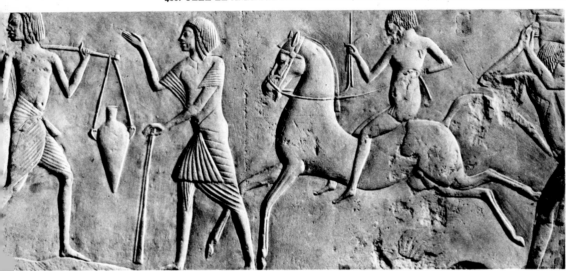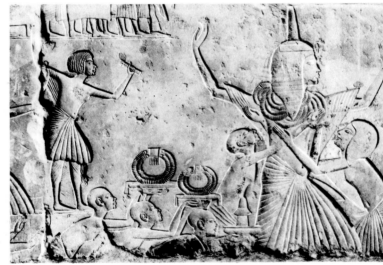

491, 492. RELIEFS FROM THE MEMPHITE TOMB OF HOREMHEB. BLACK AFRICAN CAPTIVES; SYRIAN CAPTIVES

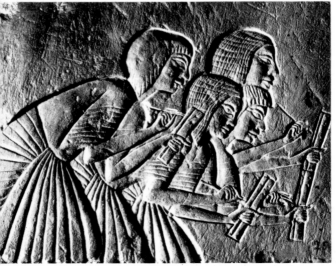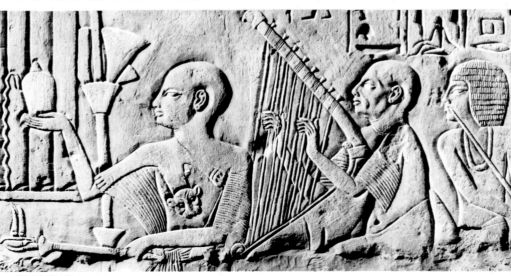

493. SCRIBES AT WORK (LATE DYN. XVIII) 494. SAQQARAH. THE BLIND HARPIST (LATE DYN. XVIII)

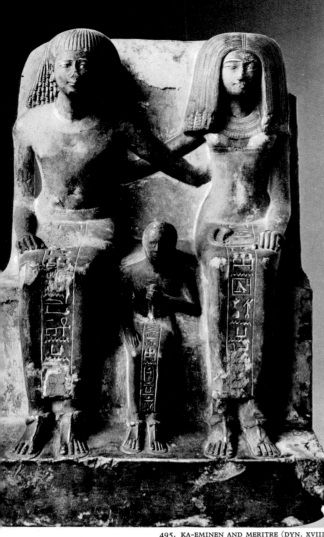

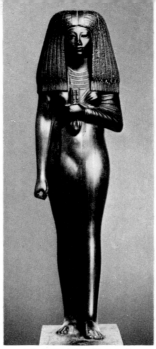

496. TUYU (DYN. XVIII–XIX)

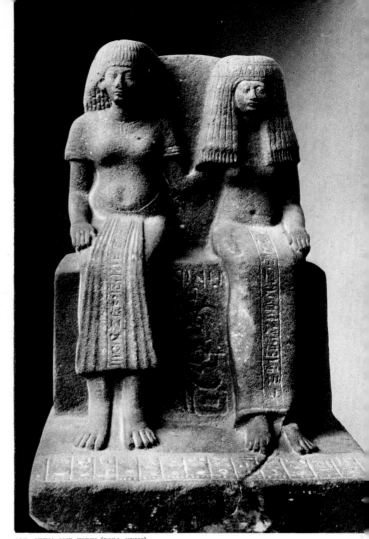

495. KA-EMINEN AND MERITRE (DYN. XVIII)

497. YUYA AND TUYU (DYN. XVIII)

499. STATUETTE (DYN. XVIII)

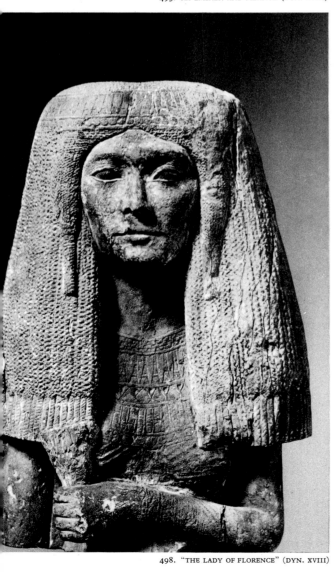

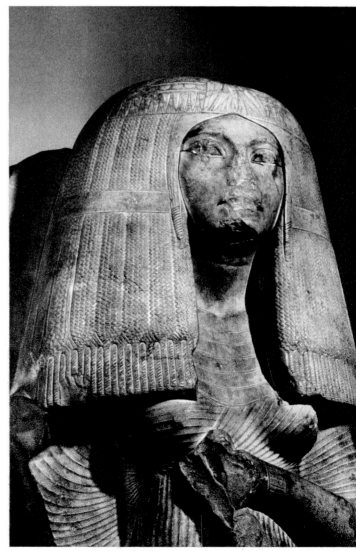

498. "THE LADY OF FLORENCE" (DYN. XVIII)

500. STATUETTE (DYN. XVIII)

501. NAKHT-MIN'S WIFE (DYN. XVIII)

403

502. THEBES. TOMB OF SETY I, PAINTED CEILING (DYN. XIX). ASTRONOMICAL REPRESENTATION. 503. CELESTIAL CONSTELLATIONS

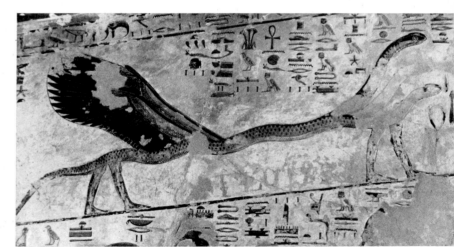

504. SNAKE AND SPIRIT OF THE AFTERWORLD

505. MONSTROUS SNAKE

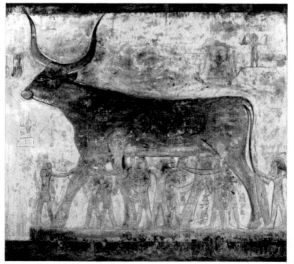

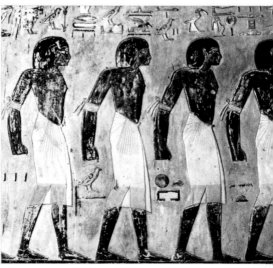

506. SPIRITS OF THE AFTERWORLD

507. THE HEAVENLY COW

508. FETTERED FOES

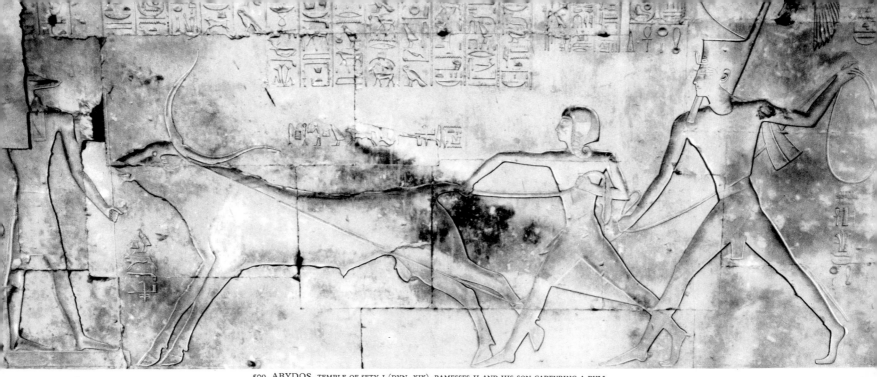

509. ABYDOS. TEMPLE OF SETY I (DYN. XIX). RAMESSES II AND HIS SON CAPTURING A BULL

510. OFFERING INCENSE

511. YOUNG PRINCE

512. IBIS-HEADED THOTH

513. SETY OFFERING INCENSE TO OSIRIS

514. ISIS PROTECTING OSIRIS

515. THE GODDESS MUT SUCKLING SETY

405

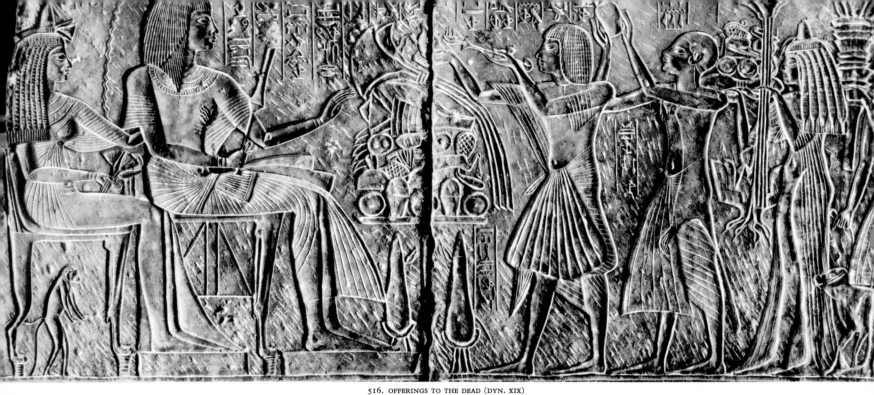

516. OFFERINGS TO THE DEAD (DYN. XIX)

517. STELE DEDICATED TO MNEVIS (DYN. XIX)

518. VOTIVE TABLET OF YOUNG RAMESSES II (DYN. XIX)

519. STELE WITH NAME OF MNEVIS (DYN. XIX)

520. DANCERS (DYN. XIX)

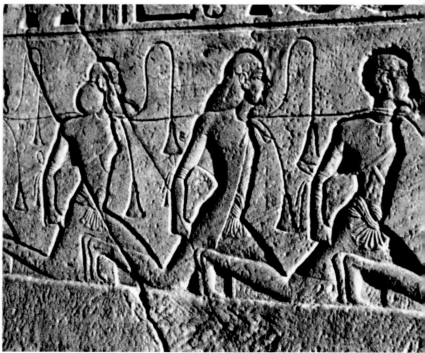

521. ABU SIMBEL. TEMPLE OF RAMESSES II (DYN. XIX). PRISONERS

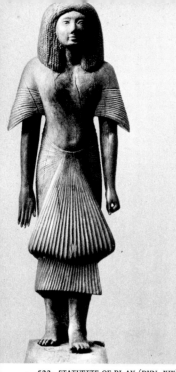

522. STATUETTE OF PI-AY (DYN. XIX)

523–525. STATUETTES WITH FALCON AND RAM INSIGNIA (DYN. XIX)

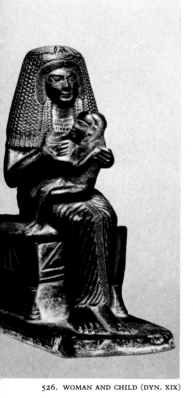

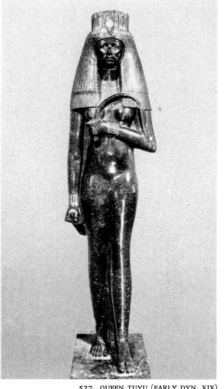

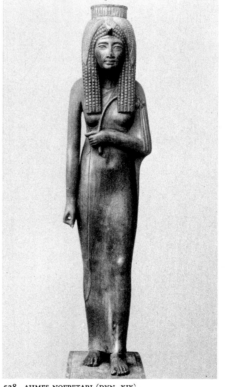

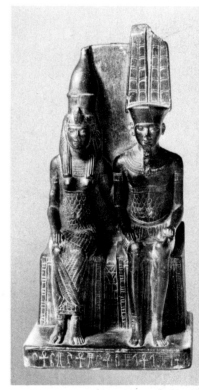

526. WOMAN AND CHILD (DYN. XIX)

527. QUEEN TUYU (EARLY DYN. XIX)

528. AHMES NOFRETARI (DYN. XIX)

529. AMON AND MUT (EARLY DYN. XIX)

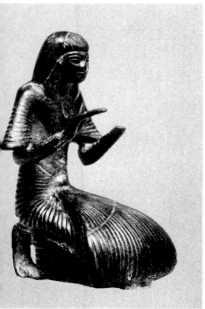

530. STATUETTE OF AN ORANT (DYN. XIX)

531. NEBMERTUWEF AND THE GOD THOTH (DYN. XIX)

532. THE GOD SETH (DYN. XIX)

533. BLOCK-STATUE OF BAKENHONS (DYN. XIX)

534. OSIRIS FLANKED BY A PHARAOH AND HORUS (DYN. XIX)

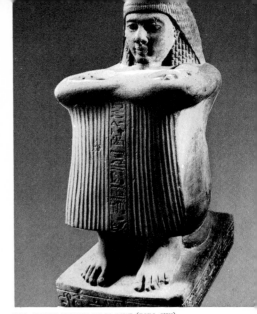

535. BLOCK-STATUE OF SA-MUT (DYN. XIX)

536. HORI AND PA-HEM-NEFER (DYN. XIX)

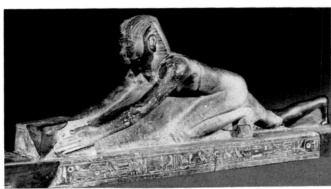

537. RAMESSES II ON HIS KNEES (DYN. XIX)

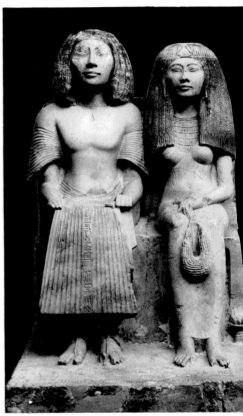

538. IWENI AND HIS WIFE (DYN. XIX)

539. BABOON WORSHIPING THE SUN (DYN. XIX–XX)

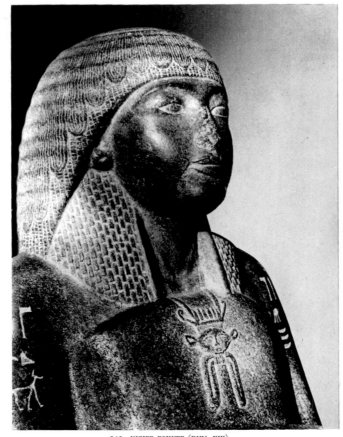

540. VIZIER PSIWER (DYN. XIX)

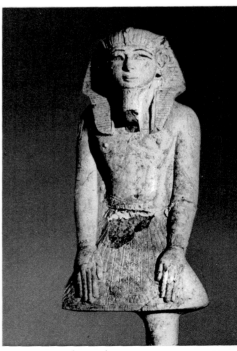

541. RAMESSES IV (DYN. XX)

408

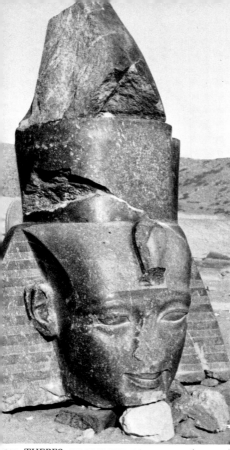

542. THEBES. COLOSSAL HEAD OF RAMESSES II (DYN. XIX)

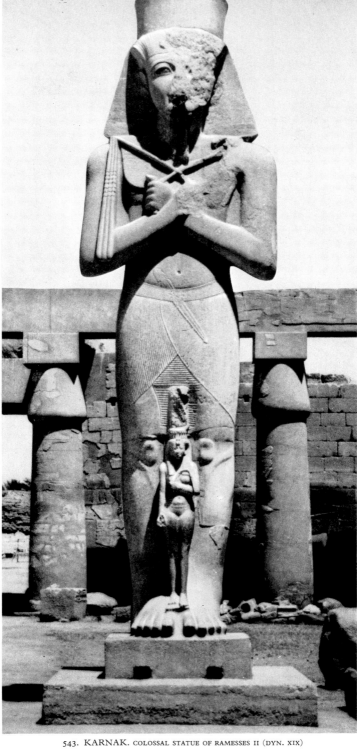

543. KARNAK. COLOSSAL STATUE OF RAMESSES II (DYN. XIX)

544. THEBES. COLOSSAL HEAD OF RAMESSES II (DYN. XIX)

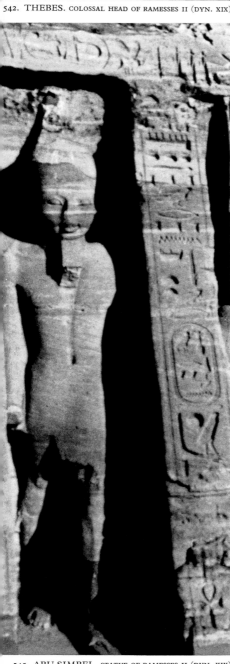

545. ABU SIMBEL. STATUE OF RAMESSES II (DYN. XIX)

546. TRIUMPHAL STATUE OF RAMESSES II (DYN. XIX)

547. LUXOR. COLOSSAL STATUE OF RAMESSES II (DYN. XIX)

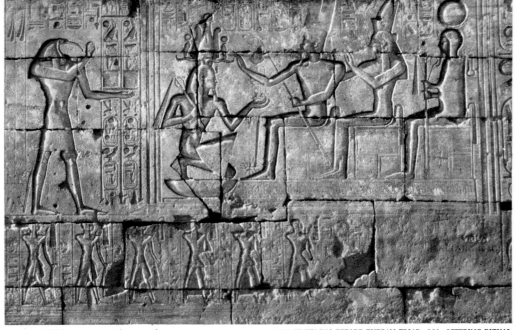

548. THEBES. RAMESSEUM (DYN. XIX). OFFERING RITUAL. 549. PHARAOH KNEELING BEFORE THEBAN TRIAD. 550. OFFERING RITUAL

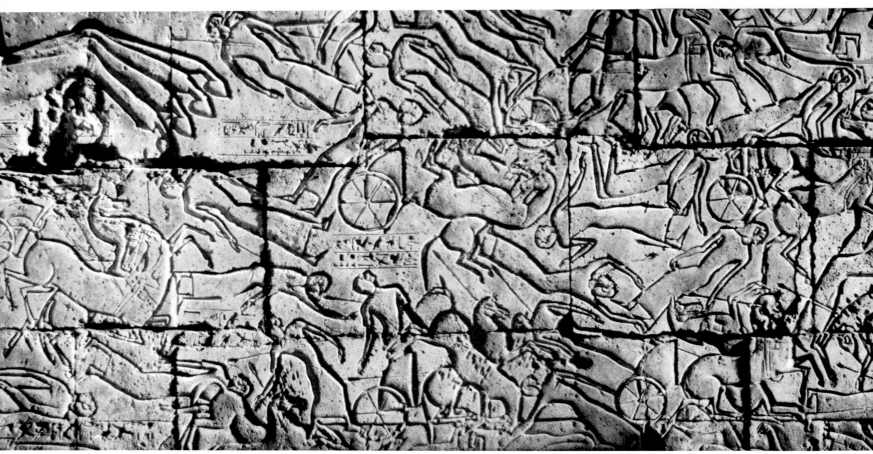

551. BATTLE OF KADESH: MELÉE

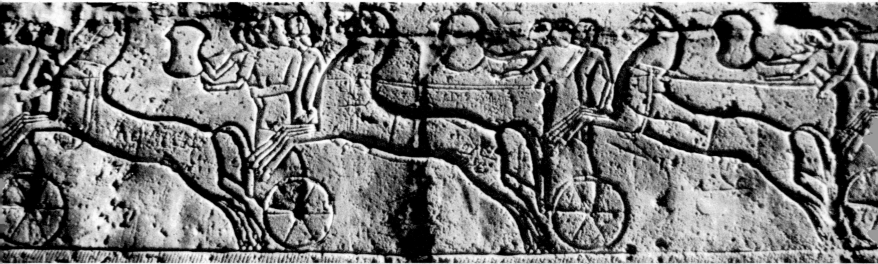

552. BATTLE OF KADESH: WARRIORS IN CHARIOTS

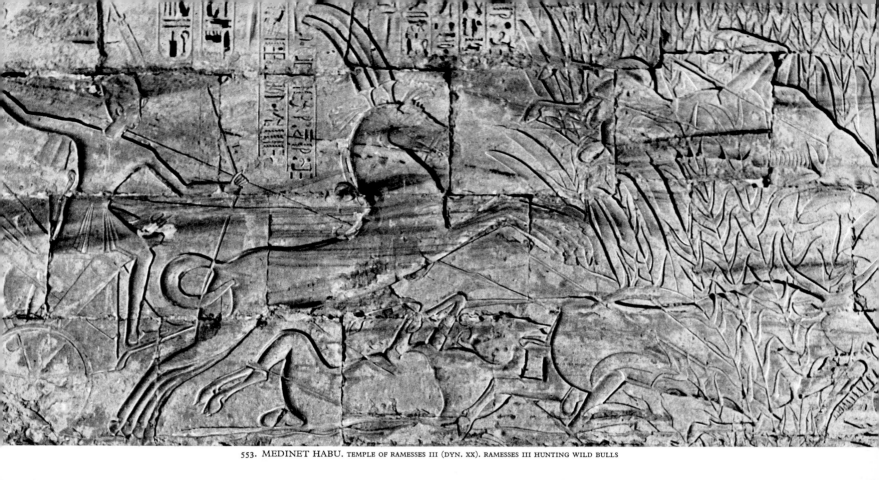

553. MEDINET HABU. TEMPLE OF RAMESSES III (DYN. XX). RAMESSES III HUNTING WILD BULLS

554-555. HUNT OF RAMESSES III, DETAILS

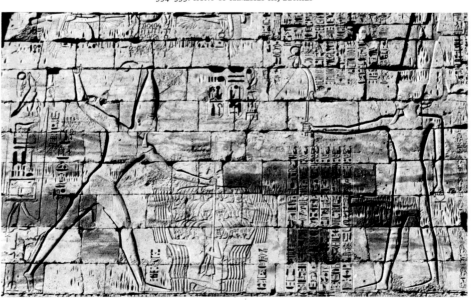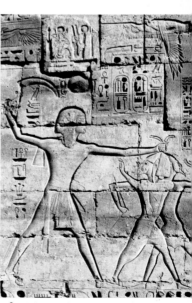

556. GODDESS AND PHARAOH 557. PHARAOH SLAYING FOES 558. FOES BEING SLAUGHTERED

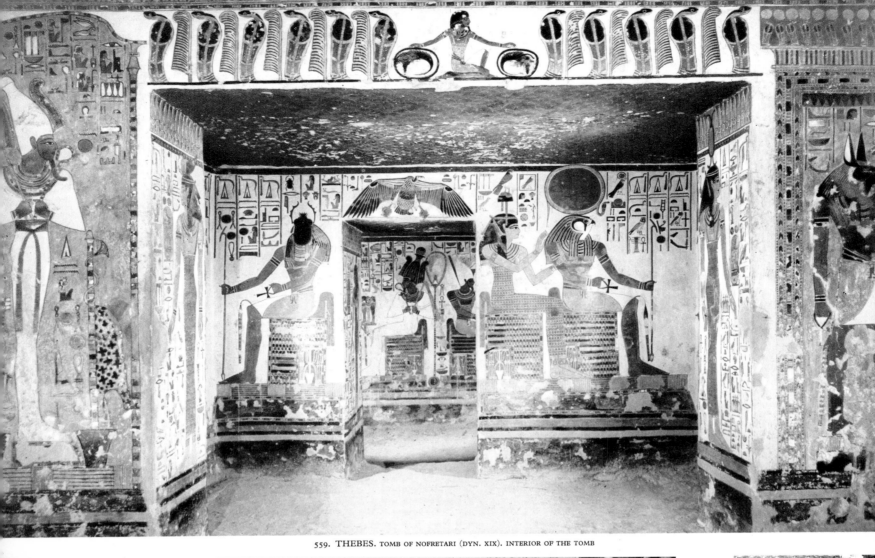

559. THEBES. TOMB OF NOFRETARI (DYN. XIX). INTERIOR OF THE TOMB

560. THE GODDESS ISIS

561. ISIS AND NEPHTHYS MOURNING OSIRIS

562. FUNERARY SPIRIT

563. ISIS KNEELING

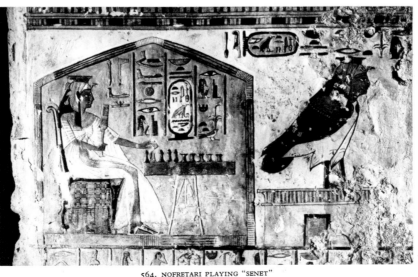

564. NOFRETARI PLAYING "SENET"

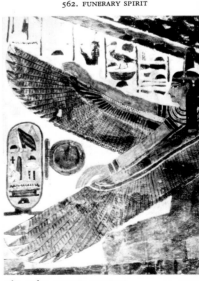

565. MA'AT, GODDESS OF TRUTH

412

566. DEIR EL MEDINEH. TOMB OF IPY (DYN. XIX). CARPENTER AT WORK. 567. CRAFTSMAN AT WORK. 568. POLISHER

569. DEIR EL MEDINEH. TOMB OF ERENEFER (DYN. XIX–XX). THE SUN RISING BETWEEN TWO SYCAMORES. 570. SCENE OF WORSHIP. 571. THE DECEASED IN SOLAR BARGE WORSHIPING THE PHOENIX

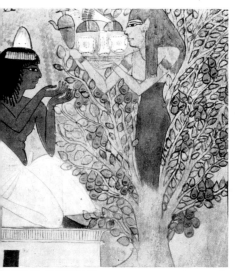

DEIR EL MEDINEH. TOMB OF SENNEDJEM (DYN. XIX). THE SYCAMORE GODDESS. 573. DEIR EL MEDINEH. TOMB OF PASHEDU (DYN. XIX–XX). THE EYE OF HORUS HOLDING A TORCH. 574. RELATIVES OF THE DECEASED

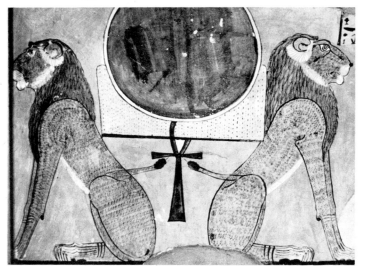

575. DEIR EL MEDINEH. TOMB OF INHERKA (DYN. XX). THE FOUR JACKALS. 576. TWO LIONS BEARING THE SOLAR DISK. 577. INHERKA AND THE PHOENIX OF HELIOPOLIS

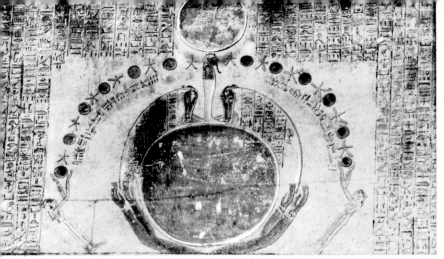

578. THEBES. TOMB OF RAMESSES VI (DYN. XX). DESCENT OF THE SOLAR DISK INTO THE ABYSS.

579. "HE BECOMES THE GREAT KHEPRI..."

580. SWIMMER

581. FIRE-SPITTING SERPENT

582. SOLAR DISK, BARGE, AND WORSHIPERS

583. "THE BODY OF DESTRUCTION"

584. SOLAR DISK WITH EAGLE'S HEAD

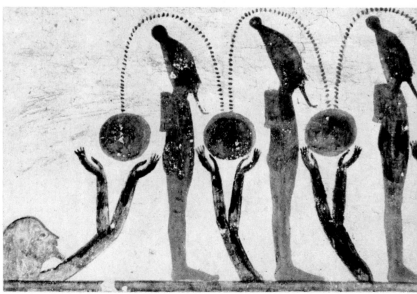

585. OSIRIS AND THE BIRTH OF THE NEW SOLAR DISK

LATE PERIOD

Dynasties XXI – XXXI

(1085 – 332 B.C.)

GREEK PERIOD

Macedonian Kings (332 – 304 B.C.)

Ptolemaic Dynasty (304 – 30 B.C.)

ROMAN PERIOD

(30 B.C. – 395 A.D.)

COPTIC AND BYZANTINE PERIOD

(395 – 641 A.D.)

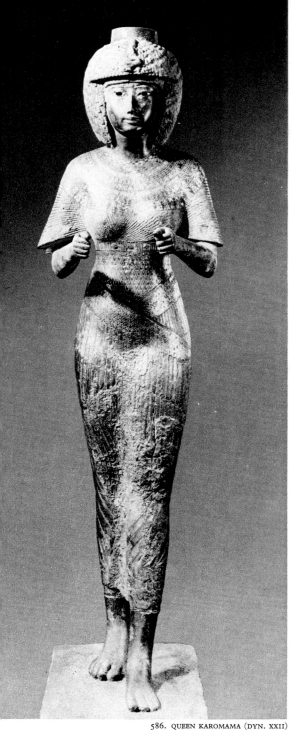

586. QUEEN KAROMAMA (DYN. XXII)

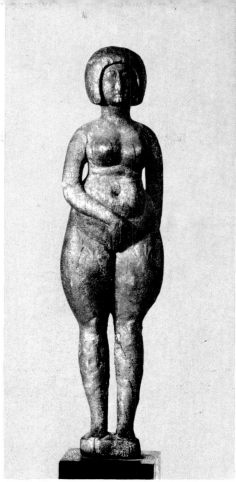

587. STATUETTE OF A WOMAN (DYN. XXV)

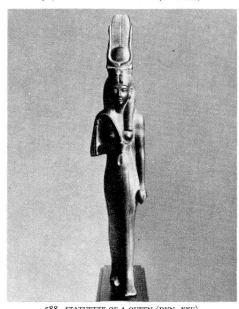

588. STATUETTE OF A QUEEN (DYN. XXV)

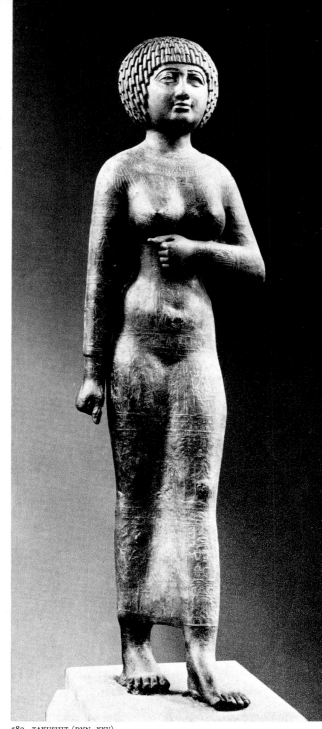

589. TAKUSHIT (DYN. XXV)

590. SEATED MAN (DYN. XXV–XXVI)

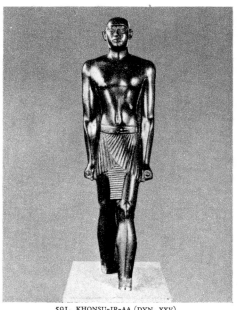

591. KHONSU-IR-AA (DYN. XXV)

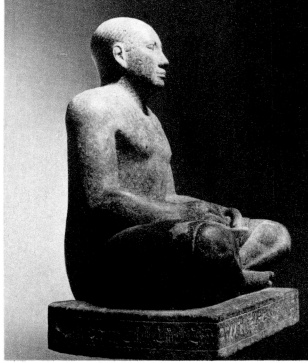

592. SEATED SCRIBE (DYN. XXV)

417

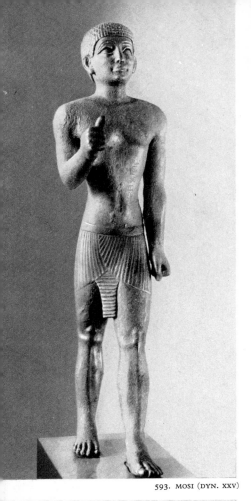

593. MOSI (DYN. XXV)

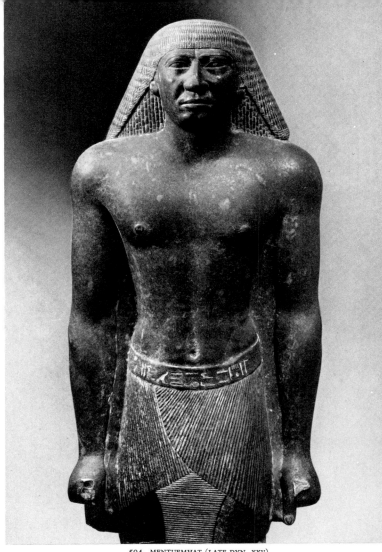

594. MENTUEMHAT (LATE DYN. XXV)

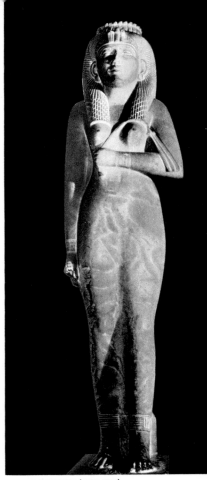

595. AMENARTAIS (DYN. XXV)

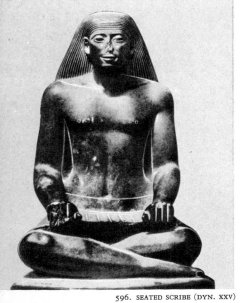

596. SEATED SCRIBE (DYN. XXV)

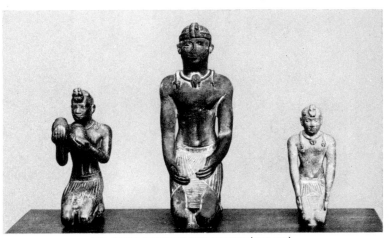

597. CENTER STATUETTE: KING TAHARQA (DYN. XXV)

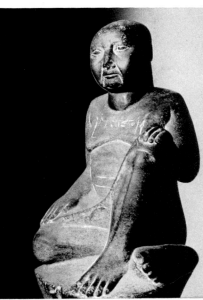

598. HARWA, MANAGER UNDER AMENARTAIS (DYN. XXV)

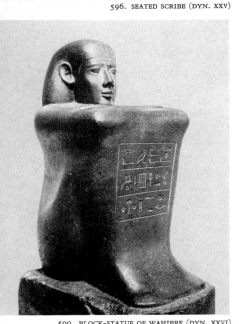

599. BLOCK-STATUE OF WAHIBRE (DYN. XXVI)

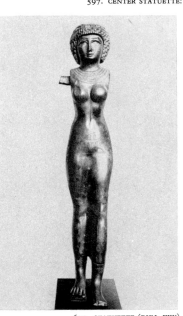

600. STATUETTE (DYN. XXV)

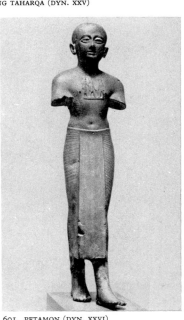

601. PETAMON (DYN. XXVI)

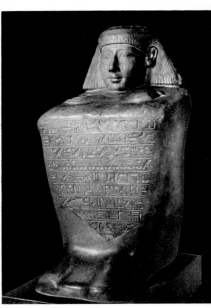

602. MAYOR WESER (DYN. XXVI)

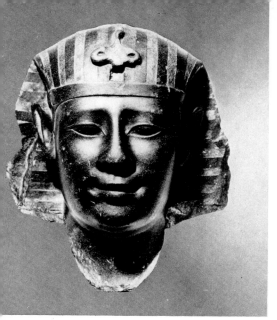

603. ROYAL HEAD (DYN. XXVI)

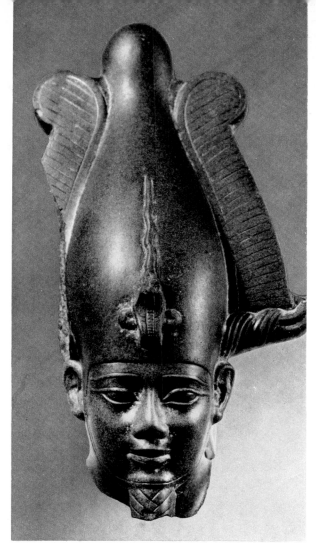

605. HEAD OF OSIRIS (LATE PERIOD)

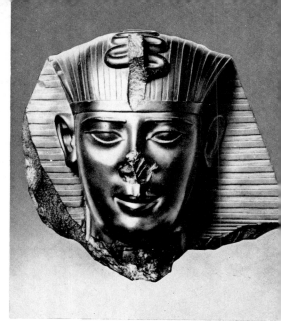

606. ROYAL HEAD (DYN. XXVI)

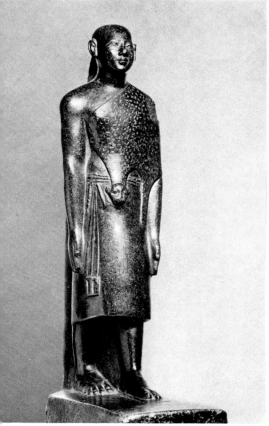

604. STANDING PRIEST (LATE PERIOD)

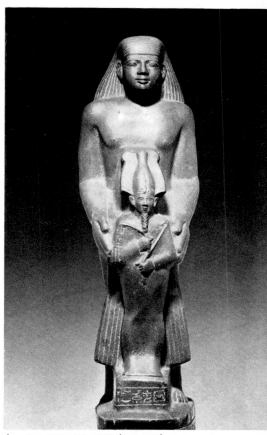

607. IRET-HERRU AND OSIRIS (DYN. XXVI)

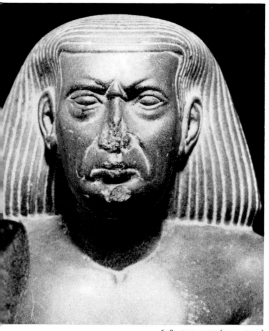

608. OLD MAN (DYN. XXVI)

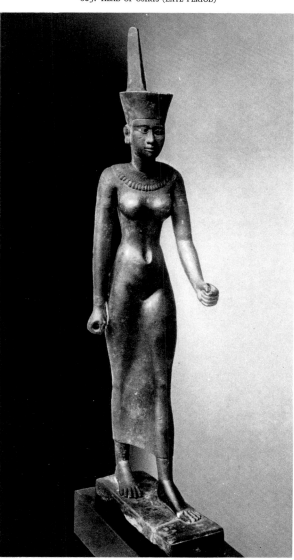

609. THE GODDESS NEITH (DYN. XXVI)

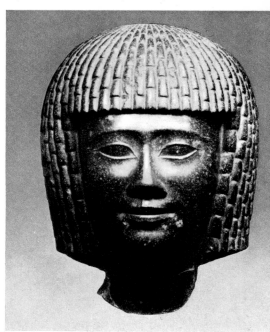

610. HEAD OF A MAN (DYN. XXVI)

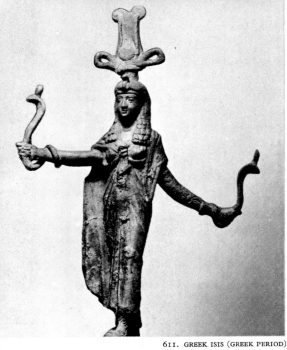

611. GREEK ISIS (GREEK PERIOD)

612. VOTIVE STATUE OF A PRIEST (DYN. XXX)

613. PRIEST HOLDING A LOTUS (LATE PERIOD)

614,615. BASTET; HORUS (LATE PERIOD)

616. STATUETTE OF APIS (LATE PERIOD)

617, 618. HARPOCRATES; ISIS AND CHILD HORUS (LATE PERIOD)

619. "HEALING" AMULET (LATE PERIOD)

620. THE GOD BES (DYN. XXX)

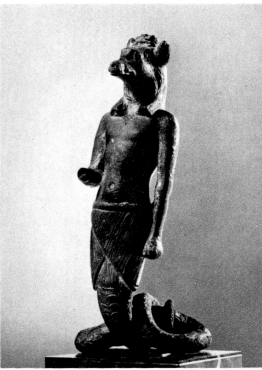

621. ANUBIS (ROMAN PERIOD)

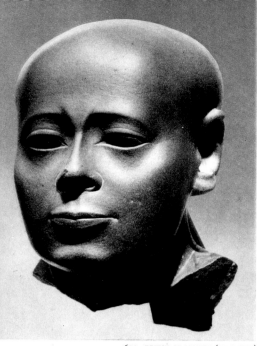

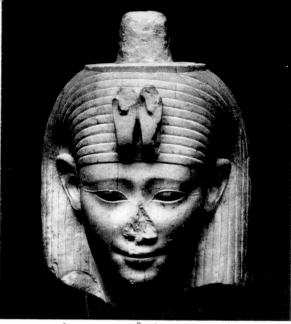

622. PRIEST OF MONTU (DYN. XXX)

623. QUEEN ARSINOË II (PTOLEMAIC PERIOD)

624. "TIRED OLD MAN" (EARLY PTOLEMAIC PERIOD)

625. HEAD OF A PRIEST (DYN. XXX)

626. VOTIVE STATUE (PTOLEMAIC PERIOD)

627. HEAD OF A PRIEST (PTOLEMAIC PERIOD)

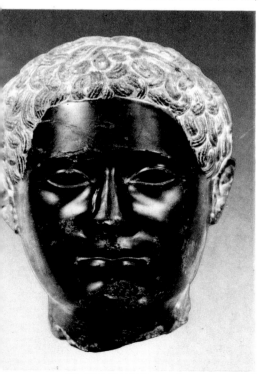

628. HEAD OF A YOUNG MAN (PTOLEMAIC PERIOD)

629. HEAD OF A BOY (PTOLEMAIC PERIOD)

630. HEAD OF A BEARDED MAN (PTOLEMAIC PERIOD)

631. TUNEH EL GEBEL. TOMB OF PETOSIRIS (LATE 4TH CENTURY B.C.). TENDING THE HERD

632. WINE MAKING

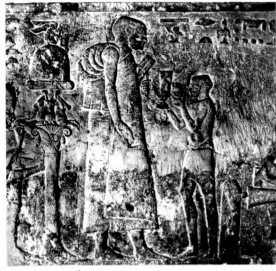

633. PRESENTATION OF OFFERINGS

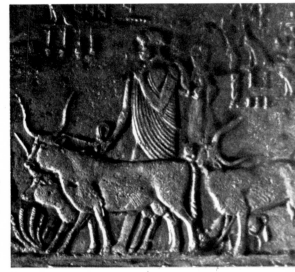

634. MOVING THE HERD

635. HARVESTING GRAPES AND MAKING WINE

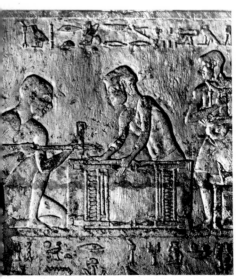

636. WOOD-WORKERS

637. WORSHIPING THE GODS

638. WORSHIPING THE SYCAMORE GODDESS

422

639. STELE WITH THE NAME OF ATHANARUS (PTOLEMAIC PERIOD)

640. WOMAN AND SERVANTS (PTOLEMAIC PERIOD)

641. EMBALMING SCENE (PTOLEMAIC PERIOD)

642. HORUS SLAYING AN ENEMY (PTOLEMAIC PERIOD)

643. THE GODDESS TUTU (PTOLEMAIC PERIOD)

644. FUNERARY RELIEF (PTOLEMAIC PERIOD)

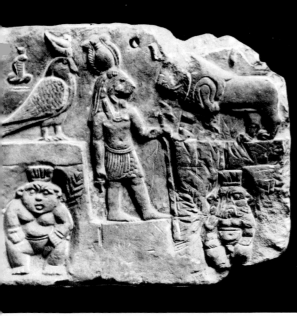

645. STELE WITH FIGURES OF GODS (PTOLEMAIC PERIOD)

646. SLEEPING NEGRO (PTOLEMAIC PERIOD)

647. THE GODDESS TUTU AS A SPHINX (GRAECO-ROMAN)

648. MUSAWARAT (MEROÏTIC PERIOD). HEAD OF HORUS

651. MUSAWARAT (MEROÏTIC PERIOD). HEAD OF A KING

649. MUSAWARAT (MEROÏTIC PERIOD). LION AND ELEPHANT

650. KING (MEROÏTIC PERIOD)

652. MUSAWARAT (MEROÏTIC PERIOD). AMON AND LOCAL GODS

653. RECLINING FIGURE (MEROÏTIC PERIOD)

654. EDFU. TEMPLE OF HORUS (PTOLEMAIC PERIOD). HORUS. 655. PHARAOH IN COMBAT. 656. HORUS AND THOTH

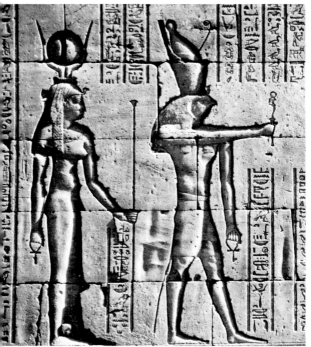

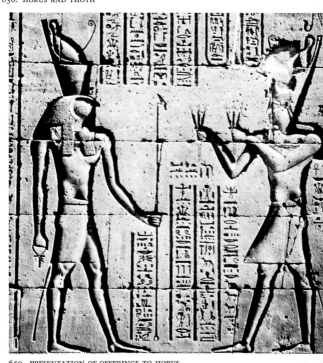

657. HATHOR AND HORUS 658. STATUE OF HORUS AS A FALCON 659. PRESENTATION OF OFFERINGS TO HORUS

660. PHILAE. TEMPLE OF ISIS (PTOLEMAIC PERIOD). PRESENTATION OF OFFERINGS TO HORUS. 661. THE KING PRESENTING OFFERINGS TO ISIS

662. DENDERAH. CRYPTS OF THE HATHOR TEMPLE (1ST CENTURY B.C.). DOUBLE SYMBOLIC REPRESENTATION OF HARSAMTAWY

663. HATHOR, IHY, MA'AT, MENAT NECKLACE, ISIS, IHY, PTOLEMY XII

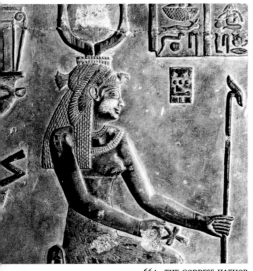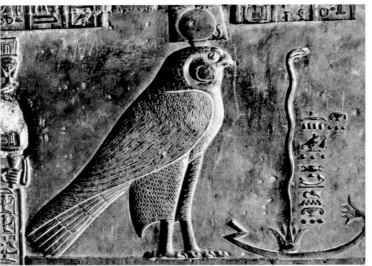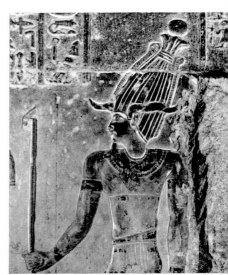

664. THE GODDESS HATHOR 665. HARSAMTAWY AS A FALCON 666. THE GOD NEBSEKHEBEF(?)

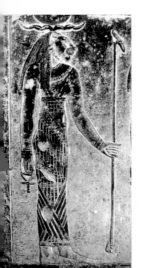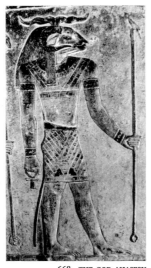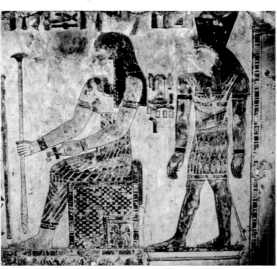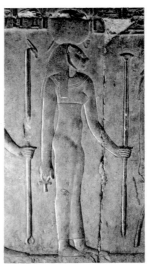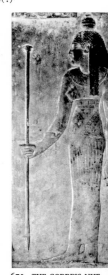

667. THE GODDESS TEFNUT 668. THE GOD AHASESU 669. WORSHIP OF HATHOR 670. THE GODDESS TEFNUT 671. THE GODDESS NUT

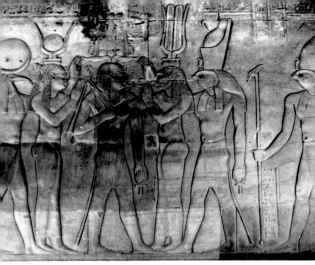
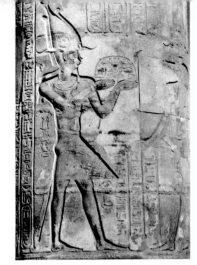
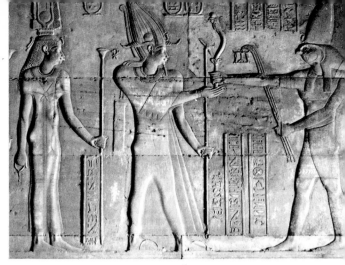

672. KOM OMBO. TEMPLE OF HAROERIS (PTOLEMAIC AND ROMAN PERIODS). RITUAL SCENE. 673. THE KING PRESENTING OFFERINGS TO THE GOD SOBEK. 674. RITUAL SCENE

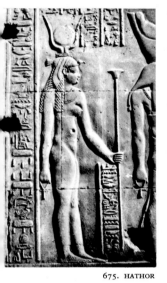

675. HATHOR 676. LION 677. WOMAN CARRYING OFFERINGS

678. RITUAL LUSTRATION OF THE KING 679. RELIEF ON A SARCOPHAGUS: LAMENTATION OF ISIS AND NEPHTHYS 680. DEITIES

681. KALABSHA. TEMPLE OF MANDULIS (ROMAN PERIOD). THE KING BEFORE MANDULIS. 682. INSIGNIA OF THE GOD MANDULIS. 683. KING SILKO (GRAFFITO, 6TH CENTURY A.D.)

427

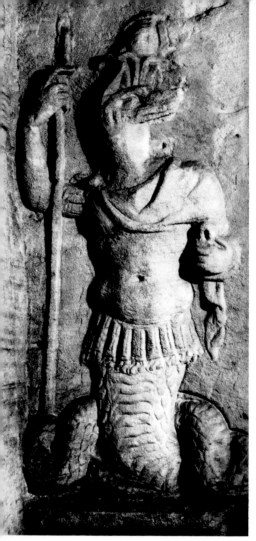

684. KOM EL SHUKAFA. TOMB (1ST–2ND CENTURY A.D.). ANUBIS. 685. THE DECEASED(?). 686. ANUBIS

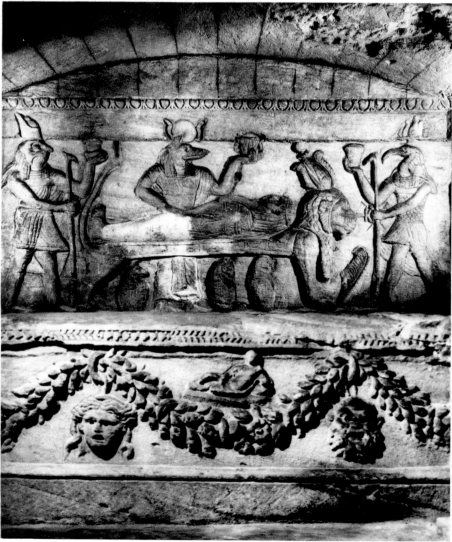

687. THE DECEASED AND A PRIEST

690. PRIEST AND A WOMAN

688. HAPI AND ISMET

689. MUMMY GUARDED BY HORUS, ANUBIS, AND THOTH

691. PTAH AND AN EMPEROR

692. BUST OF A ROMAN EMPEROR (C. 300 A.D.)

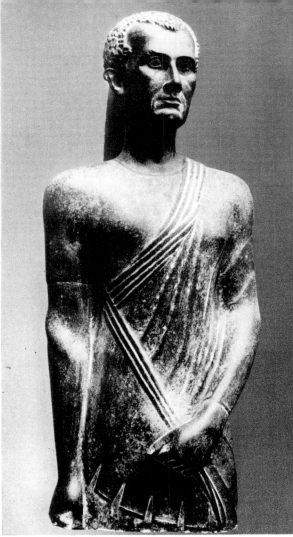

693. THE PRIEST HOR (ROMAN PERIOD)

694. BUST OF A MAN (ROMAN PERIOD)

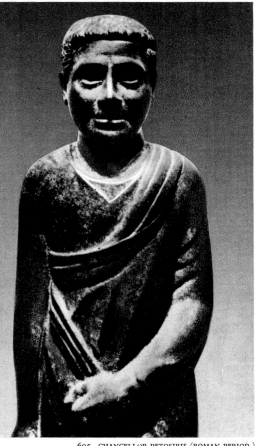

695. CHANCELLOR PETOSIRIS (ROMAN PERIOD)

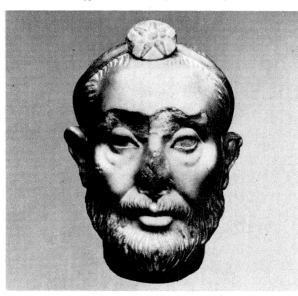

696. BEARDED HEAD (ROMAN PERIOD)

697. GENERAL PAMENKHES (ROMAN PERIOD)

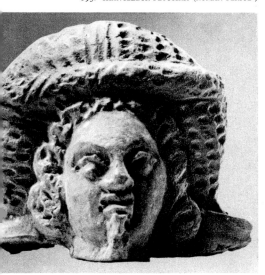

698. HEAD OF A WOMAN (ROMAN PERIOD)

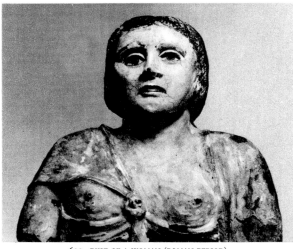

699. BUST OF A WOMAN (ROMAN PERIOD)

700. TERRACOTTA MASK (GRAECO-ROMAN PERIOD)

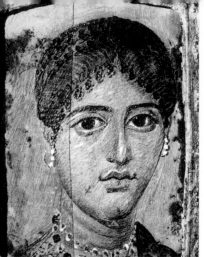
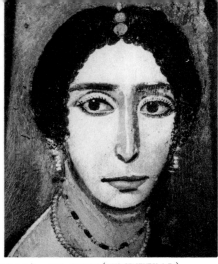
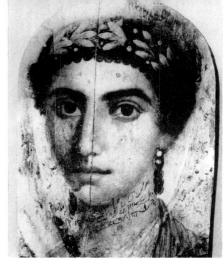
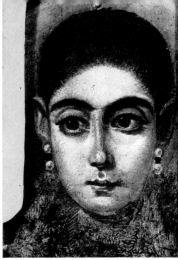

FAYUM PORTRAITS. 701. WOMAN (2ND CENTURY A.D.) 702. WOMAN (4TH CENTURY A.D.) 703. YOUNG WOMAN (ROMAN PERIOD) 704. YOUNG WOMAN (ROMAN PERIOD)

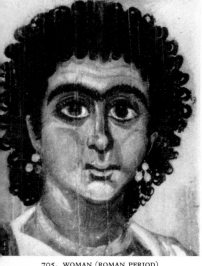
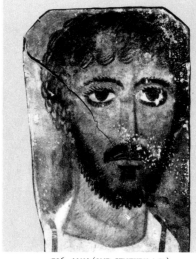
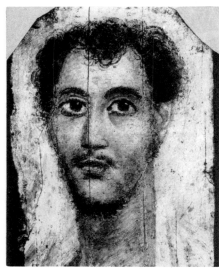

705. WOMAN (ROMAN PERIOD) 706. MAN (2ND CENTURY A.D.) 707. MAN (2ND CENTURY A.D.) 708. BOY (2ND CENTURY A.D.)

COPTIC TEXTILES. 709. HARE (5TH–7TH CENTURY A.D.) 710. HORSEMAN (5TH–7TH CENTURY A.D.) 711. MYTHOLOGICAL SCENE (3RD–5TH CENTURY A.D.)

712. HORSE (5TH–6TH CENTURY A.D.) 713. HEAD OF DIONYSOS (3RD–4TH CENTURY A.D.) 714. PORTRAIT (4TH–5TH CENTURY A.D.) 715. EAGLE (5TH CENTURY A.D.)

COPTIC SCULPTURE. 716. LOW RELIEF WITH NYMPHS 717. TYMPANUM WITH BUST (6TH CENTURY A.D.)

718. HORUS SLAYING A CROCODILE (5TH–6TH CENTURY A.D.) 719. CHRIST BEING BATHED

720. MOSES (6TH–7TH CENTURY A.D.) 721. ANNUNCIATION, FRAGMENT (4TH–5TH CENTURY A.D.) 722. CHRIST IN MAJESTY (COPTIC, 13TH CENTURY A.D.)

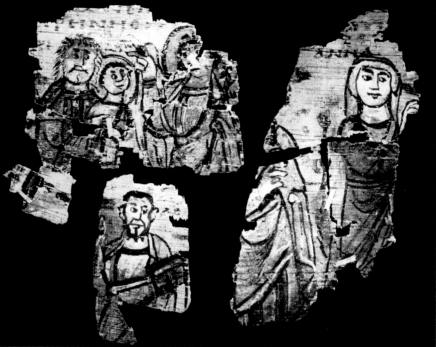

COPTIC PAINTING. 723. MANUSCRIPT: LAST SUPPER (5TH CENTURY A.D.) 724. ADAM AND EVE

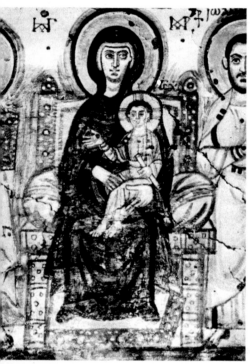

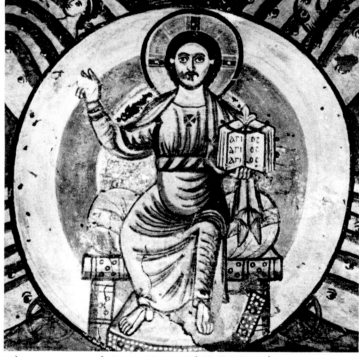

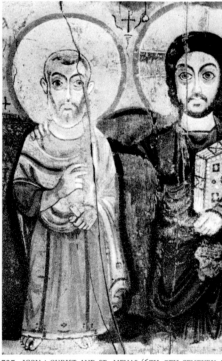

725. VIRGIN, CHILD, AND APOSTLE, FROM BAWIT (7TH CENTURY A.D.) 726. CHRIST, FROM BAWIT (7TH CENTURY A.D.) 727. ICON: CHRIST AND ST. MENAS (6TH–7TH CENTURY A.D.)

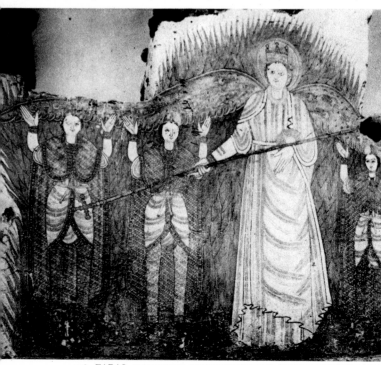

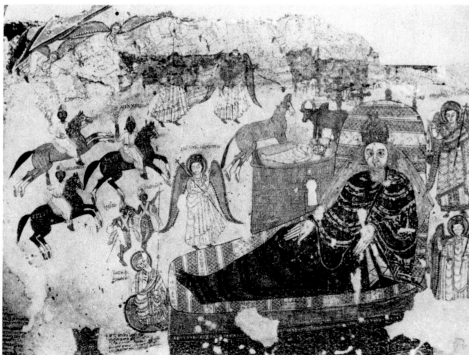

728. FARAS. THE HEBREWS IN THE FIERY FURNACE (LATE 10TH CENTURY A.D.) 729. FARAS. NATIVITY (EARLY 11TH CENTURY A.D.)

SELECTED OBJECTS

Sarcophagi

Papyri

Ostraca

Vases and Faience

Toilet Objects

Jewelry

Furniture

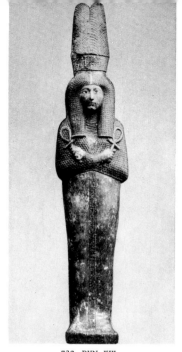

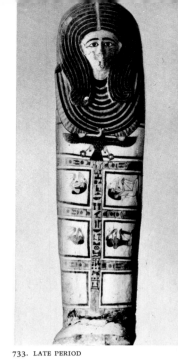

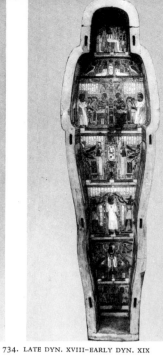

SARCOPHAGI. 730. DYN. XVII 731. DYN. XVIII 732. DYN. XIX 733. LATE PERIOD 734. LATE DYN. XVIII–EARLY DYN. XIX

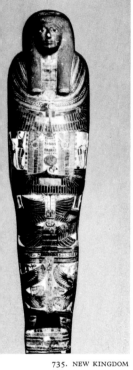

735. NEW KINGDOM 736. DYN. XXI 737. NEW KINGDOM(?) 738. SAITE PERIOD 739. SAITE PERIOD

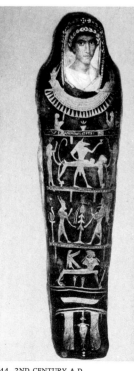

740. SAITE PERIOD 741. DYN. XXVI 742. LATE PERIOD 743. LATE PERIOD 744. 2ND CENTURY A.D.

PAPYRI. 745. HARMASHU-TUM CARRIED BY FOUR FIGURES (DYN. XIX?) 746. ISIS AND NUT KEEPING VIGIL OVER OSIRIS (DYN. XIX?)

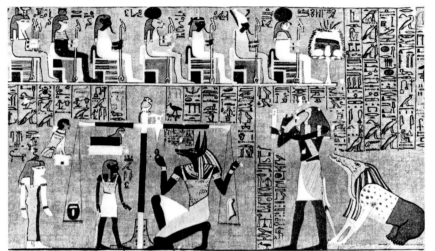

747. ANUBIS AND A MUMMY (DYN. XIX) 748. WEIGHING OF THE SOUL (DYN. XIX) 749. LABORING IN THE AFTERWORLD (D

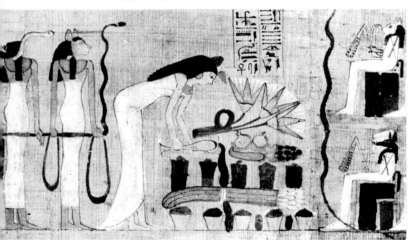

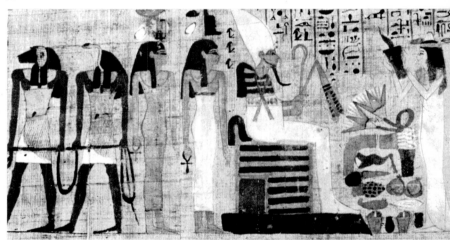

750. OFFERING TABLE 751. PRAYER TO OSIRIS

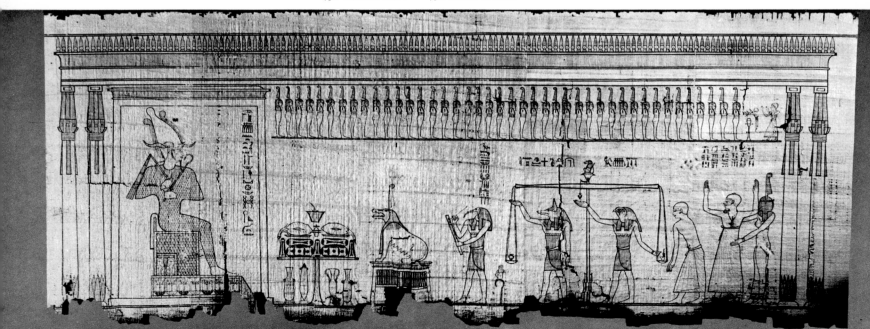

752. WEIGHING OF THE SOUL (PTOLEMAIC PERIOD)

OSTRACA. 753. DANCER 754. RITUAL DANCER (DYN. XVIII) 755. PORTRAIT SKETCH (DYN. XIX–XX)

756. KING SPEARING LION (LATE DYN. XVIII) 757. WRESTLERS (DYN. XIX–XX) 758. CHARIOT (DYN. XIX–XX)

759. TWO BULLS IN COMBAT (DYN. XIX) 760. MONKEY EATING A FIG (DYN. XIX–XX) 761. CAT GUARDING A FLOCK OF GEESE (DYN. XIX–XX)

762. HIPPOPOTAMUS (DYN. XVIII) 763. HORSE (DYN. XVIII) 764. FALCON, OSTRICH, AND JACKAL(?) (DYN. XIX–XX)

VASES AND FAIENCE. 765. ALABASTER CUP (DYN. I) 766. DISK WITH ANIMALS (DYN. I) 767. FRAGMENTS OF A LEAF-SHAPED VESSEL (DYN. II)

768. MONKEY-SHAPED PERFUME FLASK (DYN. VI) 769. HIPPOPOTAMUS (DYN. XI) 770. LION-SHAPED UNGUENT VASE (DYN. XVIII

771. CANOPIC URN (DYN. XIX–XX). 772. CALYX-SHAPED VASE (DYN. XVIII). 773. ALABASTER LAMP (DYN. XVIII). 774. PAINTED JAR (DYN. XVIII) 775. CANOPIC URN (SAITE PERIOD)

776. CUP (DYN. XVIII) 777. FALSE CANOPIC URN (DYN. XIX–XX) 778. PAINTED AMPHORA (COPTIC) 779. PAINTED VESSEL (9TH CENTURY A.D.)

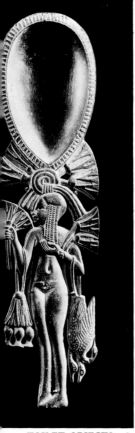

TOILET OBJECTS. 780. COSMETIC SPOON (NEW KINGDOM). 781. UNGUENT CONTAINER (DYN. XVIII). 782. COSMETIC SPOON (NEW KINGDOM). 783. RAZOR (DYN. XVIII). 784. COSMETIC SPOON (DYN. XVIII)

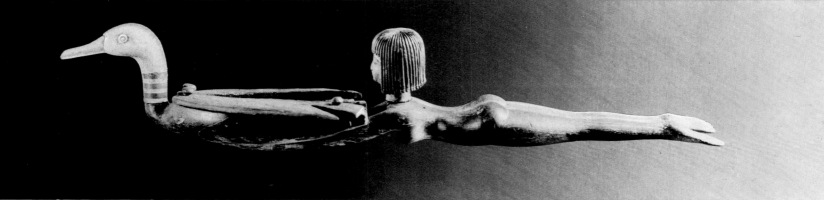

785. COSMETIC SPOON WITH SWIMMER (DYN. XVIII)

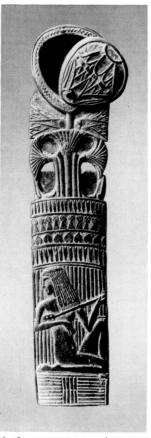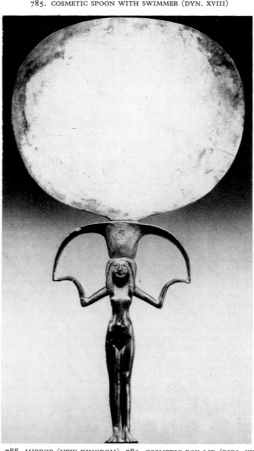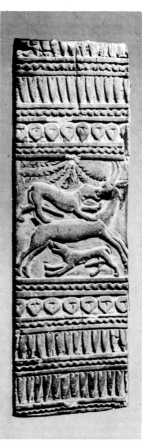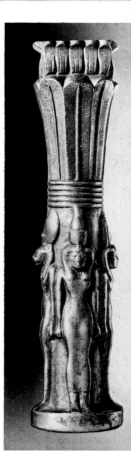

786, 787. COSMETIC SPOONS (NEW KINGDOM). 788. MIRROR (NEW KINGDOM). 789. COSMETIC BOX LID (DYN. XVIII–XIX). 790. MIRROR HANDLE (DYN. XXV)

439

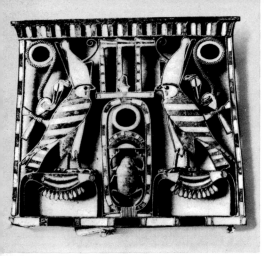

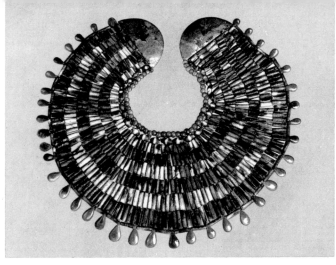

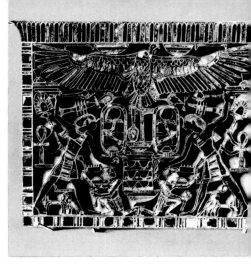

JEWELRY. 791. PECTORAL WITH FALCONS (DYN. XII) 792. GREEN FAIENCE NECKLACE WITH PEARLS (DYN. XI) 793. PECTORAL (DYN. XII)

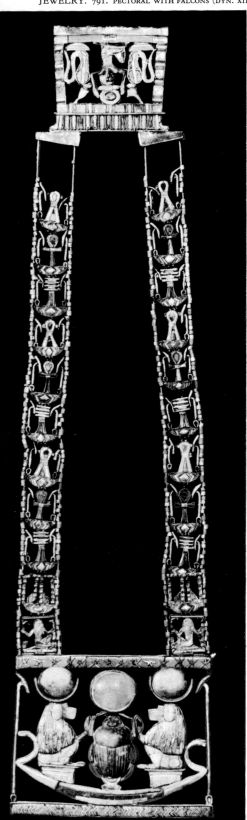

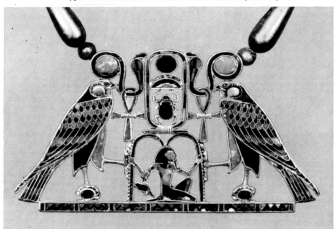

795. PECTORAL WITH NAME OF SESOSTRIS II (DYN. XII)

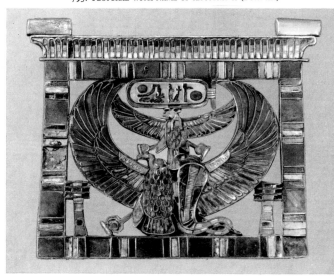

796. PECTORAL OF RAMESSES II (DYN. XIX)

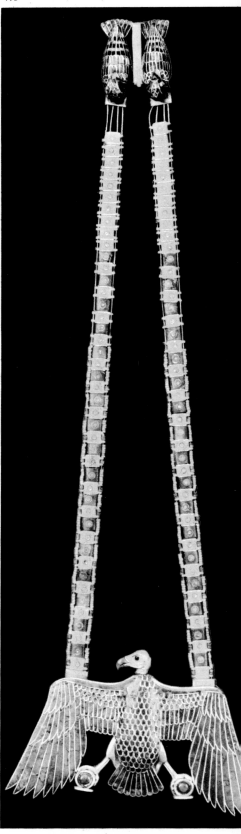

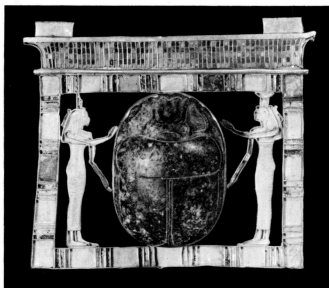

794. NECKLACE AND PECTORAL (DYN. XVIII) 797. PECTORAL WITH SCARAB OF THE VIZIER PASAR (DYN. XIX) 798. NECKLACE WITH VULTURE PENDANT (DYN. XVIII)

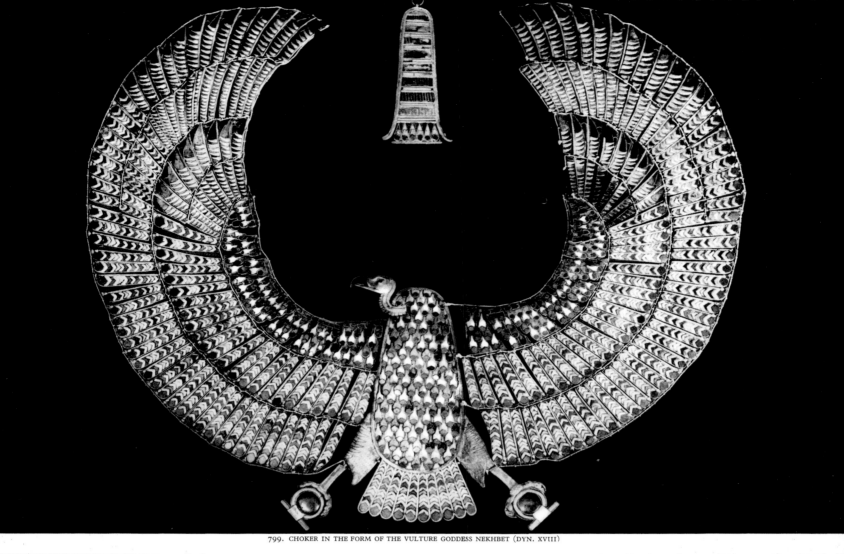

799. CHOKER IN THE FORM OF THE VULTURE GODDESS NEKHBET (DYN. XVIII)

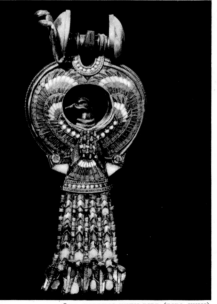

800. EARRING WITH BIRD (DYN. XVIII)

804. "HORSES" RING OF RAMESSES II (DYN. XIX)

801. GOLD BRACELET FROM MEROË (IST CENTURY B.C.)

802. GOLD JEWEL FROM MEROË (IST CENTURY B.C.). 803. GOLD NECKLACE (5TH–7TH CENTURY A.D.)

805. GOLD BRACELET FROM MEROË (IST CENTURY A.D.)

FURNITURE. 806. HEADREST OF PEPY II (DYN. VI)

807. BED OF QUEEN HETEP-HERES (DYN. IV)

808. ARMCHAIR OF HETEP-HERES (DYN. IV)

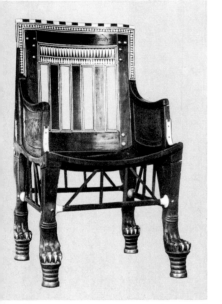

809. ARMCHAIR OF TUT-ANKH-AMON (DYN. XVIII)

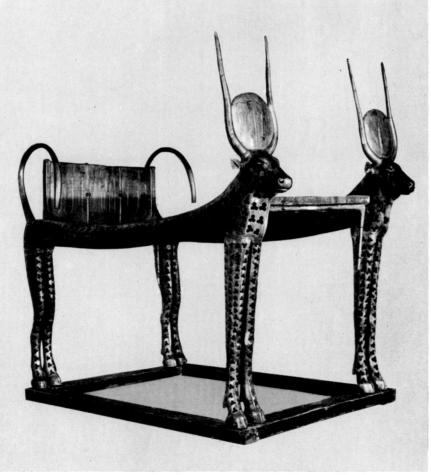

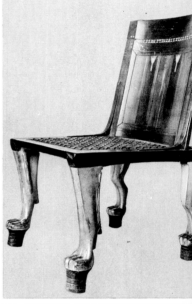

812. CHAIR WITH SLOPING BACK (NEW KINGDOM)

810. CHAIR (NEW KINGDOM?)

811. PORTABLE BED OF TUT-ANKH-AMON (DYN. XVIII)

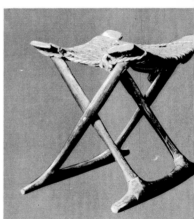

813. FOLDING STOOL (NEW KINGDOM)

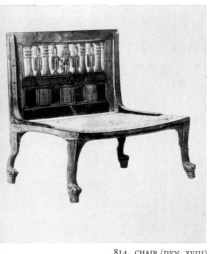

814. CHAIR (DYN. XVIII)

815. FOLDING CAMP BED OF TUT-ANKH-AMON (DYN. XVIII)

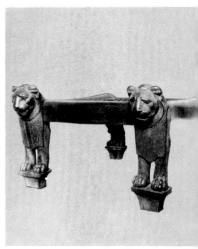

816. WOOD STOOL (SAITE PERIOD?)

LEGENDS OF THE DOCUMENTARY PHOTOGRAPHS

PREDYNASTIC AND THINITE PERIODS

144. MALE FIGURINE.
Clay, height 4 1/16". Predynastic Period, Nagadah I.
Kestner Museum, Hanover.

145. FEMALE FIGURINE.
Clay, height 10 5/8" (see also fig. 55). Predynastic Period, Nagadah I.
Royal Museum of Art and History, Brussels.

146. FEMALE FIGURINE.
Painted clay, height 9 1/2". Predynastic Period, Nagadah I.
Metropolitan Museum of Art, New York.

147. STATUETTE OF A WOMAN.
From Badari. Ivory, height 5 7/8". Predynastic Period, Nagadah I.
British Museum, London.

148. ELEPHANT-SHAPED PALETTE.
Slate, length 9 7/8". Predynastic Period, Late Amratian (Nagadah I).
Collection Kofler - Truniger, Lucerne.

149. TORTOISE-SHAPED PALETTE.
Slate, length 5 7/8". Predynastic Period, Nagadah I.
Metropolitan Museum of Art, New York.

150. STATUETTE OF A WOMAN.
From Badari. Terracotta, height 3 1/2". Predynastic Period, Nagadah II.
British Museum, London.

151. MALE FIGURINE.
Hippopotamus tooth, height 4 1/8". Predynastic Period, Nagadah II.
Royal Museum of Art and History, Brussels.

152. ANIMAL-SHAPED PALETTE.
Slate, length 7 7/8". Predynastic Period, Nagadah I.
Metropolitan Museum of Art, New York.

153. ANIMAL-SHAPED PALETTE.
Slate, length 5 1/2". Predynastic Period, Nagadah I.
Metropolitan Museum of Art, New York.

154. HEAD OF A MONKEY.
From Hierakonpolis. Clay, height 3 7/8". Thinite Period.
Kestner Museum, Hanover.

155. PERFUME CONTAINER.
From Mostagedde (Badari). Ivory, height 2 3/8". Predynastic Period, Nagadah II.
British Museum, London.

156. BABOON FIGURINE.
From Abydos. Blue-green faience, height 2 1/4". Thinite Period.
Collection Kofler - Truniger, Lucerne.

157. STONE JAR.
Breccia, height 11". Predynastic Period, Amratian or Gerzean.
Metropolitan Museum of Art, New York.

158-164. POTTERY VESSELS WITH FIGURATIVE DECORATION.
Clay, heights 2 3/4–11 3/4" (see also fig. 7). Predynastic Period, Amratian.
Metropolitan Museum of Art, New York.

165. STONE JAR.
Breccia and syenite, height 8 5/8". Dynasty I–II.
Kestner Museum, Hanover.

166. TWO-NECKED VESSEL.
Clay, height 7 3/4". Predynastic Period, Amratian.
Metropolitan Museum of Art, New York.

167. PAINTED CASKET.
Clay, height 5 1/8". Predynastic Period, Amratian.
British Museum, London.

168. TWO-NECKED VESSEL.
Clay, height 8 1/4". Predynastic Period, Amratian.
Aegyptische Staatssammlung, Munich. (Photo H. W. Müller)

169. FIGURINE OF A BOY.
From Abydos. Brown stone, height 1 1/2". Dynasty I.
Collection Kofler - Truniger, Lucerne.

170. LION-SHAPED BOARD-GAME PIECE.
From Abydos. Ivory, length 3 1/2". Dynasty I.
Metropolitan Museum of Art, New York.

171. COMB WITH RELIEF DECORATION.
Ivory, height 2". Predynastic Period, c. 3400 B.C.
Metropolitan Museum of Art, New York.

172. HIPPOPOTAMUS FIGURINE.
From Abydos. Blue-green faience, length 2 1/2". Dynasty I–II.
Collection Kofler - Truniger, Lucerne.

173. DONKEY FIGURINE.
Ivory, length 1 3/8". Dynasty I–II.
Aegyptische Staatssammlung, Munich.

174. PALETTE WITH INSIGNIA OF MIN.
Slate, height 11 1/2". Late Predynastic Period.
British Museum, London.

175. "THE HUNT" PALETTE.
Slate, height 25 7/8". Late Predynastic Period.
British Museum, London.

176. PALETTE WITH BULL'S HEAD.
From the Fayum (El Gerzeh). Slate, height 6 1/8". Late Predynastic Period.
Egyptian Museum, Cairo. (Photo Jean Mazenod)

177. PALETTE WITH MYTHICAL ANIMALS.
Slate, height 16 7/8". Late Predynastic Period.
Ashmolean Museum, Oxford.

178. PALETTE OF KING NARMER.
From Hierakonpolis. Slate, height 25 1/4" (see fig. 57). Dynasty I.
Egyptian Museum, Cairo. (Photo Jean Vertut)

179. PALETTE WITH GIRAFFES AND PALMS.
Slate, height 12 5/8". Late Predynastic Period.
The Louvre, Paris. (Photo Archives photographiques, Paris.)

180. KNIFE HANDLE.
From Gebel el Arak. Ivory, length 3 3/4" (total length of knife 11"). Late Predynastic Period.
The Louvre, Paris. (Photo Jean Vertut)

181. RELIEF ON THE MACE-HEAD OF THE SCORPION KING.
Limestone (detail). Predynastic Period.
Ashmolean Museum, Oxford.

182. STELE OF LADY KEHEN.
From Abydos. Limestone, height 13 3/8". Dynasty I.
Kestner Museum, Hanover. (Photo Hermann Friedrich.)

183. HETEPEDIEF, PRIEST OF MEMPHIS.
From Mitrahina. Granite, height 15 3/8". Dynasty II (?).
Egyptian Mvseum, Cairo.

OLD KINGDOM

184. KING ZOSER.
From Saqqarah.
Limestone, height 78 3/4" (see fig. 39). Dynasty III.
Egyptian Museum, Cairo. (Bildarchiv Foto Marburg)

185. KING ZOSER (sculptor's model).
Limestone relief, height 10 1/4". Dynasty III.
Metropolitan Museum of Art, New York.

186. PANEL OF HESIRE.
From the tomb of Hesire, Saqqarah.
Wood relief, height 45 1/4" (see fig. 67). Dynasty III.
Egyptian Museum, Cairo. (Photo Jean Vertut)

187. FRAGMENT OF THE DOOR FRAME FROM THE MASTABA OF NOFER.
From the cemetery of Cheops, Giza.
Limestone relief, height 43 1/4". Dynasty IV.
Egyptian Museum, Cairo. (Photo Jean Vertut)

188. PANEL OF HESIRE.
From the tomb of Hesire, Saqqarah.
Wood relief, height 45 1/4" (see also fig. 67). Dynasty III.
Egyptian Museum, Cairo. (Photo Jean Vertut)

189. HEAD OF KING CHEPHREN.
From Giza. Alabaster, height 8". Dynasty IV.
Museum of Fine Arts, Boston.

190. "RESERVE" HEAD.
From Giza. Limestone, height c. 7 3/4" (see also fig. 64). Dynasty IV, c. 2550 B.C.
Egyptian Museum, Cairo. (Photo Boudot-Lamotte)

191. BUST OF ANKH-HAF.
Painted limestone, height 19 7/8". Dynasty IV.
Museum of Fine Arts, Boston.

192. HEAD OF KING CHEPHREN (fragment).
Limestone, height 5 1/2". Dynasty IV.
Ny Carlsberg Glyptotek, Copenhagen.

193. "RESERVE" HEAD.
From Giza. Limestone, height 7 7/8" (see also fig. 64). Dynasty IV.
Egyptian Museum, Cairo. (Photo Boudot-Lamotte)

194. GEESE AND DUCKS.
From tomb of Atet, Medum. Painting on limestone, length 67 3/4". Dynasty IV.
Egyptian Museum, Cairo. (Photo Jean Vertut)

195. KING CHEPHREN.
Diorite, total height 66 1/8" (see fig. 62). Dynasty IV.
Egyptian Museum, Cairo. (Photo Jean Vertut)

196. HEAD OF RADEDEF.
Red quartzite, height 11". Dynasty IV.
The Louvre, Paris.

197. RAHOTEP.
From Medum. Painted limestone, height 47 1/4" (see fig. 70). Dynasty IV.
Egyptian Museum, Cairo. (Photo Jean Vertut)

198. NOFRET.
From Medum. Painted limestone, height 47 1/4" (see fig. 71). Dynasty IV.
Egyptian Museum, Cairo. (Photo Jean Vertut)

199. HEMIUNU.
Limestone, height 61 3/8". Dynasty IV.
Roemer-Pelizaeus Museum, Hildesheim.

200. KEKY.
Limestone, height 27 5/8". Dynasty IV.
The Louvre, Paris. (Photo Giraudon)

201. NESA.
Limestone, height 62 5/8". Dynasty IV.
The Louvre, Paris. (Photo Giraudon)

202. SEPA, HUSBAND OF NESA.
Limestone, height 65". Dynasty IV.
The Louvre, Paris. (Photo Giraudon)

203. MYCERINUS AND HIS WIFE.
From Giza. Slate, height 54 1/2". Dynasty IV.
Museum of Fine Arts, Boston.

204. MYCERINUS TRIAD: MYCERINUS, HATHOR, AND THE PERSONIFICATION OF THE DIOSPOLITAN ("WAS") NOME.
From Giza. Slate, height 37 3/8". Dynasty IV.
Egyptian Museum, Cairo. (Photo Jean Vertut)

205. SEATED MAN.
From Saqqarah. Limestone, height 24". Dynasty V.
Egyptian Museum, Cairo. (Photo Jean Vertut)

206. SAHURA AND THE PERSONIFICATION OF THE COPTOS ("TWO FALCONS") NOME.
Diorite, height 24 3/4". Dynasty V.
Metropolitan Museum of Art, New York.

207. SEKHEM-KA, CHIEF SCRIBE.
From Saqqarah. Diorite, height 18 7/8". Dynasty V.
The Louvre, Paris. (Photo Giraudon)

208. MYCERINUS TRIAD: MYCERINUS, HATHOR, AND THE PERSONIFICATION OF THE CYNOPOLITAN ("DOG") NOME.
From Giza. Slate, height 37 5/8" (see fig. 63). Dynasty IV.
Egyptian Museum, Cairo. (Photo Jean Vertut)

209. STATUE OF A WOMAN.
From Saqqarah. Limestone, height 53 7/8". Dynasty V.
Worcester Art Museum, Massachusetts.

210. NEFER.
From Saqqarah. Limestone, height 13 3/4". Dynasty V.
Egyptian Museum, Cairo. (Photo Boudot-Lamotte)

211. SEATED SCRIBE.
Painted limestone, height 20 7/8" (see fig. 74). Dynasty V.
The Louvre, Paris. (Photo Jean Vertut)

212. SEATED SCRIBE.
Painted limestone, height 20 1/2" (see fig. 9). Dynasty V.
Egyptian Museum, Cairo. (Photo Jean Vertut)

213. HEAD (SALT COLLECTION).
Limestone, height 13 3/8". Early Dynasty V.
The Louvre, Paris.

214. HEAD OF KING WESERKAF.
Granite, height 29 1/2". Dynasty V.
Egyptian Museum, Cairo. (Photo Jean Mazenod)

215. HEAD OF A PHARAOH WITH THE CROWN OF LOWER EGYPT.
From Abusir. Slate. Dynasty V.
Egyptian Museum, Cairo. (Photo Jean Vertut)

216. WIFE OF KA-APER.
Wood, height 24″. Dynasty V.
Egyptian Museum, Cairo. (Photo
Jean Vertut)

217. HEAD OF AN OFFICIAL.
Limestone, height 8 1/2″. Dynasty V.
Metropolitan Museum of Art, New
York.

218. FAMILY GROUP.
Limestone, height 20 5/8″. Dynasty V.
Ny Carlsberg Glyptotek, Copenhagen.

219. COUPLE.
Limestone, height 25 5/8″. Dynasty V.
Staatliche Museen, Berlin.

220. GROUP FROM THE MASTABA OF RA-WER.
From Giza. Quartzite, height 24 3/8″.
Dynasty V.
Egyptian Museum, Cairo. (Photo
Boudot-Lamotte)

221. DEMEDJ AND HIS WIFE.
From Giza or Saqqarah. Limestone,
height 32 5/8″. Dynasty V.
Metropolitan Museum of Art, New
York.

222. GROUP WITH QUEEN MERITERES.
Limestone, height 27 1/8″. Dynasty V.
Rijksmuseum van Oudheden, Leiden.

223. COUPLE.
Limestone, height 36 5/8″. Dynasty V.
Aegyptische Staatssammlung, Munich.

224. BUTCHER.
From Saqqarah. Painted limestone,
height 10 5/8″. Dynasty V.
Egyptian Museum, Cairo. (Photo
Scala)

225. MAN POLISHING A JAR.
Painted limestone, height 13 3/8″.
Dynasty V.
Egyptian Museum, Cairo. (Photo
Scala)

226. BREWER.
From Saqqarah. Painted limestone,
height 15 3/4″ (see also fig. 16).
Dynasty V.
Egyptian Museum, Cairo. (Photo
Scala)

227. YOUNG KA-APER.
From Saqqarah. Wood, height
43 1/4″ (see also fig. 72). Dynasty IV.
Egyptian Museum, Cairo.

228. THE STEWARD MITRY AND HIS WIFE.
Wood, heights 52 1/2″ and 58 1/4″.
Dynasty V.
Metropolitan Museum of Art, New
York.

229. MEMPHITE OFFICIAL AND HIS WIFE.
Wood, height of man 27 1/8″. Early
Dynasty V.
The Louvre, Paris. (Photo Giraudon)

230. METHETHY, CHIEF OF THE ROYAL FARMERS.
From Saqqarah. Wood, height
24 1/4″ (see fig. 73). Late Dynasty V.
Brooklyn Museum, New York.

231. KAWE-EM-SENEWY, SUPERINTENDENT OF GRANARIES.
From Saqqarah. Wood, height
46 1/2″. Dynasty VI.
Metropolitan Museum of Art, New
York.

232. PEPY I.
From Hierakonpolis. Copper, height
69 5/8″. Dynasty VI.
Egyptian Museum, Cairo. (Photo
Boudot-Lamotte)

233. CHANCELLOR AHY, MASTER OF THE GRANARIES.
From Saqqarah. Wood, height
40 3/4″. Dynasty VI.
Ethnographic Museum, Neufchatel.

234. KING MEN-KAU-HOR.
Limestone relief, height 32 1/8″.
Dynasty V.
The Louvre, Paris. (Photo Boudot-Lamotte)

235. SAHURA'S CAPTIVES.
Limestone relief (detail), total height
13″. Dynasty V.
Staatliche Museen, Berlin.

236. OFFERING BEARERS.
Limestone relief, length 33 7/8″.
Dynasty V.
Kestner Museum, Hanover.

237. SAQQARAH. MASTABA OF TI.
Plowing the fields. Painted relief
(see also figs. 18, 76). Dynasty V.
(Photo Jean Vertut)

238. SAQQARAH. MASTABA OF TI.
Agricultural scenes. Painted relief.
Dynasty V.
(Photo Jean Vertut)

239. SAQQARAH. MASTABA OF TI.
Fording a stream. Painted relief.
Dynasty V.
(Photo Jean Vertut)

240. SAQQARAH. MASTABA OF TI.
Picking grain and milking cow.
Painted relief. Dynasty V.
(Photo Jean Vertut)

241. SAQQARAH. MASTABA OF TI.
Donkeys carrying wheat. Painted
relief. Dynasty V.
(Photo Jean Vertut)

242. SAQQARAH. MASTABA OF TI.
Slaughtering animals. Painted relief.
Dynasty V.
(Photo Jean Mazenod)

243. SAQQARAH. MASTABA OF MERERUKA.
Scene with lynx. Painted relief.
Dynasty V.
(Photo Jean Mazenod)

244. WORKMEN BEING PUNISHED.
From the mastaba of Akhethotep,
Saqqarah. Painted relief (see also
fig. 17). Dynasty V.
The Louvre, Paris. (Photo Jean
Vertut)

245. SAQQARAH. MASTABA OF TI.
Herons. Painted relief. Dynasty V.
(Photo Jean Mazenod)

246. SAQQARAH. MASTABA OF TI.
Donkeys at the trough. Painted
relief. Dynasty V.
(Photo Giraudon)

247. SAQQARAH. MASTABA OF MERERUKA.
Hunting scene. Stone relief. Dynasty V.
(Photo Jean Mazenod)

248. GOATS.
From the mastaba of Akhethotep,
Saqqarah. Painted relief (detail; see
also fig. 17). Dynasty V.
The Louvre, Paris. (Photo Jean
Vertut)

249. SAQQARAH. MASTABA OF PTAHHOTEP.
Nautical tournament(?). Painted
relief. Dynasty V.
(Photo Jean Mazenod)

250. SAQQARAH. MASTABA OF TI.
Nautical scene. Painted relief (see
also figs. 18, 76). Dynasty V.
(Photo Jean Vertut)

251. SAQQARAH. MASTABA OF PTAHHOTEP.
Fishermen pulling in fishing net.
Painted relief. Dynasty V.
(Photo Jean Mazenod)

252. SAQQARAH. MASTABA OF PTAHHOTEP.
Offering bearers. Painted relief. Dynasty V.
(Photo Jean Mazenod)

253. SAQQARAH. MASTABA OF MERERUKA.
Offering bearers. Stone relief (detail).
Dynasty V.
(Photo Jean Mazenod)

254. SAQQARAH. MASTABA OF TI.
Female offering bearers. Painted
relief. Dynasty V.
(Photo Jean Mazenod)

255. KNEELING CAPTIVE.
From Saqqarah. Limestone, height
35 3/8″. Dynasty VI.
Metropolitan Museum of Art, New
York.

256. HEAD OF HORUS.
From Hierakonpolis. Wood and bronze plated with gold, height 13 7/8". Dynasty VI. Egyptian Museum, Cairo. (Photo Archives photographiques, Paris)

257. STATUETTE OF PEPY I.
Alabaster, height 10 1/2". Dynasty VI. Brooklyn Museum, New York.

258. MAN WORKING IN THE FIELD.
From the tomb of Seshem-Nofer IV, Giza. Limestone relief (detail) with traces of paint. Dynasty VI. Roemer-Pelizaeus Museum, Hildesheim.

259. DWARF SENEB AND HIS WIFE.
Painted limestone, height 28 3/8". Dynasty VI. Egyptian Museum, Cairo. (Photo André Vigneau)

260. DONKEYS CARRYING WHEAT.
From the tomb of Seshem-Nofer IV, Giza. Limestone relief (detail) with traces of paint. Dynasty VI. Roemer-Pelizaeus Museum, Hildesheim.

261. IPI CARRIED IN A LITTER.
Relied from his mastaba, Saqqarah. Dynasty VI. Egyptian Museum, Cairo.

262. HARPOONING FISH.
Painted relief. Dynasty VI. Egyptian Museum, Cairo. (Photo Jean Vertut)

FIRST INTERMEDIATE PERIOD

263. STELE OF THE PRIEST-LECTOR INDY
Painted limestone relief, height 28 3/8". Dynasty XI(?). Metropolitan Museum of Art, New York.

264. STELE OF BEBI.
From Denderah. Painted limestone relief. Dynasty VIII. University Museum, University of Pennsylvania.

265. STELE OF SEBEK-AA.
From Moalla (?). Painted Limestone relief, height 23 5/8". Dynasty VIII. British Museum, London.

266. STELE OF CHANCELLOR NEFER-YU.
From the Denderah area. Painted limestone relief, height 45 1/4". Dynasty VIII. Metropolitan Museum of Art, New York.

267. OFFERING SCENE.
From a tomb, Saqqarah. Painted limestone relief (detail), length 10 1/4". Dynasty IX–X. Metropolitan Museum of Art, New York.

268. STELE OF NEFER.
From Edfu. Painted limestone relief, height 11". First Intermediate Period. National Museum, Warsaw. (Photo T. Biniewski.)

MIDDLE KINGDOM

269. DJEDU AND HIS WIFE SIT-SOBEK.
Stele from Thebes (El Assasif). Painted limestone, height 15". Dynasty XI. Metropolitan Museum of Art, New York.

270. MENTUHOTEP I.
From the temple of Mentuhotep I, Deir el Bahari. Painted limestone relief, length 37 5/8". Dynasty XI. Metropolitan Museum of Art, New York.

271. AASHAYT RECEIVING OFFERINGS FROM HOUSEHOLD SERVANTS.
Stone relief on sarcophagus of Aashayt. From Deir el Bahari. Dynasty XI. Egyptian Museum, Cairo. (Photo Egyptian Expedition of the Metropolitan Museum of Art, New York)

272. STELE OF TETY.
Limestone, height 58 5/8". Dynasty XI. British Museum, London.

273. RELIEF ON THE SARCOPHAGUS OF KAWIT.
From Deir el Bahari. Dynasty XI. Egyptian Museum, Cairo. (Photo Archives photographiques, Paris)

274. RELIEF ON THE TEMPLE OF MENTUHOTEP I, DEIR EL BAHARI.
Height 10 5/8". Dynasty XI. (From Bissing, *Denkmäler Aegyptische Skulptur*)

275. RELIEF ON THE TEMPLE OF MENTUHOTEP I, DEIR EL BAHARI.
Height 10 5/8". Dynasty XI. (From Bissing, *Denkmäler Aegyptische Skulptur*)

276. STATUETTE OF A WOMAN.
Wood, height 20 7/8". First Intermediate Period (Dynasty IX–X). The Louvre, Paris.

277. STATUETTE OF A MAN.
From Meir(?). Wood, height 21". First Intermediate Period. Walters Art Gallery, Baltimore.

278. UPPER PART OF A STATUETTE.
Wood. Dynasty XI. Myers Museum, Eton.

279. STATUETTE OF MERER.
From Assiut. Painted wood, height 13". First Intermediate Period (Dynasty X–early Dynasty XI). Metropolitan Museum of Art, New York.

280. STATUETTE OF MERER.
From Assiut. Painted wood, height 13". First Intermediate Period (Dynasty X–early Dynasty XI). Metropolitan Museum of Art, New York.

281. MODEL OF A HOUSE.
Painted wood, height 22". Dynasty XI. British Museum, London. (Photo R. B. Fleming)

282. ASSIUT SOLDIERS.
Painted wood, height 15 3/4". Dynasty IX–X. Egyptian Museum, Cairo. (Photo Jean Vertut)

283. MODEL OF A TRAVELING-BOAT CABIN.
From the tomb of Meket-ra, Thebes. Painted wood, height c. 10 1/4". Dynasty XI.
Metropolitan Museum of Art, New York.

284. MODEL OF A BOAT.
From the tomb of Meket-ra, Thebes. Painted wood, length 50". Dynasty XI.
Metropolitan Museum of Art, New York. (Photo Eric Pollitzer)

285. STATUETTE OF A WOMAN.
From Harageh. Ivory, height 4 3/8". Dynasty XII.
The Louvre, Paris. (Photo Archives photographiques, Paris)

286. STATUETTE OF A WOMAN WITH A CHILD.
From Lisht. Painted limestone, height 4 3/4". Dynasty XI.
Staatliche Museen, Stiftung Preussischer Kulturbesitz, Berlin. (Photo Elsa Postel)

287. WOMAN CARRYING OFFERINGS.
From the tomb of Meket-ra, Thebes. Painted wood, height 44". Dynasty XI.
Metropolitan Museum of Art, New York.

288. WOMAN CARRYING OFFERINGS.
From Assiut. Painted wood, height 41". Dynasty XII.
The Louvre, Paris. (Photo Bulloz)

289. STATUETTE OF IY-MERET-NEBES.
Wood, height 33 1/8". Dynasty XII.
Rijksmuseum van Oudheden, Leiden.

290. STATUETTE OF A WOMAN WITH A CHILD.
From Beni Hasan. Wood, height 5 7/8". Dynasty XII.
Royal Scottish Museum, Edinburgh. (Photo Tom Scott)

291. WOMAN NURSING A CHILD WHILE A SERVANT COMBS HER HAIR.
From Lisht. Limestone, height 2 1/4". Dynasty XII.
Metropolitan Museum of Art, New York.

292. HEAD OF A WOMAN WITH WIG.
From Lisht. Wood with gold insets, height 3 1/4". Early Dynasty XII.
Egyptian Museum, Cairo. (Photo Jean Vertut)

293. SENPU AND HIS FAMILY.
Limestone and alabaster, height 9 1/2". Dynasty XII.
The Louvre, Paris. (Photo Giraudon)

294. DONKEY.
Wall painting (detail) from the tomb of Iti, Gebelein. Dynasty XI (dated Dynasty VI by G. Farina).
Egyptian Museum, Turin.

295. AGRICULTURAL SCENE.
Wall painting (portion) from the tomb of Zar, Thebes. Dynasty XI.
Metropolitan Museum of Art, New York.

296. COW AND CALF.
Wall painting from the tomb of Iti, Gebelein. Length of panel 31 1/2". Dynasty XI (dated Dynasty VI by G. Farina).
Egyptian Museum, Turin.

297. BENI HASAN. TOMB OF KHNUMHOTEP.
Caravan of Asians (see figs. 86, 87). Wall painting. Dynasty XII.
(Photo Jean Vertut)

298. BENI HASAN. TOMB OF BAKHT.
Wrestlers. Wall painting. Dynasty XII.
(Photo Jean Vertut.)

299. GYMNASTICS.
Wall painting (portion) from the tomb of Iti, Gebelein. Length of panel 40 1/2". Dynasty XI.
Egyptian Museum, Turin.

300. THEBES. TOMB OF ANTEFOKER.
Funerary scenes (see fig. 88). Wall painting. Dynasty XII.
(Photo Jean Vertut)

301. THE GODDESS SESHAT.
Relief from the temple of Sesostris I, Lisht. Limestone, height 24 3/8". Dynasty XII.
Metropolitan Museum of Art, New York.

302. SESOSTRIS I DANCING BEFORE THE GOD MIN.
Relief from the temple of Sesostris I, Lisht. Dynasty XII.
British Museum, London. (Photo R. B. Fleming)

303. ASWAN.
Offering bearer. Stone relief (detail). Dynasty XII.
(Photo Jean Vertut)

304. SESOSTRIS I AND THE GOD PTAH.
Stone relief (detail) from Karnak. Dynasty XII.
Egyptian Museum, Cairo. (Photo Jean Vertut)

305. ASWAN. TOMB OF SIRENPUT (No. 36).
Priest figure. Stone relief (detail). Dynasty XII.
(Photo Jean Vertut)

306. ASWAN. TOMB OF SIRENPUT (No. 36).
Duck. Stone relief (detail). Dynasty XII.
(Photo Jean Vertut)

307. ASWAN. TOMB OF SIRENPUT (No. 36).
Dogs. Stone relief (detail). Dynasty XII.
(Photo Jean Vertut)

308. ASWAN. TOMB OF SIRENPUT (No. 36).
Cow. Stone relief (detail). Dynasty XII.
(Photo Jean Vertut)

309. HEAD OF SESOSTRIS III WEARING THE WHITE CROWN.
From Medamud. Gray granite. Dynasty XII.
Egyptian Museum, Cairo. (Photo Boudot-Lamotte)

310. FRAGMENT OF A HEAD OF AMENEMHAT I.
From Lisht. Limestone, height 5 1/2". Dynasty XII.
Metropolitan Museum of Art, New York.

311. HEAD OF A PHARAOH.
From Medamud. Limestone, height 29 1/2". Late Dynasty XII–early Dynasty XIII.
The Louvre, Paris. (Photo Jean Mazenod)

312. FRAGMENT OF A HEAD OF SESOSTRIS III.
Yellow quartzite, height 25 5/8". Dynasty XII.
Metropolitan Museum of Art, New York.

313. SESOSTRIS III.
Black granite, total height 21 5/8". Dynasty XII.
Brooklyn Museum, New York.

314. HEAD OF AMENEMHAT III.
Gray granite, height 30". Dynasty XII.
British Museum, London.

315. SESOSTRIS III IN OLD AGE.
Black granite, height 29 1/8" (portion). Dynasty XII.
The Louvre, Paris.

316. MAN WEARING A CLOAK.
Sandstone, height 29 7/8". Dynasty XII.
Staatliche Museen, Berlin.

317. SEHETEP-IB-RE-ANKH.
From Lisht. Limestone, height 13 3/4". Dynasty XII.
Metropolitan Museum of Art, New York.

318. LADY SENNUWY.
From Kerma. Granite, height 66 1/8". Dynasty XII.
Museum of Fine Arts, Boston.

319. THE NURSE SIT-SNEFERU.
From Adana (Asia Minor). Diorite, height 15 3/8″. Dynasty XII.
Metropolitan Museum of Art, New York.

320. TWO PRIESTS (this work once consisted of three priests).
Hard sandstone relief, height 32 5/8″. Dynasty XII.
The Louvre, Paris. (Photo Giraudon)

321. AU.
From Lisht. Limestone, height 27 5/8″. Dynasty XII.
Metropolitan Museum of Art, New York.

322. BLOCK-STATUE OF A MAN.
From Saqqarah. Limestone, height 33 1/2″. Dynasty XII.
Egyptian Museum, Cairo. (Photo Boudot-Lamotte)

323. KHNUMHOTEP.
Basalt, height 7 7/8″. Dynasty XII.
Metropolitan Museum of Art, New York.

324. BLOCK-STATUE OF SI-HATHOR.
Limestone, height 16 1/8″. Dynasty XII.
British Museum, London.

325. MANED SPHINX.
From Tanis. Black granite, length 7′ 2 5/8″. Dynasty XII.
Egyptian Museum, Cairo. (Photo Jean Vertut)

326. OFFERING BEARERS.
From Tanis. Gray granite, height 63″. Dynasty XII.
Egyptian Museum, Cairo. (Photo Jean Vertut)

327. MANED SPHINX OF AMENEMHAT III.
From Tanis. Black granite, length 7′ 2 5/8″ (see fig. 85). Dynasty XII.
Egyptian Museum, Cairo. (Photo Jean Vertut)

328. QUEEN NOFRET, WIFE OF SESOSTRIS II.
Black granite, total height 44 1/8″. Dynasty XII.

Egyptian Museum, Cairo. (From Bissing, *Denkmäler Aegyptische Skulptur*)

329. SEBEKEMSAF.
Black granite, height 59″. Dynasty XII.
Kunsthistorisches Museum, Vienna.

330. KING HOR.
Wood, total height 68 7/8″. Dynasty XII.
Egyptian Museum, Cairo. (Photo Jean Vertut)

331. PHARAOH IN PRIESTLY DRESS.
From Mit Fares (Fayum). Black granite, total height 39 3/8″. Dynasty XII.
Egyptian Museum, Cairo. (Photo Jean Vertut)

332. VIZIER IY-MERU.
Sandstone, height 59″. Dynasty XIII.
The Louvre, Paris. (Photo Giraudon)

NEW KINGDOM

DYNASTY XVIII

333. HEAD OF HATSHEPSUT.
From Deir el Bahari. White limestone, painted; height 7 5/8″. Dynasty XVIII.
Metropolitan Museum of Art, New York.

334. HATSHEPSUT.
From Deir el Bahari. Crystalline limestone, total height 6′ 4 3/4″. Dynasty XVIII.
Metropolitan Museum of Art, New York.

335. HEAD OF TUTHMOSIS III.
Recently found in the temple of Tuthmosis III, Deir el Bahari. Marble. Dynasty XVIII.
Egyptian Museum, Cairo. (Photo J. Lipinska)

336. HATSHEPSUT KNEELING, WEARING THE WHITE CROWN.
From Deir el Bahari. Red granite, height 9′ 1/4″. Dynasty XVIII.
Metropolitan Museum of Art, New York.

337. SENMUT, HATSHEPSUT'S ARCHITECT.
Found in the corridor of his tomb, Deir el Bahari (see also fig. 51). Painted sketch on limestone. Dynasty XVIII.
Metropolitan Museum of Art, New York.

338. TUTHMOSIS III KNEELING.
Alabaster, height 13 3/4″. Dynasty XVIII.
Egyptian Museum, Cairo. (Photo Archives photographiques, Paris)

339. SENMUT AND A PRINCESS.
Granite, height 23 5/8″ (see also fig. 89). Dynasty XVIII.
Egyptian Museum, Cairo. (Photo Archives photographiques, Paris)

340. HEAD OF A STATUE OF TUTHMOSIS III.
Black granite, total height 6′ 6 3/4″ (see also fig. 91). Dynasty XVIII.
Egyptian Museum, Cairo. (Photo Max Hirmer, Munich.)

341. QUEEN TETYSHERI, MOTHER OF TAA-KEN (SEKENENRA).
Painted limestone, height 14 5/8″. Dynasty XVII–XVIII.
British Museum, London.

342. DEIR EL BAHARI. TEMPLE OF HATSHEPSUT.
Offering bearer. Painted relief in the offering chamber. Dynasty XVIII. (Photo Jean Mazenod)

343. DEIR EL BAHARI. TEMPLE OF HATSHEPSUT.
Offering bearers. Painted relief in the offering chamber. Dynasty XVIII. (Photo Jean Vertut)

344. DEIR EL BAHARI. TEMPLE OF HATSHEPSUT.
Offering a heron. Painted relief in the offering chamber. Dynasty XVIII. (Photo Jean Mazenod)

345. DEIR EL BAHARI. TEMPLE OF HAT-
SHEPSUT.
Head of Tuthmosis I. Painted relief
from the chapel of Anubis (third
terrace). Dynasty XVIII.
(Photo Jean Mazenod.)

346. KARNAK. PYRAMIDION OF HATSHEP-
SUT'S OBELISK.
Hatshepsut kneeling before the god
Amon-Ra. Sunken relief. Dynas-
ty XVIII.
(Photo Jean Mazenod)

347. DEIR EL BAHARI. TEMPLE OF HAT-
SHEPSUT.
Queen Senseneb, mother of Tuth-
mosis I. Painted relief from the
niche of the chapel of Anubis (third
terrace). Dynasty XVIII.
(Photo Jean Vertut)

348. DEIR EL BAHARI. TEMPLE OF HAT-
SHEPSUT.
The Egyptian army in the land of
Punt. Painted relief (see also fig. 92).
Dynasty XVIII.
(Photo Jean Vertut)

349. DEIR EL BAHARI. TEMPLE OF TUTH-
MOSIS III.
Barge with oarsmen. Painted sand-
stone relief. Dynasty XVIII.
(Photo J. Lipinska)

350. DEIR EL BAHARI. TEMPLE OF TUTH-
MOSIS III.
The god Amon-Min. Painted lime-
stone relief (see also fig. 90). Dy-
nasty XVIII; restored during Dy-
nasty XIX.
(Photo J. Lipinska)

351. DEIR EL BAHARI. TEMPLE OF TUTH-
MOSIS III.
Painted limestone relief (fragment).
Dynasty XVIII.
(Photo J. Lipinska)

352. DEIR EL BAHARI. TEMPLE OF TUTH-
MOSIS III.
Priests carrying a sacred barge. Paint-
ed limestone relief (fragment). Dy-
nasty XVIII; restored during Dy-
nasty XIX.
(Photo J. Lipinska)

353. DEIR EL BAHARI. TEMPLE OF TUTH-
MOSIS III.
Offerings. Painted limestone relief
(fragment). Dynasty XVIII.
(Photo J. Lipinska)

354. DEIR EL BAHARI. TEMPLE OF TUTH-
MOSIS III.
Fragment of an inscription. Painted
limestone relief. Dynasty XVIII.
(Photo J. Lipinska)

355-362. KARNAK. GREAT TEMPLE OF
AMON.
Reliefs from the "Botanical Gar-
den": exotic plants and animals.
Most of the plants depicted on these
reliefs cannot be identified and were
probably imagined by the artist.
Dynasty XVIII.
(Photo Jean Vertut)

363. KARNAK. GREAT TEMPLE OF AMON.
Tuthmosis III striking captives.
Sunken limestone relief. Dynas-
ty XVIII.
(Photo Jean Vertut)

364. THEBES. GREAT TEMPLE OF AMON.
Papyrus plants. Relief on a heraldic
column of Tuthmosis III. Dynas-
ty XVIII.
(Photo Jean Vertut)

365. THEBES. GREAT TEMPLE OF AMON.
Sunken relief on a heraldic column
of Tuthmosis III: The king and the
goddess Mut. Dynasty XVIII.
(Photo Jean Vertut)

366. THEBES. GREAT TEMPLE OF AMON.
Relief on a heraldic column of Tuth-
mosis III: Lotus plants. Dynas-
ty XVIII.
(Photo Jean Vertut)

367. AMENHOTEP II WITH AN OFFERING
TABLE.
From the great temple of Amon,
Karnak. Gray granite, height
47 1/4". Dynasty XVIII. (Photo
Max Hirmer)

368. COLOSSAL GROUP OF AMENHOTEP III
AND QUEEN TIY.
Limestone, height 22' 11 5/8". Dy-
nasty XVIII.
Egyptian Museum, Cairo. (Photo
Archives photographiques, Paris)

369. AMENHOTEP, SON OF HAPU.
Gray granite, height 55 7/8". Dy-
nasty XVIII.
Egyptian Museum, Cairo. (Photo
Jean Vertut)

370. HEAD OF AMENHOTEP III.
Hard sandstone, height 46 1/2". Dy-
nasty XVIII.
British Museum, London.

371. HEAD OF MUT-NEDJENET, WIFE OF
HOREMHEB.
From Karnak. Plaster cast from
limestone, height 31 1/2". Late Dy-
nasty XVIII.
Egyptian Museum, Cairo. (Photo
Giraudon)

372. GENERAL HOREMHEB.
Probably from Memphis. Gray gran-
ite, height 46 1/8". Late Dynas-
ty XVIII.
Metropolitan Museum of Art, New
York.

373. TUTHMOSIS IV AND HIS MOTHER TIY.
From Karnak. Black granite, height
43 1/4". Dynasty XVIII.
Egyptian Museum, Cairo. (Photo
Jean Mazenod)

374. AMENHOTEP-WESERU AND TANT-WASU.
Stone, height 22 7/8". Dynasty XVIII
(reign of Tuthmosis III). Staatliche
Museen, Berlin.

375. SEATED YOUNG MAN.
Limestone, height 13 1/2". Late Dy-
nasty XVII.
Royal Scottish Museum, Edinburgh.
(Photo Tom Scott)

376. FEMALE STATUETTE.
Wood, height 7 7/8". Dynasty XVIII.
The Louvre, Paris. (Photo Ar-
chives photographiques, Paris)

377. STATUETTE OF AN OFFICER.
Wood, height 11 1/4". Dynasty
XVIII (reign of Tut-ankh-amon).
Staatliche Museen, Berlin.

378. SHAWABTI OF HUY.
Limestone, height 3 1/8". Dynasty
XVIII-XIX.
Metropolitan Museum of Art, New
York.

379. MAN CARRYING A VESSEL.
Wood, height 7/8". Dynasty XVIII.
City Museum, Liverpool.

380. STATUETTE OF KHA.
Wood, height 16 1/8". Ist half of
Dynasty XVIII.
Egyptian Museum, Turin. (Photo
Rosso)

381. SERVANT CARRYING A VESSEL.
Wood, height 7 1/8". Dynasty
XVIII.
Rijksmuseum van Oudheden, Lei-
den.

382. STATUETTE OF A SLAVE.
From the Fayum. Bronze, height
3 1/4". Dynasty XVIII.
The Louvre, Paris. (Photo Archives
photographiques, Paris)

383. HEAD OF QUEEN TIY.
Wood, gold, and glass paste, height
4 1/4". Dynasty XVIII.
Staatliche Museen, Berlin.

384. STATUETTE OF A SLAVE.
Bronze, height 5 1/2". Dynasty
XVIII.
Brooklyn Museum, New York.

385. VALLEY OF THE KINGS. TOMB OF TUTHMOSIS III.
Gods and spirits of the Afterworld. Wall painting (portion). Dynasty XVIII.
(Photo Jean Vertut)

386. VALLEY OF THE KINGS. TOMB OF TUTHMOSIS III.
Mythical scene. Wall painting (portion). Dynasty XVIII.
(Photo Jean Vertut)

387. VALLEY OF THE KINGS. TOMB OF TUTHMOSIS III.
Nightly journey of the sun. Wall painting (portion). Dynasty XVIII.
(Photo Jean Vertut)

388. VALLEY OF THE KINGS. TOMB OF TUTHMOSIS III.
Spirits from the Afterworld. Wall painting (portion). Dynasty XVIII.
(Photo Jean Vertut)

389. VALLEY OF THE KINGS. TOMB OF TUTHMOSIS III.
The king suckled by Isis, represented in the form of a sacred tree. Wall painting (portion). Dynasty XVIII.
(Photo Jean Vertut)

390. VALLEY OF THE KINGS. TOMB OF AMENHOTEP II.
Sacred sheep. Wall painting (portion). Dynasty XVIII.
(Photo Jean Vertut)

391. VALLEY OF THE KINGS. TOMB OF AMENHOTEP II.
Mythical representation of a serpent and a spirit. Wall painting (portion). Dynasty XVIII.
(Photo Jean Mazenod)

392. VALLEY OF THE KINGS. TOMB OF AMENHOTEP II.
The fourth hour of the sun's journey. Wall painting (portion). Dynasty XVIII.
(Photo Jean Vertut)

393. VALLEY OF THE KINGS. TOMB OF AMENHOTEP II.
Spirits of the Afterworld submerged by the waters of the subterranean Nile. Wall painting (portion). Dynasty XVIII.
(Photo Jean Vertut)

394. THEBES. TOMB OF REKHMIRA (No. 100).
Tanners. Wall painting (see also front endpaper). Dynasty XVIII (reign of Thutmosis III–Amenhotep II).
(Photo Jean Vertut)

395. THEBES. TOMB OF REKHMIRA (No. 100).
Preparation of offerings. Wall painting. Dynasty XVIII.
(Photo Jean Mazenod)

396. THEBES. TOMB OF REKHMIRA (No. 100).
Girls playing harp, lute, and small drum (continuation of fig. 93, 3rd register from top). Wall painting. Dynasty XVIII.
(Photo Jean Vertut)

397. THEBES. TOMB OF REKHMIRA (No. 100).
Funerary banquet. Wall painting (detail; see also fig. 93). Dynasty XVIII.
(Photo Jean Vertut.)

398. THEBES. TOMB OF REKHMIRA (No. 100).
Foreign tribute: Asiatics and horses. Wall painting (detail). Dynasty XVIII.
(Photo Jean Mazenod)

399. THEBES. TOMB OF REKHMIRA (No. 100).
Foreign tribute: Negroes from Kush leading a giraffe and monkeys. Wall painting (detail). Dynasty XVIII.
(Photo Jean Mazenod)

400. THEBES. TOMB OF REKHMIRA (No. 100).
Transporting tomb furnishings. Wall painting. Dynasty XVIII.
(Photo Jean Vertut)

401. THEBES. TOMB OF REKHMIRA (No. 100).
Transporting tomb furnishings. Wall painting. Dynasty XVIII.
(Photo Jean Vertut)

402. THEBES. TOMB OF MIN-NAKHT (No. 87).
Offering scene and preparations for sacrifice; mourners and funerary procession (see fig. 109). Wall painting. Dynasty XVIII (reign of Tuthmosis III).
(Photo Jean Vertut)

403. THEBES. TOMB OF MENKHEPERRA-SENEB (No. 86).
Departure of the tribute caravan. Wall painting. Dynasty XVIII (reign of Tuthmosis III).
(Photo Jean Mazenod)

404. THEBES. TOMB OF MENKHEPERRA-SENEB (No. 86).
Tribute bearers from the south and east. Wall painting. Dynasty XVIII.
(Photo Jean Mazenod)

405. THEBES. TOMB OF MENKHEPERRA-SENEB (No. 86).
Foreign tribute bearers. Wall painting. Dynasty XVIII.
(Photo Jean Mazenod)

406. THEBES. TOMB OF MENKHEPERRA-SENEB (No. 86).
Foreign tribute bearers. Wall painting. Dynasty XVIII.
(Photo Jean Mazenod)

407. THEBES. TOMB OF SENNEFER (No. 96).
Purification scene including Sennefer and his wife. Wall painting.

Dynasty XVIII (reign of Amenhotep II).
(Photo Jean Mazenod)

408. THEBES. TOMB OF SENNEFER (No. 96).
Sennefer seated before the offering table. Wall painting. Dynasty XVIII.
(Photo Jean Mazenod)

409. THEBES. TOMB OF SENNEFER (No. 96).
Offering scene including Sennefer and his wife Merit. Wall painting. Dynasty XVIII.
(Photo Jean Mazenod)

410. THEBES. TOMB OF SENNEFER (No. 96).
Sennefer seated, with Merit and Sent-nefer, the royal nurse. Wall painting. Dynasty XVIII.
(Photo Jean Mazenod)

411. THEBES. TOMB OF SENNEFER (No. 96).
Funerary boats. Wall painting. Dynasty XVIII.
(Photo Jean Mazenod)

412. THEBES. TOMB OF SENNEFER (No. 96).
Priest presenting offerings. Wall painting. Dynasty XVIII.
(Photo Jean Mazenod)

413. THEBES. TOMB OF WESERHAT (No. 56).
Hunting scene in the desert. Wall painting. Dynasty XVIII (reign of Amenhotep II).
(Photo Jean Vertut)

414. THEBES. TOMB OF WESERHAT (No. 56).
Barber at work. Wall painting. Dynasty XVIII.
(Photo Jean Mazenod)

415. THEBES. TOMB OF NAKHT (No. 52).
Hunting and fishing; offerings to the deceased; harvesting and treading grapes; netting and plucking waterfowl (see fig. 19). Wall painting. Dynasty XVIII (reign of Tuthmosis IV).
(Photo Jean Vertut)

416. THEBES. TOMB OF DJESERKARESENEB (No. 38).
Young dancer and musicians. Wall painting. Dynasty XVIII (reign of Tuthmosis IV).
(Photo Jean Vertut)

417. THEBES. TOMB OF DJESERKARESENEB (No. 38).
Guest and servant girls (see fig. 97). Wall painting. Dynasty XVIII.
(Photo Jean Vertut)

418. THEBES. TOMB OF DJESERKARESENEB (No. 38).
Girls carrying grapes and dates (see fig. 10). Wall painting. Dynasty XVIII.
(Photo Jean Mazenod)

419. THEBES. TOMB OF DJESERKARESENEB (No. 38).
Butchers at work. Wall painting. Dynasty XVIII.
(Photo Jean Mazenod)

420. THEBES. TOMB OF DJESERKARESENEB (No. 38).
Offering table. Wall painting. Dynasty XVIII.
(Photo Jean Vertut)

421. THEBES. TOMB OF MENENA (No. 69).
Transporting wheat. Wall painting (see also figs. 95, 96). Dynasty XVIII (reign of Tuthmosis IV).
(Photo Jean Vertut)

422. THEBES. TOMB OF MENENA (No. 69).
Treading wheat. Wall painting. Dynasty XVIII.
(Photo Jean Vertut)

423. THEBES. TOMB OF NAKHT (No. 52).
Gathering wheat. Wall painting (see also figs. 19, 94). Dynasty XVIII.
(Photo Jean Vertut)

424. THEBES. TOMB OF MENENA (No. 69).
Offering bearers. Wall painting (see also figs. 95, 96). Dynasty XVIII.
(Photo Jean Vertut)

425. THEBES. TOMB OF MENENA (No. 69).
Sacrifice and purification of an ox. Wall painting. Dynasty XVIII.
(Photo Jean Vertut)

426. THEBES. TOMB OF MENENA (No. 69).
Girls offering flowers. Wall painting. Dynasty XVIII.
(Photo Jean Vertut)

427. THEBES. TOMB OF MENENA (No. 69).
Offering bearer. Wall painting. Dynasty XVIII.
(Photo Jean Vertut)

428. THEBES. TOMB OF MENENA (No. 69).
Funerary boat. Wall painting. Dynasty XVIII.
(Photo Jean Vertut)

429. THEBES. TOMB OF MENENA (No. 69).
Offering bearer. Wall painting. Dynasty XVIII.
(Photo Jean Vertut)

430. THEBES. TOMB OF MENENA (No. 69).
Wild ducks. Wall painting. Dynasty XVIII.
(Photo Jean Vertut)

431. THEBES. TOMB OF MENENA (No. 69).
Birds chased from their nests by a cat. Wall painting. Dynasty XVIII.
(Photo Jean Vertut)

432. THEBES. TOMB OF MENENA (No. 69).
Bird and fish. Wall painting. Dynasty XVIII.
(Photo Jean Vertut)

433. THEBES. TOMB OF RAMOSE (No. 55).
Figures bowing. Limestone relief (see also figs. 98, 112). Dynasty XVIII (reign of Amenhotep III–IV).
(Photo Jean Vertut)

434. THEBES. TOMB OF RAMOSE (No. 55).
Offering bearers. Limestone relief. Dynasty XVIII.
(Photo Jean Mazenod)

435. THEBES. TOMB OF KHERUEF (No. 192).
Musicians and dancers. Limestone relief (see also fig. 99). Dynasty XVIII (reigns of Amenhotep III–IV).
(Photo Jean Vertut)

436. THEBES. TOMB OF KHERUEF (No. 192).
Princesses. Limestone relief. Dynasty XVIII.
(Photo Jean Vertut)

437. THEBES. TOMB OF KHAEMHAT (No. 57).
Moving the herds. Limestone relief. Dynasty XVIII (reign of Amenhotep III).
(Photo Jean Vertut)

438. THEBES. TOMB OF KHAEMHAT (No. 57).
The royal boat at Thebes. Limestone relief. Dynasty XVIII.
(Photo Jean Vertut)

439. PRINCESS EATING A DUCK.
Limestone sketch, carved and painted; height 9 1/4". Dynasty XVIII (Amarna Period).
Egyptian Museum, Cairo. (Photo Bulloz)

440. AKHENATEN, NOFRETETE, AND THEIR DAUGHTERS.
Limestone sunken relief, height 12 5/8" (see also fig. 102). Dynasty XVIII (Amarna Period).
Staatliche Museen, Berlin.

441. OFFERINGS.
Originally from Tell el Amarna, found at Hermopolis. Stone relief (detail of same relief as fig. 444), height 8 5/8". Dynasty XVIII (Amarna Period).
Norbert Schimmel Collection, New York. (Photo Boudot-Lamotte)

442. HAND OF AKHENATEN.
Originally from Tell el Amarna, found at Hermopolis. Sunken relief, height 9 1/4". Dynasty XVIII (Amarna Period).
Norbert Schimmel Collection, New York. (Photo Boudot-Lamotte)

443. AKHENATEN'S OFFERINGS TO THE SOLAR DISK.
Limestone sunken relief, height 31 1/2". Dynasty XVIII (Amarna Period).
Egyptian Museum, Cairo. (Photo Jean Vertut)

444. HAND.
Originally from Tell el Amarna, found at Hermopolis. Stone relief (detail of same relief as fig. 441). Dynasty XVIII (Amarna Period).
Norbert Schimmel Collection, New York. (Photo Boudot-Lamotte)

445. QUEEN NOFRETETE.
Brown stone relief, height 21 1/4". Dynasty XVIII (Amarna Period).
Kestner Museum, Hanover. (Photo Hermann Friedrich)

446. MUSICIANS.
Originally from Tell el Amarna, found at Hermopolis. Stone relief (fragment), height 8 1/4". Dynasty XVIII (Amarna Period).
Norbert Schimmel Collection, New York. (Photo Boudot-Lamotte)

447. FRAGMENT OF A COLOSSAL STATUE OF AKHENATEN.
From the Aten temple, Karnak. Sandstone, height of original statue 10' 2" (see fig. 101). Dynasty XVIII (Amarna Period).
Egyptian Museum, Cairo. (Photo Jean Vertut)

448. PROFILE HEAD OF AKHENATEN.
Sandstone, height 5 1/2". Dynasty XVIII (Amarna Period).
Staatliche Museen, Berlin.

449. COLOSSAL STATUE OF AKHENATEN.
From the Aten temple, Karnak. Sandstone, total height 10' 2". Dynasty XVIII (Amarna Period).
Egyptian Museum, Cairo. (Photo Jean Mazenod)

450. FRAGMENT OF A COLOSSAL STATUE OF AKHENATEN.
From the Aten temple, Karnak. Sandstone, height of original statue 10' 2". Dynasty XVIII (Amarna Period).
Egyptian Museum, Cairo. (Photo Max Hirmer)

451. ROYAL BUST.
Limestone, height 7 7/8". Dynasty XVIII (Amarna Period).
Staatliche Museen, Berlin.

452. TWO MEN AND A BOY.
Said to have come from Gebelein. Painted limestone, height 7 7/8". Dynasty XVIII (Amarna Period).
Metropolitan Museum of Art, New York.

453. QUEEN NOFRETETE.
Limestone, height 15 3/4" (see also fig. 103). Dynasty XVIII (Amarna Period).
Staatliche Museen, Berlin.

454. ROYAL COUPLE.

From Tell el Amarna. Painted limestone, height 8 7/8". Dynasty XVIII (Amarna Period).
The Louvre, Paris. (Photo Giraudon)

455. AMARNA HEAD.

Yellow quartzite, height 7 1/8". Dynasty XVIII (Amarna Period).
Egyptian Museum, Cairo. (Photo Bulloz)

456. HEAD OF QUEEN NOFRETETE.

From Tell el Amarna. Crystalline sandstone, height 13". Dynasty XVIII (Amarna Period).
Egyptian Museum, Cairo. (Photo Jean Vertut)

457. AMARNA HEAD.

Sandstone, height 8 1/4". Dynasty XVIII (Amarna Period).
Staatliche Museen, Berlin.

458. HEAD (HARP DECORATION).

Wood, originally with incrustation; height 7 7/8". Dynasty XVIII (Amarna Period).
The Louvre, Paris. (Photo Bulloz)

459. DEFORMED HEAD OF A PRINCESS.

Dynasty XVIII (Amarna Period).
Egyptian Museum, Cairo. (Photo Jean Vertut)

460. HEAD OF AKHENATEN (?) IN RELIEF.

Sculptor's model, limestone; height 10". Dynasty XVIII (Amarna Period).
Egyptian Museum, Cairo. (Photo Jean Mazenod)

461. HEAD OF GIRL.

Limestone, height 6 1/8". Dynasty XVIII (Amarna Period).
The Louvre, Paris. (Photo Bulloz)

462. MASK OF AN OLD WOMAN.

Plaster, height 10 5/8". Dynasty XVIII.
Staatliche Museen, Berlin.

463. HEAD OF MERITATEN, DAUGHTER OF AKHENATEN.

From Thebes. Lid of a canopic urn, alabaster; height 14 1/8". Dynasty XVIII.
Egyptian Museum, Cairo.

464. FELINE HEAD, DECORATION OF A FUNERARY BED.

From the tomb of Tut-ankh-amon. Stuccoed and gilded wood. Dynasty XVIII.
Egyptian Museum, Cairo. (Photo Jean Vertut)

465. PAINTED CHEST: DESTRUCTION OF AFRICANS.

From the tomb of Tut-ankh-amon. Stuccoed wood (portion), total length 24". Dynasty XVIII.
Egyptian Museum, Cairo. (Photo Jean Vertut)

466. HEAD OF THUERIS, DECORATION OF A FUNERARY BED.

From the tomb of Tut-ankh-amon. Stuccoed and gilded wood. Dynasty XVIII.
Egyptian Museum, Cairo. (Photo Jean Vertut)

467. ALABASTER VASE.

From the tomb of Tut-ankh-amon. Dynasty XVIII.
Egyptian Museum, Cairo. (Photo Bulloz)

468. ANUBIS ON A PORTABLE NAOS (CHEST-SHRINE).

From the tomb of Tut-ankh-amon. Painted wood, height of naos 22 1/2". Dynasty XVIII.
Egyptian Museum, Cairo. (Photo Max Hirmer)

469. ALABASTER VASE.

From the tomb of Tut-ankh-amon. Dynasty XVIII.
Egyptian Museum, Cairo. (Photo Jean Vertut)

470. GODDESS PROTECTING THE CANOPIC SHRINE.

From the tomb of Tut-ankh-amon. Gilded wood, height of figure without emblem 30 3/4". Dynasty XVIII.
Egyptian Museum, Cairo. (Photo Jean Vertut)

471. FLABELLUM: OSTRICH HUNT.

From the tomb of Tut-ankh-amon. Gold, width 7 1/2". Dynasty XVIII.
Egyptian Museum, Cairo. (Photo Bulloz)

472. FLABELLUM: RETURN FROM THE HUNT.

From the tomb of Tut-ankh-amon. Gold, width 7 1/2". Dynasty XVIII.
Egyptian Museum, Cairo. (Photo Bulloz)

473. THE GODDESS SELKET PROTECTING THE CANOPIC SHRINE.

From the tomb of Tut-ankh-amon. Gilded wood, height of figure without emblem 30 3/4". Dynasty XVIII.
Egyptian Museum, Cairo. (Photo Jean Vertut)

474. TUT-ANKH-AMON.

From the tomb of Tut-ankh-amon. Lid of a canopic urn, alabaster; height 9 1/2". Dynasty XVIII.
Egyptian Museum, Cairo. (Photo Jean Vertut)

475. THE ROYAL KA-HARAKHTE OF TUT-ANKH-AMON.

From the tomb of Tut-ankh-amon. Black wood in part coated with gilded plaster, height 6' 3 5/8". Dynasty XVIII.
Egyptian Museum, Cairo. (Photo Bulloz)

476. GOLD MUMMIFORM COFFIN OF TUT-ANKH-AMON.

From the tomb of Tut-ankh-amon. Solid gold, more than 1" thick, inlaid with semiprecious stones and glass paste; height 6' 1" (see fig. 106). Dynasty XVIII.
Egyptian Museum, Cairo. (Photo Max Hirmer)

477. FUNERARY MASK OF TUT-ANKH-AMON.

From the tomb of Tut-ankh-amon. Gold inlaid with colored stones and glass paste; height 21 1/4". Dynasty XVIII.
Egyptian Museum, Cairo. (Photo Bulloz)

478. TUT-ANKH-AMON AS A HARPOONER, STANDING ON A PAPYRUS RAFT.

From the tomb of Tut-ankh-amon. Gilded wood with base, height 29 1/2". Dynasty XVIII.
Egyptian Museum, Cairo. (Photo Jean Vertut)

479. SHAWABTI OF TUT-ANKH-AMON WEARING THE RED CROWN OF THE NORTH.

From the tomb of Tut-ankh-amon. Stuccoed and gilded wood, height 25 1/4". Dynasty XVIII.
Egyptian Museum, Cairo. (Photo Jean Vertut)

480. SHAWABTI OF TUT-ANKH-AMON.

From the tomb of Tut-ankh-amon. Stuccoed and gilded wood. Dynasty XVIII.
Egyptian Museum, Cairo. (Photo Jean Vertut)

481. SHAWABTI OF TUT-ANKH-AMON.

From the tomb of Tut-ankh-amon. Stuccoed and painted wood. Dynasty XVIII.
Egyptian Museum, Cairo. (Photo Jean Vertut)

482. MUMMIFORM COFFIN FOR VISCERA.

From the tomb of Tut-ankh-amon. Gold, incrusted with carnelian and glass paste; height 15 1/2". Dynasty XVIII.
Egyptian Museum, Cairo. (Photo Bulloz)

483. SHAWABTI OF TUT-ANKH-AMON.

From the tomb of Tut-ankh-amon. Stuccoed and painted wood. Dynasty XVIII.
Egyptian Museum, Cairo. (Photo Jean Vertut)

484. SHAWABTI OF TUT-ANKH-AMON.
From the tomb of Tut-ankh-amon. Stuccoed and painted wood. Dynasty XVIII.
Egyptian Museum, Cairo. (Photo Jean Vertut)

485. SHAWABTI OF TUT-ANKH-AMON.
From the tomb of Tut-ankh-amon. Stuccoed and painted wood. Dynasty XVIII.
Egyptian Museum, Cairo. (Photo Jean Vertut)

486. TELL EL AMARNA.
Bending figures. Stone relief from a tomb. Late Dynasty XVIII.
(Photo Jean Mazenod)

487. TELL EL AMARNA. TOMB OF MERIRE.
Horses. Stone relief. Late Dynasty XVIII.
(Photo Jean Mazenod)

488. TELL EL AMARNA. TOMB OF MERIRE.
Warriors. Stone relief. Late Dynasty XVIII.
(Photo Jean Mazenod)

489. HORSEMAN.
From the Memphite tomb of Horemheb. Stone relief, length 49 5/8″.
Late Dynasty XVIII.
Museo Civico Archeologico, Bologna.

490. SCENE WITH PRISONERS.
From the Memphite tomb of Horemheb. Stone relief, total length 9′ 10 7/8″. Late Dynasty XVIII.
Rijksmuseum van Oudheden, Leiden. (Photo F. L. Kenett)

491. BLACK AFRICAN CAPTIVES.
From the Memphite tomb of Horemheb. Stone relief (detail). Late Dynasty XVIII.
Rijksmuseum van Oudheden, Leiden.

492. SYRIAN CAPTIVES.
From the Memphite tomb of Horemheb. Stone relief (detail). Late Dynasty XVIII.
Rijksmuseum van Oudheden, Leiden.

493. SCRIBES AT WORK.
Stone relief (detail). Late Dynasty XVIII.
Archaeological Museum, Florence.

494. THE BLIND HARPIST.
From the tomb of Paatenemheb, Saqqarah. Stone relief. Dynasty XVIII.
Rijksmuseum van Oudheden, Leiden.

495. KA-EMINEN AND MERITRE.
Limestone, height 18 1/2″. Dynasty XVIII (reign of Amenhotep II).
The Louvre, Paris. (Photo Archives photographiques, Paris)

496. STATUETTE OF TUYU.
Wood, height 13 3/8″. Late Dynasty XVIII–early Dynasty XIX.
The Louvre, Paris. (Photo Giraudon)

497. YUYA AND TUYU.
Red sandstone, height 18 1/8″. Dynasty XVIII (reign of Amenhotep III).
The Louvre, Paris. (Photo Archives photographiques, Paris)

498. "THE LADY OF FLORENCE."
Limestone, total height 19 5/8″. Late Dynasty XVIII.
Archaeological Museum, Florence. (Photo Giraudon)

499. STATUETTE OF A WOMAN.
Wood, height 15 3/8″. Late Dynasty XVIII.
Egyptian Museum, Turin. (Photo Rosso)

500. WOMAN CARRYING FLOWERS.
From Thebes. Wood statuette. Late Dynasty XVIII.
Egyptian Museum, Cairo. (Photo Jean Mazenod)

501. THE WIFE OF NAKHT-MIN, VICEROY OF NUBIA.
Limestone, total height 33 1/2″. Dynasty XVIII.
Egyptian Museum, Cairo. (Photo Jean Vertut)

DYNASTIES XIX AND XX

502. THEBES. TOMB OF SETY I.
Painted ceiling of funerary chamber: astronomical representation. Dynasty XIX.
(Photo Jean Vertut)

503. THEBES. TOMB OF SETY I.
Painted ceiling of funerary chamber: celestial constellations. Dynasty XIX.
(Photo Jean Vertut)

504. THEBES. TOMB OF SETY I.
Mythical scene: snake and spirit of the Afterworld. Painted relief (detail). Dynasty XIX.
(Photo Jean Mazenod)

505. THEBES. TOMB OF SETY I.
Monstrous snake (vignette from a funerary text). Painted relief. Dynasty XIX.
(Photo Jean Vertut)

506. THEBES. TOMB OF SETY I.
Spirits of the Afterworld. Painted relief. Dynasty XIX.
(Photo Jean Mazenod)

507. THEBES. TOMB OF SETY I.
The Heavenly Cow (see fig. 116). Painted relief. Dynasty XIX.
(Photo Jean Vertut)

508. THEBES. TOMB OF SETY I.
Fettered foes. Painted relief. Dynasty XIX.
(Photo Jean Mazenod)

509. ABYDOS. TEMPLE OF SETY I.
Ritual scene: Ramesses II and his eldest son roping a bull. Sunken relief. Dynasty XIX.
(Photo Jean Mazenod)

510. ABYDOS. TEMPLE OF SETY I.
Offering incense. Painted relief in the Osiris chapel. Dynasty XIX.
(Photo Jean Mazenod)

511. ABYDOS. TEMPLE OF SETY I.
Young prince (see fig. 12). Dynasty XIX.
(Photo Jean Mazenod)

512. ABYDOS. TEMPLE OF SETY I.
Ibis-headed Thoth (see also fig. 47). Painted relief. Dynasty XIX.
(Photo Jean Mazenod)

513. ABYDOS. TEMPLE OF SETY I.
Sety offering incense to the god Osiris. Painted relief (see also fig. 117). Dynasty XIX.
(Photo Jean Mazenod)

514. ABYDOS. TEMPLE OF SETY I.
Seated Osiris protected by the goddess Isis. Painted relief. Dynasty XIX.
(Photo Jean Mazenod)

515. ABYDOS. TEMPLE OF SETY I.
The goddess Mut suckling Sety I.
Painted relief. Dynasty XIX.
(Photo Jean Vertut)

516. OFFERINGS TO THE DEAD.
From the tomb of General Ria,
Memphis. Limestone relief. Dynasty XIX.
Staatliche Museen, Berlin.

517. STELE DEDICATED TO MNEVIS.
From Heliopolis. Limestone, height
15 3/4". Dynasty XIX.
Ny Carlsberg Glyptotek, Copenhagen.

518. VOTIVE TABLET OF THE YOUNG RAMESSES II.
Limestone, height 7 1/8". Dynasty XIX.
The Louvre, Paris. (Photo Archives
photographiques, Paris)

519. STELE WITH THE NAME OF MNEVIS.
From Heliopolis. Limestone, height
14 1/8". Dynasty XIX.
Ny Carlsberg Glyptotek, Copenhagen.

520. DANCERS.
Relief from the tomb of Hornim. Dynasty XIX.
Egyptian Museum, Cairo. (Photo
Jean Mazenod)

521. ABU SIMBEL. TEMPLE OF RAMESSES II.
Prisoners. Sunken relief (see also
fig. 127). Dynasty XIX.
(Photo H. de Ségogne)

522. STATUETTE OF PI-AY.
Wood, height 21 1/4". Dynasty XIX.
The Louvre, Paris. (Photo Archives
photographiques, Paris)

523. STATUETTE OF A MAN HOLDING A
FALCON-HEAD INSIGNIA.
Wood, height 13 5/8". Dynasty XIX.
The Louvre, Paris. (Photo Archives
photographiques, Paris)

524. MALE FIGURINE HOLDING A RAM-HEAD
INSIGNIA.
Wood, height 25". Dynasty XIX.
Rijksmuseum van Oudheden, Leiden.

525. STATUETTE OF A MAN HOLDING A
RAM-HEAD INSIGNIA.
Wood, height 16 3/4". Dynasty XIX.
The Louvre, Paris. (Photo Archives photographiques, Paris)

526. WOMAN NURSING A CHILD.
Limestone, height 6". Late Dynasty XVIII–Dynasty XIX.
British Museum, London.

527. QUEEN TUYU.
Granite, height 9' 1" (as restored,
9' 10"). Comparison of this colossal
statue with the following statuette
reveals the same monumental character in both. Early Dynasty XIX.
Vatican Museums, Rome.

528. STATUETTE OF AHMES NOFRETARI.
Wood, height 14". Dynasty XIX.
The Louvre, Paris. (Photo Archives
photographiques, Paris)

529. AMON AND MUT.
Brown slate, height 5 7/8". Early
Dynasty XIX.
The Louvre, Paris. (Photo Giraudon)

530. STATUETTE OF AN ORANT.
From Thebes. Bronze, height 3 1/2".
Dynasty XIX.
Metropolitan Museum of Art, New
York.

531. NEBMERTUWEF AND THE GOD THOTH.
Slate, height 7 5/8". Dynasty XIX.
The Louvre, Paris. (Photo Giraudon)

532. STATUETTE OF THE GOD SETH.
Copper, height 27 5/8". Dynasty XIX.
Ny Carlsberg Glyptotek, Copenhagen.

533. BLOCK-STATUE OF BAKENHONS.
Limestone, height 55 1/2". Dynasty XIX.
Aegyptische Staatssammlung, Munich. (Photo H. W. Müller)

534. OSIRIS FLANKED BY A PHARAOH AND
HORUS.
Rose granite, height 51 1/8". Dynasty XIX (Ramesside Period).
The Louvre, Paris. (Photo Giraudon)

535. BLOCK-STATUE OF SA-MUT.
Sandstone, height 24 3/4". Dynasty XIX.
Rijksmuseum van Oudheden, Leiden.

536. HORI AND PA-HEM-NEFER.
Limestone, height 37 3/8". Dynasty XIX.
The Louvre, Paris. (Photo Giraudon)

537. RAMESSES II ON HIS KNEES.
Slate, height 19 5/8". Dynasty XIX.
Egyptian Museum, Cairo. (Photo
Jean Vertut)

538. IWENI AND HIS WIFE.
Limestone, height 29 1/2". Dynasty XIX.
Metropolitan Museum of Art, New
York.

539. BABOON WORSHIPING THE SUN AND
PROTECTING A KING.
Rose granite, height 51 1/8". Dynasty XIX–XX.
Kunsthistorisches Museum, Vienna.

540. THE VIZIER PSIWER.
Gray granite (portion). Dynasty XIX.
Egyptian Museum, Cairo. (Photo
E. Sved)

541. RAMESSES IV.
Tan limestone, total height 18 1/8".
Dynasty XX.
Egyptian Museum, Cairo. (Photo
Jean Mazenod)

542. THEBES. RAMESSEUM.
Colossal head of Ramesses II. Dynasty XIX.
(Photo Jean Vertut)

543. KARNAK. COLOSSAL STATUE OF RAMESSES II WITH HIS WIFE NOFRETARI.
Dynasty XIX.
(Photo Jean Vertut)

544. THEBES. RAMESSEUM.
Colossal head of Ramesses II. Dynasty XIX.
(Photo Jean Vertut)

545. ABU SIMBEL, SMALL TEMPLE. COLOSSAL
STATUE OF RAMESSES II.
Dynasty XIX.
(Photo H. de Ségogne)

546. BUST OF RAMESSES II.
Gray granite, total height 30 1/4".
Dynasty XIX.
Egyptian Museum, Cairo. (Photo
E. Sved)

547. LUXOR. COLOSSAL STATUE OF RAMESSES II.
Dynasty XIX.
(Photo Jean Vertut)

548. THEBES. RAMESSEUM.
Offering ritual. Sunken relief (detail). Dynasty XIX.
(Photo Jean Vertut)

549. THEBES. RAMESSEUM.
The Pharaoh kneeling before the
Theban triad. Sunken relief. Dynasty XIX.
(Photo Jean Vertut)

550. THEBES. RAMESSEUM.
Offering ritual. Sunken relief (detail). Dynasty XIX.
(Photo Jean Vertut)

551. THEBES. RAMESSEUM.
The Battle of Kadesh. Sunken relief
from Pylon II. Dynasty XIX.
(Photo Jean Vertut)

552. THEBES. RAMESSEUM.

The Battle of Kadesh: Warriors in chariots. Sunken relief. Dynasty XIX.
(Photo Jean Vertut)

553. MEDINET HABU. TEMPLE OF RAMESSES III.

Ramesses III hunting wild bulls. Sunken relief, limestone, from the pylon. Dynasty XX.
(Photo Jean Vertut)

554. MEDINET HABU. TEMPLE OF RAMESSES III.

The hunt. Sunken relief (detail) from the pylon. Dynasty XX.
(Photo Jean Vertut)

555. MEDINET HABU. TEMPLE OF RAMESSES III.

The hunt. Sunken relief (detail) from the pylon. Dynasty XX.
(Photo Jean Vertut)

556. MEDINET HABU. TEMPLE OF RAMESSES III.

Goddess and Pharaoh. Sunken relief (detail). Dynasty XX.
(Photo Jean Vertut)

557. MEDINET HABU. TEMPLE OF RAMESSES III.

Pharaoh slaying foes. Sunken relief (see also fig. 122). Dynasty XX.
(Photo Jean Vertut)

558. MEDINET HABU. TEMPLE OF RAMESSES III.

Foes being slaughtered. Sunken relief (detail). Dynasty XX.
(Photo Jean Vertut)

559. THEBES. TOMB OF NOFRETARI.

Interior of the tomb of the wife of Ramesses II (see also figs. 6, 49, 119). Wall painting and painted relief. Dynasty XIX.
(Photo Jean Vertut)

560. THEBES. TOMB OF NOFRETARI.

The goddess Isis. Wall painting. Dynasty XIX.
(Photo Jean Mazenod)

561. THEBES. TOMB OF NOFRETARI.

Isis and Nephthys in the form of falcons mourning the dead Osiris. Wall painting. Dynasty XIX.
(Photo Jean Vertut)

562. THEBES. TOMB OF NOFRETARI.

Funerary spirit. Wall painting. Dynasty XIX.
(Photo Jean Mazenod)

563. THEBES. TOMB OF NOFRETARI.

Isis kneeling on the hieroglyph meaning "gold." Wall painting. Dynasty XIX.
(Photo Jean Vertut)

564. THEBES. TOMB OF NOFRETARI.

The queen seated under a baldachin to play "senet." Painted relief. Dynasty XIX.
(Photo Jean Vertut)

565. THEBES. TOMB OF NOFRETARI.

Ma'at, goddess of truth. Wall painting. Dynasty XIX.
(Photo Jean Vertut)

566. DEIR EL MEDINEH. TOMB OF IPY (No. 217).

Carpenter at work (see fig. 118). Wall painting. Dynasty XIX (reign of Ramesses II).
(Photo Jean Vertut)

567. DEIR EL MEDINEH. TOMB OF IPY (No. 217).

Craftsman at work (see also fig. 118). Wall painting. Dynasty XIX.
(Photo Jean Vertut)

568. DEIR EL MEDINEH. TOMB OF IPY (No. 217).

Polisher (see fig. 118). Wall painting. Dynasty XIX.
(Photo Jean Vertut)

569. DEIR EL MEDINEH. TOMB OF ERENEFER (No. 290).

The sun rising between two sycamores. Wall painting. Dynasty XIX–XX.
(Photo Jean Vertut)

570. DEIR EL MEDINEH. TOMB OF ERENEFER (No. 290).

Scene of worship. Wall painting. Dynasty XIX–XX.
(Photo Jean Vertut)

571. DEIR EL MEDINEH. TOMB OF ERENEFER (No. 290).

The deceased in the solar barge worshiping the Phoenix. Wall painting. Dynasty XIX–XX.
(Photo Jean Vertut)

572. DEIR EL MEDINEH. TOMB OF SENNEDJEM (No. 1).

Sennedjem and his wife worshiping the Sycamore Goddess. Wall painting (see also fig. 20). Dynasty XIX.
(Photo Jean Vertut)

573. DEIR EL MEDINEH. TOMB OF PASHEDU (No. 3).

The Eye of Horus holding a torch. Wall painting (see also fig. 120). Dynasty XIX–XX.
(Photo Jean Vertut)

574. DEIR EL MEDINEH. TOMB OF PASHEDU (No. 3).

Relatives of the deceased. Wall painting. Dynasty XIX–XX.
(Photo Jean Vertut)

575. DEIR EL MEDINEH. TOMB OF INHERKA (No. 359).

The Four Jackals. Wall painting. Dynasty XX (reigns of Ramesses III–IV).
(Photo Jean Vertut)

576. DEIR EL MEDINEH. TOMB OF INHERKA (No. 359).

Two lions bearing the solar disk. Wall painting. Dynasty XX.
(Photo Jean Vertut)

577. DEIR EL MEDINEH. TOMB OF INHERKA (No. 359).

Inherka before the Phoenix of Heliopolis. Wall painting. Dynasty XX.
(Photo Jean Vertut)

578. THEBES. TOMB OF RAMESSES VI.

Descent of the solar disk into the abyss. Wall painting (see also fig. 123). Dynasty XX.
(Photo Jean Vertut)

579. THEBES. TOMB OF RAMESSES VI.

"He becomes the great Khepri in the West." Wall painting. Dynasty XX.
(Photo Jean Vertut)

580. THEBES. TOMB OF RAMESSES VI.

Swimmer, from the "Book of the Gates." Wall painting. Dynasty XX.
(Photo Jean Vertut)

581. THEBES. TOMB OF RAMESSES VI.

Fire-spitting serpent, from the "Book of the Gates." Wall painting. Dynasty XX.
(Photo Jean Vertut)

582. THEBES. TOMB OF RAMESSES VI.

Solar disk, barge, and worshipers, from the ceiling of corridor G. Wall painting. Dynasty XX.
(Photo Jean Vertut)

583. THEBES. TOMB OF RAMESSES VI.

"The body of destruction," from the sarcophagus chamber. Wall painting. Dynasty XX.
(Photo Jean Mazenod)

584. THEBES. TOMB OF RAMESSES VI.

Eagle-headed solar disk surrounded by gods, from the sarcophagus chamber. Wall painting. Dynasty XX.
(Photo Jean Mazenod)

585. THEBES. TOMB OF RAMESSES VI.

Osiris and the birth of the new solar disk, from the sarcophagus chamber. Wall painting. Dynasty XX.
(Photo Jean Mazenod)

LATE PERIOD

586. QUEEN KAROMAMA.
Damascened bronze, height 23 1/4".
Dynasty XXII.
The Louvre, Paris. (Photo Giraudon)

587. STATUETTE OF A WOMAN.
Wood. Dynasty XXV.
Staatliche Museen, Berlin.

588. STATUETTE OF A QUEEN.
Stone, height 21 5/8". Dynasty XXV.
Staatliche Museen, Berlin.

589. TAKUSHIT.
Bronze inlaid with silver, height 27 1/8". Dynasty XXV.
National Museum, Athens. (Photo Giraudon)

590. SEATED MAN.
Granite, height 17 3/4". Dynasty XXV–XXVI.
Kestner Museum, Hanover. (Photo Hermann Friedrich)

591. KHONSU-IR-AA.
Diorite, height 17 3/8". Dynasty XXV.
Museum of Fine Arts, Boston.

592. SEATED SCRIBE.
Yellow quartzite. Dynasty XXV.
Egyptian Museum, Cairo. (Photo E. Sved)

593. MOSI.
Bronze, height 18 1/2". Dynasty XXV.
The Louvre, Paris. (Photo Giraudon)

594. MENTUEMHAT.
Gray granite, total height 53 1/8".
Late Dynasty XXV–early Dynasty XXVI.
Egyptian Museum, Cairo. (Photo Giraudon)

595. AMENARTAIS.
From Karnak. Alabaster, height 65 3/4". Dynasty XXV.
Egyptian Museum, Cairo. (Photo Jean Mazenod)

596. SEATED SCRIBE.
Slate. Dynasty XXV.
Egyptian Museum, Cairo. (Photo E. Sved)

597. STATUETTE OF KING TAHARQA KNEELING (center).
Bronze, height 5 1/2". Dynasty XXV.
Ny Carlsberg Glyptotek, Copenhagen.

598. SEATED STATUE OF HARWA, MANAGER UNDER AMENARTAIS.
From the Karnak cache. Dynasty XXV.
Egyptian Museum, Cairo. (Photo Jean Mazenod)

599. BLOCK-STATUE OF WAHIBRE.
Gray granite, height 40 1/2". Saite Period (Dynasty XXVI).
The Louvre, Paris. (Photo Roger Viollet)

600. STATUETTE OF A WOMAN.
Bronze, height 22 1/2". Saite Period (Dynasty XXV).
Staatliche Museen, Berlin.

601. PETAMON, SON OF HORUTA.
Height 22 7/8". Saite Period (Dynasty XXVI).
The Louvre, Paris. (Photo Roger Viollet)

602. BLOCK-STATUE OF THE MAYOR WESER.
Granite. Saite Period (Dynasty XXVI).
The Louvre, Paris. (Photo Giraudon)

603. ROYAL HEAD.
Gray-green slate, height 7 1/8".
Saite Period (Dynasty XXVI).
Egyptian Museum, Turin. (Photo Rosso)

604. STANDING PRIEST.
Black granite, height 24". Late Period.
Walters Art Gallery, Baltimore.

605. HEAD OF OSIRIS.
Green slate, height 6 1/4". Late Period.
National Museum, Warsaw. (Photo H. Romanowski)

606. ROYAL HEAD.
Greenish stone, height 9 5/8". Saite Period (Dynasty XXVI).
Staatliche Museen, Berlin.

607. IRET-HERRU AND OSIRIS.
From the Karnak cache. Slate, height 22". Saite Period (Dynasty XXVI).
Walters Art Gallery, Baltimore.

608. OLD MAN.
Green slate, total height 7 3/8". Saite Period (Dynasty XXVI).
Walters Art Gallery, Baltimore.

609. THE GODDESS NEITH.
Bronze. Saite Period (Dynasty XXVI).
Staatliche Museen, Berlin.

610. HEAD OF A MAN.
Diorite, height 10". Saite Period (Dynasty XXVI).
Aegyptische Staatssammlung, Munich. (Photo H. W. Müller)

611. GREEK ISIS.
Bronze, height 11 3/4". Greek Period.
Walters Art Gallery, Baltimore.

612. VOTIVE STATUE OF A PRIEST.
Black basalt, height 26 3/4". Dynasty XXX.
The Louvre, Paris. (Photo Giraudon)

613. KNEELING PRIEST HOLDING A LOTUS.
Bronze, height 2 1/8". Late Period.
National Museum, Cracow. (Photo Z. Malinowski)

614. THE GODDESS BASTET.
Bronze, height 3 1/2". Late Period.
National Museum, Warsaw. (Photo H. Romanowski)

615. THE GOD HORUS.
Green slate, height 18 1/8". Late Period.
National Museum, Warsaw.

616. STATUETTE OF APIS.
Bronze, length 4 1/2". Late Period.
Kestner Museum, Hanover. (Photo Hermann Friedrich)

617. SEATED HARPOCRATES.
Bronze, height 8 3/8". Late Period.
National Museum, Cracow. (Photo Z. Malinowski)

618. THE GODDESS ISIS WITH THE CHILD HORUS.
Bronze, height 7 3/8". Late Period.
National Museum, Warsaw.

619. "HEALING" AMULET.
Blue faience, height 2". Late Period.
National Museum, Warsaw.

620. THE GOD BES.
Limestone, height 39 3/8". Dynasty XXX.
The Louvre, Paris. (Photo Giraudon)

621. ANUBIS.
Bronze, height 5 1/2". Roman Period.
National Museum, Warsaw. (Photo H. Romanowski)

622. HEAD OF A PRIEST OF MONTU.
Limestone, height 5 7/8". Dynasty XXX (360–340 B.C.).
Brooklyn Museum, New York.

GREEK PERIOD

623. HEAD OF QUEEN ARSINOE II (275–270 B.C.).
Crystalline limestone, height 15″.
Ptolemaic Period.
Metropolitan Museum of Art, New York.

624. "TIRED OLD MAN."
Slate, height 3 1/4″. Early Ptolemaic Period (300 B.C.).
Walters Art Gallery, Baltimore.

625. HEAD OF A PRIEST.
Marble. Dynasty XXX (380–343 B.C.).
Staatliche Museen, Berlin.

626. VOTIVE STATUE (portion).
Basalt, height 6 3/4″. Ptolemaic Period (200–150 B.C.).
Walters Art Gallery, Baltimore.

627. HEAD OF A PRIEST ("GREEN HEAD").
Green basalt, height 8 1/4″. Ptolemaic Period (100–50 B.C.).
Staatliche Museen, Stiftung Preussischer Kulturbesitz, Berlin. (Photo F. L. Kenett)

628. HEAD OF A YOUNG MAN.
Diorite, height 4 3/4″. Ptolemaic Period (150–100 B.C.).
Walters Art Gallery, Baltimore.

629. HEAD OF A BOY.
Basalt, height 8 1/4″. Ptolemaic Period (80 B.C.).
Museum für Kunst und Gewerbe, Hamburg.

630. HEAD OF A BEARDED MAN.
Slate, height 4 5/8″. Ptolemaic Period (150–100 B.C.).
Walters Art Gallery, Baltimore.

631. TUNEH EL GEBEL. TOMB OF PETOSIRIS.
Tending the herd. Painted relief in the vestibule (Hellenistic style; see also fig. 130).
Late 4th century B.C. (Photo Jean Vertut)

632. TUNEH EL GEBEL. TOMB OF PETOSIRIS.
Making wine. Painted relief in the vestibule.
Late 4th century B.C. (Photo Jean Mazenod)

633. TUNEH EL GEBEL. TOMB OF PETOSIRIS.
Presentation of offerings. Painted relief in the vestibule. Late 4th century B.C.
(Photo Jean Mazenod)

634. TUNEH EL GEBEL. TOMB OF PETOSIRIS.
Moving the herd. Painted relief in the vestibule. Late 4th century B.C.
(Photo Jean Vertut)

635. TUNEH EL GEBEL. TOMB OF PETOSIRIS.
Harvesting grapes and making wine. Painted relief in the vestibule. Late 4th century B.C.
(Photo Jean Vertut)

636. TUNEH EL GEBEL. TOMB OF PETOSIRIS.
Woodworkers. Painted relief in the vestibule. Late 4th century B.C.
(Photo Jean Mazenod)

637. TUNEH EL GEBEL. TOMB OF PETOSIRIS.
Worshiping the gods. Relief in the chapel (Egyptian style). Late 4th century B.C.
(Photo Jean Mazenod)

638. TUNEH EL GEBEL. TOMB OF PETOSIRIS.
Worshiping the Sycamore Goddess. Relief in the chapel. Late 4th century B.C.
(Photo Jean Vertut)

639. STELE WITH THE NAME OF ATHANARUS.
Limestone, height 15 3/4″. Ptolemaic Period.
Ny Carlsberg Glyptotek, Copenhagen.

640. WOMAN AND TWO SERVANTS.
Stone stele (detail). Ptolemaic Period.
Greco-Roman Museum, Alexandria.
(Photo Jean Mazenod)

641. STELE WITH EMBALMING SCENE.
Limestone, height 18 1/8″. Ptolemaic Period.
Ny Carlsberg Glyptotek, Copenhagen.

642. HORUS SLAYING AN ENEMY.
Sandstone sculptor's model, height 9″. Ptolemaic Period.
Walters Art Gallery, Baltimore.

643. THE GODDESS TUTU WITH THE HEAD OF A LION.
Limestone relief (fragment), height 6 1/4″. Ptolemaic Period.
Kestner Museum, Hanover. (Photo Hermann Friedrich)

644. FUNERARY SCENE.
Limestone relief, height 14 1/8″. Ptolemaic Period (3rd–2nd century B.C.).
Roemer-Pelizaeus Museum, Hildesheim.

645. STELE WITH FIGURES OF GODS.
Limestone, height 8 7/8″. Ptolemaic Period.
Ny Carlsberg Glyptotek, Copenhagen.

646. SLEEPING NEGRO.
From Alexandria(?).
Limestone, height 5 1/8″. Ptolemaic Period.
Ny Carlsberg Glyptotek, Copenhagen.

647. THE GODDESS TUTU AS A SPHINX.
Painted stone relief (portion).
Graeco-Roman Period.
Egyptian Museum, Cairo. (Photo Jean Mazenod)

648. MUSAWARAT. TEMPLE OF THE LIONS.
Head of Horus. Sunken relief, stone.
Meroïtic Period.
(Photo F. Hintze)

649. MUSAWARAT. TEMPLE OF THE LIONS.
Column base with elephant and lion. Meroïtic Period.
(Photo F. Hintze)

650. STATUE OF A KING.
From the temple of Isis, Meroë.
Sandstone, height 7′ 3 3/4″. Meroïtic Period (c. 100 B.C.).
Ny Carlsberg Glyptotek, Copenhagen.

651. MUSAWARAT. TEMPLE OF THE LIONS.
Head of a king. Sunken relief (portion). Meroïtic Period.
(Photo F. Hintze)

652. MUSAWARAT. TEMPLE OF THE LIONS.
Amon and the local gods Sebiumeker and Avsnufis. Stone relief (portion).
Meroïtic Period.
(Photo F. Hintze)

653. RECLINING FIGURE.
From the royal baths, Meroë. Painted sandstone, length 55 1/8″. Meroïtic Period (50 B.C.).
Ny Carlsberg Glyptotek, Copenhagen.

654. EDFU. TEMPLE OF HORUS.
Horus. Sunken relief. Ptolemaic Period.
(Photo Jean Mazenod)

655. EDFU. TEMPLE OF HORUS.
Pharaoh in combat. Sunken relief on the pylon. Ptolemaic Period.
(Photo Jean Mazenod)

656. EDFU. TEMPLE OF HORUS.
Horus and Thoth. Sunken relief on the pylon. Ptolemaic Period.
(Photo Jean Vertut)

657. EDFU. TEMPLE OF HORUS.
Hathor and Horus. Sunken relief (detail). Ptolemaic Period. (Photo Jean Mazenod)

658. EDFU. TEMPLE OF HORUS.
Statue of Horus as a falcon, from the first court. Stone, height over 6'. Ptolemaic Period. (Photo Jean Mazenod)

659. EDFU. TEMPLE OF HORUS.
Presentation of offerings to Horus, from the first court. Sunken relief (portion). Ptolemaic Period.

660. PHILAE. TEMPLE OF ISIS.
Presentation of offerings to Horus, on the second pylon. Sunken relief (portion). Ptolemaic Period. (Photo Roger Viollet)

661. PHILAE. TEMPLE OF ISIS.
The king presenting offerings to the goddess Isis. Stone relief (portion). Ptolemaic Period. (Photo Archives photographiques, Paris)

662. DENDERAH. TEMPLE OF HATHOR.
Double symbolic representation of Harsamtawy; in the south crypt, chamber B. Stone relief (portion). Ptolemaic Period (1st century B.C.). (Photo Jean Vertut)

663. DENDERAH. TEMPLE OF HATHOR.
Hathor, Ihy, and Ma'at (left); Isis, Ihy, and Ptolemy (right); Menat necklace (center); in the south crypt, chamber B. Stone relief. Ptolemaic Period (1st century B.C.). (Photo Jean Vertut)

664. DENDERAH. TEMPLE OF HATHOR.
The goddess Hathor; in the south crypt, chamber B. Stone relief. Ptolemaic Period (1st century B.C.). (Photo Jean Mazenod)

665. DENDERAH. TEMPLE OF HATHOR.
Harsamtawy in the form of a falcon; in the south crypt, chamber C. Stone relief (detail). Ptolemaic Period (1st century B.C.). (Photo Jean Vertut)

666. DENDERAH. TEMPLE OF HATHOR.
The god Nebsekheber(?); in the south crypt, passage B–C. Stone relief (detail). Ptolemaic Period (1st century B.C.). (Photo Jean Vertut)

667. DENDERAH. TEMPLE OF HATHOR.
The goddess Tefnut; in the south crypt, passage B–C. Stone relief (detail). Ptolemaic Period (1st century B.C.). (Photo Jean Vertut)

668. DENDERAH. TEMPLE OF HATHOR.
The god Ahasesu; in the south crypt, passage B–C. Stone relief (detail). Ptolemaic Period (1st century B.C.). (Photo Jean Vertut)

669. DENDERAH. TEMPLE OF HATHOR.
Worship of Hathor; in the south crypt, chamber E. Stone relief (detail). Ptolemaic Period (1st century B.C.). (Photo Jean Vertut)

670. DENDERAH. TEMPLE OF HATHOR.
The goddess Tefnut; in the south crypt, passage B–C. Stone relief (detail). Ptolemaic Period (1st century B.C.). (Photo Jean Vertut)

671. DENDERAH. TEMPLE OF HATHOR.
The goddess Nut; in the south crypt, passage B–C. Stone relief (detail). Ptolemaic Period (1st century B.C.). (Photo Jean Vertut)

672. KOM OMBO. TEMPLE OF HAROERIS.
Ritual scene with the Sobek triad. Stone relief (portion). Ptolemaic–Roman Periods. (Photo Jean Vertut)

673. KOM OMBO. TEMPLE OF HAROERIS.
The king presenting offerings to the god Sobek. Sunken relief on a pillar. Ptolemaic–Roman Periods. (Photo Jean Mazenod)

674. KOM OMBO. TEMPLE OF HAROERIS.
Ritual scene. Stone relief (portion). Ptolemaic–Roman Periods. (Photo Jean Vertut)

675. KOM OMBO. TEMPLE OF HAROERIS.
The goddess Hathor. Stone relief (portion). Ptolemaic–Roman Periods. (Photo Jean Vertut)

676. KOM OMBO. TEMPLE OF HAROERIS.
Lion representing the triumphant king. Stone relief (portion). Ptolemaic–Roman Periods. (Photo Jean Vertut)

677. KOM OMBO. TEMPLE OF HAROERIS.
Woman carrying offerings. Stone relief (portion). Ptolemaic–Roman Periods. (Photo Jean Vertut)

678. KOM OMBO. TEMPLE OF HAROERIS.
Ritual lustration of the king. Stone relief (portion). Ptolemaic–Roman Periods. (Photo Jean Vertut)

679. KOM OMBO. TEMPLE OF HAROERIS.
Lamentation of Isis and Nephthys, on a sarcophagus. Painted relief. Ptolemaic–Roman Periods. (Photo Jean Mazenod)

680. KOM OMBO. TEMPLE OF HAROERIS.
Deities. Stone relief (portion). Ptolemaic–Roman Periods. (Photo Jean Mazenod)

ROMAN PERIOD

681. KALABSHA. TEMPLE OF MANDULIS.
The king before the god Mandulis (see fig. 34). Sunken relief (portion). Roman Period. (Photo Jean Mazenod)

682. KALABSHA. TEMPLE OF MANDULIS.
Insignia of the god Mandulis; detail of decoration, interior of temple court. This local god is represented as a bird. Stone relief (detail). Roman Period. (Photo Jean Mazenod)

683. KALABSHA. TEMPLE OF MANDULIS.
King Silko. Graffito on wall. Mid-6th century A.D. (Photo Jean Mazenod)

684. KOM EL SHUKAFA. PRINCIPAL TOMB.
Anubis wearing a cuirass and the double crown of Egypt, at entrance to the funerary chapel. Stone relief. Late 1st–early 2nd century A.D. (Photo Jean Vertut)

685. KOM EL SHUKAFA. PRINCIPAL TOMB.
Statue of the deceased (?), dressed in Egyptian style, hair in Roman style. Right niche of the pronaos. Late 1st–early 2nd century A.D. (Photo Jean Vertut)

686. KOM EL SHUKAFA. PRINCIPAL TOMB.
Anubis wearing a cuirass, the solar disk on his head; at entrance to the funerary chapel. Stone relief. Late 1st–early 2nd century A.D. (Photo Jean Vertut)

687. KOM EL SHUKAFA. PRINCIPAL TOMB.
The deceased (?), and a priest reading a parchment; on left wall of the funerary chapel. Stone relief. Late 1st–early 2nd century A.D. (Photo Jean Vertut)

688. KOM EL SHUKAFA. PRINCIPAL TOMB.
Hapi in the form of a mummy, and Ismet with a human head; on right wall of the right niche. Stone relief. Late 1st–early 2nd century A.D. (Photo Jean Vertut)

689. KOM EL SHUKAFA. PRINCIPAL TOMB.
Mummy laid out on a bed of state, guarded by Anubis (center), Horus (left), and Thoth (right); in the funerary chamber. Stone relief. Late 1st–early 2nd century A.D. (Photo Jean Vertut)

690. KOM EL SHUKAFA. PRINCIPAL TOMB.
Priest wearing feathered headdress, and a woman in prayer, perhaps the wife of the deceased; on right wall of the funerary chamber. Stone relief. Late 1st–early 2nd century A.D. (Photo Jean Vertut)

691. KOM EL SHUKAFA. PRINCIPAL TOMB.
Mummified Ptah (left) and a man clothed as an emperor; on left wall of the right niche. Stone relief. Late 1st–early 2nd century A.D. (Photo Jean Vertut)

692. BUST OF A ROMAN EMPEROR.
From Benha (Delta). Porphyry, total height 22 5/8". c. 300 A.D. Egyptian Museum, Cairo. (Photo E. Sved)

693. THE PRIEST HOR.
From Alexandria. Black slate, height 32 5/8". Roman Period (1st century A.D.). Egyptian Museum, Cairo. (Photo Boudot-Lamotte)

694. BUST OF A MAN.
Marble, height 21 5/8". Roman Period. Egyptian Museum, Cairo. (Photo E. Sved)

695. CHANCELLOR PETOSIRIS.
From Memphis. Black slate, height 33 1/2". Roman Period. Egyptian Museum, Cairo. (Photo E. Sved)

696. BEARDED HEAD.
Marble, height 11 1/4". Roman Period (c. 250 A.D.?). Staatliche Museen, Berlin.

697. GENERAL PAMENKHES.
From Denderah. Gray granite, total height 51 1/8". Roman Period (reign of Augustus). Egyptian Museum, Cairo. (Photo E. Sved)

698. HEAD OF A WOMAN.
From Tell Atrib. Clay, height 1 3/4". Roman Period. National Museum, Warsaw. (Photo H. Romanowski)

699. BUST OF A WOMAN.
Terracotta and plaster, height 11". Roman Period. Walters Art Gallery, Baltimore.

700. MASK.
Terracotta, height 13 3/4". Graeco-Roman Period. Archäologisches Institut der Universität, Tübingen.

701. PORTRAIT OF A WOMAN.
From the Fayum. Encaustic on wood. 2nd century A.D. University Museum, University of Pennsylvania.

702. PORTRAIT OF A WOMAN.
From the Fayum. Encaustic on wood, height 21 5/8". 4th century A.D. The Louvre, Paris. (Photo Bulloz)

703. PORTRAIT OF A YOUNG WOMAN.
From the Fayum. Encaustic on wood, height 13 3/4". Late 2nd century A.D. Kunsthistorisches Museum, Vienna.

704. PORTRAIT OF A YOUNG WOMAN.
From the Fayum. Encaustic on wood. Roman Period. The Louvre, Paris. (Photo Bulloz)

705. PORTRAIT OF A WOMAN.
From the Fayum. Encaustic on wood. Roman Period. The Louvre, Paris. (Photo Boudot-Lamotte)

706. PORTRAIT OF A MAN.
From the Fayum. Encaustic on wood, height 13". 2nd century A.D. National Museum, Cracow. (Photo Z. Malinowski)

707. PORTRAIT OF A MAN.
From the Fayum. Encaustic on wood. 2nd century A.D. University Museum, University of Pennsylvania.

708. PORTRAIT OF A BOY.
From the Fayum (Hawara). Encaustic on wood (see also fig. 138). 2nd century A.D. University Museum, University of Pennsylvania.

COPTIC AND BYZANTINE PERIOD

709. HARE.
Textile, 13 3/8 × 16 1/8". 5th–7th century A.D. Historical Museum of Textiles, Lyon.

710. HORSEMAN.
Textile, linen and wool, 8 1/2 × 9 1/4". 5th–7th century A.D. Cooper-Hewitt Museum of Design, Smithsonian Institution, New York.

711. MYTHOLOGICAL SCENE.
From Akhmin. Textile, height 12 1/4". 3rd–5th century A.D. Kunstmuseum, Düsseldorf. (Photo Landesbildstelle Rheinland, Düsseldorf)

712. MEDALLION WITH A HORSE.
Textile, height of fragment 16 1/2". 5th–6th century A.D. Cleveland, Museum of Art.

713. HEAD OF DIONYSOS.
Textile, 12 1/4 × 10 1/4" (see also fig. 140). 3rd–4th century A.D. Textile Museum, Washington, D.C.

714. PORTRAIT.
Textile, height of fragment 10 1/2". 4th–5th century A.D. Detroit Institute of Arts.

715. EAGLE.
Textile, height of fragment 6 3/4". National Museum, Cracow. (Photo Z. Malinowski)

716. NYMPHS.
Stone relief (see also fig. 141). Coptic. Coptic Museum, Cairo. (Photo Jean Vertut)

717. BUST OF HOLY WISDOM (?).
Limestone tympanum, length 30 1/4". 6th century A.D. Brooklyn Museum, New York.

718. HORUS SLAYING A CROCODILE.
Stone relief, height 19 5/8". 5th–6th century A.D. The Louvre, Paris. (Photo Bulloz)

719. BATHING OF THE INFANT CHRIST.
Limestone relief (fragment). Coptic. Coptic Museum, Cairo. (Photo Jean Vertut)

720. MOSES.
Wood, height 7 7/8". 6th–7th century A.D. Kestner Museum, Hanover.

721. FRAGMENT OF AN ANNUNCIATION.
Height 11 1/4". 4th–5th century A.D.
The Louvre, Paris. (Photo Giraudon)

722. CHRIST IN MAJESTY.
Ivory relief, height 6 3/4". 13th century A.D.
Walters Art Gallery, Baltimore.

723. THE LAST SUPPER.
Fragments of the manuscript "Chronicle of the Alexandrian World."
5th century A.D.
Pushkin State Museum of Fine Arts, Moscow.

724. ADAM AND EVE (THE FALL OF MAN).
Painting. Coptic.
Coptic Museum, Cairo. (Photo Jean Vertut)

725. VIRGIN, CHILD, AND APOSTLE.
Detail of the Ascension from a funerary chapel, Bawit. Wall painting. 7th century A.D.
Coptic Museum, Cairo. (Photo Jean Mazenod)

726. CHRIST.
Detail of the Ascension from a funerary chapel, Bawit. Wall painting. 7th century A.D.
Coptic Museum, Cairo. (Photo Jean Mazenod)

727. CHRIST AND ST. MENAS.
From Bawit. Icon, tempera on wood, height 22 1/2". 6th–7th centuries A.D.
The Louvre, Paris. (Photo Giraudon)

728. FARAS CATHEDRAL. THE HEBREWS IN THE FIERY FURNACE.
Wall painting. Late 10th century A.D.
(Photo Polish Center of Mediterranean Archaeology, Cairo)

729. FARAS CATHEDRAL. NATIVITY.
Wall painting (see also fig. 143). Early 11th century A.D.
(Photo Polish Center of Mediterranean Archaeology, Cairo)

SELECTED OBJECTS

SARCOPHAGI

730. SARCOPHAGUS OF SEKHEMRA HERUHER-MA'AT INTEF.
Painted wood, height 6' 2 5/8". Dynasty XVII.
The Louvre, Paris. (Photo Archives photographiques, Paris)

731. LID OF A CHILD'S SARCOPHAGUS.
From Thebes. Painted wood, height 46 1/8". Dynasty XVIII.
Metropolitan Museum of Art, New York.

732. SARCOPHAGUS OF NOFRETARI.
Stone. Dynasty XIX.
Egyptian Museum, Cairo. (Photo Archives photographiques, Paris)

733. BARBER'S SARCOPHAGUS.
From the temple of Amon Ankh-pa-khered. Height 6' 2". Late Period.
The Louvre, Paris. (Photo Bulloz)

734. SARCOPHAGUS OF AMENIMOPE.
Painted wood, height 6' 6 3/4". Late Dynasty XVIII–early Dynasty XIX.
The Louvre, Paris. (Photo Archives photographiques, Paris)

735. MUMMIFORM SARCOPHAGUS.
From Deir el Medineh. Painted wood, height 66 7/8". New Kingdom.
National Museum, Warsaw. (Photo T. Biniewski)

736. SARCOPHAGUS OF THE SINGER OF AMON.
From Thebes. Painted wood. Dynasty XXI.
Geneva Museum. (Photo Boudot-Lamotte)

737. FRAGMENTARY LID OF A SARCOPHAGUS.
Stone. New Kingdom(?).
Egyptian Museum, Turin. (Photo Anderson-Giraudon)

738. SARCOPHAGUS CASE OF TENTHAPI.
Representation of the goddess of the Amentit. Basalt, height 6' 2 3/4". Saite Period.
The Louvre, Paris. (Photo Alinari-Giraudon)

739. SARCOPHAGUS OF TISKARTES.
Basalt, height 6' 6 3/4". Saite Period.
The Louvre, Paris. (Photo Alinari-Viollet)

740. SARCOPHAGUS.
In the center, the Djed pillar. Painted wood. Saite Period.
The Louvre, Paris. (Photo Giraudon)

741. LID OF THE SARCOPHAGUS OF DJED-KHONSU-WEF-ANKH.
Painted wood. Dynasty XXVI.
The Louvre, Paris. (Photo Giraudon)

742. LID OF A DANCER'S SARCOPHAGUS.
The dwarf Puwinhetef. Gray granite, height 70 7/8". Late Period.
Egyptian Museum, Cairo. (Photo André Vigneau–Tel)

743. SARCOPHAGUS WITH THE HEAD OF HORUS.
Painted wood (see fig. 1, on front binding). Late Period.
Egyptian Museum, Cairo. (Photo Jean Vertut)

744. SARCOPHAGUS OF ARTEMIDOROS.
From Hawara. Painted wood (see fig. 136). 2nd century A.D.
British Museum, London.

PAPYRI

745. HARMASHU-TUM CARRIED BY FOUR FIGURES.
Hieroglyphic papyrus. Dynasty XIX (?).
Collection De Luynes, Cabinet des Médailles, Bibliothèque Nationale, Paris. (Photo Bulloz)

746. OSIRIS WATCHED BY ISIS AND NUT.
Papyrus. Dynasty XIX(?).
Collection De Luynes, Cabinet des Médailles, Bibliothèque Nationale, Paris. (Photo Bulloz)

747. ANUBIS AND A MUMMY.
From the "Book of the Dead" of the scribe Hunefer. Papyrus. Dynasty XIX.
British Museum, London. (Photo Viollet)

748. THE WEIGHING OF THE SOUL.
From the "Book of the Dead" of the scribe Ani. Papyrus. Dynasty XIX.
British Museum, London. (Photo Collection Viollet)

749. AGRICULTURAL LABORS IN THE AFTER-WORLD.
From the "Book of the Dead" of the priestess Anhai. Papyrus. Dynasty XX.
British Museum, London. (Photo Roger Viollet)

750. OFFERING TABLE.
Papyrus No. 2512.
Egyptian Museum, Cairo. (Photo Jean Mazenod)

751. PRAYER TO OSIRIS.

Papyrus No. 2512.
Egyptian Museum, Cairo. (Photo Jean Mazenod)

752. THE WEIGHING OF THE SOUL.

From the "Book of the Dead" of Zoser, priest of Ubastet. Papyrus, from Saqqarah. Ptolemaic Period. Egyptian Museum, Cairo. (Photo Jean Vertut)

OSTRACA

753. DANCER.

From Thebes. Painting on limestone. New Kingdom.
Staatliche Museen, Berlin. (Photo Giraudon)

754. RITUAL DANCER.

Painting on limestone fragment, c. 4 1/4 × 6 5/8". Dynasty XVIII. Egyptian Museum, Turin. (Photo Collection Viollet)

755. PORTRAIT.

Painting on limestone. Dynasty XIX–XX.
Egyptian Museum, Cairo. (Photo Boudot-Lamotte)

756. KING SPEARING A LION.

From Thebes. Painting on limestone, length 5 1/2". Late Dynasty XVIII. Metropolitan Museum of Art, New York.

757. WRESTLERS.

Painting on limestone. Dynasty XIX–XX.
Egyptian Museum, Cairo. (Photo Boudot-Lamotte)

758. CHARIOT.

Painting on limestone. Dynasty XIX–XX.
Egyptian Museum, Cairo. (Photo Boudot-Lamotte)

759. TWO BULLS IN COMBAT.

From Deir el Medineh. Painting on limestone, length 7 1/4". Dynasty XIX.
Metropolitan Museum of Art, New York.

760. MONKEY EATING A FIG.

From Deir el Medineh. Painting on limestone. Dynasty XIX–XX. Egyptian Museum, Cairo.

761. CAT GUARDING A FLOCK OF GEESE.

From Deir el Medineh. Painting on limestone. Dynasty XIX–XX. Egyptian Museum, Cairo.

762. HIPPOPOTAMUS.

From Deir el Bahari or Deir el Medineh. Painting on limestone, length 4 3/4". Dynasty XVIII. Metropolitan Museum of Art, New York.

763. HORSE.

From western Thebes. Painting on limestone (detail), total length 8 1/2". Dynasty XVIII. Metropolitan Museum of Art, New York.

764. FALCON, OSTRICH, AND JACKAL(?).

Limestone. Dynasty XIX–XX. Egyptian Museum, Cairo. (Photo Boudot-Lamotte)

VASES AND FAIENCE

765. CUP.

From Saqqarah. Alabaster. Dynasty I.
Egyptian Museum, Cairo. (Photo W. B. Emery)

766. DISK WITH ANIMALS.

From Saqqarah. Steatite, diameter 3 1/2". Dynasty I.
Egyptian Museum, Cairo. (Photo Archives Hirmer)

767. FRAGMENTS OF LEAF-SHAPED VESSEL.

Slate. Dynasty II.
Egyptian Museum, Cairo. (Photo W. B. Emery)

768. MONKEY-SHAPED PERFUME FLASK.

From the tomb of the king Mernera. Alabaster, height 7 1/8". Dynasty VI.
Metropolitan Museum of Art (Collection M. Davis), New York.

769. HIPPOPOTAMUS DECORATED WITH AQUATIC PLANTS.

Blue faience. Dynasty XI.
The Louvre, Paris. (Photo Giraudon)

770. UNGUENT VASE IN THE FORM OF A LION.

From the tomb of Tut-ankh-amon. Alabaster, height 11 5/8". Dynasty XVIII.
Egyptian Museum, Cairo. (Photo Giraudon)

771. CANOPIC URN.

On the lid, the effigy of Duwamutef. Alabaster, height 12 3/4". Dynasty XIX–XX.
The Louvre, Paris. (Photo Giraudon)

772. VASE IN THE FORM OF A LOTUS CALYX.

Height 5 5/8". Dynasty XVIII.
The Louvre, Paris. (Photo Giraudon)

773. LAMP.

From the tomb of Tut-ankh-amon. Alabaster, height 10 5/8". Dynasty XVIII.
Egyptian Museum, Cairo. (Photo Jean Vertut)

774. PAINTED JAR.

Dynasty XVIII.
National Museum, Cracow. (Photo Z. Malinowski)

775. CANOPIC URN OF PSAMTIK'S GENERAL SANEITH.

Alabaster, height 15 3/4". Saite Period.
The Louvre, Paris. (Photo Giraudon)

776. CUP.

Blue faience, diameter 6 1/2". Dynasty XVIII.
Egyptian Museum, Turin.

777. FALSE CANOPIC URN.

Blue faience, height 12 1/4". Ramesside Period (Dynasty XIX–XX).
The Louvre, Paris. (Photo Giraudon)

778. PAINTED AMPHORA.

Coptic.
Archäologisches Institut der Universität, Tübingen.

779. PAINTED VESSEL.

From Faras. 9th century A.D.
National Museum, Warsaw. (Photo K. Michalowski)

TOILET OBJECTS

780. COSMETIC SPOON.

Wood. New Kingdom.
The Louvre, Paris. (Photo Giraudon)

781. UNGUENT CONTAINER.

Wood. Dynasty XVIII.
The Louvre, Paris. (Photo Giraudon)

782. COSMETIC SPOON.

Wood. New Kingdom.
The Louvre, Paris. (Photo Giraudon)

783. RAZOR, WITH THE GODDESS HATHOR.

Bronze, height 6 3/8". Dynasty XVIII.
Metropolitan Museum of Art, New York.

784. COSMETIC SPOON.
Wood. Dynasty XVIII.
The Louvre, Paris. (Photo Giraudon)

785. COSMETIC SPOON WITH SWIMMER.
Wood, length 11 3/4". Dynasty XVIII.
The Louvre, Paris. (Photo Giraudon)

786. COSMETIC SPOON.
Wood. New Kingdom.
The Louvre, Paris. (Photo Giraudon)

787. COSMETIC SPOON WITH COVER.
Wood, height 14 1/4". New Kingdom.
Staatliche Museen, Berlin.

788. MIRROR.
Bronze. New Kingdom.
Staatliche Museen, Berlin.

789. LID OF A COSMETIC BOX.
Two dogs attacking a gazelle. Wood, 6×2 1/2". Dynasty XVIII–XIX.
Egyptian Museum, Turin.

790. MIRROR HANDLE IN THE FORM OF A PALM COLUMN.
From the tomb of King Shabako, El Kurru. Gilded silver, height 5 5/8". Dynasty XXV (Ethiopian).
Museum of Fine Arts, Boston.

JEWELRY

791. PECTORAL WITH FALCONS.
From Dahshur. Dynasty XII.
Egyptian Museum, Cairo.

792. NECKLACE.
From Saqqarah. Faience and pearls, 11×13 3/8". Dynasty XI.
Egyptian Museum, Cairo.

793. PECTORAL.
From Dahshur. Dynasty XII.
Egyptian Museum, Cairo.

794. NECKLACE AND PECTORAL.
From the tomb of Tut-ankh-amon. Gold and precious stones, total height 16 1/8". Dynasty XVIII.
Egyptian Museum, Cairo. (Photo Giraudon)

795. PECTORAL WITH THE NAME OF SESOSTRIS II.
From Lahun. Belonged to the princess Sat-hathor-yunet. Height 1 3/4". Dynasty XII.
Metropolitan Museum of Art, New York (Henry Walter and Rogers Fund).

796. PECTORAL OF RAMESSES II.
From the Serapeum, Memphis. Gold, length 5 1/2". Dynasty XIX.
The Louvre, Paris. (Photo Giraudon)

797. PECTORAL WITH THE SCARAB OF THE VIZIER PASAR.
From the Serapeum, Saqqarah. Lapis lazuli and gold, length 5 1/2". Dynasty XIX.
The Louvre, Paris. (Photo Giraudon)

798. NECKLACE WITH VULTURE PENDANT.
From the tomb of Tut-ankh-amon. Gold and gems, height 12". Dynasty XVIII.
Egyptian Museum, Cairo. (Photo Bulloz)

799. CHOKER NECKLACE IN THE FORM OF THE VULTURE GODDESS NEKHBET.
From the tomb of Tut-ankh-amon. Cloisonné gold, carnelian, and glass paste, 15 3/4×18 7/8". Dynasty XVIII.
Egyptian Museum, Cairo. (Photo Bulloz)

800. EARRING WITH BIRD.
From the tomb of Tut-ankh-amon. Gold and glass paste, height 2 1/8". Dynasty XVIII.
Egyptian Museum, Cairo. (Photo Giraudon)

801. BRACELET.
From Meroë. Gold. 1st century B.C. Sammlung antiker Kleinkunst, Munich. (Photo H. W. Müller)

802. JEWELRY PIECE (above).
From Meroë. Gold. 1st century B.C. Sammlung antiker Kleinkunst, Munich. (Photo H. W. Müller)

803. NECKLACE WITH PECTORAL.
Gold, ornamented with coins of Roman emperors. 5th–6th century A.D.
Staatliche Museen, Stiftung Preussischer Kulturbesitz, Berlin. (Photo Julia Tietz)

804. "HORSES" RING OF RAMESSES II.
Gold. Dynasty XIX.
The Louvre, Paris. (Photo Giraudon)

805. BRACELET WITH THE FIGURE OF A GODDESS.
From Meroë. Gold. 1st century A.D. Sammlung antiker Kleinkunst, Munich. (Photo H. W. Müller)

FURNITURE

806. HEADREST OF PEPY II.
Alabaster. Dynasty VI.
The Louvre, Paris. (Photo Giraudon)

807. BED OF QUEEN HETEP-HERES.
From Giza. Wood with faience inlay. Dynasty IV.
Egyptian Museum, Cairo. (Photo Jean Mazenod)

808. ARMCHAIR OF QUEEN HETEP-HERES.
Wood; openwork papyrus design. Dynasty IV.
Egyptian Museum, Cairo. (Photo Jean Mazenod)

809. ARMCHAIR OF THE CHILD TUT-ANKH-AMON.
Wood with inlay, height 28".
Dynasty XVIII.
Egyptian Museum, Cairo. (Photo Giraudon)

810. CHAIR.
Wood with inlay. New Kingdom.
Musée Borély, Marseille. (Photo Giraudon)

811. PORTABLE BED OF TUT-ANKH-AMON.
From the tomb of Tut-ankh-amon. Gilded wood, bronze, and inlay, length 6' 2" (see fig. 105).
Egyptian Museum, Cairo. (Photo André Vigneau)

812. CHAIR WITH SLOPING BACK.
Wood with inlay, height 35 3/8". New Kingdom.
The Louvre, Paris. (Photo Giraudon)

813. FOLDING STOOL.
Wood, height 17 3/4". New Kingdom.
Musée Borély, Marseille. (Photo Giraudon)

814. CHAIR.
From Thebes. Wood with inlay, linen mesh seat; height 20 7/8". Dynasty XVIII.
Metropolitan Museum of Art, New York.

815. FOLDING CAMP BED OF TUT-ANKH-AMON.
From the tomb of Tut-ankh-amon. Dynasty XVIII.
Egyptian Museum, Cairo. (Photo Ashmolean Museum, Oxford)

816. WOOD STOOL.
Saite Period(?).
The Louvre, Paris. (Photo Giraudon)

15. DESCRIPTIONS OF ARCHAEOLOGICAL SITES

CONTENTS

I. REGION OF HELIOPOLIS AND MEMPHIS

II. LOWER EGYPT

LIST OF SHORT TITLES CITED IN THIS SECTION

The titles of books frequently cited in this section have been shortened according to the list below. On p. 560 will be found the list of abbreviated titles of periodicals.

Beckerath, *Tanis und Theben:* Beckerath, J. von, *Tanis und Theben; historische Grundlagen der Ramessidenzeit in Ägypten*, 1951.

Boak and Peterson, *Karanis:* Boak, A. E. R., and Peterson, E. E., *Karanis, topographical and architectural report of excavations during the seasons 1924–1928*, 1931.

Borchardt, *Der Porträtkopf der Königin Teje:* Borchardt, L., *Der Porträtkopf der Königin Teje im Besitz von Dr. James Simon in Berlin, Deutsche Orientgesellschaft Ausgrabungen in Tell el Amarna*, I, 1911.

CAH: Cambridge Ancient History (see Bibliography, Chapter 4).

Christentum am Nil: Koptische Kunst: Christentum am Nil (see Bibliography, Chapter 13).

Description: Description de l'Égypte; ou, Recueil des observations et des recherches qui ont été faites en Égypte pendant l'expédition de l'armée française..., I–IX, 1809–18.

Description, Ant. or *État moderne: Description de l'Égypte; ou, Recueil des observations et des recherches qui ont été faites en Égypte pendant l'expédition de l'armée française: Antiquités* (Planches), I–V, 1809–22; *État moderne* (Planches), I–II, 1822–23.

Gabra, *Peintures à fresques:* Gabra, S., *Peintures à fresques et scènes peintes à Hermopolis-Ouest (Touna el-Gebel)*, 1954.

Lepsius, *Denkmäler:* Lepsius, R., *Denkmäler aus Aegypten und Aethiopien*, I–XII, 1849–59.

Lepsius, *Denkmäler, Text:* Lepsius, R., *Denkmäler aus Aegypten und Aethiopien, Text*, 1897–1913.

Mariette, *Mastabas:* Mariette, A. E., *Les Mastabas de l'Ancien Empire*, 1885.

Mariette, *Monuments divers:* Mariette, A. E., *Monuments divers recueillis en Égypte et en Nubie*, 1872, 1879.

Mariette, *Le Sérapeum de Memphis:* Mariette, A. E., *Choix de monuments et de dessins découverts... pendant le déblaiement du Sérapeum de Memphis*, 1857 (Text, with G. Maspero, 1882).

Mariette, *Voyage:* Mariette, A. E., *Voyage dans la Haute Égypte*, 1893.

Maspero, *Le Musée égyptien:* Maspero, G., *Le Musée égyptien, recueil de monuments et notices sur les fouilles d'Égypte*, I–III (vol. I by E. Grébaut), 1890.

Medinet Habu: Oriental Institute, University of Chicago, *Epigraphic and Architectural Survey, Medinet Habu*, 1930–64 (*Oriental Institute Publications* 8–9, 23, 51, 83–84, 93).

Montet, *Géographie:* Montet, P., *Géographie de l'Égypte ancienne*, I–II, 1957–61.

De Morgan, *Carte de la nécropole Memphite:* De Morgan, J., *Carte de la nécropole Memphite, Dahchour, Sakkarah, Abou-Sir*, 1897.

Naville, *Festival Hall of Osorkon II:* Naville, E. H., *The Festival Hall of Osorkon II in the Great Temple of Bubastis*, 1892.

Petrie, *Hawara:* Petrie, W. M. Flinders, *Hawara, Biahmu and Arsinoë*, 1889.

Petrie, *Heliopolis:* Petrie, W. M. Flinders, *Heliopolis, Kafr Ammar and Shurafa*, 1915.

Posener, *La première domination Perse en Égypte:* Posener, G., *La première domination Perse en Égypte, recueil d'inscriptions hiéroglyphiques*, 1936.

Quibell, *Saqqara:* Quibell, J. E., *Excavations at Saqqara*, I–VI, 1905–14.

RE: Pauly-Wissowa, *Real-Encyclopädie der klassischen Altertumswissenschaft.*

Rec. de Trav.: Recueil de travaux relatifs à la philologie et à l'archéologie égyptiennes et assyriennes, 1884.

Ricke, *Bemerkungen:* Ricke, H., *Bemerkungen zur ägyptischen Baukunst des Alten Reiches*, I–II, 1944–50.

Sethe, *Pyramidentexte:* Sethe, K., *Die altägyptischen Pyramidentexte nach den Papierabdrücken und photographien des Berliner Museums*, 1908–22.

Sethe, *Urgeschichte:* Sethe, K., *Urgeschichte und älteste Religion der Ägypter*, 1930.

Spiegel, *Das Werden der altägyptischen Hochkultur:* Spiegel, J., *Das Werden der altägyptischen Hochkultur: Ägyptische Geistesgeschichte im 3. Jahrtausend vor Chr.*, 1953.

Stock, *Die erste Zwischenzeit:* Stock, H., *Die erste Zwischenzeit Ägyptens. Untergang der Pyramidenzeit, Zwischenreiche von Abydos und Herakleopolis, Aufstieg Thebens*, 1949.

Viereck, *Philadelpheia:* Viereck, P., *Philadelpheia, die Gründung einer hellenistischer Militärkolonie in Ägypten*, 1928.

Vyse, *Operations:* Vyse, H., *Operations carried on at the pyramids of Gizeh in 1837...*, I–III, 1840–42.

Weill, *Les origines:* Weill, R., *Les origines de l'Égypte pharaonique*, 1908 (*Annales du Musée Guimet, Bibliothèque d'étude*, 25).

I. REGION OF HELIOPOLIS AND MEMPHIS

1. HELIOPOLIS

The ancient ⌂ = Junu; its Greek name was Heliopolis, its Coptic name On. Capital of Nome XIII ("The Strong Ruler") of Lower Egypt. Its ruins lie near Cairo, in the suburbs Matariyeh and Heliopolis.

Archaeological excavations have uncovered a settlement (with its necropolis) dating from the Nagadah II culture (Debono, "La nécropole prédynastique d'Héliopolis," *ASAE*, 52). It seems unlikely that Heliopolis was the capital of an Egyptian kingdom in the Predynastic Period, although the Pyramid Texts refer to the deified rulers of a prehistoric kingdom as "the souls from Junu" (Sethe, *Urgeschichte*, p. 127). What is certain, however, is that Heliopolis was a religious center from the beginning of the Old Kingdom, and that the Heliopolitan priests created one of the earliest of ancient Egypt's cosmogonies. The primordial chief deity was Atum; his sacred animal was the ichneumon. Atum very soon became Atum-Ra, the name he is given in the Pyramid Texts.

The Great Ennead of Heliopolis (see Chapter 5) may be regarded as the model of this type of cosmogony in Egyptian religion. Heliopolitan religious doctrines influenced Akhenaten's heresy to some extent. In the New Kingdom, Harakhte, Khepri, and such deities as Hathor and Seshat were also worshiped at Heliopolis. The goddess Seshat and the god Thoth recorded the name of each Pharaoh and the years of his reign on the leaves of Ishet, the sacred tree of life. The black bull Mnevis, the stone fetish *benben*, and the phoenix were objects of worship at Heliopolis, and there was another fetish, the Jun pillar, from which the city may have taken its name.

The Heliopolitan priesthood grew so powerful that it caused the replacement of one dynasty with a new line of kings (Dynasty V). The oldest Egyptian calendar, too, is the work of these priests. The rivalry between the priests of Heliopolis and those of nearby Memphis, the Old Kingdom capital, is reflected in the Memphite cosmogony, in which the god Ptah plays the leading part. It seems, however, that Heliopolis maintained its primacy for a long time and was relegated to the second rank only when worship of the Theban Amon became the official religion during the New Kingdom. The income of the temple at Heliopolis exceeded that of the Memphis temple (Erman, *SPAW*, 1903, p. 470).

At the time of Bonaparte's expedition the wall around the sacred enclosure was still in a relatively good state of preservation (*Description, Ant.*, V, pl. 56). But most of our information about the city's monuments comes from literary sources. There are many reasons to believe that the solar temple of King Ne-user-ra (Dynasty V), excavated at Abu Gurob, was modeled on the famous temple of Atum at Heliopolis. Zoser built a sanctuary of dried brick and limestone at Heliopolis, dedicated to the Great Ennead. Several tombs of high priests of Atum, excavated near the east gate of the enclosure wall, date from Dynasty VI. During Dynasty XII a monumental temple was built on the site of the older edifice; this took place in the third year of Sesostris I's reign, while he ruled jointly with his father Amenemhat I. To this temple belonged a red granite obelisk, still *in situ*, over 66 feet high, with inscriptions of Sesostris I on all four sides. This is one of two obelisks he erected to commemorate the thirtieth anniversary of his reign. The other obelisk was destroyed in the twelfth century A.D.

During the New Kingdom a number of new edifices rose at Heliopolis, but all that has come down to us are a few scattered monuments such as the two obelisks, now both known as Cleopatra's Needle—one in London and the other in Central Park, New York—that the emperor Augustus carried off to Alexandria in 22 B.C. Tuthmosis III had erected them in front of one of the pylons of the Atum-Ra temple in the thirty-sixth year of his reign; their points were originally covered with gold leaf. An inscription on a stele found at Heliopolis tells us that Tuthmosis III renovated the temple in the forty-sixth year of his reign.

Before Akhenaten founded his new capital, it seems that the temple of Atum-Ra was rebuilt to include three large courts preceded by pylons. Its design may have inspired the architects of the temple of Aten at Amarna. It also seems that Amenhotep III, Akhenaten's father and a promoter of the Amarna heresy, had a temple dedicated to Aten built at Heliopolis. A stele was found in the city showing Akhenaten and his family worshiping Aten. This stele was later usurped by Horemheb and by Paremheb, the high priest of Ra at Heliopolis.

Documents indicate that Sety I was responsible for several structures at Heliopolis; Ramesses II's building activities are confirmed by many finds and inscriptions. Ramesses III was a great benefactor of the city. Among other things, he strengthened the wall of the enclosure, which measured 1,558 by 3,280 feet. He ordered great statues of Atum to be erected, as well as a granite sanctuary for the goddess Tefnut, the copper gates of which were inlaid with gold. Moreover, he certainly built or rebuilt the three main Heliopolis temples dedicated to Atum, Ra, and Horus. The reign of this

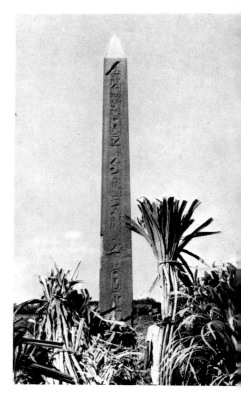

817. HELIOPOLIS.
OBELISK OF SESOSTRIS I

king marked the high point of Heliopolitan sacred architecture and sculpture (statues in the temple enclosure); also, the number of priests and lesser clerics at Heliopolis was greatest under his reign. The personnel of the Atum temple alone numbered 4,583 (Harris Papyrus I, 31, 3). The large necropolis where Heliopolitan priests were buried also dates from Ramesside times (Gauthier, *ASAE*, 27), as do the two tombs of Mnevis bulls, one of which was built under Ramesses II and the other under Ramesses III.

In the Late Period and the Ptolemaic Period certain prominent rulers continued to embellish the temple enclosure. Psamtik I, among other works, ordered a sphinx to be placed here; Psamtik II, an obelisk. Apries added two quartzite sphinxes. Nectanebo and the Ptolemies also left traces of their activity. By Ptolemaic times On-Heliopolis had seen its best days, although it is doubtful that Cambyses destroyed the city and its temples, as Strabo reported (XVII, 805-6). Herodotus offers some information about Heliopolis, and Strabo tells of being shown the house where Plato had stayed and the spot where Eudoxus made his astronomical observations. On the whole, Strabo gives the impression that it was largely an abandoned town. Beginning with Augustus, the Romans systematically stripped the city of its works of art, which were carried off to the newer metropolises of Alexandria and Rome. Two of the many obelisks that once adorned the temple enclosure were taken to Rome by order of Augustus (the Sety I obelisk, now in the Piazza del Popolo, and that of Psamtik II in the Piazza di Montecitorio). Those that were left behind were damaged, according to Strabo (XVII, 29-39).

The Arabs plundered Heliopolis freely whenever they needed stone for buildings in Cairo. According to Christian tradition, the tree that hid the Holy Family from Herod's soldiers by spreading its limbs over them is at Matariyeh.

Today it is impossible to subject the site to systematic excavation, since a new quarter of Cairo lies atop most of it. Such finds as have been made go back to the Flinders Petrie expedition *(Heliopolis)*, and to excavations by the Egyptian Antiquities Service (see reports in *ASAE* by Barsanti, Daressy, and Kamal).

2. MEMPHIS

One of Egypt's oldest capitals, situated in Nome I ("The White Wall") of Lower Egypt. The scanty remains of the city lie at the foot of the Saqqarah plateau, near the railroad station Bedrashein and the village Mit Rahineh. Its earliest name was "White Wall Palace" or "White Wall Granary." The Egyptian ⳉ⳨⳦⳨ = Men-nefer (whence the Greek Memphis) was derived from the name of the pyramid of Pepy I (Dynasty VI), which appears for the first time in an inscription dating from the reign of Ahmose, founder of Dynasty XVIII. However, the name had probably been in use much earlier.

According to Herodotus (II, 99) Menes founded the city and built the temple of Ptah. Although this account was long considered implausible, today archaeologists are inclined to regard it as basically true. That a new capital was established on the border between Lower and Upper Egypt after unification seems very probable. There was actually a fortified royal residence at Memphis, and it was an ideal place from which to oversee the two lands. Manetho's statement that Dynasty I and II rulers had their seat at Thinis in Upper Egypt can be interpreted as meaning that they had originally come from Thinis. The recently discovered mastabas of these rulers at the Saqqarah necropolis, near Memphis, would seem to indicate that Memphis was their capital. A well-known inscription on the Palermo stone indicates that the coronation ceremonies of the earliest kings included a ritual commemorating unification of the two lands and a procession around a city with white walls. It is unlikely that such ceremonies were held in a mere fortress; even at this early date Memphis was a city that had taken on a symbolic character and become the main seat of government (I. E. S. Edwards, "The Early Dynastic Period in Egypt," *CAH*, I, ch. 11, 1964).

One of the most populous of all ancient capitals, Memphis aroused the admiration of Herodotus and Diodorus Siculus (I, 50); and even its ruins astonished twelfth- and thirteenth-century Arab writers. In the Mameluke period, however, the dykes protecting it were breached and the city was swallowed up in the mud of the Nile. A palm grove—mentioned by Pliny (*Nat. Hist.*, XIII, 19)—grew over the ruins of the city. The French traveler Jean de Thévenot identified the site in the late thirteenth century, but this was not confirmed by scholars until Bonaparte's expedition (*Description*, II, ch. 18). Excavations at the site were begun in 1820 by T. B. Caviglia and Sloane, who discovered a colossal statue of Ramesses II, made of crystalline limestone. Herodotus refers to it as the statue of Sesostris.

Subsequent excavations since the time of A. E. Mariette were conducted by the Egyptian Antiquities Service. The site was also investigated by Flinders Petrie (*Memphis*, I-III, 1909-10) and later by American expeditions from the University of Pennsylvania (Fisher, *UPMJ*, VIII, 1917; R. Anthes and others, *Mit Rahineh, 1955, 1956, 1957*, Philadelphia, 1959-67).

As early as the Old Kingdom there must have been a temple dedicated to Ptah at Memphis.

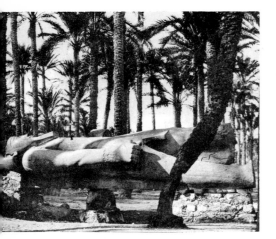

818. MEMPHIS. COLOSSAL STATUE OF RAMESSES II AT MIT RAHINEH

This deity presided over the Ennead instituted by the Memphite priests, probably in reaction to the older Heliopolitan doctrine. In the same period the Apis bull began to be worshiped as one of the incarnations of Ptah. In the ruins near the temple's sacred lake, statues of Dynasty IV and Dynasty V kings were discovered. Some Old Kingdom Pharaohs must have resided at Memphis; we know that Pepy I had a palace near his pyramid in the Memphite valley. The difficult terrain hampers systematic excavation, and the city was destroyed by the Arabs, who tore down its edifices and used the materials for buildings at Fustat, their new capital on the opposite bank of the Nile; yet it is possible, on the basis of extant written sources, to form a picture of the ancient capital. The city area originally extended about twelve miles and consisted of loosely connected residential complexes built around the royal palaces. This center gave rise to a number of suburbs inhabited by populations of various origins.

The central temple area, composed of monumental edifices, was situated around the temple of the city's chief deity, Ptah; the meager remains of this temple lie near the village Mit Rahineh. No important finds dating from the Middle Kingdom have been made at Memphis itself, but many statues from this period were found in Ramesside temples at Tanis and other places; their inscriptions show that they originally stood at Memphis.

During Dynasty XVIII the capital of Egypt was Thebes, but some rulers resided at Memphis because of its central geographical location. Tuthmosis III must have stayed often in Memphis in connection with his military expeditions to Syria. After the Amarna period, Memphis was Egypt's second capital until Ramesses II moved his residence to Tanis. During his reign a number of edifices were erected at Memphis, including the temple complex of Merenptah and other structures. From the same reign date large-scale restorations of older temples. As early as Dynasty XVIII, Memphis was the first Egyptian city to take on a cosmopolitan character. It was inhabited by many foreigners

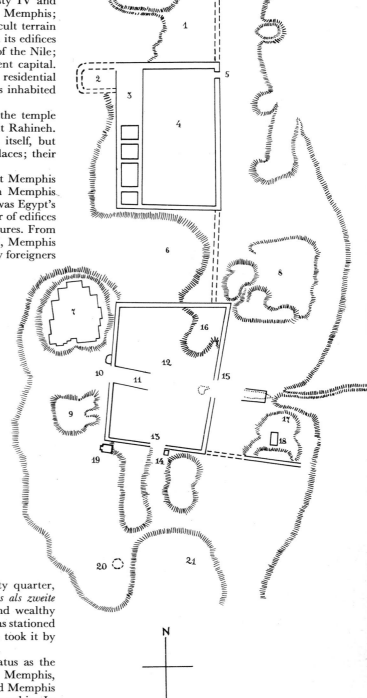

819. MEMPHIS. TOPOGRAPHIC PLAN
1 Temple of Neith
2 Palace
3 Fortress of Kom Teman
4 Camp
5 Great Gateway
6 Sacred lake of Ptah
7 Village of Mit Rahineh
8 Kom el Nawa
9 Kom el Fakhry
10 West propylaea
11 West antechamber
12 Temple of Ptah
13 South propylaea
14 Colossus
15 East propylaea
16 Kom el Khanzir
17 Kom el Kala
18 Temple of Merenptah
19 Sanctuary of Ptah
20 Temple of Sa-amon
21 Temple of Apis

—Syrians, and later Phoenicians, Greeks, and Jews—each of whom had their own city quarter, with temples dedicated to foreign gods such as Baal and Astarte (A. Badawi, *Memphis als zweite Landeshauptstadt im Neuen Reich*, Cairo, 1948). Memphis was at this time a powerful and wealthy city. It had a harbor where ships were moored to the houses with ropes. A large garrison was stationed in the capital. Piankhy was compelled to conquer it before seizing the Delta. Cambyses took it by assault after the battle at Pelusium.

Even after the founding of Alexandria, Memphis did not immediately lose its status as the national capital. Ptolemy I brought the body of Alexander the Great from Babylon to Memphis, and some of the Ptolemies were crowned there. Although Alexandria gradually supplanted Memphis as the main trade center, the old city of Menes retained its importance as a center of worship. In addition to the ancient temple of Ptah, there were a number of temples dedicated to other deities, not to mention the sacred enclosure of Apis. Toward the close of the fourth century A.D. the temples were torn down in obedience to the Edict of Theodosius. The recently discovered stone beds used for embalming Apis bulls probably date from the Late Period.

In the Christian period, Memphis was the seat of the Monophysites, but save for the monastery of St. Jeremias at Saqqarah, no remains dating from this period have been found in the area of Memphis proper.

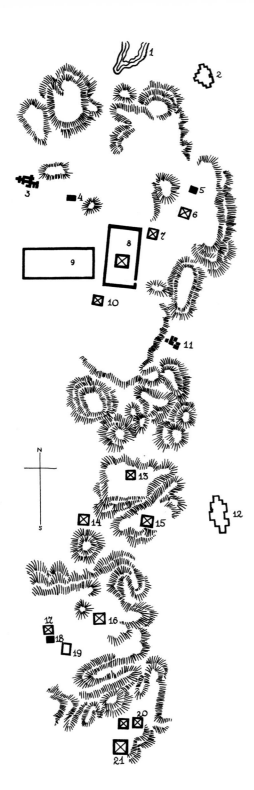

3. SAQQARAH

Large necropolis, about 5 to 11 miles long by 4 1/2 miles wide. It lies on a desert plateau across from Memphis, on the west bank of the Nile. In ancient times the area was situated in Nome I ("The White Wall") of Lower Egypt. The Arabic Saqqarah may have some connection with Sokaris, one of the gods of the necropolis. Drawings made by travelers in the seventeenth, eighteenth, and nineteenth centuries show the necropolis with the characteristic silhouette of Zoser's step pyramid (Pococke, *A Description of the East*, I, 1743-45, pl. 18; Perring, *The Pyramids of Gizeh*, III, 1839-42, pl. 7; Vyse, *Operations*, III, p. 37; Lepsius, *Denkmäler*, I, p. 33). Jean de Morgan was the first to attempt a map of the necropolis *(Carte de la nécropole memphite)*.

820. SAQQARAH. GENERAL PLAN
1. *Pond at Abusir* 2. *Village of Abusir* 3. *Serapeum* 4. *House of A. E. Mariette*
5. *Pyramid of Queen Iput I* 6. *Pyramid of Tety* 7. *Pyramid of Weserkaf* 8. *Precinct of the Zoser pyramid* 9. *Precinct of the unfinished pyramid of Sekhem-khet* 10. *Pyramid of Unas* 11. *Monastery of St. Jeremias* 12. *Village of Saqqarah* 13. *Pyramid of Pepy I*
14. *Pyramid of Mernera* 15. *Pyramid of Zed-kara Isesy* 16. *Pyramid of Iby*
17. *Pyramid of Pepy II* 18. *Pyramid of Queen Udjebten* 19. *Mastaba of Shepseskaf*
20. *Pyramid of Khendjer* 21. *Unfinished pyramid*

In modern times it has become customary to designate the five groups of monuments in the Memphite necropolis by the names of nearby Arab villages—Abu Roash, Giza, Abusir, Saqqarah, and Dahshur.

The Egyptian Antiquities Service has conducted systematic excavations at Saqqarah for more than a hundred years (Quibell, *Saqqara*). The oldest part of the necropolis is the northern end, near Abusir, where in 1912 J. E. Quibell discovered a number of Dynasty II and Dynasty III tombs (*Archaic Mastabas*, 1912-14). After an interruption, these excavations were resumed in 1932 by C. M. Firth, and after his death continued by W. B. Emery: *The Tomb of Hemaka* (with Zaki Y. Saad), 1938; *Hor-aha* (with Zaki Y. Saad), 1939; *Great Tombs of the First Dynasty*, I-II, 1949. Between 1935 and 1956, Emery discovered a number of tombs, among them fourteen large mastabas which in his opinion date from Dynasty I. They include the tombs of the following rulers: Aha (tomb no. 3357), Zer (nos. 3471, 2185), Queen Merneith (no. 3503), Zet, or Wadji, the Serpent King (no. 3504), Wedymu (nos. 3035, 3036, 3506), Az-ib (no. 3038), and Qay-a (nos. 3505, 3500).

Identifying the tombs is complicated by the fact that these rulers have similar though smaller tombs at Abydos; moreover, royal steles have been found near a few of the tombs at Abydos. That a ruler should have two tombs, one in Lower and the other in Upper Egypt, seems understandable, especially in the period directly following unification, when the traditional division was preserved in titles, insignia of rule, and government administration. Therefore, it would not be surprising that the division extended to royal burial customs. Whether the Abydos tombs were merely cenotaphs and the Saqqarah mastabas the actual burial places cannot be ascertained. The fact that sometimes two or three mastabas at Saqqarah can be ascribed to the same ruler further complicates the matter. What is certain, is that the mastabas discovered by Emery, even if not royal tombs, do indeed date from the reigns of the kings in question, for their seals and other inscriptions turn up on the furnishings. These mastabas rose several yards high over underground chambers cut in the rock. Rectangular in shape, they vary from about 66 to 164 feet long and from 40 to 121 feet wide. The dried bricks of which they were built measure approximately 9 by 4 3/4 by 2 3/4 inches. The ceiling or vaulting was generally of wood; stone was used sparingly, for door frames for instance, and for slabs to mask the opening to the underground chamber. Sometimes the latter was reached by steps cut in the rock; some chambers had wood floors. The part above ground contained a storeroom for the tomb furnishings. The outer walls in most cases followed the model of a palace façade, with characteristic panels alternately projected and recessed. Some façades still have traces of a plaster outer layer with colored wickerwork and palace-façade patterns (Chart IX, p. 000). The "Nebetek mastaba," today attributed to King Az-ib, has a superstructure of a different shape: instead of outer walls with alternate projections and recesses, it is built in steps on three sides. (The steps may have extended to the top; if so, this would be an early form of step pyramid.) In front of the Wadji mastaba stood a bench on which protomas of bulls were carved. Most mastabas were surrounded by two walls of dried brick. Those of King Aha and Queen Merneith (situated north of the Wadji mastaba) had adjacent to them separate tombs for the long sacred barges.

In the immediate vicinity of some mastabas "subsidiary tombs" have been found. These were for servants, and in addition to human remains they contained models of objects used by servants. It is conjectured that such persons were poisoned on the death of the ruler so that they might serve him in the afterlife. This custom had fallen into disuse as early as Dynasty II.

Near the mastaba of Aha the remains of a dried-brick structure similar to Zoser's funerary temple were found. It is believed to be the oldest funerary temple so far discovered in Egypt.

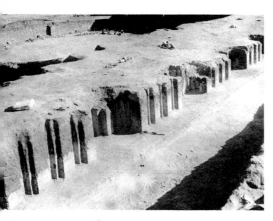

821. SAQQARAH. EAST FAÇADE OF
THE TOMB OF QUEEN HER-NEITH

The Dynasty II mastabas at Saqqarah are slightly different in construction from the earlier ones. The entrance to all underground chambers has become a flight of steps carved out of the rock. But whereas in the earlier tombs the entrance lay somewhere outside the mastaba, now it is hidden within. Façades now have fewer recesses, the largest of them on the south side.

During Dynasty III the Saqqarah necropolis acquired a new architectural element towering above the rest—Zoser's step pyramid (fig. 59) and its funerary enclosure, built for this Pharaoh by his architect Imhotep. It was excavated at the beginning of the nineteenth century. In 1821, H. M. von Minutoli *(Reise zum Tempel des Jupiter Ammon)* penetrated the underground burial chambers. In the years that followed, further excavations were conducted by J. S. Perring and H. Vyse *(Operations)*. R. Lepsius, too, investigated the site *(Denkmäler)*. From A. E. Mariette's time on, Zoser's step pyramid has been studied by a number of archaeologists (Barsanti, *ASAE*, 2; Maspero, *ASAE*, 1, 3), and the excavations of the pyramid enclosure begun by the Egyptian Antiquities Service in 1920 are still being pursued (Firth and Quibell, *The Step Pyramid*, I-II, 1935; Lauer, *La pyramide à degrés*, I-III, 1936-39; *Études complémentaires sur les monuments du roi Zoser à Saqqarah*, 1948; see also a number of articles by the latter, particularly his reports in *ASAE*). Recent investigations suggest that Imhotep built the step pyramid over an older mastaba constructed for Zoser's predecessor and older brother Sa-nekht, who was the founder of Dynasty III, according to Manetho.

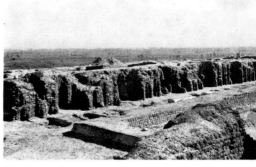

822. SAQQARAH. WEST FAÇADE OF THE TOMB OF QUEEN MERNEITH

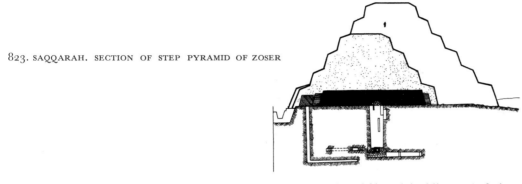

823. SAQQARAH. SECTION OF STEP PYRAMID OF ZOSER

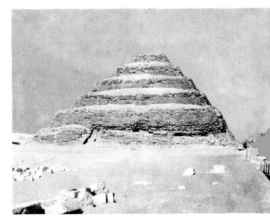

824. SAQQARAH. STEP PYRAMID OF ZOSER

Only the inner masonry of the six-step structure survives today. Of its original limestone facing, all that has been found is a few fragments. It cannot be ascertained whether the steps covered with limestone facing were the definitive exterior of the pyramid or whether the original plan (probably never carried out) called for an outer facing that would have given the pyramid the so-called standard form. In the course of construction, the pyramid was enlarged several times; in the end it measured about 459 by 387 feet at the base and its height was about 197 feet. From the original entrance on the north face a flight of steps led downward. There was a second entrance in the floor of the funerary temple adjoining the pyramid on the north. To the east of the entrance to the funerary temple was a *serdab* built of limestone blocks of dimensions similar to those of the facing blocks; placed inside it was a seated statue of the king (fig. 39).

The burial chamber was located almost directly beneath the middle of the original mastaba, that is, somewhat south of the center axis of the present pyramid. The fragment of a skeleton found in 1934 may have belonged to the mummy of the Pharaoh; Von Minutoli had removed the rest of the mummy, and it has since been lost. A wood sarcophagus may have stood inside the red granite chamber. East of this chamber were found two rooms with walls faced in magnificent blue

825. SAQQARAH.
PLAN OF THE ZOSER COMPLEX
I. *Step Pyramid* II. *Funerary temple*
III. *Altar* IV. *Altars* V. *South House*
VI. *North House* VII. *Heb-Sed chapels*
VIII. *South Tomb*

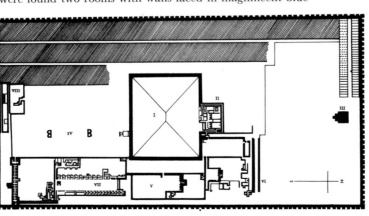

826. SAQQARAH. ZOSER COMPLEX, "PROTO-DORIC" COLUMN

827. ZOSER COMPLEX, SOUTH TOMB, COBRA FRIEZE

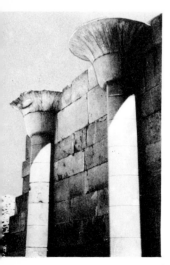

828. ZOSER COMPLEX, NORTH HOUSE, PAPYRUS HALF-COLUMNS

faience tiles; portions of these walls are in the Cairo Museum. In 1933, Quibell and J. P. Lauer discovered beneath the pyramid underground galleries in which there were two sarcophagi and about 30,000 alabaster vessels severely damaged by the collapse of a ceiling.

The Zoser complex occupied an area of about 1,804 by 918 feet, and was enclosed by a wall about 34 1/2 feet high with projections and recesses patterned on a fortress wall. This wall and the other structures in the funerary complex are built of small limestone blocks about the size of bricks. Imhotep's architectural complex is justly regarded as the first transposition of brickwork into stone; the wood pillars and reed bundles of earlier constructions were also given the monumentality of stone. The real entrance to the enclosure was on the east side, but there were thirteen *trompe-l'œil* gates as well. Entering the enclosure, one passed first through a long narrow passage with twelve ribbed columns 21 1/2 feet high, supporting a stone ceiling that imitates palm trunks. This gallery terminated in a small rectangular vestibule with eight columns, linked together in groups of two by a wall.

The court south of the pyramid was bordered on the east by buildings associated with the Heb-Sed (a festival marking the thirtieth anniversary of the Pharaoh's reign), and on the south by a chapel with burial chambers, some of them with facings of blue faience, where Canopic chests may have been kept. This chapel, called the South Tomb, may originally have been intended as a satellite, or subsidiary, pyramid; the layout of its burial chambers repeated that of the main pyramid. A screen wall masked access to the interior. As in other buildings of the Zoser complex, the façade simulates brickwork; in stone, this characteristic design is used purely for decorative purposes. The exterior walls are topped with a frieze of cobras.

In the middle of the eastern part of the court stood two large markers shaped like the letter B—perhaps associated with the Heb-Sed ceremony—and, near the south face of the pyramid, an altar. To the east of the court stood a series of Heb-Sed chapels with characteristic vaulted roofs resting on engaged columns. Near the tops of the columns on the western side were holes whose purpose has been variously interpreted. They may have served for insertion of curved elements— horns, wooden symbols, etc. These columns are fluted, and their capitals have pendent leaves carved in stone.

All the supports or engaged columns to be found on the façades of buildings in Zoser's funerary enclosure can be reduced to two basic types. Some imitate reed bundles, others brick or wood supports. The second category may, when transposed into stone, take on the shape of ribbed or channeled columns, often referred to as proto-Doric. Some of the capitals are decorated with papyrus leaves and have a small abacus.

Behind the Heb-Sed complex, to the north, are the ruins of two structures, the South House and North House (fig. 60). Their decorative elements symbolized Upper and Lower Egypt, and incorporated in the design plants traditionally associated with the two regions. In the northern section of the north court lie the ruins of a great altar with a ramp leading up to it.

The lower temple of the Zoser complex has not been discovered. The upper temple, adjacent to the north face of the pyramid, was divided into symmetrical parts. Two basins for water and a number of smaller rooms have been found within its area. Some archaeologists believe that this temple was a stone representation of the royal palace at Memphis.

In addition to the previously mentioned architectural elements—engaged columns, capitals, cobra friezes—attention must be called to a few other decorative devices important in the subsequent development of Egyptian architecture. Three types of stone cornice first appear in Imhotep's work: the cornice with a torus border; the concave leaf molding that is known as the Egyptian gorge; and the cylindrical cornice that imitates rolled matting. Also for the first time, the *khekher* pattern (in stone) and Sed pillars (in stone or faience) are used for frieze decorations.

In 1954 the Egyptian archaeologist Zakaria Goneim brought to light the unfinished pyramid of Sekhem-khet, Zoser's presumed successor (*The Lost Pyramid*, 1956; *Horus Sekhem-khet*, 1957), situated southwest of the Zoser pyramid. It was enclosed by a stone wall similar in construction to the wall around the Zoser complex. The funerary enclosure measured 1,840 by 656 feet. The pyramid had a square base with sides measuring 393 1/2 feet. The entrance was outside, on the pyramid's northern side; the corridor leading to the burial chamber was 236 feet long. The burial chamber, measuring about 27 feet long, 17 feet wide, and 16 1/2 feet high, contained an alabaster sarcophagus, which had been plundered. Although this pyramid is incomplete, it supplies an important link in the development of this type of structure because it is the earliest known that has a square base; its core was built in steps.

In the northern group of mastabas near the Zoser pyramid, some belonged to Dynasty III dignitaries (Quibell, *The Tomb of Hesy*, 1913; Weill, *Les origines;* Mariette, *Mastabas;* see also reports on Emery's latest discoveries, *JEA*, LI). In 1966, Emery discovered the largest Dynasty III mastaba so far known. The brick walls of its superstructure have been completely destroyed; the stone vases

829. SAQQARAH. RECONSTRUCTION OF THE MASTABA OF SHEPSESKAF

found in its shafts suggest that its owner must have been an important personage (*Orientalia*, 36, 2, 1967, p. 188).

Dynasty IV had its main necropolis at Giza; the monuments from this period at Saqqarah are of minor historical importance. A large complex of Dynasty IV mastabas is situated in the northern part of the necropolis, but none differs essentially from the tombs of Old Kingdom dignitaries (Mariette, *Mastabas*). At South Saqqarah, however, there is one royal tomb—not a pyramid but a gigantic mastaba—belonging to the last ruler of Dynasty IV, Shepseskaf. It is surprising that this ruler, who married a daughter of Mycerinus and completed the latter's pyramid at Giza, built for himself a tomb different from the then current type of pyramid. This monument was discovered in 1858 by Mariette; a scientific study (*Le Mastabet Faraoun*, 1928) was published by G. Jéquier, who excavated the site in 1924. The rectangular superstructure (328 by 236 feet) rose to a height of 59 feet, and unlike the standard mastabas, it had two parapets that crowned its shorter sides. On the north side a descending corridor led to a hall measuring about 23 1/2 by 10 by 14 1/4 feet, which was lined with large granite blocks; its ceiling was lined with V-shaped granite slabs. To the left of this hall a narrow gallery led to storerooms, to its right was the burial chamber, somewhat larger than the hall; its ceiling, originally similar to that of the hall, was later cut and remodeled in imitation of a barrel vault. The chamber contained fragments of a black granite sarcophagus. Against the east side of the mastaba stood a funerary temple, now so completely ruined that it is difficult to reconstruct its plan. It was built of granite blocks resting on granite *orthostatai* (upright shafts). The mastaba was enclosed by a wall of dried brick; at a distance of 131 1/4 feet from this wall stood a second enclosure wall. Remains of a covered causeway leading to the lower temple (as yet not excavated) have also been found. Although the tomb of Shepseskaf is not a pyramid, it was beyond doubt a monumental edifice possessing all the features of the austere classical style of Dynasty IV funerary architecture. Above all, the use of granite for the facing of chambers in the temple and in the lower portions of its wall, and for the exterior facing of the mastaba itself, is entirely consistent with the building practices of this dynasty's great rulers. With its two distinctive parapets the mastaba must have looked like a gigantic stone sarcophagus on a mound dominating the desert.

Dynasty V left three royal pyramids at Saqqarah—those of its first ruler and its last two—and a large number of mastabas of dignitaries, famous for the sculptures and low reliefs decorating them. Weserkaf built his pyramid next to Zoser's funerary complex (somewhat to the northeast). Originally its sides measured about 231 feet at the base, and its height was about 145 1/2 feet. It was constructed of gigantic rough-hewn limestone blocks; there are no traces of its facing. Its granite-lined entrance on the north face was discovered by Perring and Vyse, who were the first to explore the pyramid. Later investigations were conducted by Firth (*ASAE*, 29). The pyramid had several underground chambers; two were lined with limestone and had ceilings in the form of an inverted V. Inside the walled enclosure a small funerary chapel stood against the east face of the pyramid; the main temple was situated south of the pyramid because the ground on the east side sloped too steeply. The temple was constructed of limestone, the facing was of granite, and the pavement of basalt. The latest investigations (Ricke, *Bemerkungen*, II; Lauer, *ASAE*, 53) show that its plan differed from that of other funerary temples of the period. It had an inner court with a covered colonnade on three sides. Here probably stood the colossal granite statue of the Pharaoh, the head of which (now in the Cairo Museum) was found during the excavations. The temple walls were decorated with beautiful low reliefs. Adjacent to the temple on the west side stood a small satellite pyramid, and south of the temple the small pyramid of the queen.

The pyramid known as Harm esh-Shawaf ("Pyramid of the Sentinel"), situated at South Saqqarah on the edge of tilled fields, was identified in 1945 by A. Varille as that of King Zed-kara Isesy. Its base was a square with sides measuring about 262 1/2 feet, and it rose to a height of about 78 1/2 feet (Vyse, *Operations*). It was constructed of rough-hewn limestone blocks; the facing has vanished. A corridor led from the north face to the interior. The substructure, the burial chamber, and the funerary temple followed a typical Dynasty V plan (see the pyramid of Unas, below). The funerary temple was built of limestone blocks and had columns of red granite and walls decorated with reliefs (Fakhry, *Pyramids*). A causeway led to the lower temple (not yet investigated). North of the funerary temple was a small pyramid belonging to Zed-kara Isesy's wife, in which appears the name of his successor, Unas.

The Unas pyramid is situated southwest of Zoser's step pyramid. Its earliest explorers were A. Barsanti (*ASAE*, 2) and G. Maspero (*Rec. de Trav.*, III). Today it is in a state of almost complete ruin. The preserved portion of its core is about 62 feet high, whereas originally it rose to 144 feet. Its square base had sides measuring about 219 1/2 feet. Parts of the beautifully executed white limestone facing have survived. On blocks from this facing, in 1937, J. P. Lauer discovered an inscription—the best-preserved of its type—which mentions the restoration of this pyramid by Prince Kha-em-wast. The entrance to the pyramid is on the north side, under a platform outside the pyramid. The plan of its substructure was copied in Dynasty VI pyramids—those of Tety, Pepy I, Mernera, and Pepy II, although it had been anticipated in the pyramid of Zed-kara Isesy.

From the entrance a narrow corridor gradually widens to form an offering room; it then narrows

830. SAQQARAH. PLAN AND SECTION OF THE PYRAMID OF UNAS

again and runs horizontally for 59 feet and terminates in a square vestibule. Three granite port-cullises are placed approximately halfway between the offering room and the vestibule. Up to this point the corridor was lined with limestone; beyond the portcullises the walls were lined with granite. East of the vestibule is a *serdab* formed of three niches carved out of the rock. West of the vestibule is the burial chamber, preceded by a short narrow passage. At a distance of 4 3/4 feet from the vestibule, the walls are faced with limestone instead of granite. In the chamber were found the earliest known Pyramid Texts (Maspero, *Les Inscriptions des pyramides de Saqqarah;* Sethe, *Pyramidentexte*)—a collection of formulas concerning the king's status in the afterlife. These texts are inscribed in vertical registers and stand out clearly, because the hieroglyphs have been filled with pigment (figs. 5, 38). In the western part of the chamber, the lower portions of the southern and northern walls are lined with alabaster slabs that form a sort of niche. Here stood the king's sarcophagus, which had been robbed in antiquity. This niche was decorated with sculptured false doors painted green and black.

The funerary temple, adjoining the pyramid on the west side, represents a transition between the temple styles of Dynasty V and Dynasty VI. It was excavated by Barsanti (*ASAE*, 2), Maspero (*ASAE*, 1, 3), and Firth (*ASAE*, 30), and more recently by Lauer *(Le problème des pyramides d'Égypte)*. It had a beautiful inner court surrounded by a portico of granite palm columns—an element characteristic of Dynasty V. But the paving is alabaster, not basalt; the walls are limestone, and they do not have the granite foundations found in so many other Dynasty V structures. The storehouses are situated north and south of the temple entrance. The inner part of the temple is entirely in the new style. It contains a hall with five niches, corresponding to the five royal names, and is flanked by storerooms. The temple was entered through a red granite portal completed by King Tety of Dynasty VI. In the southern section of the temple enclosure, a small satellite pyramid stood at the point where the main and inner parts met. The temple complex was enclosed by a wall.

From the lower temple (only partially excavated), which had a roof resting on palm columns, the funerary temple was reached by a ramp, excavated by Selim Hassan (*ASAE*, 38), about 218 1/2 feet long and 22 feet wide, surmounted by a corridor roofed with stone slabs. The inner walls of the corridor were decorated with magnificent reliefs. Some of them treat subjects not encountered elsewhere. There is, for instance, a realistic famine scene showing victims of starvation. Other scenes show the transport by ship of granite palm columns. The ceiling was decorated with stars on a blue background.

Among the many Dynasty V mastabas grouped at North Saqqarah (Mariette, *Mastabas;* Murray, *Saqqara mastabas*, 1905-37), the tomb of High Priest-Lector Ka-aper deserves special mention: it contained the famous Sheikh el Beled (fig. 72), a wood statue of a village mayor (Mariette, *Mastabas*). The best-known mastaba of this period is undoubtedly that of Ti, Overseer of Pyramids and of the Sahura temple (Steindorff, *Das Grab des Ti*, 1913). Its superstructure had a pillared hall, two *serdabs*, and several corridors; its walls are covered with magnificent painted reliefs representing scenes from Ti's life and various activities on his estates. Among the best known are those showing Ti hunting birds in the marshes, geese being fed, statues being polished and prepared to be moved, cooks and bakers at work, peasants harvesting and threshing grain, craftsmen building boats, butchers at work, men fishing with nets, hippopotamus hunts, and cows being milked (figs. 18, 76, 237-42, 245, 246, 250, 254).

The Dynasty V mastabas in the northern part of the necropolis also include those of Ptahhotep I, vizier under Zed-kara Isesy; Ptahhotep II, Inspector of Priests; Akhethotep, Overseer of Pyramid Towns (N. de Garis Davies, *The Mastaba of Ptahhetep and Akhethetep*, I-II), and the mastaba, discovered in 1966, of the court official Nefer and his wife Khonsu, with perfectly preserved polychrome reliefs (*Orientalia*, 36, 2, p. 190). (Painted reliefs from these are illustrated in figs. 17, 244, 248, 249, 251, 252.)

During Dynasty VI, the Saqqarah necropolis was enriched by several royal pyramids and a considerable number of mastabas of dignitaries. Tety, the first ruler of this dynasty, had his pyramid built northeast of the pyramid of Weserkaf and thus in perfect alignment with the Weserkaf and Zoser pyramids. The name given this pyramid, Djed-esut, was probably that by which Memphis was known in the Heracleopolitan period (Dynasties IX-X) and in the early Middle Kingdom, when it was nome capital. The structure is severely damaged. Perring did not penetrate its interior, which was investigated later by Maspero (*La Pyramide du roi Teti*, in *Rec. de Trav.*, V). The sides of the pyramid measured between 197 and 213 feet at the base; its present height is about 65 1/2 feet. Its core, constructed like that of the Unas pyramid, was faced with white limestone. The layout of the corridors and chambers, already anticipated in the tomb of Zed-kara Isesy, is also like that of the Unas pyramid. The walls of the chambers are covered with Pyramid Texts less well-preserved than those in the burial chamber of Unas (Maspero, *Les Inscriptions des pyramides de Saqqarah*). In 1951, Sainte-Fare Garnot discovered more fragments of Pyramid Texts (*ASAE*, 55). In the course of investigations carried out in 1964-66 by J. P. Lauer and J. Leclant, 700 blocks with inscriptions were removed from the burial chamber and antechamber (*Orientalia*, 36, 2, p. 188).

On the north side of the pyramid stands a small chapel shaped like the hieroglyph ⊏⊐ *pr*, from which a corridor leads to the burial chamber. The funerary temple is completely ruined, but

its plan exhibits all the features of Dynasty VI temples, including the characteristic court with five granite niches. It is worth noting that alabaster largely supplants basalt and granite (Quibell, *Saqqara*, I; Leclant, *Orientalia*, 36, 2, p. 188). Near the southeast corner of the pyramid stands a small satellite pyramid, and about 328 feet north is the severely damaged pyramid of the king's wife Iput, which was entered through a shaft sunk in the core of the pyramid, behind the funerary temple (Loret, *Fouilles dans la nécropole memphite, 1897-99*, 1899; Firth and Gunn, *Teti Pyramid Cemeteries*, I-II, 1926). The limestone sarcophagus found in the chamber had been robbed, but it still contained a coffin, made of cedar boards, with the queen's bones, parts of her necklace, and a gold bracelet (today in the Cairo Museum). It is to be noted that the angle of inclination of this pyramid is 65°, so that its form is unusually slender; the same is true of the pyramids of Pepy II's queens. For some reason, certain queens' pyramids were shaped very differently from the "classical" pyramid, whose angle of inclination was about 51°.

Pepy I had his pyramid built on the central Saqqarah plateau, between the northern and the southern groups of tombs. The name of this pyramid = Men-nefer-Pepy (whence the Greek Memphis) turns up for the first time as the name of the city early in Dynasty XVIII. It may, however, have been known by this name much earlier.

Pepy I's pyramid is associated with one of the most dramatic of all Egyptian archaeological finds. Mariette, who contributed so much to our knowledge of ancient Egypt and whose discoveries at Saqqarah are among the greatest in the history of archaeolgocial field work, maintained that there were no inscriptions in or on pyramids—a view not held by his colleague and co-worker Gaston Maspero. In 1880, toward the end of Mariette's life, he was granted a sizable subsidy by the French government to open one of the Saqqarah pyramids and investigate its burial chambers. Mariette chose the pyramid marked no. 5 on Perring's plan. In May, 1880, he reached the burial chambers in the pyramid of Pepy I and found that the walls were covered with inscriptions. Under the impression that he was dealing with a mastaba, not a pyramid, he sent rubbings of the inscriptions to Maspero in Paris, without mentioning where he had found them. Maspero grasped at once that the inscriptions referred to the pyramid of Pepy I, but Mariette was not persuaded to alter his conviction that the pyramids "do not speak." Toward the end of the same year, when Mariette was near death, H. Brugsch called on him in his Cairo apartment and told him that the burial chambers adjacent to the Mernera pyramid had just been excavated and that they contained similar inscriptions. Only then did Mariette acknowledge that Maspero had been right in the earlier instance: some pyramids, at least, do "speak" (Maspero, *Rec. de Trav.*, V, IX).

Today Pepy I's pyramid is completely ruined. At present its sides measure about 229 1/2 feet at the base; its height is about 39 feet. It would be interesting to know whether blocks from mastabas (already destroyed when it was built) had been used in its construction (Maspero, *Rec. de Trav.*, V). The interior of the pyramid follows the plan of the pyramids of Unas and Tety, but its *serdab* is without niches. The pyramid's temples have not yet been excavated.

Pepy I's successor and probable co-regent, Mernera, built his pyramid southwest of his predecessor's. It is somewhat better preserved; originally its sides measured about 311 1/2 feet at the base; today its height is less than 75 1/4 feet. Like that of Pepy I, this pyramid contains inscriptions

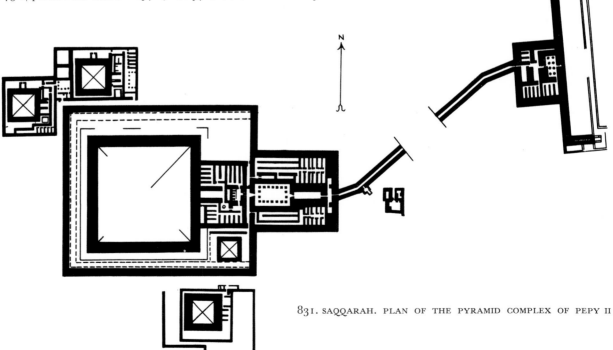

831. SAQQARAH. PLAN OF THE PYRAMID COMPLEX OF PEPY II

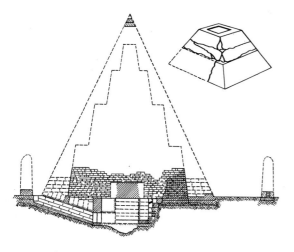

832. SAQQARAH.
SECTION OF THE PYRAMID OF QUEEN
UDJEBTEN AND DETAIL OF APEX

(Vyse, *Operations*, III; Maspero, *Rec. de Trav.*, IX). A granite sarcophagus with a mummy was found in the burial chamber, but the mummy was not that of the king. The well-known biographical inscription of Weni, which Mariette discovered at Abydos (*Abydos*, II, pls. 44-45), contains information on how the granite and alabaster used in the building and decoration of this pyramid came from quarries in Upper Egypt. The ramp leading from the lower temple to the funerary temple on the east side of the pyramid curves to avoid the pyramid of Zed-kara Isesy, which is situated still farther east.

Mernera's successor Pepy II, who ruled for 94 years, built his pyramid at South Saqqarah, northwest of the mastaba of Shepseskaf. Next to Zoser's, his pyramid complex is one of the most thoroughly investigated in the necropolis. The Pyramid Texts found in its vestibule and burial chamber served as the basis for Maspero's publication and provided the core of the collection of inscriptions in the great dictionary of the Berlin Academy. Excavations of the pyramid complex began in the 1920s. In 1932, Jéquier began to classify and to reconstruct partially the architectural fragments found there (*Le monument funéraire de Pepi II*, I-III, 1936-40; *Douze ans de fouilles dans la nécropole memphite, 1924-36*, 1940).

The pyramid's sides measured about 256 feet at the base; it rises to a height of 249 1/4 feet. Its masonry consists of six stepped layers of small stones reinforced with mortar. A facing of limestone blocks from Turah masked the interior stepped construction. After completing the structure, the architects found that the facing had cracked, perhaps as the result of a landslide; a stone parapet was then built around the bottom, supporting the foundations with two rows of blocks. This led in turn to further changes. A small chapel on the north side was torn down to provide blocks for the parapet. Also, the enclosure wall was extended on the east to include the inner part of the funerary temple and the satellite pyramid.

The entrance to the pyramid is in the north face. The layout of the interior chambers is of the same type as that adopted by Pepy II's predecessors. Thanks to Jéquier's excavations, the funerary temple is one of the best-known Dynasty VI temples. It follows the plan commonly used in this period: the storerooms are disposed on either side of the entrance and along a gallery inside. A ramp about 547 yards long led up to the pyramid from the lower temple and surrounding fields. This lower temple had an interesting long portico running north-south with rectangular pillars. Jéquier reconstructed the fragments of low relief decorations on the walls of the two temples and of the ramp. The scenes in the lower temple reproduce motifs from the temple of Sahura at Abusir. The funerary complex of this pyramid served as a model for that of Sesostris I at Lisht.

The pyramid of Pepy II is surrounded by three queens' pyramids—of Queen Udjebten on the southeast, and of Iput and Neith on the northwest (Jéquier, *La pyramide d'Oudjebten*, 1928; see also *Les pyramides des reines Neit et Apouit*, 1933). Like the Pepy II pyramid, they have funerary temples, walled enclosures, and pillars rather than columns. It seems that all of them had satellite pyramids, although no satellite pyramid has been found near the Udjebten pyramid. Essentially, the interiors follow the layout of the Pepy II pyramid, and all of them contain Pyramid Texts. Some characteristic features must be noted. Two small obelisks stood at the entrance to the enclosure of the pyramid of Neith. The silhouette of Iput's pyramid did not differ greatly from the king's pyramid (its angle of inclination was 55° while that of Pepy II's was 53°), but the other two are distinguished by their slender shape, like that of the pyramid of Iput I, Tety's wife. The angle of inclination of the pyramid of Udjebten was 65°, the same as that of Iput I's, and that of Neith's was 61°. Pyramids of this steep, slender shape survived in the pyramidions that crowned the Middle Kingdom tombs at Abydos and the New Kingdom private tombs at Deir el Medineh. Monumental examples do not appear again, however, until the pyramids of Piankhy at El Kurru and the pyramids of the Meroïtic rulers in the Sudan.

Mastabas of courtiers were discovered in the vicinity of each of the royal pyramids. The most interesting and richest complex of these structures is at North Saqqarah, near the pyramid of Tety. First, there is the small mastaba of one of Tety's wives, Queen Khuit, situated near the pyramid of Iput I (Loret, *BIE*, 3; *ZAeS*, 39). To the north of it, near the enclosure wall of Tety's pyramid, a street of mastabas was excavated (Capart, *Une rue de tombeaux à Saqqarah*, 1907; Firth and Gunn, *Teti Pyramid Cemeteries*, I-II). Most of them are distinguished by an extensive system of chapels and corridors in the superstructure. The walls of these tombs are covered with fine low reliefs portraying the life of dignitaries (Montet, *Scènes de la vie privée*) and burial scenes (figs. 243, 247, 253). Among the most magnificent are the mastaba of Vizier Kagemni, Overseer of the Pyramid Town, (Bissing, *Die Mastaba des Gem-ni-kai*, I-II, 1905-11), and the triple mastaba of Mereruka, which served as the tomb of this vizier, his wife, and his son Meriteti (Duell, *The Mastaba of Mereruka*, University of Chicago, Oriental Institute, 1938). Near the mastaba of Kagemni, among the tombs situated near the "street of mastabas," was discovered the mastaba of Vizier Ankh-mahor (surnamed Sesy); its reliefs include a scene representing a surgical operation (Capart, *Une rue de tombeaux*). Among other Dynasty VI mastabas is a small tomb to the south of the Zoser enclosure, which was built by Ikhekhy, and as early as Dynasty VI was usurped by Princess Idut (Macramallah, *Le mastaba d'Idout*, 1935). This is an early example of the usurpation of an older tomb by a member of a subsequent royal family.

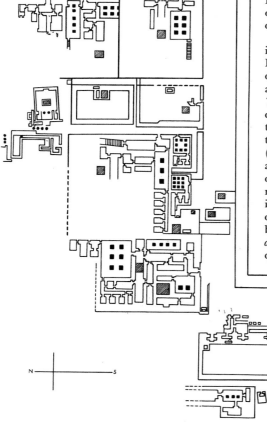

833. SAQQARAH. PLAN OF TOMBS OF DIGNITARIES, NORTH OF THE PYRAMID OF TETY

The Dynasty VI pyramids and the groups of mastabas around them give the Saqqarah necropolis a truly monumental character. There are no fewer than thirteen pyramids of kings and queens, each with a satellite pyramid; there are funerary temples linked by magnificent causeways, and there is the monumental mastaba-shaped mausoleum of Shepseskaf. These structures are scattered over the entire area of the desert plateau, although three groups of structures are especially impressive—the North, Middle, and South. Near several pyramids there were living quarters for priests and overseers. Toward the close of the Old Kingdom the Saqqarah necropolis constituted an unusually splendid city of the dead with real streets leading up to particular tombs. The structures of later date were merely additions, and the tombs of the Pharaohs continued to dominate all the rest.

Immediately after the fall of the Old Kingdom, in the First Intermediate Period, Saqqarah was enriched by one funerary monument—the pyramid of Iby, last ruler of Dynasty VII or VIII (Stock, *Die erste Zwischenzeit*). This fairly small pyramid—its sides measured about 103 feet at the base, its height is somewhat uncertain—stood near the covered causeway leading from the lower to the upper temple of Pepy II (Jéquier, *La pyramide d'Aba*, 1935). It was built of irregular limestone blocks and had a double facing of Turah limestone. The entrance was in the north face, and the burial chamber contained Pyramid Texts, the most recent inscriptions of this type found thus far in a royal tomb. The funerary temple of dried brick is today completely ruined, as is the pyramid itself.

Few tombs from the First Intermediate Period have so far been excavated, but it seems that in this period the funerary temples of Old Kingdom pyramids had caretakers.

It is not surprising that the tombs of Middle Kingdom dignitaries at Saqqarah were rather modest: during Dynasty XI the capital was moved to Thebes, and the kings and important officials of this dynasty built their tombs there, on the west bank of the Nile. As for Dynasty XII rulers, their pyramids were built south of Saqqarah—at Dahshur, Lisht, and on the edge of the Fayum—for the royal residence and the government were then located in that area at a place called Ith-tawe, the site of which has not yet been found. From inscriptions in the funerary temple of Tety and in some mastabas (for example, the tomb of Hetep, Overseer of Priests of the Tety Pyramid under Amenemhat I), it seems that during Dynasty XII some of the Old Kingdom pyramids were looked after with special care, probably in connection with the worship of past Pharaohs.

About a mile south of the tomb of Shepseskaf, Jéquier discovered the remains of two royal funerary enclosures (*Deux pyramides du Moyen Empire*, 1933). In the first enclosure there were two pyramids; the larger measured about 172 feet on each side of the base and originally stood 122 1/2 feet high. The base of the other pyramid was almost exactly half that size; its original height is unknown. The other enclosure was located to the southwest; its single pyramid had a square base measuring 311 1/2 feet on each side. All three pyramids were built of dried brick and covered with facings of polished limestone. The first pyramid was the tomb of Pharaoh Khendjer of Dynasty XIII and was entered from the west face. Its burial chamber was in effect one large quartzite sarcophagus hollowed out of a single block; it weighed about 60 tons. The pyramid was surrounded by two walls. The inner one, of Turah limestone, was built over an older brick wall of characteristic sinusoidal shape. Between the inner stone wall and the outer brick wall stood the second, smaller pyramid, entered from the east face. Its chambers disclosed two quartzite sarcophagi, the lids of which had never been lowered to seal the tombs (showing that they were never used). It is as yet impossible to ascertain whether this pyramid was planned as the burial place of a ruler or members of his family.

The third pyramid, too, remains anonymous. The fact that its enclosure wall is of dried brick—probably intended to be replaced with a stone wall, as in the case of the Khendjer pyramid—suggests that it was never completed. The entrance was in the east face. Its interior is a superb example of Middle Kingdom funerary architecture. The corridor is lined with Turah limestone; some distance inside, from the offering room on, vertical black stripes appear, spaced about 4 inches apart. One of the burial chambers (recalling one in the smaller pyramid of the Khendjer complex) is entirely filled with a quartzite sarcophagus, the lid resting on supports. The royal chamber proper is lined with limestone and granite. One immense quartzite block, weighing about 150 tons, had been lowered into it, filling the whole chamber. This enormous quartzite block was then hollowed out, perhaps because a sarcophagus and a Canopic chest were intended to be placed inside. The lid consisted of three quartzite slabs; one of these, resting on four pillars, was intended to be lowered onto the sarcophagus once the mummy of the Pharaoh was in place. The pyramid's brick masonry was never covered with a stone facing. The complicated layout of the interior and the monumentality of the burial chamber make it one of the most admirable architectural works of ancient Egypt.

During the rest of the Second Intermediate Period, Saqqarah received no new monuments; indeed, there is good reason to believe that some royal funerary enclosures, among them the funerary temple of Tety, were destroyed. During this period some old tombs were reused. For instance, the sarcophagus of the dignitary Abed, dating from the reign of the Hyksos Apophis I, was discovered in one of the burial chambers of the pyramid of Queen Iput I (Müller, "Neues Material zur Geschichte der Hyksos," *OLZ*, 1902).

During Dynasty XVIII new funerary structures rose once again at Saqqarah. The tomb of

475

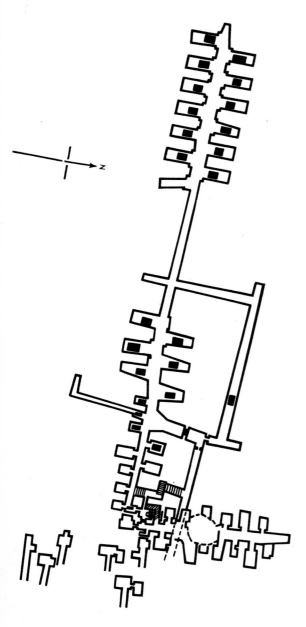

834. SAQQARAH. PLAN OF THE SERAPEUM

the dignitary Mose, for example, was found to be resting atop the funerary temple belonging to the pyramid of Iput II. In this period there was a cemetery for commoners within the Tety enclosure. Lauer and Leclant discovered in 1966, in front of the Tety funerary temple, the remains of a mastaba belonging to Chief Embalmer Akhpet and fragments of reliefs in a style reminiscent of the tomb of Horemheb near Memphis (*Orientalia*, 36, 2, p. 189). The tomb of another Dynasty XVIII dignitary named Raya was discovered near the pyramid of Unas. Many other tombs of Dynasty XVIII dignitaries are situated at South Saqqarah.

The largest entirely new funerary structure dating from Dynasty XVIII is the celebrated Serapeum, a cemetery for Apis bulls, the discovery of which is perhaps Mariette's most memorable achievement *(Le Serapeum de Memphis;* Mariette and Devéria, *Description des fouilles).* Although the complex of buildings and underground galleries dates from later times, and most of the super-structure from the Ptolemaic Period, the group of five mausoleums of Apis bulls dates from Dynasty XVIII.

The last Pharaoh of Dynasty XVIII was Horemheb; while he was still a general under Akhen-aten, he returned from a military expedition to Palestine, and had a tomb built near Memphis. Its walls were decorated with low reliefs in the Amarna style. Fragments of these decorations are now in various museums (figs. 489-92); the tomb must have been destroyed in ancient times, for its site can no longer be found. After acceding to the throne, Horemheb built a new tomb in West Thebes, in the Valley of the Kings; during the New Kingdom Saqqarah ceased to be used as a royal necropolis.

The Dynasty XIX rulers continued to bury Apis bulls in the enclosure later known as the Sera-peum, and they restored some old royal tombs. A great deal of this reconstruction work must be credited to Prince Kha-em-wast, a son of Ramesses II and priest of Ptah at Memphis, as we learn from inscriptions discovered in the vicinity of several mastabas, mainly those *in situ* on the southern face of the Unas pyramid and in the tomb of Shepseskaf. Incidentally, this prince built a tomb for himself at Giza, near the Cheops pyramid—not at Saqqarah. All this building activity suggests that by that time the royal necropolis at Saqqarah must have been partially destroyed, and that the great ceremonies associated with the burial of Apis bulls restored Saqqarah as an important center of worship. Several tombs of dignitaries also date from this period.

Subsequent dynasties continued to enlarge the cemetery of the sacred bulls but no longer bothered to keep up the royal necropolis. Besides their sarcophagi, the Apis tombs have yielded a large number of funerary steles which are of great importance for establishing the chronology and genealogies of the Late Period. Some funerary temples were dismantled and treated as sources of building material. Saite tombs have been found in the ruins of Weserkaf's funerary temple, already a heap of rubble when they were dug. Three Saite tombs near this temple, which were excavated in the 1940s—those of Hor, Neferibre-Sa-Neith, and Amentefnekh—are of special interest: inscribed on their walls is a late version of the Pyramid Texts (Drioton, *ASAE*, 52). Emery's recent excavations in the northwest section of Saqqarah have brought to light an underground cemetery—a labyrinth of galleries more than a mile long, which contained mummified ibises dating from the Late and Ptolemaic Periods. Because some of the mummy bandages were decorated with images of Thoth or Imhotep, Emery has suggested that Imhotep's tomb and the later Asklepieion must have been situated in this area (*Orientalia*, 35, 2; 36, 2, p. 187).

During Dynasty XXX and in the Ptolemaic Period the necropolis of Apis bulls was enriched with a number of buildings, becoming a monumental architectural complex in its own right. It seems likely that Ramesses II built a temple at Saqqarah. His successor Merenptah placed two sphinxes near the road leading to the funerary enclosure. The earliest tombs of bulls date from Dynasty XVIII; the first catacombs were cut in the rock during the reign of Ramesses II and additional ones during later dynasties. The monumental semicircular ramp, which today leads from cultivated fields to the enclosure, was called *dromos* by the Greeks; it was built by Dynasty XXX rulers. Nectanebo I lined it with rows of stone sphinxes on either side, built a portal leading from the necropolis proper to this avenue, and placed two statues of lions in front of the necropolis; probably he also built the enclosure wall. Nectanebo II built two temples dedicated to Apis, one to the east and one to the west of the necropolis. Further additions to the Serapeum were made by the Ptolemies. Ptolemy I decorated the *dromos* with statues in the Greek style, featuring Dionysian motifs. Next he built the famous *exedra*, with statues of Greek poets and philosophers (Lauer and Picard, *Les statues ptolémaïques du Serapieion de Memphis*, 1955). Greek papyri refer to many other buildings in the Serapeum area which served as administrative offices. There was, for instance, the so-called Anubidion complex, connected with the worship of Anubis, which included apartments for priests, schools and inns open to pilgrims, and military police headquarters. Nearby were cells in which some Greeks led a monastic life as early as the Ptolemaic Period; a market place (the *pastophonum*); and other structures which served as a kind of sanitarium for pilgrims who came in hope of having their illnesses cured by Serapis, the chief deity of the necropolis since the time of Ptolemy I. In a sense this deity may be regarded as a political-religious creation of the Ptolemies; they converted the Egyptian deity Osor-hapi into Serapis, endowing him with the features of Osiris, Apis, Dionysos, Asklepios, Hades, and to some extent Zeus. It is, however, possible that the so-called

Asklepieion was not in the Serapeum area but near the catacombs of ibises, at the site of Emery's recent excavations. The great efforts to enlarge and decorate the Serapeum and its surroundings, and the use of predominantly Greek motifs in architecture and sculpture, apparently reflected a deliberate government policy of stressing the ideological values of Greek culture.

However, the importance of the Serapeum was short-lived. It was already buried in the sand when Strabo saw it, an occasional bust or head of a sphinx still visible (XVII, I, 32). But it was precisely this passage in Strabo that induced Mariette to look for the Serapeum at this site when, in October, 1850, he noticed the head of a sphinx during a preliminary survey of the necropolis. In November and December of that year he excavated a causeway about 656 feet long, discovered a row of sphinxes, and, on Christmas Eve, brought to light the famous statue of Pindar, one of the eleven statues in the original hemicycle of Greek poets and philosophers. Mariette's most interesting discovery here, however—this time in the domain of Egyptian sculpture—was entirely accidental. While excavating the Serapeum causeway, he stumbled on several Dynasty V tombs, and one of the seven statues found in them was the famous seated scribe (figs. 74, 211). Despite financial problems and government interference, Mariette kept on digging at this site, with interruptions, through 1851. On November 12 of that year he finally made his way into the catacombs containing gigantic granite and basalt sarcophagi weighing almost 70 tons where formerly lay mummified bulls. The main gallery had been ransacked in antiquity, but in the lower galleries, situated north of the entrance to the catacombs, Mariette found a few intact tombs of Apis bulls. One of them, dating from the reign of Ramesses II, contained a wooden sarcophagus inside which was the mummy of a bull. The mummy was decorated with precious stones and amulets inscribed with the name of Prince Kha-em-wast.

So far no remains of monumental buildings dating from Roman times have been discovered at Saqqarah. Only the cemetery for dogs discovered southeast of the pyramid of Iput I shows that the necropolis was still used in Roman times. The last building at Saqqarah dating from antiquity was erected in the Coptic period.

Southeast of the Unas pyramid lie the ruins of the great complex of the monastery of St. Jeremias (Quibell, *The Monastery of Apa Jeremias*, 1912), which was founded in 430 A.D. It survived until the second half of the tenth century. It was built mainly of dried brick, but many blocks from the nearby necropolis were used. The basilica, abandoned in the eighth century, had an apse decorated with mosaics; there was also another church, where St. Jeremias was buried. The monastery had a large refectory and a group of farm buildings with a bakery and wine and olive presses; west of the basilica were many small buildings with monks' cells. Many objects from the monastery, including a pulpit, are today in the Coptic Museum in Cairo. Among the most important are fragments of wall paintings dating from the sixth and seventh centuries. Besides figures of apostles, there is a Madonna, the *Virgo lactans*. This subject, alien to the Monophysite Coptic Church, seems to indicate that for some time Melkites stayed in this monastery (K. Wessel, "Zur Ikonographie der koptischen Kunst," in *Christentum am Nil*, p. 234).

Saqqarah is important, not just for its monuments, but because it gives a picture of the development of ancient Egyptian art and architecture from archaic times, through the magnificent achievements of the New Kingdom, down to the Coptic period. The sculptures in the Serapeum are a splendid manifestation of Greek art in Egypt, and the paintings in the monastery of St. Jeremias are among the few valuable relics we have of Christian art in Egypt.

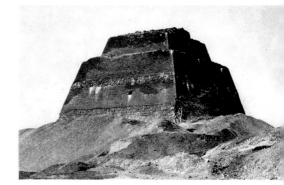

835. MEDUM. PYRAMID OF SNEFERU

4. MEDUM

The ancient ⟨glyph⟩ = Mer-tem, a village on the left bank of the Nile, on the same latitude as the Fayum.

Near the village lies an extensive necropolis; its most spectacular feature is a pyramid, now truncated, which attracted the attention of the earliest travelers (Denon, *Voyage*, pl. XXVI). It is generally believed that the pyramid was built for Sneferu, the father of Cheops, but some archaeologists surmise that it was built for Huni, last ruler of Dynasty III. The name of this pyramid has not come down to us. In the demotic history of Petubastis, Medum is described as a fortress that Tef-nekht, a Saite prince, surrendered to King Piankhy.

Around this pyramid extends a large field of Dynasty III and Dynasty IV mastabas. The site was excavated by A. E. Mariette *(Voyage; Mastabas; Monuments divers)*, Flinders Petrie *(Medum, 1892; Petrie, Mackay, and Wainwright, Memphis, III)*, and A. Rowe *(UPMJ, XXII, 1931)*. A large group of these mastabas is on the north side of the necropolis; among them is the tomb of Prince Rahotep and his wife Nofret, both relatives of Sneferu. Their statues (figs. 70, 71, 197, 198) are among the most valuable examples of Old Kingdom sculpture (Daninos, *La découverte des statues de Meidoum*, in *Rec. de Trav.*, VIII). Another interesting mastaba is that of Nefermaat, where the famous panel of geese (fig. 194) was discovered in the tomb of his wife Atet.

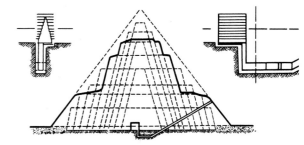

836. MEDUM. SECTION OF THE PYRAMID OF SNEFERU

The pyramid's enclosure wall was linked with the lower temple (now submerged) by an east-west causeway, double-walled to a height of about 7 feet. At some points the causeway was about 7 3/4 feet wide, at a few others almost 10 feet. It did not lead directly to the small upper temple, but to a gate in the enclosure wall, straight across from the small funerary temple built against the east face of the pyramid. This temple, 29 1/2 feet long, consisted of two large chambers and a court that separates the sanctuary proper from the pyramid. Between the pyramid's south face and the enclosure wall stood a small satellite pyramid. The purpose of such subsidiary pyramids, often found near the larger ones, has been variously interpreted: according to C. M. Firth they may have been associated with the Heb-Sed; or in the course of the funeral ceremony, the mummy of the Pharaoh may have been kept there before it was taken to the burial chamber (*ASAE*, 29). G. Jéquier was of the opinion that they were "offering pyramids" associated with the cult of the sun god (*Les pyramides des reines Neit et Apouit*, pp. 10-11). L. Borchardt first thought that they were queens' pyramids (*Die Entstehung der Pyramide*); later he expressed the view that they were tombs of the king's *ka* (*ZAeS*, 73). In our Chapter 7, Wieslaw Kozinski's hypothesis is discussed; he believes that they were monumental scale models of the main pyramid.

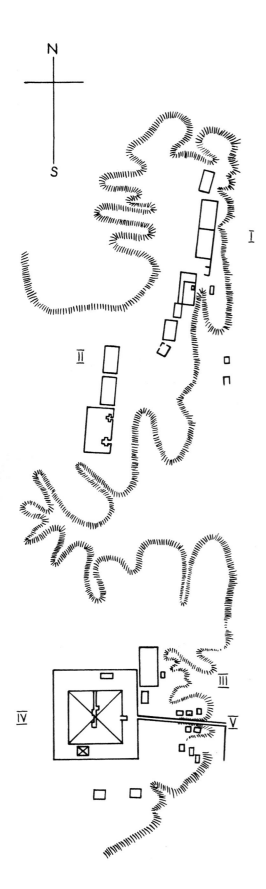

837. MEDUM. GENERAL PLAN
 I *Roman necropolis*
 II *Field of mastabas (north)*
 III *Field of mastabas (south)*
 IV *Pyramid of Sneferu*
 V *Lower temple*

Much of our knowledge of techniques of pyramid construction comes from Medum. In addition to the causeway mentioned above, another causeway was discovered which, as Borchardt points out, served for hauling building material. As for the pyramid itself, three main stages of construction can be distinguished. The earliest structure may have been a mastaba with a rectangular ground plan, but very soon the builders, perhaps inspired by the Zoser pyramid at Saqqarah, transformed the mastaba into a step pyramid. At the first stage of development, it had seven steps. Then another step was added, the height of each step was increased, and the whole was overlaid with a facing of Turah limestone. Finally the steps were filled in with rubble and the entire structure was given an additional facing; it was thus transformed into a "true" pyramid. In this state it rose to a height of about 302 feet; the sides each measured about 472 feet at the base; the angle of inclination is 51° 53'.

Today the pyramid is in ruins; only part of the third and fourth steps of the original structure, and the fifth, sixth, and part of the seventh step of the second stage of its development have survived. The entrance to the pyramid was discovered by Gaston Maspero in 1882. It is on the north face, about 65 1/2 feet above ground level. The interior was reached by a descending corridor, originally closed by a wood door; the corridor passes through several vestibules and leads into the burial chamber, situated approximately in the middle of the superstructure. The lower portion of this chamber is cut in the rock; its upper portion runs into the pyramid's masonry.

No trace of a stone sarcophagus was found in the burial chamber; it contained only fragments of a wood coffin. Because the pyramid has no inscriptions, its identification presents difficulties, but it seems likely that it was one of several pyramids built by Sneferu. A number of graffiti dating from the Old Kingdom, scratched on the walls of the funerary temple, mention Sneferu, and a still greater number of ink inscriptions dating from the New Kingdom confirm this identification. Morever, it has been discovered that the blocks of the Medum pyramid and those of the Bent Pyramid at Dahshur bear the same masons' mark (Varille, *A propos des pyramides de Snefrou*, p. 10). It is not impossible that the same teams of masons were employed in the construction of both pyramids. This would argue in favor of Kozinski's hypothesis that a specialized group of contractors was in charge of pyramid building. Finally, it may be noted that the tombs of dignitaries around the pyramid are those of Sneferu's government officials. The Sneferu pyramid complex at Medum represents the first realization of the classical plan of these funerary structures.

The presence of the pyramid and the mastabas of dignitaries suggests that as early as Dynasty IV there was a town and perhaps a royal residence in the neighboring area. A fortress was situated here in the Late Period. Some of the Old Kingdom mastabas were reused as tombs during Dynasties XVIII, XXII, and XXX, and in Graeco-Roman times.

5. DAHSHUR

Royal necropolis on the west bank of the Nile, between Saqqarah and Lisht; in Nome XXI of Upper Egypt.

Some of the most important monuments of ancient Egyptian funerary architecture are to be found at Dahshur. These include two pyramids of Sneferu, the first ruler in Dynasty IV, and mastabas of Old and New Kingdom dignitaries. There are also the remains of a town that housed laborers employed in tomb building and officials in charge of the funerary enclosure.

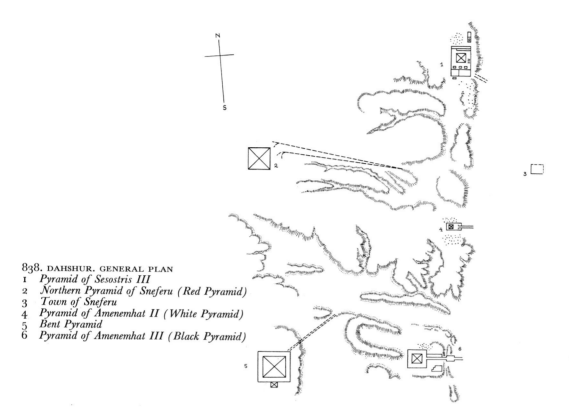

838. DAHSHUR. GENERAL PLAN
1 *Pyramid of Sesostris III*
2 *Northern Pyramid of Sneferu (Red Pyramid)*
3 *Town of Sneferu*
4 *Pyramid of Amenemhat II (White Pyramid)*
5 *Bent Pyramid*
6 *Pyramid of Amenemhat III (Black Pyramid)*

839. DAHSHUR. BENT PYRAMID

The oldest and most interesting monumental structure on this site is the so-called Bent Pyramid. One of the best-preserved of all pyramids, it attracted the attention of seventeenth- and eighteenth-century travelers. In 1838, J. S. Perring and H. Vyse explored its interior and drew up a fairly accurate plan (H. Vyse, *Operations*, III). In 1894-95, Jean de Morgan excavated the site and partly cleared the Bent Pyramid (Morgan, *Fouilles à Dahchour*, I-II). Systematic excavations and investigations by the Egyptian Antiquities Service, begun in 1924 under G. Jéquier (*ASAE*, 25) and, since 1945 continued, under Abdel Salam Hussein in collaboration with A. Varille *(à propos des pyramides de Snefrou)*, found inside the pyramid two blocks inscribed with Sneferu's name, confirming that this Pharaoh was the builder of the Bent Pyramid. Since 1951 excavations in this area have been conducted by A. Fakhry (*The Monuments of Sneferu at Dahshur*, I-II, 1959-66). It was he who brought to light the lower temple of this pyramid—the oldest known example of this type of "reception" temple.

The Bent Pyramid is built of blocks of local limestone, with a facing of polished Turah limestone slabs, most of which still remain in place. It is distinguished from all other pyramids by its shape and by its two entrances. Each side measures about 618 1/2 feet at the base; the height is 328 feet. Near the mid-point of its height (147 1/4 feet according to Reisner, *Development of the Egyptian Tomb*, pp. 197-99, and about 151 feet according to Fakhry) the pyramid's angle of inclination (54° 14′ according to Reisner, 54°31′13″ according to Fakhry) decreases abruptly (to 42°59′ according to Reisner, 43°21′ according to Fakhry). It is this "bend" in the angle that gives the pyramid its unique shape. The latter has given rise to various interpretations. In the nineteenth century, Wilkinson suggested that the pyramid was finished in haste and that the volume of its upper part had accordingly been reduced. In 1839, Perring observed that the stones in the upper part were laid with less care than those below (I. E. S. Edwards, *Pyramids*). Others believe that the builders of the pyramid sought above all to decrease the weight of the stone mass in order to avoid collapse of the

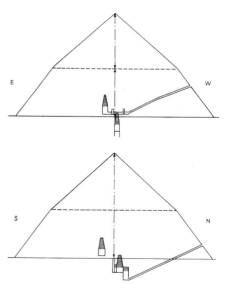

840. DAHSHUR. BENT PYRAMID
I. *East-West section* II. *North-South section*

479

ceilings of the inner chambers and passages. Varille rejects this explanation: according to him the shape of the pyramid had from the outset been intentional, to emphasize the dual character of this structure, with its two entrances. In other words, he believes that the pyramid is an architectural realization of a symbolic idea.

The north entrance to the pyramid, at a height of about 39 1/2 feet above ground level, gives access to a descending corridor about 256 feet long, first through the core of the pyramid and then into the rock. At a depth of about 82 feet below ground level it reached a vestibule covered by a corbeled vault, followed by a chamber with the same type of vault. The height of the chamber was about 79 feet; thus it almost reached ground level. Both corridor and chamber were lined with carefully fitted blocks of white limestone. The second entrance to the pyramid, on the west face at a height of about 98 1/2 feet above ground level, opens into a descending corridor which led through the core of the pyramid into a chamber, probably shaped like the lower chamber reached from the north side.

The pyramid complex included two funerary temples. The upper temple, near the east wall of the pyramid, is badly damaged; it was rebuilt and enlarged several times. The building material was mainly dried brick, and originally the temple consisted of a small chapel with steles on either side and an altar in front. Here, too, some reconstruction was done, probably during the Middle Kingdom, and perhaps also in the Late or Ptolemaic Periods.

To the south of the pyramid, within its enclosure wall, stood a small satellite pyramid with a corridor leading to the burial chamber. Each side of this smaller pyramid measured about 180 1/2 feet at the base; its original height was about 105 feet. Formerly it was believed to be the tomb of Sneferu's wife (Cheops' mother), Queen Hetep-heres. Today we know that it had nothing to do with this queen's tomb but was a part of the Sneferu complex.

The lower temple, linked by a ramp with the pyramid enclosure, was also surrounded by a wall. The temple's dimensions were about 154 1/2 by 86 feet; its orientation was north-south. The causeway was extended beyond the gate in the enclosure wall, up to the southwest corner of the temple. The entrance to the temple is on the south side; it leads into a narrow forecourt and then into a long hall decorated with reliefs and flanked by large structures, apparently used as storerooms; one of these was perhaps the temple treasury. Directly beyond this hall is an open court, supported at the far end by a portico of ten sculptured pillars, today in ruins; at the rear of the portico were six chapels. These were like monolithic naoi; inside stood statues of the king. There are indications that worship of the Pharaoh in this temple continued a long time after his death. The temple was destroyed during Dynasty XVIII.

North of the Bent Pyramid stands another Sneferu pyramid, the so-called Northern Pyramid, which, if not the first classical pyramid, is certainly the first whose regular shape had been determined from the outset, although its angle of inclination (about 43°40') is considerably less than the classical angle of inclination of Dynasty IV pyramids (51° or more). Its sides measure about 656 feet each, and it rises to a height of about 328 feet. Its core was built of local pink limestone, its casing of white Turah limestone. It is also called the Red Pyramid after the pinkish color of the stones, which are still visible. It has been almost entirely destroyed. Like the Bent Pyramid, it was first studied by Perring and Vyse. The excavations conducted by the Egyptian Antiquities Service in 1947 and 1953 have yielded no significant results, and this pyramid is among the least-investigated to date. Its interior was reached from the north side by a descending corridor, entered about 98 1/2 feet above ground level. At the end of the corridor three chambers with corbeled vaults were built in the core, their floors at ground level. No trace of a royal tomb has been found there.

There are three arguments that favor Sneferu as the builder of the Northern Pyramid: 1) it is surrounded by mastabas of this Pharaoh's dignitaries; 2) a stone with an inscription of Pepy I, found north of this pyramid, refers to "two pyramids of Sneferu" (Borchardt, *ZAeS*, 42); and 3) the same masons' marks are found on the blocks of this pyramid and those of the Medum pyramid (Maystre, *BIFAO*, 35). The funerary enclosure has not yet been excavated, but aerial photographs (Grinsell, *Egyptian Pyramids*, pl. 13a) show that two ramps led to this pyramid.

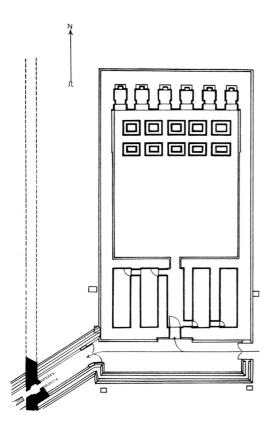

841. DAHSHUR. PLAN OF THE LOWER TEMPLE OF SNEFERU

842. DAHSHUR. NORTHERN PYRAMID OF SNEFERU

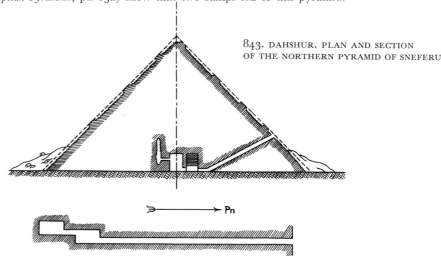

843. DAHSHUR. PLAN AND SECTION OF THE NORTHERN PYRAMID OF SNEFERU

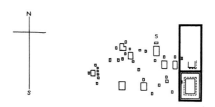

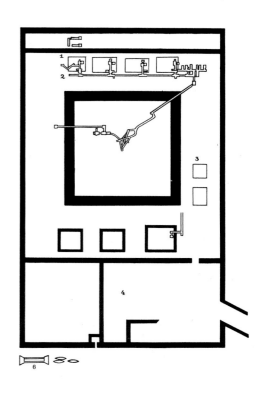

In the vicinity of the two pyramids are mastabas of Old Kingdom dignitaries, but only some of those near the Northern Pyramid (mastabas of Sneferu's dignitaries) have been investigated.

During the Middle Kingdom three new pyramids were raised at Dashur. The oldest belonged to Amenemhat II, north of it is the pyramid of Sesostris III and southwest is that of Amenemhat III.

The pyramid of Amenemhat II is almost completely ruined. It is not even possible to determine the dimensions of its sides—some archaeologists believe that the base measured no more than 164 feet on each side, while others think that the pyramid was as large as the first two Dynasty XII pyramids at Lisht. Because we have no data for determining its angle of inclination, we cannot calculate its height. It was constructed so that eight limestone walls radiated outward from the center of the base, forming eight triangular compartments which were subsequently filled with sand. The white limestone used for the facing, contrasting with the gray dried-brick masonry of the neighboring pyramids, led to its name, the White Pyramid. De Morgan, who excavated it in 1894-95, also explored its interior. The entrance was on the north face, and the corridor, lined with carefully fitted limestone slabs, led to two burial chambers. The corridor and the upper burial chamber had

844. DAHSHUR.
PLAN OF THE PYRAMID OF SESOSTRIS III
1. *Mastabas of the princesses* 2. *Gallery of the princesses* 3. *Funerary temple* 4. *Southeast court* 5. *Tombs of dignitaries* 6. *Sacred barges*

vaults of large limestone blocks disposed in the form of the letter A. The upper chamber contained a sarcophagus made of limestone slabs. The pyramid was surrounded by a wall enclosing a long area; on the east side, blocks from a funerary temple are still visible, many with the cartouche of Amenemhat II. From this part of the enclosure wall a causeway more than 65 feet wide and almost half a mile long, bordered with brick walls, led to a lower temple, as yet not found.

East of the pyramid, within the temple enclosure, stood the tombs of Queen Keminub, the chancellor Amenhotep, and the princesses Ita, Ituret, and Khnumet. In the tombs of Ita and Khnumet, De Morgan discovered the Dahshur jewels, which were to make the site world famous. Today these jewels are in the Cairo Museum. About 410 feet southeast of the pyramid of Amenemhat II there is a mound of rubble; from this spot a causeway leads toward cultivated fields. This site has not yet been investigated.

The builders of the pyramid of Sesostris III were inspired, not by the neighboring pyramid of his grandfather Amenemhat II, but by that of his father Sesostris II at Lahun. Although the Dahshur structure is today only a mound of rubble, De Morgan's studies have made it possible to determine a number of details concerning its construction. Its inner core was of dried brick laid directly on the platform, whereas in the pyramid of Sesostris II at Lahun it consisted of a knoll of

845. DAHSHUR.
PLAN OF THE PYRAMID OF AMENEMHAT III
1. *Royal tombs* 2. *Funerary temple* 3. *Priests' quarters (?)*

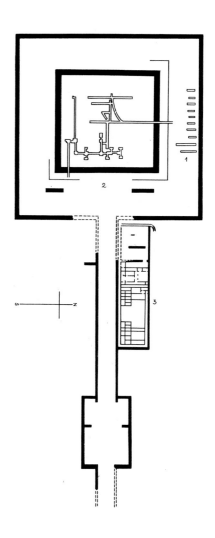

natural rock. The brick stepped construction was covered with a facing of Turah limestone. According to De Morgan the sides measure about 330 1/2 feet at the base (344 feet including the facing). The pyramid's angle of inclination was 56°, its height 255 feet. The entrance to the pyramid was in a court on the west. A corridor led across several vestibules into the burial chamber built of immense red granite blocks. It contained a sarcophagus of the same material. The chamber and the sarcophagus had been plundered. Inside the pyramid are other corridors. Before discovering the entrance, De Morgan tried to penetrate the interior through a corridor leading from the northeast corner. South and east of the pyramid are a few mastabas of dignitaries. The mastabas of princesses, situated at different levels on the north side, were reached through an underground gallery, the entrance to which was on the northeast side. In the tombs of the princesses Sat-hathor and Merit, De Morgan discovered sarcophagi, chests containing Canopic jars, and another magnificent collection of jewelry (figs. 791, 793).

This entire complex was surrounded by a wall of dried brick. The enclosure has a long corridor on the north side, and two courts on the south. A ramp built entirely of dried brick led to it from the east. North of the enclosure was a necropolis of Dynasty XII dignitaries. The most important discovery by De Morgan south of the pyramid complex was an underground chamber with a vault

of dried brick walled up on two sides. It contained two wood boats and a wood sledge. The sledge and the two boats (one now in the Cairo Museum, the other in the Museum of Natural History in Chicago) may originally have served to transport the mummy of the ruler during the burial ceremony; later they were placed near the pyramid, where they served as ritual barges.

South of the temple of Amenemhat II lies the so-called Black Pyramid of Amenemhat III, son of Sesostris III. As is well known, this ruler was buried in his second pyramid, which stood at Hawara. His pyramid at Dahshur—today nothing but a mass of brick—was similar in construction and presumably in dimensions to the pyramid of Sesostris III. It was built of dried brick and had a stone facing. Originally its sides measured about 328 feet at the base; its height is unknown. One intact facing block, found by Perring, had an angle of inclination of 57°20′. The entrance to the pyramid was on the east side, a short distance from the southeast corner. A shaft led into a maze of underground passages lined with limestone—one of the most striking features of this pyramid. The burial chamber contained a sarcophagus of red granite. East of the pyramid was discovered the beautiful pyramidion of gray granite bearing the name of Amenemhat III (today in the Cairo Museum).

The funerary temple, today completely ruined, stood on the east side of the Black Pyramid and inside a wall of dried brick that enclosed the pyramid complex. Within the same enclosure on the north were tombs, since destroyed. Special mention, however, must be made of the underground tomb of King Hor, who according to some was co-regent with Amenemhat III and according to others the first ruler in Dynasty XIII. In the wood cella of this tomb De Morgan found the famous wood statue of this king, his sarcophagus (also wood) surrounded with tomb furnishings, and, in a hiding place nearby, a chest decorated with gold leaf and containing Canopic jars. Today all these objects are in the Cairo Museum (fig. 330).

The ramp that ran from the valley temple (so far undiscovered) was 60 5/8 feet wide, paved with limestone slabs and bordered with dried brick. The walls on both sides of the ramp were also of dried brick. A kind of bridge of large limestone blocks crossed a trench that marked the eastern boundary of the necropolis; here the ramp widened to form a small court. To the north the ruins along the ramp may be the remains of dwellings occupied by officials and priests in charge of the pyramid complex.

6. GIZA

Royal necropolis of Dynasty IV on the west bank of the Nile, situated in what was Nome I ("The White Wall") of Lower Egypt. In antiquity each pyramid had its own name. The necropolis was more often referred to by the general term Kher(t)-netjer ("The City of the Dead") or Iment ("The West"). A term specifically designating the necropolis at Giza ⚊⚊ , = r gs Hr ("The Slope of the High Place"), occurs only in one instance—an inscription dating from the time of Mycerinus.

The plateau of Giza is almost a mile in length from east to west and three-quarters of a mile from north to south. The plateau drops away sharply on the east and the north. Giza is one of the few archaeological complexes of Egypt that is historically all of a piece: what was built there, and for the most part survives to this day, is essentially the work of Dynasty IV rulers. Only scanty remains have survived of tombs from earlier times. The most notable of these are a mastaba belonging to the wife of Zet, or Wadji (Dynasty I), and a tomb in which the seals of the jars bore the name of Ny-neter (Dynasty II). Although Giza has a number of tombs of Dynasty V and Dynasty VI dignitaries, and a few dating from even later times—for instance, tombs built during the Persian period and one tomb of a Dynasty XXX general—these structures have not in the least altered the general character of the necropolis. The same is true of the small sanctuary dedicated to Isis, "Mistress of the Pyramid," which Psusennes I (Dynasty XXI) built east of the Great Pyramid. The character of the Giza complex is defined by three pyramids—those of Cheops, Chephren, and Mycerinus—with the temples attached to each, the Sphinx, and the vast fields of dignitaries' mastabas which are situated in the western and eastern parts of the plateau (figs. 4, 15 a, 58 a).

Pliny (*Nat. Hist.*, XXXVI) lists twelve ancient writers who described or mentioned the Giza pyramids. The essential texts are Herodotus' description of the necropolis and his account of how the Great Pyramid was constructed (II, 129). Other important sources are Diodorus Siculus (I, 63) and Strabo (XVII).

From the descriptions given by these ancient authors it is clear that the pyramids were intact when they saw them: they still had their facings, and the corridor leading to the substructure of the Cheops pyramid was open. The pyramids are frequently mentioned by Arab writers, who give fantastic accounts of their construction; we also learn that the looting of pyramids by treasure seekers must have begun at an early date. Caliph Mamun made his way into the two upper chambers of the Cheops pyramid, hoping to find treasure. Abdalatif writes that during the rule of Saladin (c. 1169-1193) a number of satellite pyramids were torn down for their building materials. The

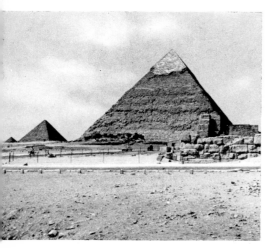

846. GIZA. PYRAMID OF CHEPHREN AND PYRAMID OF MYCERINUS

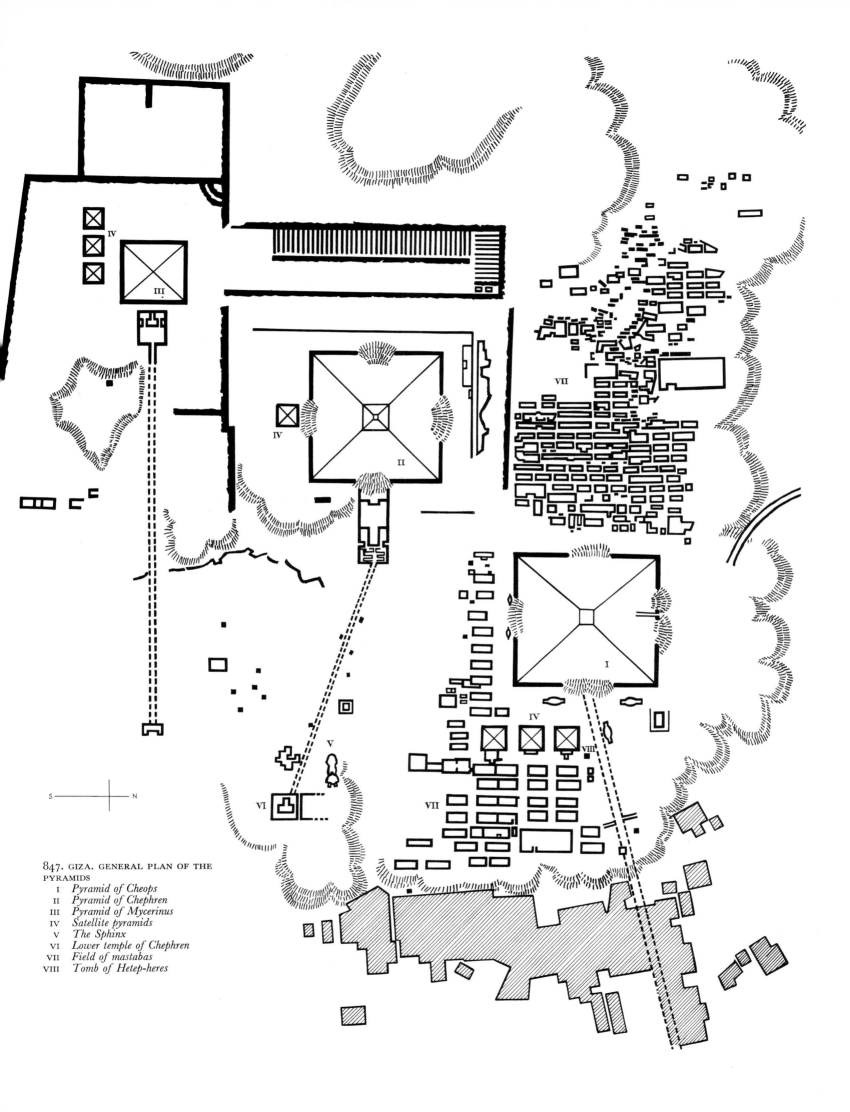

847. GIZA. GENERAL PLAN OF THE
PYRAMIDS
I *Pyramid of Cheops*
II *Pyramid of Chephren*
III *Pyramid of Mycerinus*
IV *Satellite pyramids*
V *The Sphinx*
VI *Lower temple of Chephren*
VII *Field of mastabas*
VIII *Tomb of Hetep-heres*

S —|— N

mouth of a long shaft hewn in the rock by order of Saladin's son El Malek—another treasure hunter—can still be seen today in the west face of the pyramid of Mycerinus. It is not easy to determine exactly when the facings of the three pyramids were removed. Although Wilhelm von Boldinsel's account, written in 1336, does not mention the absence of facings, archaeological evidence suggests that as early as the Ayyubid Dynasty (late twelfth century) the pyramids were used as quarries from which stone was transported to Cairo.

In the eighteenth century Giza was visited by a number of travelers whose accounts provide us with valuable descriptive data. The same is true of the scholars who accompanied Bonaparte's expedition to Egypt, when Denon, Coutelle, and Jomard (followed in 1891 by Hamilton) studied and sketched the Giza monuments (fig. 15 c).

The first excavations began in 1815. The subsequent investigation of the great royal necropolis falls into three periods. The first was devoted primarily to removing the rubble around the Sphinx and the pyramids, and clearing the entrances to the latter; toward the end of this period, mastabas of dignitaries and the funerary temples adjacent to the pyramids began to be excavated. The archaeologists connected with this period are T. B. Caviglia, who worked in 1815-18; G. B. Belzoni, in 1818; H. Vyse and J. S. Perring, in 1837-38; R. Lepsius, in 1842-43; and A. E. Mariette, who conducted extensive excavations between 1850 and 1880. Concurrently with the diggings, scholars such as J. F. Champollion, I. Rosellini, and J. G. Wilkinson, began to record the finds and, above all, the inscriptions.

The second period is characterized by systematic study based on exact measurement, and by the earliest attempts to explain how these fascinating monuments were built. In 1864-65 Piazzi Smyth published his three-volume *Life and Work at the Great Pyramid*, which gave rise to a number of esoteric speculations. In 1880-82 Flinders Petrie carried out detailed measurements and observations, which provide the basis for modern scientific views concerning the construction methods used by the pyramid builders. The question has since been dealt with in many essays and books. Of particular interest are the studies published by Ludwig Borchardt between 1894 and 1932 (*Einiges zur dritten Bauperiode der grossen Pyramide bei Gise*, 1932). Of the more recent contributions, the most notable are passages in *Ancient Egyptian Masonry*, by Engelbach and Clarke; *Le problème des pyramides d'Égypte*, by J. P. Lauer; *Egyptian Pyramids*, by L. Grinsell; *The Pyramids of Egypt*, by I. E. S. Edwards; and *The Pyramids*, by A. Fakhry.

The third period began in 1902, when the Egyptian Antiquities Service granted to three expeditions permission to explore the Giza necropolis: an American group under G. A. Reisner, a German group under Georg Steindorff (followed by Ludwig Borchardt, and then by Hermann Junker), and an Italian group under Ernesto Schiaparelli. Two years later the Italians handed over their concession to the American expedition. Each expedition was assigned a separate area. In 1906-7 Petrie took over the one assigned to the American group. Part of the German area was taken over by the Academy of Science in Vienna and then, after World War I, by the University of Cairo, which entrusted the excavations to Selim Hassan. In 1949 the University of Alexandria took over part of the American concession; the excavations were directed by Professor Abdel Moneim Abu-Bakr.

The clearing operations around the Sphinx, begun by Caviglia, were later conducted on a larger scale by Mariette and Gaston Maspero; they were interrupted in 1888, and resumed in 1925 by E. Baraize on behalf of the Egyptian Antiquities Service. The latest excavations around the Sphinx were conducted by Hassan in 1936-37. The findings of these expeditions were published separately for each area (G. A. Reisner, *Mycerinus*, 1931; *A History of the Giza Necropolis*, 1942-55; *The Development of the Egyptian Tomb down to the Accession of Cheops*, 1936; H. Junker, *Giza*, I-XII, 1929-55; U. Hölscher, *Das Grabdenkmal des Königs Chephren*, 1912; S. Hassan, *Excavations at Giza*, I-X, 1932-60; A. M. Abu-Bakr, *Excavations at Giza, 1949-50*, 1953).

The first of the monumental edifices erected at Giza was the pyramid of Cheops, or the Great Pyramid. The site selected is the most conspicuous spot on the plateau, near the place where the eastern edge drops off sharply. Its ancient name was ⟨hieroglyphs⟩ = "Cheops is a dweller in Akhet." According to Herodotus (II, 124), to build it required 100,000 laborers working three months a year for thirty years. In Chapter 7 there is a full discussion of the recent research of Wieslaw Kozinski, who has advanced new explanations to the numerous questions that have arisen concerning the construction and interior layout of the Great Pyramid.

Originally the Great Pyramid, like the other pyramids at Giza, was oriented to the four cardinal points. Today a slight discrepancy ($0°3'6''$) exists—a result of the phenomenon of precession, that is, the gradual shifting of the angle of the earth's axis during the more than 4,000 years that have passed since the Great Pyramid was built. The pyramid is square at the base, each side measuring about 756 feet; its original height was 480 feet; its present height is 450 feet (part of the apex, including the capstone, is missing). The pyramid's angle of inclination is $51°50'$.

The core of the pyramid consists of carefully fitted blocks of local limestone centered on a rocky mass; it has been calculated that about 2,300,000 blocks were used in building it. Grinsell (*Egyptian Pyramids*, p. 103) says that traces of inscriptions in red and black encaustic, twice repeating the names of the workmen's teams and "Cheops," are visible on some stones in the fifth and sixth

tiers of the south, east, and west faces. In addition there are masons' marks consisting of lines and triangles. The name of Cheops and a date designating the seventeenth year of his reign have been found in the two highest, so-called relieving chambers above the King's Chamber, which Perring and Vyse reached in 1837. These chambers were inaccessible in antiquity, and the inscriptions on rough-hewn limestone blocks prove that in the seventeenth year of Cheops' reign the construction of the pyramid had progressed to that level. The facing was of Turah limestone; today nothing remains but a few pieces on the north and south faces at the base of the pyramid. The facing blocks, weighing up to 15 tons each, were fitted so accurately that the joints are practically invisible. It is generally believed that such extraordinary accuracy in the fitting of masonry is unique in history.

The entrance to the pyramid was situated on the thirteenth course of stones in the north face, above the shaft which Mamun cut through the core in the ninth century A.D. The interior layout (fig. 58 b) discloses three basic stages in construction and three changes in the original plan.

(1) The first stage of construction: a descending corridor runs from the entrance for about 252 feet, at a gradient of 26°31′23″. Then, running horizontally, it reaches a rectangular chamber, and beyond extends a corridor for about 59 feet; a second chamber, like that in the Northern Pyramid at Dahshur, may have been intended here. The rock-cut chamber that lies approximately on the pyramid's central vertical axis was not completed and never had a stone facing. Apparently the builders began construction soon after the king's accession to the throne, and wanted to complete his eternal resting place as quickly as possible. When the superstructure reached a certain height, the original plan was altered and a burial chamber was built in the core of the pyramid (though still on the pyramid's axis) instead of in the underlying rock.

(2) At about 62 1/4 feet from the entrance, one slab was removed from the ceiling of the descending corridor, and a new corridor, ascending for about 128 feet at an angle of 26°2′30″, was cut through the masonry. From this point on, the corridor ran horizontally for 118 feet to a small chamber situated at about 65 feet above ground level. The Arabs incorrectly called this the Queen's Chamber: actually it was intended for the king. It was partly completed with a corbeled vault, the walls are lined with carefully fitted slabs, and there is a niche which was probably destined for the statue of the king. As shown in a cross section view, two shafts for ventilation were begun at the floor level. But this project, too, was abandoned, and it was decided to place the King's Chamber higher inside the pyramid.

(3) At the point where the ascending corridor changes to the horizontal and leads to the second chamber, the passage was extended upward for more than 151 feet. But the new corridor's character was changed altogether: it became a gallery 28 feet high, and its walls and ceilings were lined with large slabs of fine-grained crystalline Moqattam limestone (known as Egyptian alabaster). The Grand Gallery is one of the most magnificent creations of ancient Egyptian architecture. During the third stage of construction, however, the plan was altered again for some reason, and as a result the Pharaoh's body was never placed in the pyramid. The Grand Gallery, which had been intended to lead to the King's Chamber (or its antechamber), was extended horizontally southward, as far as the pyramid's axis. The builders obviously had not planned this originally, for the mouth of the northern ventilation shaft, instead of opening into the King's Chamber, now opened into the uppermost end of the ceiling of the Grand Gallery. A passage closed by a trap door and a small antechamber were built later, so that the final location of the King's Chamber was considerably south of the pyramid's axis. Why this was done we do not know; what is certain is that to shift the chamber from the axis to the southern part of the pyramid's interior spelled failure for the whole construction. Although the chamber was served by the so-called southern ventilation shaft, it had no northern shaft, for this opened into the Grand Gallery. The builders may have realized that the ceiling of the King's Chamber was in danger of collapsing in its new location, for the weight of the stone mass above it was poorly distributed. This may have been the reason five "relieving" chambers (discovered by Perring and Vyse) were constructed above, to relieve the weight. But even these countermeasures failed. After the pyramid was completed, the granite ceiling of the chamber, composed of nine slabs (each more than 16 feet long), cracked. This probably explains why the Pharaoh's body was never put in the granite sarcophagus that had been placed against the west wall of the chamber. Like the Grand Gallery, the chamber (measuring about 17 by 34 by 19 feet) was lined with blocks joined together with exceptional care—another example of the technical perfection of ancient Egyptian masons. It is well known that neither the lid of the sarcophagus nor the three portcullises that were to bar access to the King's Chamber from the antechamber were ever found. Various opinions have been advanced on this subject: the most plausible hypothesis seems to be that both the lid of the sarcophagus (which measured about 4 by 5 1/2 by 1 1/2 feet), as well as the granite portcullises, were placed inside the pyramid before its completion. They could not have been carried inside through the narrow corridor leading to the Grand Gallery. After the ceiling cracked and the builders decided not to use the chamber as the Pharaoh's resting place, these valuable granite slabs—always in great demand for funerary steles and other decorative uses— must have been cut up and removed through the corridor. Other granite blocks, used for facing the Grand Gallery and the burial chamber, were too solidly jointed to justify the labor of removing them. So much for the so-called riddle of the Great Pyramid, which has often been held up as an

848. GIZA. PYRAMID OF CHEOPS, INTERIOR OF THE FUNERARY CHAMBER

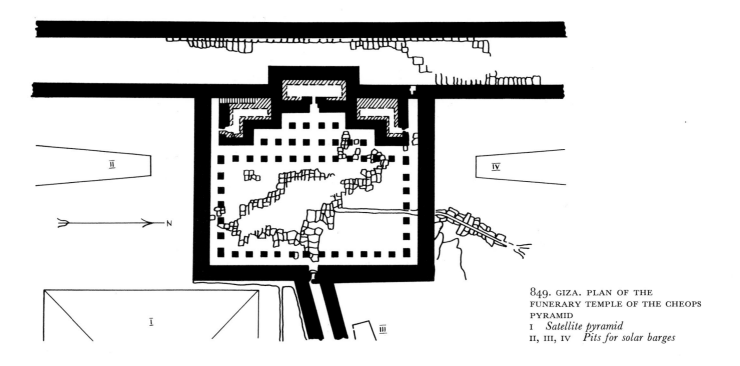

849. GIZA. PLAN OF THE
FUNERARY TEMPLE OF THE CHEOPS
PYRAMID
I *Satellite pyramid*
II, III, IV *Pits for solar barges*

example of ancient Egypt's esoteric wisdom, and even alleged to embody the sum total of ancient science plus a forecast of mankind's fate.

Like other pyramids, the Great Pyramid was only one element in a funerary complex that included two temples—the upper and the lower—linked by a ramp. The lower, or valley, temple has not been found, but remains of the upper one, opposite the east face of the pyramid, have recently been freshly investigated. The details of its plan are still a matter for debate. A ramp leading up to this temple was still partly visible when Lepsius visited the area. As is known, Herodotus admired the construction and decorations of the temple. Underneath it was a tunnel 4 1/2 feet wide, which linked the northern and southern parts of the cemetery of dignitaries near the Great Pyramid. Both temple and pyramid were surrounded by a limestone wall 7 1/2 feet thick, which stood about 33 feet from the base of the pyramid. At the place where the temple stood, the enclosure wall jutted out to form a rectangle measuring 172 feet on the north-south side and about 131 feet on each east-west side: thus the area of the temple is defined. Only the central sanctuary falls within the 33-foot space between the pyramid and the enclosure wall. The layout of the temple displays a striking disproportion between the large court and its portico of rectangular granite pillars, and the smaller sanctuary proper. The sanctuary was composed of a central chamber with a recessed chamber on either side; in front of these were two rows of pillars (one row of eight and one row of four). The plan of the inner sanctuary is not known because so little remains: it may have contained steles with false doors and niches. The ruins suggest that it had great artistic value: the court paved with black basalt must have been in striking contrast with the white limestone walls and the red granite pillars.

Two pits cut out of the rock to the north and south of the temple served as repositories for sacred "solar" boats, but just what part they—or the other boats discovered near the pyramid—played in the funerary ceremonies remains uncertain. A third repository for a sacred boat lies north of the causeway, not far from the temple. In 1954, a similar pit was discovered near the south face of the pyramid, but this one contained a wood boat which had been partly dismantled; its parts are perfectly preserved, including the hull and cordage. The boat is more than 131 feet long and is being reassembled in the temporary museum near the pyramid. On the wall above the boat certain stone blocks bear masons' marks in red; some of the blocks also had the cartouche of King Radedef.

East of the pyramid (south of the ramp) lie the ruins of three small pyramids, the so-called Queens' Pyramids. As discussed in Chapter 7, these might have been scale models that, each time the plan of the Great Pyramid was altered, were set up to serve as monumental maquettes (the scale is approximately 1:5). Like the Great Pyramid, they are built of limestone blocks, and had facings which today have almost completely disappeared. They also have burial chambers carved out of the rock, and funerary temples similar to Cheops' upper temple; the slight differences in

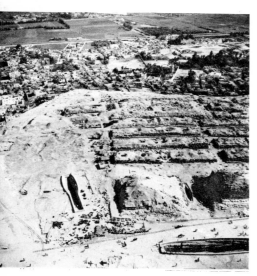

850. GIZA. PITS FOR SOLAR BARGES

layout may indicate successive changes in the design of the temple. It is not impossible that the wives of Pharaohs were actually buried here. According to Herodotus (II, 124), the middle pyramid served as the tomb of one of Cheops' daughters. Near the small pyramid to the south, whose funerary chapel was converted into an Isis chapel during Dynasty XXI, an inscription has been found with the name of Cheops' wife Henutsen, which is said to be a copy of an older inscription: thus the pyramid is generally regarded as her tomb. Finally, the third (northern) pyramid, probably built last—as is suggested by the fact that an underground corridor was begun south of it—had a pit for a solar boat near its south face. What part the so-called Queens' Pyramids played in the funerary rites is uncertain. The whole matter is further complicated by the fact that near the southeast corner of the northernmost small pyramid, the American expedition discovered a shaft leading to the tomb of Cheops' mother, Queen Hetep-heres, and, in the tomb itself, her furnishings. It is assumed that she had first been buried at Dahshur in a small pyramid near the tomb of her husband Sneferu, and that her son Cheops, fearing that the tomb would be robbed, ordered her body and tomb furnishings to be transferred to the tomb near his own pyramid. According to some archaeologists, it was because Hetep-heres was reburied that the northernmost small pyramid was shifted slightly to the west. This hypothesis is not convincing, because the three satellite pyramids are in perfect alignment. The queen's remains were not found, but there were superb furnishings in the tomb (figs. 807, 808).

The necropolis destined for the rest of the royal family and for high government officials was probably laid out when the site of the Great Pyramid was chosen. Most of the mastabas were grouped east and west of the pyramid; this was dictated by the nature of the terrain. The plateau falls away steeply to the north, leaving little room for additional tombs; to the south, the quarries that supplied building materials took up all but one narrow strip of ground close to the pyramid. The row of tombs preserved in this space includes some that date from subsequent dynasties.

The largest mastabas are situated east of the Cheops pyramid. Here were buried the members of the king's family and the courtiers closest to him. The western part of the necropolis, excavated with unusual care by German, Austrian, and American archaeologists, had a regular grid of streets that made every tomb easily accessible. Not until Dynasties V and VI did this tidy layout begin to be obscured, as tombs were added wherever there was an unoccupied space. The reliefs adorning the walls of some mastabas in this section include the greatest works of art in Dynasty IV.

Among the sculptures discovered here, one of the most valuable is the seated limestone statue of Prince Hemiunu (fig. 199); others include the red-painted bust of Prince Ankh-haf (fig. 191), and several "reserve" heads (figs. 64, 190, 193). According to ancient Egyptian belief, such heads provided a true image of the deceased in the event that his facial features became altered during mummification. In addition to Dynasty IV sculptures, the cemetery yielded other sculptures in painted limestone representing workmen; most of them date from Dynasty V.

After Cheops' death and the eight-year reign of his brother Radedef (buried at Abu Roash), Cheops' son Chephren acceded to the throne and began to build his own pyramid. The task proved relatively easy; the most suitable spot was the area where the stone for the Great Pyramid had been shaped and stored. The road leading to this area needed only some architectural treatment to become a dignified ramp linking the lower with the upper temple. Aware of the setbacks that had dogged the builders of the Cheops pyramid, the builders of Chephren's did not attempt to place the burial chamber deep underground, but merely hollowed a chamber out of the rock at the level of the pyramid's base—only its upper part extended into the masonry. The Chephren pyramid is smaller and steeper than the Cheops pyramid: the base originally occupied about 707 feet on each side, and it stood about 470 feet high. According to some writers, the angle of inclination was 53° 10′, according to others 52° 20′. The building materials are similar to those used in the Cheops pyramid, but the blocks of the inner masonry are less carefully jointed. The original facing of Turah limestone has been preserved at the top; the capstone may have been carved out of a single block of granite. Granite was also used in the facing of the lower courses. It surely took less time to build this pyramid than the Cheops pyramid, but it seems that the plan changed here, too (fig. 58). There are two entrances, one cut out of the rock foundation in the pavement on the north side, the other several yards higher up in the north face. Apparently the original intention was to construct the burial chamber about 160 feet from the lower entrance: a passageway hewn out of the rock actually extends to such a chamber. Later the builders must have decided to place the chamber more or less on the pyramid's axis; the lower chamber was filled with rubble, and the passage leading to it was extended upward to meet the passage that leads to the chamber from the upper entrance. The lower passage may have been used by the laborers putting the finishing touches on the burial chamber. The walls of the upper passage were lined with granite slabs, the walls of the chamber with limestone. The monolithic granite sarcophagus was lowered into the floor of the chamber near its west wall. In 1818, when Belzoni entered the chamber, the sarcophagus was empty and the lid broken. Thus there is no doubt that Chephren had actually been buried in his pyramid. His tomb was robbed, despite two portcullises—one in the upper, the other in the lower passage—which barred access.

The wall enclosing the Chephren pyramid stood about 44 feet from the base of the pyramid. South of the wall lie the remains of a small satellite pyramid constructed on the same plan, approxi-

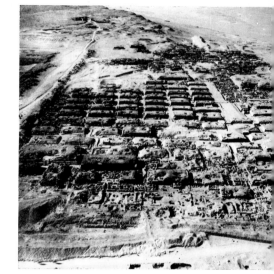

851. GIZA. WESTERN NECROPOLIS

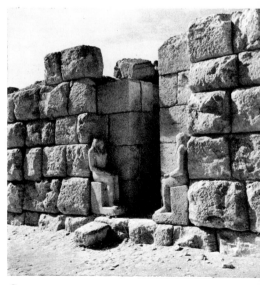

852. GIZA. ENTRANCE TO THE MASTABA EAST OF THE CHEOPS PYRAMID

mately one-tenth the size. It has been conjectured that Chephren's wife was buried here, for the burial chamber contained fragments of a jar-stopper bearing the king's cartouche and a seal mentioning the name of his (otherwise unknown) son.

The upper funerary temple, situated to the east on the axis of the pyramid, had the form of a rectangle measuring 367 by 164 feet. The rear wall was against the pyramid's enclosure wall. The building presents a typical Old Kingdom funerary temple plan; it is composed of two parts—one accessible to the faithful, the other reserved for sacred rites. The entrance to the temple was near its southeast corner. Inside, to the right, were four small chambers disposed like the teeth of a comb, and beyond, a staircase led to the roof; a passage on the longitudinal axis of the temple led to a hypostyle hall, the shape of which recalls the western part of the court in the Cheops temple. There followed another passage leading to a narrow hall with ten pillars, behind which was a large court with seated and Osiride statues of the king. Farther west were five elongated chapels, reached by a narrow passage extending from the southern part of the court. The temple, now in ruins, was built of blocks of local limestone faced with granite; the pillars, too, were of granite; the floors were of alabaster. Five pits for solar boats were hewn in the rock outside the temple and decorated with reliefs showing how the boats were built. A sixth repository for a boat may also have been here.

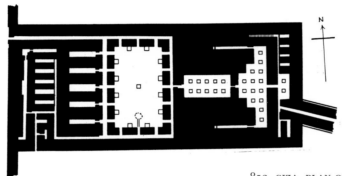

853. GIZA. PLAN OF THE UPPER TEMPLE OF CHEPHREN

This upper funerary temple was situated 147 1/2 feet higher than the lower temple, and the two were linked by a ramp more than one quarter of a mile long and about 15 feet wide. The ramp was partly cut in the rock; its walls were faced with limestone on the inside, with granite on the outside. Originally it was probably roofed, with openings for light. The crypto-porticus thus created may have been decorated with reliefs.

One of the most magnificent and best-preserved Old Kingdom structures is the lower temple of the Chephren pyramid. Its square ground plan measured 147 1/2 feet on each side; it was built of large granite blocks and in certain parts granite was used to face the local limestone walls and the protruding parts of the rocky core. The outer walls rose to a height of about 42 feet, and are slightly inclined, so that the whole structure, especially the façade, looked like a monumental mastaba. In front was a landing stage. According to Hölscher, the entrances to the temple were guarded by four granite sphinxes. In the middle was a kind of naos, where a statue of the Pharaoh may have stood. From each entrance, a corridor led into the temple. More than halfway along its length, each corridor had a narrow passageway connecting it to an elongated transverse antechamber. From here, a door on the central axis of the temple led to a smaller antechamber, which opened onto a T-shaped hypostyle hall containing sixteen monolithic granite pillars (fig. 61) and twenty-three statues of the king, made of alabaster, slate, and diorite (figs. 62, 195).

On the left side of the hypostyle hall were three narrow chambers in a comblike arrangement; on the right side a corridor led to the ramp; and from the corridor a staircase led to the roof. It is to be noted that the builders of this temple made the most of the effect of light on polished granite. Entering through slits in the ceiling, the light would have been reflected by the alabaster floor, bathing the statues of the king in a diffuse glow.

A small pavilion for funeral rites probably stood on the temple roof. Certain archaeologists even conjecture that the lower temple was not a standard "reception" temple to which the body was taken after mummification; they prefer to see it as the place where embalming ceremonies—as well as purification rituals—were actually performed.

Not far from the lower temple, to the north of the ramp, the architects of the Chephren temple made use of an outcropping of rock, 187 feet long and 65 feet high, which the quarrymen had spared. Its shape suggested a recumbent lion, so the architects proceeded to turn it into the most famous of all sphinxes, with the help of plaster, sculptor's tools, and paint. The face reproduced the features

854. GIZA. VALLEY TEMPLE OF CHEPHREN

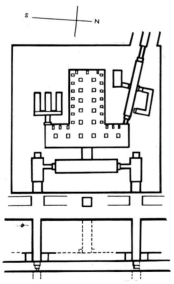

855. GIZA. PLAN OF THE VALLEY TEMPLE OF CHEPHREN

488

of the dead Pharaoh. This symbolic guardian of the temple became very popular in the New Kingdom, when avenues of sphinxes were built.

In front of the Sphinx lie the ruins of a temple whose walls of gigantic limestone blocks may have been faced with granite. The temple's central court and lateral chambers (accessible by a passageway) are characteristic of Dynasty IV architecture. It seems that this temple and the Sphinx, together with the lower Chephren temple, originally formed a single architectural complex. The mysterious figure of the Sphinx (who looks eastward) has given rise to many fantastic interpretations over the centuries. The Greeks regarded it as one of the Seven Wonders of the World. It came to be looked upon as a personification of all that is enigmatic, inscrutable. Some saw in it the mystery of woman, maintaining that woman's breasts had been modeled in plaster over the rock. One of the archaeologist's many duties is to replace legends with scientific truth, and so today the "mystery of the Sphinx," like the "riddle of the Great Pyramid," has become nothing more or less than a document of a particular stage in the development of Egyptian civilization, the period of Chephren.

The mastabas to the west of the pyramid date from the same period as the Chephren complex; they are laid out in much the same way as the mastabas of Cheops' courtiers.

The third monumental complex at Giza is that of Mycerinus. His is the smallest of the three pyramids and, like the others, was built on a square base (each side 346 feet). Its original height was about 215 feet, its angle of inclination 51°. Surprisingly, it was built with the most enormous blocks of all. Its lower courses were faced with granite, some of which was left unpolished; the upper courses were faced with white Turah limestone. Originally a smaller structure had been intended, with a square base about half the size of the present pyramid (fig. 58 d). After the corridor leading to the burial chamber had been cut through the rock, the builders decided to enlarge the pyramid; a new corridor was cut, starting at the entrance in the north face. It led to an antechamber with "palace façade" paneling, then to a chamber protected by portcullises, and terminated in the original burial chamber. At this point the plan was changed again. Under the original burial chamber a considerably larger chamber was carved out of the rock and linked to the first chamber by a sloping ramp. Both the ramp and the lower burial chamber are faced with granite; the ceiling was originally shaped like an inverted V but later rounded out to make a sort of barrel vault. In 1837, when Perring and Vyse entered this chamber, they found a magnificent royal sarcophagus of basalt, with "palace façade" decoration. The sarcophagus was lost at sea while being transported to England, but a drawing of it has survived.

The arrangement of the lower chamber, the decorations on the sarcophagus, and above all a wood fragment of the coffin (discovered by Perring and Vyse) bearing the name of King Menkaure (known since Herodotus as Mycerinus) led to the conjecture that the ensemble was restored during the Saite period. Today this is considered unlikely; we must rather suppose that the interior decorations of all parts the pyramid were executed in Dynasty IV. The fragment of the wood coffin certainly dates from the Saite period, but it may have been placed there in this later period—the Saite rulers were not the only ones who restored the ancient monuments at Giza when they became deteriorated.

South of the Mycerinus pyramid lies an east-west row of three small satellite pyramids within an enclosure wall. The easternmost had a granite facing, part of which has been preserved; the other two have survived in the form of step pyramids. The size of all three at the base is roughly one-third that of the Mycerinus pyramid. The burial chambers of the easternmost and of the middle pyramid contained granite sarcophagi. Each of these pyramids—generally assumed to have served as tombs of royal wives—had a funerary temple against its south wall. The temples were built of dried brick on stone foundations; the columns were of wood. The plan of the temple near the easternmost pyramid is the best preserved; two sections of the temple—one public, one private—are clearly distinguishable.

The Mycerinus pyramid and its adjacent temples are less monumental in scale than those of his predecessors. Mycerinus certainly intended to use stone for both the upper and the lower temples, but the unfinished state of the private section in the upper temple indicates that probably neither of them was completed. The hypostyle hall in the upper temple, where statues of the king were probably to be placed, had a limestone facing. The L-shaped inner sanctuary had a granite floor. After Mycerinus died, his successor Shepseskaf completed the buildings, but used poorer materials: the limestone walls were given a facing of dried brick coated with white plaster. As for the lower temple, Shepseskaf moved it slightly to the east but did not alter the original plan. It had a vestibule with four columns, flanked by four halls on either side, and from a central court a flight of steps led down to the sanctuary through a colonnaded portico. Storerooms were situated on either side.

In one of these storerooms Reisner discovered four slate groups—the so-called Mycerinus triads (three of them are now in Cairo, the other in Boston). A large seated figure of Mycerinus in alabaster (now in Boston) was also found and fragments of four smaller statues in the same material. These are the most valuable of the fifty-two sculpture fragments discovered by American archaeologists in the area of the Mycerinus complex (figs. 63, 203, 204, 208).

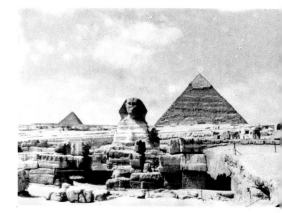

856. GIZA. THE SPHINX

857. GIZA. TEMPLE OF THE SPHINX

858. GIZA. THE ROAD OF THE DEAD

Access to the ramp was through a corridor on the south side of the lower temple; the narrow ramp was originally over 800 feet long, its walls lined with whitewashed bricks. The part adjoining the upper funerary temple was wider and had a roof of wood beams. We need not be surprised that this structure was relatively short-lived; as early as Dynasty VI, Mernera reinforced it, and Pepy II, the last Dynasty VI ruler, rebuilt the lower temple.

The Mycerinus complex had no separate cemetery for dignitaries; a few were buried in a cemetery southwest of the Chephren pyramid.

The royal necropolis at Giza under Dynasty IV owed its monumental character to the three pyramids, the Sphinx, the funerary and valley temples, the ramps, and the vast cities of the dead grouped around the first two pyramids; to complete the picture, however, we must mention the remains of a row of buildings west of the Cheops pyramid. Petrie conjectured that they were barracks housing laborers, and estimated that three to four thousand people could have been accommodated there. It remains possible, however, that these are the remains of storehouses.

South of the Chephren ramp, a group of dried-brick structures was discovered that may have served to house the priests in charge of the funerary services during Dynasty IV. Working near this site in the 1930s, Hassan excavated the funerary complex belonging to Queen Khent-kaw-s, wife of King Shepseskaf (Dynasty V), whose tomb at Saqqarah is shaped like a gigantic sarcophagus. His wife's tomb at Giza, the base of which was 90 by 69 feet, has a similar shape. The funerary chapel was situated on the west side, part of it cut from the natural rock upon which the sarcophagus-shaped structure stood. The chapel consisted of three chambers; from the middle chamber—the sanctuary proper—a shaft led to the underground chambers. The ramp linking the lower temple with the chapel first runs east and then abruptly turns south—an exceptional feature in this type of ramp. Both Dynasty V and Dynasty VI left many mastabas of dignitaries at Giza.

The Middle Kingdom brought no changes in the appearance of the necropolis at Giza, but there is reason to believe that by then the city of the dead, including the Sphinx, had been largely buried under sand.

The New Kingdom Pharaohs hunting gazelles in this region could see the Sphinx's head protruding from the sand and dedicated commemorative steles to it, taking it for the figure of the sun god Hermakhis (Horus of the Horizon). In 1816, Caviglia discovered the great granite stele of Tuthmosis IV, which stood between the Spinx's paws. It bore an inscription saying that the sand had been cleared away from the monument. In the 1930s, Hassan excavated the remains of a dried-brick temple, part of which was built over the Sphinx's temple, long since buried under the sand. The dried-brick temple was probably built by Amenhotep II; its limestone portal bears this king's inscription. Besides the stele of Amenhotep II, the temple contained a number of votive offerings dating from a later period, including the stele of Sety I, father of Ramesses II. During the New Kingdom, the Sphinx was worshiped as the god Hermakhis. Votive offerings in the form of small steles, discovered in the temple of Amenhotep II and in surrounding tombs, indicate that the Sphinx was a place of pilgrimage in this period.

Southeast of this temple, Prince Kha-em-wast, son of Ramesses II, built another dried-brick temple, probably also dedicated to Hermakhis.

Under Dynasty XII the upper chapel adjacent to the tomb of Queen Henutsen was rebuilt and dedicated to Isis, Mistress of the Pyramids. A number of tombs dating from the Saite period are situated to the east of the Chephren pyramid. One of them, discovered in 1837, is called Campbell's tomb, for the English consul general in Egypt at the time.

A few tombs date from the Persian occupation and from Dynasty XXX, indicating that even at this late period some dignitaries wished to be buried in the ancient necropolis of the Pharaohs. They were not above usurping older structures for the purpose. In the Ptolemaic and Roman Periods the Sphinx continued to be one of Egypt's greatest tourist attractions, and attempts were made to arrest its disintegration. Without much concern for artistic values, the Sphinx's legs, sides, and tail, which had in part crumbled away, were shored up with small limestone blocks. Steps were built to make it easier to see the Sphinx. In the Roman period Mycerinus' upper funerary temple was used as a cemetery.

For thousands of years, the necropolis of ancient Egypt's rulers at Giza has resisted sand and sandstorm, natural decay, and human depredation. To this day it remains the most monumental archaeological complex in Egypt, if not in the whole world. It is certainly an enduring testimony to the power of the Old Kingdom Pharaohs, but it is also (and more important to us today) evidence of the skill and creativeness of architects, artists, construction engineers, masons, and ordinary workmen at a very early stage of human development.

7. ABU ROASH

An Arab village about 5 1/2 miles north of the pyramids of Giza and 10 miles west of Cairo. Not far from Abu Roash is a necropolis dating from the Predynastic Period and the Old Kingdom. This marked the boundary between Nome I ("The White Wall") and Nome II ("The Thigh") of Lower Egypt.

The site was investigated by J. S. Perring and H. Vyse *(Operations)* and by R. Lepsius *(Denkmäler, Text,* I, p. 21). Dutch excavations conducted by A. Klasens in 1957-59 brought to light an important cemetery dating from Predynastic and Early Dynastic times. Twelve different types of burial have been classified according to the position of the body and the style of tomb construction (Klasens, *Abu-Roash*).

Excavations undertaken by the French Institute of Oriental Archaeology, begun in 1900 under E. Chassinat and continued with interruptions until 1934 by F. Bisson de la Roque, uncovered Predynastic tombs as well as some tombs of Dynasty IV dignitaries. These excavations also cast new light on the pyramid of Radedef (Dynasty IV) and the remains of this Pharaoh's funerary temple.

This complex is situated on a hill southwest of the dignitaries' tombs. Among the latter are the ruins of a small pyramid built of dried brick. Today no trace is left of its superstructure, although when Lepsius saw it in 1842 it was 55 3/4 feet high and the underground burial chamber carved out of the rock was still accessible. This pyramid may be a royal tomb dating from the Middle Kingdom.

As for the pyramid of Radedef, called = "Radedef is an inhabitant of Shedu," it was built on a base about 328 feet on each side. Today the ruins of its superstructure are barely 39 feet high. Flinders Petrie *(Pyramids and Temples of Giza,* 2nd ed., 1885, p. 53) relates that 300 camels carried stone blocks daily from this pyramid to Cairo, where they were used in new buildings.

Radedef remains a fairly mysterious figure. Not all sources mention his name, and scholars have differed greatly on the dates of his reign. Today most historians believe that he was Cheops' second son, born to a Libyan mother. After murdering his older brother Ka-wab, whose mother was Egyptian, he usurped the throne for eight years, and was then succeeded by his younger brother Chephren (Drioton and Vandier, *Les peuples,* pp. 201-2).

Radedef's doubtful status as a ruler is invoked to account for the fact that his pyramid is situated at some distance from the Giza necropolis, farther north than any other royal pyramid. Probably never completed, it was conceived in a monumental style worthy of a successor to Cheops. The underground passages and the burial chamber were faced with large blocks of limestone and granite about 6 1/2 feet thick. Traces of granite facing have also been found at the bottom of the pyramid walls. There is reason to believe that rooms were built above the burial chamber (as inside the Cheops pyramid) to reduce the weight of the pyramid's mass.

A carefully constructed ramp almost a mile long led to this pyramid complex from the north. To the east of the pyramid stood a funerary temple, and to the south was a rock-cut chamber for the sacred barge. The dimensions of this chamber were about 115 by 12 1/4 by 30 1/2 feet. It contained three beautiful heads from statues of Radedef; two are now in the Louvre and one in the Cairo Museum (fig. 196).

Near the southwest corner of the pyramid are the remains of a smaller pyramid, probably a satellite. Due west lie the ruins of a mastaba and a fragment of the enclosure wall. The lower temple has not yet been excavated.

There is little doubt that the entire Radedef complex deserves further exploration. This monument dates from the period of the architects who built the great pyramids of Giza, and any detail may cast light on the many problems presented by the more famous pyramids.

8. ABUSIR

The area of Old Kingdom necropolises south of Giza comprises three groups: the site known as Zawiyet el Aryan; south of it the one known as Abu Gurob; still farther south, the group of pyramids at Abusir. Inscriptions in Memphite tombs refer to the whole area by the terms Kher(t)-netjer ("The City of the Dead") and Iment ("The West").

At Zawiyet el Aryan lie the remains of two pyramids. One, built of limestone blocks, about 272 1/4 feet at its base, has the character of a step construction like the pyramid of Zoser. G. A. Reisner and Fisher *(BMFA,* IX, pp. 54-59) were inclined to attribute it to a Dynasty II king, but today it is generally attributed to Kha-ba of Dynasty III (Lauer, *La pyramide à degrés,* pp. 8-9).

There is no general agreement, however, on the date of the second pyramid, which was never completed. It is considerably larger than the first, and a great quantity of polished red granite blocks was used in its construction. A granite sarcophagus that had been encased in the floor has

859. ABUSIR. GENERAL PLAN
1. *Sun temple of Ne-user-ra*
2. *Unfinished pyramid of Neferefra*
3. *Pyramid of Neferirkara* 4. *Pyramid of Ne-user-ra* 5. *Pyramid of Sahura*

been found. A. Barsanti ("Ouverture de la pyramide de Zaouiyet el-Aryan," *ASAE*, 7-8) and other archaeologists suppose that this pyramid was built for King Neb-ka, who, according to a list of kings found at Saqqarah, reigned between Kha-ba and Huni, last ruler of Dynasty III. Recently J. P. Lauer has rejected this attribution. In his opinion, such great quantities of granite could not have been used during Dynasty III, and he believes that the unfinished structure was the work of one of the last Dynasty IV rulers.

The ruins of a great sun temple erected by Pharaoh Ne-user-ra (Dynasty V) lie on the edge of the desert at Abu Gurob. The site was excavated in 1898-1900 by Friedrich von Bissing (Bissing, Borchardt, and Kees, *Das Re-Heiligtum des Königs Ne-Woser-re*, I-III). This temple, believed to have been modeled on an older sun temple at Heliopolis, is unlike any other ancient Egyptian religious edifice that has survived. It stood upon a mighty man-made platform laid over a terrace of leveled sand. A ramp, surmounted by a covered corridor lighted by twenty evenly spaced windows in the ceiling, connected the temple entrance with a monumental gateway in the valley below. This gateway was built of limestone blocks with a facing of limestone slabs. There is good reason to suppose that the gateway originally had sloping walls; if so, it would be the earliest known example of a monumental pylon.

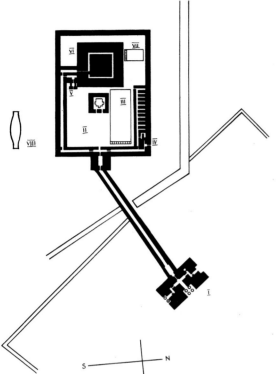

860. ABUSIR. PLAN OF THE SUN TEMPLE OF NE-USER-RA
I. *Monumental gateway* II. *Court with altar* III. *Great sacrificial hall* IV. *Storerooms* V. *Chapel* VI. *Obelisk* VII. *Small sacrificial hall* VIII. *Solar barge*

The ground plan of the temple, oriented on an east-west axis, had the form of a rectangle measuring 262 1/2 by 360 3/4 feet. Within the high, thick enclosure wall there was, directly behind the entrance, a large court with an altar at the far end; behind the altar stood a structure consisting of a base supporting an obelisk. The base has the form of a truncated pyramid rising about 65 1/2 feet above the court level; it was faced with blocks of polished granite at the bottom, with limestone slabs at the top. The obelisk, faced with limestone slabs, was probably 118 feet high, its apex presumably overlaid with granite slabs or sheets of gilded copper. Unlike later obelisks, this one had a core of irregular small blocks of limestone; only the outer layer was of polished slabs. This gigantic monument was without doubt a symbol of the sun god, and may have been the first monumental structure of its kind in history. An interior ramp gave access to the platform that supported the truncated pyramid; from the top level (65 1/2 feet for the base, plus 52 1/2 feet for the terrace), visitors could enjoy a view, not just of the temple, but of the entire valley. A covered corridor began at the temple entrance, extended around the south and east sides of the temple enclosure, and was connected with the obelisk's ramp. The walls of the corridor were lined with magnificent reliefs

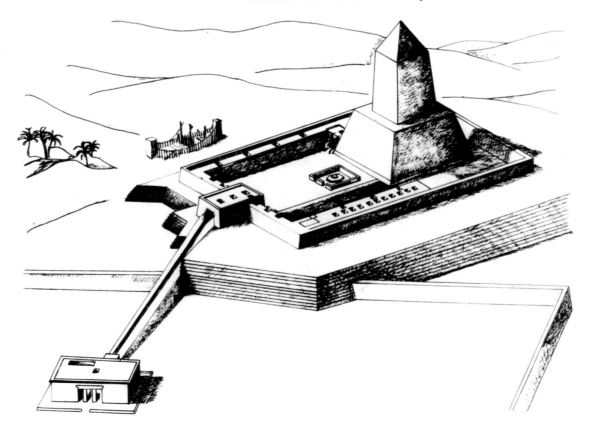

861. ABUSIR. RECONSTRUCTION OF THE SUN TEMPLE OF NE-USER-RA

that represented the tutelary deities of the nomes, the gods of the Nile, and the deities personifying the seasons of the year. The reliefs showing farm laborers at work constituted a kind of sculptural hymn to the sun, to whose beneficent rays Egypt owed its prosperity. Unlike the corridor, the ramp inside the base of the obelisk had no windows, and visitors must have carried torches for light by which to admire the famous reliefs representing the Heb-Sed, marking the thirtieth anniversary of the reign of the Pharaoh who erected the obelisk to celebrate that very occasion. Most of these reliefs are today in the Berlin Museum. The question arises, What class of people had access to the platform? Who was entitled to make use of the corridor and climb to the top of the truncated pyramid? Given the strictly hierarchical nature of Egyptian society, it may be assumed that this passage was originally accessible only to dignitaries and to the priests in charge of the temple of Ne-user-ra.

Southeast of the obelisk lie the remains of a small chapel. Along the northern part of the court were situated large storerooms and an enclosure for the sacrificial slaughter of animals. Neither the altar nor the obelisk is situated at the center of the temple precinct; the storehouses and the sacrificial enclosure cover more ground than the south side of the court where the chapel and the southern corridor are located. A solar boat, partly carved out of the rock and partly built of dried and painted bricks, was found south of the temple enclosure. The boat, which played an essential part in sun worship, was about 98 1/2 feet long. The sun god had a day boat *(meandjet)* and a night boat *(mesketet)*, but despite painstaking search, no second boat has been discovered. Could it be that the builders of this magnificent temple were not allowed enough time to construct a second boat?

At a short distance southeast of Ne-user-ra's sun temple lie the ruins of a similar temple built by Weserkaf, first ruler of Dynasty V (H. Ricke, *Das Sonnenheiligtum des Königs Userkaf*, I, 1965). Farther southeast we find the famous group of pyramids of Weserkaf's four successors (L. Borchardt, *Das Grabdenkmal des Königs Ne-user-re*, 1907).

The pyramid of Sahura is the one in the best state of preservation. When Perring discovered it, the ruins measured about 213 1/4 by 210 feet and rose to a height of about 114 3/4 feet. Originally each side of the pyramid was 256 feet at the base, it was about 153 1/2 feet high, and its angle of inclination was 51°42'35". It was built of irregular limestone blocks in the form of six large steps around the core; the facing was of Turah limestone. The entrance was from the north, at the level of the outside platform, from which a corridor faced with limestone slabs led to the burial chamber. At three points in the corridor, where portcullises were situated, the facing was of granite. The rectangular burial chamber, faced with limestone, had V-shaped triple vaulting; it was situated exactly on the pyramid's axis. The whole complex was surrounded with a stone wall about 124 1/2 feet high and almost 10 feet thick at the base. Off the southeast corner stood a satellite pyramid, also within the enclosure wall; it was entered from the north, and its layout was similar to that of the main pyramid.

Sahura's funerary complex included the usual two temples, upper and lower, linked by a ramp. The lower temple differed in shape from other "reception" temples. Built on a high platform, it had two entrances, on the east and south sides; during the flood season they were accessible by narrow ramps. The east ramp led to a portico of eight columns, the other to a portico of four columns. In the western part of the temple was a chamber with two granite columns in the form of date palms. From there a ramp 771 feet long led to the upper temple; the center element in the latter was a court paved with basalt and surrounded by a colonnade of granite columns with palm capitals. The white limestone walls of the court and the hall leading to it were decorated with reliefs of war scenes. The subject (often repeated later) was the king's victory over the Libyans, whose ruler is shown kneeling at the Pharaoh's feet. At the far end of the court stood a chapel with five niches for statues of the king. (Five niches are occasionally found during Dynasty IV; the number becomes habitual only at the beginning of Dynasty V.) Farther back was a sanctuary with an alabaster floor, and behind were large two-level storehouses, which were reached by way of a corridor with a flight of steps. The lower rooms probably had no light. In addition to its beautiful painted reliefs, Sahura's funerary temple is noteworthy for the variety of stone used in its construction—granite, basalt, limestone, and alabaster—and for the palm columns which make their earliest appearance here. But perhaps the most interesting feature of this temple was its drainage system. Rainwater from the roof flowed down through stone spouts shaped like lions' heads into basins lined with copper, and from these, together with other liquids used for ritual purposes, the water emptied into an elaborate underground drainage system.

South of the Sahura pyramid lies the funerary complex of Ne-user-ra, whose pyramid stood between the complex of Sahura and that of Sahura's successor Neferirkara. Ne-user-ra usurped Neferirkara's lower temple and part of the ramp, changing its course to lead to his own funerary temple. The layout of the lower temple was similar to that of Sahura, but it had papyrus columns instead of palm columns. The ramp leading to the upper temple may have had a roof. Ne-user-ra's upper temple was L-shaped—perhaps because there were older tombs at this spot. It was divided into public and private sections; the private section, besides traditional elements such as niches for statues of the king, a sanctuary, and a large false door, also had storehouses. The pyramid of Ne-user-ra, whose east face was adjacent to the funerary temple, is today almost entirely destroyed.

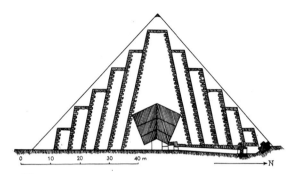

862. ABUSIR. SECTION OF THE PYRAMID OF SAHURA

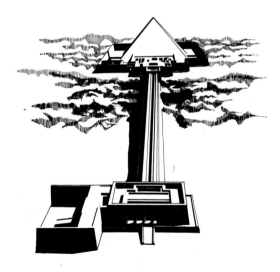

863. ABUSIR. RECONSTRUCTION OF THE PYRAMID AND FUNERARY TEMPLE OF SAHURA
In foreground: the temple in which the ceremonies occurred prior to the funeral. Between the temples: the walled ramp open to the sky.

Its sides measured more than 255 feet at the base, it rose to a height of more than 164 feet, and its angle of inclination was 52°. Like the neighboring pyramid of Sahura it was built in steps, later overlaid with Turah limestone. The entrance was on the north side, where a corridor led to two burial chambers separated by a wall, both vaulted as in the pyramid of Sahura. The first burial chamber served as a kind of vestibule; the second contained no trace of a sarcophagus or tomb furnishings. Near the pyramid's southeast corner stood a small satellite pyramid—an exact reproduction of the king's pyramid on a reduced scale.

Near the pyramid's southwest corner lie the ruins of the pyramid of Neferirkara and its upper funerary temple. This was the largest pyramid in the Abusir group: its sides originally measured about 341 feet at the base; it stood about 241 feet high, with an angle of inclination of 53°5′. Although it is severely damaged, its entrance has been ascertained to be in the north face. The corridor and the burial chamber (of which only the upper part has survived) were slightly different from those in the Sahura pyramid. Something like a system of double vaulting seems to have been used here, to relieve the weight of the stone.

Neferirkara probably reigned no more than ten years, and certainly did not complete his pyramid. He barely began to construct his funerary temple, which was intended to be a large edifice commensurate with his pyramid. Only the hall with five niches and the sanctuary were of stone. The court and some of the storehouses were built by Neferefra, the rest by Ne-user-ra. All the parts of the temple completed by Neferirkara's successors were built of dried brick and roofed with wood beams. The columns, too, were of timber, and were probably of the lotus type.

Neferefra may not have completed Neferirkara's temple because he intended to build his own funerary enclosure, south of the Neferirkara pyramid, but he died before finishing it. Only meager remains of his pyramid have come down to us. Ne-user-ra completed (though in inferior materials) the great funerary temple of Neferirkara but did not bother about Neferefra's funerary enclosure.

In addition to royal tombs, the necropolis at Abusir had a cemetery for dignitaries where a few Dynasty V and Dynasty VI mastabas survive. (Since 1962 the Czech Archaeological Institute has conducted excavations near the mastaba of Ptah-shepses.) Abusir was also used as a necropolis during the First Intermediate Period and the Middle Kingdom. During the New Kingdom a number of tombs and a small shrine were built. The shrine was placed against one of the walls of the corridor that led to the court of Sahura's funerary temple, at the place in the corridor where a low relief represents Sahura sacrificing to the cat-headed Bastet. By that time the Sahura temple was partly in ruins, so the builders of the shrine added a separate enclosure wall and a roof. They apparently mistook the cat-headed Bastet for the lion-headed Sekhmet, wife of Ptah, the main Memphite god, and dedicated the new shrine to the "goddess Sekhmet of King Sahura."

The latest tombs at Abusir date from the Ptolemaic Period.

II. LOWER EGYPT

9. BUTO

Today, Tell el Farain; the ancient ■☉ = Pe in "The Mountain Bull" nome of Lower Egypt. Together with the adjacent ⟅☉ =. Dep, it formed a single urban complex which eventually came to be called Per-Wadjet in Egyptian and Buto in Greek.

Buto was an important religious center where the cobra goddess known as Edjo, Wadjet, or Uto, was worshiped. From the earliest dynasties this deity was one of the king's guardians and figured on his crown as a uraeus; it is also possible, however, that this tradition dates back to Predynastic times, when Lower Egypt first emerged as a kingdom with Buto as its capital. The cobra goddess became the symbol of Lower Egypt, the counterpart of the vulture goddess Nekhbet of El Kab, the oldest tutelary deity of Upper Egypt. In any case, Horus was associated with Pe, and Edjo with Dep. According to later legends Horus was born on an islet of papyrus tufts near Buto where he was tended by Isis and Edjo.

The great Buto tradition was reflected clearly in certain Egyptian religious rituals: in the Heb-Sed ceremonies that marked the thirtieth anniversary of every Pharaoh's reign, and in the so-called Buto or Osiris funerals. The legendary kings of Buto, called "the souls of Pe," were worshiped almost as gods. Horus was regarded as their ancestor (this is why they were represented with falcon heads) and later their cult merged with that of the four sons of Horus. These legendary rulers of Buto, together with their Upper Egyptian counterparts, "the souls of Nekhen," accompanied the king to his palace after his coronation.

As early as the first dynasties Buto had a temple; subsequent rulers built or rebuilt some parts of it. Herodotus (II, 155) mentions the famous oracle of Buto. In his day, shrews and falcons were worshiped in this temple.

The large *koms* at Buto were excavated as far back as 1886 by Flinders Petrie (*Ehnasya*, 1905, pp. 36-37). Excavations on this site were resumed in 1904, and since 1965 the Egypt Exploration Society has investigated it systematically. So far the results have been modest; most of the finds date from Ptolemaic and Roman times.

In Nome XIX of Lower Egypt, south of Tanis, lay a town first called Imet and later Buto, where the goddess Uto was worshiped. For some time it was the capital of "The Lower Cherub" nome. Its ruins lie near present-day Nebesheh (Flinders Petrie, *Tanis*, II).

10. MENDES

Capital of "The Dolphin" nome in Lower Egypt, its Egyptian name was ⟅☉ = Djedi, Dedi. Two *koms* in this area, Timai and Tell el Ruba, are what remains of the towns Thmouis and Mendes. Ammianus Marcellinus (fl. late fourth century A.D.) lists the city formed by these two adjacent towns among the four largest cities in Egypt, with Memphis, Oxyrynchos, and Athribis. Its main deity was the ram *(ovis longipedes)* though the Greeks took it to be a goat (Herodotus, II, 46) and so identified Mendes' principal god with the Greek Pan. The ram was venerated as a symbol of fertility from Dynasty IV on.

American excavations, begun in 1964 by the Institute of Fine Arts, New York University, have brought to light an Old Kingdom necropolis with tombs whose walls are decorated with paintings (D. Hansen, *JARCE*, IV, 1965, p. 31 f.; VI, 1967). During the New Kingdom there must have been considerable building activity. In 1839, Nestor L'Hôte saw a granite basin bearing the cartouche of Ramesses I at the entrance to the avenue of sphinxes; a number of inscribed blocks dating from Dynasties XIX and XX also come from Mendes. During the Saite Dynasty the city was the object of special attention. Blocks with inscriptions of Saite kings have been found, and the enormous granite naos of Amasis remains *in situ;* beneath it American archaeologists have discovered a huge stone platform related to the great temple of this Pharaoh. According to Manetho the rulers of Dynasty XXIX traced their family tree from Mendes. The two *koms* contain remains of the Ptolemaic and Roman cities on this site. One of the best-known finds from this period is the so-called Mendes Stele representing Ptolemy II and Arsinoë II bringing offerings to the city's tutelary diety, shown standing on a pedestal. In Coptic times, Thmouis was the seat of a bishopric. Fifteenth-

century Arab writers admired the ruins of the city's monumental edifices, and mentioned a hypostyle hall and oddly shaped cisterns (E. H. Naville, *Ahnas el Medineh*, 1894, p. 15 f.). At the time of Bonaparte's expedition (*Description*, IX, p. 369 f.), stone sarcophagi containing the embalmed carcasses of sacred rams were found.

11. SAIS

𓋴𓄿𓊖 = Sa, Sau, Sai. Its ruins lie near the village of Sa el Hagar, on the east bank of the Rosetta branch of the Nile, north of Tanta. In the Old Kingdom, Sais was capital of a province later divided into two nomes of Lower Egypt: Nome IV ("South Neith"), called in Greek Prosopites, with its capital Prosopis; and Nome V ("North Neith"), with its capital at Sais.

One of the oldest towns in Egypt, founded before historical times, Sais is mentioned in the "mystical geography" of the Book of the Dead, the earliest version of which dates from the Predynastic Period. Old Kingdom records mention the titles borne by the priestesses and officials in charge of the palace of the Red Crown in Sais.

The name Sau does not appear until the Middle Kingdom. In the New Kingdom, Sais became a center of linen manufacture. According to tradition, shrouds and mummy bandages were woven in the temple of Neith by Isis and Nephthys (but surely also by mortal weavers). Neith eventually became the patroness of weaving. Later texts refer to her as the "Mistress of the House of Embalming" (Per-nefer). During Dynasty XVIII the Phoenicians set up a trading post at Sais. Under Ramesses III, the Libyans settled in the Delta and became particularly important in the city.

The written history of the city dates from the time of Prince Tef-nekht (Dynasty XXIV), conqueror of the Delta and Middle Egypt. Sais became the seat of two Dynasties—XXIV and XXVI—and no doubt the main center of Egyptian civilization at the time. It was also an artistic center and developed under Dynasty XXVI a distinctive Saite style, related to New Kingdom classicism. Although the proximity of Alexandria decreased the political importance of Sais in the Ptolemaic Period, it retained its rank as a religious center in Roman times, and was later the seat of a Christian bishopric.

The main deity of Sais was the goddess Neith, usually represented with a bow and two arrows in her hands and the Red Crown on her head. Earlier she had also been worshiped in the form of the Heavenly Cow, and as such had been the patroness of the two nomes. In this form she was identified with Hathor and even Isis. Besides Neith, the Saites also worshiped Osiris. Our earliest description of Sais is by Herodotus (II), who visited it around 460 B.C. He mentions the royal palace and speaks of the temple of "Athene" (whom he identified with Neith) with a dromos and propylaea built by Amasis. The core of this temple may have been a tree-lined avenue leading to the sanctuary proper, in front of which stood a small pyramid (Montet, *Géographie*, I, p. 82, fig. 15). Herodotus especially admired the cella carved from a single block of stone, and the colossi and sphinxes lying on the ground. The royal necropolis seems to have been situated within the temple enclosure, to the left of the entrance. Herodotus noted the sarcophagi of Amasis, Apries, and the latter's predecessors; he says that their tombs were destroyed by Cambyses. He also mentions a large portico with palm columns behind the temple of Neith, the tomb of Osiris (he probably means a cenotaph), and a sacred lake, like the one he had seen on Delos, where Osiride mysteries were celebrated.

A few centuries later, Strabo speaks of Sais as one of Egypt's most important cities (XVII, 18); he mentions the tomb of Psamtik. J. F. Champollion (*Lettres écrites d'Égypte et de Nubie*, 1828-29, p. 50, pl. I; plan, pl. II) gives us a description and plan of the ruins of the temple enclosure, but thirty years later R. Lepsius (*Denkmäler*, I, pp. 55-56; *Denkmäler, Text*, I, pp. 3-4) was no longer able to find many of the ruins mentioned by Champollion and did not include them in his own plan.

Neither A. E. Mariette's excavations nor the later ones by Daressy (*ASAE*, 2, pp. 230-39) yielded important results, but accidental finds, mainly those made by the Sebbakhin, brought to light many sculptures and architectural decorations (now in various museums) dating from the Late Period. Noteworthy is the naophoros statue in the Vatican Museum (Posener, *La première domination perse en Égypte*, pp. 1-26), bearing an inscription referring to the temple of Neith. Among other finds there is a collection of jewelry dating from Roman times, now in the Cairo Museum.

In the early 1940s, L. Habashi showed that many of the building blocks in dwellings at Sa el Hagar were from the Sais sanctuary (*ASAE*, 42, pp. 369-416). In 1959, T. Andrzejewski (*Rocznik Orientalistyczny*, 25, 2, pp. 10-11) was just able to make out the remains of an old rectangular enclosure wall of dried brick, measuring about 1,574 by 1,830 feet.

Recent experimental diggings conducted at Sais by the Egyptian Antiquities Service yielded no important results (*JARCE*, 52, July 1964, p. 13). The main obstacle to systematic excavations here, as elsewhere in the Delta, is subsoil water.

12. BUBASTIS

Ⲧⲟ = Baset, Per Baste; the Greek Bubastis, the Arab Tell Basta. Capital of Nome XVIII ("The Upper Cherub") of Lower Egypt. The site is near today's Zagazig.

The city's main deity was the lion-headed goddess Bastet. Apart from her name, she is identical with Sekhmet. The inhabitants also worshiped cats—a cemetery of them was brought to light together with a cemetery of ichneumons (Naville, *Bubastis*, 1891). In later times the goddess was represented with a cat's head, but she is essentially a leonine deity, often represented with her lion-headed son Mahes. German explorations in 1929 (*MDAIK*, II) confirmed the existence of ovens in which the cats were cremated. Other gods were also worshiped at Bubastis: Wadjet, "Lady Imet," Harakhte, and Atum (the gods of Heliopolis); Shu, the son of Atum-Ra; and, from the time of Ramesses II on, Seth and Ptah as well.

Excavations of the site, sponsored by the Egypt Exploration Fund, offer rare confirmation of Herodotus' description (II, 137, 156). Further chance finds and careful investigations conducted by the Egyptian Antiquities Service complete the picture of the ancient temple enclosure. A number of blocks with cartouches of Cheops and Chephren may have come from a Dynasty IV temple. At all events, during Dynasty VI Pepy built a temple here, enclosed by a rectangular wall (287 by 210 feet) of dried brick; its ruins were discovered by L. Habashi (*Tell Baste*, 1957). From the inscription of Amenemhat I on one of the blocks, we can infer that this king built or more probably remodeled the temple of his "mother Bastet," to which he also added a gate. Sesostris I and Sesostris III made further additions. It may be assumed that Amenemhat III, too, contributed to the embellishment of the temple: two of our finest portraits of that ruler were found here, and recent excavations by the Egyptian Antiquities Service have uncovered extensive structures of dried brick, possibly a palace of Amenemhat III (*Orientalia*, 34, 1965). Several Hathor-head capitals, decorated on two sides only, and papyrus and palm columns probably date from the Middle Kingdom. E. Naville's findings seem to indicate that the great temple, the underlying structure of which dates from the Middle Kingdom, was enlarged during the New Kingdom. The Hyksos, apart from usurping certain monuments, do not appear to have otherwise damaged it.

Dynasty XVIII, too, left its mark on the site. Many statues dating from the reign of Amenhotep III have been found outside the temple enclosure, and Habashi discovered fragments of a chapel built by this king. Ramesses II usurped some older monuments, but he also built a temple (later usurped by Osorkon I) a few hundred yards from the great temple. He enlarged the older Bastet temple, which in his day had a large antechamber leading into the first hall, a second hall, and a hypostyle hall to which Nectanebo later added another hall. The Pharaohs responsible for particular parts of the temple have not been completely identified, for certain older sections were incorporated in the new building, and later rulers usurped parts built by their predecessors. Thus the columns of the hypostyle hall were usurped both by Ramesses II and by Osorkon II. The latter decorated the great hall with reliefs representing the thirtieth anniversary of his reign, and the hall is known as the Osorkon II festival hall (Naville, *Festival Hall of Osorkon II*). Osorkon II also built a portico north of the temple. It is not surprising that these Dynasty XXII rulers left their mark on the Bubastis area; Manetho calls it the "Bubastite dynasty," and some of its Pharaohs had their residences in the city.

During the New Kingdom, Bubastis was very wealthy; this can be seen from the famous treasure accidentally discovered in 1906, when a railroad was being built in the area. Parts of this find, which dates from Dynasty XIX, are now in the Cairo Museum (Edgar, in Maspero, *Le Musée égyptien*), parts in Berlin, others in France, and a number of items have been purchased by the Metropolitan Museum, New York (K. Simpson, "The Tell Basta Treasure," *BMMA*, n.s. VIII).

From the same period are the tombs of two viceroys of Nubia: that of Hori I dates from the reign of Ramesses III and was discovered by Habashi, that of Hori II (son of the former) from the reign of Ramesses IV. In 1964-65 the Egyptian Antiquities Service excavated many New Kingdom tombs, including that of the vizier Djehuty.

When Herodotus visited Bubastis (II, 137), he was struck by the fact that the temple was visible from wherever one walked in the city. The temple stood in a hollow and was surrounded by the city, which was at a greater elevation: what had happened was that a sort of *kom* had been created over the centuries, whereas the temple area was not encroached upon. As newer structures rose around it, the temple enclosure remained at the Old Kingdom level, encircled by two canals of the Nile. Herodotus (II, 59-60) describes a great festival at Bubastis, in his day one of the most famous in Egypt. It was celebrated in the second month of the flood season; pilgrims came from all parts of Egypt, many of them arriving by boat; the festivities were accompanied by a great deal of wine drinking. The Bubastis of the Roman period has not yet been excavated, but its position at the site has been determined by some mosaics, possibly from Roman baths. Part of a necropolis dating from this period has been brought to light.

Bubastis was still inhabited in Coptic times, and the seat of a bishopric; subsequently it was depopulated, like other cities in the eastern Delta. Even today its ruins form a mighty *kom*, because excavations have been concentrated on the site of the temple. Only very recently has the Egyptian Antiquities Service begun to uncover some dried-brick houses dating from the Late Period.

13. TANIS

In Nome XVI of Lower Egypt (Montet, *Géographie*, 10). Its ruins lie near the village of San el Hagar in the eastern Delta, on the edge of the desert. The name Tanis appears for the first time in the papyrus containing *The Adventures of Wenamon* (I, 3) dating from the ninth century B.C. and describing events that took place in the eleventh century B.C.

Most Egyptologists today accept P. Montet's hypothesis that the town, then called Pi-Ramesses, was built by Ramesses II on the site of the Hyksos fortress Avaris. Later its name was changed to ⌐ ‿⊙ = Djanet. No other site except Karnak has yielded so many sculptures (most of which are now in the Cairo Museum), yet the history of this town, at least its early history, is still in the realm of conjecture. Judging from the fragments of sculpture and the architectural remains, one might assume that a granite temple already stood at Tanis in the days of Cheops and Chephren. Other finds might be taken as evidence of building activity during Dynasties V and VI. The well-known baboon statues, among which one was later usurped by Psusennes, may date from Dynasty V and may have belonged to the temple of Khonsu, the meager remains of which were excavated by Montet in the northern part of the enclosure ("Sur une statue de babouin...," *BSFE*, 10, 1952).

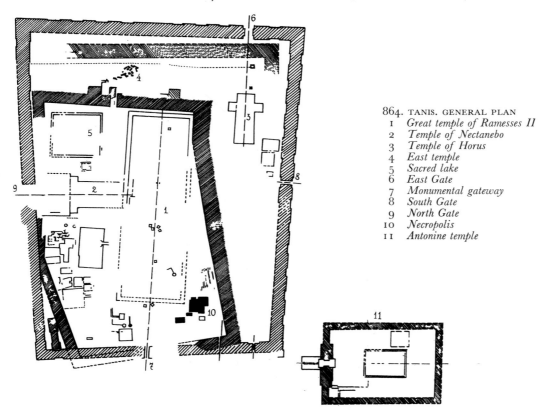

864. TANIS. GENERAL PLAN
1 *Great temple of Ramesses II*
2 *Temple of Nectanebo*
3 *Temple of Horus*
4 *East temple*
5 *Sacred lake*
6 *East Gate*
7 *Monumental gateway*
8 *South Gate*
9 *North Gate*
10 *Necropolis*
11 *Antonine temple*

Many finds date from the Middle Kingdom, including a number of sphinxes (figs. 325, 327) and other statuary, including works usurped by later rulers. We cannot be sure, however, that because such works were found at Tanis, they were not originally located in other towns. The same is true of the so-called Hyksos sphinxes, which were usurped by Ramesses II, Merenptah, and Psusennes. Dedicated to Amenemhat III, the heads are all portraits of this king (fig. 85). His features can also be discerned in the well-known granite group of two men carrying a fish, a work in archaistic style dating from Dynasty XII, which was usurped by the Hyksos (fig. 326). The colossi of Dynasty XII were certainly at Tanis in Hyksos times, but they may have been brought there by the Hyksos from some nearby town to add glamour to their capital. The matter is further complicated by our ignorance of the town's name in the early period. The inscriptions on the above-mentioned monuments refer to deities worshiped at Memphis and Heliopolis; there are also references to Hathor of Denderah and Anubis of Karnak. If we assume that all these monuments were from the first intended for Tanis, then the matter of the town's system of worship during the Old and the Middle Kingdoms becomes fairly complex.

During the Hyksos period the cult of Seth was dominant at Avaris, but it is not known whether this deity was worshiped there in earlier times. After the Hyksos king Apophis was driven out by

Kamose, the worship of Seth continued. It is puzzling that Dynasty XVIII built no structures in the local temple enclosure. The date of the town's founding, or, more accurately, rebuilding, can be inferred from the well-known inscription on the Stele of the Year 400 (discovered at Tanis by A. E. Mariette in 1863, then buried again in the sand, sought in vain by Flinders Petrie and A. Barsanti, and rediscovered by Montet in 1933). The stele dates from the reign of Ramesses II, but its inscription refers to a decree that may go back to the town's founding. Depending on how the inscription is interpreted, the date of founding would be 1730 or 1714 B.C. (Beckerath, *Tanis und Theben*).

However that may be, there can be no doubt that the Ramessides, descendants of the priests of Seth, established their residence at Tanis. The temple built under Ramesses II was enclosed by a dried-brick wall, irregularly quadrangular in shape. It was about 49 feet thick, and on two sides there were shallow projections and niches. The entrance was on the east side. It is possible that statues of Ramesses II stood in front of the portal. This king erected eight pairs of obelisks at Tanis, plus one obelisk that stood apart, and a square pillar. A great deal of the building materials from the Ramesses temple (parts of door frames, stone blocks from walls) were found in later buildings. The foundations of the so-called East Temple contained ten palm columns dating from the Old Kingdom and usurped by Ramesses II. This suggests that Ramesses II built a chapel nearby and perhaps the East Temple itself, although its pavement dates from a time later than Dynasty XXI. The temple of Horus was situated south of the East Temple.

It seems almost certain that during the reign of Ramesses II a temple (measuring 285 1/2 by 360 3/4 feet) dedicated to Anat, Seth's companion and goddess of war, was built outside the enclosure. Many stone sculptures, building blocks, and reliefs dating from the reign of Ramesses II were reused in this temple. This proves that it was originally built by this king, though it was rebuilt later. One red granite statue representing the seated Ramesses II with the goddess Sekhmet has remained *in situ*.

Tanis was more suitable than distant Thebes as a residence for rulers who wished to pursue an aggressive (and defensive) policy toward the eastern countries. It was at Tanis that Ramesses II concluded a treaty with the Hittites. In the religious conflicts between the partisans of Amon and those of Seth, Tanis certainly sided with the latter. During Dynasty XXI, Egypt was under the dual rule of the priest-kings of Thebes and a dynasty at Tanis founded by Smendes. Most likely the Tanis kings actually governed the country; the Theban priest-kings' authority was purely religious in character. The Tanite kings restored edifices that had already become heaps of rubble. Sa-amon and Psusennes I restored the granite sanctuary, using blocks from older buildings for this purpose.

Sa-amon also built around the Anat temple a wall of dried brick with a monumental stone gateway. Psusennes built a second enclosure inside the earlier sacred enclosure, and a large temple surrounded by a limestone wall 14 3/4 feet thick, measuring 270 by 787 feet. It is almost certain that the Psusennes temple stood on the site of the old Ramesses II temple; for it was within the enclosure of this temple that most of the building material dating from the reign of Ramesses II was found.

The Dynasty XXII kings continued the reconstruction of Tanis begun during Dynasty XXI. Sheshonq III built a monumental granite gateway near his tomb, for example, utilizing blocks from Ramesside structures. The sacred lake situated at the northeastern corner of the second enclosure may also have been restored at this time.

Although Tanis had already been explored by many archaeologists—A. E. Mariette *(Fragments et documents relatifs aux fouilles de Sân*, in *Rec. de Trav.*, IX; *Notice des principaux monuments du Musée à Boulaq)*, Petrie *(Tanis*, I-II), Barsanti ("Rapport" in Maspero, "Transport des gros monuments de Sân," *ASAE*, 5)—not until the systematic excavations conducted by Montet after 1929 was real light cast on Tanis' ancient monuments, especially those from the period when Tanis was the main center of government authority under Dynasties XIX and XX *(BFLS*, 7e-10e année; *Kêmi*, I, IV, V, VII, VIII, IX; *ASAE*, 39, 46, 47, 50; *CdE*, XXII, 1947, pp. 260-63; *Le drame d'Avaris; Mission Montet*, I-III; *Les énigmes de Tanis*, 1952). Montet called attention to the interesting method of laying foundations of buildings at Tanis: rectangular constructions of dried brick were filled with sand, and overlaid with limestone slabs.

At Tanis, Montet discovered several partly plundered royal tombs within the temple area, and some that had been used to store the remains from other tombs threatened with destruction. For instance, the tomb of Psusennes I contained seven bodies, including that of Amen-em-ipet, who was formerly buried nearby; the vestibule of this tomb contained the mummy of King Heqa-kheperra-Sheshonq who, according to Montet, reigned between Osorkon I and Takelot I—the mummy was in a silver sarcophagus with a falcon head. In this tomb was also the body of Wenw-djebaw-n-djedet, Psusennes I's commander of archers, encased in a silver anthropoid coffin, placed in a coffin of gilded wood, and the whole encased in a granite sarcophagus. The body of Psusennes I had been treated in a similar manner: it is in a silver casing inside a sarcophagus of black granite, both of these within a pink granite sarcophagus. This last had formerly served to house the mummy of Merenptah (Dynasty XIX).

The most noteworthy Dynasty XXII tombs are those of Osorkon II and Sheshonq III. Built of large cubiform stone blocks in an austere style, these tombs had several chambers each. They may originally have had chapels for the worship of the dead kings. The sarcophagus of Osorkon was carved from a single granite block, and other members of the royal family were buried in his tomb, including King Takelot II and an unidentified figure, possibly Sheshonq III. The Dynasty XXI and XXII tombs contained rich furnishings; particularly noteworthy are silver vessels and necklaces.

The successors to the Dynasty XXVI Pharaohs also left traces of their building activity at Tanis. Among their architectural remains are blocks bearing the cartouche of Taharqa and Saite inscriptions. Blocks with the name of Nectanebo were found near the great temple outside the north gate of the Ramesside enclosure: these are probably the remains of a temple.

At the center of the sacred enclosure a large stone substructure was discovered that still showed marks of the auger. This was a peripteral pavilion erected in the Ptolemaic Period. The Ptolemies also rebuilt the temple that Ramesses II had dedicated to the goddess Anat. Near the west gate of the enclosure Ptolemy II and Arsinoë II built a chapel. Within the precincts of the great temple, near the obelisks, Mariette found the famous trilingual stele with the decree of Canopus, issued in the ninth year of the reign of Ptolemy III Euergetes. The ruins of a structure built by Ptolemy IV, with one block in its foundations dating from the Old Kingdom, were discovered near the temple of Anat. In Roman times ordinary dwellings seem to have been built within the enclosure, but the residential section proper was situated outside to the east and so far has not been excavated. In the Coptic period Tanis had a bishop's palace.

Tanis, so rich in evidences of Egypt's glorious past, is one of the most damaged ancient sites; today it appears to be a complete ruin. And yet Tanis had great avenues of sphinxes, obelisks, and rows of colossal statues of kings. The town's chief periods of splendor were under the Hyksos, and especially under Dynasty XIX.

That the town and its sacred enclosure were so often destroyed, is largely accounted for by political events. The first great disaster occurred after the fall of the Middle Kingdom when, according to Manetho, the Hyksos destroyed temples and burned cities (Josephus, *Contra Apion*, I, 76). The powerful capital rebuilt by Ramesses II was also reduced to rubble, as is attested by fragments of earlier monumental edifices discovered in later buildings; possibly religious conflicts, above all "the war of the impure" mentioned by Josephus (*ibid.*, 232-50) explain this state of affairs. Rebuilt once more under Dynasties XXI and XXII, the town began to decline after the center of government was moved first to Sais, then to Alexandria. Tanis, thanks to its geographical position, had been an important center during Dynasties XIX and XX—it is enough to recall how frequently this proud metropolis is mentioned in the Bible (Numbers 13: 23; Psalms 77: 12, 43; Isaiah 19: 11; 30: 4); but it was gradually relegated to the periphery of Egypt's political and cultural life. The earthquake of 20 A.D. (Strabo, I, 11, 16) probably caused considerable damage at Tanis; we know that the city suffered destructive fires. Dio Cassius *(Nero)* mentions that in 68 A.D. the sea broke into the eastern Delta. Later, under Theodosius, the coastline sank by about 40 feet, and the eastern Delta must again have been flooded. In this period the coastline was steadily receding and the water of Lake Manzala flooded the surrounding region, ruining formerly arable fields with salt water. Great earthquakes along the coast in the tenth and eleventh centuries had similar effects, as they later did in Syria. It was probably then that Tanis was finally abandoned (Petrie, "Changes in the Egyptian Coast," *AE*, 1935, pp. 52-54; De Lacy O'Leary, "The Destruction of Temples in Egypt," *BSAC*, IV, 1938). French excavations have recently been resumed under M. Yoyotte (cf. "Reprise des fouilles de Tanis," *CRAI*, 1965, pp. 391-98), and we may yet arrive at a fuller and more exact knowledge of this once great but now utterly ruined site.

14. TELL ATRIB

□ ⌂ ☵ ✦ ☼ = Hut-ta-hry-ib, Greek Athribis, Coptic Athrebi or Atrepè, was the ancient capital of Nome X ("The Black Bull") of Lower Egypt. The site is not far from Benha, one of the largest modern cities in the Delta. A stele found at the site mentions the name of Senkhtawy-Sekhemkara, second king of Dynasty XIII. That it was a flourishing city during the New Kingdom is attested by a stele erected by Amenhotep III.

Scarcely anything remains of the city's ancient splendor. Ammianus Marcellinus (XXII, 16) considered it one of the most important settlements in Egypt, possibly because it had been enlarged and fortified in his day (late fourth century A.D.). Located in the heart of the fertile Delta it surely played an important part in the region's economy, probably serving as the agricultural supplier for the port of Alexandria. Between Qafr el Soraya and the little village of Tell Atrib on the outskirts of Benha, one could a few years ago still make out the meager traces of the temple of Ramesses II, including one granite triad. Just east of this site, south of the highway, some of the foundations

of another temple were visible in 1956, along with columns broken up into their original drums. North of the highway stand three small *koms;* the middle one contains the tomb of a sheikh and serves as an Arab cemetery. A large number of objects discovered in the course of random excavations at this site have found their way to various museums.

Scholarly literature is comparatively meager on Athribis. So far as the layout of the ancient city is concerned, the plan drawn up in 1798-99 and published in *Description de l'Égypte* (E. F. Jomard, *Description des Antiquités d'Athribis*, in *Description*, II; see also L. Dabrowski, "La topographie d'Athribis à l'époque romaine," *ASAE*, 57) supplies our most important evidence. In those days it was still possible to see at the site a Roman aqueduct, an arch, a brick pyramid, and the ruins of a temple of Horus that was begun under Ptolemy XII Neos Dionysos and rebuilt in Roman times (an inscription on an architrave dates from the year 9 A.D., and mentions Tiberius and Germanicus). The last remains of the temple disappeared in 1852. There was also a tetrapylon erected in honor of the emperor Valens.

In his *Aegyptiaca* (1820), Prisse d'Avennes makes only a brief mention of Athribis, and J. G. Wilkinson was equally brief in his *Modern Egypt and Thebes* (1845). The razing of the ruins in 1862 took place during the building of the railway between Alexandria and Cairo. A few smaller mounds north of Benha were still in existence in 1902. Apart from the three small hills mentioned above, the ancient site has been all but obliterated by the encroachment of modern Benha.

In 1939 A. Rowe headed a field party to this site, sponsored by the Archaeological Institute of Liverpool. A water-supply system dating from Roman times was uncovered. In 1946 Naguib Farag, inspector of the Egyptian Antiquities Service, discovered an interesting complex of Roman baths on the east slope of the central *kom*, and in 1950, just north of the same *kom*, the sarcophagus of Queen Tahut, wife of Psamtik I (Dynasty XXVI).

Systematic excavations conducted since 1957 by the Polish Center of Mediterranean Archaeology in Cairo (K. Michalowski, *ASAE*, 57, 58; "Tell Atrib," *VDI*, 1960; "Les constructions ptolémaïques et romaines à Tell Atrib," *Atti del VIIº congresso internazionale di archeologia classica*, III, Rome, 1961) resulted in the discovery of a foundation deposit of Amasis (Dynasty XXVI) in foundations analogous to those P. Montet discovered at Tanis. The same excavations revealed that a bath establishment had been built on the site in the Julio-Claudian period and rebuilt during the reigns of Trajan and Hadrian. This structure was torn down at the close of the third century to make room for foundations supporting great colonnades of colored marble. A Roman portico and a large number of lime kilns were also uncovered.

15. ALEXANDRIA

In the winter of 332-331 B.C. Alexander the Great founded a new city near the ancient village ⌐▯▯ = Ra-kedet (Greek 'Ραχωτιζ, Rhakotis) in "The Western Harpoon" nome. Bounded north and west by the Mediterranean, and south and east by Lake Mareotis, Rhakotis (like Alexandria in later times) had considerable strategic importance. In the Dynastic Period this village served as a fortified post against sea raiders. The island of Pharos, less than half a mile offshore, is mentioned in early Greek legends and in the Odyssey (IV, 351 ff.). The remains of harbor buildings (today underwater) which have been discovered near the island are assigned to the Dynastic Period by some writers, to Hellenistic times by others.

According to tradition, the famous Greek architect Deinocrates of Rhodes designed the new city; another Greek architect, Cleomenes, a native of the nearby Greek colony Naukratis, was entrusted with building it. The city grew rapidly. As early as the reign of Ptolemy I, it became the capital of Egypt; under his successor Ptolemy II it was considerably enlarged, and during the Ptolemaic Period it developed into a metropolis, the greatest trade emporium of the ancient world, and the capital of Hellenistic culture and art.

Ancient writers are enthusiastic about the magnificent new city. Strabo (XVII, 8 f.) and Diodorus Siculus (XVII, 52, 5) left us relatively accurate descriptions of Alexandria. Roman writers and Early Christian and Arab sources complete the picture of ancient Alexandria (bibliography in A. Calderini, *Dizionario dei nomi geografici e topografici dell'Egitto greco-romano*, I, 1935, p. 9; and O. Puchstein, in *RE*, I, 1894, cols. 1376-98). It can be inferred from the data they supply that the Egyptian Rhakotis, though entirely absorbed into the new capital, remained a distinct quarter, inhabited by Egyptians. The Greeks settled primarily in the center of the city, the so-called Neapolis, and in the Bruchium quarter situated closer to the harbor, which included the Regia, the royal city. Other nationalities, such as the Jews, had their own quarters. Strabo mentions the necropolis to the south, and the eastern suburb Nikopolis which had an amphitheater and a hippodrome. The Eleusis quarter south of Nikopolis is a later addition (E. Breccia, *Alexandria ad Aegyptum*, 1919 and 1922; see also most recent basic publications: A. Bernand, *Alexandrie, la Grande*, 1966; and A. Adriani, *Repertorio, Architectura*, 1966).

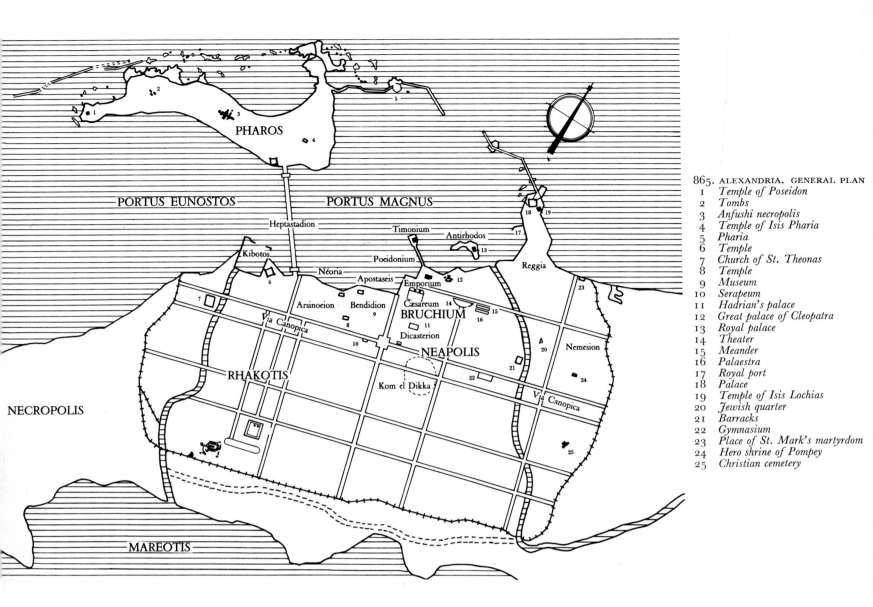

Like present-day Alexandria, the city extended along the sea. According to Strabo, its length was 30 stadia (more than 3 miles) and its width 7 to 8 stadia (less than 1 mile). In addition to the splendid royal palaces at Lochias and in the Regia, there were admirable harbor installations, temples, public buildings, broad streets, and many cisterns for water brought by underground aqueducts from the Nile Canal running north-south across the city. The famous lighthouse on Pharos—regarded in antiquity as one of the Seven Wonders of the World—was built by Sostratus of Knidos in the reign of Ptolemy II, and linked to the mainland by an embankment known as the Heptastadion. Today it is believed that the lighthouse stood on the site of the Turkish fort Kait Bey. There was a harbor on each side of the Heptastadion, the larger one being on the northeast side. A small harbor on Lake Mareotis was connected by a canal with the west sea harbor called Eunostos. This canal terminated in the rectangular artificial basin known as the Kibotos (G. Jondet, *Atlas historique de la ville et des ports d'Alexandrie*, 1921).

In the Ptolemaic Period, the eastern Mediterranean was the center of the ancient world's political and economic life. With its excellent harbors and rich agricultural hinterland, Alexandria enjoyed great advantages from its geographical position. But this position also had its drawbacks. Tidal waves caused by undersea tremors frequently flooded the shores, devastating low-lying quarters. This fact is mentioned by Strabo, Dio Cassius, and other writers (Flinders Petrie, "Changes in the Egyptian Coast," *AE*, 1935). Many monuments were reduced to rubble, and the remains of some are now underwater. Despite these ravages, and destructive armed conflicts that frequently shook the city after the time of Julius Caesar, the remains of its former splendor aroused the admiration of the Arabs as late as 642 A.D. when it surrendered to Caliph Omar's army after a fourteen-month siege. Alexandria lost its importance as a seaport after the Turkish conquest of Egypt. In 1798, when Bonaparte's army landed at a point about 7 1/2 miles west of the ancient harbor, the city, once numbering 500,000 inhabitants, had barely 6,000, most of them living on the promontory that had been formed by mud deposits on both sides of the Heptastadion. Although the ruins of the city had for centuries served as a quarry, the remains of buildings listed by the scholars accompanying

Bonaparte constituted a considerable archaeological complex (*Description, Ant.*, V, pl. 31; *État Moderne*, II, pl. 84).

Had systematic excavations been started at that time, ancient Alexandria would be today in a state of preservation comparable to that of Pompeii. But only a few years after Bonaparte's expedition, Mohammed Ali, founder of a new Egyptian dynasty (at first as khedives, later as kings), decided to build a new Alexandria to serve as a great seaport. The new city developed quickly, and in less than 100 years became an important trade metropolis; today its population is around two million.

Ancient Alexandria was lost insofar as systematic archaeological exploration is concerned, and today we know less about one of the greatest cities of antiquity and possess fewer of its monuments than is the case for many less important archaeological sites.

Literary sources have preserved the names of many ancient buildings in Alexandria, and often contain descriptions of them. The most important of these buildings was the famous Library, which contained 400,000 papyrus rolls at the time of Ptolemy II; the number of rolls is reported to have reached 700,000 by the time the Library was destroyed by fire, during Julius Caesar's stay in Alexandria. The Library was part of a complex of buildings, the so-called Museum, which might be considered the world's oldest university (E. A. Parsons, *The Alexandrian Library*, 1952). The group of scholars and scientists active there included the mathematician Euclid, the geographer Eratosthenes, and Aristarchus, literary critic and head of the Library. The poets Theocritus and Callimachus, the painter Apelles, and the epigrammatist Antiphilus added brilliance to the intellectual and artistic life of Alexandria.

The most important buildings in the harbor area included the lighthouse on the island of Pharos, the temple of Poseidon with its annexes, the great Emporium, warehouses (the Timonium and the Apostaseis), shipyards *(neoria or navali)*, the palaces and theater in the royal quarter, the temple of Isis, and the Arsinoeion. Nothing remains of these. The monuments that were situated in the center of the city suffered the same fate: these included the agora, the tetrapylon, the Adrianeion stoa, the shrines of Agathodaimon, Dionysos, Hermes, Hephaistos, Chronos, and Tyche, and several temples of Isis. According to literary sources, other buildings located near the center were Hadrian's palace, the mausoleum of Alexander the Great, a gymnasium, the Paneion, the Moon Gate and the Sun Gate erected by Antoninus Pius, the so-called Ptolemaion (a great mausoleum containing the tombs of the Ptolemaic kings), and the tomb Cleopatra built for herself and Antony.

We possess archaeological data concerning the location of only three architectural monuments in Alexandria mentioned in literary sources. The first is the so-called Caesareum, a temple begun by Cleopatra as a memorial to Antony and completed by Octavian. In front of it were two obelisks which had been brought from Heliopolis during Octavian's reign as Augustus; today one is in New York and the other in London, both known locally as Cleopatra's Needle.

The second building is one of several temples dedicated to Isis and Serapis, built by Ptolemy IV and Arsinoë III: a tablet set in the foundations of this building has been discovered near the intersection of present-day Horrey and Sherif Streets.

The third is the Serapeum, the great temple of Serapis, in the Rhakotis quarter, which was known as the work of the architect Parmeniskos. A. Rowe's excavations brought to light the foundations of this building and of the adjacent Harpocrates shrine (*Discovery of the famous temple and enclosure of Serapis at Alexandria, ASAE*, supplement 2, 1946). Nothing remains of their superstructures; what has come down to us is a number of underground corridors cut in the rock, where the mysteries of Serapis may have been celebrated; the niches in these corridors perhaps served to store papyrus scrolls belonging to the temple's library.

On the site of the former Serapeum enclosure stands "Pompey's Pillar," until recently the only important relic of antiquity in Alexandria. However, it dates from a relatively late period, for it was actually erected after 297 A.D., to commemorate Diocletian's victory over the city's rebellious inhabitants, who had resisted him for eight months. This pillar, made of red granite, is nearly 88 feet high, including pedestal and capital. It has aroused the admiration of travelers since the early fifteenth century.

Although only a few ancient structures in Alexandria have been reliably located, Mahmud Bey el Fallaki published in 1872 a hypothetical plan of the city. He was able to do so because of accidental discoveries (often made in the course of constructing modern buildings), ancient descriptions, and the data gathered by the scholars who founded the Institute of Egypt, and their successors. Fallaki's plan has retained its value to this day, although later discoveries have necessitated corrections and additions. It is still uncertain whether the street grid of Roman Alexandria (which is shown in Fallaki's plan) reproduces that of the Ptolemaic city. The matter is difficult to settle, because the Ptolemaic level lies very deep underground (in the center of the city, it is about 65 1/2 feet below the present level), while the early buildings near the seashore are today underwater.

Apart from "Pompey's Pillar" and the Serapeum, and some fragments of architecture discovered in the course of sporadic excavations—for example, the fragment of the late Roman colonnade in Nabi Daniel Street—until recently the only accessible ancient relics in Alexandria have been portions of cemeteries. The oldest, dating from the Hellenistic period, include those discovered in the Shatby, Sidi Gaber, Mustafa Pasha, and Anfushi quarters of the modern city. The tombs

866. ALEXANDRIA. "POMPEY'S PILLAR"

867. ALEXANDRIA. MUSTAFA PASHA, INTERIOR COURT

868. ALEXANDRIA. ANFUSHI NECROPOLIS

are contructed on a plan similar to that of their contemporaneous dwellings, and often have a court, a peristyle, and lateral chambers. Their painted decoration is a development of the "incrustation" style typical of Hellenistic and early Pompeian houses. The richest furnishings were in the tombs discovered in the Hadra quarter, which yielded many objects now in the Graeco-Roman Museum in Alexandria. The necropolises and accidental finds in other parts of the city have yielded mosaics, numerous vessels, terracotta figurines, and many sculptures. Although usually only fragments of the latter have survived, they provide important data concerning the sculptural style of Hellenistic Alexandria. They are characterized by subtly modeled bodies and the typical Alexandrian *sfumato* treatment of eyes, which softens the contours (A. Adriani, *Repertorio, Sculpture*, series A, 1961; *Documenti e ricerche*: I-II, 1946-48). The Hadra necropolis itself has not been given the protective status of a historical landmark.

Another group of tombs dates from the Roman period (end of the first and the second century A.D.). They are the so-called catacombs at Mex (Wardian), those on the slopes of the Kom el Shukafa, and those discovered quite recently in Tigrane Pasha Street. The most impressive of these three groups is that of Kom el Shukafa, discovered by G. Botti in 1892. It is a multilevel hypogeum dug in the rock; its central part consists of a circular shaft descending into a rectangular chamber of the triclinium type and a mortuary chapel with three niches. Around this complex are a number of lateral chambers *(Expedition Ernst von Sieglin, I, Die Nekropole von Kom-Esch-Schukâfa)*.

The paintings and reliefs decorating the chapel are in the eclectic Hellenistic-Egyptian style characteristic of Alexandrian art in the early Roman period. Some of the figures of Egyptian gods attending mummification procedures may wear Greek garments or Roman armor. The sarcophagi are decorated with festoons and Greek masks; the sea shells in the niches are characteristic of architectural decorations in the eastern provinces of the Roman Empire. Along with these elements are friezes with Egyptian cobras and other decorations characteristic of Egyptian temples and tombs (figs. 684-91).

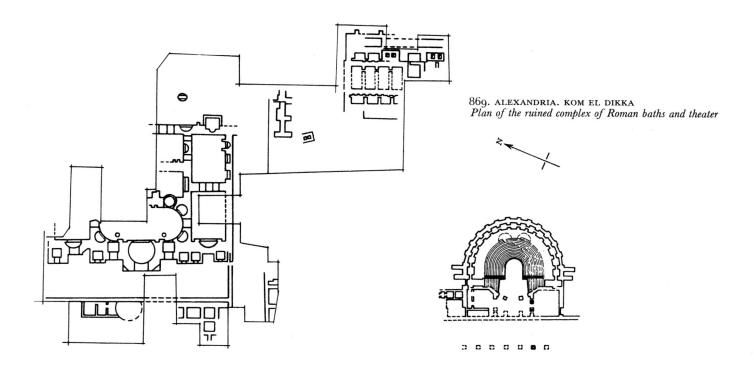

869. ALEXANDRIA. KOM EL DIKKA
Plan of the ruined complex of Roman baths and theater

At present the archaeology of Alexandria is beginning to change character. In the center of the city, on the so-called Kom el Dikka, where the citadel dating from Napoleonic times once stood, the Polish excavations begun in 1960 have brought to light monumental Roman baths, fragments of cisterns which supplied water to this public building, and, most important of all, the first ancient theater in Egypt (K. Michalowski, "Teatr w Aleksandrii," *Polska*, 11, 1966, p. 147; "Polish Archaeological Discoveries in the Middle East," *Polish Facts and Figures,* no. 790, June 1966;

"L'Archéologie méditerranéenne en Pologne après la seconde guerre mondiale," *Études et Travaux, Travaux du centre d'archéologie méditerranéenne de l'Académie Polonaise des Sciences*, III; J. Lipinska, "Polish Excavations at Kom el Dikka in Alexandria," *ibid.*; J. Leclant, *Orientalia*, 33-36, 1964-67).

Although they date from the late Roman period, these buildings are the only extant architectural relics of ancient Alexandria. The results of the Polish excavations have already considerably modified our previous view of the city's topography. What was though to be the ancient Paneion hill turnr out to be a mound of rubble dating from Arab and Napoleonic times. The bath establishment is one of the best-preserved buildings of this type in Egypt. The height of the surviving portions of the walls reaches 19 1/2 feet. The cisterns and filters discovered near the baths will help to answes one important question concerning ancient Alexandria, for its water-supply system was one of the best in ancient metropolises. As late as the mid-nineteenth century there were up to 700 cisterns in the city. Today only one of them, the so-called El Nabi cistern near Sultan Hassan Boulevard, is accessible. Some three-storied cisterns supported by granite columns were rebuilt several times in the Christian and Arab periods.

The theater at Kom el Dikka also discloses several stages of rebuilding. The foundations may go back to the second century A.D.; it is probable that it was rebuilt twice and reduced in size. The seats were made from marble friezes and architraves taken from older (now submerged) buildings near the shore. Under the seats, coins have been found dating from the reign of Constantius II (337-361 A.D.), making it possible to fix the approximate date of this remodeling. There were then semicircular loges in the upper part of the structure, and the stage was adorned with monolithic granite and marble columns. The theater was eventually dismantled and the stage covered over with a brick dome. Marble consoles with the sign of the cross were found in its ruins, indicating that the theater was converted into a church. From coins discovered under the fallen columns, it appears that the vault collapsed in the sixth century A.D., perhaps from the earthquakes that shook Alexandria and the coast of Syria and Egypt at that time. The theater was found in a state that permits partial reconstruction. The first phase was completed by the Polish mission in 1967 (architect W. Kolataj). The missing parts of the seats on the stage have been replaced with stone blocks from Moqattam, and a partial restoration was carried out.

Many other ancient Alexandrian buildings were converted into churches or houses of prayer in the Christian period: the temple of Chronos was converted into the church of St. Michael, the Caesareum into a cathedral, and possibly the Serapeum into the church of St. John the Baptist. Also new churches were built in Alexandria, notably those dedicated to St. Mark and to St. Athanasius. At the end of the fourth century, during the persecutions of pagans under Theodosius I, the patriarch Theophilus ordered the destruction of many ancient monuments, sculptures, and buildings, including the temple of Dionysos, the theater in the royal quarter, and, most important of all, the Serapeum. In 415, the patriarch Cyril led a mob of fanatics who destroyed the Jewish quarter and murdered the pagan philosopher Hypatia, daughter of the mathematician Theon. A hundred years later, the empress Theodora ordered part of Alexandria to be burned because its inhabitants refused to recognize her protégé, the Monophysite bishop Theodosius.

The capture of Alexandria in 619 by Chosroes (Khosrau), king of Persia, and in 642 by Caliph Omar's army put an end to the growth of the ancient city. The powerful defensive walls that had been the pride of Alexandria since the Hellenistic period were considerably damaged during these invasions. In the ninth century the Arab governor of Egypt, Ahmed ibn Tulun, ordered part of the walls to be dismantled, and blocks from them were used to build Arab fortifications which enclosed a considerably smaller area. This event vividly illustrates the decline of the once magnificent Alexandria-in-Egypt, whose historical role, however, had already ended: in a sense, its fate was sealed when the Arabs founded the new capital Fustat.

Alexandria poses a riddle so far unsolved: where is the mausoleum of Alexander the Great? This question has long tantalized archaeologists and students of ancient civilizations. The location of the famous Soma (σωμα or σημα) which contained the tombs of the great conqueror and his successors has given rise to many conjectures and interesting hypotheses (A. Adriani, *Annuario del Museo greco-romano*, 1935-39; M. L. Bernhard, *RA*, 1956; A. J. B. Wace, *Bulletin of the Faculty of Arts of Farouk I University, Alexandria*, II, 1944; A. Lane, *ibid.*, V, 1949), as well as to numerous fantastic speculations that have been disproved by archaeological investigations. Modern archaeologists are in no better a position than was the Church Father John Chrysostom, who as early as the end of the fourth century searched in vain to locate Alexander's mausoleum.

870. ALEXANDRIA.
VIEW OF THE THEATER

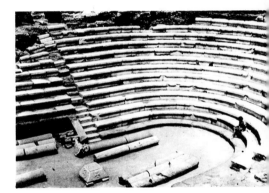

871. ALEXANDRIA.
SEATS OF THE THEATER

III. REGION OF THE FAYUM

16. THE FAYUM

The name derives from Pa-yum ("sea"), used during the New Kingdom to designate the lake formerly called Cha-resy ("South Lake"). The Fayum is an oasis in Middle Egypt which lies west of the Nile and is connected with the river by one of its arms, called the Bahr Yusuf (G. Caton-Thompson and E. W. Gardner, *The Desert Fayum*, I-II, 1934).

The shores of the great lake had already been settled in the late Paleolithic Period (*ibid.*, II). In the Neolithic Period the regions bordering on the oasis were partly inhabited by Bedouin tribes whose material culture corresponded to the so-called Group A of Upper Egypt. Relics dating from the early Chalcolithic Period (4000-3600 B.C.) have been found near the Fayum; they correspond to Group B of Upper Egypt (W. C. Hayes, *Most Ancient Egypt*, 1965). Since prehistoric times the region has steadily become more arid. The nobles of the Old Kingdom hunted in papyrus thickets on the shores of the lake, which was noted for its succulent fish. An early text reports that cucumbers were cultivated in the area.

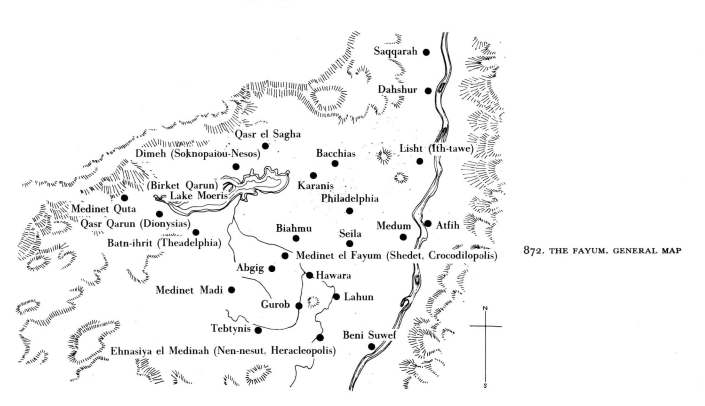

872. THE FAYUM. GENERAL MAP

On the eastern edge of the oasis, near the present-day village of Seila, stands an unfinished pyramid made of limestone blocks, its base about 72 feet on each side. Most scholars date it from Dynasty III because of its similarity to the famous step pyramid of Zoser at Saqqarah. But is this really a pyramid? So far no one has investigated the substructure. It stands entirely alone: unlike other pyramids, it has no tombs around it (Borchardt, *ASAE*, 1; Fakhry, *The Pyramids*). Another entirely isolated monument in the Fayum area is the small, unfinished temple built of limestone blocks at Qasr el Sagha, a few miles from Dimeh. There are neither reliefs nor inscriptions on the walls. One portion seems to date from the Old Kingdom. The temple consists of seven chapels opening onto a court, and one can infer that seven deities were worshiped here (Caton-Thompson and Gardner, *The Desert Fayum*, pp. 134-35).

The ancient architecture in the Fayum and its distribution around the oasis clearly point to

two distinct historical periods—the Middle Kingdom and the Ptolemaic Period. Accurate demarcation of the oasis boundary is no simple task. According to Greek travelers, the area extended about 447 miles at its longest point, but this figure seems exaggerated, even when the subsequent encroachment of the desert is taken into consideration. Moreover, a number of sites along the Bahr Yusuf, near the oasis but not within it, are today sometimes referred to as Fayum sites, such as Lahun, Gurob, and Hawara. This discussion is restricted to sites that were incontestably within the oasis area in antiquity. An entirely schematic plan of the Fayum has come down to us, the famous Lake Moeris Papyrus (Lanzone; Botti, in *VIII^me Congrès international d'histoire des religions*, Rome, 1955). P. Montet (*Géographie*, II, p. 213) rejects the view that the papyrus published by Lanzone is a description of the Labyrinth at Hawara; according to him it deals with the geography of the oasis, as does the Amherst Papyrus. Other lists (see also Yoyotte, "Processions géographiques mentionnant le Fayum et ses localités," *BIFAO*, LXI) mention sixty-five settlements there in the Late Period. Up to now a scant few of these have been identified. The Middle Kingdom rulers undoubtedly constructed dikes, dams, and canals in this area, reclaiming considerable tracts for cultivation and for building towns and temples.

According to a tradition handed down by Herodotus (II, 149-50), one of the most remarkable engineering works of the Dynasty XII Pharaohs was a network of canals that regulated the water level in the great lake by collecting the overflow in the flood season and serving as a reservoir for the Nile valley during the rest of the year. In other words, the lake that the Greeks called Moeris (today Birket Qarun) may have served Middle and Lower Egypt in ancient times much as the reservoir created by the Aswan dam does today.

First among the temple structures is the Amenemhat III temple in the capital of the Fayum, which was called Shedet by the Egyptians, Crocodilopolis by the Greeks (because the population worshiped crocodiles, animals sacred to the god Sobek), and today is known as Medinet el Fayum. Only a few blocks remain of the temple, fragments of granite palm columns, and a few decorated fragments now scattered among various museums (Petrie, *Hawara; Orientalia*, 35). The red granite obelisk with the cartouche of Sesostris I, found in the vicinity of Abgig (or Begig), presumably came from this temple. One might infer from this that Amenemhat III merely enlarged a sanctuary begun by his predecessors, but the majority of the blocks found here date back to this Pharaoh. Dynasty XIII kings added decorations, such as the statue of Neferhotep (today in the Museo Civico of Bologna).

Excavations in the Fayum have yielded the best-preserved example of a Dynasty XII temple. This is the small temple built by Amenemhat III and Amenemhat IV, discovered at Medinet Madi in 1936 by the Italian archaeologist Vogliano (*Secondo rapporto degli scavi... Medinet Madi*, 1936-37; Donadoni, *Orientalia*, 3). It was dedicated to Rennut, the goddess of harvests, and the god Sobek.

The many relics of monumental sculpture discovered in the Fayum area include the pedestals of the Amenemhat III colossi at Biahmu mentioned by Herodotus (II, 149). These have little importance to the study of Middle Kingdom art, but enough works of sculpture have been discovered in the oasis and neighboring sites to enable us to recognize a distinct "Fayum School" with a style of its own and a discernible influence in the history of ancient Egyptian sculpture (Vandier, *Manuel d'Archéologie*, III, pp. 173, 195, 265).

Were the Fayum not the most fertile and most densely populated province of Egypt—a circumstance that hampers systematic excavation—it would surely supply us with many valuable architectural and artistic monuments dating from the Middle Kingdom. The New Kingdom rulers had little interest in this province. Finds made at Dimeh indicate that there was some building activity under Dynasty XVIII; the Ramessides enlarged the temple of Sobek at Medinet el Fayum. There is a New Kingdom papyrus (Gardiner, *The Wilbour Papyrus*) listing the temples that stood in the Fayum in that period.

Under the Ptolemies the oasis had a second flowering. Ptolemy II carried out ambitious irrigation projects to counteract the area's gradual desiccation. In this period the city of Crocodilopolis was made capital of a separate nome, named Arsinoë for the king's sister-wife; previously the Fayum had fallen within Nome XXII ("The Scraper"). Ptolemy II founded many cities in the Fayum, peopling them with veterans or with Greeks from the Delta. The Greeks enjoyed a privileged status here, as can be seen in their material possessions and higher living standards. It was they who introduced large-scale viniculture into the Fayum. The social and economic life of the Ptolemaic Period is well known to us, thanks to large collections of Greek papyri. Among the most important are those discovered by Flinders Petrie (J. Mahaffy and J. Smyly, *The Flinders Petrie Papyri*, I-III, 1891-1905), and those discovered later at Magdola by P. Jouguet and G. Lefebvre (O. Guéraud, *Papyri grecs*, II).

Particularly interesting is the so-called Zeno archive, accidentally discovered near Darb Gerzeh by fellaheen a few years before World War I (see A. Swiderek, *La société gréco-égyptienne du Fayoum*, in Polish, with French summary, Warsaw 1959). The Greek papyri from the Fayum include fragments of lost literary works (R. A. Pack, *The Greek and Latin Literary Texts from Greco-Roman Egypt*, 1965).

873. THE FAYUM. SCHEMATIC PLAN, *from the Lake Moeris Papyrus*

In addition to founding new cities (B. P. Grenfell, A. S. Hunt, and D. S. Hogarth, *Fayoum Towns and their Papyri*, 1900) the Ptolemies considerably enlarged Crocodilopolis, whose ruins are located in the northern part of Medinet el Fayum, in the Kiman Fares quarter. This site yielded numerous objects from the Middle Kingdom (*ASAE*, 37) and includes the ruins of the Graeco-Roman city. It had been systematically looted, especially at the end of the nineteenth century. Recently an Italian expedition carried out excavations (*Orientalia*, 35). It was in this city, on the shore of the temple's sacred lake, that Strabo (XVII, 811) watched crocodiles being fed—no doubt one of the great tourist attractions of the period. Bacchias, situated on the shore of the lake, was excavated by Hogarth and Grenfell in 1895-96 (Hogarth and Grenfell, "Cities of the Fayum," *Arch. Rep.*, 1895-96). They discovered a small brick temple dedicated to a local variant of the god Sobek. One of the most thoroughly investigated settlements of the Fayum is Karanis (today's Kom Aushim), excavated by the University of Michigan expedition in 1924-29. Two temples and sizable sections of different quarters were brought to light. One temple, completed under Nero, was dedicated to the local deities Pnepheros and Petosukhos. The deity worshiped in the other (northern) temple was the crocodile. The American excavators accurately determined the layers of the town from the Ptolemaic to the Early Christian period. Apparently it was abandoned early in the fifth century A.D. (A. E. Boak and E. E. Peterson, *Karanis*).

On the northern shore of the lake lie the ruins of Soknopaiou-Nesos, the present-day Dimeh. This city flourished from the second century B.C. to the third century A.D. Excavations here, first by the Egyptian Antiquities Service, then by a German and lastly an American expedition, uncovered a paved road that led to the temenos where two temples were found. One of them, as the foundations indicate, was of stone. Dimeh is probably the only place in the Fayum where decorated Dynasty XVIII blocks have been discovered, testifying to building activity in that period. At Dimeh also was found a famous set of granite and basalt sculptures dating from the end of the first century A.D. These portraits of local dignitaries and priests are executed in the Egypto-Roman style.

On the western shore of the lake lie the ruins of two Ptolemaic settlements—Medinet Quta and Qasr Qarun. The latter, then called Dionysias, contains the ruins of a late Ptolemaic stone temple dedicated to Amon-Khnum. There are also the ruins of a pavilion and of a brick temple. The excavations conducted there by a Franco-Swiss expedition (J. Schwartz and H. Wild, *Qasr-Qarun-Dionysias, 1948*, 1950) brought to light the remains of a building with well-preserved baths.

Another town in the Fayum in the Ptolemaic Period was Theadelphia (present-day Batn-ihrit). Although small, it had no fewer than seven temples, four of which possessed the right of asylum. The main temple, dedicated to the local god Pnepheros, was founded by Ptolemy III Euergetes. Its pylons and altar are reconstructed in the courtyard of the Alexandria Museum (E. Breccia, *Alexandrea ad Aegyptum*, 1914, p. 285). The excavations, which also brought to light Greek papyri, were conducted by the German expedition under O. Rubensohn from 1902 on.

Another city founded by the Ptolemies is especially noteworthy—Philadelphia (today's Darb Gerzeh), situated halfway between the lake and the Nile. Grenfell and Hunt investigated it as early as 1900, but in 1908-9 the ruins of the ancient settlement were discovered by the German archaeologists Zucker and Viereck. Among their most important finds are ostraca and papyri (Viereck, *Philadelpheia*), among them the Zeno archive.

South of the site of Crocodilopolis (Kiman Fares) lies Medinet Madi, where once stood a small temple built by Amenemhat III and Amenemhat IV and later enlarged by Sety II, Ramesses III, and Osorkon. In the Ptolemaic Period the ancient town was considerably larger and bore the Greek name Narmouthis. The Middle Kingdom temple was embellished with a processional walk quite out of proportion to so modest a sanctuary. A small chapel added at the back had an entrance on the north. The first excavations conducted here by P. Jouguet uncovered a number of houses from the Graeco-Roman period and some Greek papyri of the second century A.D. The excavations conducted in 1963 at Kiman Fares by the Egyptian Antiquities Service, under the direction of El-Kachab, uncovered well-preserved Graeco-Roman baths, with separate facilities for men and women.

Tebtynis, a site south of Medinet Madi, fell within the area known in ancient times as Tebdeben (today's Tell Umm el Breigat). It has been excavated by several missions. Grenfell and Hunt, who excavated this site in 1899-1900 under the auspices of the Egypt Exploration Fund, discovered a large number of Greek and demotic papyri in the mummy cases of crocodiles, dating from the Roman period (*Tebtynis Papyri*, I-III, 1902-38). The German excavations conducted by O. Rubensohn in 1900 and the successive Italian expeditions after 1930, under Anti, Bagnani, Fiocco, and Vogliano, yielded more papyri and brought to light an early Ptolemaic temple and part of the city's ruins.

The sites discussed here were the most important centers of population in the Ptolemaic Period. Grenfell and Hunt also investigated Philoteris and Euhemeris, and the Ptolemaic texts mention a great many more towns and settlements in the Fayum. In Roman and Early Christian times the oasis did not develop further, although towns such as Dimeh have yielded interesting statues in the Graeco-Roman style.

The excavated cities show that in Roman times building activities continued, often using Ptolemaic foundations. Many of the papyri discovered in these cities date from the Roman period. Among the most important finds are the famous Fayum portraits (figs. 136, 138, 701-8). These were executed either on mummy cases or on wood tablets placed over the mummy's face. They were painted in tempera or encaustic. The first great discovery was made in 1887, when fellaheen scouring the *koms* for Fayum antiquities—then in great demand—stumbled on a considerable collection of these portraits in a cemetery. They were bought by Teodor Graf, a Vienna dealer, and now the collection is scattered among museums in Berlin, Vienna, New York, and Berkeley, California. From the time of their discovery, the Fayum portraits have aroused great interest in the learned world. Similar works found outside the Fayum have been classified under the same label. However, most of the investigations have been concentrated in the oasis, and on the advice of Gaston Maspero, then director of the Egyptian Antiquities Service, Flinders Petrie went twice to the Fayum looking for portraits of this kind in cemeteries of the Roman period. The original collection has steadily grown until, in 1961, 77 museums and private collections on four continents owned 478 so-called Fayum portraits, dating from the first four centuries A.D. (H. Zaloscer, *Porträts aus dem Wüstensand*). Some are portraits of pagans, some of Christians, but they have one stylistic feature in common—the promise of a new style of expression, which was to culminate in the Byzantine icon. In the second century A.D. the Coptic Christian community at Arsinoë was one of the best-organized centers of the new religion, and during the reign of Commodus, Arsinoë had three bishops and 10,000 monks. Thus it is hardly surprising that many Coptic reliefs and sculptures come from the Fayum. As for the architecture of the Coptic period, eight monasteries have survived to this day.

17. LAHUN

The Egyptian ⌐⌐⌐⌐⌐ = Ro-henty, which may be translated as "gate of the canal (or the lake)" or "mouth of the crocodile." Situated on the east bank of the Bahr Yusuf, across from Gurob, at the entrance to the Fayum oasis (Petrie, *Kahun, Gurob, and Hawara*, 1890; *Illahun, Kahun, and Gurob*, 1891; Brunton, *Lahun*, I; Petrie, Murray, and Brunton, *Lahun*, II, 1920-23). Today the area is in the desert, at the edge of the cultivated section. It is bounded on the south by Predynastic and Old Kingdom (Bashkatib) cemeteries, on the north by the ruins of the town of Kahun.

At the mouth of the Fayum canal stood the Osorkon I fortress; no trace of it remains. According to Strabo (XVII, 36), the dykes serving to regulate the water level of Lake Moeris were situated near the fortress.

The funerary complex of Lahun and the town were built by Sesostris II. His pyramid at Lahun has a number of noteworthy peculiarities in its superstructure. Its square base measured about 351 by 351 feet, its height was probably 157 1/2 feet, and its angle of inclination was 42°35'. Its core consisted of an outcropping of rock; low stone walls radiated from the center outward and were joined by others to form a lattice pattern; the spaces between were filled with dried bricks; and the whole was faced with thin polished limestone. At the top was a pyramidion of black granite—parts of it were discovered by Flinders Petrie when he first excavated this site. Around the base of the pyramid a shallow trench filled with sand served to drain off rain water; the trench was bordered by a stone pavement that extended to a low, niched parapet hollowed out of the rock. A second wall of dried brick surrounded the entire funerary complex.

The entrance to the pyramid was through shafts dug in the rock a short distance to the south—an exceptional feature—and led to the burial chamber via a number of corridors and inner shafts. This complicated design suggests that the builders might have made use of an older tomb which had protective devices against plunderers. In the chamber was the royal sarcophagus, and a gold uraeus from the crown was found. Near the shafts leading to the pyramid of Sesostris II four other underground entrances were brought to light. One of these led to the tomb of Princess Sat-hathor-yunet, where in 1914 an ebony case containing her beautiful jewelry was discovered in one of the niches (some of it is now in the Cairo Museum, some in the Metropolitan Museum, New York; see Brunton, "The Treasure," in *Lahun*, I). Particularly interesting is a beautiful gold and enamel pectoral (fig. 795).

Adjacent to the pyramid on the east side was a funerary temple, today completely destroyed; it was probably built of red granite. It is still possible to locate the spot where the lower "reception" temple stood, as well as the ramp leading to it. On the north side of the enclosure, against the wall are eight mastabas; to the east is the so-called Queen's Pyramid, of which the burial chamber has not yet been excavated. This pyramid, larger than most other such structures, necessitated a sizable bulge in the enclosure wall to accommodate it.

At a short distance north of the pyramid are the remains of a structure which some archaeologists think was a Heb-Sed pavilion. East, north, and west of the pyramid are rock tombs of Dynasty XII dignitaries. Some of them were reused under Dynasties XVIII and XXII. A separate group of tombs dating from Dynasties XXII-XXV lies southwest of the pyramid on the edge of cultivated fields.

874. LAHUN.
PLAN OF THE PYRAMID OF SESOSTRIS II
1 *Royal mastabas*
2 *Queen's Pyramid*
3 *Funerary temple*
4 *Tombs of the princesses*

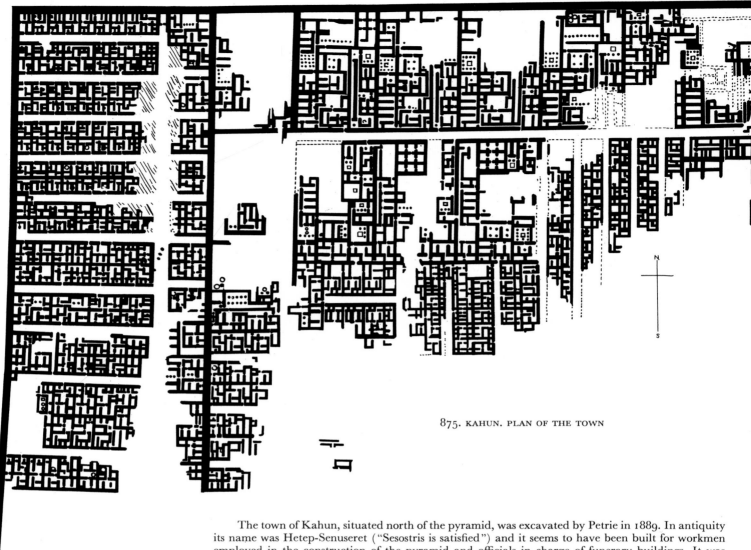

875. KAHUN. PLAN OF THE TOWN

The town of Kahun, situated north of the pyramid, was excavated by Petrie in 1889. In antiquity its name was Hetep-Senuseret ("Sesostris is satisfied") and it seems to have been built for workmen employed in the construction of the pyramid and officials in charge of funerary buildings. It was surrounded by a dried-brick wall enclosing a rectangle of 1,148 by 1,312 feet which was perhaps open on the side of the Nile. Two gates led to two sections of the town. The western quarter, occupying about one-third of the surface of the town, was separated from the eastern quarter by a dried-brick wall; it was bisected by a street running north-south, which was 28 1/2 to 32 feet wide, and from which narrow lanes led to individual residential complexes. More than 200 houses, rarely of more than three rooms, served as workmen's dwellings. The eastern quarter, more than twice the size of the other, had spacious houses composed of many rooms—sometimes as many as 70. Some of these houses have colonnades forming something like peristyles, with ponds. There were also large patios, courtyards, women's apartments, service quarters, kitchens, and storehouses. The plan of Kahun with its regular grid of streets and its crowded buildings is an eloquent picture of living conditions in ancient Egypt and the class differentiations of Egyptian society.

The so-called acropolis near the wall in the western quarter may actually have been a royal palace. At all events, Kahun seems to have been Sesostris II's main royal residence and the country's capital city.

Excavations in this area have yielded many objects which give us an idea of how the dwellings were furnished. The most important finds, however, are the hieratic papyri, discovered in dwellings and particularly in the temple of Anubis situated near the town's southern wall. (Stone blocks from this temple were used by Ramesses II for rebuilding the temple at Heracleopolis.) The papyri date from the last kings of Dynasty XII and the first two kings of Dynasty XIII; they include literary works, medical and mathematical treatises, private letters, and legal and financial documents. These are especially interesting, for they enable us to reconstruct the administrative divisions of the town and the province during the Middle Kingdom. From them we also learn a great deal about the methods of taking census of the population and heads of cattle, and other administrative practices. The papyri also include notarial acts such as wills made by private individuals (Griffith, *Hieratic Papyri from Kahun and Gurob*, I-II, 1898).

Lahun has cemeteries dating from various historical periods—the oldest go back to Predynastic times, the most recent is a cemetery of crocodiles built in Roman times. But the most important elements of this archaeological complex are associated with the activities of a single ruler, Sesostris II.

18. GUROB

On the west bank of the Bahr Yusuf, near the southern border of the Fayum. Identified with
〜〜☉ = Mer-ur, which is mentioned in papyri; in hieroglyphs, the determinative indicating
"city" distinguished its name from that of the lake.

The main god worshiped was Sobek. The nearby necropolis was excavated by Brunton and Engelbach; it contains tombs dating from the Predynastic Period, the Old Kingdom, the First Intermediate Period, and the New Kingdom (G. Brunton and B. Engelbach, *Gurob*, 1918; Loat, *Gurob*, 1904). As a site of monumental architecture, however, this town owes its importance to Tuthmosis III. The ruins of two temples were discovered here. The better-preserved temple was enclosed by a wall of bricks stamped with the royal cartouche. The position of a few surviving columns enables us to state that the temple had a covered portico and a hypostyle hall. Some of the blocks from this temple bear the cartouches of Amenhotep III, Akhenaten, and Tut-ankh-amon. It seems that it was torn down by Ramesses II.

Flinders Petrie's excavations of 1889-90 (*Kahun, Gurob, and Hawara; Illahun, Kahun, and Gurob*) in the vicinity of this temple brought to light another, smaller one, built entirely of brick and dedicated to Tuthmosis III. Today even the place where this temple stood is difficult to find, but we have its plan, which was drawn during the excavations. The temple had two courts with columned porticoes. From the smaller court a staircase led to a terrace with three sanctuaries at the far end. The middle sanctuary was used for the cult of the Pharaoh; the two others contained votive steles dedicated to him.

Gurob also had a palace belonging, probably, to Amenhotep III's wife Queen Tiy, who owned large estates in the Fayum. The plan of the palace cannot be reconstructed. Its ruins contained an ebony head of the queen (fig. 383), which is one of her most beautiful portraits (Borchardt, *Der Porträtkopf der Königin Teje*, p. 3). Other finds from Gurob included a group of ebony statuettes dating from the time of Amenhotep III and Tiy; today these are scattered in various museums and private collections.

19. LISHT

Royal necropolis of Dynasty XII; north of Medum, between the Old Kingdom necropolis at Giza and the Fayum oasis. Rock-cut tombs dating from the Old Kingdom were also found here. According to some scholars, the capital referred to in texts as Ith-Tawe, which was founded by a Dynasty XII ruler near the Fayum, on the border between Upper and Lower Egypt, was situated in the vicinity of Lisht (Petrie, *Hawara, Biahmu, and Arsinoë*, 1889; *Kahun, Gurob, and Hawara*; Petrie, Wainwright, and Mackay, *The Labyrinth, Gerzeh, and Mazghuneh*, 1912).

At Lisht are the ruins of two pyramids of Dynasty XII kings, surrounded by mastabas of their dignitaries. Systematic excavations at this site were conducted by the French Archaeological Institute (Gauthier and Jéquier, *Mémoire sur les fouilles de Licht*) and later by the Metropolitan Museum of Art (*BMMA*, II-IV, IX, and Part II, 1920-24, 1926, 1932-34). The northern pyramid belonged to Amenemhat I, and we can identify the names given to its pyramidion, its temple, and its pyramid complex. The core of this pyramid was constructed on a rocky platform with blocks that had been cut during the Old Kingdom, probably coming from the Memphite necropolis (Abusir and Giza). Blocks of the same provenance were also used for paving the platform around the pyramid and in some adjacent structures. No thorough study has yet been made of the pyramid's core, which certainly might supply valuable documentation from the earlier period. Little has been left of the facing of polished Turah limestone. Originally this pyramid was about 194 feet high, each side measured 275 1/2 feet at the base, and its angle of inclination was about 54°.

The entrance to the pyramid was in the middle of the north face, behind the false granite door built into the back wall of a small chapel, similar to the chapels that one finds adjacent to pyramids of Dynasty VI and sometimes of Dynasty V. The corridor leading into the pyramid was lined with granite; after the king's funeral, the corridor was blocked with large granite slabs. The burial chamber beneath the center of the pyramid has never been investigated because it is permanently flooded by subsoil water. The pyramid was surrounded by a stone wall, and on a lower terrace east of the pyramid stood the funerary temple. A ramp connected it with the valley temple (of which nothing is left); fragments of the ramp have been preserved; it did not extend beyond the funerary temple to the pyramid.

We can discern two stages in the construction of the upper funerary temple. First it was built of dried brick; later it was rebuilt in stone on a platform, but it was still lower than the level of the pyramid. Near the pyramid stood a small satellite pyramid; a little farther away was the mastaba of the vizier Antefoker, superintendent of the pyramid town. The large mastaba of the vizier Rehu-er-djersen lies at the southwest corner. West of the pyramid are several tombs of princesses, and northeast are two large mastabas. A second wall of dried brick enclosed the tombs nearest the pyramid and the upper temple; outside were the mastabas of Dynasty XII dignitaries.

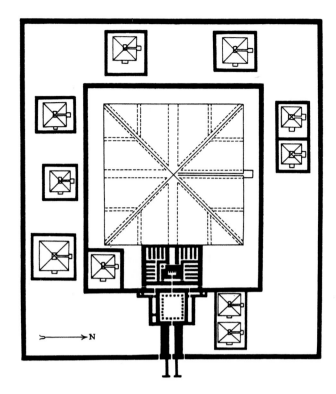

876. LISHT.
PLAN OF THE PYRAMID OF SESOSTRIS I

> N

About a mile south of the pyramid of Amenemhat I lie the ruins of the pyramid of Sesostris I, which has been thoroughly explored by French and American archaeologists. It bears a close resemblance to the pyramid of his father. Its name, too, has been found. Like the northern pyramid, it was surrounded by a stone wall (partly preserved) within which stood a satellite pyramid and the inner half of a funerary temple. The wall around the pyramid deserves special mention: it was 6 1/2 feet thick and about 16 feet high, and was decorated at regular intervals, both inside and outside, with monumental low reliefs bearing the royal emblem. These reliefs are 3 1/4 feet wide and inscribed with the king's Horus name (Serekh). Between this wall and an outer wall of dried brick stood the front half of the funerary temple and nine small pyramids belonging to members of the royal family. Each of these had its own enclosure wall, a small funerary temple, and a north chapel.

Originally the pyramid of Sesostris I was about 200 feet high, its sides each about 344 feet at the base, and its angle of inclination about 49°. Its core consisted of a skeleton of retaining walls radiating from the center and linked by auxiliary walls. The compartments thus formed were filled with rubble and sand, and covered with a facing of polished limestone, partially preserved. The entrance was on the north face, partly masked by the small chapel. The corridor leading into the pyramid was faced with granite; it widened beyond the first 49 1/4 feet. The mortuary chamber beneath the center of the pyramid is inaccessible because of subsoil water.

The plan and decorations of this pyramid's funerary temple exactly reproduce those of the temple of Pepy II at South Saqqarah. It was a truly monumental edifice, consisting of a court with a portico and several inner chambers. The beautiful reliefs on its walls are among the finest of the Middle Kingdom (figs. 301, 302). On both sides of a corridor linking the lower and upper temples, at intervals of about 33 feet, were magnificent painted limestone statues of the Pharaoh, ten showing him seated, the others in the pose of the god Osiris, each in its own niche; some of these are in the Cairo Museum, others in the Metropolitan Museum, New York (fig. 83). Among the other objects found by American excavators is the collection of jewels from the tomb of Senebtisi (Dynasty XII), discovered near the Amenemhat I complex (H. E. Winlock and A. C. Mace, *The Tomb of Senebtisi at Lisht*, 1916).

The successors of Amenemhat III and Sesostris III are also represented at Lisht by a number of structures, such as the mastaba of Sehetep-ib-re-ankh (fig. 317), south of the pyramid of Sesostris I. American archaeologists have brought to light the remains of a town including a jeweler's shop dating from Dynasty XX. In shafts leading to burial chambers near the small pyramids around the funerary temple of Sesostris I, offering tables were discovered with inscriptions dating from Ptolemaic and Roman times. These finds show that the Lisht necropolis, whose most important structures go back to Dynasty XII, was also used in later periods.

20. HAWARA

At the southern tip of the so-called Fayum Corridor, where the Bahr Yusuf enters the Fayum through a gap in the desert hills.

Hawara is the site of the ruins of the funerary complex around the pyramid of Amenemhat III (Petrie, *Hawara, Biahmu, and Arsinoë; Kahun, Gurob, and Hawara;* Petrie and others, *The Labyrinth, Gerzeh, and Mazghuneh*). This Pharaoh had another pyramid at Dahshur, but he was buried at Hawara. The superstructure of his Hawara pyramid was of dried brick overlaid with a thin facing of limestone. The base is a square roughly 328 feet to a side, it stood about 190 feet, and its angle of inclination was 48° 45'. The entrance was in the south face. Instead of an inclined corridor, a flight of steps led down from the entrance to a vestibule cut out of the rock. There, one passage ran northward to a dead end; a second passage ran east, then north, and finally west, to the burial chamber. The latter passage was blocked at several points by large stone slabs.

The construction of the burial chamber deserves special attention. First a large shaft was sunk in the rock and faced with stone. Then a huge single block of quartzite which had been hollowed out was lowered into the chamber. It weighed more than 100 tons. Its lid consisted of three enormous quartzite slabs. Just outside the chamber was a vestibule whose floor was level with the quartzite lid. The intention of this ingenious design was to block access to the chamber after the royal mummy had been put in place. Further to confuse would-be grave robbers, false shafts were sunk in the corners of the vestibule. Such devices did not foil Egyptian grave robbers; the wood sarcophagi were burned, and all that remained were two quartzite sarcophagi without inscriptions but believed to be those of the Pharaoh and his daughter Ptah-neferu, and some Canopic chests, also of quartzite. In 1956 a red granite sarcophagus containing Ptah-neferu's jewelry and silver vases inscribed with her name were found among the remains of a small brick pyramid(?) situated southeast of the pyramid of Amenemhat III; this treasure is now in the Cairo Museum.

Directly south of the pyramid lie the scanty remains of what must have been one of ancient Egypt's most magnificent edifices—the famous Labyrinth. Greek travelers admired it more than the pyramids. Herodotus probably called it a labyrinth not so much from fidelity to what the Egyptians may have called it, but simply because the complicated layout of the structure reminded him of the mythical labyrinth of Minos. Today there remain only rubble and fragments of limestone blocks and granite columns. In Roman times and later, the building served as a source of lime; a number of lime kilns have been found on the site. The Labyrinth complex was excavated by Flinders Petrie, who reconstructed a portion of its plan, working from surviving fragments of columns and a few limestone blocks, and relying mainly on the descriptions of Herodotus (II, 148) and Strabo (XVII, I, 37). According to these ancient writers, the Labyrinth comprised a large number of halls, chapels, open courts, porticoes, and peristyles. Herodotus says that it had 1,500 rooms above ground and 1,500 underground, in groups of three and six; that each group had a court surrounded with a portico; and that the entire building was enclosed by a wall and a colonnaded ambulatory. According to Strabo, every ceiling was covered with enormous monolithic blocks of stone, a feature that astonished all visitors. The only material used was stone. Strabo also notes that each nome had its own court and halls in the building. This suggests that the Labyrinth might have been a gigantic civic and religious center, a monument symbolizing the geography of Egypt and erected by Dynasty XII rulers at the entrance to the Fayum oasis. It was they who had made the region Egypt's principal source of grain.

Just what was this edifice? In its ruins Petrie found fragments of statues of Sobek, Hathor, and a king, and two cellae. In 1895 a magnificent statue of Amenemhat III (now in the Cairo Museum) was accidentally discovered nearby. This statue is a masterpiece of the Fayum school of sculpture, distinguished for its far-reaching idealization of royal figures. Most scholars tend to regard the Labyrinth as Amenemhat III's funerary temple. But this view is open to serious objections. The Labyrinth's dimensions are 991 by 793 feet, an area sufficient to include the great temples of Karnak and Luxor. Its complicated layout differs radically from those of earlier and later funerary temples, whose design was dictated by the requirements of the cult of the deceased Pharaohs.

Recently certain writers (Drioton and Vandier, *Les peuples*, II, p. 254; Daumas, *La civilisation de l'Égypte pharaonique*, p. 82) have described the Labyrinth as Amenemhat III's residential palace and seat of government. This view, too, arouses serious doubts. Residential palaces of the Pharaohs were for the most part built of brick; stone was used only for palaces of a more formal character, adjacent to temples, where the Pharaoh showed himself to the people on special occasions at the so-called "window of appearances." At such times he handed out various awards (such as necklaces) to deserving subjects. The palace of Ramesses III at Medinet Habu and that of Sety I at Abydos were of this type. But they are incomparably smaller edifices than the Labyrinth at Hawara, having been built for a specific official purpose. A system of underground rooms such as existed in the Labyrinth, according to Herodotus, would make no sense in a royal palace, whether residential or purely ceremonial.

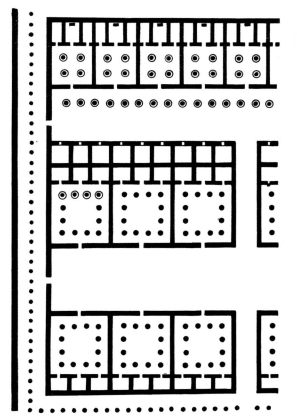

877. HAWARA. RECONSTRUCTED PLAN OF THE WEST PART OF THE LABYRINTH

Since neither hypothesis is satisfactory, one is tempted to reconcile them. Perhaps the Labyrinth was a palace adjacent to a temple—a combination often encountered in Egypt. But, apart from the fact that there is no archaeological evidence to support this theory, the scale of this building rules it out. There remains the possibility that the Labyrinth was a monumental administrative center linked with the archives, founded by Amenemhat III but perhaps already started by his predecessors when they established their residence and government center near the Fayum, a region that was the economic mainstay of Dynasty XII. Could it be that their capital Ith-Tawe, referred to in ancient texts but as yet unlocated, was here? (See W. K. Simpson, *JARCE*, II, 1963.) To set up a center of government practically on the border between Upper and Lower Egypt, near the old capital of Memphis and also near Heracleopolis, with its traditionally dissident rulers, would be consistent with the political realities of the Middle Kingdom. Such a center would have provided a monumental assertion of the country's unity—the organizational unity of all nomes under a single ruler, together forming a single state. This explanation is perfectly consistent with what is known of the history of the Middle Kingdom and the objectives of its domestic policies, but it is unsupported by archaeological evidence, which alone can settle the matter.

The purpose of the Labyrinth, however, is not the only thing that remains in the realm of conjecture. It is very difficult to believe that a structure originally built during Dynasty XII could survive down to Strabo's day without the extensive repairs or remodeling that characterize so many other buildings surviving from the Egypt of the Pharaohs. And yet there is no evidence of such work at the Labyrinth. There is one other possible solution. From the description given by Herodotus, it seems that the Labyrinth was built by Egyptian dynasts immediately after the Ethiopian kings were driven out; this could only refer to Dynasty XXVI. Incidentally, Herodotus' account of Psamtik's seizure of power is accepted in its essentials by modern historians (Drioton and Vandier, *Les peuples*, p. 575). In this period Egypt's economic situation was very similar to that of the Middle Kingdom. Although the Saite kings employed different tactics, they achieved the same end as the Middle Kingdom Pharaohs—a redistribution of their feudal lords' wealth. (An income tax was introduced by Amasis.)

But is it possible that so expensive and monumental a structure as the Labyrinth could have been erected in the Saite period? The fact is, despite all kinds of trouble, both at home and abroad, Egypt was economically prosperous in this period. Herodotus (II, 175-80) relates that under Amasis, Egypt was very wealthy; he lists the many edifices and statues this king erected. Amasis even donated a considerable sum for the rebuilding of the temple of Apollo at Delphi. The Saite rulers had no choice but to pursue a flexible policy in their relations with Upper Egypt. Even before Psamtik I, they were faced with the problem of reducing the authority of Mentuemhat, governor of Thebes, who continued to be favorably disposed toward the preceding Ethiopian dynasty. We know that Mentuemhat's most faithful dignitaries, those with the title *iry-pat-haty-a* (a title once used by the nomarchs of the fortress south of Memphis), looked after the royal interests throughout Upper Egypt. One of them, Smatutefnakht, bore the titles "General of Heracleopolis" and "Chief of Boats." At this time the princelings of Heracleopolis had a privileged position that had been granted them by Psamtik I (see Kees, *Nachrichten. . . zu Göttingen, Philologische-Historische Klasse*, 1935, pp. 98-99, 101; Griffith, *Catalogue of the Demotic Papyri in the John Rylands Library*, III, Manchester, 1909, pp. 72-77). Thus, Hawara's geographical location would have been altogether suitable to serve as a center of government in this period. And so, assuming hypothetically that the Saite rulers had problems similar to those faced by their Middle Kingdom predecessors, it would not be unrealistic to suppose they would have recognized the desirability of a center that symbolized Egyptian unity and was located at the very place where practical administrative functions might best have been served.

This hypothesis has the virtue of accounting for a number of otherwise puzzling facts, such as the gigantic size of the Labyrinth and its having survived intact down to the Christian era, without remodeling. Moreover, it accounts for the circumstance that so little has remained of so huge a structure. Only the ruins of other great Saite temples, once so numerous in the Delta region, present a similar picture of such utter destruction. The white limestone of which they were built was used for the production of lime in late Roman and Christian times, at Hawara and elsewhere.

According to P. Montet (*Géographie*, II, pp. 210-11) the Labyrinth has yet to be excavated, for its actual remains may lie inside *koms* as yet unexplored elsewhere in the Fayum Corridor. Consequently, to solve the problem of the Labyrinth, further systematic work on the site of Hawara must be done.

It should be mentioned that north of the pyramid of Amenemhat III lie some Middle Kingdom tombs, and that some of the Dynasty XII rock tombs were reused during Dynasty XXIII; so also were tombs dating from Dynasties XXVI and XXX, and the early Ptolemaic Period, some of which probably belonged to inhabitants of Shedet-Crocodilopolis. Another site 500 yards southeast of the pyramid has a group of Dynasty XII funerary chapels, tombs from Dynasties XX-XXVI, and a vast cemetery dating from the Roman period where some Fayum portraits were found (Petrie *Memphis*, IV).

IV. MIDDLE EGYPT

21. EHNASIYA EL MEDINAH

The ancient ✝︎≈♭☼ or ✝︎♭♭♭☼ = Nen-nesu, from which derived the Arabic Ehnasiya; the Greek name of the town was Herakleous polis, the Roman Heracleopolis Magna. It was the capital of Nome XX ("The Upper Nar Tree") of Upper Egypt, near Tebtynis in the Fayum, on the east bank of the Bahr Yusuf.

Since early times the ram-headed god Herishef (the Greek Harsaphes) was worshiped in this place; the god's sanctuary is mentioned on the Palermo stone. One of the predecessors of King Ny-neter of Dynasty II is said to have visited this sanctuary. Flinders Petrie, continuing in 1904 the excavations begun ten years earlier by E. Naville—who discovered the ruins of the Heracleopolis temple (Ahnas el Medinah)—found a block dating from Dynasty IV (Petrie, *Ehnasya*); this suggests that an Old Kingdom sanctuary had stood here.

According to a tradition handed down by Manetho, Heracleopolis was the capital of Egypt during Dynasties IX and X. No monument from this period has survived *in situ*, nor has the necropolis of the rulers of this capital been found. On the other hand, several rock tombs situated between Mayan and Sedment, west of Heracleopolis, date from Dynasties VII, VIII, XVIII, and XIX. The necropolis at Deshasheh, south of Heracleopolis, also contains Dynasty V and Dynasty VI tombs. The titles of the dignitaries buried there refer neither to the city nor to the Heracleopolitan nome. In Dynasty XII a temple of Harsaphes was built on the site of an older necropolis—hence the inference that the Old Kingdom sanctuary must have been situated elsewhere. Petrie, interpreting the disposition of the blocks remaining from the Middle Kingdom temple, advanced the hypothesis that it had no hypostyle hall. Two of these blocks bear the cartouches of Sesostris II, Sesostris III, and Amenemhat III. The kings of Dynasty XVIII, Ramesses II, and the Pharaohs of the Late Period from Dynasty XXII to XXX enlarged this temple, adding a portico and hypostyle hall. The Spanish excavations conducted in the area of the Harsaphes temple in 1966 (*Orientalia*, 36, 2, 1967, p. 192) found no indication that it ever had a pylon. It had the lower part of a yellow quartzite statue of a king, which was similar to the two statues of Ramesses II discovered southeast of the temple in 1915 (Daressy, *ASAE*, 17, 1918, pp. 33-38).

Ramesses II built another temple to the south, near today's Kom el Aqrib, using some blocks dating from the Middle Kingdom. King Sheshonq I, whose family came from Heracleopolis, was an especially zealous worshiper of Herishef; he even revived the old custom of sacrificing one bull every day to this god. The city was later captured by Piankhy after a victorious battle with the army of Tef-nekht. One of the blocks found near the temple is inscribed with the name of Antoninus Pius, showing that it was restored as late as the middle of the second century A.D. About 590 feet south of the temple the Spanish excavations brought to light a vast necropolis, containing several successive layers of tombs made of crude bricks.

Throughout the history of ancient Egypt, Heracleopolis was an important religious center. Originally its inhabitants worshiped the Nar tree, a species that has not been identified. In Egyptian mythology this was the place where the solar eye destroyed mankind, where one of the battles between Horus and Seth was fought, and where Osiris (and later his son Horus) assumed the title of ruler of mankind. It is not surprising that, as we learn from later sources, the high priest of Heracleopolis bore the title of King of Upper Egypt. Hathor too was worshiped at Heracleopolis, but the main diety was Herishef. He was never one of the great gods of Egypt, but there are many indications that in the Predynastic Period he had been one of the primordial deities in the ancient cosmogonies. During the Old Kingdom, when Ra and Osiris for the first time appear as rivals in the Egyptian cults, Herishef took on features common to both. Plutarch (*De Iside*, 37) identifies Harsaphes with Dionysos. The Greeks also identified him with Herakles—hence the Greek name of the city.

What has been excavated of the Roman city is particularly rich in details of everyday life (Petrie, *Roman Ehnasya*, 1905). The most interesting of the discoveries made here, however, date from Christian times. The fine Heracleopolitan sculptures and architectural decorations which today adorn the Coptic Museum in Cairo were discovered by Naville. They must have belonged to local churches and monasteries whose plans can no longer be determined.

22. HERMOPOLIS MAGNA

The Egyptian ⌷⌷⌷⌷ = Khmunu, in Nome XV of Upper Egypt; the Coptic name for it was Chmun. Its ruins lie near El Ashmunein and Melawy, on the west bank of the Nile. It was capital of Nome XV of Upper Egypt; ancient inscriptions mention Unu, a name derived from the nome's emblem, "The Hare." The Greeks called it Hermopolis.

German excavations during the years 1929-39 uncovered several cultural layers and ruins of religious buildings (Roeder, *Hermopolis, 1929-1939*, 1959). Thanks to many references in ancient texts and inscriptions and the results of archaeological research, the city's development can be traced from prehistoric times down to the Arab period; it was one of the most important cult centers of ancient Egypt.

Its ancient history was bound up with a religious tradition according to which one of the first hills emerged here from the primeval ocean. The greatest deity of Hermopolis was Thoth, referred to as the "Lord of Khmunu" in texts dating as early as Dynasty V. Besides the Great Octad of Hermopolitan deities headed by Thoth, the local population worshiped the goddess Nekhemawy, who was Thoth's companion, Khnum, and the human-headed god Shepsy. From other texts it appears that the god Ahe and the goddess Unut, patroness of the nome, were also worshiped. According to the Hermopolitan tradition, even the Theban Amon was originally a Hermopolitan god. From the earliest times, the Hermopolitan cosmogony competed with the Heliopolitan cosmogony and its famous Ennead.

Underneath the walls of a Middle Kingdom temple were discovered fragments of an Old Kingdom structure. The alabaster quarries in nearby Hat-nub, today's Tell el Amarna, and the nomarch tombs in the nearby necropolis of Sheikh Said, today much ruined, also date from this period. Certain textual references seem to suggest that Hermopolitan nomarchs helped Zoser to the throne (J. Spiegel, *Das Werden der altägyptischen Hochkultur*, pp. 185-91), and according to Middle Kingdom texts Cheops and Mycerinus lavished particular care on the temple of Thoth at Hermopolis. The Sheikh Said necropolis continued to serve the nomarchs in the First Intermediate Period; in the Middle Kingdom it was supplanted by Deir el Bersheh as the main cemetery for nobles. Amenemhat II built the monumental gateway leading to the temple of Thoth, which he remodeled. This temple, then, must have been built early in the Middle Kingdom.

The building activity of Dynasty XVIII at Hermopolis cannot be reliably established, although an inscription in the Speos Artemidos at Beni Hasan mentions buildings erected by Queen Hatshepsut near the temple of Thoth. There are similar references to the building activity of other Pharaohs of Dynasty XVIII. Amenhotep III ordered four colossal granite statues of baboons to be placed in the Thoth temple. Reconstructed from the surviving fragments, they stand today in front of the building that served as the headquarters for the German expedition. Many blocks bearing Akhenaten's cartouche have been found in later structures, but they may have been brought here from nearby Amarna. It is well established that the buildings at Amarna were being torn down for construction material as early as Dynasty XIX. Only two Dynasty XIX structures at Hermopolis are preserved *in situ*. One is a new temple of Thoth built by Sety II not very far from the Middle Kingdom structure; two oversized limestone statues of Ramesses II have been found in front of its gateway. The other temple, south of the first, was dedicated to Amon; begun by Ramesses II, it was completed by Merenptah. A colossal red granite statue of Ramesses II has been discovered in front of this Amon temple. The Harris Papyrus I mentions building activity at Hermopolis under Ramesses II who, in addition to other works, is said to have renovated the enclosure wall of the Thoth temple.

Finds from the Late Period testify that Egyptian rulers still took an interest in this city and its temples. After Piankhy's troops stormed the city, this Pharaoh made ritual sacrifices in the temples of Thoth and the Great Octad.

Mentuemhat, who served as governor of Thebes under Taharqa, was also closely associated with Hermopolis. The names of the high priests of Thoth in the Saite period have been preserved in their tombs. Nectanebo I placed an oversized granite statue of himself in front of the Thoth temple, and near it were found fragments of colossal limestone statues of this Pharaoh. In front of the gateway he also placed sphinxes that had human hands. According to the inscription on a stele discovered at Hermopolis, he renovated the city's temples. Nectanebo II erected two obelisks in the temple of Thoth.

A separate chapter in the history of Hermopolis could be written around the high priest Petosiris, whose family held important offices in the city, beginning in the fourth century B.C. Petosiris built a magnificent mausoleum for himself and his family in the nearby necropolis at Tuneh el Gebel, and renovated the temple of Thoth and the walls of the sacred enclosure.

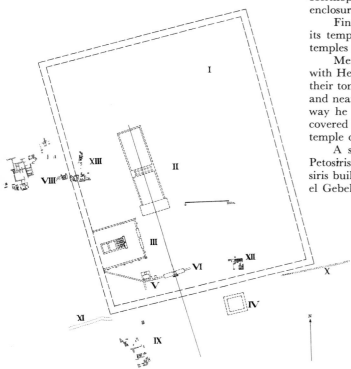

878. HERMOPOLIS MAGNA. GENERAL PLAN
I. *Temple enclosure* II. *Temple of Thoth* III. *Temple of Amon* IV. *Agora* V. *Middle Kingdom temple* VI. *Gateway and sphinxes* VII. *Temple of Ramesses II and emplacement of seated statues* VIII. *Bathing installations* IX. *Nymphaeum* X. *Street of Antinoüs* XI. *Street of Serapis* XII. *Macellum* XIII. *Coptic houses*

The German excavations also uncovered a part of Hermopolis dating from the New Kingdom and the Late Period. The finds cast a great deal of light on the material culture of these times. They include granaries, ovens for baking bread, furniture, faience, bronze, glass jewelry, and large quantities of pottery.

The Ptolemaic and Roman periods mark a high point in the city's history. Greek and Roman writers mention Hermopolis. Many sculptures in the Graeco-Roman style have been preserved. The large number of papyrus fragments of Hermopolitan provenance are evidence that this city was a center of Hellenistic culture equal to Alexandria and Antinoupolis.

A new temple of Thoth was built soon after the Macedonian conquest of Egypt, in the time of Alexander the Great and Philip III Arrhidaeus. Its columned portico survived until early in the nineteenth century, and to several travelers it was one of the most interesting monuments they encountered in Egypt (Denon, *Voyage*, pl. 33); not long after, it was destroyed.

Unlike Alexandria, which was an entirely new city, Hellenistic Hermopolis was an extension of the older city complex. Ptolemy I and his successors completed the temple built by the Macedonians; their names appear in blocks found in its ruins. The papyri mention many temples dedicated to Greek gods built under the Ptolemies. So far, only the remains of temples to Serapis, Aphrodite, and (perhaps) Athene have been discovered, and some inscriptions from a temple to Apollo.

In the late 1940s excavations sponsored by the University of Alexandria and conducted by A. J. B. Wace brought to light the foundations of an Early Christian basilica, formerly regarded as the colonnade of an agora. Many architectural elements from a Ptolemaic sanctuary (second half of the third century B.C.) have also been found. This was probably dedicated to the cult of Ptolemy III Euergetes and his wife Berenice.

The main place of assembly in the Ptolemaic Period was undoubtedly the agora south of the temple enclosure, from which it was separated by a street leading to Antinoupolis. Judging from descriptions by early travelers and from other literary sources, as well as from the papyri, the agora was a square surrounded by columned porticoes. Nearby was probably a bouleuterion.

In the Hellenistic period the city was divided into four main quarters, two northern ones situated on either side of the sacred enclosure, and two south of it. Despite the difficulty of establishing the stratification of Graeco-Roman Hermopolis, archaeological finds such as ceramics and terracottas make it possible to distinguish older Hellenistic elements in the Roman city. Some Roman dwellings also used construction materials from earlier buildings. The Romans seem to have altered the layout of Hermopolis when they rebuilt it. There is a new avenue dating from the reign of Domitian. The city walls, too, were rebuilt; the literary sources mention two gates bearing the same names as gates in Alexandria—the Sun Gate and the Moon Gate. Hadrian, too, built a magnificent avenue; he visited Hermopolis during his stay in Egypt. Although it is recorded that the main arteries ran north-south and east-west, it is impossible today to locate these streets with complete certainty. Tetrastyles stood at intersections; one was excavated by E. Baraize in 1939 (Kamal, *ASAE*, 46). Cartouches of Augustus, Tiberius, Claudius, and Trajan appear on blocks found in the debris near the temple enclosure.

In the Roman period Hermopolis had a temple of Augustus, the Caesareion, and a temple of Hadrian and the Antonines; possibly, Faustina too had a separate temple here. Of Roman civic buildings, the foundations of a macellum have survived; it was situated within the old temple enclosure. Judging from written sources, the town also had a gymnasium, near which the emperor Hadrian established great thermae. Remains of a few public and some small private baths have been discovered in the Roman quarter. The hill on which the ancient temple enclosure was situated was transformed into a kind of fortified castle; the temple enclosure itself had probably been fortified in Ptolemaic times. Four water towers supplied the city with water through underground conduits. It was drawn from the nearby canal, perhaps by means of water wheels.

The Christian period brought far-reaching changes. Many churches of dried brick were built, and the ancient temples were systematically torn down. A Coptic village was built on the ruins of the temple enclosure, and east of the enclosure wall are remains of what must have been more of this village. The most important monumental edifice dating from the Christian period is the great columned basilica built by Bishop Andrew between 410 and 440 A.D. on the site of a Ptolemaic temple. The monolithic granite columns from this basilica are to this day one of the most impressive architectural elements surviving from ancient Hermopolis Magna. Of the triconch type (with three apses), the basilica is one of the oldest religious edifices in Christian Egypt. It is 180 1/2 feet long; the main nave is 48 feet wide; the lateral naves are 18 1/2 feet wide (A. J. B. Wace, A. H. S. Megaw, T. C. Skeat, *Hermopolis Magna-Ashmunein*, Alexandria University of Arts, Publication no. 8, 1959). Formerly it was thought that the Hellenistic agora was located on the site of this basilica, but Wace's investigations have cast considerable doubt on this view.

El Ashmunein still presents many puzzles to the archaeologist. The sculptures found heres have been dispersed among the museums of the world, and there are few architectural fragment to be seen except for the columns of the basilica. Essentially, this is an ancient site awaiting further excavation.

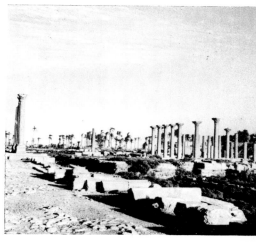

879. HERMOPOLIS MAGNA.
RUINS OF THE TEMPLE ENCLOSURE

23. TUNEH EL GEBEL

West of Hermopolis, inland from the Nile.

This part of the desert was inhabited as early as the Predynastic Period. But from Dynasty XVIII on, it served as a necropolis for dignitaries and inhabitants of Hermopolis. So far no tombs of New Kingdom nomarchs have been discovered here.

At the foot of the Gebel stands an unusually well-preserved stele, one of those marking the boundaries of Akhetaten (Amarna). According to the Harris Papyrus, Ramesses III built a temple to Thoth in this area, as well as a palace. In 1920, G. Lefebvre *(Le tombeau de Petosiris)* brought to light one of the most important monuments so far found in this necropolis—the well-known tomb of Petosiris, high priest of Thoth (365-305 B.C.). It has the form of a small temple, and was constructed in two stages, corresponding to the two styles of the reliefs decorating it. Petosiris himself built the mortuary chapel, in which reliefs in the traditional Egyptian style predominate; even in this part of the structure, however, the figures in the processions represented on the lower frieze on the west and east walls wear Greek garments and their hair is dressed in the Greek manner. By contrast, in the vestibule added after his death, probably by his son or grandson, the iconography and composition are entirely Greek, though the low relief technique is Egyptian. The tomb contained a beautiful sarcophagus inlaid with hieroglyphs in glass mosaic (today in the Cairo Museum). The tomb of Petosiris is notable for its intimations of a new art in Egypt, which was never to be fulfilled (figs. 130, 631-38).

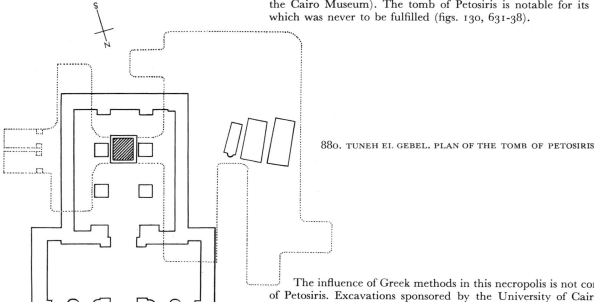

880. TUNEH EL GEBEL. PLAN OF THE TOMB OF PETOSIRIS

The influence of Greek methods in this necropolis is not confined to the decorations of the tomb of Petosiris. Excavations sponsored by the University of Cairo, begun in the 1930s by S. Gabra *(CdE, 20, 22; BSFE, 30; Peintures à fresques)*, brought to light a vast necropolis dating from the Graeco-Roman period. This is indeed a city of the dead: some tombs—built of stone and brick, and decorated with pediments supported by columns in the Hellenistic style—were multilevel dwellings, big enough to house the family of the deceased when they came to make offerings.

In these houses, fragments of beautiful stuccoes and mural paintings have been found, treating such Greek mythological subjects as the Rape of Persephone, the myth of Oedipus, etc. The oldest date from the third or early second century B.C., the latest from the end of the second century A.D. The city of the dead had streets leading to individual tombs. Especially interesting is the tomb of Isidora, built during the reign of Antoninus Pius; besides mural paintings, it contained a poem in Greek commemorating the premature death of Isidora, who was drowned in the Nile. Not far from the tomb of Petosiris the foundations of a great temple to Thoth have been discovered. Rebuilt several times, it measured about 426 by 115 feet and was surrounded by a balustrade of stone pillars over 3 feet high, forming a kind of esplanade 1,968 feet long and 656 feet wide. There is also a maze of underground galleries to which four entrances lead, covering an area of 30 acres. These were catacombs used as burial places for the embalmed bodies of ibises and baboons, animals sacred to Thoth. The remains of thousands of them have been found here.

The many structures discovered in the Tuneh el Gebel necropolis include a two-story brick well joined by a windlass which drew water from the lower basin, possibly to irrigate a man-made garden in the desert or to feed a sacred lake. An interesting hydraulic system was also discovered by A. Badawy.

The Tuneh el Gebel necropolis has yielded a large number of demotic, Aramaean, and Greek papyri containing valuable data on the history of this region and individual local families. Many objects from this site, mostly discovered in the course of older excavations, are today in various museums. Those from the most recent excavations are in the regional museum at Melawy.

24. BENI HASAN

An Arab village on the east bank of the Nile, north of the town of Melawy; the name derives from that of a local family. The rock tombs at Beni Hasan date from Dynasties XI and XII. They were built for the dignitaries of 𓈗𓇼𓈖 = Menat-Khufu, which in ancient times was situated on the Nile at the foot of the necropolis.

Menat-Khufu is one of the oldest place names of which we have record in ancient Egypt, and was probably the birthplace of Cheops and his father Sneferu. Never very large, it would seem to have been administratively dependent on nearby Hebenu, capital of Nome XVI, not far to the north. Nothing is left of Hebenu, but north and south of Beni Hasan several extremely damaged Old Kingdom tombs have been discovered. We know from ancient texts that this nome, like most Egyptian provinces, was completely independent during the First Intermediate Period, and that as late as Dynasty XII its nomarch Amenemhat (surnamed Ameni) had considerable autonomy. The inhabitants of this province worshiped the lion-headed goddess Pakhet, the ram god Khnum, and the frog goddess Heket, as well as Hathor. As the nome's emblem, the oryx antelope, indicates, this animal must have been worshiped there. Great battles took place in this province between the followers of Seth and the followers of Horus. The latter were victorious, and thus some of Horus' titles were "Lord of Hebenu" and "He who smites the enemy in Hebenu."

The rock tombs at Beni Hasan rank among the most important monuments of ancient Egypt (Newberry and Griffith, *Beni Hasan*, I-IV, 1893-1900). Thirty-nine tombs (including twelve with painted decoration), arranged in a row about 65 feet above the Nile, belonged to local princelings; hundreds of more modest tombs are situated a little farther down the slope. Together they constitute archaeological evidence of the greatest value. The famous biographical inscriptions are as invaluable to students of Middle Kingdom history as to students of its art.

Among the most characteristic features of these tombs is the open portico hewn out of the rock itself, and giving access to the chambers within. Each portico is "supported" by two columns, and each column has sixteen flattened channels. The capitals are crowned with abacuses over which rests an architrave, also cut from the rock. Most of the funerary chambers have octagonal columns topped by abacuses, their capitals sometimes decorated with plant motifs. Some chambers, such as the one in the tomb of the nomarch Amenemhat, have polygonal columns with sixteen facets and more elaborate channelings than the columns of the porticoes. Champollion (*Not. Descr.*, II, pp. 433-56) was the first to call these columns "proto-Doric," and this term has passed into general use, but it is inexact because the columns have no direct link with the Greek Doric column; a more suitable term is "channeled column." There were also lotus columns. Sometimes there are two funerary chambers with niches, in which stood statues representing the deceased and members of his family. Not all the tombs at Beni Hasan, however, were conceived on a monumental scale; some, for example, had no portico.

Among the best-preserved and the richest tombs of Beni Hasan are those belonging to Khety (a nomarch under Dynasty XI), Bakht (the father of Khety), Khnumhotep (the mayor of Menat-Khufu) and Amenemhat, surnamed Ameni (nomarch under Sesostris I). The tomb walls are not decorated with painted reliefs, as in tombs of the preceding period, but with mural paintings executed on rocky walls made smooth with plaster.

The paintings in these tombs represent scenes of farming, hunting, fishing, and cattle breeding, craftsmen in their workshops, athletes competing, and acrobatic dancers. These themes are a direct continuation of those encountered in the mastabas of Old Kingdom nobles. Among the best-known scenes are those showing servants feeding antelopes (tomb of Khnumhotep) and a ball game (tomb of Bakht). There are also scenes of vassals paying tribute, funeral ceremonies, and episodes related to the afterlife (figs. 86, 87, 297, 298).

The only important New Kingdom monument at this site is the so-called Speos Artemidos (in Arabic, Istabl Antar), a rock chapel dedicated to the goddess Pakhet by Hatshepsut and Tuthmosis III. The entrance is through a portico of four pillars cut out of the rock; inside there is a long narrow chamber, also with four pillars, and a smaller chamber with a niche where the statue of the goddess probably stood. Over the outside pillars extends a broad band of carved stone that constitutes a sort of horizontal, rather than vertical, stele. Along with plant ornamentation, there is a lengthy inscription dating from the reign of Hatshepsut. Tuthmosis III later erased the names of his aunt, and still later Sety I inserted his own name in the cartouches. Not far from this chapel is another, smaller one, executed in the same period, also dedicated to the goddess Pakhet.

One small rock chapel dates from the Ptolemaic Period. A cartouche incised on the cornice exhibits the name of Ptolemy XI Alexander II.

This entire area of rock tombs was inhabited by hermits during the Coptic period. They, too, left inscriptions on the tomb walls. A Coptic alphabet discovered on a wall in Tomb 23 (that of Netjer-nakht) suggests that it may have served as a school. Tomb 28 seems to have been used as a church. Along the Nile, below the group of Middle Kingdom tombs, lie the ruins of an abandoned Arab village known as Beni Hasan el Khadim (Old Beni Hasan).

881. BENI HASAN.
ROCK-CUT TOMB WITH OPEN PORTICO

882. BENI HASAN. PLAN OF THE SPEOS ARTEMIDOS
1. *Sanctuary* 2. *Portico*

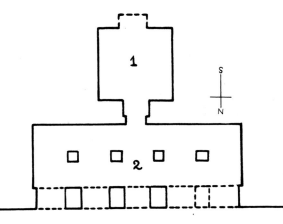

25. DEIR EL BERSHEH

On the east bank of the Nile, near Melawy, between Beni Hasan and Tell el Amarna. Necropolis of the nomarchs of Nome XV ("The Hare") in Upper Egypt, dating from the First Intermediate Period and the Middle Kingdom. Numerous limestone quarries in this area were exploited in antiquity; the hieratic and demotic inscriptions discovered here include two cartouches of one of the Nectanebos. A few modest Old Kingdom tombs are grouped at Sheikh Said, south of Deir el Bersheh.

In the course of excavations sponsored by the Egypt Exploration Fund in 1891-93 (Griffith and Newberry, *El Bersheh*, 1893-94) the tombs situated on both sides of Wadi Deir el Nakhleh were cleared and investigated. Among the most interesting are the tombs of the nomarchs Djehutynekht and Djehuty-hetep. On a wall of the latter is the famous scene representing the transportation of a colossal seated statue of the king across the desert. The statue is secured with ropes on a sledge which is drawn by workers arranged in pairs in four rows. On the prow of the sledge stands a man pouring a lubricant on the ground (Chart VIII, pp. 000-00).

The plan of these rock tombs is similar to that of the tombs at Beni Hasan. Some have only one burial chamber, others are larger. The tomb of Djehuty-hetep had two palm columns in front.

This site was severely damaged by hermits, who lived in these tombs in Christian times; in modern times the exploitation of the quarries was resumed. To the north of the tombs there is an eighth-century Coptic church in a palm grove; remains of paintings have been preserved in its niches.

26. TELL EL AMARNA

The name of this site is derived from El Amran, a Bedouin tribe, and El Tell, an Arab village on the east bank of the Nile near Melawy in Middle Egypt. Here, on a sandy plain adjoining a narrow strip of farmland, bounded on the east by a semicircular range of cliffs, Amenhotep IV (Dynasty XVIII) founded a new capital, which spread out along the river for about 6 miles. It was this Pharaoh who broke with the priests of Amon, adopted the name Akhenaten, and introduced the worship of a single supreme deity—Aten, the solar disk. The site lay in Nome XV of Upper Egypt and was chosen because it was situated halfway between Thebes and the old capital of Memphis.

The boundaries of the ancient city, called ◡▬▮ | ⌂ = Akhetaten ("The Horizon of Aten"), were marked out by steles, eleven of which are still standing on the slopes of the eastern hills. Three others stood on the west bank of the Nile, because the Pharaoh wanted some of the fertile land on the other side within the city area. Three surviving steles date from the fourth year of the king's reign, and the rest from the sixth. Texts that have survived on some steles contain indications as to how the boundaries of the city were laid out, and there are warnings of dire punishment for anyone who might tamper with the boundary markers. Surprisingly, the text on one stele, dating from the eighth year of the king's reign, reiterates his oath never to add more land to the territory of Aten. In other words, the city, which included a temple enclosure and a royal residence, was built in barely ten years' time. After the king's death the city was abandoned, and his successor transferred the capital back to Thebes. Horemheb, the last ruler of Dynasty XVIII, ordered the Aten sanctuary to be torn down.

The short-lived Amarna heresy, however, left a deep mark on Egyptian culture. The cuneiform tablets discovered at Tell el Amarna are extremely important historical documents, containing the Pharaoh's correspondence with Babylonian, Hittite, and Mitannian rulers, and with his Syrian and Phoenician vassals (Mercer, *The Tell el-Amarna Tablets*, I-II, 1939). This royal archive was discovered quite accidentally by local fellaheen, and for a number of years was exploited by them. Altogether about 320 tablets were found, and information gleaned from them greatly influenced the choice of sites to explore when Flinders Petrie started systematic excavations in 1891 (*Tell el-Amarna*, 1894). As early as 1893, Gaston Maspero began to clear the rock tombs on the slopes of the desert Gebel, where an English expedition (the Egypt Survey) was already conducting excavations. A. Barsanti excavated the site for the Egyptian Antiquities Service ("Sulla scoperta della Tomba del Faraone Amenofi IV," *Rendiconti Reale Acc. dei Lincei*, 1894), and in 1892 the Egypt Exploration Fund resumed excavations where the Egypt Survey had left off (N. de G. Davies, *Rock Tombs of el-Amarna*, I-VI, 1903-8). Early in the twentieth century an expedition of the Deutsche Orient Gesellschaft was also active in the area (Borchardt, *Voruntersuchung von Tell el-Amarna; Ausgrabungen in Tell el-Amarna*, 1911). The work of the German archaeologists was interrupted by World War I. In the 1920s systematic excavations were resumed by the Egypt Exploration Society (Peet, Pendlebury, Woolley, Gunn, Frankfort, Fairman, Newton, Guy, *The City of Akhenaten*, I-III, 1923-51).

Archaeologists' finds at Tell el Amarna have brought to light a previously unknown chapter of Egypt's history. The inscriptions discovered there, and above all the magnificent art objects, make it possible today to draw a fairly accurate picture of this unique episode in Egyptian history: the rebellion of a ruler against centuries-old, rigidly fixed religious conventions. Despite the abundance of documents, the reign of Akhenaten has given rise to much discussion. One of the contro-

883. TELL EL AMARNA.
BOUNDARY STELE OF AKHENATEN

versial points concerns the dates of his reign, for it is not clear under what circumstances he exercised joint rule with his father Amenhotep III during the last years of the latter's reign. The family relationship between Akhenaten and his successors, Semenkhkara and Tut-ankh-amon, is not clear; nor has the matter of Akhenaten's joint regency with Semenkhkara been clarified (see discussion of this point in Drioton and Vandier, *Les peuples*, p. 658 f.). The genealogies of the Amarna royal family given in two recently published works on this subject exhibit considerable differences (E. Bille de Mot, *Die Revolution des Pharao Echnaton*; C. Desroches-Noblecourt, *Toutankh-amon et son époque*). One thing seems certain today, namely, that Akhenaten's wife Nofretete was an Egyptian, not a Mitannian princess as formerly believed. We have no reliable data concerning the events that brought the Amarna heresy to an end. It appears probable that in the last years of Akhenaten's reign his wife fell into disfavor and moved with Tut-ankh-amon to the so-called North Palace. Soon after her death, her name was removed from inscriptions and replaced with that of her daughter Meritaten.

Tut-ankh-amon, who either succeeded directly to the throne on the death of Akhenaten or after the death of Semenkhkara, moved the capital back to Thebes. After a short reign he was buried in the famous tomb discovered at Thebes by the Earl of Carnarvon and Howard Carter in 1922. To this day, however, we do not know the circumstances surrounding the death of Akhenaten—the founder of the Horizon of Aten and the author (or perhaps co-author with his father Amenhotep III) of the Amarna heresy. In 1907, Davies uncovered a tomb in the Valley of the Kings directly behind that of Tut-ankh-amon and near those of Horemheb, Tuthmosis IV, and Merenptah; formerly it was thought to be the tomb of Queen Tiy (Akhenaten's mother), of Akhenaten himself, or of Semenkhkara. The mummy found there was identified by the eminent English anthropologist Elliot Smith as that of Akhenaten, but a few years later another anthropologist, D. E. Berry, identified it as that of a much younger man. Could it be the mummy of Semenkhkara? An inscription discovered at Thebes mentions that Semenkhkara built a temple there—perhaps his own funerary temple.

Another hypothesis is possible concerning the location of Akhenaten's tomb. In the course of his excavations at Tell el Amarna, Barsanti discovered the remains of a rock tomb destined for the entire royal family. Akhenaten evidently enjoyed being represented with his queen and their children, and he may well have planned a tomb not just for himself but for the whole family. A fragment of the pink granite sarcophagus bears the name of Princess Meketaten. Conceivably Akhenaten had been buried in this family tomb, and shortly thereafter—when it was decided to destroy every trace of the Amarna heresy and King Horemheb ordered all Akhenaten sanctuaries to be razed—his mummy was taken to Thebes by his devotees, and placed in the tomb discovered by Davies. During the transfer, the mummy of the king may have been confused with that of his successor.

At the time of Napoleon's expedition (*Description, Ant.*, IV, pl. 63) the plan of the city was easier to make out than it is today, and visitors in subsequent decades indicate that this was true for some time. Actually, today, the mounds of rubble left by successive archaeological expeditions make it harder, not easier, to re-create the ancient Akhetaten. On the north, where the Gebel hills are closest to the Nile, stood a great gateway. Directly behind, inside a dried-brick wall, is one of the most interesting and most symmetrical of all Amarna buildings, the so-called North Palace. It has been rightly described as a kind of transposition into architecture of Akhenaten's magnificent hymn to the sun.

Large chambers with peristyles, hypostyle halls, and a number of smaller rooms were arranged around three sides of two central courts. There was no lack of gardens. According to some archaeologists, the apartments of Nofretete were in the southeast section of the palace. Akhenaten's official residence was situated at the center of the city, near the main sanctuary. This residence was composed of two complexes linked by a covered bridge having a window at which the royal pair showed themselves to the people on holidays and festivals. Between the two complexes ran the Royal Road, connecting the temples situated on either side of the palace. The main part of the palace consisted of a throne room, a great hypostyle hall, storehouses, two harems, a garden with a pond, a large court with colossal statues of the king, and a number of other rooms of an official character. There was direct access to the Nile from this part of the palace. Although at first sight the plans seem quite complicated (indicating that the residence was built in several stages), it is basically two intersecting axes, one north-south through the throne room and the large hypostyle hall, the other east-west. The bridge linking the two parts of the palace over the Royal Road lay on the east-west axis. Rooms were built over the terrace at certain points. The king's private apartments seem to have been situated in the east part of the palace, beyond the bridge.

884. TELL EL AMARNA. PLAN OF THE GREAT TEMPLE OF ATEN
1. *Hypostyle hall with open nave* 2. *First court* 3. *Second court* 4. *Third court* 5. *Hypostyle hall* 6. *The Gem Aten*

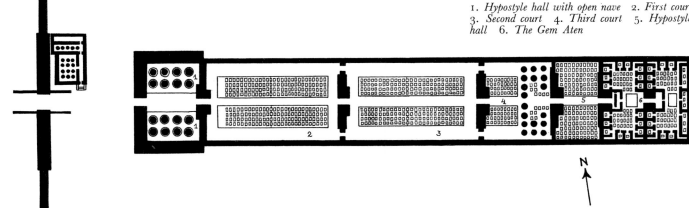

N

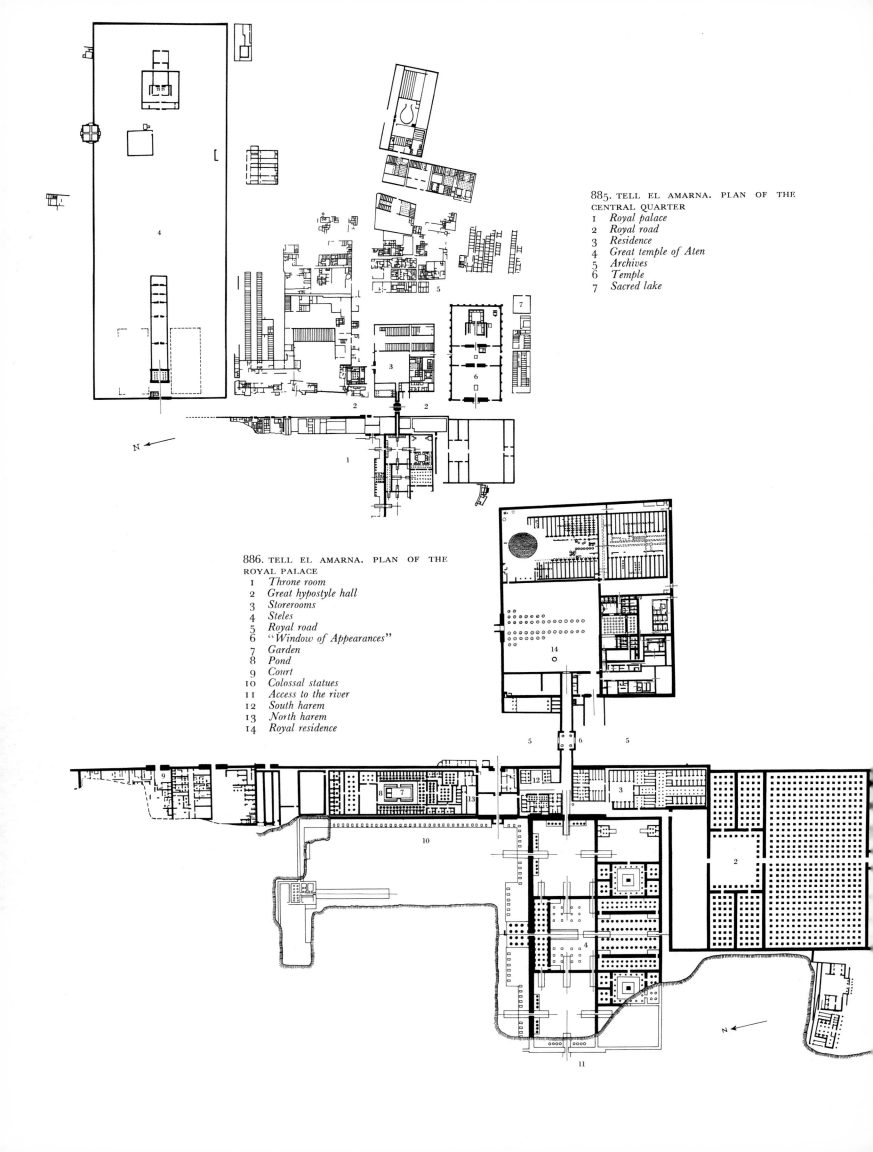

885. TELL EL AMARNA. PLAN OF THE
CENTRAL QUARTER
1 *Royal palace*
2 *Royal road*
3 *Residence*
4 *Great temple of Aten*
5 *Archives*
6 *Temple*
7 *Sacred lake*

886. TELL EL AMARNA. PLAN OF THE
ROYAL PALACE
1 *Throne room*
2 *Great hypostyle hall*
3 *Storerooms*
4 *Steles*
5 *Royal road*
6 *"Window of Appearances"*
7 *Garden*
8 *Pond*
9 *Court*
10 *Colossal statues*
11 *Access to the river*
12 *South harem*
13 *North harem*
14 *Royal residence*

N

The most interesting piece of architecture at Amarna, however, is the Great Temple dedicated to Aten. It lay east-west within a large rectangular enclosure 875 by 301 yards. It was not just one temple but several independent clusters of sacred edifices. It might seem surprising that today, when all these buildings have long since been destroyed, we can accurately reconstruct their layout and even how they looked. The temple appears in a number of representations on the walls of Amarna tombs. Our knowledge of its layout is the result of "collaboration" between modern archaeologists and the Amarna architects. The latter, to establish the design of a building, first of all prepared the foundations by drilling the rock. These cavities were filled with a plaster preparation on which the exact limits of the walls were drawn in black, with the aid of a tautly stretched string. The entire surface of the temple enclosure was then covered with this plaster preparation, and the architectural elements outlined on it. Once the stone foundations were laid, the ground was covered with sand to a height just above the flood level of the Nile. The walls of the buildings at Tell el Amarna were built of small blocks of limestone (10 by 19 1/2 inches) reinforced with a mortar similar to the plaster used in laying the foundations. When the enemies of Aten destroyed the city, the layer of sand protected the detailed architectural design underneath it.

In excavating the site of the Great Temple the successive layers were carefully noted, and thus it has been possible to reconstruct the layout of this edifice. In a sense it is unique in Egypt, for this temple looked most unlike other temples. Behind a pylon adorned with flagpoles was a hypostyle hall roofed only at the sides of the entrance, leaving the main nave uncovered. One next entered a number of courts separated from one another by pylons, or by porticoes like those in the hypostyle hall. In these courts stood rows of altars partly raised on bases of dried brick. These were arranged along the axis of the temple in straight lines, four by four. At the far end of the temple was the Gem Aten, where the worshiper was brought into the presence of Aten. Rectangular platforms stood at either end of the enclosure; the one on the south contained the so-called Per-Hai ("House of Jubilation"), where offerings were brought to Aten. In the northern part of the enclosure, behind an altar on which animals were sacrificed and a room where tributes were received, stood a sanctuary where the king made offerings to the god and performed his personal devotions. The most characteristic feature of Amarna sanctuaries is their openness to the sky—there are few roofed areas. The architecture seems to have been designed to let the rays of the sun in everywhere.

South of the palace there was another, smaller temple with a layout similar to that of the Great Temple. The city proper spread out around the palace and the temples. Near the king's residence were the villas of dignitaries, in design resembling certain parts of the palace—peristyles, hypostyle halls, gardens, ponds, courts, and a number of secondary buildings. In this respect Amarna architecture did not deviate from tradition. Similarly, the workmen's quarter on the southern edge of the city had a symmetrical layout like that of workmen's towns dating from the Middle Kingdom—for instance, at Kahun. Most Amarna houses had dried-brick terraces, occasionally with outbuildings.

One detail of Amarna civic architecture deserves mention: the houses have no separate women's apartments. Only the villa of the vizier Nakht seems to have had a separate bedroom for his wife. One house at Amarna, situated near the palace, is of particular interest—that of the sculptor Tuthmosis, where many studies were found, including the famous polychrome study for a portrait of Nofretete (fig. 103), a mask and bust of Akhenaten, and, among other heads, that of Amenhotep III. According to some scholars—and they may be right—Akhenaten's father spent some time at Amarna toward the end of his life. In the southern part of the city there was one more royal palace called Maru Aten. Here were discovered parts of a painted floor including pictures of birds and plants. The surviving fragments of these decorations were removed and reconstructed in front of the Cairo Museum (F. von Bissing, *Der Fussboden aus dem Palaste des Königs Amenophis IV zu el Hawata im Museum zu Kairo*, 1941).

In addition to its steles and altars in the desert, Tell el Amarna is noteworthy for its alabaster quarries (called Hat-nub in antiquity), where workmen living in a nearby village obtained the alabaster used in decorations of Amarna buildings. These quarries were exploited as early as the Old and the Middle Kingdom.

A separate category of monuments is a complex of twenty-five rock tombs in the hills east of Tell el Amarna. There are five groups, classified according to the layout and form of the burial chambers and the shafts leading to them. The most important tombs include that of Huya, Overseer of the Royal Harem and Two Treasuries and Servant of the Great Royal Wife (Tiy), those of the king's scribe Merire, of another Merire who was high priest of Aten, and of Mahu, chief of police at Akhetaten. Finally we must mention the tomb of Ay, priest and royal fan-bearer who later became king and built a second tomb for himself at Thebes. His tomb contained one of the best-preserved texts of the Hymn to Aten.

The city of Akhetaten lasted only as long as it was the capital of Egypt. It was never abandoned but razed to the ground by royal order. The area around it was inhabited until the end of ancient Egypt. No trace of later settlers has survived, but the small temple that stood near the Nile in

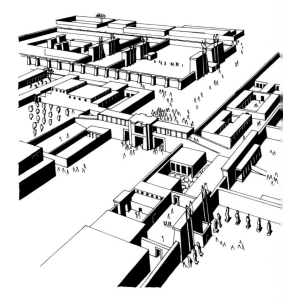

887. TELL EL AMARNA. RECONSTRUCTION OF THE RESIDENTIAL QUARTER

888. TELL EL AMARNA. ROCK-CUT TOMB OF PA-NEHESY (NO. 6), HYPOSTYLE CHAMBER WITH CLOSED PAPYRIFORM COLUMNS

the Amarna period was rebuilt in Dynasty XX and in Dynasty XXVI. In Roman times a military camp was established in the desert between the city and the palace Maru Aten.

In Coptic times, one of the most impressive rock tombs, that of Pa-nehesy, Chief Servant of Aten, Second Prophet, Overseer of the Herds of Aten, and Chancellor of the King of Lower Egypt, was converted into a chapel. A wall was added in front of the tomb façade, and one of the tomb niches was enlarged and used as a baptistery.

27. ANTINOUPOLIS

(also Antinoë, Adrianoupolis). Near the present village of Sheikh Abadeh, on the east bank of the Nile between Beni Hasan and Deir el Bersheh. In ancient Egypt it stood directly across the Nile from Hermopolis, capital of Nome XV ("The Hare") of Upper Egypt. According to P. Montet (*Géographie*, II, p. 152), it may have been the ancient city of Neferusi, where Hathor was the chief tdeity.

Very recent Italian excavations (*Orientalia*, 36, 2, 1967, p. 192; *Bulletin de la Mission italienne*, Cairo, 1968) have brought to light thirteen tombs dating from the Predynastic Period, so there can be no question of the antiquity of the site. However, no remains have been found of Old or Middle Kingdom architecture; the oldest monumental buildings at Antinoupolis date from the New Kingdom.

Gayet's excavations (*Annales du Musée Guimet*, XXX, 2), later continued by Donadoni's Italian mission (*ASAE*, 39), gave us the pylons, the court, and the hypostyle hall of a temple dating from the reign of Ramesses II. The building materials came largely from the Akhenaten chapel which was nearby. Cartouches of Merenptah and Ramesses III discovered here seem to be evidence of these rulers' activities. Not far from Neferusi a battle was fought between the Pharaoh Kamose and the Hyksos. The city was captured and its walls were razed. The inscription on the great Piankhy stele mentions that in the course of conflicts between Tef-nekht and Piankhy, King Nemrat again tore down the walls of Neferusi (Breasted, *Ancient Records*, par. 796 ff.). The fortifications in question probably guarded both the sacred enclosure of Ramesses and Hermopolis, the nome capital.

Several columns from the temple of Ramesses II are still standing—four from the façade, five from the north wall, and four from the south wall. The emperor Hadrian founded a city here in 130 A.D. to commemorate his favorite, Antinoüs, who was drowned in the Nile that same year. The city was settled with Greeks from the Fayum to whom the emperor granted the right of conubium, meaning that they could marry Egyptians without prejudicing the status of their children. The new city was laid out in a rectangular grid of streets; it had a theater and many temples. One was dedicated to Serapis, and in another the dead Antinoüs was worshiped as Osir-Antinoüs, the equal of Osiris. Recent excavations conducted by the University of Rome have established that some fragments of columns which Gayet believed to come from a temple dedicated to Isis were actually part of a great colonnade marking the east boundary of the city (*Orientalia*, 36, 2, 1967, p. 193). A triumphal arch led into the city from the south. There was also a circus and a hippodrome. Today these buildings are all but obliterated. In 1672 on his visit to Egypt the Abbé Vansleb was impressed by the ruins of the city, mistaking it for Thebes. Early in the eighteenth century, Claude Sicard, the Jesuit who first located the site of ancient Thebes, gave us a description of Antinoupolis, still at that date comparatively well preserved (L. Greener, *The Discovery of Egypt*). Its ruins were still impressive to members of the Bonaparte expedition, as can be seen from the drawings and plan of the city they prepared (*Description*, IV, pls. 53, 54). In the middle of the nineteenth century the ruins were drastically reduced when stones were taken away to be used in building a sugar refinery at Roda.

Antinoupolis' period of grandeur was not limited to Hadrian's reign. Under Diocletian the city was made the capital of the Thebaid. Whereas little remains of Antinoupolis, many relics found in cemeteries dating from Roman times illustrate the development of so-called Graeco-Roman art in Upper Egypt. These include polychrome masks, mummy cases, and beautiful fabrics, all of which maintain the traditions of Alexandrian art. There is an excellent collection of these finds in the Musée Guimet in Paris. More recent excavations in the necropolis of Antinoupolis were conducted by E. Breccia and A. Adriani until 1940 (discovery of Theodosia's funeral chapel), and then by the universities of Florence and of Rome (*Orientalia*, 36, 2, 1967, pp. 193-94).

Memories of the city's splendid past, its municipal system, and the ethnic makeup of the population may explain the fact that as late as the emperor Valens (364-378 A.D.) the city was predominantly pagan and resisted complete Christianization, although after the middle of the third century it was the seat of a bishopric. In the middle of the fourth century it even had two bishops, one orthodox, one schismatic.

In the southern part of the city are three churches, one of which has a trilobe apse, and another an apse with an eastern bay—details that point to Hellenistic influence on the design. Thus it is not surprising that Coptic relics from Antinoupolis still exhibit strong Hellenistic influence in the composition and modeling of the figures.

V. UPPER EGYPT

28. ABYDOS

The Egyptian ⌘⌘⌘ = 'bdw (whence the Greek Abydos) was one of the oldest centers of Osiris worship. Worship of Khentiamentiu, the earlier jackal-god, became fused with Osiris worship under Sesostris I. Abydos was located within Nome VIII of Upper Egypt, the capital of which (known as Thinis) has not yet been discovered. It was the seat of the first two, so-called Thinite dynasties.

 The ancient city's ruins, which face the modern town of El Balyana, extend from the west bank of the Nile to the desert's edge. The site is divided into three sectors. The north sector includes the ruined temple of Osiris-Khentiamentiu and important cemeteries to the west and south of the temple. The central sector includes, among other structures, a small temple, more cemeteries, and most important, the tombs of the Thinite kings. One of these tombs, built for the Pharaoh Zer, was considered the cenotaph of Osiris under Amenhotep III. The Old Kingdom tombs in this sector include that of the dignitary Weni, which dates from the time of kings Tety, Pepy I, and Mernera; its inscriptions, containing the well-known biography of this dignitary, were discovered by A. E. Mariette, and are now in the Cairo Museum. The third, south sector of the site contains the best-preserved Dynasty XIX structures, among them the famous temple of Sety I and that of Ramesses II.

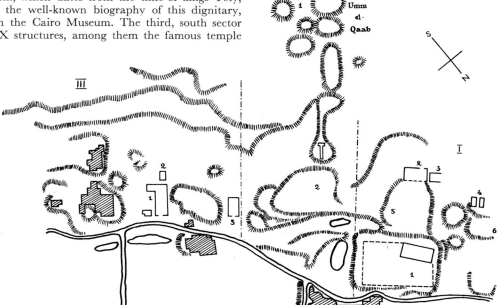

889. ABYDOS. GENERAL PLAN

I. NORTH SECTOR
1 *Precinct of the temple of Osiris*
2 *Archaic (Thinite) fort — Shunet el Zebib*
3 *Archaic (Thinite) fort*
4 *Monastery*
5 *North necropolis of A. E. Mariette*
6 *Cemetery*

II. CENTRAL SECTOR
1 *Royal Thinite necropolis*
2 *Central necropolis of A. E. Mariette*

III. SOUTH SECTOR
1 *Temple of Sety I*
2 *Cenotaph of Sety I (Osireion)*
3 *Temple of Ramesses II*

 Abydos has been explored again and again by many expeditions. It is known that the site was inhabited in prehistoric times (Nagadah I and II); an oven for drying grain, very characteristic of this period, has been found (T. E. Peet, *Cemeteries of Abydos*, II, 1913-14, pp. 7-13), as well as many early cemeteries. But the most important cemetery for the study of the early period of Abydos is that of Umm el Qaab, in the southern part of the central sector, where tombs of Dynasty I and II kings, surrounded by tombs of contemporaneous dignitaries, have been discovered (E. Amélineau, *Les nouvelles fouilles d'Abydos, 1895-98*, I-III, 1899-1905; F. Petrie, *The Royal Tombs of the First Dynasty*, I-II, 1900-1; E. Naville, *The Cemeteries of Abydos*, I, 1914). At first it was supposed that the kings were actually buried in these tombs, which contained royal steles, seals, and furnishings. However, in the light of W. B. Emery's recent discoveries, it may be assumed that even at so early a period it had become customary to build two tombs for each king—one near the capital Thinis at Abydos, and another at Saqqarah. This custom was bound up with the unification of Egypt, which had recently taken place, and was intended to emphasize the Pharaoh's hegemony over both kingdoms. To this day, however, it has been impossible to ascertain which of the two sites served as the actual place of burial.

 Northwest of the royal necropolis, on the hill known today as Shunet el Zebib, have been discovered the ruins of two forts, the walls of which were built of dried brick. The less well-preserved fort dates from the reign of Peribsen (Dynasty II), whereas the walls of the other date from the reign of Khasekhemuwy, last ruler of Dynasty II.

890. ABYDOS. THINITE FORT

891. ADYBOS. WALLS OF THINITE FORT

The earliest traces of religious architecture, however, date from Dynasty I. In the north sector of Abydos, Flinders Petrie discovered the foundations of a temple going back to this period (Petrie, *Abydos*, I-II, 1902-4). Though the archaeological remains are meager, his study deserves special attention. By thorough analysis of individual wall fragments, remnants of foundations, and foundation deposits, and by careful differentiation of the seven layers the site disclosed, Petrie was able to define the different building stages of this ancient sanctuary. The results of his investigation are the more remarkable because the same area was excavated earlier by A. E. Mariette (*Abydos*, I-II, 1869-80), who discovered a considerable number of objects from various periods. The originally small temple, situated near the enclosure wall and containing three cellas, had been rebuilt as early as Dynasties II and III. During Dynasties IV and V a number of alterations were made, particularly in the area of the storehouses. Dynasty VI kings added new structures. Pepy II erected two stone gates, a colonnaded entrance, and other elements which suggest that the sanctuary may have served for religious processions—in this respect it would be similar to the temple of Sesostris I situated within the enclosure of the great temple of Amon at Karnak, built much later. In the temple at Abydos Petrie discovered many alabaster vases, copper objects, and tablets with the cartouches of Pepy I and Pepy II. His excavations revealed that under their reigns the temple was still dedicated to the local deity Khentiamentiu.

West of this old temple, Mentuhotep I built a columned portico and, a little farther, altars. Mentuhotep III also left traces of his activity here. Sesostris I, however, ordered the old temple (already in ruins) to be razed and a new one of a different design built on the same site. The enclosure wall was enlarged; the new temple, dedicated to Osiris, was larger and oriented east-west, whereas the old one was oriented north-south.

Under Dynasty XVIII the plan of the temple was radically changed. Amenhotep I erected a small chapel dedicated to his father Ahmose; it was a limestone structure with carefully executed reliefs on the walls. The ceiling of the main chamber rested on six pillars; adjacent to this chamber south and west were smaller chambers. This chapel was included in the new temple complex built by Tuthmosis III and Amenhotep III. In this period two pylons (one of granite) and a processional way leading to the necropolis were added. This temple was larger than the previous ones, but so little of it has been preserved that without its foundation deposits, its existence would hardly have been suspected. The Ahmose chapel, on the other hand, altered first by Ramesses III and later by the Saite kings, has survived rather better: when Petrie began his excavations, its walls were still about 1 1/2 feet high. Judging from the foundation deposits of Apries, Amasis, and Nectanebo I, the last phase of building activity in this area dates from the reigns of these Pharaohs.

Beginning with the Middle Kingdom—a necropolis dating from this period is situated between the enclosure of the temple of Osiris and the Dynasty II forts—Abydos became the place to erect cenotaphs and funerary steles. These were supposed to obtain for the deceased the protection of Osiris, ruler of the nether world and supreme judge of souls. In the south sector there are symbolic places of burial ranging from the most modest steles to monumental royal cenotaphs. Sesostris III had a cenotaph at Abydos, where he also built a temple. Ahmose, the founder of Dynasty XVIII, in addition to a terraced temple near his cenotaph, erected a pyramidal brick structure nearby (E. R. Ayrton, C. T. Curelly, and A. E. P. Weigall, *Abydos*, III).

Abydos' most famous cenotaph is that of Sety I, situated behind his temple. It was described by Strabo (XVII, 1). A mighty structure, partly underground, its outside walls are limestone, the inside walls sandstone, and the central hall granite (H. Frankfort, *The Cenotaph of Seti I at Abydos*, I-II, 1933). It was conceived as the symbolic tomb of Osiris and is sometimes referred to as the Osireion. It stood on a tree-covered hillside; its central hall, encircled by a canal, resembled an island. From the central hall two staircases led to an underground area which has still to be investigated. It is conjectured that this area may have contained the sarcophagus and chests for the Canopic jars; this is by no means certain, for situated on the same level as the central hall is the so-called sarcophagus chamber, with limestone walls and a sandstone ceiling (the latter in the form of an inverted V). The walls of the central hall and the ceiling of the sarcophagus chamber were decorated with reliefs representing the wanderings of the deceased Pharaoh's soul, similar to certain tomb reliefs found in the Valley of the Kings. Surviving reliefs and inscriptions are found in the greatest number on the walls of a passage at the northwest portion of the cenotaph. Some of them date from the reign of Merenptah. Was this structure the symbolic tomb of Osiris or merely another royal cenotaph? From the present state of knowledge, one is inclined to combine the two hypotheses: the king, who became Osiris after his death, built a cenotaph modeled on symbolic tombs of Osiris, of which there was certainly no lack at Abydos.

Northeast of the cenotaph stands the famous temple built by Sety I, completed and enlarged by Ramesses II (J. Capart, *Abydos: Le temple de Séti I^{er}*, 1912; A. M. Calverley and A. H. Gardiner, *The Temple of King Sethos I at Abydos*, I-IV, 1933-38). Strabo called it the Memnonium. This structure departs from the standard temple plan: behind the pylon were two large courts; beyond them seven doors (some walled up and converted into niches by Ramesses II) led into the first hall, its roof supported by two rows of columns. On axis with the original seven doors were seven other doors leading through a great hypostyle hall to seven sanctuaries. Inscriptions

on the doors indicate that each was dedicated to a different god. The central sanctuary was dedicated to Amon; toward the left side (to the right of the statue of Amon, which faced the entrance) were, successively, the sanctuaries of Ra-Harakhte, Ptah, and Sety I himself; in succession toward the right (Amon's left) were the sanctuaries of Osiris, Isis, and Horus. This layout clearly reveals the hierarchy of the gods in this period. The central deity was the Theban Amon; the primordial deities were relegated to second place, and the chapel dedicated to the deceased king was assigned a place equal to that of his tutelary deity, Horus. This monumental "exposition" of the Theban theology contains other "passages" as well, to be read in the polychrome reliefs where the king is shown sacrificing to the gods (figs. 12, 47, 117, 509-15).

Behind the sanctuaries were a small hypostyle hall, auxiliary side chambers, and chapels dedicated to the gods and to the king. From the façade of the hypostyle hall an entrance on one side led to chambers dedicated to Ptah-Sokaris and Nefertum, on the other to the gallery containing the famous list of kings, which is one of the most important documents used to establish a chronology of the successive Pharaohs. This gallery in turn opened onto a number of chambers whose decoration was never completed. A stairway led to the temple terrace, another chamber had an exit leading toward the cenotaph.

The entire Sety I complex, together with a palace whose ruins lie east of the second court, had an enclosure wall. In addition to the pylon leading to the main temple court, this wall included a second pylon on the southwest side. North of the enclosure are the sparse remains of a temple which has been identified as the one Sety I built for his father Ramesses I (H. Winlock, *The Temple of Ramesses I at Abydos*, 1937).

Farther west lies the temple of Ramesses II (Mariette, *Abydos*, II); its plan departs considerably from the standard type. From a court surrounded by a portico, one entered by three flights of stairs into a deep portico, which led to two octostyle halls. The second of these had several chapels at each side, dedicated to various deities; the three central chapels, situated on the temple's main axis, may have been dedicated to the Osiris triad. A fragment of red granite found in the middle chapel (faced with alabaster slabs) suggests that this material may have been used for the roofing of the chapels. On the outside wall of the temple there is a representation of the battle of Kadesh—a scene often shown on the walls of the temples of Ramesses II. It was in this temple that another list of kings, now in the British Museum, was found.

Many alterations and additions dating from the reign of Merenptah have been found, but Abydos declined in architectural importance after the Ramessides. Only a few funerary steles date from later times. The Saite period saw a resumption of the Osiris cult. Under the Ptolemies and in Roman times Abydos was still visited, as evidenced by the names of Greek pilgrims and tourists scratched on the temple's walls (Perdrizet, *Les graffiti grecs du Memnonium*). Strabo, who visited Abydos and admired the temple and the cenotaph of Sety I, says that it must once have been a large city, second only to Thebes, but that it was quite a small place when he saw it. In his day, the great temple of Sety I made room for an oracle of the god Bes. The necropolis, too, had changed in character: cemeteries for animals date from this period. Ibises and dogs were buried and there was also worship of fish (C. Desroches-Noblecourt, in *Mélanges K. Michalowski*, pp. 71-81).

In the Coptic period some temple reliefs, including part of the list of kings, were destroyed. The largest tombs were converted into Christian places of worship. As the centuries passed, sand buried the ruins of Abydos, and not until the present day were the splendid monuments of this important religious center again brought to light.

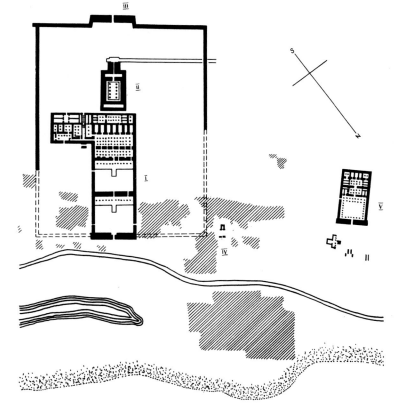

892. ABYDOS. GENERAL PLAN OF THE SOUTH SECTOR
(see fig. 889, III)
 I *Temple of Sety I*
 II *Cenotaph of Sety I (Osireion)*
 II *Pylon in the desert*
 IV *Temple of Ramesses I*
 IV *Temple of Ramesses II*

29. THEBES

An important city in Nome IV ("The Scepter"), later the capital of Egypt (Pillet, *Thèbes, palais et nécropoles*, I-II, 1928-30; C. Nims, *Thebes of the Pharaohs;* Vandier, *Manuel d'archéologie*, II). In ancient Egypt the city was referred to by the same name as the nome, *Was* (the Scepter), but its inhabitants called it "the city of Amon" or "the city of the South." Its Greek name, Thebai, was probably derived phonetically from the Egyptian name of one of this city's temples (the temple of Amon at Karnak) or of one quarter of the city, which sounded to the Greeks like the name of Thebes in Boeotia. It appears for the first time in Homer (*Iliad*, IV, 406). The Greeks also called it Diospolis Magna, "the great city of Zeus" (who was identified with Amon). (A general map of Thebes appears on pp. 580-81.)

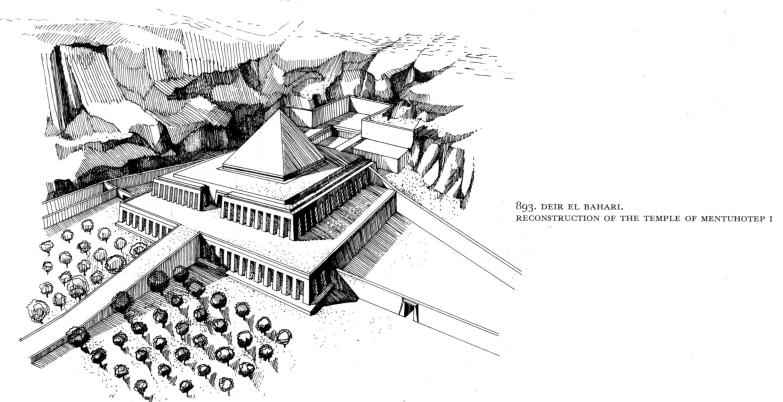

893. DEIR EL BAHARI.
RECONSTRUCTION OF THE TEMPLE OF MENTUHOTEP I

Little is known of the history of Thebes in the period preceding the Middle Kingdom. However, finds in the nearby desert indicate that settlements had existed here as early as the Middle Paleolithic Period. These settlements gave rise to three towns in the Predynastic Period and the Old Kingdom. The oldest capital of Nome IV seems to have been Hermonthis, today's Erment, on the west bank of the Nile. On the east bank arose another town, Tod; later, north of what became Thebes, arose Medamud. The chief deity worshiped in these towns was the god Montu. During the first five dynasties the Theban district was of little political importance, although its emblem ⟨𓋾⟩ appears in one of the Mycerinus triads discovered in the funerary temple of this Pharaoh (Dynasty IV) at Giza. Religious edifices may have existed even then on the site of Thebes, but no trace of them remains. Toward the close of the Old Kingdom several Theban nomarchs had tombs cut in the rock of the slopes of Khokh, a hill situated east of Deir el Bahari. At the end of the First Intermediate Period, Intef, a Theban nomarch who controlled seven southern nomes of Upper Egypt forming the "South Gate" district, consolidated his hold over this region, although it was nominally subject to the kings residing at Heracleopolis; Intef's son Mentuhotep assumed the title of king. When a new city was founded on Thebes' future site, the authority of Amon seems to have increased: the name of this god makes its first appearance at Thebes early in the First Intermediate Period. The first temple of Amon must have been built then; although no trace of it has been found, inscriptions state that such a temple existed (Petrie, *Qurneh*, 1901, pl. X, 1, 3). Under Dynasty XII, Amon became the chief Theban god.

Toward the end of the third millennium the confederation of southern nomes, which meanwhile had been joined by Nomes VIII and IX, waged a victorious war against the Heracleopolitan kingdom, and Thebes became the capital of Egypt—the residence of Dynasty XI kings. There can

be no doubt that this was a period of monumental temple-building in Thebes and elsewhere: blocks bearing the cartouches of Mentuhotep have been discovered in later buildings at Karnak, and at Deir el Bahari there are the ruins of the mighty temple of Mentuhotep I, surrounded by mastabas of dignitaries. The great city of Thebes, divided into two parts by the Nile, seems to have begun to take shape in this period. On the east bank developed the "city of the living," the center of government and religious worship; on the west bank was the "city of the dead," the necropolis at the foot of the hill Dra Abul Naga, founded by the princes of Dynasties IX and X bearing the name of Intef. At that time the greatest structure in the Theban necropolis was the temple of Mentuhotep I (Dynasty XI) at Deir el Bahari, built on terraces and crowned with a pyramid. His successor began to build a similar funerary temple in the adjoining valley; this temple was never completed, but around it lies a cemetery of dignitaries that includes the well-known tomb of Meket-ra, which contained many so-called models carved in wood (figs. 283, 284).

Although the Dynasty XII rulers moved their political and administrative seat to Ith-Tawe near the Fayum (a site as yet unlocated), Thebes continued to increase in importance as a center of the cult of Amon. The first Dynasty XII ruler, Amenemhat I, began to embellish the temple enclosure of the Theban Amon, but the king who contributed most was his successor Sesostris I. Probably the latter built the temple whose ruins were discovered in the central section of the later temple. The pavilion built by Sesostris I is one of the finest architectural monuments of this period. It was torn down by Amenhotep III who used blocks from it to build Pylon III of the temple of Amon. The pavilion was reconstructed north of the Great Temple at Karnak in 1937-38 by the architect H. Chevrier. The famous Middle Kingdom geographical list was preserved on the masonry of this pavilion.

Although the necropolises of the Dynasty XII kings are situated near their residences—at Hawara, Lahun, Gurob, and Saqqarah, the tombs of local dignitaries, including that of Antefoker, governor and vizier under Sesostris I, are at Thebes (figs. 88, 301).

894. KARNAK.
KIOSK OF SESOSTRIS I

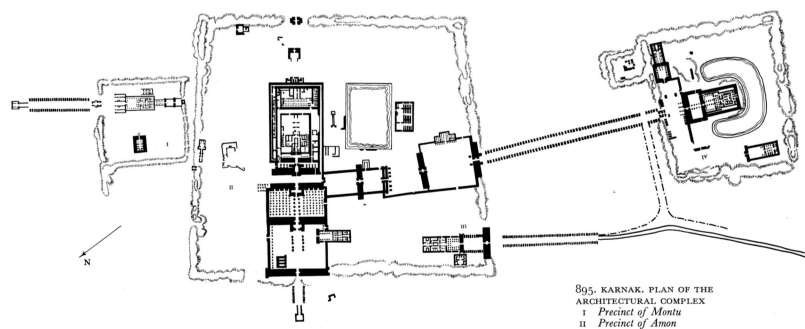

895. KARNAK. PLAN OF THE
ARCHITECTURAL COMPLEX
 I *Precinct of Montu*
 II *Precinct of Amon*
 III *Temple of Khonsu*
 IV *Precinct of Mut*

During the Second Intermediate Period, the Theban princes—who succeeded in remaining somewhat independent of the Hyksos—adorned the enclosure of the Theban Amon with monuments, some of which have been excavated. The Dynasty XVII rulers continued to make use of the Dra Abul Naga necropolis, where they were buried in tombs topped with brick pyramidions (H. Winlock, *Rise and Fall*).

The greatness of Thebes—the city of the living as well as the city of the dead—dates from Dynasty XVIII, when it became the capital of Egypt and took on the character of a splendid metropolis. Subsequent rulers, though no longer residing at Thebes, continued to embellish it. Its most magnificent quarter grew up on the east bank of the Nile. On the north it was bounded by the temple of Amon-Ipet-isut on the site of present-day Karnak (G. Legrain, *Les temples de Karnak*, 1929; P. Barguet, *Le temple d'Amon-Ré à Karnak*, 1962), and on the south by the temple of Ipet-reset-Imen ("the southern harem of Amon") on the site of present-day Luxor (A. Gayet, "Le temple de Louxor,"

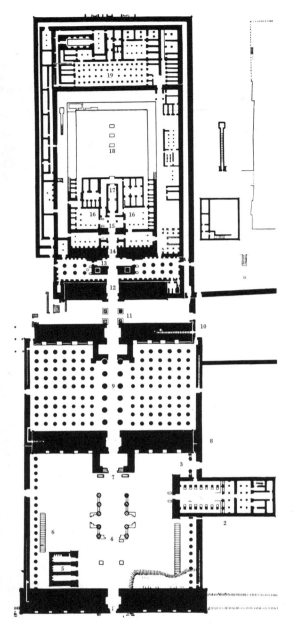

896. KARNAK. PLAN OF THE TEMPLE OF AMON
1 Pylon I
2 Temple of Ramesses III
3 Bubastite portico
4 Colonnade of Taharqa (ruined)
5 Temple of Sety II
6 Sphinx
7 Portico of Horemheb
8 Pylon II
9 Great hypostyle hall
10 Pylon III
11 Obelisks of Tuthmosis I and Tuthmosis III
12 Pylon IV
13 Obelisk of Hatshepsut
14 Pylon V
15 Pylon VI
16 Buildings of Hatshepsut
17 Granite chapel of Philip Arrhidaeus
18 Middle Kingdom court
19 Temple of Tuthmosis III

MIFAO, XV, 1941). In this quarter stood the royal palaces, the residences of dignitaries, and multilevel dwellings: all were built of dried brick and were surrounded by gardens, so cherished by the ancient Egyptians. The suburbs of Thebes extended far beyond present-day Luxor and Karnak, but except for ruins of stone temples, almost nothing of all this has come down to us.

As early as the New Kingdom, the group of temples at Karnak included three distinct complexes. The northernmost complex, enclosed by a wall of dried brick, was that of the temple of Montu dating from the reign of Amenhotep III (C. Robichon, P. Barguet, J. Leclant, *Karnak-Nord*, IV, 1954). But Amenhotep I, first ruler of Dynasty XVIII, had earlier begun large-scale building on both banks of the Nile. An alabaster pavilion at Karnak dating from his reign has been successfully reconstructed, using original blocks found incorporated into later structures. This pavilion is slightly smaller than that of Sesostris I. Cartouches of Amenhotep I have been discovered in chapels which Tuthmosis III later included in his own complex. Amenhotep I also built two funerary temples for himself on the west bank of the Nile. However, the New Kingdom practice of building both a hidden rock tomb and a separate funerary temple cannot be definitely attributed to this Pharaoh; in any case, this practice was followed by his successor Tuthmosis I. The latter greatly enlarged the temple of Amon, incorporating a newly rebuilt Middle Kingdom sanctuary and erecting three pylons (now designated as Pylons IV, V, and VI), which lead to the rectangular temple (actually the temple was slightly wider on the south end of its central axis). In front of Pylon IV, which in his time stood at the entrance, Tuthmosis I erected two obelisks. The name of his successor Tuthmosis II appears in structures built at Karnak by Hatshepsut and Amenhotep II. Thus it would seem that Tuthmosis II was not particularly interested in the temple of Amon, although about thirty blocks from structures he built have turned up among other blocks used in the construction of Pylon III.

The building activity of Queen Hatshepsut in the area of Thebes is far more impressive. It is particularly apparent in the temple of Amon at Karnak. The queen added a quartzite chamber for the sacred barge in the central section built by Tuthmosis I; on both sides of it there are several chambers known as the Queen's Apartments. She also erected four obelisks—two between Pylons IV and V in the old hypostyle hall of Tuthmosis I, and two near the temple's east wall—as well as Pylon VIII on the south side of the temple.

The greatest monument built by Hatshepsut is her famous funerary temple at Deir el Bahari designed by Senmut, her chief architect, vizier, and favorite, who borrowed the idea of a terraced structure with porticoes in front (on the east) from the nearby temple of Mentuhotep (fig. 125). The finest decorations in this edifice include the celebrated reliefs, in the middle portico at the left, commemorating an expedition to Punt (possibly present-day Somali) during the queen's reign (figs. 92, 348). The temple was excavated by A. E. Mariette and E. Naville in the nineteenth century; the six-volume work by the latter is still the basic study of this splendid monument. Later excavations at Deir el Bahari, conducted by H. E. Winlock and his successor A. Lansing, led to a number of other discoveries in the funerary complex and in the temple itself (J. Lipinska, *Historical Topography of Deir el Bahari*, in press). Restoration of the temple of Hatshepsut was begun by Naville and continued by E. Baraize, an architect employed by the Egyptian Antiquities Service; at present it is being carried on by the Polish Center for Mediterranean Archaeology in Cairo.

Tuthmosis III, under whom Egypt's boundaries attained their maximum expansion, left clear evidence of his hostility toward his predecessor Hatshepsut. He ordered the construction of a wall around the obelisks built by the queen in the hall of Tuthmosis I. (Since the obelisks were 100 feet high and the wall was 66 feet high, only the uppermost portions of the former remained visible.) At the same time, he considerably enlarged the temple of Amon at Karnak, erecting two obelisks in front of those erected by Tuthmosis I, and, above all, adding a magnificent Heb-Sed hall on the east side, surrounded by a number of chapels and other rooms. Moreover Tuthmosis III began his building activity at Karnak by dismantling and rebuilding the structures his predecessors had erected. He completely altered the appearance of the hall of Tuthmosis I, between Pylons V and IV, by placing in it the Osiride statues of that king which had formerly adorned the wall of the temple enclosure. He also rebuilt the portico between Pylons V and VI, in which he placed the famous list of the peoples he had conquered. Pylon VI was given its facing during his reign. Between this pylon and a structure erected by Hatshepsut, he built an antechamber in which stand two heraldic columns with lotus and papyrus flowers (figs. 364-66). Parts of the Annals of Tuthmosis III devoted to his military successes have been preserved on the walls of this antechamber, called the West Hall of Records. A similar text has been preserved on the wall Tuthmosis III erected along the south wall of Hatshepsut's northern set of apartments. Some of the reliefs represent the king bringing offerings to Amon. The great Heb-Sed hall, called Akh-menu, is surrounded by many rooms. Particularly noteworthy is Room 21; on its walls are magnificent reliefs known as the "Botanical Garden" (figs. 355-62). The same motif continues in part of Room 22. The reliefs in another small room near the southwest corner of the hypostyle hall were taken to the Louvre by Prisse d'Avennes. They represent the king sacrificing to his predecessors. When first discovered, sixty-one royal cartouches were still recognizable. This inscription, invaluable for determining the chronology of ancient Egypt, has given the room its name—"Chamber of the Ancestors."

East of the great temple complex, adjoining its east wall between two obelisks erected by

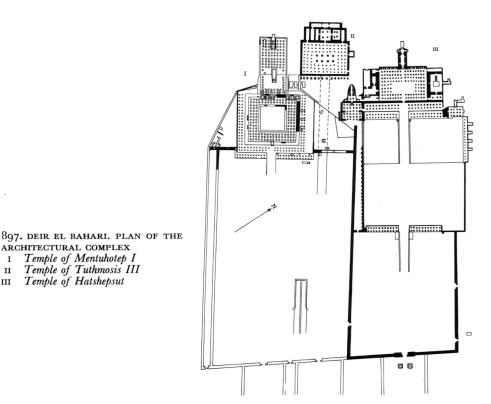

897. DEIR EL BAHARI. PLAN OF THE
ARCHITECTURAL COMPLEX
I *Temple of Mentuhotep I*
II *Temple of Tuthmosis III*
III *Temple of Hatshepsut*

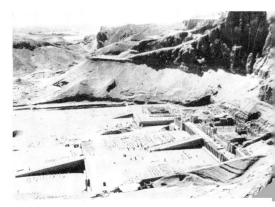

898. DEIR EL BAHARI.
TEMPLE OF HATSHEPSUT

899. KARNAK. HERALDIC COLUMNS
OF TUTHMOSIS III

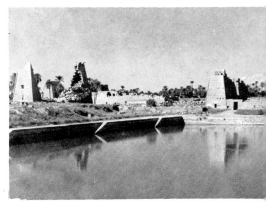

900. KARNAK. SACRED LAKE

Hatshepsut Tuthmosis III built a smaller temple. On the south side, in front of the pylon erected by Hatshepsut he erected Pylon VII. He also built a chapel on the side of the temple closest to the sacred lake. The court between the two pylons was adorned with granite statues of the king. Tuthmosis III is also responsible for the Nilometer beside the sacred lake and the small temple of Ptah in the north part of the temple enclosure of Amon. A number of portals and reliefs were added in a later period.

Tuthmosis III was also active at Luxor, where he built an altar with three chapels. Still more evidence of his activity is to be found in the Theban necropolis on the west bank of the Nile. At Medinet Habu he built a temple dedicated to Amon, which today stands in front of the main temple of Ramesses III. In the same area he rebuilt the temple of Tuthmosis II. At Gurneh he erected a new funerary temple, which was excavated by Quibell and Weigall, and published by Ricke (*Der Totentempel Thutmoses III*, 1939). Toward the end of his reign he built a temple at Deir el Bahari, located between the temples of Hatshepsut and Mentuhotep, which was brought to light recently by the Polish archaeological mission. In addition to magnificent polychrome reliefs in perfect condition (figs. 90, 100), the Polish archaeologists discovered many sculptures; particularly noteworthy is a granite statue of the king 6 1/2 feet high (fig. 91). The temple had been severely damaged in ancient times, but as late as Dynasty XX it was visited by large numbers of pilgrims who left hieratic inscriptions of great historic value on the temple walls and columns (M. Marciniak, *Les inscriptions hiératiques du temple de Thoutmès III à Deir el-Bahari*, in press).

Apart from this temple, which occupied a dominant position in the valley of Deir el Bahari, there are remains of this Pharaoh's activity in the temple of Hatshepsut, where he mutilated the reliefs representing her, obliterated her name, and removed her statues. His magnificent tomb in the Valley of the Kings was probably begun soon after he acceded to the throne.

Unlike Tuthmosis III, who had reason for embellishing the temple of Amon at Karnak—it was his expression of gratitude for being proclaimed king of Egypt—his successors Amenhotep II and Tuthmosis IV exhibited little interest in Karnak. Although Amenhotep II built one small temple on the east side of a court created when Horemheb erected Pylons IX and X, he left few traces in the main section of the temple of Amon. It is not certain whether the architectural fragments found between Pylons V and IV also came from the chapel this ruler built. Both he and Tuthmosis IV built small alabaster chapels; blocks from them have been found in the ruins of Pylon III. Tuthmosis IV also built bastions on the west side near Pylon IV. Both Pharaohs had their funerary temples at Gurneh; the ruins of the temples lie on either side of the Ramesseum, which was built later. The tombs of these rulers are in the Valley of the Kings.

The Pharaoh who contributed most to the embellishment of the capital was Amenhotep III (E. Riefstahl, *Thebes in the Time of Amenhotep III*, 1964). His main achievement is the temple at Luxor, where the magnificent colonnade has campaniform capitals (fig. 126). Among the reliefs on the southeast side, those representing the well-known scene of the Pharaoh's birth deserve special attention. The same theme is treated in a less developed form in the temple of Hatshepsut at Deir el Bahari. The temple at Luxor was even then linked to the sacred enclosure at Karnak by an avenue of sphinxes. Some of the sphinxes of Amenhotep III are preserved *in situ*, the others are from a later period. Processions between the two temples moved along this avenue.

There are traces of Amenhotep III's activity at Karnak, too. South of the temple of Amon, in the enclosure of the goddess Mut, lie the ruins of a north-south oriented temple which this Pharaoh

531

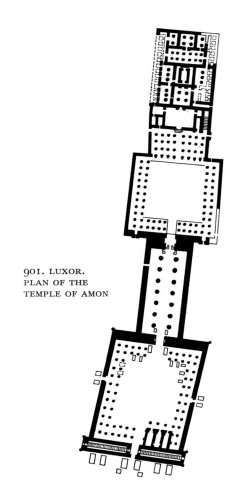

901. LUXOR.
PLAN OF THE
TEMPLE OF AMON

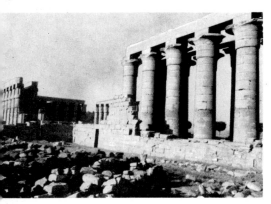

902. LUXOR. COLONNADES OF THE TEMPLE

903. LUXOR. AVENUE OF THE SPHINXES

built or rebuilt to replace an older structure. South of it is a sacred lake shaped like a half moon. In and around this temple, chiefly in its court, were 600 seated statues of the goddess Sekhmet, each of them 6 1/2 feet high. Many of these statues are today in museums all over the world. If, as is believed, all of them date from the reign of Amenhotep III (though some were usurped by subsequent rulers), they raise a puzzling question: What could have prompted this Pharaoh to place so many granite and diorite statues of the goddess in the sanctuary of Mut?

On the shore of the sacred lake of the temple of Amon, Amenhotep III placed a colossal granite scarab dedicated to Atum-Khepri. Inside the temple of Amon he made some radical changes. Pylon III, built by Amenhotep III, contained in its ruins hundreds of blocks taken from older structures in the temple enclosure. The central colonnade of the great hypostyle hall, consisting of twelve columns with calyx capitals (originally there were fourteen columns, the other two standing on the east side with Pylon II), was probably built during the same Pharaoh's reign, and was intended as an avenue leading to the new entrance. Also the temple of Montu situated north of the great temple of Amon was built by Amenhotep III.

Finally Amenhotep III may have had a hand in another temple at Karnak—that of Khonsu. It is generally believed that this temple was begun by Ramesses III, whose successors added reliefs and made a number of alterations. Mariette had suggested that Ramesses raised the temple on the site of an earlier one built by Amenhotep III; this hypothesis has been modified by the Russian Egyptologist Mrs. M. Mathieu (*Iskusstvo Drevnego Egipta, Novoye Tsarstvo*, pp. 24 f., 47, 54), who believes that this temple must have been started by Amenhotep III. She points out that it contained a statue of Amenhotep, son of Hapu, Amenhotep III's architect, and that older blocks have been discovered in its ruins, for instance, a stele dating from the reign of Amenhotep II. One of her arguments seems particularly convincing. We know that the Karnak end of the Luxor-Karnak avenue of sphinxes was somewhere near the entrance to the temple of Khonsu—a fact which implies that a temple must have been standing there when the avenue was built. We also know that as early as the Middle Kingdom a sanctuary of Khonsu stood south of the temple of Amon. It is unlikely that Khonsu, one of the Theban triad (himself and his parents Amon and Mut), had to wait until the reign of Ramesses III for a temple at Karnak. Finally, it must be remembered that the funerary temple of Amenhotep III erected on the opposite bank of the Nile—the largest of all Theban funerary temples, from which only the two famous Colossi of Memnon (fig. 124) and one stele have survived—was designed by the famous Amenhotep, son of Hapu, the only architect in ancient Egypt who was granted the privilege of building his own funerary temple (C. Robichon and A. Varille, *Le temple du scribe royal Amenhotep, fils de Hapou*). The classical plan of New Kingdom religious architecture is realized for the first time in this temple; and the best extant example of this architecture is precisely the temple of Khonsu at Karnak (K. Michalowski, "Sozdatiel Kanona Egipietskovo Khrama," *VDI*, 4, 1956, pp. 119-30). (See Chart X, p. 577.)

In addition to his funeral temple on the west bank of the Nile and his rock-cut tomb west of the Valley of the Kings, Amenhotep III had a palace south of his funerary temple, overlooking a man-made lake fed by a canal from the Nile. It was in this palace that he often resided with his beloved wife Tiy. Its ruins, at a site known today as Malkata, were excavated by an American expedition from the Metropolitan Museum, New York (A. Lansing, "Excavations at the Palace of Amenhotep III at Thebes," *BMMA*, XIII, March, 1918, Suppl., pp. 8-14).

Before moving his residence to Amarna, Akhenaten built a temple enclosure dedicated to Aten east of the Amon enclosure at Karnak. After his death the Aten temple complex was destroyed. Its location is known, and a number of monuments belonging to it have survived, the most important of which are colossal statues of the king. Originally they stood against pillars which formed a kind of peristyle. All of them exhibit the naturalism typical of portraits of this king (fig. 101). There are also many sandstone blocks decorated with reliefs in the Amarna style, which have been discovered in the ruins of later structures, particularly in Pylon IX erected by Horemheb. In recent years many blocks decorated in Akhenaten's time have been found in front of the temple at Luxor. They show that this king did not fail to add luster to his name here as elsewhere.

His successors Tut-ankh-amon and Ay also built at Karnak: architraves bearing the names of these rulers have been discovered there. They dedicated statues and steles to Amon on a scale suggesting that they wanted to exonerate themselves of all taint of Amarna heresy. Tut-ankh-amon decorated the walls of the magnificent colonnade of Amenhotep III at Luxor with low reliefs. But this ruler is best known for his tomb at Thebes, discovered in 1922 by Howard Carter, who conducted excavations for the Earl of Carnarvon (H. Carter, *The Tomb of Tut-ankh-Amun*, I-III, 1925-33). This is the only known royal tomb to have come down to us intact. Its rich gold furnishings make up the most valuable part of the Cairo Museum's collection (C. Desroches-Noblecourt, *Vie et mort; Toutankhamon et son temps*). (See figs. 105-7, 464-85, 794, 798-800, 809, 811, 815.)

Horemheb, the last ruler of Dynasty XVIII, left substantial evidence of his building activity at Karnak. Three pylons are attributed to him—II, IX, and X. Pylon II, formerly attributed to Ramesses II, was in fact almost entirely built by Horemheb. In front of it stands a small antechamber (like the one in front of Pylon III), whose walls were almost entirely decorated by Horemheb, but his name in all but one of the cartouches was obliterated and replaced with those of Ramesses I and

Ramesses II. Pylons IX and X were built with blocks from the older structures mentioned above. Horemheb was also responsible for the avenue of sphinxes linking Pylon X with the temple enclosure of Mut. Steles dedicated by this ruler have been found in various buildings at Karnak, for example, in the temple of Ptah.

At Luxor, Horemheb added his own cartouches to the relief decorations on the great colonnade erected by Amenhotep III and Tut-ankh-amon. This ruler "specialized," so to speak, in usurping Theban monuments. His funerary temple actually belonged to his predecessor Ay—Horemheb enlarged it slightly. At the same time he must be credited with restoring the temple of Hatshepsut at Deir el Bahari and the temple of Tuthmosis III at Medinet Habu. His tomb in the Valley of the Kings is one of the largest and most impressive of all the tombs of Dynasty XVIII kings.

During this dynasty, too, the necropolis for dignitaries on the eastern slopes of the desert hills (near present-day Sheikh Abd el Gurneh) was considerably expanded. Many of these tombs are beautifully decorated with low reliefs and paintings. Those of the following persons deserve special mention: the architect Ineni, superintendent of Amon's granaries, who directed the construction of the tomb of Tuthmosis I; Senmut, famous architect and favorite of Queen Hatshepsut, with the celebrated astronomical decorations on its ceiling (but Senmut was not buried here); Menkheperra-seneb, high priest of Amon under Tuthmosis III; Rekhmira, acting vizier under Tuthmosis III and Amenhotep II; Sennefer, mayor of South Thebes, and superintendent of Amon's gardens under Amenhotep II; Menena, superintendent of cultivated fields under Tuthmosis IV; and Nakht, priest of Amon in this same period. Dating from the reigns of Amenhotep III and Akhenaten, the tombs of the dignitaries Kheruef and Ramose are of special interest (N. de G. Davies, *The Tomb of the Vizier Ramose*, 1941). They are particularly famous for the magnificent reliefs that decorate the walls of the burial chambers (see G. Steindorff and W. Wolf, *Die thebanische Gräberwelt*, 1936). The decorations of these tombs are illustrated in fig. 51 (Senmut); figs. 403-6 (Menkheperra-seneb); figs. 2, 93, 394-401, Chart VII on p. 571 (Rekhmira); figs. 407-12 (Sennefer); figs. 95, 96, 111, 421, 422, 424-32 (Menena); figs. 19, 94, 415, 423 (Nakht); figs. 99, 435, 436 (Kheruef); figs. 98, 112, 433, 434 (Ramose).

In connection with the construction of royal tombs in the Valley of the Kings, a town grew up at Deir el Medineh in West Thebes during Dynasty XVIII. It housed laborers who cut the underground galleries and burial chambers out of the rocks and the craftsmen who decorated them. Many tombs in the cemetery near the town are decorated with beautiful paintings. The town and the cemetery, both of which increased in size during Dynasties XIX and XX, were excavated by an expedition from the French Institute of Oriental Archaeology under B. Bruyère (*FIFAO*, I-VIII, X, XIV-XVI, XX).

The greatest architectural contribution made by Dynasty XIX to Karnak is the hypostyle hall between Pylons II and III, built by Sety I and Ramesses II (fig. 3). On either side of the central colonnade erected under Amenhotep III, they added seven rows of columns on an east-west axis. The rows nearest the colonnade of Amenhotep III consist of seven columns each, the others of nine. Above the central nave (taller than the others) were windows with stone gratings, but the

904. KARNAK. TEMPLE OF KHONSU

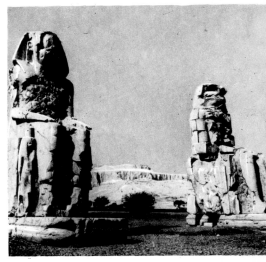

905. THEBES. COLOSSI OF MEMNON

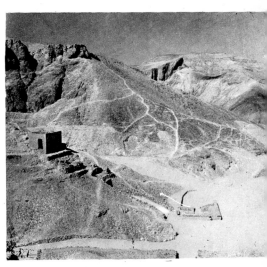

907. THEBES. THE VALLEY OF THE KINGS

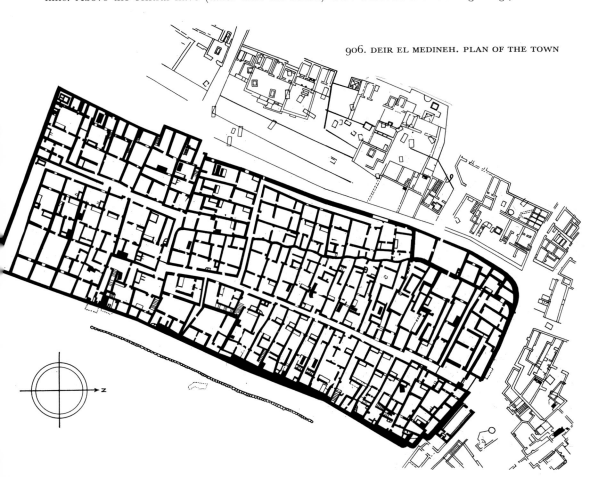

906. DEIR EL MEDINEH. PLAN OF THE TOWN

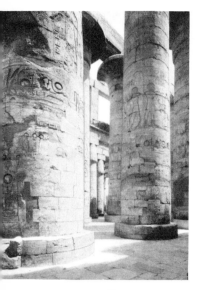

908. KARNAK. TEMPLE OF AMON, HYPOSTYLE HALL

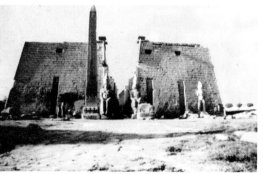

909. LUXOR. TEMPLE OF AMON, PYLONS, CO-LOSSI, AND OBELISKS

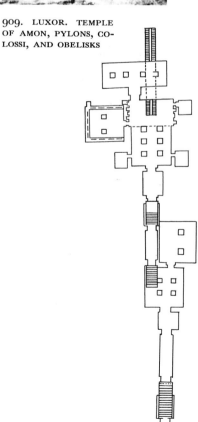

910. THEBES. PLAN OF THE TOMB OF SETY I IN THE VALLEY OF THE KINGS

ceiling above the lateral naves had only slits. Despite the semidarkness that prevailed here, the walls of the hall and its columns were richly decorated with reliefs. Furthermore, the exterior walls of both the hypostyle hall and the central section of the temple erected under Tuthmosis III were covered with reliefs (fig. 363). On the north exterior wall of the hypostyle hall the exploits of Sety I in Syria, Palestine, and Libya are shown. The most interesting relief of Ramesses II is on the south exterior wall; it illustrates the victory of the king over the Palestinians and contains a fragment of the famous Epic of Pentawur. Ramesses II added more inscriptions to the walls of the court between Pylon VII and the south entrance to the temple of Amon, including texts referring to the treaty he concluded with the Hittites. In front of Pylon II stood two colossal granite statues of this Pharaoh. The ante-chamber in front of this pylon was also decorated with reliefs. Leading up from the Nile to this entrance was an avenue of ram-headed sphinxes built during the reign of Ramesses II (fig. 128). The west part of this avenue remains *in situ*, while the east part was later shifted south, after the construction of the first court. Two other colossal statues of the king with his wife Nofretari stood in front of Pylon IX (fig. 543). Two small temples—one dedicated to Amon, east of the great temple of Amon, and one near the temple of Mut at the east corner of the enclosure—also date from his reign.

Ramesses II also rebuilt the temple of Amon at Luxor, adding to the construction of Amenhotep III a court surrounded by a double row of columns and pylons, which do not lie on the axis of the older structure. In the court stood many granite statues of this king, and, in front of the pylons, two colossal statues (fig. 126) and two obelisks, one of which stands today in the Place de la Concorde in Paris.

Both Sety I and Ramesses II had magnificent tombs in the Valley of the Kings. That of Sety I is distinguished by a complicated layout of corridors and chambers carved out of the rock at many levels. Its rich polychrome reliefs (figs. 69, 116, 117, 502-8) are among the finest works of Dynasty XIX funerary art, both iconographically and formally (E. Lefebure, *Le tombeau de Seti I, MIFAO*, II, 1886).

In this period the royal wives were buried in the so-called Valley of the Queens (southwest of the Valley of the Kings). One of the most beautiful tombs is that of Queen Nofretari, wife of Ramesses II, where the polychrome reliefs on the walls of the mortuary chamber have been perfectly preserved (figs. 119, 559-65). Both sovereigns had temples in the city of the dead. The temple of Sety I at Gurneh is one of the best-preserved monuments of this type. His second, smaller temple was incorporated into the funerary temple complex of Ramesses II, the ruins of which are today called the Ramesseum. Of special interest are the remains of a red granite colossus and reliefs on the inner side of Pylon II showing the battle of Kadesh (figs. 548-52). Like other rulers of Dynasty XIX, Ramesses II had a palace near his funerary temple. Portions of the dried brick vaulted storehouses have survived near the temple. Both Sety I and Ramesses II restored many old buildings in the area of Thebes, above all, the temples in the city of the dead.

Merenptah, who succeeded Ramesses II, did not embellish Thebes with new buildings but his cartouches have been found in many places. Among the most important historical records dating from his reign are the reliefs on the east wall of the court north of Pylon VII representing the king's struggles with the Libyans, the Etruscans, and the Achaeans. In West Thebes, Merenptah had his tomb in the Valley of the Kings and his funerary temple (today completely destroyed) south of the Ramesseum.

Sety II, the last ruler of Dynasty XIX, erected a pylon in front of the temple of Mut at Karnak and built a tripartite chapel dedicated to the Theban triad in front of the great temple of Amon. When the great court was built, its enclosure included the area of the chapel (H. Chevrier, *Le temple reposoir de Seti II à Karnak*, 1940). Apparently Sety II intended to enlarge the temple in the direction of the Nile; the obelisk he erected on the quay may be an indication of this.

Of Dynasty XX rulers, Ramesses III contributed most to the embellishment of the capital. This Pharaoh, who built new temples to win the support of the priests of Amon, was also compelled—as witness the Harris Papyrus—to grant them rich subsidies. A north-south oriented temple was built near Pylon II of the temple of Amon at Karnak; Osiride statues of Ramesses II stand on both sides of the court. Along with the temple of Khonsu, this temple is one of the best preserved at Karnak. North of the temple of Amon, Ramesses III built a smaller sanctuary near Pylon III. He was also responsible for a third temple at the west corner of the Mut enclosure on the other side of the sacred lake. The temple of Khonsu as we know it today dates from his reign, although his successors added decorations. However, they did not erect any large structures at Karnak, except for Ramesses IX, who reconstructed or built a wall with a gate between Pylons III and IV.

The greatest architectural work built by Ramesses III, next to his tomb in the Valley of the Kings, is situated in West Thebes. This is the complex at Medinet Habu *(Medinet Habu)*. It was realized in two stages. First the Pharaoh's funerary temple and dependent structures were built and enclosed by a rectangular wall. Inside the wall, to the left of the entrance to the sacred enclosure, was the royal palace. The second stage, realized toward the end of the Pharaoh's reign, gave the complex a pronounced defensive character. A second wall was added, considerably thicker than the first (32 3/4 feet) and more than 59 feet high; the temple of Tuthmosis III now stood within its perimeter. To the east and west stood fortified gateways; the east gateway, three stories high, and a

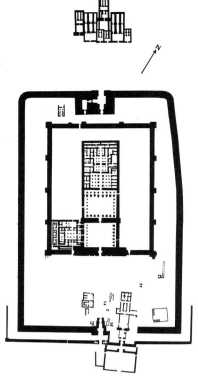

considerable portion of the temple are in a good state of preservation. The low reliefs decorating the chambers represent the king with the princesses—for this reason these chambers are referred to as the "harem." A bypass from the Nile canal led up to this gateway. The apartments of priests and officials in charge of this temple were also inside the enclosure wall. The royal palace was built at this time. The bastions on the east side and the temple walls themselves were decorated with reliefs, which include battle and hunting scenes. The Pharaoh is shown in a chariot drawn by plumed horses (figs. 553-58).

Nearly all that is known of the funerary temples built by Ramesses III's successors is based on the text of a single papyrus. The foundation deposits of Ramesses IV, discovered during American excavations at El Assasif, and the remains of an immense temple with two courts and two pylons suggest that Ramesses IV planned an architectural complex that would eclipse that of his predecessor at Medinet Habu. However, he never completed his project: none of the reliefs found on the temple site can be definitely attributed to Ramesses IV. The identifiable blocks are either taken from temples of earlier rulers—Hatshepsut, Tuthmosis III, Amenhotep II, Ramesses II—or bear cartouches of his successors Ramesses V and Ramesses VI. The funerary temples of Mentuhotep I, Hatshepsut, and Tuthmosis III at the head of the valley of Deir el Bahari were cut off from the Nile by this complex at El Assasif, which was considerably larger than the complex of Ramesses III at Medinet Habu (Hayes, *Scepter of Egypt*, II, pp. 364 f.).

Tombs of the later Ramessides have been discovered in the Valley of the Kings. In their time the necropolis of dignitaries on the sloping desert hills (as at Deir el Medineh) was considerably enlarged. It is interesting to note that in the sixteenth year of the reign of Ramesses IX an official investigation was launched into the systematic pillage of royal tombs (T. Peet, *The Great Tomb-Robberies of the Twentieth Egypt Dynasty*, I-II, 1930).

The Theban priest-kings (Dynasty XXI) were primarily interested in perpetuating their names on the walls of existing buildings. The conflict between the secular authorities and the priesthood of Amon had ended with the victory of the latter, and unlike their predecessors, the new rulers felt no need to seek the favor of the gods by building monumental religious edifices in East Thebes. Moreover, the economic consequences of the division then existing between Upper and Lower Egypt (the latter governed by kings residing at Tanis) were unfavorable to large-scale building activities. Only Herihor, first ruler of the Theban Dynasty, contributed a colonnaded court to the temple of Khonsu at Karnak.

Dynasty XXII kings marked their presence at Karnak by building a portico in the southeast corner of the first court, between the temple of Ramesses II and Pylon II. King Osorkon II also built a chapel on the shore of the sacred lake.

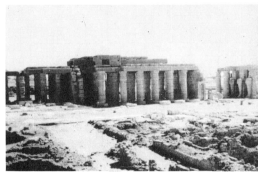

The Nubian Pharaohs from Napata, once they had conquered Egypt, were obliged to seek the favor of Amon in order to strengthen their authority as Egyptian dynasts. Shabako built a pavilion on the shore of the sacred lake at Karnak and a gateway near the temple of Ptah. He also embellished a temple at Medinet Habu. Taharqa completed Pylon II (begun by Shabako) in front of the temple of Tuthmosis III at Medinet Habu, and erected many buildings at Karnak. The most impressive work of this Pharaoh is the great colonnade in the first court of the temple of Amon; one mighty column (68 7/8 feet high) remains *in situ*. He also erected a religious edifice between the temple's south wall and the sacred lake, and a colonnade adjacent to the small temple of Ramesses II in the east part of the Amon enclosure. Between the sanctuaries of Amon and Mut he built a chapel dedicated to Osiris-Ptah, and remodeled one of the chapels in the temple of Mut. Toward the end of his reign Thebes experienced its greatest disaster. In 667 B.C. Ashurbanipal conquered Egypt and occupied the capital. During his second campaign in 663 B.C., just a few months after Taharqa's death, Ashurbanipal completely destroyed the city. The governor of Thebes at the time was Mentu-emhat, who loyally served the successive rulers. Several of his portraits have been preserved; he was a Nubian, appointed to his post by Nubian kings (fig. 594). Later he became a supporter of the Saite dynasty. He died at a ripe age and was buried at El Assasif in a tomb as large as or larger than the royal tombs there. One pylon of dried brick from his tomb still stands in the middle of El Assasif.

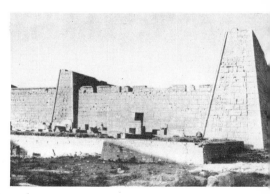

The four dynasties that followed (XXVI to XXIX) confined their activity at Thebes to a partial restoration of buildings and usurpation of inscriptions on old monuments. Dating from this period are a few small structures, including chapels of Saite princesses at Medinet Habu, an Osiris enclosure built by Psamtik III northwest of the temple of Montu at Karnak, and a few chapels in the Amon enclosure there.

However, new constructions and the restoration of buildings destroyed by the Assyrians did not begin on a large scale until Dynasty XXX. Nectanebo I erected Pylon I of the temple of Amon and enclosed the entire area with a wall of dried brick with a gate on the east side. He also added a pylon to the temple of Montu. Dating from the same period is the avenue of sphinxes leading from the pylon of Ramesses II at Luxor to Karnak; this avenue was uncovered during recent Egyptian excavations. All these structures were undoubtedly part of a broadly conceived plan for reconstructing the old monuments: some portions of the avenue of sphinxes at Karnak date from the reign of Amenhotep III, and it would be unlikely that it did not run as far as the temple at Luxor during Dynasty XVIII. Nectanebo I also enlarged the Dynasty XVIII temple at Medinet Habu—this

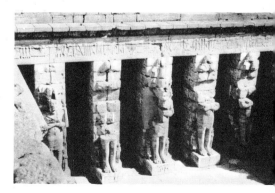

915. KARNAK. COLUMN OF TAHARQA

916. KARNAK. PRECINCT OF
AMON, TEMPLE OF PTAH

work had been begun on the east side by the Kushite rulers. His successors Teos and Nectanebo II continued rebuilding the ruined temples at Thebes, and Nectanebo II built a small chapel east of the Mut enclosure at Karnak.

After conquering Egypt, Alexander the Great not only consulted the Amon oracle in the oasis of Siwa, but also stressed his association with this god by visiting the main seat of his cult, the temple of Amon at Karnak. At his order certain alterations were made in one of the chambers behind the Heb-Sed hall of Tuthmosis III, and, probably because this chamber was damaged, it was decorated with new reliefs, which no doubt reproduced the subject matter of their predecessors. Other alterations were made by Alexander in the temple of Amon at Luxor. In front of the main sanctuary a new chapel was built for Amon's barge, replacing the earlier one which had four columns.

Philip III Arrhidaeus built a large granite chapel for Amon's barge on the axis of the temple of Amon at Karnak, in the middle of a structure erected by Hatshepsut. The Ptolemaic dynasty was eager to win the same devotion the population had accorded the ancient Pharaohs, and so devoted special attention to Thebes, although the city rebelled against it on three occasions. The Ptolemies did not simply add their own cartouches to the temple walls; they also erected new structures at Thebes. These fall into two main architectural categories: religious structures, like those Ptolemy II erected in the temple of Mut at Karnak and those his successors erected inside the Montu enclosure; and independent sanctuaries, like that dedicated to the goddess Apet (Thueris), who was worshiped with Osiris in a temple adjoining the Khonsu temple. This sanctuary was begun by Ptolemy VIII Euergetes II; its decoration was continued by his successors. The most impressive Ptolemaic monuments at Karnak, however, are gates and pylons. They include the gateway erected by Ptolemy III Euergetes in front of the temple of Khonsu, a propylaeum built by Ptolemy II and Ptolemy III Euergetes leading to the Mut enclosure, another leading to the Montu enclosure, and pylons in front of the temple of Ptah.

The activity of the Ptolemies at Karnak probably has some connection with the famous "Karnak cache," discovered by G. Legrain in 1903-4, which contained about 20,000 ancient objects. This was a large pit more than 45 feet deep in the court in front of Pylon VII; at its bottom were found some 75 sculptures and steles. Although it has recently been suggested that the cache was filled with sculptures at different times, concurrently with the successive enlargements of the temple (B. Bothmer, *Egyptian Sculpture of the Late Period*, p. 152), Maspero's opinion seems more plausible. He believed that the pits were filled in the time of Ptolemy III Euergetes or Ptolemy IV; for it is difficult to imagine that this pit, which was a sort of dump or junk pile, would have been left open for all to see for very long in what was after all the most important sanctuary of Egypt.

In West Thebes, too, the Ptolemies restored ruined structures and built small sanctuaries. At Deir el Bahari, Ptolemy VIII Euergetes II rebuilt the colonnaded hall on the upper terrace of the Hatshepsut temple complex. He also erected a small portico in front of the rock-cut sanctuary of Amon dating from the reign of Hatshepsut, and added a chamber to the latter. In the Ptolemaic Period this part of the temple, which was situated farthest from the entrance, was used for the worship of Imhotep and Amenhotep, son of Hapu, as well as the Greek Hygeia, who was daughter of Asklepios, whom the Greeks identified with Imhotep. In this way the funerary temple of Hatshepsut now became a kind of sanitarium under the patronage of Imhotep-Asklepios.

Near Deir el Medineh, the Ptolemies built a small temple near the New Kingdom necropolis. At Medinet Habu they built a pylon in front of the temple of Tuthmosis III, and farther south at Qasr el Aguz, a chapel dedicated to Thoth (Ptolemy VIII Euergetes II).

In the Ptolemaic Period Thebes became a great attraction for Greek tourists. As early as the fifth century B.C., Herodotus had alerted the Greeks to the splendor of Egypt's temples. Under the Ptolemies the number of tourists kept increasing, and many left their names on temple walls, sometimes adding expressions of admiration. At the beginning of the Christian era the greatest attractions at Thebes were the Colossi in the temple of Amenhotep III. These statues were carved from sandstone blocks brought from quarries near Memphis, almost 435 miles away. Their height exceeds 49 feet not counting the bases which are more than 6 1/2 feet high (fig. 124).

In 27 B.C., following an earthquake which damaged the temple, the north Colossus revealed a crack at about the middle of the torso. Sudden changes of temperature and humidity, such as occur at sunrise, caused the statue to vibrate and emit a gentle sound, which not only attracted the attention of the Egyptians but also that of the proverbially inquisitive Greeks. Strabo described the phenomenon (XVII, 816), and the Greeks soon began to identify this statue of Amenhotep III with the mythical Memnon, a hero Achilles had slain under the walls of Troy. According to the Greeks, the plaintive sounds that issued from the Colossus were Memnon's dawn greetings to his mother Eos, "the rosy-fingered dawn." The great career of the Colossi as a tourist attraction for cultivated Graeco-Roman society appears to date from Germanicus' visit to Thebes in 19 A.D. Both statues are covered with scrawls left on them by visitors who considered them one of the Seven Wonders of the World. Eventually Septimius Severus thought it necessary to protect the "musical" Colossus from further damage and had it repaired, and so it was that Memnon lost his "voice." The name has survived because the Greeks who associated the fallen hero with worship of the dead Pharaoh called the enclosure Memnonoeia.

Like Alexander the Great, the emperor Augustus perpetuated his name on the temple walls at Karnak. After the priests accorded him the epithet of Synnaos, "sharing the naos with the gods," his statue was placed in the temple (K. Michalowski, *BIFAO*, XXXV, 1935, pp. 73-88). Domitian added a court with a gate in front of the pylon of Nectanebo at Medinet Habu, and Hadrian, who visited Thebes in 130 A.D., embellished the temple of Isis at Deir esh Shelwit, built by the first Roman emperors in West Thebes south of Medinet Habu. Decorations were added during the reign of Antoninus Pius. Toward the end of the third century Thebes rebelled against Roman rule; at this time a Roman legion probably set up a camp at Luxor.

Christianity took hold in Thebes toward the end of the fourth century. Certain temples were adapted to the new cult; old statues were destroyed and some of the reliefs obliterated. As in Roman times, blocks from ruined buildings continued to be used as a source of lime. In the seventh century a number of monasteries were founded in West Thebes. The main religious center was at Medinet Habu where a church dedicated to St. Menas was built. A monastery developed on the site of the Hatshepsut temple; its ruins were removed from the upper layer of the temple by Naville. There was another monastery at Deir el Medineh. Hermits often chose old tombs to live in, and the tomb of the vizier Dagi, dating from the Middle Kingdom, was converted into a monastery (H. Winlock, *The Monastery of Epiphanius at Thebes*, I-II, 1926). Two churches were built on the site of the temple at Luxor. The old temples at Karnak were converted into places of Christian worship.

Meanwhile, the dwellings of ordinary Thebans were spilling over into the former temple enclosures. No new religious edifice was erected at Thebes in Christian times, though this was not the case elsewhere in the Nile valley. The explanation is probably that old buildings were remodeled for use as churches; also, Thebes by now had lost its former importance. The political decline of the once great metropolis had begun much earlier, as far back as the fall of the New Kingdom. Later, when the capital was moved to Alexandria, Thebes was important only as a city of great historical monuments and a seat of religious tradition. After the introduction of Christianity and the fall of the Roman empire, the historical and religious traditions that Thebes had cultivated for the last thousand years of ancient Egypt's history lost their *raison d'être*. Only quite recently has the city experienced a revival—purely as an archaeological site. Today Luxor, Karnak, and the necropolis of Thebes constitute the most valuable single cultural and artistic complex surviving from ancient times.

The rediscovery of Thebes is a story in its own right. The earliest European travelers could not even locate its site. In the thirteenth century, Bucardus of Mt. Zion mistook the ruins of Memphis for Thebes. Although a Dutch traveler and cartographer, Ortelius, clearly marked the position of Thebes on his map in 1584, it was not until the eighteenth century that the Jesuit Claude Sicard identified the ruins of Karnak and Luxor as parts of the ancient metropolis. Then ensued a period of successive expeditions and visits by individual travelers. They collected materials and sketched monuments, many of which have since found their way into European museums. Bonaparte's expedition to Egypt and the publication of Vivant Denon's work provided the basis for new, systematic investigations. Early in the nineteenth century one of the most ardent collectors of Egyptian antiquities, G. B. Belzoni, was active at Thebes. From then on, nearly every prominent Egyptologist has added something to our knowledge of the city's temple enclosures and necropolis. Systematic excavations, however, have been conducted only since the mid-nineteenth century, when the Egyptian Antiquities Service came under the directorship of Mariette (*Karnak*, I-II, 1875) and then Maspero. After them, Victor Loret continued the excavations, primarily in the Theban necropolis. The Egypt Exploration Fund, later the Egypt Exploration Society, sponsored the excavations of the prominent English archaeologist Flinders Petrie and his field party. They worked in the Ramesseum and the western necropolis. Naville excavated Deir el Bahari. Later the expedition of the Metropolitan Museum of Art under Winlock (followed by Lansing and Hayes) was active at Deir el Bahari and Malkata. The Oriental Institute of Chicago is conducting excavations at Karnak and Medinet Habu.

French archaeologists and architects working for the Egyptian Antiquities Service—Legrain, Pillet, and Chevrier—undertook large-scale investigations and restorations in the enclosure of the temple of Amon at Karnak. The French Institute for Oriental Archaeology worked in the northern part of Karnak. Recently an agreement was reached between the French and the Egyptian governments concerning conservation work in this area. A similar agreement was reached between the Polish and the Egyptian governments concerning the reconstruction of the temple of Hatshepsut at Deir el Bahari.

In conclusion, the outstanding investigators Theodor Davies and Howard Carter should be mentioned. They made important discoveries in the area of the Theban necropolis, and Carter won international fame for his discovery in 1922 of the tomb of Tut-ankh-amon in the Valley of the Kings.

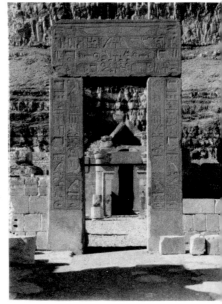

917. DEIR EL BAHARI.
TEMPLE OF HATSHEPSUT, PORTICO

30. MEDAMUD

The ancient Egyptian ⸢�géné ⸣ = Madu, 5 miles northeast of Luxor. One of the three suburbs of Thebes in which the god Montu was worshiped.

Systematic excavations were conducted at Medamud by the Louvre and the French Institute for Oriental Archaeology from 1929 to 1940 (Bisson de la Roque, *Rapport sur les fouilles de Medamoud*, I-II; Robichon and Varille, *Description sommaire du temple primitif de Medamoud*, 1940). These excavations disclosed that before Montu had become the chief local god, Medamud possessed one of the oldest sanctuaries of Osiris in Egypt. Robichon and Varille discovered it beneath a Middle Kingdom temple. Enclosed by a hexagonal wall, it consisted of pylons and a court, from which two winding vaulted corridors led into two Osiris mounds. We know from reliefs that such mounds were primitive shrines of this god. The corridors and the walls of the court and the enclosure were built of dried brick. This sanctuary seems to have been built during the First Intermediate Period; after it was destroyed by fire, Sesostris III erected a temple of brick dedicated to Montu on the same site. A number of statues of Sesostris III, now in museums (figs. 84, 309), were discovered in this temple. A new temple oriented east-west was erected during Dynasty XVIII (the Middle Kingdom temple was oriented north-south).

The Dynasty XVIII temple (a granite portal belonging to it is still standing) was incorporated in a new temple enclosure in the Ptolemaic Period; in Roman times Tiberius erected a gateway, and Antoninus Pius embellished it with many new structures.

31. TOD

The ancient Egyptian ⸢�⸣ = Djeret, a village about 12 1/2 miles south of Luxor. Like Erment and Medamud, Tod worshiped the god Montu.

The French excavations at Tod, conducted from 1934 to 1936 (Bisson de la Roque, *Tôd*, 1937; *Trésor de Tôd*, 1950), brought to light a granite pillar with the cartouche of Weserkaf (Dynasty V) in the foundations of a Dynasty XII temple, but it is doubtful that a religious structure stood here in the Old Kingdom. The earliest sanctuary of Montu, built of limestone and sandstone blocks by Mentuhotep I and Mentuhotep II (Dynasty XI), was rebuilt at the beginning of Dynasty XII. One of its limestone architraves bears a cartouche of Amenemhat I; a fragment of the granite statue of this king with the goddess Sekhmet was also found, although according to a later tradition this temple was built by Sesostris I. In 1936, Bisson de la Roque discovered four bronze chests with cartouches of Amenemhat II under the floor of the temple (according to Lucas, *Ancient Egyptian Materials*, pp. 247 f., the chests are of copper). They contained pieces of lapis lazuli, gold, silver, and lead in small bars, as well as amulets and cylindrical seals inscribed with cuneiform characters. Some of the objects seem to be of Aegean or Mesopotamian provenance. None is of Egyptian manufacture—they must have been gifts or tribute sent to the king.

Tuthmosis III built a small sandstone repository for Montu's sacred boat slightly north of the older temple. In the Ptolemaic Period, Ptolemy VIII Euergetes II added a pronaos, also of sandstone. The sacred lake behind the temple lies exactly on its axis. Four pairs of steps lead down to it.

Antoninus Pius made certain repairs in the temple (the chapel, a treasury above it) and built a gateway leading to the court.

32. ERMENT

Or Armant; in Egyptian ⸢�⸣ = Iwn Mntw ("The On of the god Montu"); in Greek, Hermonthis. One of the oldest settlements in the nome of Thebes, situated on the west bank of the Nile, across from Tod.

The Egypt Exploration Society has been responsible for the rediscovery of vast cemeteries dating from prehistoric and Predynastic times, corresponding to the periods designated Nagadah I and Nagadah II (R. Mond and O. Myers, *Cemeteries of Armant*, I-II, 1937). Relatively few monuments in the necropolis date from the Old Kingdom, but some writers conjecture that by this period Erment had become capital of Nome IV of Upper Egypt. Thebes, of course, assumed this dignity toward the close of the Old Kingdom. Erment again rose to a position of importance during Dynasty XI (Mond and Myers, *Temples of Armant*, I-II, 1940). By then Mentuhotep I had built a temple dedicated to Montu, and from this point on the god was the principal object of worship in the town, as at nearby Tod and Medamud. In addition to Montu, the goddesses Junit and Tjenenet were worshiped, and later Montu's wife Rat-tawy. There was also a cult of Sobek and many other gods, including Ra and Aten. In the Late Period Buchis, a white bull with a black head, was the object of special veneration.

Many stone blocks have been found on the site of the temple; it appears that the temple was at least partly built of stone. The surviving low reliefs from Dynasty XI are stylistically very close to reliefs found in the temple at Tod, and so it is possible that both structures were decorated by the same artists of the Theban school. Unfortunately the site has been badly despoiled. It is certain, however, that the Dynasty XII kings enlarged the old temple and added new sanctuaries.

During his joint reign with Hatshepsut, Tuthmosis III restored the temple and erected a pylon which was later usurped by Ramesses II and his successors. He also rebuilt the temple court, which was at least in part decorated with colossal Osiride statues, some of which have been brought to light in the course of the excavations. Many were usurped by Merenptah. Building blocks inscribed with the names of Amenhotep III and Akhenaten show that the latter built a temple dedicated to Aten. During the New Kingdom, Erment was often called "The On of Upper Egypt," to distinguish it from Heliopolis, known as "The On of North Egypt."

A temple was built by Nectanebo II in the Late Period; and in the Ptolemaic Period Cleopatra VII built a "birth temple" dedicated to Montu, Rat-tawy, and their son Harpre. Baths and two gates were built in Roman times—by this time the town had replaced Thebes as the nome capital.

In the Coptic period, the Erment region was a major center of Christianity in Upper Egypt, as many ruined monasteries scattered around the nearby desert attest. In the town itself a church was built, stones from ancient temples serving as building material. Despite such despoiling of its monuments, Abu Salah in the thirteenth century found Erment still impressive, describing it as a town of magnificent buildings. It is not surprising, then, that the Arabs believed it was the birthplace of Moses. Destruction of this ancient site only began in earnest in the nineteenth century. Cleopatra's temple was still standing in 1860, when it was torn down to make room for the local sugar refinery.

About 4 miles west of Erment, R. Mond discovered an extensive cemetery of bulls where, like the Apis bulls in the Serapeum at Saqqarah, the Buchis bulls were buried in monolithic sarcophagi set in rows (Mond and Myers, *The Bucheum*, I-III, 1934). However, unlike the Serapeum, which was relatively well preserved when Mariette discovered it, the Bucheum has survived in pitiable condition. Its discovery has great archaeological value however, for the oldest of the dated tombs was built during the reign of Nectanebo II, the latest during the reign of Diocletian. A cemetery of cows, mothers of the sacred bulls, has been discovered near a village called Baqaria.

33. HIERAKONPOLIS

The Egyptian ⊙ = Nekhen, in Nome III of Upper Egypt, which was called the Nekhen nome. Its ruins lie at Kom el Ahmar, on the west bank of the Nile, north of Edfu.

In the Predynastic Period, Nekhen was the capital of Upper Egypt and a religious center. Here resided the king who called himself *nesut* and whose tutelary deity was the vulture goddess Nekhbet the White. Her sanctuary was at Nekheb (El Kab) on the east bank of the Nile. As can be inferred from finds made in the course of Quibell's excavations in the late 1890s (J. E. Quibell and F. W. Green, *Hierakonpolis*, I-II, 1900-2), Narmer, the ruler of Nekhen, succeeded in unifying the country after victory in battle over the king of Lower Egypt, whose title was *biti* and whose residence was at Buto. This event took place c. 3100 B.C. Narmer's predecessor, the so-called Scorpion King, had attempted unification but had failed. During the Old Kingdom, it would seem, Nekhen lost its earlier political importance. In the First Intermediate Period the governor of the Nekhen nome resided at Hefat (presumably today's Moalla or Asfun on the east bank of the Nile; see Vandier, *Mo'Alla*). From Dynasty XVIII on, the nome capital was at Nekheb.

At Hierakonpolis the chief deity was Horus, "Lord of Nekhen," represented with two feathers on his head. Along with Khnum, the "souls" of prehistoric kings were also worshiped; in the Late Period, the souls of the Buto kings were identified with the four sons of Horus. These "servants of Horus," that is, the rulers of the two Predynastic kingdoms, were worshiped throughout Egypt.

Among the finds of the English excavations were: the ruins of the city walls, and inside them the temple precinct; the ruins of a so-called Predynastic fort, possibly dating from Dynasty I or II; the Predynastic necropolis (the so-called Decorated Tomb situated at its edge is of particular interest); and, west of this complex, the rock tombs of the Middle Kingdom, and farther south, those of the princes of Nekhen dating from Dynasty XVIII. The excavations in the city and the temple enclosure uncovered five layers corresponding to five periods to which the buildings can be assigned. The Predynastic necropolises fall into Period I, and Period II also precedes the monumental architecture of Hierakonpolis. The famous circular wall found within the temple enclosure dates from Period II; built of sandstone blocks, it may have been a naos or a small sanctuary. The hieroglyph for Hierakonpolis derives from the shape of this structure. Period III corresponds to the first two dynasties; the earliest monumental temple probably dates from this time. Period IV, from which most of the dwellings date, corresponds to Dynasties III and IV, and Period V probably extends to Dynasty VI. The new temple and the city wall—an irregular quadrangle with sides measuring 623 1/4, 721 1/2,

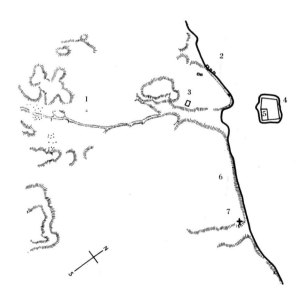

918. HIERAKONPOLIS. GENERAL PLAN
1 *Dynasty XVIII rock-cut tombs*
2 *Middle Kingdom rock-cut tombs*
3 *Fort*
4 *City walls*
5 *Temple precinct*
6 *Predynastic necropolis or town*
7 *Decorated Tomb*

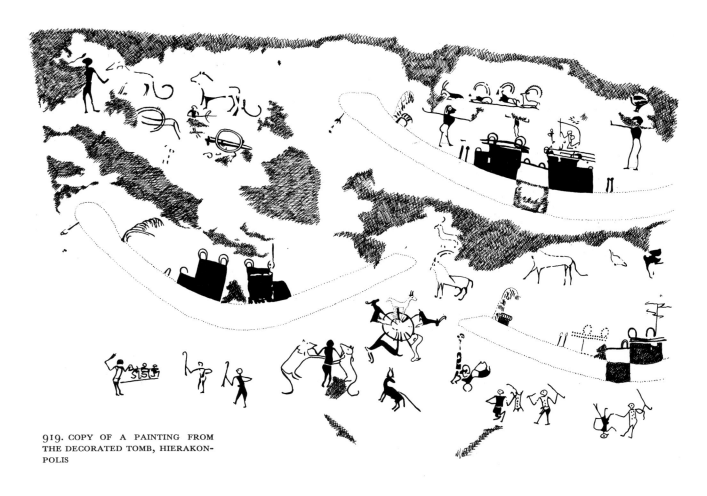

919. COPY OF A PAINTING FROM
THE DECORATED TOMB, HIERAKON-
POLIS

852 3/4, and 984 feet—probably dates from Period VI. The city wall of dried brick was rebuilt under Tuthmosis III, as is attested by the foundation deposit of this Pharaoh and certain blocks from the pylon marked with his name. The temple, too, was built of dried brick; it measured 442 3/4 by 262 1/2 feet. The little that remains shows that it was constructed in two stages.

The most important finds, which are basic for our knowledge of Egyptian history, were made within the temple. These are the limestone mace head that belonged to the Scorpion King (fig. 181), and the famous Narmer palette (figs. 57, 178). The scenes represented refer to the struggles between Upper and Lower Egypt and Narmer's victory culminating in unification of the two territories. The finds also include fragments of jars and fragments of steles bearing the inscriptions of the Dynasty II rulers Khasekhem and Khasekhemuwy, and fragments of a limestone statue of Khasekhem.

In the east section of the temple were discovered copper sheets from the well-known statue of Pepy I with his son Mernera (Dynasty VI) and a slate statue of Khasekhem with a relief on the base. A vertical shaft lined with dried brick contained the famous gold falcon's head dating from Dynasty VI (fig. 256). Its eyes are made of obsidian; the head was originally part of a statue of Horus made of sheets of gold and copper over a wood core. All these priceless objects were found in a cunningly concealed hiding place, which may have been arranged at some later period; certain finds made during the excavations show that the last king who enlarged the temple was Pepy II.

In the necropolis the most important discovery is the Decorated Tomb, thought by Brunton to be a dwelling ("The Predynastic Town-site at Hierakonpolis," in *Studies Presented to F. L. Griffith*, pp. 272-76). A wall painting in the mausoleum shows warriors in boats, the defeat of an enemy, and a hunting scene. This is the earliest painting so far found in Egypt; the iconography discloses strong eastern (Mesopotamian) influences. It may represent an episode from the oldest struggles between the Nagadah population and the invading "servants of Horus." It is generally assumed that this painting dates from the beginning of the late Gerzean period (SD 60 in Flinders Petrie's sequence).

We must also notice, in the group of Middle Kingdom tombs, the tombs of Pepynenankh of the end of Dynasty VI and Horemkawef, Chief Prophet of the Nekhen Horus. The Dynasty XVIII tombs include that of Djehuty, Overseer of Sculptors, and that of Hormosi, First Prophet of the Nekhen Horus under Tuthmosis III.

It may be added that Nome III was famous for the fertility of its narrow strip of land along the Nile. During the First Intermediate Period the nomarch of this province was able to feed his own subjects during a great famine, and even to help out his neighbors.

34. EL KAB

On the east bank of the Nile, north of Edfu. The ancient ⨂ = Nekheb, the Greek Eileithyiaspolis, in Nome III of Upper Egypt. In Predynastic times the town's main deity was the vulture goddess Nekhbet, patroness of the rulers of Hierakonpolis-Nekhen on the opposite bank of the Nile.

The name of the town appears at an early date, on fragments of a stone vase and on the stele of King Khasekhem (Dynasty II). The inscriptions on the latter refer to battles against a northern invader in the neighborhood of Nekheb (Emery, *Archaic Egypt*, pp. 99-100).

Systematic excavations at the site were begun in the late 1890s by Quibell (*El-Kab*, 1898) and continued by Sayce and Clarke (*ASAE*, 6; *JEA*, VII, VIII). Beginning in 1937, they were conducted by Jean Capart for the Belgian Queen Elisabeth Foundation (Capart, *Fouilles en Égypte, El-Kab*, 1946; Stienon, *CdE*, XXV), and after an interruption resumed by Meulenaere in 1966-67.

The scientific importance of El Kab will forever be associated with the name of the great Belgian Egyptologist, Jean Capart. He made important archaeological discoveries at this site and, in addition to his penetrating technical studies, wrote a book recording his impressions and recollections of El Kab, probably the only Egyptian site that can boast of having inspired an "archaeological romance" by a great scholar.

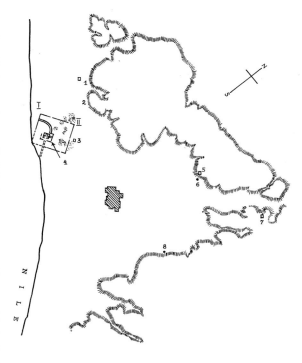

920. EL KAB. GENERAL PLAN
I *Town enclosure*
II *Necropolis*
1. *Chapel of Tuthmosis III* 2. *Rock-cut tombs*
3. *Chapel of Nectanebo I* 4. *Sacred precinct*
5. *Ptolemaic temple* 6. *Chapel of Thoth* 7. *Chapel of Amenhotep III* 8. *Burg el Hamam*

Of the oldest buildings at Nekheb, scarcely a trace has been preserved, except perhaps a portion of the oval city walls of dried brick, situated within a fortified area dating from later times. Nearby a few objects from Predynastic tombs have been found, as well as remains of granaries probably dating from the Old Kingdom. In the neighboring Gebel are preserved Predynastic rock drawings representing boats. As for the Old Kingdom, the Dynasty IV mastabas of Kaimen and Nefershemem outside the town are the most notable structures to have survived. The rock tomb of Senweseret in the same area dates from the Middle Kingdom (Dynasty XII).

Early in Dynasty XVIII, Nekheb became the capital of Nome III. From that time, until Dynasty XXX, many structures were erected; their remains are visible today, and were even more visible at the time of Bonaparte's expedition (*Description*, I, pp. 343-50) and Champollion's visit (*Lettres écrites d'Égypte et de Nubie*, pp. 159-60).

The earliest New Kingdom monuments are the rock tombs. Of particular interest is the tomb of Ahmose, son of Abana, Chief of Sailors under Ahmose I, founder of Dynasty XVIII. Inscribed on the walls of this tomb is the famous account of the capture of the city of Avaris and the pursuit of the Hyksos into Palestine (see, among others, Loret, *L'inscription d'Ahmès, fils d'Abane*, 1910). Beside the tomb of Ahmose, there is that of his grandson Paheri, decorated with reliefs showing the harvest, village scenes, hunts, and burial ceremonies (J. J. Tylor and F. L. Griffith, *The Tomb of Paheri at El Kab*, 1895). The tomb of Renni, Chief of Prophets, dates from the reign of Amenhotep I.

West of these tombs, Tuthmosis III built a small chapel (today in ruins) dedicated to Nekhbet, tutelary deity of the town. The chapel was surrounded by an ambulatory, and later Nectanebo I imitated its layout in one of his own structures at El Kab (Borchardt, *Aegyptische Tempel mit Umgang*, 1938, pp. 93 f.; Vandier, *Manuel d'archéologie*, II, pp. 808 f.). But the most important building Tuthmosis III erected was the temple to Nekhbet, which stood on a low hill at the center of the town (on the site of an earlier temple). To the west of this temple, his son Amenhotep II built a temple dedicated to Thoth.

Amenhotep III built a small chapel in the rocky Gebel east of Nekheb; it had only one hall, in which the columns were adorned with Hathor capitals (Tylor, *The Temple of Amenhotep III at El Kab*, 1918). Ramesses II remodeled parts of the temple of Amenhotep II and added pylons. To the west the same king built a small chapel, today completely destroyed; it is known through drawings made by early travelers.

During the reign of Ramesses II, Setawe, one of the best-known viceroys of Nubia, built a small chapel dedicated to Thoth west of the Amenhotep III chapel at the foot of the Gebel. Ramesses II placed his cartouche in the Amenhotep III chapel, which had been restored under his predecessor Sety I. Nekheb was a prominent religious center during Dynasties XVIII and XIX; building blocks originally from structures erected by such Pharaohs as Amenhotep III and Ramesses III have been found in later buildings. The rock-cut tomb of another Setawe, First Prophet of the goddess Nekhbet (Ramesside period), was found near the Dynasty XVIII tombs mentioned above.

In the Late Period, the main Nekhbet sanctuary was entirely rebuilt by Achoris of Dynasty XXIX and Nectanebo of Dynasty XXX. It was considerably enlarged, partly at the expense of the temple of Amenhotep II. Its new layout diverges considerably from the classical type. Probably dating from the same period is the wall surrounding the complex of the temples of Tuthmosis III and Amenhotep II; a third, small temple (perhaps a Mammisi, or birth temple) was

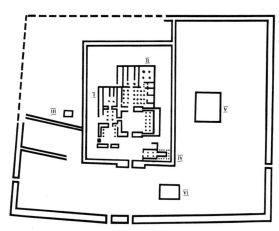

921. EL KAB. PLAN OF THE SACRED PRECINCT
I *Temple of Amenhotep II*
II *Temple of Tuthmosis III*
III *Temple of Ramesses II*
IV *Temple (Mammisi?)*
V *Sacred lake*
VI *Ptolemaic building*

922. EL KAB.
BRICK REMAINS OF OVAL CITY WALLS

added near the pylons of this enclosure, to the right of the entrance. In front of one pylon are the remains of a narrow portico which may date from a later period. Nectanebo I also built a small chapel northeast of the town, similar to the Tuthmosis III chapel at the foot of the Gebel. Also dating from Dynasty XXX is the defensive wall which now gives the whole ruined complex its monumental character. Built of dried brick, it is 39 3/8 feet thick and 19 3/4 feet high; originally it enclosed an area of about 1,738 feet squared. This wall, part of which cuts across an Old Kingdom cemetery, is perhaps one of the last monumental structures erected at Nekheb during Dynasty XXX (Clarke, *JEA*, VII).

El Kab, like other important religious centers in Egypt, discloses traces of Ptolemaic building activity. The ruins of two edifices (the smaller one was certainly religious in character) lie outside the temple enclosure wall on either side of the pylon. The Ptolemies may also have been responsible for a second dried-brick wall which had the form of an irregular rectangle measuring about 492 by 656 feet, and encompassed not only the temple precincts but also the sacred lake, the small Ramesses II temple, and the new Ptolemaic buildings (?). Ptolemy VIII Euergetes II restored the small Amenhotep III chapel in the Gebel, adding to it a monumental portico, today destroyed. Most important of all, however, is the temple northwest of the Thoth chapel, partly cut in the rock, which was begun during the reign of Ptolemy VIII Euergetes II and completed by Ptolemy X Alexander and Ptolemy XI Alexander II. The steep ramp leading up to it terminates in a platform followed by two courts with porticoes and the rock-cut sanctuary.

In the Roman period, private dwellings were built in the southwest part of the main temple enclosure. In the Coptic period, the city wall was torn down on the Nile side and the building materials were used to construct a fortified monastery.

35. DENDERAH

𓉺𓏏 = Iunu, Iunet, later Iunet Taneteret, from which is derived the Greek Tentyris. Capital of Nome VI of Upper Egypt, on the west bank of the Nile, between Abydos and Luxor, near Qena.

Denderah was one of the oldest centers of the worship of Hathor in ancient Egypt, where the kings of Upper Egypt, "worshipers of Horus," honored the goddess long before unification. From later texts one can infer that a temple built in Cheops' time, and subsequently rebuilt by Pepy I, stood in Denderah. The fragment of a statue of Pepy I was found in the ruins of the Mammisi, or birth temple, that stood in front of the great temple (Daumas, *BIFAO*, LII). Another inscription implies that Pepy II also erected buildings here.

Flinders Petrie's excavations in the necropolis here (*Denderah*, *1898*, 1900) brought to light a number of Old and Middle Kingdom mastabas: the oldest of these, the tomb of Neibunesu, prophet of Hathor, dates from Dynasty III. Most of the other mastabas where local dignitaries were buried date from Dynasty VI; there are two from the First Intermediate Period (Dynasty VII), and two from the beginning of the Middle Kingdom (Dynasty XI). These mastabas were built of dried brick and had false doors and stone steles. Within the temple enclosure Daressy (*ASAE*, 17) excavated a small chapel of Mentuhotep I (7 1/4 by 8 feet); reconstructed, it stands today in front of the Cairo Museum. As certain reliefs indicate, this chapel was remodeled by Merenptah. From several blocks which were reused in later buildings, it can be assumed that some work was done on the temple in the period of Amenemhat I. Judging from one of the inscriptions, Tuthmosis III built a new Hathor shrine, modeled on Cheops' older edifice. Tuthmosis IV, Ramesses II, and Ramesses III, whose cartouches were discovered on individual building blocks in the course of excavations, embellished the Hathor shrine.

Archaeological evidence from the New Kingdom on has revealed one of the most important features of worship at Denderah. Petrie excavated a vast cemetery with catacombs containing mummified animals *(Denderah, 1898)*. Besides birds, particularly falcons, it contained gazelles, cats, ichneumons, and snakes. This custom was still observed in Dynasties XVIII-XXVI, and in catacombs dating from Ptolemaic and Roman times even the mummies of dogs were discovered. The absence of cows—Hathor's sacred animals—comes rather as a surprise, however. Could it be that there was a separate place of burial for them, so far undiscovered?

The temple complex, or what has survived from it, dates from the period between Dynasty XXX and Roman times. It seems, however, that as early as the first half of the eighth century B.C. Piankhy began to build the old Mammisi, which was later completed by Nectanebo I; some decorations were added under Ptolemy VIII Euergetes II and Ptolemy IX Soter. This is the oldest known birth temple in Egypt. The main temple and the sanctuaries around it only date back to the last of the Ptolemies and the Roman period. According to one inscription, the great Hathor temple (Mariette, *Denderah*, I-V, 1871-80; Chassinat, *Temple de Dendera*, I-V [vol. V edited by Daumas]; Duemichen, *Baugeschichte des Denderatempels*, 1897) followed the plan of the Tuthmosis III sanctuary exactly. It would seem that the main section of the great temple of Hathor was erected under Ptolemy IX Soter II and Ptolemy XII Neos Dionysos. These kings, however, died before they could cover the entire wall space with reliefs.

923. DENDERAH. GENERAL PLAN
I. *Great temple of Hathor* II. *Sacred lake* III. *Temple of Isis* IV. *Sanctuary of Hathor-Mentuhotep III* V. *Old Mammisi* VI. *Coptic church* VII. *Mammisi of Ihy* VIII. *Propylon*

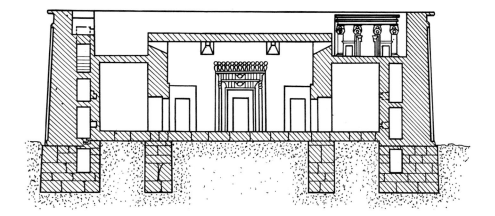

924. DENDERAH. SECTION OF THE TEMPLE OF HATHOR

The decoration of the temple began in the crypts, which are among the most interesting features of this edifice. They are hollowed out of the thick temple wall at the southern end, on both sides of the sanctuary proper. Twelve long, narrow chambers (only two of them are accessible today) are disposed at three levels, the lowest being underground, in the foundations. Denderah is the only place where crypts of this kind with reliefs have been found. Dedicatory texts and cartouches of Ptolemy IX Soter II and Ptolemy XII Neos Dionysos are found only in these crypts (figs. 662-71). Their exact function has not yet been explained; the reliefs seem to indicate that they served as safes and archives and that the most valuable ritual objects were kept here. They possibly reflect the influence of a tradition of underground sanctuaries, such as are found in some older temples. These underground chambers were considered to be symbolic burial places of gods; the worship in the temple assured their rebirth.

If one assumes—and this seems to be the only logical explanation—that decoration of the temple was begun by carving reliefs on the least accessible walls, there would have been no need for coordinating such work with the rest of the construction schedule. At all events, it may be assumed that the south portion of the temple, inside which the sanctuary was situated, was completed in the Ptolemaic Period, since two monumental reliefs on the south (or rear) wall show Cesarion (with his mother Cleopatra VII) burning incense to the gods of Denderah. These later reliefs are still entirely within the traditions of the Ptolemaic style: soft modeling of the figures and strongly emphasized chiaroscuro effects. Decorations on the east and west walls date for the most part from the period of Augustus, and the lower band of inscriptions on the west wall refers to Augustus' building activity at Denderah. This emperor appears on all the outside walls of the temple, most often fairly high up. Nero appears on the west wall only, beside Augustus. Decoration of the interior hypostyle hall was begun in Augustus' time as well, also that of the two vestibules and the chambers surrounding the sanctuary. Of special interest in the so-called Birth Chapel is a representation of the goddess Nut on the ceiling. It is also interesting that in the same part of the temple the name of Augustus appears beside empty royal cartouches. This is not the only site where such cartouches have been found.

Considering all the emperors' names that appear on the temple walls, one might suppose that the exterior hypostyle hall was built after Augustus. Along with the astronomical symbols on the ceiling, there are the names of Tiberius and (in the central part) Caligula. The names and portraits of Caligula, Claudius, and Nero appear on the walls, and the names of Domitian and Trajan are at the temple entrance. Yet, even if the exterior hypostyle hall with its twenty-four Hathor columns had been added at some post-Augustan date, still the rooms on the temple roof, over its south extremity, could only have been built under Augustus or at latest under Nero—who is represented on the exterior west wall and who may actually have had something to do with the completion of the temple's main structure.

The temple roof is reached by two staircases, east and west, which lead to three chapels closely connected with the Osiris cult. The one at the southwest corner is a pavilion dedicated to Hathor, where the union-with-the-solar-disk ceremony took place during the New Year's festivities. The chapel in the northwest part of the terrace is made up of three chambers decorated with representations of episodes from the myth of Osiris. It probably consituted one of Osiris' traditional six tombs. The chapel in the northeast part of the terrace is also composed of three chambers and decorated with more episodes from the Osiris myth. In the second chamber there is a plaster cast of the famous Denderah zodiac, the original of which is in the Louvre.

Decoration of the great Hathor temple was by no means the emperor Augustus' only architectural activity at Denderah. Near this temple's rear (south) wall he erected a small temple celebrating the birth of Isis. From this a formal walk (for processions) led to the sanctuary farther to the east, which was dedicated to the Horus of Edfu. This structure supposedly dates from the Middle Kingdom (Giron, ASAE, 26). Here Horus resided as Hathor's husband on his annual visit, when his statue was carried in solemn procession from Edfu on New Year's day. This procession was the main event of the New Year's festival at Denderah.

The children begotten by Horus and Hathor were also entitled to separate buildings in this temple enclosure. Possibly the Mammisi dating from the time of Nectanebo was dedicated to their son Harsamtawy. This building was partially demolished when a stone wall was erected around the temple of Hathor early in the Roman period. This would explain why the worship of Harsamtawy was transferred to another chapel within the new enclosure to the east of the great temple.

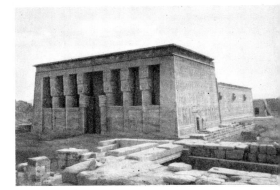

925. DENDERAH. TEMPLE OF HATHOR

926. DENDERAH. TEMPLE OF HATHOR, ROOF CHAPEL

543

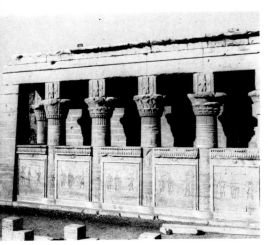

927. DENDERAH. MAMMISI OF IHY

Today this shrine is completely destroyed; its pylons were inscribed with the names of Marcus Aurelius, Antoninus Pius, and Tiberius. Another divine son, named Ihy, was honored in a more fitting manner. A great Mammisi, set against the north wall of the temple enclosure, had an east-west. orientation. It was begun by Augustus (or possibly by Nero); the most frequent names and figures in the relief decorations are those of Trajan, Hadrian, and Antoninus Pius. The walls of this temple and the low screens between the columns of the portico are decorated with reliefs showing the young Ihy on a lotus flower, along with other deities connected with his birth.

In the second century A.D., in the Roman period, this entire complex of temples was enclosed by a rectangular wall of dried brick (951 1/4 by 918 1/2 feet), with a width at the base of approximately 35 feet, and a height of 33 feet. The principal gate, built of stone, stands on the north side and exhibits the cartouches of Domitian, Nerva, and Trajan. There are some remains of Roman wells or fountains in front. The east gate dates from the times of Augustus, Tiberius, and Nero, and may have been the propylaeum of a small Roman temple, now completely destroyed.

East of this complex one can make out vestiges of two more brick-walled enclosures, one of which may have been dedicated to Ihy, son of Horus. West of the temple is a large sacred lake; its masonry also dates from the Roman period.

The splendor of Denderah outlasted the Roman period. The first real destruction was by Christians, who meticulously obliterated all the figurative representations on the temple walls, or at least all they could reach. Between the north wall of the temple and the Mammisi of Ihy they built a three-nave basilica with a trilobe apse, which probably dates from the fifth century A.D. Near it was a large building with many small rooms, perhaps a monastery or a sanitarium.

The Coptic town and the early Arab town grew up within the temple precincts, and until Mariette cleared the temples, an Arab village (at least part of one) was built over the roof of the Hathor sanctuary.

36. EDFU

𓍋𓏤𓈉 = Djeba, Djebawe, the Roman Apollinopolis Magna, the Coptic Atbo, on the west bank of the Nile, between Luxor and Aswan.

In ancient times Edfu was the capital of Nome II ("The Seat of Horus") of Upper Egypt, important from an early date as an agricultural center. Trading caravans set out from here to the south. It probably served as the granary for a considerable region around it. The proximity of Nubia enhanced its political importance. A religious center as well, the worship of Horus had long radiated from Edfu. All in all, it appears today to have been a major outpost of ancient Egyptian culture.

928. EDFU. RECONSTRUCTION AND PLAN OF A HOUSE

The French excavations of 1921-33 and the Polish-French excavations of 1936-39 brought to light a considerable part of the ancient town and its necropolis (*FIFAO*, I, II, VI, IX, X; *Fouilles francopolonaises, Tell Edfou*, I-III). In the latter were discovered a number of dried-brick mastabas of Dynasty VI nomarchs and local dignitaries, such as those of Qar, Pepy-nefer, Sabni, and Isi (fig. 66). There was also a cemetery from the First Intermediate Period and the Middle Kingdom. Sometime between the close of the Middle Kingdom and the beginning of the New Kingdom, Edfu was hastily fortified. Even part of the cemetery was utilized, with mastabas incorporated in the new walls built along the southwest side.

During the New Kingdom another defensive wall was built on the west utilizing the mastabas as foundations; by this time they were buried under the sand. The New Kingdom and Late Period cemetery was situated at the foot of the mountains of the western desert. Some sixty tombs have been

929. EDFU. THREE TYPES OF TOMBS
FROM THE FIRST INTERMEDIATE PERIOD
a) *"Catacombs"*
b) *"Columbaria"*
c) *Vaulted tombs (end of 1st Intermediate Period)*

930. EDFU. PTOLEMAIC TEMPLE OF HORUS

931. EDFU. TEMPLE OF HORUS, HYPOSTYLE
HALL AND FIRST COURT

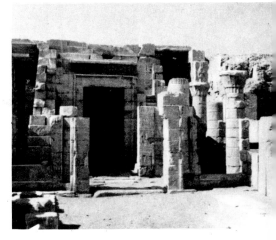

932. EDFU. MAMMISI

found; the best preserved date from Dynasty XXVI (the tombs of Khonsuritis, Petamon, and his son). The New Kingdom city, which lies under a Ptolemaic and a Roman layer, has not yet been excavated. Of special interest is the Jewish quarter, where many Greek ostraca have been found. The inscriptions on them show that they were tax receipts, the so-called *ioudaion telesma*. The Roman layer revealed private bathing facilities, including such refinements as the hypocaustum, and a small public establishment for bathing in a standing position. On top of the Roman layer stood the Coptic city with a small monastery, and an Arab cemetery was found in a layer over this.

A great temple of Horus dating from the Ptolemaic Period is situated west of the *kom* which constitutes the excavation area. At the east and the south, on the summit of the *kom*, stand the buildings of present-day Edfu. The foundations of an older shrine, which survived down to the time of Tuthmosis III, have been discovered under the Ptolemaic temple. As can be seen from Denon's drawings (*Voyage*, pls. 56, 1-3; 57, 1 f.; 58, 1) and those in *Description de l'Égypte* (I, pl. 48), at the beginning of the nineteenth century the Ptolemaic temple was buried under sand, and *sebakh*, the houses of the fellaheen, were standing over it. Later A. E. Mariette cleared all this away and brought to light the best-preserved shrine of ancient Egypt. As shown by the texts inscribed on its walls, its construction took 180 years, having been interrupted several times. The foundation stone was laid on August 23, 237 B.C., in the reign of Ptolemy III Euergetes. The architect bore the same name as the famous builder of Zoser's step pyramid—Imhotep. Construction continued into the time of Ptolemy XII Neos Dionysos, and was finally completed in 57 B.C.

Incised on the temple walls is the famous list of nomes, from which we learn that Edfu had three other names: Ayn, Hebenu, and Mesen. Among other synonyms for Edfu the most frequently encountered is Behdet, "Lord of the Sky," an epithet of Horus, the chief god worshiped at Edfu. His worship originated in a very old sanctuary of Lower Egypt, mentioned on one of Zoser's steles (Montet, *Géographie*, II, p. 34; see Alliot, *Le culte d'Horus à Edfou au temps des Ptolémées*, 1949-54).

At Edfu, Horus was represented as a winged disk, as a falcon, and often, too, as a man with a falcon's head. In the inscriptions in his temple at Edfu he is also called Horus-Ra, and the reliefs strongly emphasize his ties with his father Osiris, his mother Isis, and his wife Hathor. These three deities made up the "House of Horus." Hathor paid Horus a visit each year, when her statue was carried from Denderah to Edfu. At Edfu he is also called Horus the Valiant, the Golden Horus, and Horus Khenty-Khety, and is connected with the local divine Ennead. Other gods worshiped there included Hathor, Min, Ptah, Shu and Tefnut, Montu, and Khonsu. The great sacred text found at Edfu mentions only one festival, whereas the list of nomes mentions more than twenty. In fact, every day was somehow connected with one or another festive ceremony.

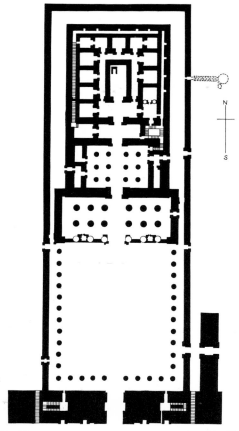

933. EDFU. PLAN OF THE TEMPLE OF HORUS

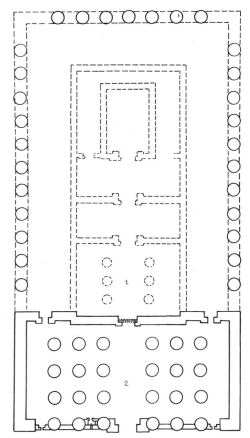

934. ESNEH. PLAN OF THE TEMPLE OF KHNUM
1. *Columned hall*　2. *Hypostyle hall*

The temple itself, 449 3/8 feet long and 259 feet wide, with pylons 118 feet high, has the classical layout. Behind the pylons stands a court surrounded on three sides by a covered colonnade. The capitals are striking in their variety: no three adjoining capitals are of the same type, but each type is repeated on the other side of the court. Beyond the court are the hypostyle hall, the hall of appearance, and then the hall for offerings, from which a staircase leads to the temple roof. Behind the hall for offerings is a sanctuary with a monolithic granite naos preceded by what may have been the chamber for the sacred barge. Beginning with the second hypostyle hall, there are a number of small side chambers; the function of each is indicated by inscriptions. On the exterior face, close to the bottom of the wall of each chamber, its dimensions are also given in ells and fractions of ells. These side chambers include a storeroom for fabrics, a so-called Laboratory with the formulas for perfumes and scented ritual ointments on the walls, and chapels dedicated to Ptah, Osiris, Khonsu, and other gods.

Between the enclosure wall and the temple proper there was a large hallway. All the temple walls, inside and out, are covered with reliefs and inscriptions (published in the 14-volume work by Rochemonteix and Chassinat, *Le temple d'Edfou*, 1897-1934). The most important decorations, besides the famous list of nomes, are the low reliefs of processions, feast-day ceremonies, and a number of ritual proceedings (figs. 654-59). These make Edfu one of the main sources of knowledge of ancient Egypt. Of special interest are the reliefs showing the contests of strength between Ra and Seth, and the scene in which Horus kills Seth (represented as a hippopotamus) by striking him with a harpoon.

East of the temple near the pylon are a Nilometer and the remains of a small temple built under Ramesses III. Directly in front of the temple are the ruins of a small birth temple built by Ptolemy VIII Euergetes II and decorated by Ptolemy IX Soter II. Like other birth temples, such as those at Denderah and Philae, it consists of two chambers surrounded by a gallery with pillars. The capitals bear the head of the god Bes, who appears as the patron of childbirth. The reliefs show episodes connected with the birth of Horus : one of them shows him being nursed by the Denderah Hathor. The little court in front of this birth temple was surrounded by a colonnade with representations of deities playing musical instruments (Chassinat, *Le Mammisi d'Edfou*, 1910).

The list of nomes mentions a sacred lake; this would suggest that the capital of this nome once stood on the shore of a lake which has now vanished.

37. ESNEH

𓈖𓇌𓏏 = Junyt, to the Greeks Latopolis, a town south of Luxor, on the west bank of the Nile, in Nome III of Upper Egypt. This town is referred to in Egyptian texts by three names. Senyt appears on a stele of Sesostris I, where the god Khnum is called "the Lord of Senyt." In the New Kingdom the place is called Junyt, and in the Late Period Ta-Senet, whence came the Arabic name Esneh (Montet, *Géographie*, II, p. 47). In the Ptolemaic Period, Esneh replaced El Kab as the capital of Nome III. Because Junyt sounds like Junu (Heliopolis), Esneh has occasionally been called the Heliopolis of Upper Egypt.

From early times the city had worshiped Khnum, the ram-headed god who created man, and who at Esneh was represented with a feather on his head, like Shu, the god of air. In later times, two local deities—the lion-headed Mehnit and the goddess of the fields Nebut—formed a divine triad with Khnum. Another deity closely associated with this town is the goddess Neith, who emerged from chaos here, created the world, and later traveled on the rising waters of the Nile to Sais in Lower Egypt, which became the main center of her cult. The fish *lates*, which accompanied her, became her sacred animal. This accounts for the Greek name of the town, Latopolis, the prohibition against eating this fish in the nome, and the cemetery of mummified *lates* near Esneh (Desroches-Noblecourt, "*Une fiole évoquant le poisson 'lates' de la déesse Neith*," in *Mélanges K. Michalowski*, pp. 71 ff.).

Near the cemetery of *lates* were found traces of prehistoric workshops. Also surviving are tombs dating from Dynasty XII and from the Second Intermediate Period, a few dried-brick tombs from the New Kingdom and from the period between Dynasties XX-XXII (Garstang, *ASAE*, 8; De Morgan, *ASAE*, 12), and vestiges of three *koms*—remains of ancient sanctuaries.

The most important surviving monument is the great temple of Khnum dating from the Ptolemaic and Roman periods (*Description*, Ant., Texte, I, pp. 366-83; Champollion, *Lettres écrites d'Égypte et de Nubie*, pp. 88-89). Another temple (the "northern temple"), also built in the Ptolemaic Period, was completely destroyed in the nineteenth century. A decorated block dating from Dynasty XVIII and a slab with a cartouche of Psamtik I were found in the temple of Khnum in the course of clearing operations conducted by the Egyptian Antiquities Service. From 1951 on the excavations and documentary studies in the temple have been conducted (with interruptions) by the French Institute of Oriental Archaeology in Cairo (S. Sauneron, *Quatre campagnes à Esna*, Cairo, 1959). This temple is mentioned only in texts dating from the end of the New Kingdom (Pleyte and Rossi, *Papyrus de Turin*, 1869-76, 155-11). It was entirely rebuilt by Ptolemy VI Philometor and Cleopatra II. Cult scenes, representing these rulers with their parents Ptolemy V Epiphanes and Cleopatra I, are located on the internal façade of the hypostyle hall. But most of the temple walls date from Roman times.

Added to the Ptolemaic façade was a large hall with twenty-four columns, built under Claudius and Vespasian. The other Roman emperors represented are Titus, Domitian, Nerva, Hadrian, Antoninus Pius, Septimius Severus, and Caracalla. The temple decorations constitute important evidence that the Roman emperors deliberately followed the Pharaonic tradition of representing themselves as participants in religious ceremonies.

The texts from the temple of Khnum are among the most complicated hieroglyphic inscriptions. Besides spelling errors, we find here the so-called new hieroglyphs, derived from the hieratic script, and many instances of deliberate cryptography, such as whole rows consisting of figures of crocodiles and rams. One of the texts describes a feast celebrating the invention of the potter's wheel. The temple roof is decorated with astronomic symbols.

In Coptic times the hypostyle vestibule of the temple was converted into a church. The most important of the many Coptic monasteries in the Esneh region are the Monastery of the Martyrs (Deir el Shenuda) and Deir Abba Matteos. Both date from the tenth century, although they are traditionally believed to be much older.

38. KOM OMBO

⸗]⳩⳧ ⸗ = Nebit, the Coptic Embo, the Greek Ombos, in Nome I of Upper Egypt, on the east bank of the Nile, north of nearby Aswan.

The site was inhabited in the Late Paleolithic Period; remains of the so-called Sebilian culture (simultaneous use of bone and flint) have been found (E. Vignard, *BIFAO*, XXII; P. E. L. Smith, *American Anthropologist*, 1966).

It seems that from Dynasty XVIII on, the town was an independent province within Nome I, of which the capital was the island of Elephantine. In the Ptolemaic Period the nome capital was transferred to Ombos. Tuthmosis III built a temple dedicated to the Great Horus (the Greek Haroeris), Sobek, and his mother Hathor. Only the doorstep of this temple has survived. Other finds indicate that Amenhotep I and later Ramesses II erected buildings.

The ruins of the town are buried in sand. The most important religious monuments, situated on a high point of land projecting into the Nile, were cleared and partly reconstructed by the Egyptian Antiquities Service in 1893 under the supervision of Jean de Morgan (De Morgan and others, *Catalogue des monuments de l'Égypte antique*, I, ser., II, III). The ruins are among the most picturesque in Egypt.

The temple precincts were enclosed by a dried-brick wall. The left wing of a gateway built by Ptolemy XII Neos Dionysos has survived, but nothing remains of the gateway built by Queen Hatshepsut and Tuthmosis III in the south part of the wall on the Nile side (Champollion, *Not. Descr.*, I, pp. 231-32).

In addition to the Great Horus, Sobek, and Hathor, many other gods were worshiped in the main temple—Amon, Ptah, Khnum, Osiris, Nephthys, Min, and Thoth, to mention only the most important. Most of these deities had to content themselves with one chapel each inside the temple; in the Late Period, however, two triads of deities emerged. The Great (also called the Old) Horus, falcon-headed, had for his partners the goddess Senetnofret (the "Good Sister") and Panebtawy (the "Lord of Both Lands"). The triad of the crocodile-headed Sobek included his mother Hathor and the god Khonsu, who figured here as her son.

That the two chief deities (later triads) were accorded equal honors is clear from the temple's plan, unique in ancient Egypt. The longitudinal axis of the building divides it into two parallel halves, each with its own entrance and cella. The duality of the temple is stressed by two circumambulatory corridors and two hypostyle halls, inner and outer. Its architecture, or at least the low reliefs on its walls, reflect the history of the late-Ptolemaic and Roman periods. Thus, the inscriptions and decorations in the central section comprising the two sanctuaries and the three preceding halls date from the reign of Ptolemy VI Philometor and his wife Cleopatra II. The inner hypostyle hall is decorated with cartouches of Ptolemy VIII Euergetes II. The outer hypostyle hall has cartouches of many Ptolemies, but it was built by Ptolemy XII Neos Dionysos, who also erected the pylons in front of the open court; the court itself, the colonnade, and the outer circular corridor date from Roman times. The sanctuaries and the chapels were built by the last Ptolemy and the Roman emperors (figs. 672-80).

The inner corridor has cartouches of Augustus, Tiberius, and Claudius; on its exterior wall is a representation of Domitian. The situation is similar in the partially preserved Mammisi, or birth temple, the ruins of which are visible in front of the west corner of the temple (Borchardt, *Aegyptische Tempel mit Umgang*, pp. 7-8, pl. 3); it seems to be the work of Ptolemy VIII Euergetes II, but blocks of Tiberius have been found here along with blocks of Tuthmosis II and Ramesses III, these latter perhaps taken from other buildings.

Not far from the Mammisi is an intricate system of wells and basins. In one of them young crocodiles may have been kept—this animal was the object of special worship at Ombos.

The Hathor chapel near the east wall of the temple enclosure was built by Domitian; the Sobek chapel near the north wall, today completely ruined, was built by Caracalla.

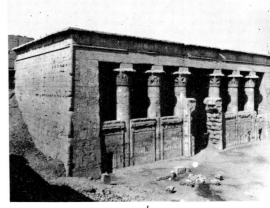

935. ESNEH. FAÇADE OF THE TEMPLE OF KHNUM

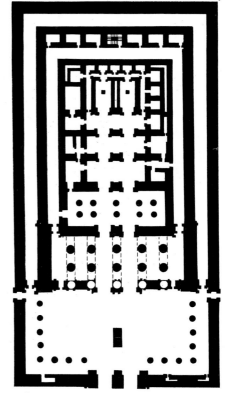

936. KOM OMBO. PLAN OF THE TEMPLE OF HAROERIS

937. KOM OMBO. TEMPLE OF HAROERIS, VIEW OF HYPOSTYLE HALL FROM COURT

VI. REGION OF THE FIRST CATARACT AND NUBIA

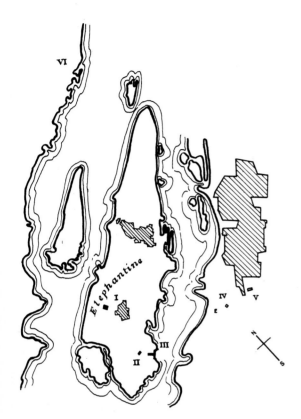

39. ASWAN

Modern town and province situated near the First Cataract. In ancient times this region was Nome I (To-Seti) of Upper Egypt, which extended northward, as far as the Silsileh Mountains and had no clearly defined southern boundary. The nome capital was on the island of Elephantine, in Egyptian, Abu, a word otherwise denoting "elephant" and "ivory."

The granite quarries in this region were exploited as early as Dynasty I, as is attested by the granite used in tombs of Dynasty I kings. Elephantine and the area around it enjoyed an advantageous geographical position: boats and caravans carrying goods from Nubia to Egypt stopped there. To-Seti early became a center of trade in ivory, ebony, gold, and rare minerals, as well as a take-off point for merchants and explorers traveling south in search of semiprecious stones. The local population was no doubt especially skilled in helping boats negotiate the strong currents of the First Cataract, where the Nile flows between steep cliffs.

938. ASWAN. GENERAL PLAN
I. *Temple of Tuthmosis III* II. *Temple of Amenhotep III* III. *Quay and nilometer* IV. *Roman temple* V. *Ptolemaic temple* VI. *Rock-cut tombs*

In the nome capital the principal deity was Khnum, "Lord of the Cataract," whose companions were the goddesses Anukis and Satis. The latter was the object of special worship on the island of Seheil, famous for its Famine Stele. Two other important islands in this area were Philae and Bige. One of Osiris' tombs was situated on the latter—a spot where no mortal was allowed to set foot. Near this tomb were numerous libation tables. Herodotus (II, 28) recorded an Egyptian tradition about Aswan. His informant, whom the Greek historian did not take very seriously, told Herodotus that two hills lie between the Aswan quarries and the island of Elephantine, and that the sources of the Nile lie midway between the hills. The waters of one flow north into Egypt, and the waters of the other south into Ethiopia. Actually the misunderstanding arose out of the worship of Hapi, god of the Nile. According to ancient Egyptian belief, Hapi dwelt in a cave near the First Cataract and from there regulated the Nile floods in Upper Egypt. Another "House of Hapi" was believed to be situated on the boundary between Upper and Lower Egypt, from which point the god sent the Nile waters downstream to the Delta. The Gate of Hadrian on the island of Philae has a representation of Hapi's cave.

During the earliest dynasties, the First Cataract formed the southern boundary of Egypt. Elephantine was ruled by princelings whose tombs, dating from the period between Dynasty VI and Dynasty XII, are cut from the rock on the west bank of the Nile. Some of them—for instance, the double tomb of Sabni and Mekhu, dating from Dynasty VI—have large chambers with pillars and columns carved out of the rock. Of the tombs dating from Dynasty XII, the large tomb of Sarenput I deserves special mention: its layout recalls the rock tombs at Beni Hasan. These tombs are reached by steep ramps from the Nile. Polychrome reliefs of great artistic value have been preserved in them.

Elephantine may have had a defensive wall around it at the close of the Old Kingdom. The granite naos of Pepy I dates from this period. From Dynasty IV on, granite was used more and more; special envoys came to Aswan to obtain the huge blocks from which sarcophagi were made. Because the Old Kingdom pyramid builders needed great quantities of granite, the Aswan quarries were exploited on an ever larger scale, and this remained the case into the Byzantine period. During the Middle Kingdom and the New Kingdom they supplied granite for the great obelisks and colossal statues. The quarrymen became highly skilled. During Dynasty XVIII, we know, it took only seven months to cut and dress an obelisk, to polish it, engrave the inscriptions, transport it to Thebes, and install it. One obelisk still remains in the quarries; dressed on three sides, it is 137 feet long and 13 3/4 feet wide at the base. Had it ever been set up, it would be the tallest known obelisk, surpassing the Lateran obelisk in Rome which is 105 feet high.

During the Middle Kingdom, Sarenput built a stone sanctuary on Elephantine dedicated to one of his ancestors, Heka-ib, who lived during Dynasty VI. It was discovered by Labib Habashi in 1946 (*CdE*, 1946, p. 200). From sculptures and blocks bearing the cartouches of Dy-

939. ASWAN. ROCK-CUT TOMBS

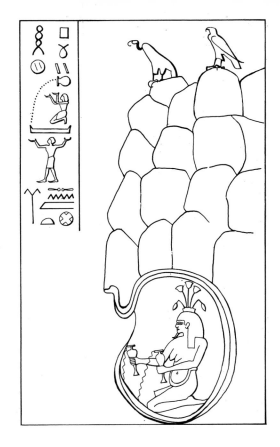

nasty XI and Dynasty XII rulers we know that during this period Elephantine possessed monumental edifices. There are ruins of an Amenemhat II chapel on the neighboring island of Seheil, and on Bige the lower portion of a granite seated statue of Sesostris III was found within a temple enclosure. The peripteral temples of Tuthmosis III and Amenhotep III still stood on Elephantine at the beginning of the nineteenth century, but have been almost completely destroyed since.

Excavations by Clermont-Ganneau and Clédat have yielded a great number of blocks bearing the cartouches of Dynasty XVIII and Dynasty XIX kings. Some of them unquestionably come from temples that could still be seen at the time of Bonaparte's expedition. In the same period buildings were also erected on the island of Bige. Granite statues of Tuthmosis III and Amenhotep II have been found there. During the New Kingdom, Elephantine was subject to the viceroy of Nubia, but in Saite times it once more became an Egyptian fortress protecting the country's southern frontier from Nubian incursions.

Nectanebo II built a temple to Khnum, and Alexander IV erected a granite gateway. The German excavations of 1906-8 under Honroth, Rubensohn, and Zucker uncovered many records which cast light on the history of Elephantine. The most important find was a collection of Aramaean papyri dating from the Persian period, which confirm that there was a Jewish colony from the sixth century B.C. on, with its own temple. In 1918 the Pontifical Biblical Institute took over where the German archaeologists had left off.

940. THE ROCKS OF SENMUT
Representation of the Nile god pouring water from two libation vases; the outline of the grotto in which he sits is circled by a serpent

In the Ptolemaic Period the town, on the island and on the east bank (the site of modern Aswan), continued to develop. South of Aswan, a temple to Isis was built by Ptolemy III Euergetes and Ptolemy IV Philopator; the latter built a small temple on the island of Seheil. Toward the close of the Ptolemaic Period and under Augustus, new buildings rose also on the island of Bige. The preserved portion of the waterfront and the Nilometer found at the southern tip of Elephantine probably date from this time, for their state of preservation is in keeping with Strabo's description. Aswan was famous for a well, the bottom of which was lighted by the sun precisely at noon on the day of the summer solstice. Having learned this, the Greek mathematician Eratosthenes deduced that Aswan lay on the Tropic of Cancer. He measured the azimuth of the sun at Alexandria at the same hour and knowing that the distance between Alexandria and Aswan corresponded to one-fiftieth of a circle, he was able to calculate the circumference of the earth with a high degree of accuracy.

In the Roman period Elephantine was linked to the east bank of the Nile by a stone bridge with brick arcades. Then called Syene (in Egyptian, Sunu), the city possessed large, clearly differentiated quarters. The island was largely residential, while a large community of workmen and craftsmen grew up on the east bank. The Roman emperors were not lavish in their building activity. Domitian and Nerva built small chapels on the site of modern Aswan, and there is evidence of some building at Elephantine under Trajan. A Roman garrison was stationed at Syene, and the poet Juvenal, who fell into disgrace under Trajan, commanded a cohort there. He expressed his feelings about the hardship of his post in a famous satire (*Sat.* XV).

The city must have suffered greatly from the raids of the Blemmyes. In Christian times Syene was the seat of a bishopric. Among the most important monuments dating from this period is the Monastery of St. Simeon, situated west of the Old and Middle Kingdom rock tombs, about a mile from the Nile. This is a fortified structure, surrounded by a wall about 23 feet high, of stone at the bottom and dried brick at the top. Founded in the eighth century, the monastery is one of the largest in Egypt. Some of its paintings date from the ninth century. The interior consists of three unevenly shaped terraces at different levels. On the lowest terrace is the church, which has three naves, each terminated by a *haikal*, or sanctuary; other buildings have cells where narrow, short beds of earth have been preserved. There are also rooms for kitchens, storerooms, stables, olive presses, and other service quarters. Although the monastery is completely ruined, one can still make out on the walls figures of saints with halos and inscriptions in the Coptic alphabet. The monastery was probably abandoned in the thirteenth century.

In ancient times the island of Philae was important for its religious cult and for its buildings; today it is important for the value and character of its monuments, many of which have been transported from other places. Its name in ancient Egyptian was ▪⌣̊ = Pa-ju-rek. It is impossible to ascertain exactly when Isis began to be worshiped on the island, which was also sacred to Hathor, "Mistress of Nubia." According to tradition, it was on this island that she first set foot in Egypt after having returned from the torrid south in the form of the lion-headed Tefnut. Osiris, whose tomb was on the neighboring island of Bige, was also worshiped here with his wife Isis. But the island did not become important as a religious center until a fairly late date.

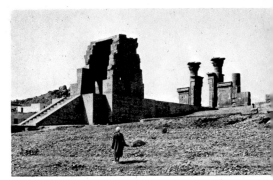

941. ASWAN. ISLAND OF BIGE, TEMPLE OF PTOLEMY III EUERGETES

942. ASWAN. ST. SIMEON MONASTERY

The oldest known structure at Philae dates from the time of Nectanebo I. It is a small portico built on the southwest tip of the island, from which a road led to the main temple of Isis. Destroyed by a flood, the portico was rebuilt by Ptolemy II. Behind it two colonnades were erected during the reigns of Augustus and Tiberius. The east colonnade was never completed. Adjacent to the latter were two temples dedicated to the Nubian gods Avsnufis and Mandulis. A third temple, closer to the temple of Isis, was dedicated to Imhotep.

One of the pylons of the temple of Isis is more than 147 feet wide. In front of it stood two small obelisks dating from the reign of Ptolemy VIII Euergetes II (they are today at Kingston Hall, England). On the inside of the gateway is a French inscription commemorating General Desaix's expedition to Syene. Between Pylons I and II on the west stands a Mammisi (birth temple) begun by Ptolemy VIII Euergetes II and completed by Tiberius. Pylon II is not so wide (about 105 feet) as Pylon I; both are decorated with large reliefs representing Ptolemy XII Neos Dionysos (figs. 660, 661). Traces of paint remain on the columns of the hypostyle hall, though for several decades, since completion of the first Aswan dam, Philae has been covered with water for nine months every year. The sanctuary proper comprises twelve chambers and a crypt whose walls are covered with reliefs. A staircase leads from it to a terrace and an Osiris chapel. The low reliefs on the outer walls of the temple date from the reigns of Augustus and Tiberius.

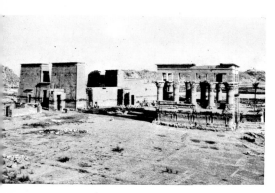

943. PHILAE. GENERAL VIEW OF THE TEMPLES

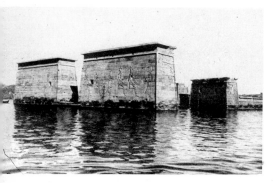

944. PHILAE. PYLONS OF THE TEMPLE OF ISIS

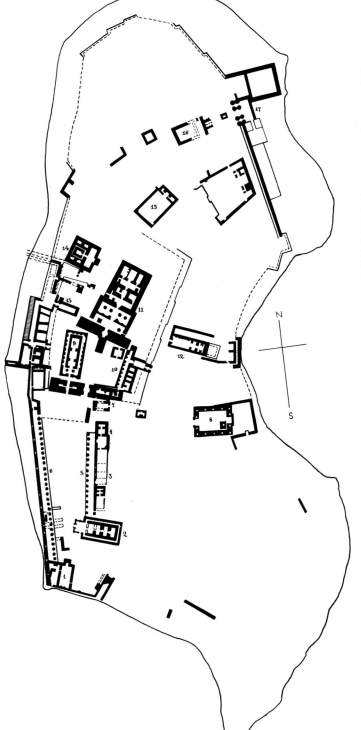

945. PHILAE.
PLAN OF THE SACRED COMPLEX
1 Portico of Nectanebo I
2 Temple of Avsnufis
3 Temple of Mandulis
4 Temple of Imhotep
5 First east colonnade
6 West colonnade
7 Gateway of Ptolemy II
8 Kiosk of Trajan
9 Mammisi
10 Second east colonnade
11 Temple of Isis
12 Temple of Hathor-Aphrodite
13 Hadrian's Gateway
14 Temple of Harendotes
15 Coptic church
16 Temple of Augustus
17 Diocletian's Gateway

West of the temple of Isis, directly facing a lateral wall of Pylon II, stands Hadrian's Gateway, the walls of which were decorated with reliefs in the reigns of Marcus Aurelius and Lucius Verus. Because these reliefs represent rites of Osiris, the structure has sometimes been referred to as an Osiris chapel.

North of the gateway lie the ruins of the temple of Harendotes (Horus sheltering his father Osiris) built by the emperor Claudius. Northeast of it lie the remains of a temple built under Augustus, and adjacent to these ruins is a gateway built by Diocletian. Just east of the temple of Isis are located the remains of the small temple of Hathor-Aphrodite built by Ptolemy VI Philometor and Ptolemy VIII Euergetes II. South of this temple, on the very edge of the island, rises Philae's most beautiful architectural monument, the famous kiosk of Trajan, which has the form of a portico. Its fourteen columns had calyx capitals which, according to some writers, were further embellished with carved Hathor capitals. There were two Nilometers on the island. In Coptic times two churches and one monastery were built here.

Many inscriptions dating from Ptolemaic and Roman times bear witness to the fact that large numbers of pilgrims visited the temple of Isis. The cult of this goddess on Philae was by no means limited to the inhabitants of Egypt. She was also worshiped by the Nobadas and the Blemmyes, Nubian tribes who raided this southernmost outpost of Byzantium early in the fifth century. Although fierce battles were fought in this region, on the island of Philae the two enemies coexisted peacefully. The priests of these warlike tribes were allowed to worship Isis in her temple, and in 453 A.D. a treaty granted the Blemmyes and the Nobadas the right to carry the statue of Isis to their own country at certain times. The ancient goddess continued to be worshiped on Philae long after the Christianization of Egypt. Not until Nubia became officially Christian did Justinian order the temples on Philae to be closed, and parts of them converted into Christian places of worship.

As plans to construct the new dam at Aswan have gone forward, efforts have been made to safeguard the architectural complex of Philae so that it may be permanently accessible to visitors. This region around the First Cataract—until very recently of archaeological interest solely for its own ancient sites—has in the past two years been enriched by new acquisitions from Nubia, from sites flooded when the dam at Sadd el Aali was completed.

Today, on the west bank of the newly formed lake, stand three ancient temples which were carefully dismantled in Nubia and reconstructed here. The largest is the temple of Kalabsha, built under the emperor Augustus on the site of an older temple dating from the reign of Amenhotep II (figs. 134, 681-83). The German Federal Republic carried out the task of moving this architectural monument in 1965 (H. Stock and K. Siegler, *Kalabscha*, Wiesbaden, 1966). Beside it the Egyptian Antiquities Service has also reconstructed a small rock-cut temple originally built by Ramesses II on a site at Beit el Wali, and a kiosk from Kertassi, which bears a close resemblance to Trajan's kiosk at Philae. In this way, a new "archaeological site" has been created in the region of the First Cataract, with monuments brought from Nubia. It might be more accurate, however, to call it an "open-air museum," grouping, as it does, structures taken from many sites, dating from different epochs, and ranging from religious architecture to prehistoric and early dynastic rock drawings.

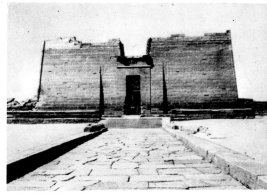

946. KALABSHA. TEMPLE OF MANDULIS

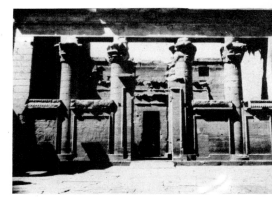

947. KALABSHA. TEMPLE OF MANDULIS, INTERIOR COURT

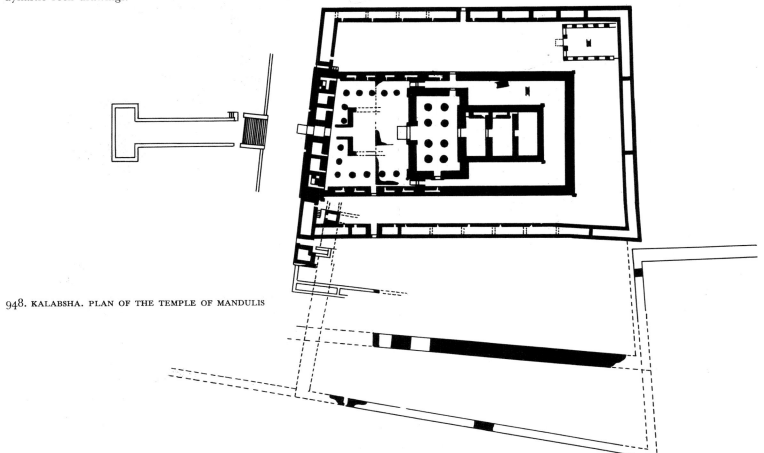

948. KALABSHA. PLAN OF THE TEMPLE OF MANDULIS

949. DABOD. TEMPLE

950. DENDUR. TEMPLE

40. NUBIA

This region, which reaches from the First Cataract to south of the Sixth Cataract, was for three millenniums closely linked with ancient Egypt culturally and, in some periods, even politically. There are many sites within this vast area that are rich in archaeological ruins. A great number of these depend directly upon works of Egyptian art, while others remain strongly influenced by it. Thus it is not surprising that Nubia should be included in most studies of the Egyptian past. Porter and Moss published a many-volumed work with a site-by-site bibliography, devoting two-thirds of one volume to Egyptian hieroglyphic inscriptions, reliefs, and paintings in Nubia (Porter and Moss, VII: *Nubia, the Deserts and outside Egypt*, 1962). It would seem natural that a survey of the most important archaeological complexes in Egypt should cover such well-known localities as Aniba, Abu Simbel, Faras, and Semneh, all of which lie between the First and the Second Cataracts, and farther to the south, Soleb, Kerma, El Kurru, Argo, Kawa, Gebel Barkal, Meroë, Musawarat, Naga, and Soba. There are a great many other sites in both Lower and Upper Nubia that deserve mention in even a cursory survey; however, Nubia will be treated less comprehensively than Egypt for two reasons.

First, Lower Nubia—the area richest in ancient monuments—which extends from the First to the Second Cataract, no longer exists. The population of Egyptian Nubia was evacuated to settlements north of the First Cataract, in the area of Kom Ombo; that of Sudanese Nubia was moved to Khasm el Girba on the borders of Ethiopia. During the past few years Lower Nubia's twenty-thousand-year-old life has ended. Construction of the new Aswan dam, called Sadd el Aali, has created a man-made lake more than 300 miles long, the waters of which have already submerged many ancient settlements rich in architectural monuments. Large towns like Aniba and Faras, temple sites like that at Buhen, the tumuli at Ballana and Qustul, and the fortresses at Serra and Semneh are today all under water. To be sure, the most valuable monuments have been salvaged. Following the appeal of UNESCO in 1960, a number of scientific institutions, universities, and museums the world over sent out large-scale archaeological expeditions—not, as was the case before the first dam was built at Aswan, for the purpose of exploring areas threatened with inundation, but to salvage the most important monuments of ancient art and culture, to dismantle temples and move them to safety. So there is today little point in discussing the historical topography of Aniba or Faras, a problem of continuing interest to a handful of specialists, but one which can no longer be verified on the spot. Yet, if old archaeological sites in Lower Nubia have disappeared, new ones have come into being. The dismantled temples from Kalabsha, Beit el Wali, and Kertassi have been reconstructed near Shellal, creating an archaeological site without historical tradition, an "open-air museum." Temples from Amada, Aniba, Derr, Dakka, Wadi es Sebua, and Maharraka have been moved a few miles from their original sites, into the desert, where they are being grouped (the work is not yet complete) in new archaeological complexes. Eventually they will stand on the shores of the man-made lake. The chapels from Qasr Ibrim and Abu Oda, and the remains of the temple from Gerf Hussein have been dismantled, but no new site has yet been chosen for them. Some of the first temples to be dismantled—those from Dabod, Dendur, and Tafeh—have been offered as gifts by the Egyptian government to countries that made sizable financial contributions to the Nubian salvage operation. (The Dendur temple will be re-erected on the grounds of the Metropolitan Museum in New York.) The work of removing the rock-cut temples of Ramesses II and his wife Nofretari at Abu Simbel—which some years ago gave rise to heated discussion—has now been completed.

The Swedish project for carrying out the gigantic task at Abu Simbel was supported by the Egyptian government, but not adopted until almost the last moment, when the waters of the new dam had begun to rise and threaten the monuments. The two temples were to be cut into blocks weighing up to 30 tons, and reassembled on a desert plateau at an altitude of 197 feet above the original site, in a landscape arranged for them. This most arduous task has been carried out successfully. Both professional archaeologists and lovers of antiquity have approved the reconstruction of the temples; the new site will undoubtedly become one of Egypt's major tourist attractions.

Nubian monuments closer to the borders of the Sudan have been dismantled and moved to Khartoum. Temples from Buhen, Semneh West, and Semneh East have been reassembled there, and have already been placed inside roofed halls, which protect them during the rainy season. The temples that in the years to come will form new archaeological groups on the shores of the lake enjoy no such protection.

The new "archaeological sites" in Lower Nubia are still in the process of formation. Perhaps ten years from now it will again be possible to write a complete survey of the area.

The second reason for the sketchiness of this survey of the Nubian monuments is that every excavation yields new discoveries, which often necessitate revision of established views. The results of the lively archaeological activity in Lower Nubia since 1960 have not all been published. Moreover, excavations are now in progress south of the Second Cataract, over almost the entire area of Upper Nubia, the ancient land of Kush. These excavations have not often affected knowledge

of previously excavated sites, but they do cast new light on the history of Nubia under Egyptian rule, under the Meroïtic kingdom, and in the Christian period (see W. Y. Adams, "The Nubian Campaign: Retrospect and Prospect," in *Mélanges K. Michalowski;* "Continuity and Change in Nubian Cultural History," *Sudan Notes and Records,* XLVIII, 1967).

I shall offer only two examples of the difficulties that stand in the way of an over-all grasp of the history of Nubia at the present time. First, the existence of a so-called Group B in Nubian culture, supposedly roughly contemporary with the Old Kingdom, has recently been questioned. Second, the view that there were no settlements antedating the Christian period in the area of Old Dongola has been challenged. (This area is between the Third and Fourth Cataracts. Dongola was the capital of the central Nubian kingdom of Makuria, and in the early eighth century became the capital of the united Nubian kingdoms.) Polish excavations begun four years ago have already discovered settlements dating back to the Middle Paleolithic Period, as well as inscriptions from the reign of Taharqa and relics of Meroïtic culture. Thus any attempt at present to outline the historical development in Nubia of particular religious or funerary enclosures seems doomed to failure. At the same time, however, this is precisely what today fascinates archaeologists, historians, and Africanists. The very difficulties involved have inspired a number of attempts at a fresh synthesis. I will mention here, as examples, only three very recent books: W. B. Emery, *Egypt in Nubia,* 1965; Fritz and Ursula Hintze, *Alte Kulturen im Sudan,* 1966; and P. L. Shinnie, *Meroë,* 1967.

Human settlement in Nubia goes back to the Paleolithic Period. Even then, as certain finds attest, Nubia had contacts with Egypt. The oldest rock drawings date from the Mesolithic Period (in Nubia, 7000-4000 B.C.). The Nubian Neolithic Period falls within the fourth millennium B.C. At the time when Upper and Lower Egypt were unified, around 3100 B.C., a culture known as Group A flourished in Nubia. The tombs of this still anonymous people contained thin-walled pottery of fired clay, red outside and black inside. The modest tomb furnishings included Egyptian imports. The only thing that seems certain today about this people is that they were not of Negro origin. If we judge by the archaeological remains, their cultural level was comparable to that of the Badari culture in Egypt.

From earliest dynastic times in Egypt, Nubia fell within the sphere of interest of the Pharaohs. One relief dating from the reign of King Zer (Dynasty I), found near Wadi Halfa (Gebel Sheikh Suleiman), refers to this ruler's victory over the Nubians. Sneferu (Dynasty IV) captured much booty and took many prisoners in the course of his Nubian campaigns, as is shown by the inscription on the Palermo stone. At this time a lively trade began between Egypt and Nubia, which was then probably divided into a number of independent territories. Wawat, the territory closest to the borders of Egypt and the one most often mentioned in early inscriptions, was just south of the First Cataract. In this period the princes of Elephantine controlled trade with Nubia, although the first Egyptian trading posts and towns were even then being established in Nubia, as has recently been proved by Emery's excavations at Buhen (*Kush,* 7-13).

Nubia supplied Egypt with diorite and copper. Caravans transporting valuable commodities from farther south, such as ivory, ostrich feathers and eggs, leopard skins, ebony, timber, and sweet-smelling oils and spices, crossed Nubia on their way to Egypt. The Pharaohs even enjoyed such exotic imports as pygmies. Toward the close of the Old Kingdom a new cattle-breeding people made its appearance in Nubia. Their graves belong to what has been called Group C; their ceramics are characterized by black-polished clay goblets decorated with geometric patterns. Some jars are molded in the shape of horned cattle. The German excavations at Aniba (Steindorff, *Aniba,* 1935-37), north of the Second Cataract, revealed an important center of this culture. The social upheaval and political disturbances that marked the First Intermediate Period in Egypt must have weakened contacts with Nubia, but these were resumed as soon as the Theban princes gained control of the entire country. During the Middle Kingdom, Egypt began to push into the region south of the Second Cataract, then called Kush. As early as Dynasty XII a system of Egyptian fortresses was erected in this area. The most important of them were at Buhen, Mirgissa, and Semneh. The garrison at Semneh sent regular reports to the Pharaohs concerning the level of the Nile waters and the political situation in the area. Some smaller fortresses in Lower Nubia, such as the fortress at Kuban near Wadi el Alaki, were for the protection of gold mines.

Egyptian colonization of Lower Nubia during the Middle Kingdom did not proceed peacefully: the many Egyptian forts in this area indicate that the Group C people resisted the settlers from the north. However, this matter is still unclear, as is the character of Egypt's political penetration south of the Second Cataract. These problems are connected with the still uncertain role of the so-called Kerma culture, south of the Third Cataract. G. A. Reisner's excavations between 1913 and 1916 first called attention to it (*Harvard African Studies,* V-VI, 1923). He conjectured that during the Middle Kingdom an Egyptian colony existed in this area, known as "Amenemhat's

951. GEBEL BARKAL. PLAN OF THE TEMPLE
1. *Pylon I* 2. *Exterior court* 3. *Pylon II* 4. *Interior court* 5. *Pylon III* 6. *Hall* 7. *Chapel of Ramesses II*

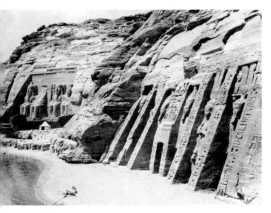

952. ABU SIMBEL.
SMALL TEMPLE OF NOFRETARI, FAÇADE

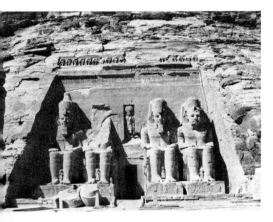

953. ABU SIMBEL.
GREAT TEMPLE OF RAMESSES II, FAÇADE

954. ABU SIMBEL. PLAN OF THE GREAT TEMPLE OF RAMESSES II

Walls," and that Hepsef, a statue of whom was found at Kerma, was one of its governors. Today most archaeologists believe that Kerma was the residence of a politically independent ruler. Ruins of three monumental brick structures lie here: (1) the so-called fort; (2) the residence of the ruler, which stood on a high platform and was reached by a staircase from an inner court; (3) a funerary chapel near the necropolis. It was in this cemetery that Reisner discovered the tombs of rulers with the skeletons of their concubines and servants, who had been buried alive.

The ceramics produced by the Kerma culture are among the finest in the Nile valley. The vessels, characterized by thin walls, are of fired red clay, painted black and polished. Considering the high quality of Group A ceramics as well, not to mention the later Meroïtic ceramics, it would seem that in this field Nubia achieved a much higher level than Egypt. Kerma was politically strongest toward the close of the Middle Kingdom and during the Second Intermediate Period. This is attested by J. Vercoutter's recent discovery of a cemetery near the Egyptian fortress at Mirgissa ("Le cimetière 'Kerma' de Mirgissa," in *Mélanges K. Michalowski*). The Kerma princes maintained diplomatic and trade relations with Egypt and then with the Hyksos who ruled the country during the Second Intermediate Period. The Kerma culture came to an end at the start of Dynasty XVIII; the new rulers of Egypt proceeded to reconquer Nubia just as soon as they had driven out the Hyksos. Ahmose recovered the area between the First and Second Cataracts, built a temple at Buhen, and repaired a damaged Middle Kingdom fortress. Amenhotep I created a new government office, that of viceroy of Nubia, whose residence was later at Aniba. The residence of the original rulers of Kerma was destroyed by Tuthmosis I in the course of extending Egypt's borders to the Fourth Cataract. During the reign of Tuthmosis III a fortified town was founded at Napata, near the Fourth Cataract, and this marked the farthest outpost of Egyptian rule in the south.

During the New Kingdom, Nubia enjoyed a period of relative prosperity, although perhaps only the upper levels of the society, which had undergone a superficial Egyptianization, were affected. Egypt drew considerable wealth from Nubia. Under Tuthmosis III the annual income from Lower Nubia (the land of Wawat) included nearly 551 pounds of gold, besides many other items which Nubia had from earliest times paid as tribute to Egypt—minerals, timber, ivory, animal hides, cattle, and slaves. In this period some units of the Egyptian army and police were made up of Nubian mercenaries. The Dynasty XVIII and XIX rulers built a number of magnificent temples in Nubia. Hatshepsut erected temples at Faras and Buhen; Tuthmosis III built a far more splendid religious edifice at Faras and began a temple at Amada; Amenhotep III built temples at Buhen, Semneh, Kumna, Soleb, and Sedenga. Even during his short reign Akhenaten erected three small sanctuaries at Sesebi. Tut-ankh-amon built a sacred enclosure at Faras and a temple at Kawa.

One of the most important edifices erected in Nubia by Dynasty XVIII rulers was the temple of Amon near the Holy Mountain (present-day Gebel Barkal) in the vicinity of Napata. Subsequent Pharaohs considerably enlarged it. But the greatest builder in Nubia was Ramesses II. Some of the temples he built, such as those at Gerf Hussein and Derr, have sanctuaries cut out of the rock. Others, like the two famous temples at Abu Simbel, were entirely carved out of the rock before the twenty-fourth year of this Pharaoh's reign. The façade of the larger temple is shaped like a pylon with four Colossi of the Pharaoh (fig. 127). Each seated statue is more than 65 feet high. The interior of the temple contains a hypostyle hall and other chambers cut more than 196 feet into the rock. By order of Ramesses II, both temples (his own and that of his second wife Nofretari) were decorated with representations of his immediate family, giving continuity to ideas which had appeared in Egypt's official art since Akhenaten (figs. 521, 545). (L. Christophe, "Les temples d'Abou Simbel et la famille de Ramsès II," *BIE*, 38, 2, session 1956-57; *Abou Simbel et l'épopée de sa découverte*, 1965.)

The Late Period saw a radical change in the relations between Egypt and Nubia. The situation was reversed, in a sense. In the period preceding Dynasty XXV, an autonomous principality arose between Dongola and Napata, and soon grew in strength. At some point before 750 B.C. Kashta, one of the rulers of this first kingdom of Napata, succeeded in conquering Upper Egypt, and his successor Piankhy founded Dynasty XXV, sometimes called the Kushite Dynasty. Some of its rulers resided at Thebes and Tanis (for instance Taharqa, who erected monumental edifices in these cities), but they built their pyramid tombs (far smaller than those of the Dynasty IV rulers at Giza) near their ancestral capital at Napata; these pyramids are characterized by their slender form. The Dynasty XXV rulers, especially Taharqa, embellished their native Nubia with religious edifices. In addition to smaller sanctuaries, Taharqa built an immense temple at Kawa and enlarged the sacred enclosures at Gebel Barkal and Sanam.

Nubian power was maintained in Egypt until the Assyrian conquest of the country. The last ruler of Dynasty XXV, Tanutamon (Tanwetamani), who ruled from 664 to 656 B.C., retreated to his capital at Napata. Having been expelled from Egypt, Nubians proceeded to play an im-

portant part in forming the first non-Egyptian state along the middle course of the Nile. This was the kingdom of Kush. Although little of its history is known, it can at least be divided into two periods: the Napatian period, when the capital was at Napata (655-295 B.C.), and the Meroïtic period (295 B.C.-350 A.D.), when the capital was at Meroë.

Relations between Kush and Egypt took various forms; there were lively trade contacts and there were military clashes. In the nineteenth century, archaeologists mainly concerned themselves with documenting the Nubian monuments that remained above ground—such was Lepsius' expedition in the 1840s (*Denkmäler*, VI). Not until the pyramids at Napata and Meroë were excavated by the Harvard-Boston expedition under Reisner (between 1916 and 1923) was it possible to trace the order of succession of Kushite rulers and to begin to establish the dates of their reigns (*The Royal Cemeteries of Kush*, I-III, 1950-55, published by Chapman and Dunham after Reisner's death). Nonetheless, no general agreement has yet been reached on chronology.

955. ABU SIMBEL. PLAN OF THE SMALL TEMPLE OF NOFRETARI
1. *Sanctuary* 2. *Antechamber* 3. *Hall*

In its first period, Kush was obliged again and again to repel raids by its Egyptian neighbors. Psamtik II, whose army was composed of Greek and Carian mercenaries, conquered Napata and partially destroyed it. Less than fifty years later Cambyses repeated the exploit. The continuing threat to the capital by conquerors from the north probably induced the rulers of Kush to move their capital to Meroë, between the Fifth and Sixth Cataracts. In any case, during the reign of Arkakamani (295-275 B.C.) the royal necropolis was moved from the old capital at Napata to Meroë. According to Diodorus Siculus, a Greek historian who wrote in the late first century B.C., the Ethiopian king Ergamenes, as part of his policy of subordinating the priesthood to royal authority, abolished the custom of having the rulers of Kush slain by priests of Amon. It is possible that Diodorus here refers to Arkakamani, who undoubtedly weakened the importance of the priests of Amon at Napata by building his pyramid at Meroë.

Excavations at Meroë began in 1909 under J. Garstang (Garstang and others, *Meroë, the City of the Ethiopians*, 1911); at present the work is being continued by the University of Khartoum, under P. L. Shinnie. Garstang discovered the ruins of a great temple of Amon, and part of a royal palace where, on the threshold of a naos-like chapel, he found a magnificent bronze portrait of Augustus (Garstang, "A bronze portrait head," *University of Liverpool, Annals of Archaeology and Anthropology*, 4, 1912). This unexpected find is one of the concrete relics of a northward incursion by Meroïtic troops in 24 B.C. They captured Philae and Elephantine near the First Cataract and brought the colossal statue of Augustus home, where they placed it within a naos on a high pedestal specially built for the purpose. This was probably done in 23 B.C., after a peace treaty was concluded between Augustus and the Meroïtes on the island of Samos. The conditions were advantageous to Meroë: the Roman garrison was to be withdrawn from Primis (present-day Qasr Ibrim), the boundary of Egypt was drawn back to Hiera Sykaminos (today's Maharraka), and the Meroïtic kingdom was exempted from tribute. Regular diplomatic relations between Meroë and Rome date from this time—the Meroïtic ambassador in Rome bore the title "Great Envoy in Rome."

Other towns besides Meroë flourished in the kingdom. In the region of the Sixth Cataract lie the impressive ruins of a sacred enclosure at Musawarat, which was explored and partly reconstructed by an expedition from the Humboldt University in Berlin under F. Hintze. The function of this enclosure has not been determined, but it had been begun before the capital was moved to Meroë. Another notable monument is the so-called Temple of the Lions built toward the close of the third century B.C. by King Arnehamani. It was dedicated to the chief Meroïtic deity, the lion-headed Apedemak. In the same period another city grew up in this region on the site of present-day Naga, where lie the ruins of many temples erected between the second century B.C. and the Roman conquest of Egypt.

The Meroïtic culture, which we are learning more about every year, was the first great African civilization closely associated with Mediterranean culture. It left monuments of an art and architecture strongly influenced by Egypt. Into the molds of ancient Egyptian artistic form, the artists of Meroë poured their own original artistic content. The Meroïtic pantheon, though based on ancient Egyptian tradition—above all on worship of such gods as Amon, Osiris, and Isis—made room for local gods. Meroïtic artists produced statues and vast reliefs on temple walls (figs. 648-53). Their local character is apparent only in the iconography—garments, attributes, etc. Their originality is best appreciated in the works of less monumental format. The gold jewelry is very fine, and Meroïtic ceramics are of high quality, as previously mentioned (figs. 801, 802, 805).

Meroë was an iron-smelting center. It maintained trade contacts not only with Abyssinia, Arabia, the Near East, Black Africa, but probably also with India and China, as well as with Egypt. Meroë developed its own written characters with an alphabet of twenty-three signs, related to the cursive hieroglyphic script. F. L. Griffith was the first to decode the Meroïtic written lan-

956. MEROË. PYRAMIDS

957. MEROË. PYRAMIDS

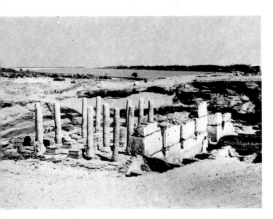

958. OLD DONGOLA. CHRISTIAN BASILICA

guage, working from a bilingual inscription discovered by Lepsius at Ben Naga. However, the main difficulty has not yet been overcome, because we do not know the spoken language of Meroë. Since Griffith, other scholars such as E. Zychlarz, C. Meinhof, B. G. Trigger, and J. H. Greenberg have tried to solve the riddle. At present the most advanced studies are those by F. Hintze.

It is not known exactly when the Meroïtic kingdom came to an end (J. Leclant, "Les études méroïtiques, état des questions," *BSFE*, 50, December 1967). A date around 350 A.D. is usually accepted, for King Aizanas of Axum bore the title of King of Kush about this time. In one of his long inscriptions, Aizanas mentions a military expedition he made to Meroïtic territory, and in the same inscription the Noba are mentioned. Today it is assumed that the "Black" Noba lived in an area around the Sixth Cataract and south of it—an area much the same as that occupied later by the kingdom of Alodia, or Aloa. The "Red" Noba, meanwhile, would have occupied the area around Dongola, later the kingdom of Makuria. After the Meroïtic kingdom fell apart, three independent kingdoms took form in the geographical region today designated as North and Middle Sudan. Alodia, with its capital at Soba near Khartoum, would have been the southernmost of these; north of it Makuria, with its capital at Old Dongola; north of that the kingdom of Nobatia, whose last capital was Pachoras (in Arabic Faras). At that time (around 400 A.D.) there appeared in northern Nubia a population until recently designated by the letter X. (B. G. Trigger, *History and Settlement in Lower Nubia*; L. P. Kirwan, *The X-Group Enigma*). The latest excavations conducted by W. Y. Adams at Meinarti, an island in the Nile (*Kush*, 13, 1965, pp. 148-76), have shown that Group X did not consist of invaders but of descendants of settlers who had lived in this area since Meroïtic times. They still constituted the ethnic core of the population in the Christian period. We know from Roman writers that two tribes, the Blemmyes and the Nobadas, fought each other in northern Nubia in this period. Led by Silko, who perpetuated his name in an inscription in the temple at Kalabsha (Talmis), the Nobadas were victorious and founded the kingdom of Nobatia. Emery, who discovered the magnificent tumuli at Ballana and Qustul, believed that they were the graves of Blemmye rulers (Emery, *The Royal Tombs of Ballana and Qustul*, 1938), but today the majority of historians believe that the tumuli at Ballana are of a later date, namely the fifth century, and were the tombs of Nobada rulers. In the light of the most recent excavations in Nubia, particularly the discoveries made by the Polish expedition at Faras (K. Michalowski, "Does the X-Group Still Present an Enigma?" *VDI*, 2 [100], 1967, pp. 104-11), the problem presented by Group X can be solved as follows.

The finds until recently believed to be relics of late Meroïtic culture in Lower Nubia, as well as the objects found by Emery in the tumuli at Ballana, are in fact expressions of the courtly culture of the rulers of Nobatia. The modest graves of the Group X people in this area are the remains of the folk culture of the broad masses of Nobatia.

The rulers of Nobatia, in this view, kept up the traditions of Meroïtic culture, but without any strong popular base. South of Nobatia, the kingdom of Meroë now lay in ruins, and to the north Egypt was already Christianized. The new religion must have exerted enormous powers of attraction on the impoverished, war-exhausted population of Nubia. We should not be surprised that Christianity spread first among the poorer classes; yet, the "official" conversion of Nobatia in 543 (thanks to the efforts of the Monophysite priest Julian, sent by the empress Theodora of Byzantium) was confined to baptism of the ruling class.

Since the pioneering efforts of Monneret de Villard (*La Nubia Medioevale*, I-III, 1935-37; *Storia della Nubia Cristiana*, 1938), the history of Christian Nubia has been the object of many studies, especially in recent years, following discoveries in Lower Nubia spurred by the UNESCO rescue effort. Churches and monasteries long buried in the sand have been uncovered "at the last moment"—before being forever swallowed up by the waters of the man-made lake. Monneret de Villard's synthesis will need to be thoroughly revised on the basis of these recent discoveries.

As has been pointed out, the most valuable Nubian antiquities are no longer in Nubia but in museums. For example, the great gallery of Christian paintings in the cathedral of Faras, which the Polish archaeological mission brought to light (K. Michalowski, *Faras, die Kathedrale aus dem Wüstensand*), has been divided equally between the Archaeological Museum of Khartoum and the National Museum in Warsaw. As shown by the Dutch excavations under A. Klasens at Abdallah Nirgi and by the Italian excavations under S. Donadoni at Sonki, Faras was a great artistic center, and its school of painting inspired the decorations in other Nubian churches (K. Michalowski, *Faras, Centre artistique de la Nubie chrétienne*). (See figs. 13, 143, 728, 729.)

This circumstance is the more noteworthy because, as is known, early in the eighth century King Merkurios united the northern Nubian kingdom (with its capital at Faras) and the central Nubian kingdom of Makuria, establishing his capital at Old Dongola. Here the Polish expedition recently discovered the ruins of a great colonnaded basilica dating from the first half of the eighth century, and underneath it an older church, probably the first Christian church built here (K. Michalowski, *Kush*, 14). This new Christian kingdom held out against repeated incursions from Moslem Egypt until the beginning of the fourteenth century. It finally fell to the Arabs in 1323. However, the southern Nubian kingdom of Alodia, which for some time was part of the Christian kingdom at Dongola, managed to preserve its independence until the year 1504.

VII. CHRISTIAN MONASTERIES

41. SOHAG

Near this town in Upper Egypt are two important Coptic monasteries known as Deir el Abiad (the White Monastery) and Deir el Ahmar (the Red Monastery).

Deir el Abiad was founded about 440 A.D. by Abbot Amba Shenuda, a native of the nearby Akhmin. The monastery has high, slightly inclined walls crowned with an Egyptian cornice and provided with water spouts, reminiscent of Egyptian temple façades. The church has a basilical plan with three long naves terminating at the east in a trilobe apse. The decoration of the latter consists of two stories of superposed niches separated by columns. A number of the architectural elements (columns, door frames) came from ruined temples in nearby Athribis. Fragments of wall paintings have been preserved in the niches and under the cupola. There are two narthexes, one at the west end of the building and one along its south side. The funerary stele of Shenuda, now in Berlin, comes from this monastery.

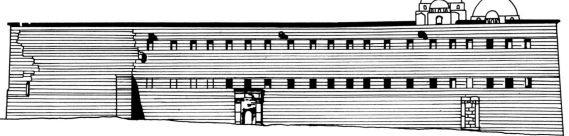

959. SOHAG. DEIR EL ABIAD (WHITE MONASTERY), NORTH WALL

At Deir el Ahmar, about 3 miles northwest of the White Monastery, is the Red Monastery, so named because of the red color of its bricks. It was built by a disciple of Shenuda and modeled on the White Monastery. In plan and exterior appearance the two are almost identical, and their interiors are also very similar. The sculptural decoration is more elaborate than that of the White Monastery. Remains of wall paintings have been preserved in the niches under the cupola.

Both edifices have been studied by scholars who specialize in Christian architecture in Egypt. The first plans and sections were drawn in 1912 by Somers Clarke (*Christian Antiquities in the Nile Valley*), who was followed by Monneret de Villard (*Les couvents près de Sohag*, 1925-26). In 1962 a German expedition from Darmstadt took new measurements of both monasteries and prepared models showing their proposed reconstruction (H. G. Evers and R. Romero, *Christentum am Nil*, pp. 175 f.).

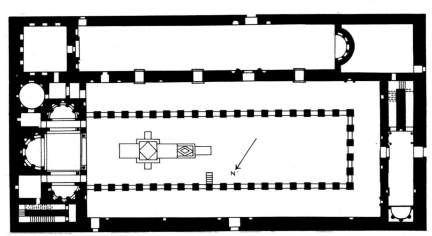

960. SOHAG. DEIR EL ABIAD (WHITE MONASTERY), PLAN OF THE CHURCH

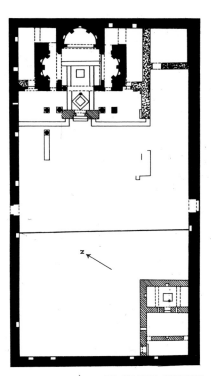

961. SOHAG. DEIR EL AHMAR (RED MONASTERY), PLAN OF THE CHURCH

42. RED SEA MONASTERIES

Although the Monastery of St. Anthony at Wadi el Arabah was founded in the third century A.D., most of its preserved portions date from the middle of the fourth century. The complex of churches, residential and service buildings, and gardens are enclosed by a wall 39 feet high. Obviously obliged to defend itself, the monastery community was rebuilt several times. Some chapels are decorated with wall paintings depicting subjects popular in Christian Egypt—saints on horseback, hermits, and the archangels Michael and Gabriel. Some of these date from the tenth century. A group of paintings representing the patriarchs of Alexandria dates between the eleventh and the thirteenth centuries. Most of them are blackened with soot. The monastery survived more or less intact until the end of the fifteenth century, when it was pillaged. It never recovered its former splendor, although monks began to live in it again after the middle of the sixteenth century (W. Muller-Wiener, *Christentum am Nil*, Essen, pp. 131 f.; P. du Bourget, *Die Kopten*).

The Monastery of St. Paul at Wadi el Deir, southeast of the Monastery of St. Anthony, is closer to the Red Sea. Founded about the same time, it is smaller and preserves more of the appearance of the original structure, having been subjected to less remodeling. It, too, is decorated with paintings treating subjects similar to those in the chapels of the Monastery of St. Anthony. However, a dubious restoration made in the eighteenth century makes it difficult to decide today whether the devils pierced by the lances of saintly knights are a late addition, for the theme occurs nowhere else in Egyptian art.

The best-known monastery near the Red Sea is the Monastery of St. Catherine on Mount Sinai. It is situated in a valley almost a mile high surrounded by three hills—Safsafa, Musa, and Moneiga. Its origins go back to the fourth century, when a number of hermits (among them St. Onuphrius) sought shelter in these mountains from hostile nomads. The emperor Justinian fortified the site to ensure the safety of the anchorites. A citadel was built whose walls, nearly 5 feet thick and from 39 to 49 feet high, enclosed an area measuring 275 1/2 by 242 1/4 feet. Within this area rose a number of churches and dwellings. Among the oldest is a three-nave basilica dating from the second half of the sixth century. Largely rebuilt in subsequent periods, it nonetheless contains many valuable relics of Byzantine and medieval European art. It is famous primarily for its collection of icons, including one of the oldest known examples of this art form: the seventh-century icon of St. Peter (see K. Weitzmann, *National Geographic*, January 1964; G. Gerster, *Sinai, Land der Offenbarung*, 1961). The monastery library contains such rare manuscripts as the famous Syriac Palimpsest of the Gospel according to St. Luke. Its Codex Sinaiticus, however, a Greek manuscript of the Bible dating from the fourth century A.D., is now in the British Museum.

962. MONASTERY OF ST. ANTHONY

963. MONASTERY OF ST. PAUL

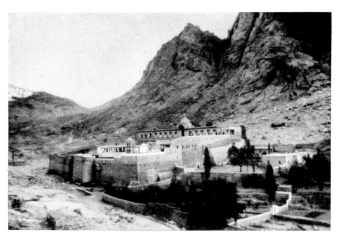

964. MONASTERY OF ST. CATHERINE

43. WADI NATRUN

The Greek Nitria or Nitriotis, the Roman Scythiaca Regio, the Coptic Shiêt. A site in the Libyan desert not far from the Mediterranean.

From earliest times this site was probably a source of natron, a substance used in mummification. During the Middle Kingdom a fort was located here within which was a temple dating from Dynasty XII (Fakhry, *ASAE*, 40). In Ptolemaic and Roman times large quantities of white natron were exposed when lakes dried up during the summer.

The Wadi Natrun area was one of the earliest settlements of the "desert fathers" in Christian times. The first hermits lived in caves; after their death, small chapels were built nearby. These chapels gave rise to monasteries, only four of which have been preserved: Deir Abu Makar, Deir Suriani (Monastery of the Syrians), Deir Amba Bishoï, and Deir el Baramus. These were founded in the fourth century A.D. and subsequently destroyed and rebuilt several times.

Each monastery is surrounded by a wall about 36 feet high and about 6 feet thick. Its uncoursed rubble masonry is coated with a hard lime plaster. Access to the monastery was through a single gate. In the floor of the upper room of the gatehouse—within the walls—was a trap door through which visitors could be scrutinized, or prevented from entering. The need for self-defense in these monasteries is clearly shown by the high surrounding walls, and by the *qasr*, or keep, a quadrilateral tower of two or more stories which could be entered only by a drawbridge. The *qasr* was also used for storing valuable monastic property.

Near the *qasr* was the principal church of the monastery. Today, no church earlier than the ninth century remains, although the existing churches may have been rebuilt on old foundations (H. G. Evelyn-White, *Monasteries of the Wadi'n Natrun*, PMMA, 8, 1928). The principal churches are all variations on a single type of plan. At the eastern end are three *haikals*, or sanctuaries (the Church of St. Macarius at Deir Abu Makar originally had four), all with a square east end. Immediately to the west is a transverse choir, equal in length to the combined width of the three *haikals*, and west of the choir a nave with continuous side aisles. The *haikals* were crowned with cupolas, and the walls of the central *haikal* were pierced by two or three rows of windows. Porches enclose some of the north and south entrances, as at Deir el Baramus. In some churches wall paintings are preserved. Those decorating the interior of the church at Deir Suriani were executed at the time of its latest rebuilding, in the eleventh century; strong Byzantine influence is evident in the subject matter.

44. ABU MINA

About 26 1/2 miles northwest of Alexandria. The most recent excavations, begun in 1961 by the German Archaeological Institute in Cairo, have shown that there was continuous occupation of the site after the end of the fourth century B.C.

According to Christian tradition St. Menas is buried here. Among the structures uncovered are the remains of a small stone church and crypt which was built over the original burial place of the saint and completed about 375 A.D., and a larger church and baptistery finished in the late fifth century. The smaller church replaced a mud-brick chapel on the same site and was itself remodeled in the fifth century, when the larger church was constructed. The latter was subsequently abandoned, and in the ninth century another small church was built over the original grave by the Alexandrian patriarch Joseph. This late ninth-century church, incorporating remains of earlier buildings on the site, survived down to the twelfth century (H. Schläger, *Christentum am Nil*, pp. 158 f.; *MDAIK*, 19-21; J. Leclant, *Orientalia*, 31-36; J. B. Ward-Perkins, *PBSR*, 17, 1949, pp. 37 f.).

At some distance from the religious area is a large bath building with separate facilities for men and women. The baths had a hypocaust and drew water directly from cisterns and a well provided for this purpose.

Abu Mina was a place of pilgrimage. The emperor Justinian ordered an inn to be built between the harbor and the church, with a well for the convenience of pilgrims. Abu Mina had a reputation as the site of many miraculous cures. Eventually a town and a cemetery grew up around the sacred area. One of the main products of local craftsmen were the famous St. Menas ampullae of fired clay (M. Krause, *Christentum am Nil*, Essen, pp. 65 f.).

965. WADI NATRUN. DEIR SURIANI

966. WADI NATRUN. DEIR AMBA BISHOÏ

967. WADI NATRUN. DEIR EL BARAMUS

968. ABU MINA. MONASTERY OF ST. MENAS

LIST OF ABBREVIATED TITLES OF PERIODICALS

Arch. Rep. : Archaeological Reports comprising the work of the Egypt Exploration Fund and the progress
of Egyptology.
AE : Ancient Egypt.
ASAE : Annales du Service des Antiquités de l'Égypte.
BFLS : Bulletin de la Faculté des Lettres de Strasbourg.
BIE : Bulletin de l'Institut d'Égypte.
BIFAO : Bulletin de l'Institut Français d'Archéologie Orientale.
BMFA : Bulletin of the Museum of Fine Arts, Boston.
BMMA : Bulletin of the Metropolitan Museum of Art, New York.
BSAC : Bulletin de la Société d'Archéologie Copte.
BSFE : Bulletin de la Société Française d'Égyptologie.
CdE : Chronique d'Égypte. Bulletin périodique de la Fondation Égyptologique. Reine Elisabeth,
Bruxelles.
CRAI : Comptes rendus de l'Académie des Inscriptions et belles-lettres.
FIFAO : Fouilles de l'Institut français d'Archéologie Orientale du Caire.
JARCE : Journal of the American Research Center in Egypt.
JEA : Journal of Egyptian Archaeology.
Kêmi : Kêmi, Revue de Philologie et d'Archéologie égyptiennes et coptes.
Kush : Kush, Journal of the Sudan Antiquities Service.
MDAIK : Mitteilungen der Deutschen Archaeologischen Instituts, Abteilung Kairo.
MIFAO : Mémoires publiés par les membres de l'Institut Français d'Archéologie Orientale du Caire.
OLZ : Orientalische Literaturzeitung.
Orientalia : Orientalia, Commentarii Periodici Pontifici Instituti Biblici, Rome.
PBSR : Papers of the British School in Rome.
PMMA : Papers of the Metropolitan Museum of Art.
RA : Revue Archéologique.
SPAW : Preussische Akademie der Wissenschaften zu Berlin. Sitzungsberichte.
UPMJ : University of Pennsylvania Museum Journal, Philadelphia.
VDI : Vestnik Drevney Istorii.
ZAeS : Zeitschrift für Ägyptische Sprache und Altertumskunde.

16. CHARTS AND MAPS

CHARTS

I. CHRONOLOGY OF ANCIENT EGYPT

II. ROYAL CROWNS AND SCEPTERS

III. GODS AND GODDESSES OF ANCIENT EGYPT

IV. HIEROGLYPHS

V. CANONS OF EGYPTIAN ART

VI. COMPOSITIONAL SCHEMES OF THE OLD AND MIDDLE KINGDOMS

VII. PROJECTIVE PERSPECTIVE

VIII. TRANSPORT OF A STATUE AND SCULPTURAL TECHNIQUES

IX. FUNERARY ARCHITECTURE

X. CANON OF THE EGYPTIAN TEMPLE

XI. COLUMNS AND CAPITALS

MAPS

I. GENERAL MAP OF THEBES

II. GENERAL MAP OF EGYPT

III. PRINCIPAL PYRAMIDS IN LOWER EGYPT

CHART I. CHRONOLOGY OF ANCIENT EGYPT

PREHISTORIC PERIOD

BEFORE 4000 B.C. SETTLEMENT OF MERIMDEH BENI SALAMEH IN THE FAYUM; EL OMARI IN LOWER EGYPT; DEIR TASA AND BADARI IN UPPER EGYPT

PREDYNASTIC PERIOD (CHALCOLITHIC, 4000 – 3100 B.C.)

NAGADAH I (AMRATIAN)
NAGADAH II (GERZEAN)

THINITE PERIOD (3100 – 2686 B.C.)

DYNASTY I (3100–2890 B.C.)

Narmer-Menes
Aha
Zer
Zet (Wadji)
Wedymu
Az-ib
Semerkhet
Qay-a

DYNASTY II (2890–2686 B.C.)

Ra-neb
Hetep-sekhemuwy
Ny-neter
Peribsen
Sened
Khasekhem
Khasekhemuwy

OLD KINGDOM (2686 – 2181 B.C.)

DYNASTY III (2686–2613 B.C.)

Sa-nekht
Zoser
Sekhem-khet
Kha-ba
Huni

DYNASTY IV (2613–2494 B.C.)

Sneferu
Cheops (Khufu)
Radedef
Chephren (Khafre)
Zedefhor
Bawefra
Mycerinus (Menkaure)
Shepseskaf

DYNASTY V (2494–2345 B.C.)

Weserkaf
Sahura
Neferirkara
Shepseskara (Isy)
Neferefra
Ne-user-ra
Men-kau-hor
Zed-kara Isesy
Unas

DYNASTY VI (2345–2181 B.C.)

Tety
Weserkara
Pepy I
Mernera
Pepy II

FIRST INTERMEDIATE PERIOD (2181 – 2133 B.C.)

DYNASTIES VII–X

MIDDLE KINGDOM (2133 – 1786 B.C.)

DYNASTY XI (2133–1991 B.C.)

Tepia Mentuhotep
Intef I (Seher-tawy)
Intef II (Wah-ankh)
Intef III (Nekht-neb-tep-nefer)
Mentuhotep I (Neb-hepet-ra)
Mentuhotep II (Se-ankh-kara)
Mentuhotep III (Neb-tawy-ra)

DYNASTY XII (1991–1786 B.C.)

Amenemhat I (Sehetep-ib-ra) (1991–1962)
Sesostris I (Kheper-ka-ra) (1971–1928)
Amenemhat II (Neb-kau-ra) (1929–1895)
Sesostris II (Kha-kheper-ra) (1897–1878)
Sesostris III (Kha-kau-ra) (1878–1843)
Amenemhat III (Ny-ma'at-ra) (1842–1797)
Amenemhat IV (Ma'at-kheru-ra) (1798–1790)
Queen Sebek-neferura (Sebek-kara) (1789–1786)

SECOND INTERMEDIATE PERIOD (1786 – 1650 B.C.)

DYNASTIES XIII–XVI

NEW KINGDOM (1650 – 1085 B.C.)

DYNASTY XVII (1650–1567 B.C.)

Intef VII
Taa-aa
Taa-ken (Sekenenra)
Kamose (Waz-kheper-ra)

DYNASTY XVIII (1567–1320 B.C.)

Ahmose I (1570–1546)
Amenhotep I (1546–1526)
Tuthmosis I (1525–1512)
Tuthmosis II (1512–1504)
Hatshepsut (1503–1482)
Tuthmosis III (1504–1450)
Amenhotep II (1450–1425)
Tuthmosis IV (1425–1417)
Amenhotep III (1417–1379)
Amenhotep IV/Akhenaten (1379–1362)
Semenkhkara (1364–1361)
Tut-ankh-amon (1361–1352)
Ay (1352–1348)
Horemheb (1348–1320)

DYNASTY XIX (1320–1200 B.C.)

Ramesses I (1320–1318)
Sety I (1318–1304)
Ramesses II (1304–1237)
Merenptah (1236–1223)
Amen-meses (1222–1217)
Sety II (1216–1210)

DYNASTY XX (1200–1085 B.C.)

Sety-nekht (1200–1198)
Ramesses III (1198–1166)
Ramesses IV (1166–1160)
Ramesses V–Ramesses VIII (1160–1142)
Ramesses IX (1142–1123)
Ramesses X (1123–1114)
Ramesses XI (1114–1085)

LATE PERIOD (1085 – 332 B.C.)

DYNASTY XXI (1085–935 B.C.)

TANIS:

- Smendes
- Psusennes I
- Amen-em-ipet
- Sa-amon
- Psusennes II

THEBES:

- Herihor
- Paynozem I
- Masaherta
- Menkheperra
- Paynozem II

DYNASTY XXII (935–730 B.C.) BUBASTITE

- Sheshonq I (935–914)
- Osorkon I (914–874)
- Takelot I (874-860)
- Osorkon II (860-837)
- Sheshonq II (837)
- Takelot II (837–823)
- Sheshonq III (822–770)
- Pami (770–765)
- Sheshonq IV (765–725)

DYNASTY XXIII (817?–730 B.C.)

- Petubastis (817?–730)

DYNASTY XXIV (730–709 B.C.)

- Tef-nekht
- Bocchoris

DYNASTY XXV (750–656 B.C.) KUSHITE

- Piankhy (751–716)
- Shabako (716–695)
- Shebitku (695–690)
- Taharqa (689–664)
- Tanwetamani (664–656)

DYNASTY XXVI (664–525 B.C.) SAITE

- Psamtik I (664–610)
- Necho II (610–595)
- Psamtik II (595–589)
- Apries (589–570)
- Amasis (570–526)
- Psamtik III (526–525)

DYNASTY XXVII (525–404 B.C.)
FIRST PERSIAN DOMINATION

- Cambyses (525–522)
- Darius I (521–486)
- Xerxes (486–466)
- Artaxerxes (465–424)
- Darius II (424–404)

DYNASTIES XXVIII and XXIX (404–378 B.C.)

- Achoris (393–380)

DYNASTY XXX (380–343 B.C.)

- Nectanebo I (380–363)
- Teos (362–361)
- Nectanebo II (360–343)

DYNASTY XXXI (341–332 B.C.)
SECOND PERSIAN DOMINATION

GREEK PERIOD (332 – 30 B.C.)

MACEDONIAN KINGS (332–304 B.C.)

- Alexander the Great (332–323)
- Philip III Arrhidaeus (323–316)
- Alexander IV (316–304)

PTOLEMAIC DYNASTY (304–30 B.C.)

- Ptolemy I Soter I (304–282)
- Ptolemy II Philadelphus (285–246)
- Ptolemy III Euergetes (246–221)
- Ptolemy IV Philopator (221–205)
- Ptolemy V Epiphanes (205–180)
- Ptolemy VI Philometor (180–145)
- Ptolemy VII Neos Philopator (145)
- Ptolemy VIII Euergetes II (170–116)
- Ptolemy IX Soter II (Lathyros) (116–107)
- Ptolemy X Alexander I (107–88)
- Ptolemy IX Soter II (restored) (88–81)
- Ptolemy XI Alexander II (80)
- Ptolemy XII Neos Dionysos (80–51)
- Cleopatra VII Philopator (51–30)

ROMAN PERIOD (30 B.C. – 395 A.D.)

COPTIC AND BYZANTINE PERIOD (395 – 640 A.D.)

ARAB CONQUEST (640 – 641 A.D.)

CHART. II ROYAL CROWNS AND SCEPTERS

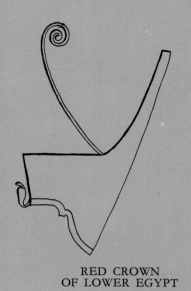

RED CROWN
OF LOWER EGYPT

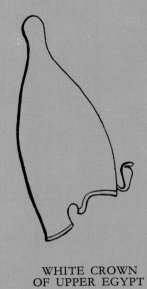

WHITE CROWN
OF UPPER EGYPT

DOUBLE CROWN
OF UPPER AND LOWER EGYPT

BLUE HELMET, OR *KHEPERESH*

CROWN OF AMON

ATEF CROWN

ROWN OF THE QUEEN MOTHER

Vulture skin surmounted
by two feathers which
spring from a mortar

ABA SCEPTER

HEDJ SCEPTER

NEKHEKHW WHIP

HEQA SCEPTER

WAS SCEPTER

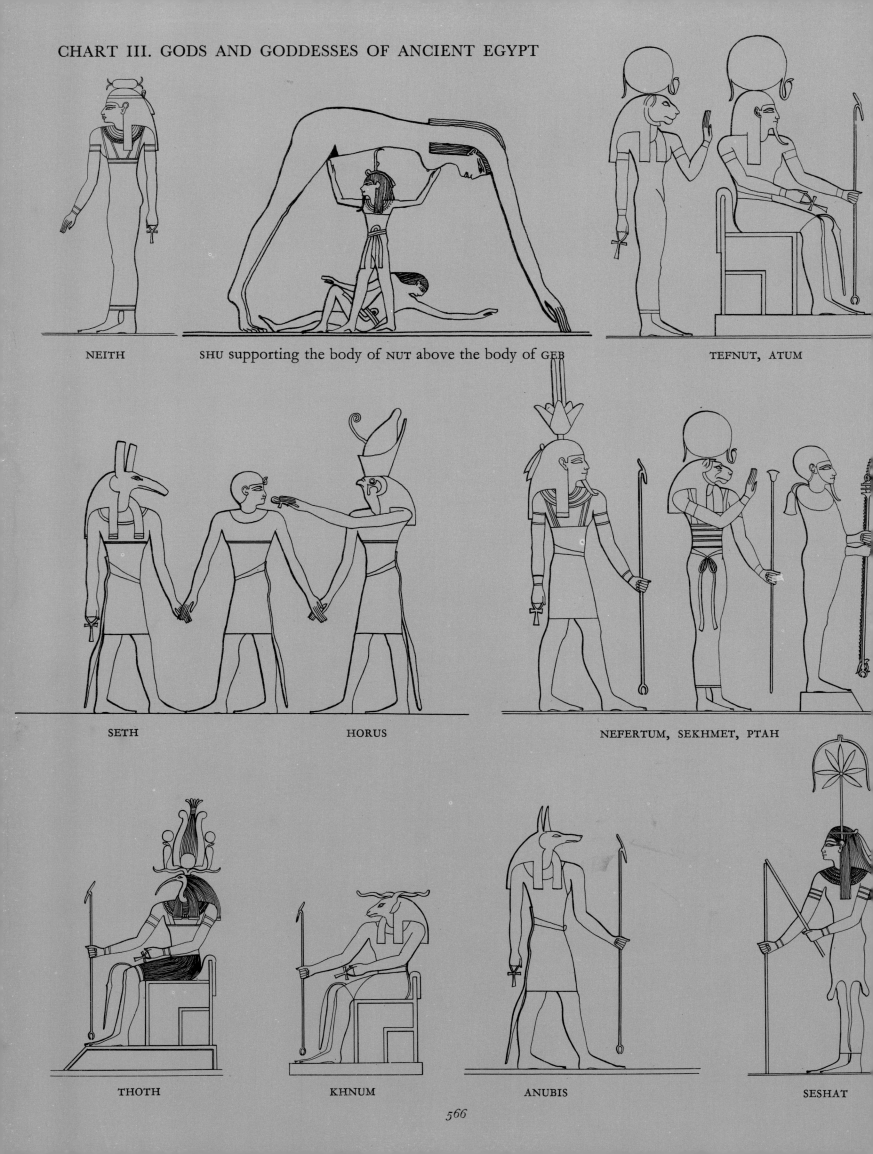

CHART III. GODS AND GODDESSES OF ANCIENT EGYPT

NEITH SHU supporting the body of NUT above the body of GEB TEFNUT, ATUM

SETH HORUS NEFERTUM, SEKHMET, PTAH

THOTH KHNUM ANUBIS SESHAT

RA ISIS, OSIRIS, NEPHTHYS

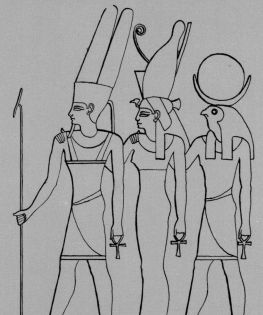

THEBAN TRIAD: AMON, MUT, KHONSU HATHOR, SOBEK, MA'AT

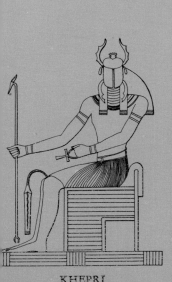
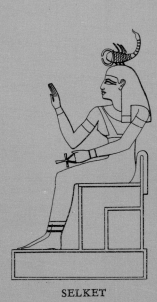
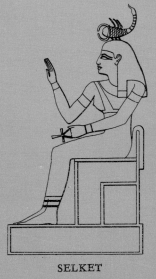

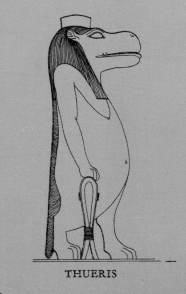

KHEPRI SELKET THUERIS BES

CHART IV. HIEROGLYPHS

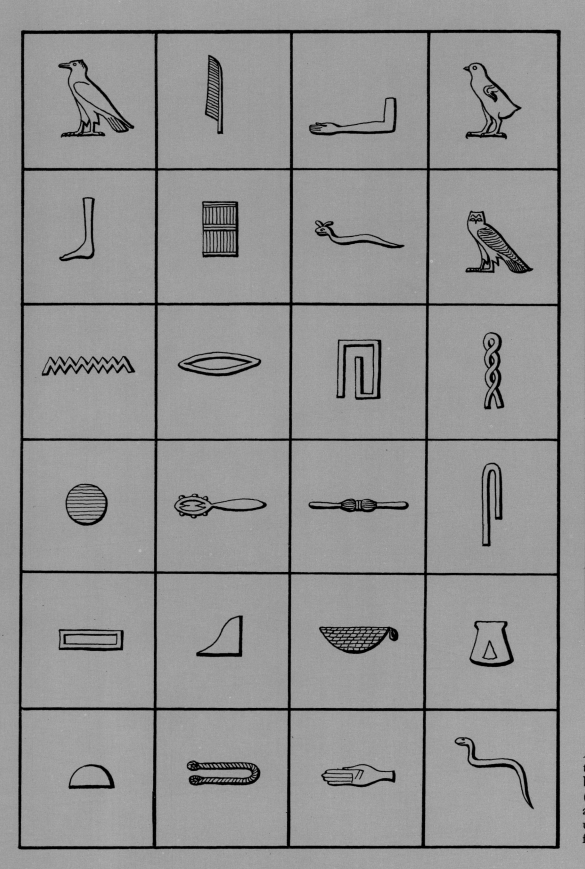

a	i, j	â	ou
b	p	f	m
n	r	h	ḥ
kh	<u>h</u>	s	ś
ch	q	k	g
t	th	d	dj

As Egyptian writing developed, the twenty-four hieroglyphs at left came to be used for rendering consonant sounds (see corresponding chart above), creating a kind of "alphabet" which could be used for writing all words, especially foreign names.

CHART V. CANONS OF EGYPTIAN ART

STANDING AND SEATED FIGURES DRAWN ON A GRID (left)

The model of the standing figure was drawn on papyrus or a stone slab divided into eighteen rows of small squares: thus, the area from the top of the forehead (at the hairline) to the base of the neck occupied two rows of squares; from the neck to the knees, ten rows; from the knees to the soles of the feet, six rows. For the hair above the forehead, an additional row of squares was added. Following the same principles, a seated figure occupied fifteen rows of squares. This system remained in effect until the Late Period, although from Dynasty XXVI (Saite) on, the number of rows was increased to twenty-one and a quarter.

CORRECT AND INCORRECT RENDERING BY THE ARTIST (above)

Although the division into squares permitted no error, it sometimes happened that a provincial artist made a mistake when reversing a figure.

STUDY OF BALANCE (right)

While the figures of the Old Kingdom showed a certain rigidity, those of the New Kingdom—which used similar artistic formulas—introduced some flexibility into the movement.

CHART VI. COMPOSITIONAL SCHEMES OF THE OLD AND MIDDLE KINGDOMS

The Egyptian artist used well-known formulas in the representation of certain scenes. They usually—but not always—were repeated, and were varied according to the period. To show the chopping down of a tree the Old Kingdom artist depicted each stage of the woodcutter's action separately *(above)*, whereas the Middle Kingdom artist gave the same scene a more naturalistic rendering *(right)*.

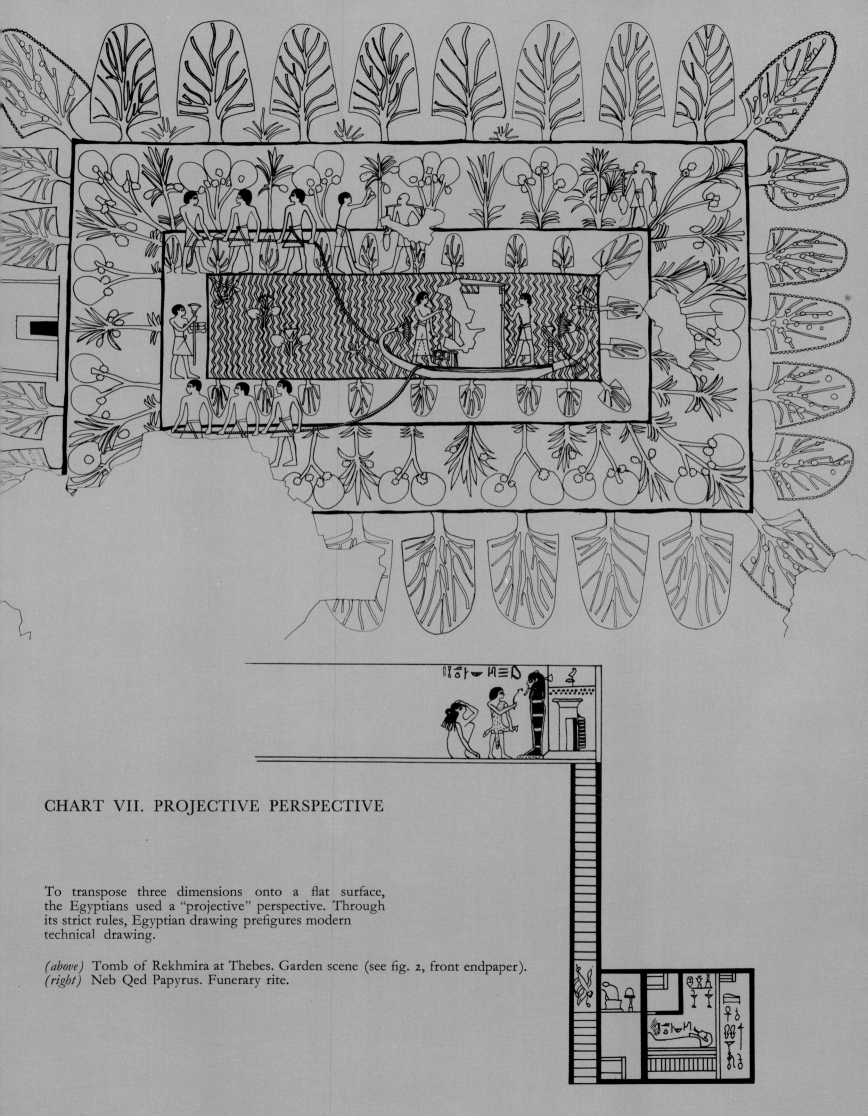

CHART VII. PROJECTIVE PERSPECTIVE

To transpose three dimensions onto a flat surface,
the Egyptians used a "projective" perspective. Through
its strict rules, Egyptian drawing prefigures modern
technical drawing.

(above) Tomb of Rekhmira at Thebes. Garden scene (see fig. 2, front endpaper).
(right) Neb Qed Papyrus. Funerary rite.

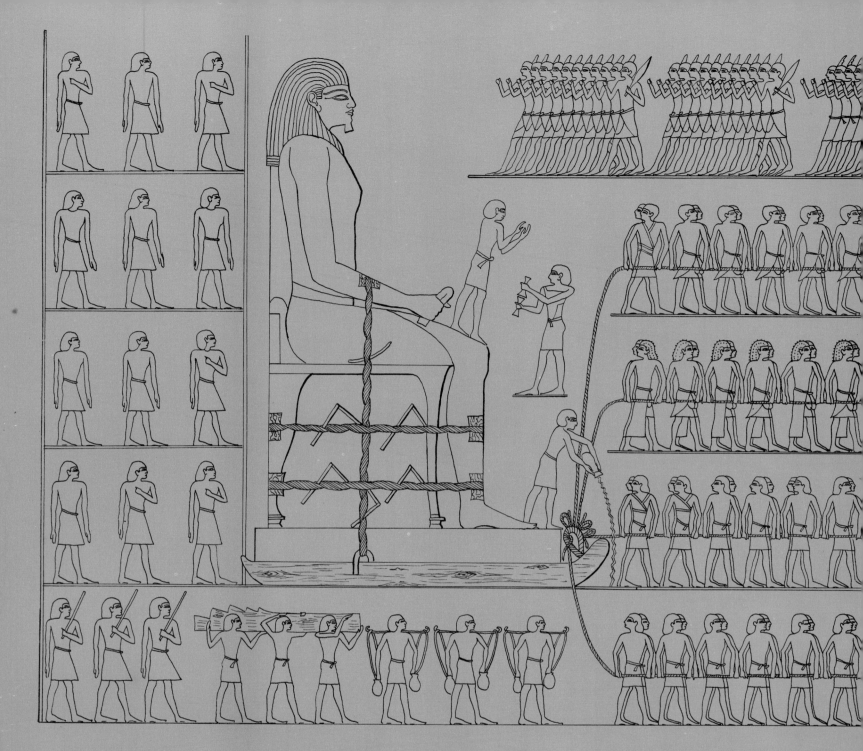

TRANSPORTING A STATUE
FROM THE QUARRY TO THE NILE TO THE
PYRAMID *(above)*

In this drawing of a badly deteriorated relief from
the tomb of Djehuty-hetep at Deir el Bersheh, a
colossal granite statue is shown attached by ropes
to a sledge and pulled by hundreds of workmen.
One stands at the base of the statue and pours water
in front of the sledge to make the soil slippery.
Below the sledge are water carriers and bearers of
spare parts. On the left are more workmen, to
replace those who become exhausted. At the bottom
left corner stand three supervisors holding wooden
staffs, symbols of their authority. In the upper
register, at right, a row of soldiers oversees the
moving of the statue.

A SCULPTURE WORKSHOP *(right)*

A workshop employed many artisans,
whom the work was distributed. Eac
assigned a different sculptural task: the
of the model, the drawing of the o
the cutting of the stone, the carving of
and statues, the chiseling, the polish
the decoration of temple walls.

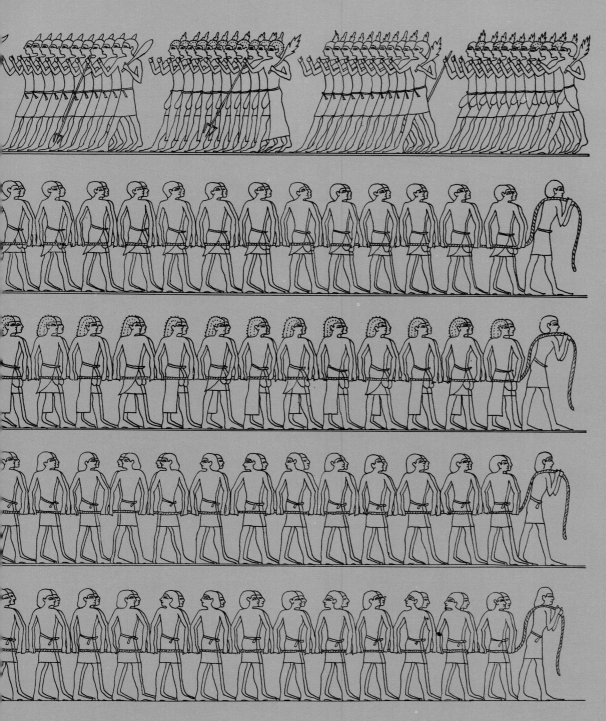

CHART VIII. TRANSPORT
OF A STATUE AND
SCULPTURAL
TECHNIQUES

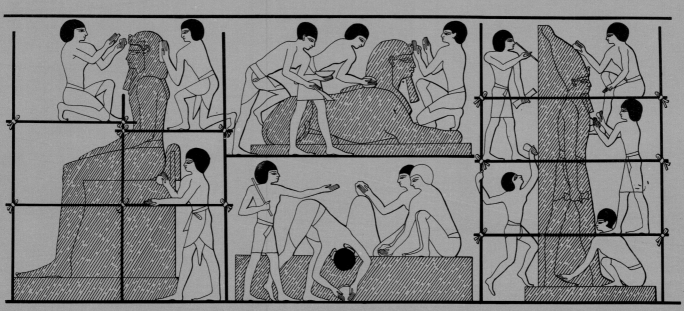

CHART IX. FUNERARY ARCHITECTURE

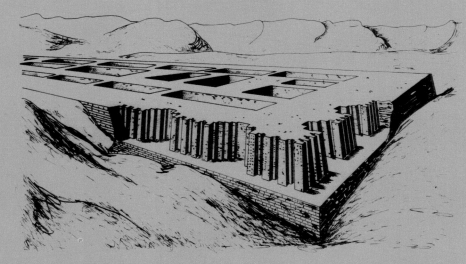

RECONSTRUCTION OF A TOMB AT NAGADAH (DYNASTY I)

The first Egyptian king were buried at Nagadah The shape of their tomb prefigured that of the mas taba, which during the Old Kingdom became the typica sepulcher for dignitaries.

PLAN AND FAÇADE OF AN ARCHAIC MASTABA *(right)*

The façade of the mastaba imitated the façade of the royal palace.

FIELD OF MASTABAS *(below)*

Each mastaba had a visible part, the superstructure in which the chapels were arranged.

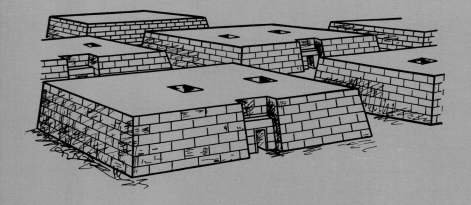

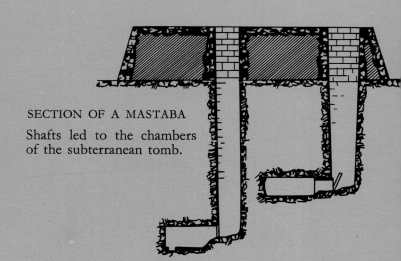

SECTION OF A MASTABA

Shafts led to the chambers of the subterranean tomb.

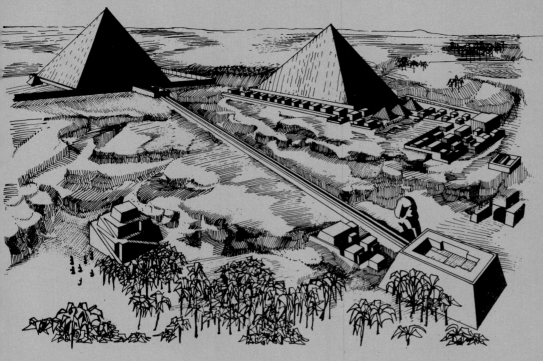

RECONSTRUCTION OF A FUNERARY COMPLEX IN THE OLD KINGDOM

The classic plan of the funerary complex included the royal pyramid and such secondary structures as the upper and lower funerary temples (linked by a ramp), satellite pyramids, and a cemetery for dignitaries.

QAW EL KEBIR. RECONSTRUCTION OF THE TOMBS OF WAHKA AND IBU

These tombs of princes of Nome X of Upper Egypt, built during the Middle Kingdom, recall the general plan of the Old Kingdom funerary complex. Here the pyramid has been replaced by the steep, rocky natural cliff.

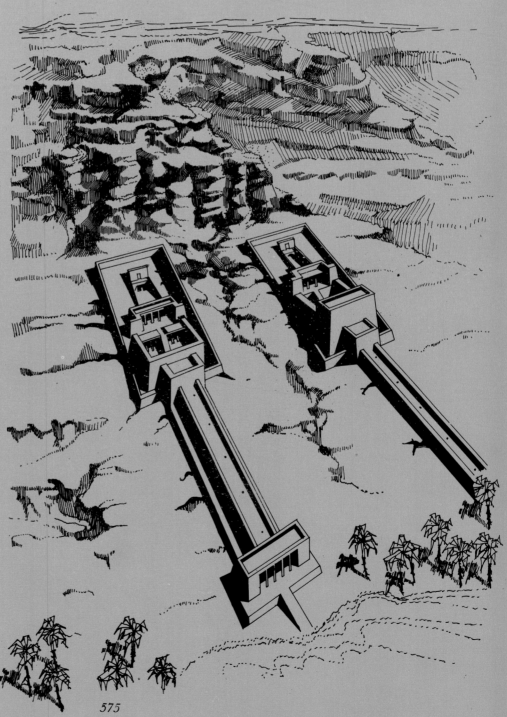

CHART IX. FUNERARY ARCHITECTURE *(continued)*

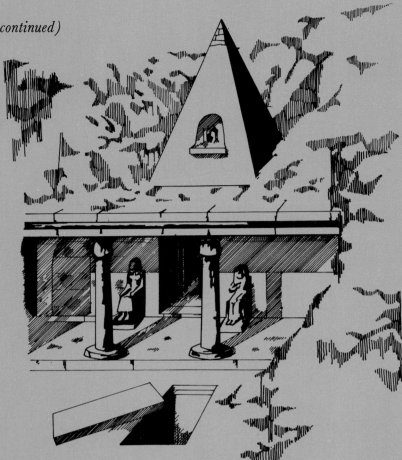

RECONSTRUCTION OF FUNERARY ENSEMBLES AT DEIR EL MEDINEH

During the New Kingdom the pyramid reappeared in the form of a pyramidion set atop private tombs.

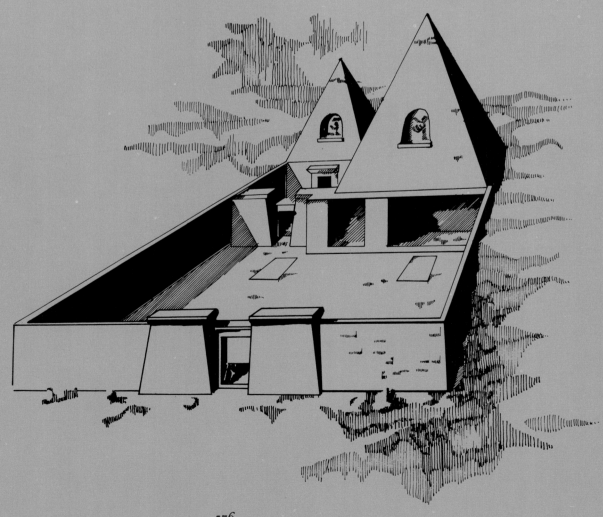

CHART X. CANON OF THE EGYPTIAN TEMPLE

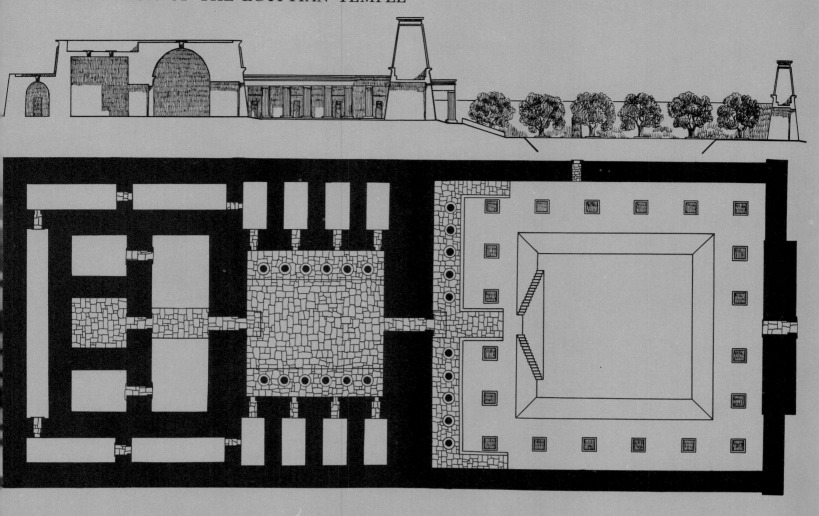

PLAN AND SECTION OF THE
FUNERARY TEMPLE OF AMENHOTEP,
SON OF HAPU, AT MEDINET HABU *(above)*

In his own funerary temple, Amenhotep,
son of Hapu, chief architect to King
Amenhotep III, worked out the proto-
type of the classic temple. The temple
of Khonsu at Karnak is the best pre-
served example of this type.

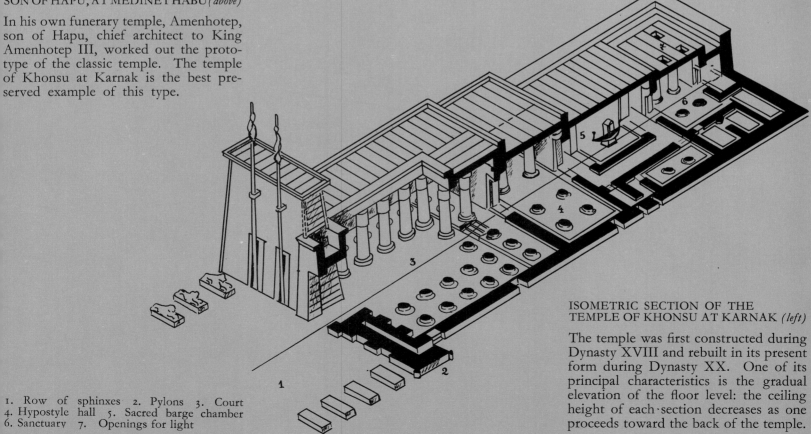

ISOMETRIC SECTION OF THE
TEMPLE OF KHONSU AT KARNAK *(left)*

The temple was first constructed during
Dynasty XVIII and rebuilt in its present
form during Dynasty XX. One of its
principal characteristics is the gradual
elevation of the floor level: the ceiling
height of each section decreases as one
proceeds toward the back of the temple.

1. Row of sphinxes 2. Pylons 3. Court
4. Hypostyle hall 5. Sacred barge chamber
6. Sanctuary 7. Openings for light

577

CHART XI. COLUMNS AND CAPITALS

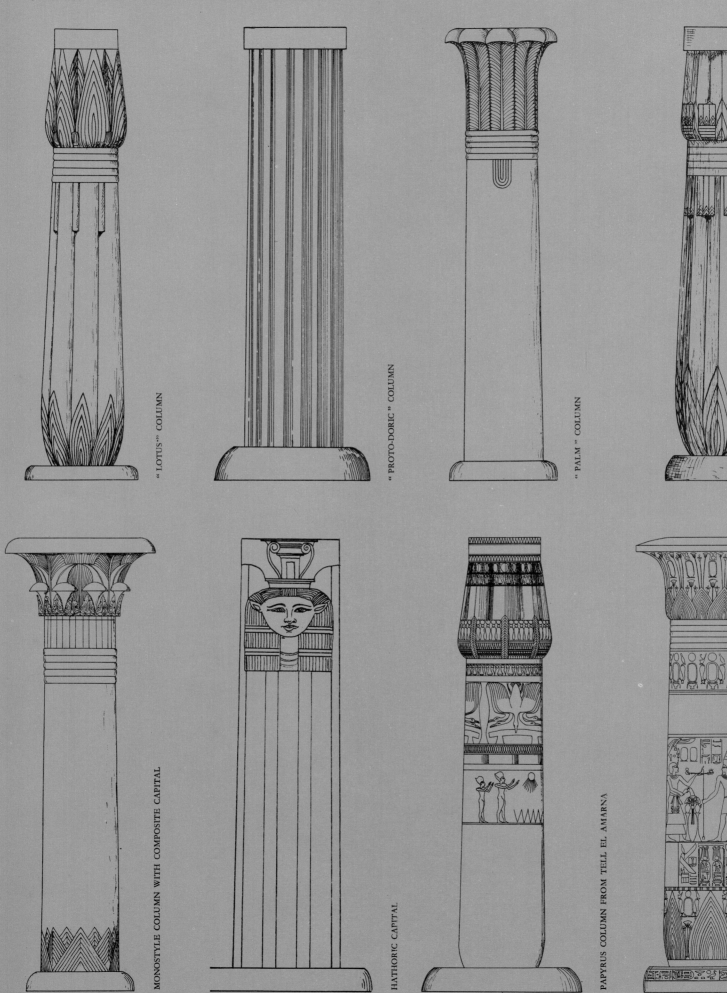

"LOTUS" COLUMN

"PROTO-DORIC" COLUMN

"PALM" COLUMN

"PAPYRUS" COLUMN WITH BUD CAPITAL

MONOSTYLE COLUMN WITH COMPOSITE CAPITAL

HATHORIC CAPITAL

PAPYRUS COLUMN FROM TELL EL AMARNA

MONOSTYLE COLUMN WITH COMPOSITE CAPITAL

SAQQARAH (DYN. III)

ABUSIR (DYN. V)

LUXOR (DYN. XVIII)

KARNAK (DYN. XVIII)

KARNAK (DYN. XVIII)

KARNAK (DYN. XX)

KARNAK, COLUMN OF TAHARQA (DYN. XXV)

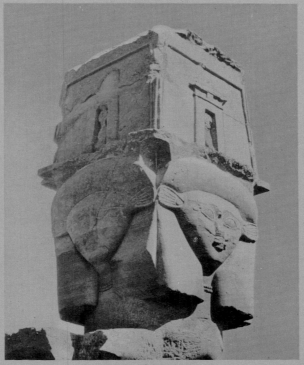

KALABSHA (ROMAN PERIOD)

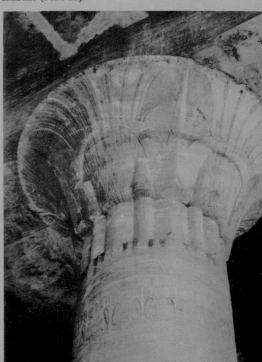

EDFU (PTOLEMAIC PERIOD)

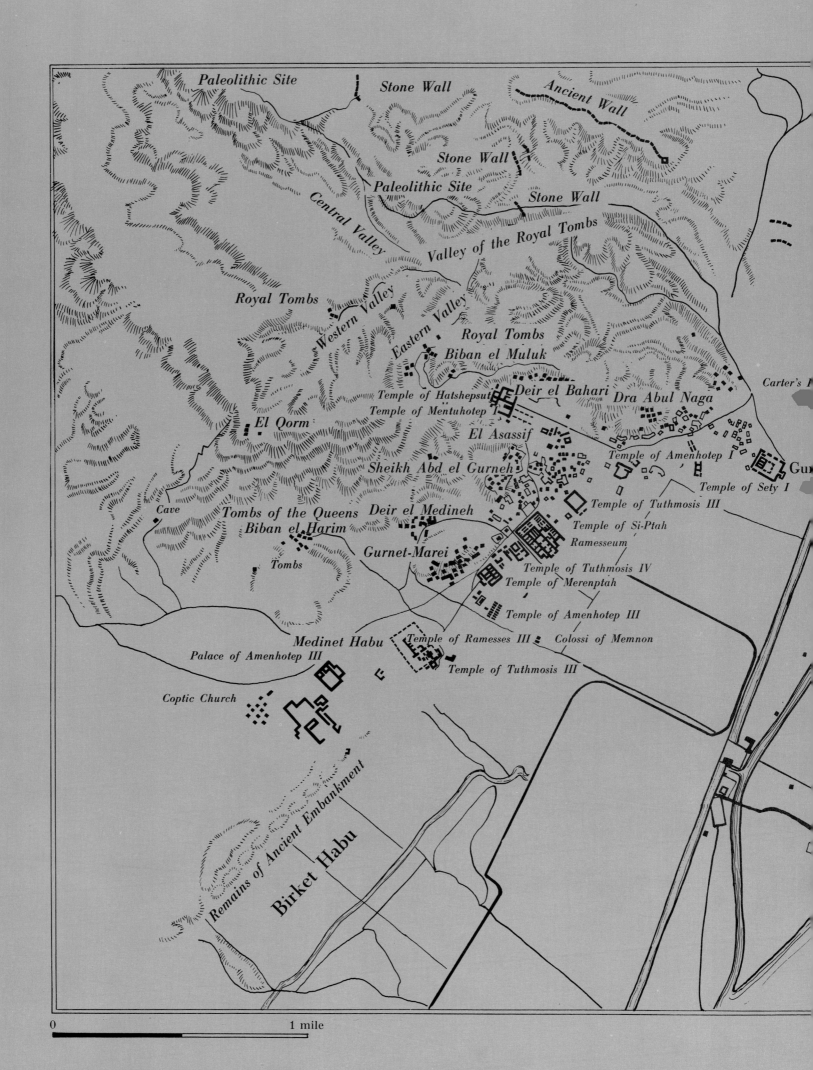

Paleolithic Site

Stone Wall

Ancient Wall

Stone Wall

Paleolithic Site

Stone Wall

Central Valley

Valley of the Royal Tombs

Royal Tombs

Western Valley

Eastern Valley

Royal Tombs

Biban el Muluk

Temple of Hatshepsut

Deir el Bahari Dra Abul Naga

Carter's F.

El Qorm

Temple of Mentuhotep I

El Asassif

Temple of Amenhotep I

Gur

Sheikh Abd el Gurneh

Temple of Sety I

Cave

Deir el Medineh

Temple of Tuthmosis III

Tombs of the Queens

Temple of Si-Ptah

Biban el Harim

Ramesseum

Gurnet-Marei

Temple of Tuthmosis IV

Tombs

Temple of Merenptah

Temple of Amenhotep III

Medinet Habu

Temple of Ramesses III

Colossi of Memnon

Palace of Amenhotep III

Temple of Tuthmosis III

Coptic Church

Remains of Ancient Embankment

Birket Habu

0 1 mile

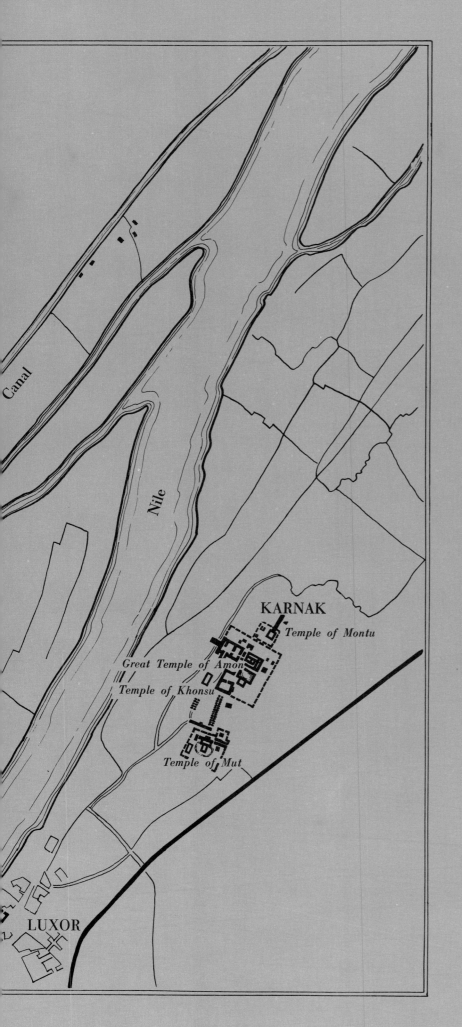

Canal

Nile

KARNAK

Temple of Montu

Great Temple of Amon

Temple of Khonsu

Temple of Mut

LUXOR

MAP I. GENERAL MAP OF THEBES

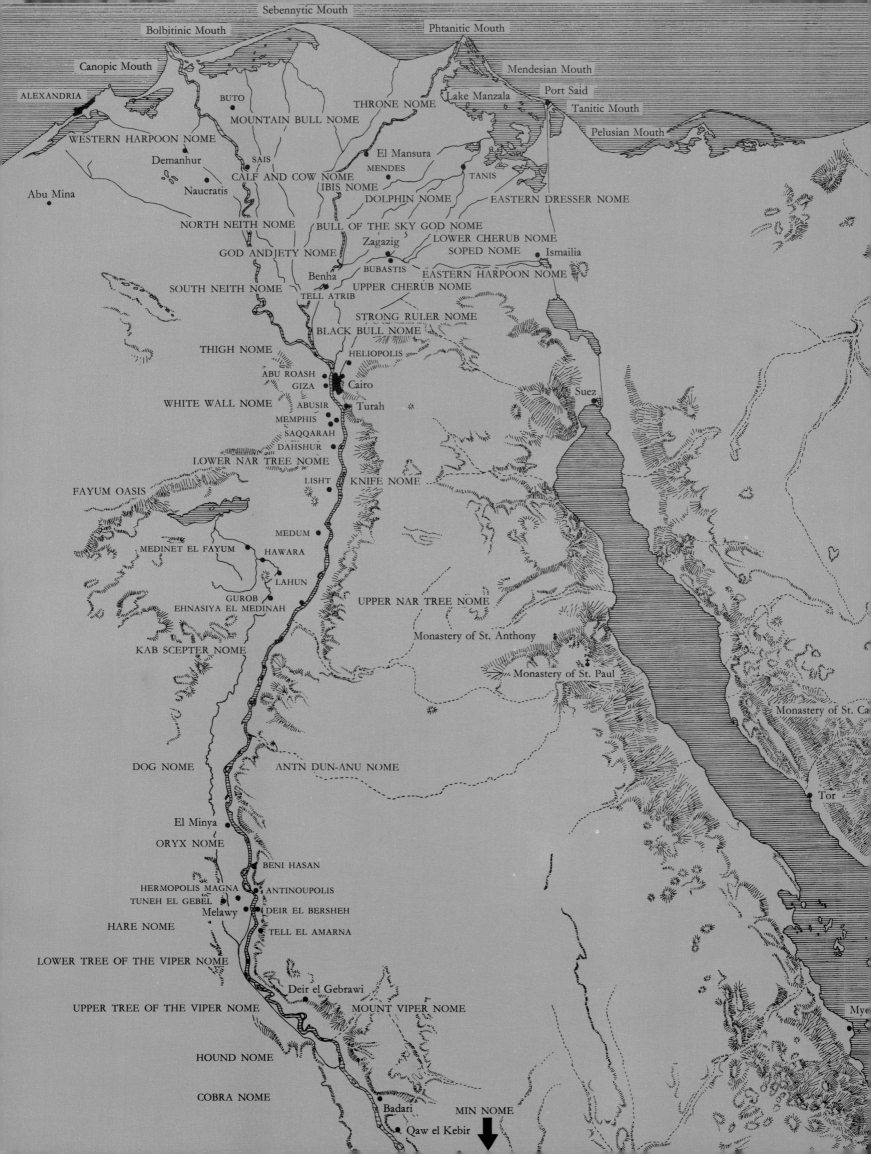

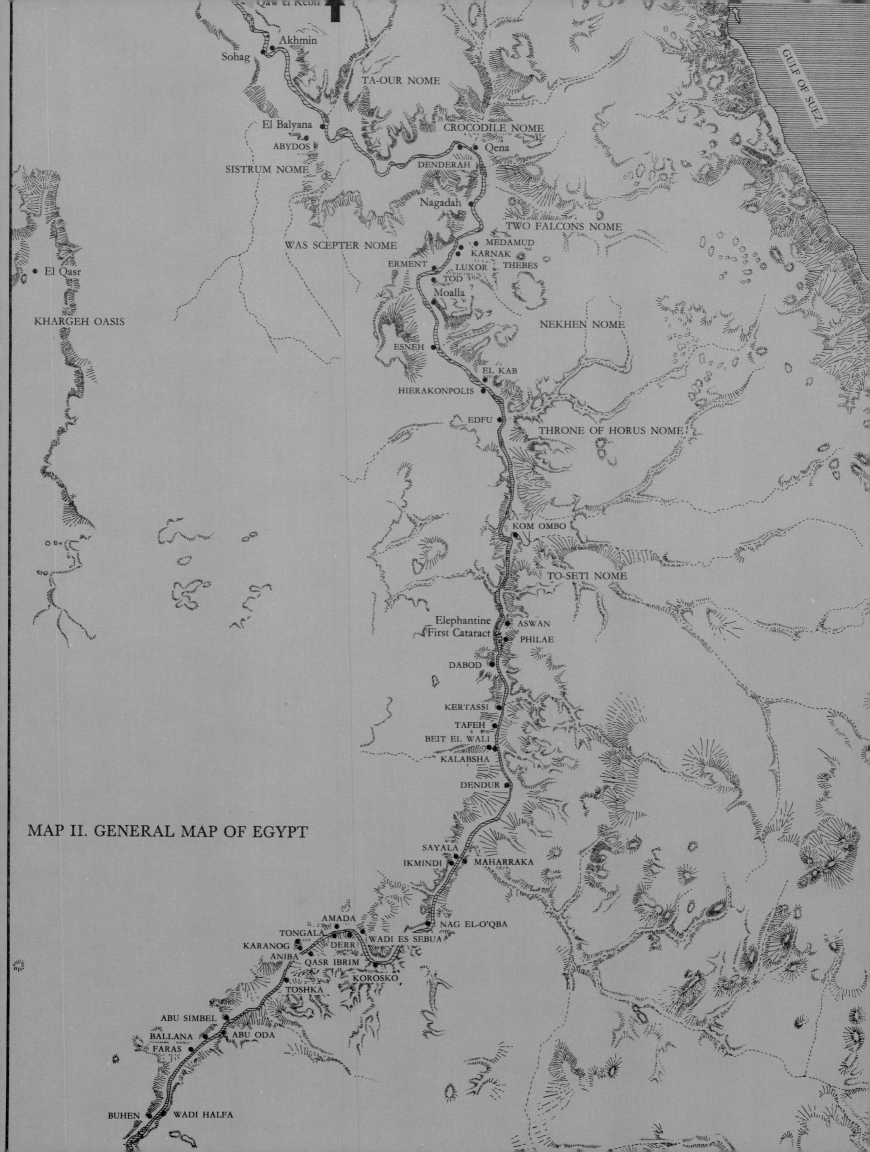

MAP II. GENERAL MAP OF EGYPT

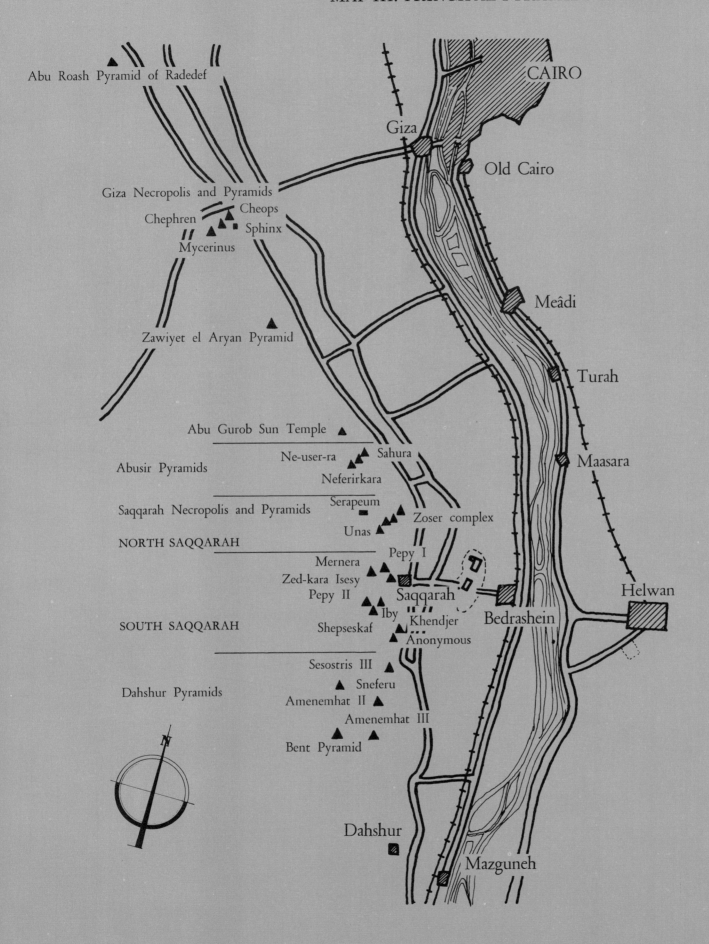

MAP III. PRINCIPAL PYRAMIDS IN LOWER EGYPT

Abu Roash Pyramid of Radedef

CAIRO

Giza

Old Cairo

Giza Necropolis and Pyramids

Chephren

Cheops

Sphinx

Mycerinus

Meâdi

Zawiyet el Aryan Pyramid

Turah

Abu Gurob Sun Temple

Ne-user-ra Sahura

Abusir Pyramids

Neferirkara

Maasara

Serapeum

Saqqarah Necropolis and Pyramids

Zoser complex

Unas

NORTH SAQQARAH

Pepy I

Mernera

Zed-kara Isesy

Saqqarah

Helwan

Pepy II

Iby

Khendjer

SOUTH SAQQARAH

Shepseskaf

Anonymous

Bedrashein

Sesostris III

Sneferu

Dahshur Pyramids

Amenemhat II

Amenemhat III

Bent Pyramid

N

Dahshur

Mazguneh

SELECTED BIBLIOGRAPHY

SELECTED BIBLIOGRAPHY

GENERAL

Works in book form only are given here, primarily the most recent and most easily obtainable.

BISSING, Friedrich Wilhelm von,
Ägyptische Kunstgeschichte, 2 vols. and atlas, Berlin-Charlottenburg, 1934–38.

BOURGUET, P. du, and DRIOTON, Étienne,
Les pharaons à la conquête de l'art, Paris, 1965.

CAPART, Jean,
L'art égyptien, 4 vols., Brussels, 1922–42.

DAUMAS, François,
La civilisation de l'Égypte pharaonique, Paris, 1965.

DESROCHES-NOBLECOURT, Christiane,
L'art égyptien, Paris, 1961.
Le style égyptien, Paris, 1946.

JÉQUIER, Gustave,
Manuel d'archéologie égyptienne, I, Paris, 1924.

MASPERO, Gaston,
History of Egypt, Chaldea, Syria, Babylonia and Assyria, 9 vols., London, 1901.

MATHIEU, Milice,
Iskusstvo drevnego Egipta (The Art of Ancient Egypt), Leningrad-Moscow, 1961.

MICHALOWSKI, Kazimierz,
Nie tylko piramidy (Not Just the Pyramids), Warsaw, 1966.

PIRENNE, Jacques,
Histoire de la civilisation de l'Égypte ancienne, 3 vols., Neuchâtel, 1961–63.

PORTER, Bertha, and MOSS, Rosalind,
Topographical Bibliography of Ancient Egyptian Hieroglyphic Texts, Reliefs, and Paintings, 7 vols., Oxford, 1927–52.

POSENER, Georges, in collaboration with SAUNERON, Serge, and YOYOTTE, Jean,
Dictionary of Egyptian Civilization, New York, 1959.

SMITH, William Stevenson,
The Art and Architecture of Ancient Egypt, Baltimore, 1958.

STEINDORFF, Georg,
Die Kunst der Ägypter, Leipzig, 1928.

VANDIER, Jacques,
Manuel d'archéologie égyptienne, 3 vols., Paris, 1952–58.

WILSON, John A.,
L'Égypte, vie et mort d'une civilisation, Paris, 1961.

WOLF, Walther,
Die Kunst Ägyptens, Stuttgart, 1957.

WRESZINSKI, Walter,
Atlas zur altägyptischen Kulturgeschichte, 3 parts in 8 vols., Leipzig, 1923–36.

CHAPTER 1

BRUNNER-TRAUT, Emma, and HELL, Vera, *Ägypten*, Stuttgart, 1962.

BUDGE, Ernest A.W., *The Dwellers on the Nile*, London, 1927.
————, *The Nile*, London, 1901.

CARRÉ, Jean-Marc, *Voyageurs et écrivains français en Égypte*, 2 vols., Cairo, 1956.

CHAMPOLLION, Jean-François, *Monuments de l'Égypte et de la Nubie*, 4 vols., Paris, 1835–45.

DAWSON, Warren R., *Who Was Who in Egyptology*, London, 1951.

DENON, Dominique-Vivant, *Travels in Upper and Lower Egypt*, London, 1803.
————, *Voyage dans la basse et la haute Égypte*, 2 vols., Paris, 1802.
————, *Description de l'Égypte, ou recueil des observations et des recherches qui ont été faites en Égypte pendant l'expédition de l'armée française*, 9 vols., Paris, 1809–18.

GREENER, Leslie, *Discovery of Egypt*, London, 1966.

LEPSIUS, Karl Richard, *Denkmäler aus Ägypten und Äthiopien*, 12 vols., Leipzig, 1897–1913.

MONTET, Pierre, *Isis, ou A la recherche de l'Égypte ensevelie*, Paris, 1956.

ROSELLINI, Ippolito, *I monumenti dell'Egitto e della Nubia*, 3 parts in 9 vols.: Part I, Monumenti storici, Pisa, 1832; Part II, Monumenti civili, Pisa, 1834; Part III, Monumenti del Culto, Pisa, 1844.

CHAPTER 2

BORCHARDT, Ludwig, and RICKE, Herbert, *Egypt*, New York, 1929.

CHRISTOPHE, Louis A., *Abou-Simbel et l'époque de sa découverte*, Brussels, 1965.

DESROCHES-NOBLECOURT, Christiane, *Campagne internationale de l'UNESCO. Pour la sauvegarde des monuments de la Nubie. Fouilles en Nubie (1959–61)*, Cairo, 1963.

ERMAN, Adolf, and RANKE, Hermann, *Life in Ancient Egypt*, London, 1894.

GREENER, Leslie, *High Dam over Nubia*, London, 1962.

KEES, Hermann, *Ancient Egypt*, London, 1961.

LUCAS, Alfred, *Ancient Egyptian Materials and Industries*, London, 1948.

MONTET, Pierre, *Everyday Life in Egypt in the Days of Ramesses the Great*, London, 1958 (*La Vie quotidienne en Égypte au temps de Ramsès*, Paris, 1946).

NAWRATH, Alfred, *Ägypten, Land zwischen Sand und Strom*, Bern, 1962.

STOCK, Hanns, *Kalabsha*, Wiesbaden, 1965.

WILKINSON, John G., *The Manners and Customs of the Ancient Egyptians*, 3 vols., London, 1878.

WINLOCK, Herbert E., *Models of Daily Life in Ancient Egypt*, Cambridge, Mass., 1955.

CHAPTER 3

ANDRZEJEWSKI, Tadeusz, *Le papyrus mythologique de Te-hem-en-mout*, Warsaw, 1959.

CHAMPOLLION, Jean-François, *Précis du système hiéroglyphique des anciens Égyptiens*, Paris, 1824.

DAVIES, Nina de Garis, *Picture Writing in Ancient Egypt*, Oxford, 1958.

DONADONI, Sergio, *Storia della letteratura egiziana antica*, Milan, 1957.

GARDINER, Alan H., *Egyptian Grammar*, London, 1957.

LACAU, Pierre, *Sur le système hiéroglyphique*, Cairo, 1954.

LEFEBVRE, Gustave, *Romans et contes égyptiens de l'époque pharaonique*, Paris, 1949.

———, *Grammaire de l'égyptien classique*, Cairo, 1955.

POSENER, Georges, *Littérature et politique dans l'Égypte de la XIIᵉ dynastie*, Paris, 1956.

SETHE, Kurt, *Das ägyptische Verbum im Altägyptischen, Neu-ägyptischen und Koptischen*, 3 vols., Leipzig, 1899–1902.

ZABA, Zbynek, *Les Maximes de Ptahhotep*, Prague, 1956.

CHAPTER 4

BAUMGARTEL, Elise J., *The Cultures of Prehistoric Egypt*, 2 vols., Oxford, 1955–59.

BREASTED, James H., *Ancient Records of Egypt*, 5 vols., Chicago, 1906–7.

———, *A History of Egypt*, New York, 1945.

Cambridge Ancient History, vols. I and II, Cambridge, 1961–65.

DRIOTON, Étienne, and VANDIER, Jacques, *Égypte; les peuples de l'Orient méditerranéen*, II, Paris, 1962.

GARDINER, Alan H., *Egypt of the Pharaohs*, Oxford, 1964.

HAYES, William C., *Most Ancient Egypt*, University of Chicago, 1965.

MONTECCHI, Alberto, *Un impero scomparso; l'Egitto faraonico*, Milan, 1957.

MORET, Alexandre, *Histoire de l'Orient*, 2 vols., Paris, 1936.

———, *The Nile and Egyptian Civilization*, London, 1927.

PARKER, Richard A., *The Calendars of Ancient Egypt*, Chicago, 1950.

PETRIE, W. M. Flinders, *A History of Egypt*, 3 vols., New York-London, 1924–25.

CHAPTER 5

ANDRZEJEWSKI, Tadeusz, *Ksiega Umarlych piastunki Kai (The Book of the Dead of the Nurse Kai)*, Warsaw, 1951.

BONNET, Hans, *Reallexikon der ägyptischen Religionsgeschichte*, Berlin, 1952.

BREASTED, James H., *Development of Religion and Thought in Ancient Egypt*, New York, 1959.

CERNY, Jaroslav, *Ancient Egyptian Religion*, London, 1952.

DAUMAS, François, *Les dieux de l'Égypte*, Paris, 1965.

ERMAN, Adolf, *La religion des Égyptiens*, Paris, 1937.

FRANKFORT, Henri, *Ancient Egyptian Religion*, New York, 1948.

KEES, Hermann, *Der Götterglaube im alten Ägypten*, Leipzig, 1941.

LEXA, Frantisek, *La magie dans l'Égypte antique*, 3 vols., Paris, 1925.

SAINTE FARE GARNOT, Jean, *La vie religieuse dans l'ancienne Égypte*, Paris, 1948.

SAUNERON, Serge, *Les prêtres de l'ancienne Égypte*, Paris, 1957.

VANDIER, Jacques, *La religion égyptienne*, Paris, 1944.

CHAPTER 6

BAUMGARTEL, Elise J., *The Cultures of Prehistoric Egypt*, 2 vols., Oxford, 1955–59.

CAPART, Jean, *Les débuts de l'art en Égypte*, Brussels, 1904.

EMERY, Walter B., *Archaic Egypt*, Edinburgh, 1961.

———, *Great Tombs of the First Dynasty*, 3 vols., Cairo-London, 1949–58.

HAYES, William C., *The Scepter of Egypt*, I, New York, 1953.

MASSOULARD, Émile, *Préhistoire et protohistoire d'Égypte*, Paris, 1949.

PETRIE, W. M. Flinders, *Prehistoric Egypt*, London, 1920.

SCHARFF, Alexander, *Die Altertümer der Vor- und Frühzeit Ägyptens*, 2 vols., Berlin, 1929–31.

CHAPTER 7

ALDRED, Cyril, *Old Kingdom Art in Ancient Egypt*, London, 1949.

BADAWY, Alexander, *Le dessin architectural chez les anciens Égyptiens*, Cairo, 1948.

———, *A History of Egyptian Architecture*, vol. I, Giza, 1954.

DRIOTON, Étienne, and LAUER, Jean-Philippe, *Sakkara, les monuments de Zoser*, Cairo, 1939.

EDWARDS, Iorwerth E. S., *The Pyramids of Egypt*, London, 1961.

ENGELBACH, Reginald, and CLARKE, Somers, *Ancient Egyptian Masonry*, London, 1930.

FAKHRY, Ahmed, *The Pyramids*, Chicago, 1961.

GONEIM, Mohammed Zakaria, *The Lost Pyramid*, New York, 1956.

GRINSELL, Leslie V., *Egyptian Pyramids*, Gloucester, 1947.

HASSAN, Selim, *Le Sphinx*, Cairo, 1951.

KOZINSKI, W., *The Great Pyramid Enigma*, Warsaw (in press).

LAUER, Jean-Philippe, *Le problème des pyramides d'Égypte*, Paris, 1952.

MONTET, Pierre, *Les scènes de la vie privée dans les tombeaux égyptiens de l'Ancien Empire*, Strasbourg, 1925.

REISNER, George A., *The Development of the Egyptian Tomb down to the Accession of Cheops*, Cambridge, Mass., 1936.

RÜHLMANN, Gerhard, *Kleine Geschichte der Pyramiden*, Dresden, 1962.

CHAPTER 8

FECHHEIMER, Hedwig, *Die Plastik der Ägypter*, Berlin, 1923.

GARDINER, Alan H., *Ancient Egyptian Onomastica*, 3 vols., Oxford, 1947.

IVERSEN, Erik, *Canon and Proportions in Egyptian Art*, London, 1955.

SCHÄFER, Heinrich, *Von ägyptischer Kunst besonders der Zeichenkunst*, Wiesbaden, 1963.

CHAPTER 9

ALDRED, Cyril, *Middle Kingdom Art in Ancient Egypt, 2300-1590 B.C.*, London, 1950.

BADAWY, Alexander, *The History of Egyptian Architecture*, II, Berkeley, Cal., 1966.

HAYES, William C., *The Scepter of Egypt*, I, New York, 1953.

MATHIEU, Milice, *Iskusstvo drevnego Egipta, Sredneye Tsarstvo (The Art of Ancient Egypt, Middle Kingdom)*, Leningrad, 1941.

WINLOCK, Herbert E., *The Rise and Fall of the Middle Kingdom in Thebes*, New York, 1947.
———, *The Treasure of El Lahun*, New York, 1934.

CHAPTER 10

ALDRED, Cyril, *New Kingdom Art in Ancient Egypt during the Eighteenth Dynasty, 1590-1315 B.C.*, London, 1951.

BILLE-DE MOT, Éléonore, *Die Revolution des Pharao Echnaton*, Munich, 1965.

CHAMPDOR, Albert, *Die altägyptische Malerei*, Leipzig, 1959.

DESROCHES-NOBLECOURT, Christiane, *L'ancienne Égypte. L'extraordinaire aventure amarnienne*, Paris, 1960.
———, *Tutankhamen: Life and Death of a Pharaoh*, New York, 1963.
———, *Toutankhamon et son temps*, Paris, 1967.

FARINA, Giulio, *La pittura egiziana*, Milan, 1929.

HAYES, William C., *The Scepter of Egypt*, II, New York, 1959.

MATHIEU, Milice, *Iskusstvo drevnego Egipta, Novoye Tsarstvo (The Art of Ancient Egypt, New Kingdom)*, Leningrad, 1947.

LIPINSKA, Jadwiga, *Historical Topography of Deir el Bahari*, Warsaw (in press).

MEKHITARIAN, Arpag, *Egyptian Painting*, New York, 1965.

NIMS, Charles F., *Thebes of the Pharaohs*, New York, 1965.

CHAPTER 11

ARNOLD, Dieter, *Wandrelief und Raumfunktion in ägyptischen Tempeln des Neuen Reiches*, Berlin, 1962.

HÖLSCHER, Uvo, *Die Wiedergewinnung von Medinet Habu*, Tübingen, 1958.

JÉQUIER, Gustave, *L'architecture et la décoration dans l'ancienne Égypte*, 3 vols., Paris, 1920-24.

LECLANT, Jean, *Dans le pays des pharaons*, Paris, 1958.

MICHALOWSKI, Kazimierz, *Kanon w architekturze egipskiej (The Canon in Egyptian Architecture)*, Warsaw, 1955.

ROBICHON, Clément, and VARILLE, Alexandre, *Le temple du scribe royal Amenhotep, fils de Hapou*, Institut Français, Cairo, 1936.

WERBROUCK, Marcelle, *Le temple d'Hatshepsout à Deir el-Bahari*, Brussels, 1949.

ZABA, Zbynek, *L'orientation astronomique dans l'ancienne Égypte*, Prague, 1953.

CHAPTER 12

ADRIANI, Achille, *Repertorio d'arte dell'Egitto Greco-Romano*, 2 vols., Palermo, 1961.

BELL, Harold I., *Cults and Creeds in Graeco-Roman Egypt*, Liverpool, 1953.
———, *Jews and Christians in Egypt*, London, 1924.

BOTHMER, Bernard von, *Egyptian Sculpture of the Late Period; 700 B.C. to A.D. 100*, Brooklyn, N.Y., 1960.

BRECCIA, Evaristo, *Alexandrea ad Aegyptum; a Guide to the Ancient and Modern Town*, Bergamo, 1922.

COCHE DE LA FERTÉ, Étienne, *Les portraits romano-égyptiens du Louvre*, Paris, 1952.

HINTZE, Fritz, *Alte Kulturen im Sudan*, Leipzig, 1967.

KIRWAN, Laurence P., *The X-Group Enigma*, New York, 1963.

LEFEBVRE, Gustave, *Le tombeau de Petosiris*, 3 vols., Cairo, 1923-24.

SIEGLIN, Ernst von, and SCHREIBER, Theodor, *Die Nekropole von Kôm esch-Schukâfa*, I, Expedition Ernst von Sieglin, Leipzig, 1908.

TRIGGER, Bruce G., *History and Settlement in Lower Nubia*, New Haven, 1965.

ZALOSCER, Hilde, *Porträts aus dem Wüstensand*, Vienna, 1961.

CHAPTER 13

BOURGUET, P. du, *Die Kopten*, Baden-Baden, 1967.

CAULEUR, S., *Histoire des Coptes d'Égypte*, Paris, 1960.

Koptische Kunst: Christentum am Nil (exhibition catalogue), Essen, Zurich, Recklinghausen, 1963-64.

MATHIEU, M., and LAPUNOVA, K., *Tkani koptskovo Egipta (Textiles of Coptic Egypt)*, Moscow, 1951.

MICHALOWSKI, Kazimierz, *Faras. Centre artistique de la Nubie chrétienne*, Leiden, 1966.
———, *Faras. Die Kathedrale aus dem Wüstensand*, Zurich, 1967.

PIOTROVSKII, Boris Borisovich, and others, *Drevniaya Nubia (Ancient Nubia)*, Moscow-Leningrad, 1964.

SOTIRIOU, Georgios and Marias, *Les icônes du Mont Sinaï*, Athens, 1956-58.

WESSEL, Klaus, *Koptische Kunst. Die Spätantik in Ägypten*, Recklinghausen, 1963.

INDEX OF ANCIENT NAMES
AND SITES IN EGYPT

INDEX

Page numbers having an asterisk refer to the main discussion of the particular site. Figure numbers in bold face type indicate colorplates; figure numbers in text type indicate black-and-white illustrations.*